FREEDOM

Text by Manning Marable
and Leith Mullings
Pictures edited
by Sophie Spencer-Wood

FREEDOM

A PHOTOGRAPHIC HISTORY OF THE AFRICAN AMERICAN STRUGGLE

1840 | 1880

1880 | 1919

1919 | 1954

1954 | 1975

1975 | PRESENT

INTRODUCTION

Freedom will not come
Today, this year
 Nor ever
Through compromise and fear . . .

 Freedom
 Is a strong seed
Planted
In a great need.
I live here too.
I want freedom
Just as you.

 — Langston Hughes, "Freedom"

As African Americans sought to forge themselves as a people in the leviathan of slavery, and in the process expanding democracy for all Americans, the concept of freedom has been central to our struggle. Though freedom has meant different things, at different times, to different people, it has nonetheless been the golden thread in the tapestry of African American history. In the 1960s "freedom now" was the ringing cry of the civil rights movement. Two of its principal expressions were the "Freedom Riders" — black and white young people who rode integrated buses through the segregated South in 1961, and the "Freedom Summer" — the legendary summer of 1964 when several hundred northern college students headed south to work with local black leadership and SNCC activists to help to register voters in Mississippi. "Free at last," the phrase used by Dr. Martin Luther King, Jr. at the climax of his "I Have a Dream" speech of 1963, sadly also became his epitaph.

But as King reminded us, African Americans "with their minds on freedom" emerged much earlier than the 1960s. For centuries African Americans drew on their African cultural background, as well as their experience in the New World, to construct notions of freedom that were significantly different to those of most white Americans. Unlike the emphasis on "life, liberty, and the pursuit of happiness" found in the Declaration of Independence, which celebrates individualism and private property, for much of African American history, there has been a strong awareness of collective approaches to freedom. Deriving in part perhaps from African world views that emphasized the mutual responsibility of society's members, but also imposed by the construction of blackness and whiteness by European settlers, black people immediately understood that the fates of all people of African descent trapped in these terrible circumstances

were linked. In his dedication to the first edition of the *North Star* in 1847, abolitionist Frederick Douglass expressed this unity between free blacks and slaves: "What you suffer, we suffer; what you endure, we endure. We are indissolubly united, and must fall or flourish together." Similarly, early black nationalist leader Martin R. Delany in his black nationalist manifesto, written in 1852, notes: "It is true that our enslaved brethren are here, and we have been led to believe that it is necessary for us to remain, on that account. Is it true, that all should remain in degradation, because a part are degraded? We believe no such thing. We believe it to be the duty of the Free, to elevate themselves in the most speedy and effective manner possible; as the redemption of the bondman depends entirely upon the elevation of the freeman; therefore, to elevate the free colored people of America, anywhere upon this continent forebodes the speedy redemption of the slave."

American notions of freedom formed during the revolutionary period emphasized issues of liberty: freedom *from* constraints — prohibition of state restrictions on personal activities, private property, and protecting the individual from the authority of the state. African Americans' thoughts about freedom, on the other hand, tended to emphasize group justice, rather than liberty, freedoms *to*, for example, work and receive the fruits of one's labor, have families, build institutions, and to determine one's destiny. At the end of America's Civil War in 1865, Union General William Tecumseh Sherman and Secretary of War Edwin Stanton met with a group of African American ministers who discussed the meaning of freedom. One black clergyman observed, "freedom, as I understand it . . . is taking us from under the yoke of bondage, and placing us where we could reap the fruit of our labor, take care of ourselves, and assist the Government in maintaining our freedom."

In order to enact these collective concepts of freedom, African Americans have had to undertake two immense endeavors at the same time. The first was to create a space from which to address the system that held them in bondage. This required imagining and constructing a community. From this foundation it was then necessary to find the means to develop the strategies to confront the structures of oppression.

African Americans created themselves as a people in a context of crushing brutality and inequality. Africans, seized from various societies in Africa, were forced into a system of chattel slavery in the Americas. While forms of bondage existed in some of the societies from which they were captured, chattel slavery — in which individuals surrendered all rights and became solely the property of their owners — rarely existed in Africa. In the U. S., slavery combined the definition of human beings as commodities with the central role of phenotype, more specifically skin color, as the basis of enslavement.

Though most Americans now think of race and slavery as unavoidably linked, enslavement on the basis of racial identity was not inevitable. A contested process, race-based slavery was imposed at different historical points in different places, and in some places, not at all. But once imposed, hereditary enslavement based on race required a powerful series of explanations to rationalize it. The "explanations" that attempted to justify slavery as an institution ranged from religious to pseudo-scientific. Religious doctrines, for example, suggested that the people of Africa were the descendants of Ham, the cast-off son of Noah, or that for African "heathens" salvation lay in enslavement. The pseudo-scientific explanations were perhaps the more dangerous. The now discredited theory of polygenesis, for example, claiming that Africans and Europeans constituted different and unequal species, eventually evolved into more sophisticated notions of race and race difference that persist to this day.

It was within this barbaric system of slavery, supported by a well-developed set of ideologies of inferiority permeating almost all institutions, that African Americans confronted the task of constructing a community. Enslaved Africans, who might find themselves chained together on a slave ship or sold from the same auction block, had been seized from different types of societies, ranging from village communities to ancient states; they spoke different languages and were practitioners of different religions. But as strangers in a strange land, they soon discovered that they could build on what they had in common: nearly all had a sophisticated knowledge of agriculture; most came from societies where kinship was the organizing principle, where everyone was born into a lineage — a long line of kin that situated the individual in an interactive universe; many shared similar rituals around birth and death. With these common cultural elements from their past, as best they could in the conditions of New World slavery, African Americans created a community, an identity, and a voice.

Perhaps one of the cruelest aspects of bondage was the plight of the family and, not surprisingly, family figured strongly in how African Americans thought of freedom. Under slavery, families could create, to some extent, a distinct space apart. Yet family was at once a strength and a vulnerability, a reason to resist but also an impediment to resistance, making people reluctant to place their loved ones in jeopardy. Though the stability of slave families varied with time, region, size of plantation, and predilections of the slave owner, nowhere in the United States was the slave family a legal entity. Separation of families was dreaded. Between 1790 and 1860, as one million enslaved African Americans were moved further south and west to cotton-producing states, there was massive separation and upheaval of existing families. It is estimated that in the upper South, of first marriages one in three was broken by sale, and one-half of the children were separated from at least one parent. The myth of the friendly master was indeed a myth. When family members were separated by death or sale, non-blood kin stepped in, creating extended families. Enslaved relatives tried to maintain ties, seeking news of those from whom they had been separated. After emancipation, the newly freed people attempted to rebuild families, desperately searching for family members who had run away or been sold. In response to the hard times under segregation, migrations, and periodic depressions, African Americans recreated family forms to pool resources and ensure survival. More recently, with the ravages of post-industrialism, family structures are once again in transformation as limited employment opportunities mean that more and more women raise children without financial help from a male spouse. The struggle for the freedom to maintain the integrity of black families has been, and remains, an on-going work in progress.

The African American church played a central defining role in the construction of the African American community. Religion was crucial both as a belief system and a social institution. Africans adopted Christianity as the basic expression of their faith, but not the Christianity of their masters. They drew heavily on Christian beliefs and symbols, but by consciously reworking and transforming them developed a distinctive African American form of Christianity that served their own purposes. Familiar Old Testament stories of the sojourn and liberation of the Hebrews, "let my people go," became a central theme of spirituals and other rituals. This form of Christianity talked about the realities of contemporary life, as well as providing a transcendent vision and faith for a future. Religion was also a means of organization, and the church was one of the few institutions whites permitted to exist in a systematic way during slavery. The formation of African American churches such as the African Methodist Episcopal Church was thus a consequence of both the racial segregation and the desire to create free social space. Churches became the center of black social life, where African Americans could meet, develop leadership, and find mutual sustenance to confront the challenges of segregation and discrimination. In some places churches housed the first schools; during good times and bad, they fed the hungry. Not surprisingly, African American churches eventually became the womb of the civil rights movement, providing much of its formal leadership and organizational infrastructure. As the 1984 and 1988 presidential campaigns of Reverend Jesse Jackson illustrate, the importance of religion as a defining element of African American organizing continues to be highly relevant.

Voluntary associations became the infrastructure of African American civil society. Benevolent societies, burial societies, savings and loan associations, sororities and fraternities were formed to care for the sick, elderly, and disabled, to pool resources, as well as to provide arenas for the development of leadership. Critically important among these were black women's clubs. In the late nineteenth century, across the

country, African American women formed thousands of organizations that became the sole provider of social services to a black community confronting segregation. Through these clubs, tens of thousands of women organized schools, offered care to the impoverished, sick, and elderly, provided child care services, and constructed dormitories for women in domestic service who were constantly subject to sexual exploitation by their employers. These clubs evolved into national associations that were actively involved in the anti-lynching struggle and the campaigns for political enfranchisement. Building upon that tradition, today black feminists actively challenge racist and sexist discrimination within and beyond the African American community.

As African Americans sought to build communities that would allow them to determine their own destiny, there were important themes that infused their thinking about how freedom was to be enacted. For African Americans, freedom, at the most fundamental level, meant freedom of livelihood, freedom to work, freedom to be compensated for the fruits of one's labor. In 1865, in answer to the question of what the newly emancipated freedmen wanted, Frederick Douglass observed: "What is freedom? It is the right to choose one's own employment. Certainly it means that, if it means anything; and when any individual or combination of individuals undertakes to decide for any man when he shall work, where he shall work, at what he shall work, and for what he shall work, he or they practically reduce him to slavery. He is a slave."

After emancipation, as African Americans struggled to gain a foothold in the emerging industrial working class at the turn of the century, and their labor continued to be exploited, some again considered the meaning of freedom of livelihood. For example, in 1912 labor activist Hubert Harrison asked: "Today, fellow sufferers, they tell us that we are free. But are we? If you will think for a moment you will see that we are not free at all. We have simply changed one form of slavery for another. Then it was chattel slavery, now it is wage slavery. For that which was the essence of chattel slavery is the essence of wage slavery. It is only a difference in form. The chattel slave was compelled to work by physical force; the wage slave is compelled to work by starvation. The product of the chattel slave's labor was taken by his master; the product of the wage slave's labor is taken by the employer." Black workers, who created themselves as a militant, self-conscious sector in the 1930s, became the financial base and bedrock of the civil rights movement in the 1960s. Today, with the disappearance of millions of manufacturing and industrial jobs, many now find themselves in precarious economic conditions, facing long term unemployment and underemployment, and uncertain futures.

The freedom to learn has been a critical theme in the construction of the black community, and access to quality education, along with the political franchise, was always an essential demand of the freedom movement throughout its history. In 1903 W. E. B. Du Bois noted: "The bright ideals of the past, — physical freedom, political power, the training of brains and the training of hands, — all these in turn have waxed and waned, until even the last grows dim and overcast. Are they all wrong. — All false? No, not that, but each one alone was over-simple and incomplete. . . . To be really true, all these ideals must be melted and welded into one. The training of the schools we need to-day more than ever, — the training of deft hands, quick eyes and ears, and above all the broader, deeper, higher culture of gifted minds and pure hearts."

The struggle for the freedom to know and to learn began in slavery. Recognizing the empowering nature of knowledge, nearly every state that sanctioned slavery made it illegal for the enslaved to learn to read or write. Not only were slaves punished for these infractions, but anyone teaching them was also subject to severe penalties. Some free blacks were able to obtain an education, however, through schools and literacy and education programs created by religious groups or churches. After emancipation, the yearning for education was so great that it was difficult, if not impossible, to meet the demand. The Freedman's Bureau, a federal agency created in 1865 to assist freemen, established many schools. Free northern blacks and whites went south, setting up makeshift schools, sometimes teaching children during the day and parents at night. So strong was the demand for education that during Reconstruction, African Americans used their newly won right to vote to establish the first publicly funded educational systems in the South. During this period, historically black institutions of higher learning, such as Howard University, Fisk University, Atlanta University, and Hampton Institute, were established. But in the 1880s and 1890s, as the gains of Reconstruction were rapidly being dismantled, blacks were relegated to segregated and poorly funded institutions. Despite their limitations, these schools fostered the development of scholarship and professional service, enhancing the quality of life for millions of African Americans. They became the essential building blocks from which the black middle class and many black political organizations developed. As the civil rights movement gave birth to the black student movement, the understanding of what constituted freedom to learn expanded beyond issues of access. The black student movement of the 1960s, 1970s and 1980s, particularly in predominantly white universities of the North, began to address the question of content, and to demand that the experiences of women, workers, people of color and all subaltern groups be reflected in the curriculum, challenging the foundation of what was traditionally defined as knowledge.

Finally, one of the most important themes of the freedom movement has been freedom of imagination — a people's imagination. This precious freedom to imagine a people

and a future, but also to create music, dance, works of art, poetry, folklore, humor, and to envision new boundaries for the limits of the body, has profoundly influenced Western and world culture. In his 1903 book *The Souls of Black Folk,* Du Bois speaks to the complexity of the meaning of freedom: "Freedom, too, the long-sought, we still seek, — the freedom of life and limb, the freedom to work and think, the freedom to love and aspire. Work, culture, liberty — all these we need, not singly but together, not successively but together, each growing and aiding each, and all striving toward that vaster ideal that swims before the Negro people, the ideal of human brotherhood, gained through the unifying ideal of Race." Through imagining and creating a community, African Americans constructed the foundation from which ordinary women and men pursued their collective dreams of freedom. Families, churches, schools, voluntary associations, poetry, art, and athletics all became sites for the realization and enactment of the freedom struggle. This book presents the rich tradition of ordinary women and men who accomplished the extraordinary. They emerged from these communities and made the connections between the demands for freedom and the strategies to achieve these objectives, acting at specific moments to achieve specific goals.

In pursuit of freedom, African Americans have frequently differed in their views concerning timing, strategies, and tactics. At some historical moments, some have placed more emphasis on racial assimilation within the existing social order, others have advocated the creation of separate institutions, and still others have insisted on changing the socio-economic foundations of the society in which they found themselves. But within this rich diversity, the voices from the pages of black history have produced a common cry of freedom — a freedom to live and pursue their grandest hopes for themselves and their children, to serve others, and to build a nation dedicated to justice.

Freedom has never been bestowed from above, but has been won through struggle from below. "Freedom" has never been "free." There have been victories and disappointments, successes and failures, but there can be no doubt that by testing the limits of democracy, the African American struggle has profoundly altered the meaning of freedom for all Americans. In discussing the student sit-ins, civil rights organizer Fannie Lou Hamer noted: "By and large, this feeling that they have a destined date with freedom, was not limited to a drive for personal freedom, or even freedom for the Negro in the South. Repeatedly it was emphasized that the movement was concerned with the moral implications of racial discrimination for the 'whole world' and the 'Human Race.'" The black freedom movement's successful desegregation efforts produced the context for the 1965 liberalization of the immigration laws, which were previously based on race. It helped to create a model and process for legislation for the expanded rights of senior citizens, women, tenants, the disabled,

Latinos, American Indians, Asian Americans, and others. African American women, through their long history of denial of protections and restrictions afforded to women, have taken the lead, through word and deed, in challenging the subordination of women.

Furthermore, from early on, African Americans have connected their struggles to those throughout the world, and the tactics and symbols of the movement have inspired anti-colonial, liberation, and anti-discrimination movements — from India, where a group of Dalits (untouchables) adopted the name of the Black Panthers, to South Africa under the apartheid regime where the liberation movement sang, "We Shall Overcome." As King wrote in 1957: "The determination of Negro Americans to win freedom from every form of oppression springs from the same profound longing for freedom that motivates oppressed peoples all over the world. The rhythmic beat of deep discontent in Africa and Asia is at the bottom of a quest for freedom and human dignity on the part of people who have long been victims of colonialism. The struggle for freedom on the part of oppressed people in general and of the American Negro in particular has developed slowly and is not going to end suddenly. Privileged groups rarely give up their privileges without strong resistance. But when oppressed people rise up against oppression there is no stopping point short of full freedom. Realism compels us to admit that the struggle will continue until freedom is a reality for all the oppressed peoples of the world."

The struggle continues.

1840

1880

LET MY PEOPLE GO

LET MY PEOPLE GO

When Israel was in Egypt land,
Let my people go,
Oppressed so hard they could not stand,
Let my people go.

 — "Go Down Moses," traditional Negro Spiritual, nineteenth century

Slavery was not an accidental element in the development of the New World colonies that would, after 150 years, be known as the United States of America. European settlers who came to British North America were driven by a variety of motives. Some came in search of religious freedom; Georgia was originally populated by convicts, the poor, and indentured servants; the Dutch established New Amsterdam (subsequently New York) as a trading and commercial center of its large overseas empire of colonies from southeastern Asia to the Caribbean. But in every colony, to a greater or lesser degree, the enslavement of Africans as involuntary labor played a central chapter in the construction of these frontier societies. Historians estimate that perhaps fifteen million Africans were transported across the Atlantic Ocean between 1500 and 1870. This figure does not count the millions of Africans who perished along the way, whose dead bodies were hurled to the bottom of the ocean. Nor does it account for the millions more who were killed resisting capture and imprisonment, nor those who died of starvation and disease in European dungeons at trading outposts established along the West African coastline by Europeans to facilitate trade. From the beginning it was a brutal business: the separation of families, the division of children from parents; the branding of human beings with hot pokers, like livestock; the use of the whip and other methods of discipline to impose fear; the deliberate use of rape as an act to terrorize women and men alike. All historical evidence drawn from the narratives and writings of formerly enslaved Africans and African Americans tells this terrible story of human suffering. It was this series of crimes and the utility of exploiting the involuntary labor power of the enslaved that produced the ideology of white supremacy and black subordination that many people throughout the world still believe to be true. And it was the struggle by people of African descent to assert their dignity as human beings, to resist their constant degradation, that formed the foundation of the struggle for black freedom that continues to this day.

Almost from the beginning the transatlantic slave trade was a regulated monopoly. By the mid-1500s, ten to fifteen thousand Africans a year were being transported in overpacked slave ships to the Americas. The Spanish and Portuguese first controlled all the traffic in slaves; Dutch merchants became aggressively involved in the late 1500s and for sixty years largely dominated the trade. The French and English began controlling the traffic of human chattel at the beginning of the eighteenth century. Over time, the amount of human cargo became massive. About four million Africans were forcibly transported to the Portuguese colony of Brazil. Jamaica received at least 750,000 slaves. The French sugar cane plantation island of San Domingue, later known as Haiti, imported nearly 900,000 slaves, with the approximate ratio of males to female at ten to one. Traders and planters did not expect African laborers to reproduce families; they were there simply to work until they died. Between 1619 and 1860, about 650,000 Africans were involuntarily transported into what would later become the United States. Charleston and New York City were the largest slave trade depots. By 1750, there were about 240,000 Africans living in the American colonies, about one-fourth of the European settler population of 950,000. By the time of the American Revolution, the slave population exceeded 450,000 and was increasing annually. In South Carolina, blacks outnumbered whites by a margin of two to one. In the United States, as elsewhere, the slave trade was a lucrative enterprise. In 1800, a prime field worker, an adult male in his early twenties, could fetch $500 at most slave auctions.

African slaves quickly understood the nature of the regime in which they lived — and they fought it constantly and relentlessly. The most common form of protest was what historians have described as "day-to-day resistance." Enslaved blacks destroyed farm tools, burned barns and storage bins, broke machinery, and engaged in work slowdowns. Thousands simply ran away, forming maroon or runaway communities of ex-slaves in frontier woodlands and swamps outside of white settlers' areas of control. In rarer instances, they plotted conspiracies and open rebellions. In 1739, blacks near Charleston murdered armed white guards, captured weapons, and for several days terrorized and killed local white planters and their families. Before the Stono, South Carolina rebellion was suppressed, thirty whites and forty-four blacks had died. In 1800, Gabriel Prosser organized a widespread conspiracy involving more than one thousand slaves, with the goal of seizing Richmond, Virginia, taking control of the city's armory, and distributing weapons to provoke a general uprising. In 1831 Nat Turner, a slave preacher, incited a revolt in southern Virginia, leaving sixty whites dead. In retaliation, several hundred slaves, most of whom had no involvement in the uprising, were summarily executed, with some decapitated and their heads publicly displayed as a general warning to other blacks. An estimated 50,000 slaves successfully fled the southern states and escaped to free territories in the North and Canada, which had abolished slavery in the early nineteenth century.

The reality of slavery as an important economic and social institution required whites to impose restrictions on the movements and activities of all African people, whether slave or free. Slave codes varied, but nearly all of them stripped blacks of any real

rights. Slaves were not permitted to travel without written permission from their masters; they had no freedom of assembly; they were subjected to curfews at night; they could not own firearms; in most slave states, it was illegal to teach slaves to read and write; slaves could not make contracts, vote, or claim access to any civil liberties; they could not testify against whites in courts; the rape of an enslaved woman was not generally considered a crime and no slaves under any circumstances had a legal right of self-defense. Free blacks and mulattoes experienced similar, if less severe, restrictions.

The question of slavery constantly surfaced as a dilemma, especially for white Americans who espoused their own rights to democratic government and civil liberties. One notable example of this occurred during the American Revolution. George Washington, the commander of the American Continental Army, initially issued strict orders prohibiting the recruitment and arming of slaves. However, Virginia's British governor, Lord Dunmore, issued a proclamation in late 1775 granting freedom to all slaves and white indentured servants who took up arms for the British crown and joined in the suppression of the colonial rebellion. Recognizing their mistake, Washington and the Continental Congress hastily reversed their position, inviting African Americans to join their crusade for liberty — a liberty that they did not enjoy. About 5,000 blacks fought for the American forces during the revolution, many fighting with distinction in critical battles. The great majority of blacks, however, wisely sided with the British Empire. Corps of runaway slaves were trained and served in the British army; an estimated 12,000 Georgia slaves escaped with the British army when the conflict came to the South. Virginia slaves abandoned their plantations by the tens of thousands. About 25,000 former slaves departed the states with the British after the battle of Yorktown, when the peace treaty was signed in France.

Although the northern states in the new American republic had already taken steps toward the gradual abolition of slavery, the "peculiar institution" was too central to the southern economy to be abandoned. At the Philadelphia Constitutional Convention of 1787, twenty-five of the fifty-five delegates in attendance were slave owners, including George Washington, who presided over the deliberations. The new Constitution that established the United States of America was a contradictory document, which in key respects reinforced slavery as a regional institution. The Constitution's article I, section 2, the so-called "three-fifths compromise," permitted slave states to count three-fifths of their slave populations for purposes of determining representation in the new House of Representatives. Article I, section 9 declared that the transatlantic slave trade could not be prohibited for at least twenty years. Article IV, section 2 stated that "no person held to Service or Labour in one State, under the Laws thereof, escaping into another, shall, in Consequence of any Law or Regulation therein, be discharged from such service or Labour, but shall be delivered up on Claim of the Party to whom such Service or Labour may be due." But the same constitution established the basic framework for the construction of a representative democracy in which its citizens could claim freedoms that did not exist anywhere else in the world at that time. "We, the People" did not yet include African Americans, women, indentured servants, American Indians, immigrants of non-European descent, and many white males without property. Yet the promise of a process of democracy was imbedded within the Constitution, and it seemed possible to expand the boundaries of that social contract one day to include those who had initially been excluded from citizenship.

In the eighteenth century, slaves were concentrated largely in two geographical regions: the Chesapeake basin and tidewater lands of Virginia and Maryland, and the seacoast of the Carolinas. Africans already had extensive experience in planting and cultivating rice and other tropical crops in West Africa, and they took those same skills with them to the New World. Rice and sugar were the chief agricultural commodities produced in South Carolina, and tobacco predominated in Maryland and Virginia. It was only in 1793, with the invention of the cotton gin, and the industrial revolution in Western Europe — and later in New England — that cotton developed as a mass-produced commodity for a global market. The Chesapeake region began to shift its investments into the reproduction of slaves for the developing markets in the new states of Mississippi, Alabama, Tennessee, Arkansas, and Louisiana. In 1820, there were only 75,000 slaves in Alabama and Mississippi, but by 1840 their numbers had reached nearly 500,000. Cotton production required large teams of disciplined, hardworking field hands, who were capable of working twelve hours and sometimes more per day doing backbreaking labor. By the 1830s the South was producing more than 550 million pounds of cotton annually. Slaves were integral to the economic welfare of millions of white Americans who themselves never owned slaves, and the profits generated by this system of slave labor were enormous, affecting nearly every aspect of American society. Northern banks and commercial institutions loaned money to cotton merchants; insurance companies issued life insurance policies on slaves with their masters as beneficiaries, thus protecting them from the loss of their investments; major universities established their endowments and constructed buildings with the profits of the slave trade; roads, canals, and railroads were often constructed with slave labor; even the White House, the Capitol building, and the foundations of the Washington Monument in the nation's capital were constructed in part by slaves.

Historians generally estimate that about three-fourths of all African Americans who were enslaved worked in agricultural production; but slaves were assigned to perform

a wide variety of tasks. In Charleston, South Carolina, slaves and free blacks were commonly employed as butchers, blacksmiths, carpenters, painters, plasterers, plumbers, brick masons, stonecutters, and shoemakers. In Philadelphia, prior to the abolition of slavery by the Commonwealth of Pennsylvania, enslaved Africans worked as candlemakers, clockmakers, silversmiths, cooks, barbers, tailors, and in childcare. Urban slaveholders generally owned small numbers of slaves, with two or three in individual households. Even in the rural cotton-growing regions, work-gangs seldom numbered more than fifty slaves. The vast majority of whites, even in the South, owned no slaves at all. The typical white master owned about twelve slaves — about three-quarters of all slaveholders owned less than twenty slaves. But, remarkably, the overwhelming majority of white Americans — who did not directly profit from enslavement — nevertheless believed in the legality and morality of keeping millions of human beings in bondage. They benefited materially from the exploitation of others, and after a bitter, intersectional debate that threatened to destroy the United States, they were prepared to sacrifice their lives to preserve slavery as an institution.

From the beginning of the development of free black communities in North America, African Americans sought to create institutions that could sustain themselves and foster greater degrees of independence and empowerment. The central institution that was critical to this process of community building was the church. The African Methodist Episcopal (AME) Church's origins go back to 1786, under the leadership of the Reverend Richard Allen. The most popular Christian denomination for African Americans was the Baptists, whose racial egalitarianism and outreach efforts into slave communities set them apart from other whites. Black faith found expression through a new and extraordinary musical form, the Negro spirituals. These songs conveyed the deep faith blacks held in God and in their own humanity, and conveyed, in a powerful language, their ideals of freedom. They were brilliantly constructed to convey hidden messages of resistance, which most slaveholding whites did not understand.

Free blacks in the northern states soon developed fraternal organizations and social clubs to create networks of friendship and cooperation. The Prince Hall Masonic lodges were established in Boston, Philadelphia, Providence, and other cities by the early 1800s. Other fraternal groups, such as the Grand Order of Odd Fellows, the Daughters of Jerusalem, and the United Brothers of Friendship and Sisters of the Mysterious Ten soon followed. Such voluntary associations allowed blacks to pool their resources and provided networks to construct housing, schools, and businesses. Historian John Hope Franklin observes that Philadelphia blacks owned almost one hundred homes in that city by 1800. Blacks in New York City owned $1.4 million worth of real estate in 1837. Maryland's free black community owned $1 million in real estate

prior to the Civil War, and free blacks in New Orleans owned $15 million worth of property. Blacks started about thirty newspapers in the North prior to emancipation, including Frederick Douglass' *North Star*, Martin R. Delany's *Mystery*, and John Russwurm and Samuel Cornish's *Freedom's Journal*.

Free blacks were actively engaged in the growing national debate over slavery. They established vigilance committees, secret underground networks that provided food, clothing, and shelter to runaway slaves. They petitioned legislatures to demand voting rights and attempted to abolish racial segregation in northern schools, public transportation, and public accommodations. In 1830, black representatives gathered in Philadelphia to establish what historians later termed the Negro Convention Movement, a series of people's assemblies held at regular intervals throughout the North, debating strategies and public initiatives designed to overthrow slavery in the South and institutional racism across the nation. The Negro Convention Movement produced a generation of abolitionists who influenced the course of American history: Douglass, the chief orator and spokesman of the freedom movement; Delany, black nationalist leader and advocate of black migration; the Reverend Henry Highland Garnet, who declared that the Negro's "motto" should be total "resistance." African American women were also among the leaders in this fight for freedom: Sojourner Truth, orator and visionary; Frances Ellen Watkins Harper, popular public lecturer, poet, and early feminist; Mary Ann Shadd Cary, newspaper editor, author, and abolitionist organizer; and the fearless Harriet Tubman, who personally led nineteen successful trips into the slave South, bringing back 350 enslaved blacks to freedom.

In 1861, when Abraham Lincoln launched the Civil War with the prime objective of preserving the Union, African Americans and their white abolitionist allies understood immediately that victory would mean the death of slavery. As in the American Revolution, whites in the North first opposed the armed participation of blacks in the conflict. But as the North's casualty figures mounted, and after a series of military defeats by the South's armies, the federal policy for black volunteers was reversed. By the end of the conflict, more than 180,000 African Americans had joined the Union Army, 38,000 of whom died, with another 30,000 wounded. Blacks fought with special determination, because if they were captured, they would be sold into slavery. Confederate soldiers sometimes did not permit African American combatants from the Union Army to surrender after battles: many hundreds of captured black Union soldiers were simply executed and in some cases burned alive.

Through their own actions and by their own sacrifices, African Americans had freed themselves, and in 1865 the passage of the Thirteenth Amendment to the

Constitution, which abolished slavery, legally sanctioned this fact. For a decade after the conflict, blacks pressed for the creation of a new democracy, a new social contract that would include them as full citizens, with access to the same rights and opportunities as their fellow citizens who were white. America's first experiment in biracial democracy, Reconstruction, was a massive effort to redefine the meaning of American freedom. As black males won the right to vote with the Fifteenth Amendment, the beginnings of representative democracy took shape across the South. But contrary to the images popularized by films such as *Gone With the Wind*, black domination never existed in the postbellum South. Only twenty African Americans were elected to the House of Representatives, and only two served in the U. S. Senate, but many of these officials were better prepared and better educated than their white colleagues in Congress. Four of the Reconstruction-era black Congressmen held college degrees, and five were attorneys. Mississippi Senator Hiram Revels, for example, had been trained at an Ohio seminary and had attended Knox College in Illinois. During the war he had served as a regimental chaplain. John Roy Lynch was elected to the Mississippi state legislature in 1869, where he served as House Speaker before his election to Congress for three terms. Francis L. Cardozo, South Carolina's secretary of state from 1868 to 1872, had been educated at the University of Glasgow. Black legislators throughout the region emphasized the establishment of public educational systems, the passage of laws protecting civil liberties and rights, and the construction of local infrastructure to assist commerce, such as roads, railways, and harbors. They made no efforts to expropriate the land and property of most of the wealthy white Southerners who had profited from enslaving them. At the national level, the Freedman's Bureau was established, which provided over twenty-one million rations of food to war-stricken areas, and one-fourth of the recipients were white. By 1870, Freedman's Bureau–sponsored schools were educating a quarter of a million students with almost 10,000 teachers. The African Methodist Episcopal Church and Baptist churches actively participated in constructing new schools that benefited both races. From 1865 to 1869, black religious organizations established over 250 schools in North Carolina alone, which served 15,600 students.

If the masses of African Americans during Reconstruction had been granted the promised "forty acres and a mule" and had become small property owners and farmers, owning the necessary equity to finance their own businesses, schools, and industries, a civil rights movement one hundred years later might not have been necessary. This form of reparations, payment for nearly 250 years of uncompensated black labor, would have moved black history into a new different direction. But the great tragedy of the Reconstruction era was the failure of general land reform. In southern states, the wealthiest whites controlled their old estates and continued to exercise economic power over blacks and poor whites alike. By 1875, roughly 5 percent of the South's white population owned 40 percent of the region's productive farmland. The top 10 percent of all white farmers controlled 50 to 70 percent of each state's land. More than 90 percent of the black rural population never achieved the dream of "forty acres." Despite their general lack of capital, however, and burdened with an illiteracy rate of 95 percent, the newly freed men and women still struggled, with some success, to acquire their own land. By the early 1870s, black farmers in Virginia had managed to purchase over 80,000 acres. By 1875, Georgia's black community owned 400,000 acres of land, appraised at $1.3 million.

The southern white elite was determined to regain state power, and as white northern support for Reconstruction subsided, the new structures of biracial democracy were dismantled, brick by brick. Virginia and North Carolina state governments were regained by white conservatives in the early 1870s; by the mid-1870s, Texas, Alabama, and Arkansas had also reverted to conservative Democratic rule. In the presidential election of 1876, Democratic candidate Samuel J. Tilden defeated the Republican, Rutherford B. Hayes, in the popular vote, but contested votes in the Electoral College left the result uncertain. Democrats agreed to let Hayes become president if federal troops were removed from the South, and if the "Negro Question" was permitted to become, once again, a "Southern Question." Behind these political maneuvers was the terrible reality of racist violence. Vigilante groups such as the Ku Klux Klan and the Knights of the White Camellia carried out attacks against black churches, schools, and public officials. The Republican Party retreated from its brief commitment to black equality. In 1883, the Supreme Court declared the Civil Rights Act of 1875 unconstitutional. The short-lived experiment in freedom would soon wither away, only to be reborn after many bitter years of struggle.

001. Enslaved African
Americans, South Carolina,
c. 1860s. The exploited labor
of enslaved Africans was
essential to the construction
of the U. S. economy. For
example unfree black labor,
producing millions of bales
of cotton, was central to the
development of the textile
industry and the industrial
revolution in the North.
Approximately three fourths
of all enslaved African
Americans worked in agricul-
tural production and the
majority lived in the South,
but slavery was legal in most
northern states until
the late eighteenth and early
nineteenth centuries.

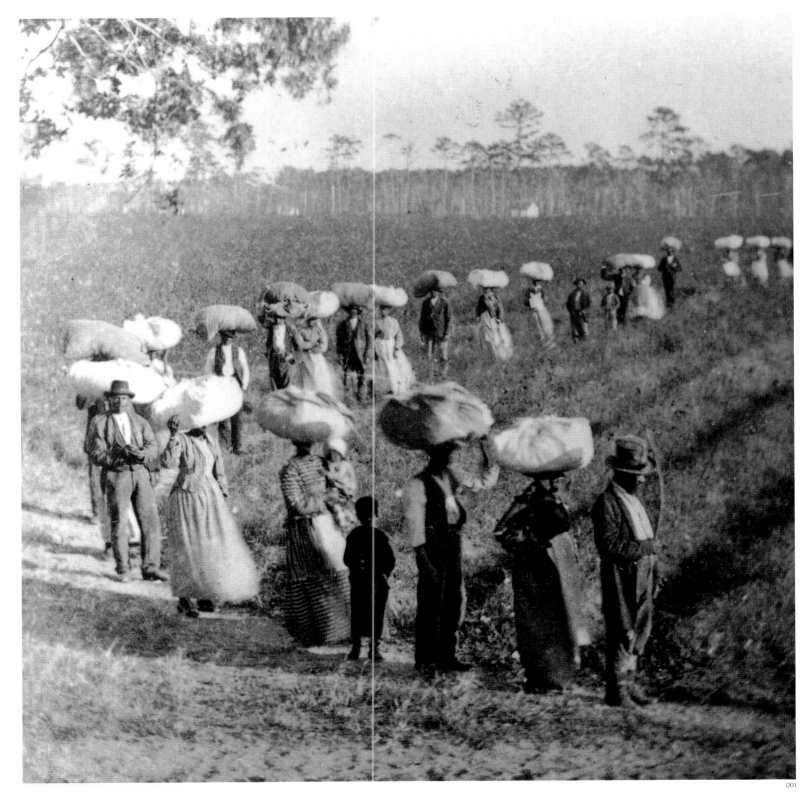

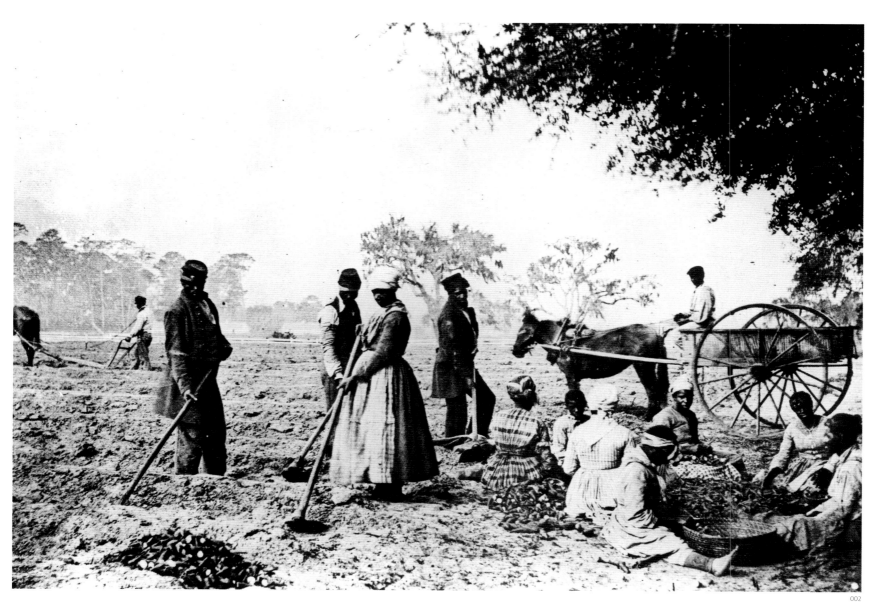

002. Slaves planting sweet potatoes on the James Hopkinson Plantation, South Carolina, 1862. Although a sizable proportion produced cotton, enslaved black people were assigned to do a wide variety of jobs. Recent historians have observed that the majority of fieldworkers were women. A significant number of men were employed as mechanics, skilled artisans, brick masons and gang laborers building roads, railroads, and canals.

003. Negro quarters, Drayton's Plantation, Hilton Head, South Carolina, c. late 1860s. Although the physical distance between the master's mansions and the slave shanties was small, the cultural and psychological distance between the two communities was wide indeed. Within the slave quarters, black people built a world of their own through kinship, ritual, folklore, and tradition.

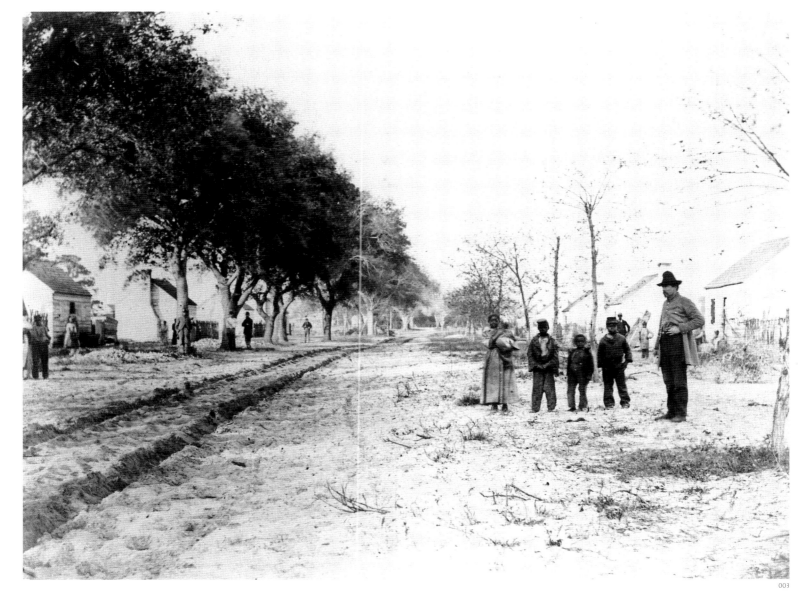

003

004. Frederick A. Douglass (second from left in the foreground) at a Fugitive Slave Convention, Cazenovia, New York, 22 August 1850. Frederick Douglass was born into slavery in Talbot County, Maryland in 1818. He was the son of an enslaved woman named Harriet Bailey and an unknown father rumored to be her master. As a teenager he was apprenticed to work in the shipbuilding industry in Baltimore. With the assistance of a free black woman named Anna Murray, whom he later married, he successfully fled the South in 1838. He soon began an extraordinary career as a public lecturer and political activist in the growing anti-slavery movement. Douglass' first memoir, *Narrative of the Life of Frederick Douglass*, published in 1845, was influential in building popular support for the abolition of slavery. He founded several important anti-slavery publications, including the *North Star* (1847–51) which later became *Frederick Douglass' Paper* (1851–60).

With the passage of the Compromise of 1850, the legal rights of former slaves living in free states were severely jeopardized. The Cazenovia meeting was called to protest the Fugitive Slave Act of 1850, which allowed federal marshals to arrest fugitive slaves and return them to their alledged owners regardless of where in the Union they might be situated at the time of their arrest. The meeting was held in an apple orchard because the crowd, too large for the original meeting hall, was not permitted to use any other building. Douglass compared the abolitionist movement to a nearby tree which, "like the cause it shelters has grown large and strong and imposing." As the photo illustrates, black and white women were central figures in the anti-slavery movement, and Douglass was an active proponent of women's suffrage and the emancipation of women.

For four decades after the Civil War, Douglass was a leader of the anti-slavery Republican Party and the most prominent African American spokesperson in the country. Douglass died in 1895.

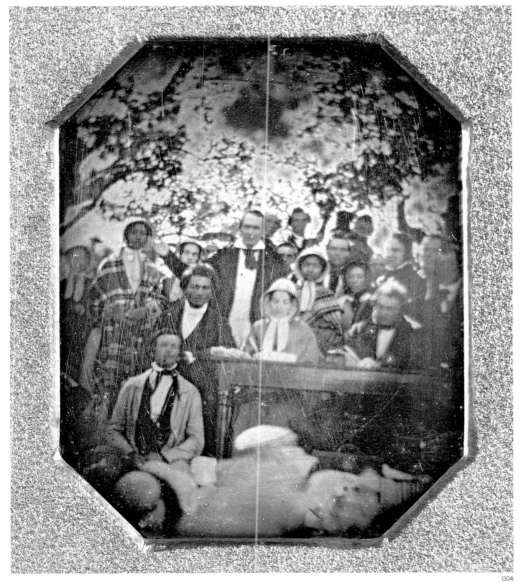

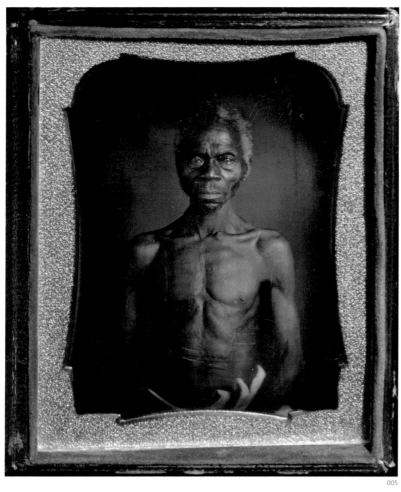

005

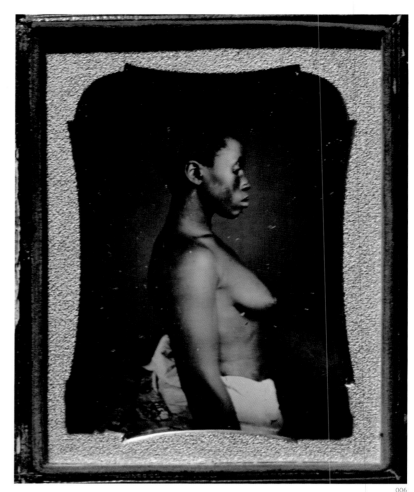

006

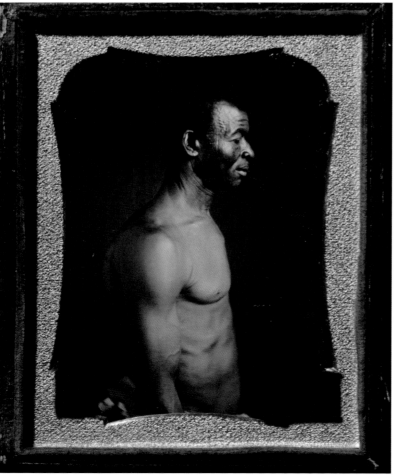

007

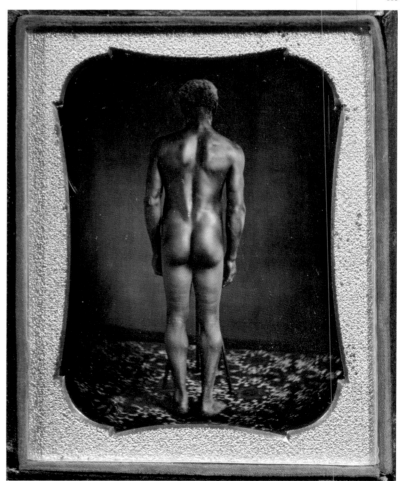

008

005. Renty, Congo, 1850.

006. Delia, American-born daughter of Renty, Congo, 1850.

007. Jack (driver), Guinea, 1850.

008. Jem, Gullah, 1850.

009. Fassena (carpenter), Mandingo, 1850.

In 1850 photographer Joseph T. Zealy created daguerreotypes of seven enslaved Africans. Swiss-born biologist and naturalist Louis Agassiz commissioned these early photographs, which were usually labeled with the individuals' names, geographic origins, and names of the owners of the plantation where they were enslaved. The individuals were photographed in poses designed to provide anthropomorphic evidence that Africans constituted a biologically distinct, and inferior, human group. Polygenesis, the now discredited theory that races, like species, evolved separately and are endowed with different and unequal capacities, provided defenders of slavery with a pseudo-scientific rationale for the enslavement of Africans.

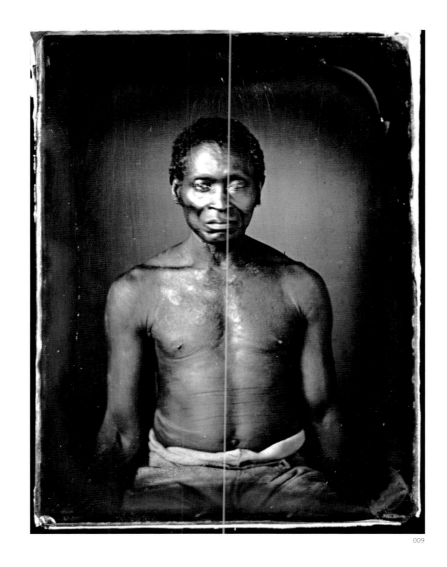

009

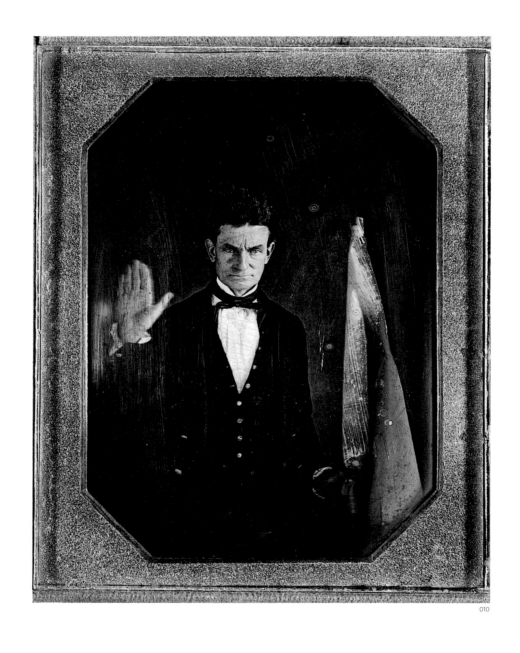

010

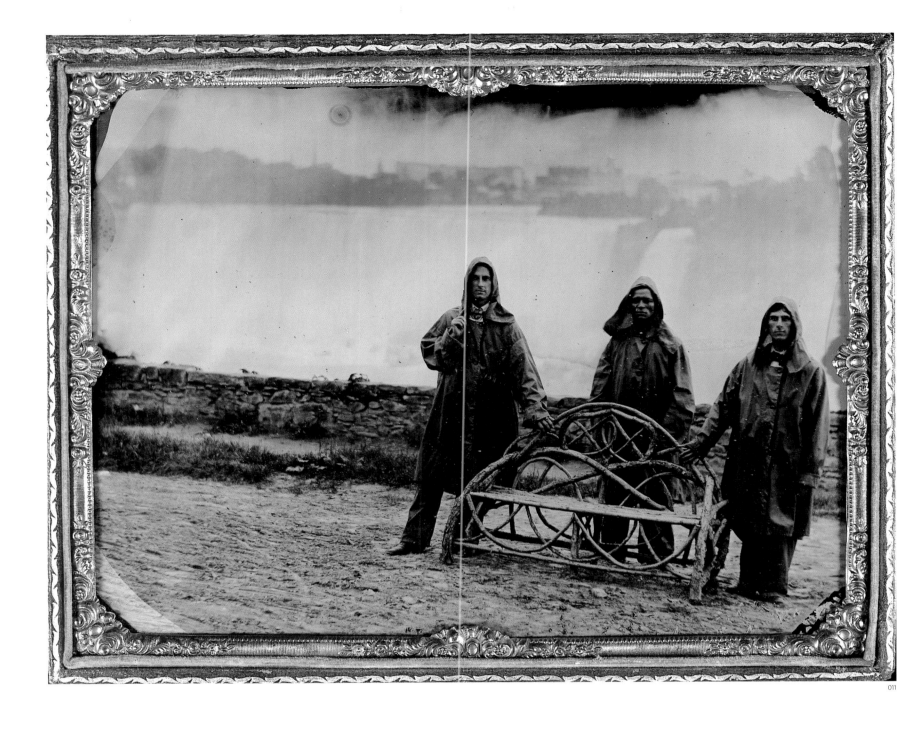

011

010. Portrait of John Brown, Hartford, Connecticut, 1846. This daguerreotype by African American photographer Augustus Washington, who advertised his studio in a Connecticut anti-slavery paper, is the earliest portrait of John Brown. Brown (1800–1859) was one of the most prominent radical abolitionists. Born into a deeply religious Virginia family that opposed slavery, he became active in the anti-slavery movement in the 1840s. He helped to organize the underground railroad and in 1851 was co-founder of the League of Gileadites, an interracial group that provided support to fugitive slaves. In 1854 Congress passed the Kansas–Nebraska Act, establishing the principle of "popular sovereignty" mandating territorial legislatures to determine whether their states would permit or outlaw slavery. Thousands of anti-slavery and pro-slavery settlers traveled to Kansas, where violent confrontations occurred. When pro-slavery zealots attacked the anti-slavery town of Lawrence, Kansas in 1856, Brown launched a series of raids against pro-slavery settlements in retaliation. A few years later he planned a military attack on a federal arsenal at Harper's Ferry, Virginia (now West Virginia) in the hope that it would spark a general slave uprising. On 16 October 1859, Brown led a small band of 17 white (some of whom were Brown's sons) and five black men to attack the arsenal. A battalion of marines, led by Colonel Robert E. Lee, overwhelmed and captured Brown and most of his party. After a brief trial, Brown was hanged on 2 December 1859. Before his execution, he declared "I have only a short time to live — only one death to die: and I will die fighting for this cause."

011. Abolitionists at Niagara Falls, c. 1860. This scene shows two white men assisting a black man to freedom in Canada. The Fugitive Slave Act of 1850 required the arrest and return to the South of any black person accused of being a runaway slave. As a result, several thousand African Americans in the North, including many who had never been enslaved, fled to Canada where slavery had been outlawed years before.

25

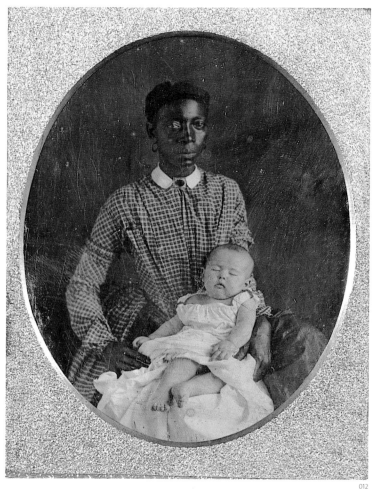

012

012. Enslaved woman and white child, c. 1850. For generations African American women were the primary caretakers of well-to-do southern children. The representation of the "mammy" — the faithful, obedient domestic servant — became part of white southern folklore. Contemporary African American scholars have deconstructed the image of the "contented mammy," however, suggesting a figure of complexity who used a stereotype as a means of surviving and working in oppressive environments.

013. Unidentified woman, probably of the McGill family, Liberia, c. 1857. This group of four daguerreotypes (013–016) are portraits of African Americans who resettled in Liberia in the 1830s and 1840s. In 1816 the American Colonization Society was founded to encourage the immigration of African Americans to West Africa. The motives of those supporting repatriation varied. Many felt that people of African descent could never be successfully assimilated into a white majority society; others thought that the presence of African Americans posed a threat to white America; still others believed that African Americans could promote the spread of Christianity on the African continent. A small number of African American leaders, such as Philadelphia merchant James Forten, were interested in commercial trade with Africa and supported colonization efforts. With the establishment of Liberia in 1822, the American Colonization Society began to finance the transportation of free African Americans back to Africa. After three decades the society had transported over 12,000 African Americans to Liberia. These photographs were taken by Augustus Washington, who moved to Liberia in 1853.

014. Edward James Roye, senator, Liberia, c. 1857.

015. Philip Coker, chaplain of the Senate, Liberia, c. 1857.

016. James Skivring Smith, Secretary of State, Liberia, c. 1857.

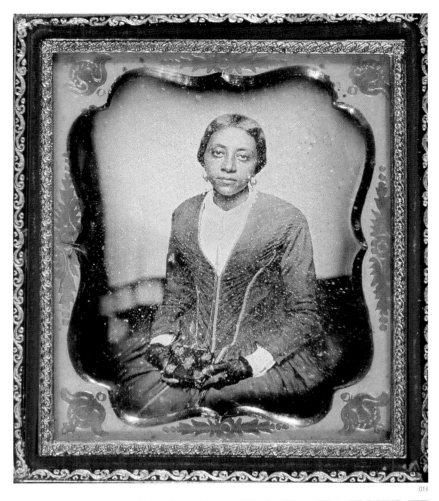

013

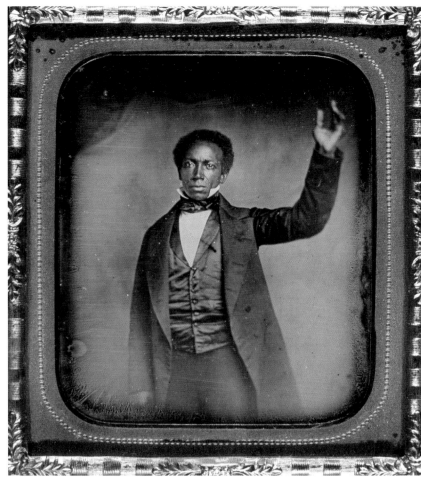

014

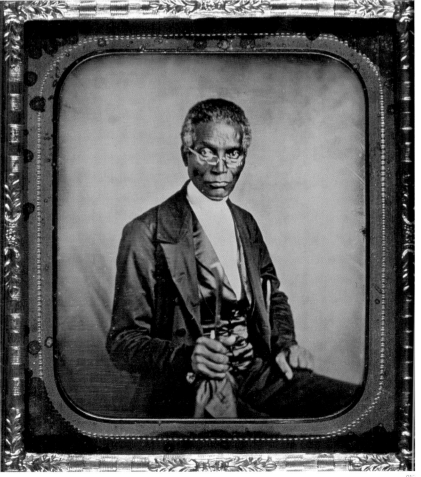

015

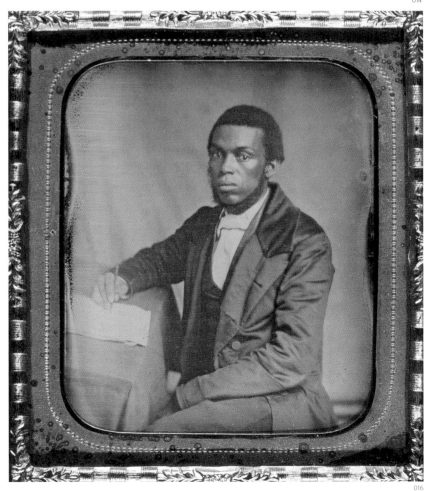

016

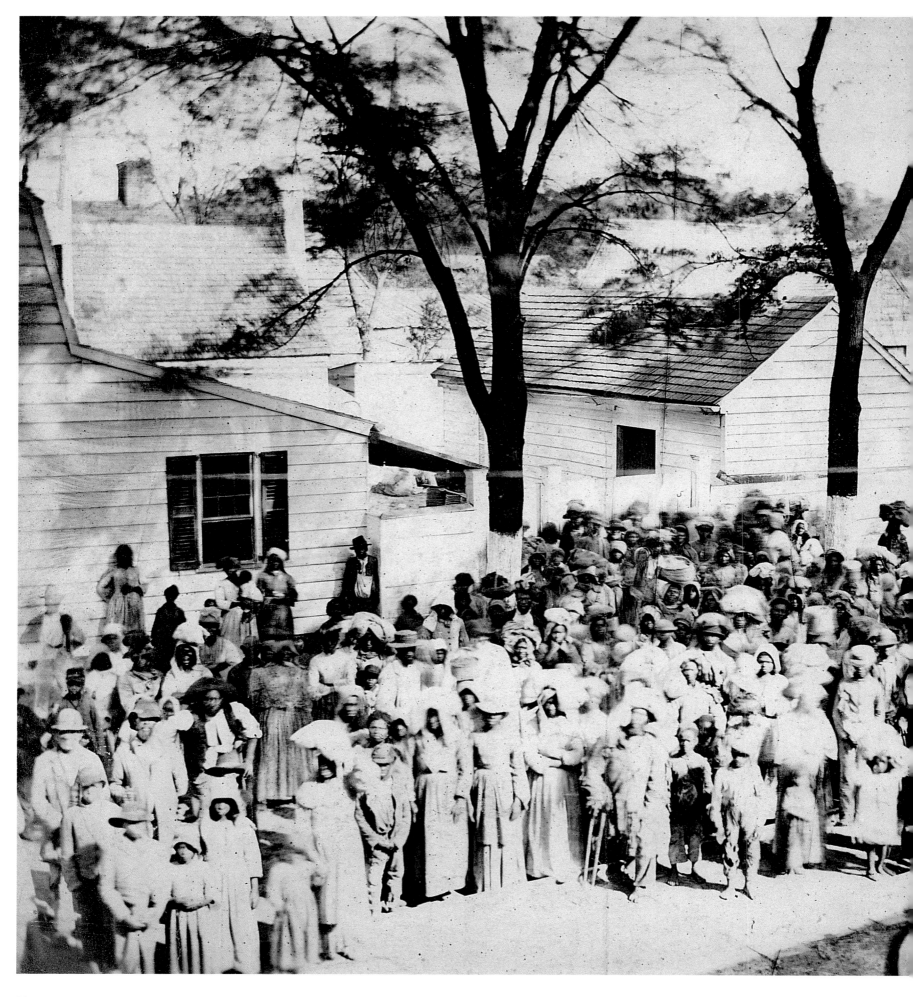

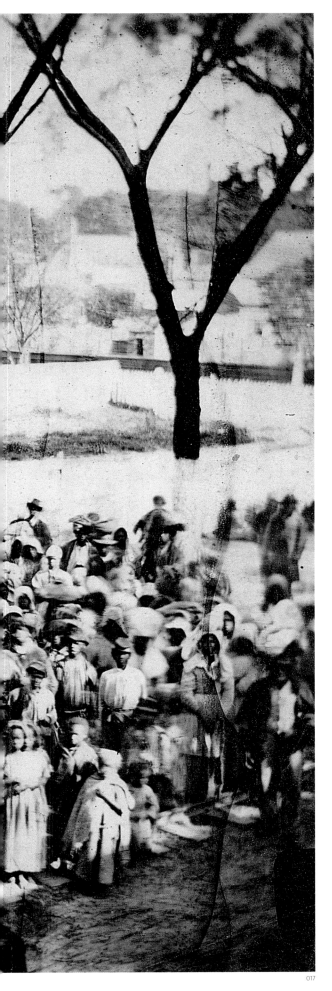

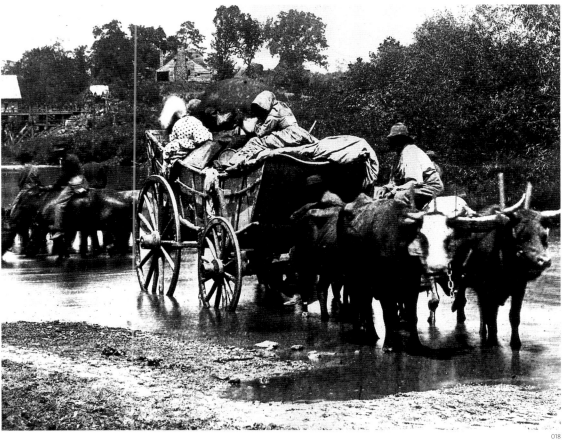

017. Slaves on the James Joyner Smith Plantation, Beaufort, South Carolina, 1862. This photograph was taken just after the owners had fled from Union troops. Approximately four million African Americans were enslaved at the beginning of the Civil War in 1861. As the Union army advanced through the South, some of the first blacks to be liberated lived in the islands along the Georgia coastline. Black and white abolitionists soon established schools and relief efforts in the areas occupied by the Union. Federal officials were surprised when the new freemen did not immediately volunteer as laborers in the Union army. The majority of ex-slaves chose to work for themselves on their former plantations or to hire themselves out for wages.

018. Fugitives fording the Rappahannock River fleeing from General "Stonewall" Jackson's Confederate army, Virginia, August 1862.

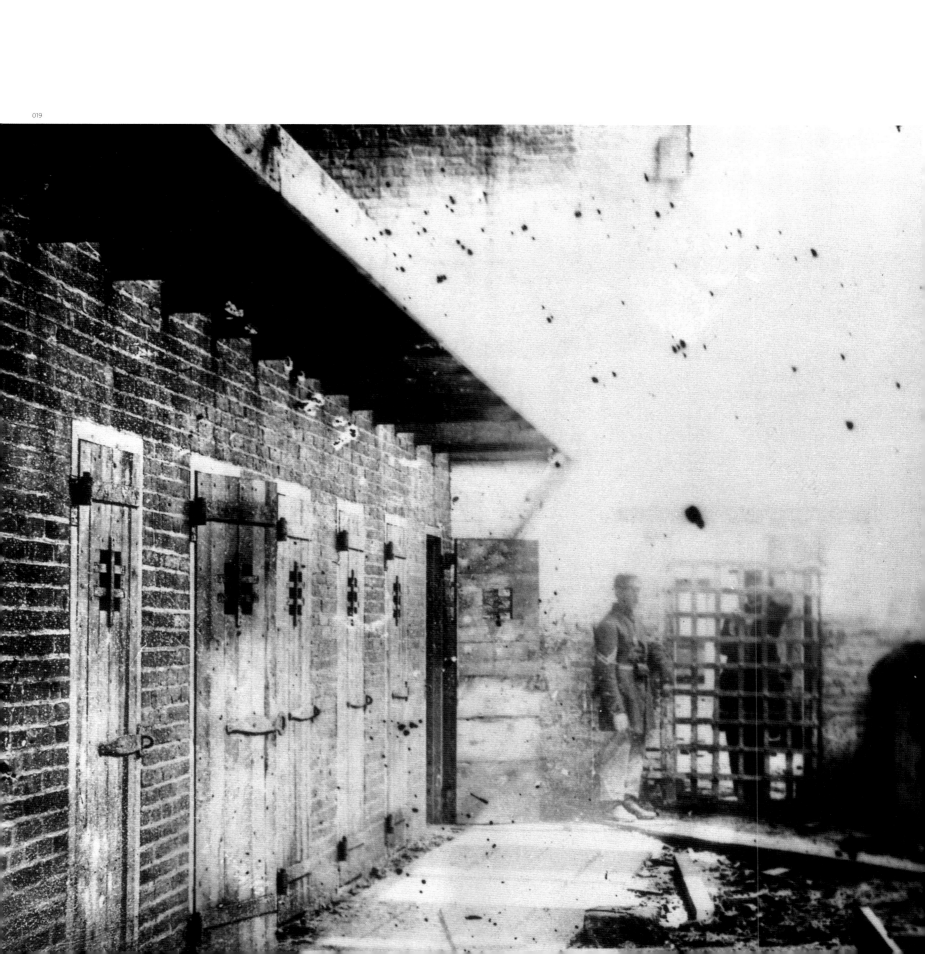

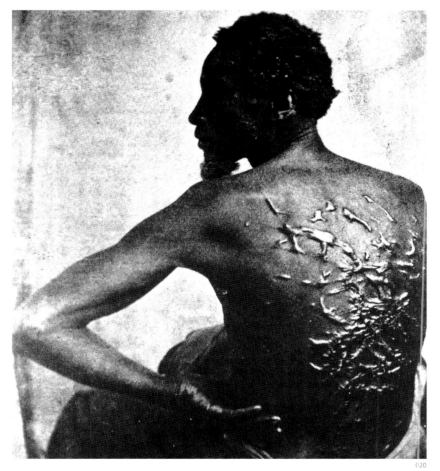

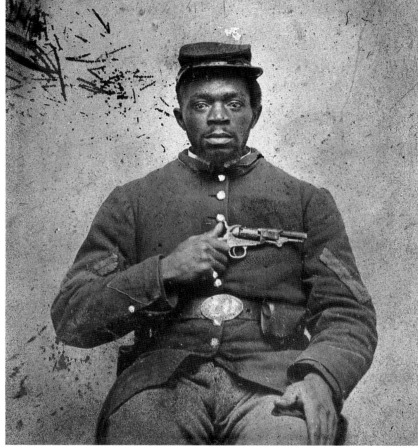

019. The pen where enslaved black people were held for auction at Alexandria, Virginia, c. 1860–65. In Washington, D. C. and northern Virginia in the 1850s, the average price of a young, able-bodied, but unskilled, African American male adult was $1,300. Slave owners frequently leased or rented their slaves for hire by the day, or month. Slave traders usually received commissions ranging between 5 and 30 percent of the sale price. Especially during times of economic recession, slave owners and traders frequently broke up families and sold off individual members to different buyers.

020. Former slave from Louisiana who escaped to Union lines, 1863. Coercion was central to the system of American slavery. The most common tool of discipline administered by southern whites was the whip. Advertisements for runaway slaves or for the sale of slaves frequently described them as being disfigured by branding or deep scars from frequent whipping.

021. Soldier of the Union Infantry with a Colt pocket revolver, c. 1862–65. As the federal armies approached Confederate-controlled areas, hundreds of thousands of slaves fled across Union lines. The Enlistment Act of 17 July 1862 established the terms for African American recruitment into the Union army. By the end of the war, over 186,000 African Americans had joined the ranks, one half of whom came from the Confederate states. Thirty-eight thousand black soldiers were killed during the conflict.

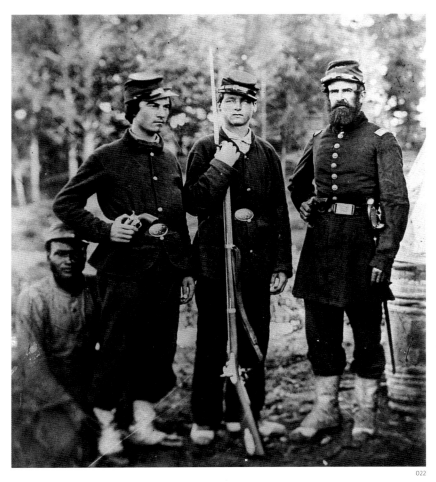

022

022. African American quarter-master with three white Union soldiers, c. 1862–65. African Americans performed various kinds of services in the Union army. They constructed roads and fortifications, dug trenches and carried out menial tasks. Racial discrimination at every level was not only tolerated but codified. For example, in 1862, white privates received $13 a month compared to $7 for black privates. In some cases African Americans who had not enlisted or volunteered were coerced at gunpoint to become military laborers.

023. Company E, Fourth Colored Infantry at Fort Lincoln, c. 1862–65. Black men fought in racially segregated units. The first black regiments were composed of freemen in the federally occupied regions in southern Louisiana in 1862. These early regiments had African American officers, but they were replaced by white officers in 1863. The most famous black regiment was the 54th Massachusetts Volunteer Infantry, led by Colonel Robert Gould Shaw.

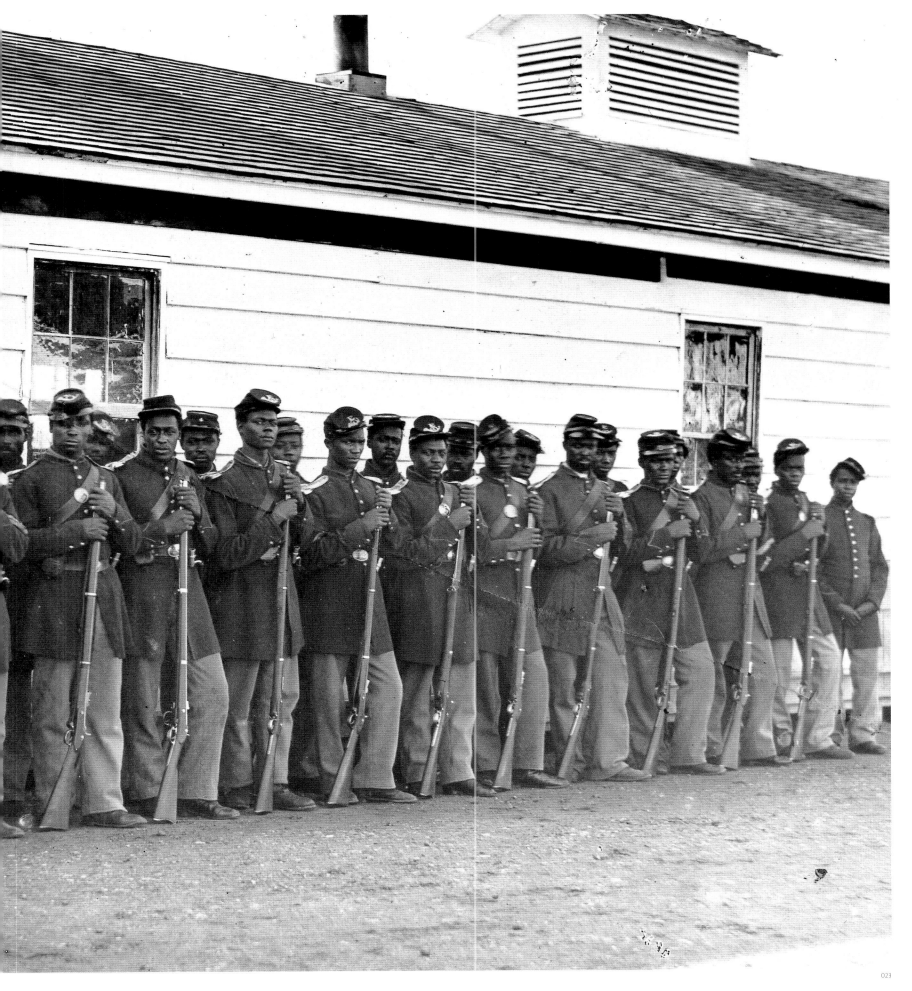

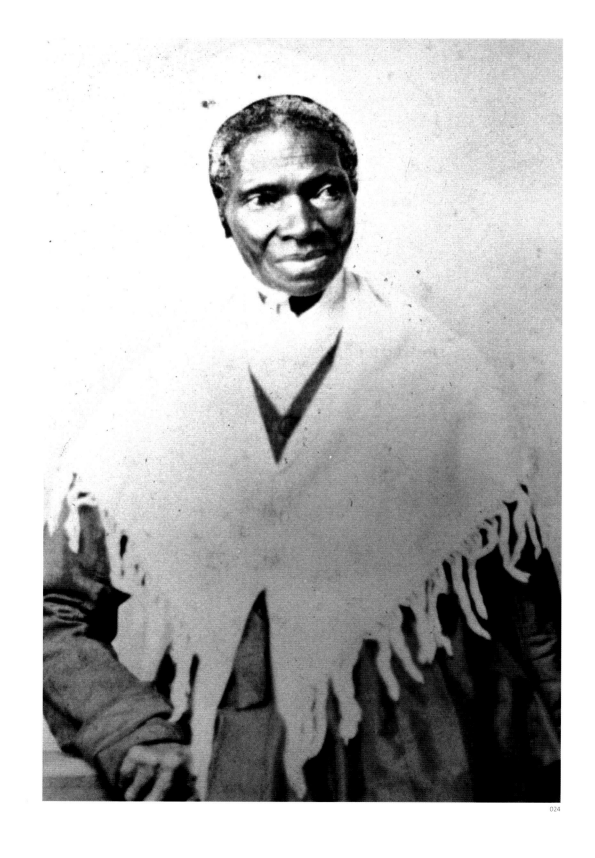

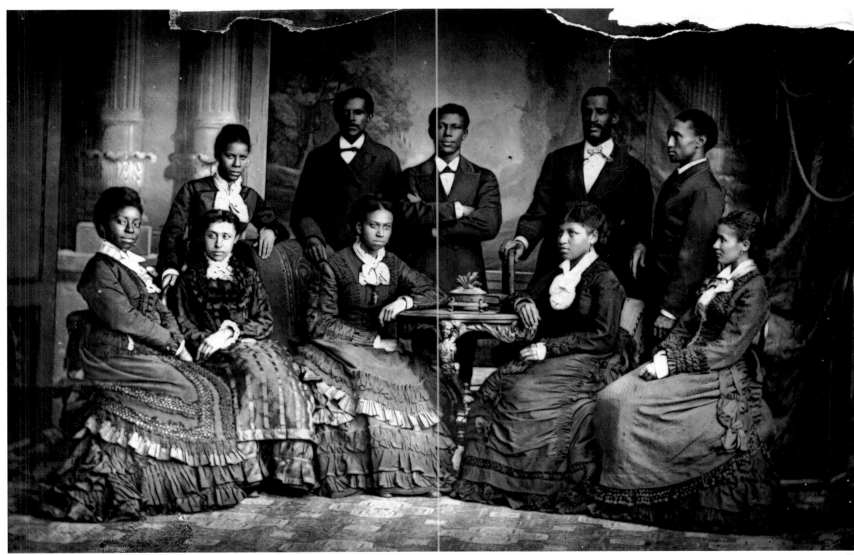

024. Sojourner Truth, c. 1870. Born in slavery in upstate New York as Isabella Bomefree in 1797, she was emancipated when the state abolished slavery in 1827. In 1843, Bomefree assumed the name Sojourner Truth and became an itinerant singer and orator, traveling throughout the northern states and speaking before anti-slavery audiences.

In 1850 her memoirs were published as *The Narrative of Sojourner Truth: A Northern Slave*. After the Civil War, Truth advocated black suffrage, civil rights, and the redistribution of land to former slaves. Today she is best known for her famous address, "A'n't I A Woman" delivered at a women's rights convention in Akron, Ohio in May 1851. She died in Battle Creek, Michigan in 1883.

025. The Fisk Jubilee Singers in London, 1872. The Jubilee Singers were initiated at Fisk University, a small black college in Nashville, Tennessee soon after the Civil War. In October 1871, the Fisk Jubilee Singers toured the Midwest and East Coast, introducing slave spirituals to white audiences whose response was overwhelmingly enthusiastic. In less than a year the singers raised $20,000,

which provided the college with a much-needed endowment. Between 1873 and 1878, the Jubilee Singers toured Europe twice, singing before audiences of thousands, who for the first time were presented with the beauty and power of African American music. These tours sowed the seeds for the widespread popularity of African American music among Europeans.

1880

1919

SEPARATE AND UNEQUAL

We wear the mask that grins and lies,
It hides our cheeks and shades our eyes,—
this Debt we pay to human guile;
With torn and bleeding hearts we smile,
And mouth with myriad subtleties.

— Paul Laurence Dunbar, "We Wear the Mask"

The period following the demise of Reconstruction did not immediately lead to a collapse of the rights of African Americans. Throughout the South in the 1880s, thousands of African Americans continued to vote, and blacks continued to be represented in Congress until as late as 1901. Nevertheless, the withdrawal of federal troops from the South following the Compromise of 1877, and the Republican Party's abandonment of its historic commitment to the constitutional and civil rights of African Americans set the context for the emergence of what would be called "Jim Crow segregation." The development of racial segregation in the United States should also be understood against the rise of European colonialism in the late-nineteenth century, and imperialistic foreign policies that led to the partition of Africa and much of Asia. Non-whites all over the world were viewed by most Europeans and white Americans as being incapable of governing themselves. The logic expressed by British author Rudyard Kipling, the "white man's burden," provided legitimacy for extending European political, economic, and cultural hegemony throughout the globe.

As under slavery, the structure of white racial domination was simultaneously political, legal, economic, and social. African Americans began to be largely ejected from governmental and political processes. Mississippi led the way in 1890, when in a state constitutional convention, delegates authorized provisions that eliminated over 120,000 black voters from the state's voting rolls. South Carolina purged blacks from its electorate several years later, when it adopted literacy tests, a poll tax, and other restrictions on exercising their electoral right. In Louisiana, the adoption of a white supremacist state constitution in 1898 led directly to the elimination of about 125,000 African American voters in that state. By 1910, blacks had become effectively disfranchised in the southern United States. Blacks were declared not to have access to the same constitutional rights as other citizens. And, in 1896, in the *Plessy v. Ferguson* decision of the U. S. Supreme Court, legal racial segregation of public institutions was held to be constitutional.

However, the legal consensus for white supremacy and black exclusion was not unchallenged. In the *Plessy* decision, Associate Justice John Marshall Harlan dissented from the judicial majority, insisting that "in [the] view of the Constitution, in the eye of the Law, there is in this country no superior, dominant, ruling class of citizens. There is no caste here. Our constitution is color-blind, and neither knows or tolerates classes among citizens. In respect of civil rights, all citizens are equal before the law." Nearly six decades would have to pass before Harlan's dissent would become the majority opinion on the nation's high court.

The *Plessy* decision provided the legal rationale for consolidating a system of unequal education for blacks throughout the South. White state legislatures allocated expenditures strictly on racial lines, with white students receiving per capita five to twelve times the funds allocated for black students. In 1916, there were only sixty-seven black public high schools in the United States. As of 1920, over 80 percent of all African American public school children were enrolled in only the first four grades. White teachers' salaries were usually two to four times that of black instructors at segregated schools. Blacks were barred from all-white colleges, graduate, and professional schools. When one southern academic institution, Berea College of Kentucky, attempted to enroll black students, the Supreme Court in 1908 ruled against the college. The long-term impact of the "separate but equal" principle of the *Plessy* decision was to create a system of racial domination that in many respects was like the system of apartheid under the former white minority regime of South Africa.

This pervasive pattern of rigid racial discrimination touched upon virtually every aspect of daily life for all African Americans, regardless of their income, education, or class background. In public accommodations, blacks were generally prohibited from staying in hotels or eating in restaurants. Blacks were usually denied access to public libraries. Some department stores barred black customers, but most provided selective services under specific guidelines. Blacks were prohibited from trying on shoes, clothing, or other items prior to purchasing them, and were not permitted to return items after they had been sold. Blacks could not attend white churches, nor could they be buried in whites-only cemeteries. Whites-only covenants attached to the purchase documents for private homes made it illegal for blacks to buy homes in white neighborhoods. Public toilets, water fountains, bus and train terminals were strictly segregated by race. In major cities, blacks were generally permitted to enter public buildings, but frequently had to use service entrances, rear stairwells, and service elevators. On public transportation, blacks sat in restricted areas and were expected to surrender their seats to whites on demand. Businesses providing personal services, such as beauty salons and barber shops, were closed to black patrons. Many public parks restricted the hours in which blacks were allowed to enter. In terms of social interaction, black women were rarely referred to in casual conversation as "Mrs." or "Miss," and black

males were never called "Mister." Most whites refused to shake hands with blacks, and avoided any acts of public courtesy or deference toward them.

The cruelest manifestations of Jim Crow racism were placed on the shoulders of black women. After emancipation, in rural areas virtually all adult black women continued to labor in the fields, and were involved in every aspect of cotton production. Especially in urban areas, hundreds of thousands of women were employed as domestic servants in white households. In both circumstances, black women frequently were separated from their children, husbands, and families for months and even years. Rape and sexual exploitation by their white employers was not infrequent. Black women therefore fought constantly to defend themselves and their communities. In black public life, women were usually central in the construction of social and cultural institutions. Through their activities, they sought to transform and democratize the gendered structures of patriarchy, as well as those of racism. As Anna Julia Cooper, an early black feminist, observed in her book *A Voice from the South*, published in 1892: "the colored woman of to-day occupies, one may say, a unique position in this country. . . . She is confronted by both a woman question and a race problem, and is as yet an unknown or an unacknowledged factor in both. . . . She is always sound and orthodox on questions affecting the well-being of her race. You do not find the colored woman selling her birthright for a mess of pottage."

The overwhelming majority of African Americans continued to live and work in the rural South. As of 1900, the black American population was 7.8 million, approximately 11.6 percent of the country's population of 66.8 million. About 90 percent of all blacks were located in the South, and nearly 80 percent lived in rural areas, and were primarily involved in cotton farming. They comprised 50 percent of the South's total population. However, white southerners owned about 1.1 million farms in 1900; by contrast, blacks in the region owned less than 160,000 farms. Blacks were normally confined to the most labor intensive, dangerous, and dirtiest jobs. Relatively few were employed in skilled mechanical and manufacturing work; and virtually all were excluded from white-collar clerical, professional, and managerial positions. In 1910, about 50 percent of the black labor force was employed in agriculture; of this group, nearly 900,000 were classified by the census as "farm operators," but three-fourths of them did not own the land on which they labored. Black farmers were generally confined to the worst and poorest agricultural lands, and were rarely trained in soil conservation, fertilizing, and crop rotation techniques that increased yields. Black tenant farmers generally worked on farms that were less than one-half the size of those worked by white tenants. At least 30 percent of all black male adults were forced to work away from their homes as agricultural workers.

The majority of rural blacks were forced into the system of "sharecropping." Under this form of agricultural production, African American families signed contracts with white landlords, in which they received rudimentary shelter, farm animals, seeds, and farm implements, and were responsible for producing a crop — generally cotton — at the end of a growing season. After the sale of the crop at market, the black sharecropper would usually receive one-half of the profits. In many instances, there were no subsidies to cover the basic living expenses of most households, such as food and clothing. White merchants charged high interest rates on household items, and frequently blacks owed more money at the end of the growing season than they received from the sale of their harvest. Unable to pay off their debts, poor farmers were essentially tied legally to their landlords in perpetuity. Those who ventured off their land or attempted to escape were subject to fines and imprisonment, sometimes on chain gangs working for local governments or even leased out to work as convict laborers.

Behind all of these manifestations of discrimination was the brutal reality of lynching. Thousands of African Americans were lynched across the South in the last decade of the nineteenth century and first two decades of the twentieth century. Such acts of vigilante violence rarely took place within the sanction of law or the courts. Blacks who owned successful businesses were sometimes victimized by "whitecapping," the deliberate destruction of black-owned properties — sometimes even the murder of the black owners — by racist whites. In some areas of the South, public lynchings became popular events. In 1916 in Waco, Texas, for example, a black man named Jesse Washington was publicly burned in front of a cheering crowd of over several thousand whites, including many children.

Under these harsh and brutal conditions, African Americans attempted to organize their communities for self-defense and survival. One of the first priorities was economic development. Wherever possible, blacks endeavored to purchase land and started small businesses. Strict racial segregation had the effect of limiting the amount of capital investment by whites in predominantly black areas, and the absence of white competition, paradoxically, permitted black entrepreneurs to develop their own businesses based on black consumer markets. In 1900, the National Negro Business League was established by black educator Booker T. Washington to promote the growth of black-owned enterprises. By 1907, the organization had 320 branches throughout the United States. The first bank owned and operated by African Americans was founded in Richmond, Virginia in 1888, and in less than thirty years over fifty black-owned banks had been established throughout the South. This created the foundation for the first genuine black middle class. Pooling their

meager resources, blacks frequently established economic cooperatives, which ran different kinds of businesses. Through sacrifice and careful planning, by 1915 African Americans had successfully acquired over fifteen million acres of land.

Frederick Douglass and Blanche K. Bruce provide remarkable examples of this economic success. Both men were born into slavery and escaped their bondage. Douglass became famous prior to the Civil War for playing a prominent role in the abolitionist movement. He was appointed to a series of government posts by Republican administrations, serving as Marshal of the District of Columbia in 1877, Recorder of Deeds for the District of Columbia in 1881, and U. S. Minister to Haiti in 1889. Douglass was able to purchase real estate in three cities, and his Washington, D. C. home, "Cedar Hill," was a twenty-room mansion set on a fifteen-acre estate. At the time of his death he was worth at least $100,000, a considerable sum at that time. Bruce emerged during Reconstruction as a leader of the Republican Party, winning election to the U. S. Senate in 1874. While in office he also purchased large amounts of real estate, and by the end of his term he had accumulated a small fortune. Serving as the Register of the Treasury and Recorder of Deeds for the District of Columbia, at the time of his death in 1897 Bruce was worth over $200,000.

To protect their newly established businesses and private property, blacks organized their collective resources to insure them. In 1884, more than two thousand African Americans met in Baltimore to promote the creation of what were then called "mutual benefit societies." This led in 1893 to the creation of the Southern Aid Society, chartered in Richmond, Virginia, which was the first African American insurance company. Other insurance companies initiated by black entrepreneurs quickly followed: the North Carolina Mutual Life Insurance Company, established in 1898; Pilgrim Health and Life, started in Augusta, Georgia, also in 1898; Afro-American Life, located in Jacksonville, Florida, in 1901; Atlanta Life Insurance, started by A. F. Herndon in 1905; and Winston Mutual Life, in Winston-Salem, North Carolina, in 1906.

The consolidation of segregation also created the conditions for the emergence of a black-owned press. Although several hundred black newspapers were produced in the nineteenth century, regular weekly publications did not appear until the 1880s. Robert S. Abbott's *Chicago Defender*, established in 1905, and William Monroe Trotter's *Boston Guardian*, agitated for equal rights. The militant monthly journal *The Crisis*, edited by black scholar W. E. B. Du Bois, reached a national readership of over one hundred thousand by the end of World War I. A series of more radical periodicals also came of age at this time, such as A. Philip Randolph and Chandler Owen's *Messenger*, Hubert H. Harrison's *Negro Voice*, and black nationalist Marcus Garvey's weekly

newspaper, the *Negro World*. The first black news service, the Associated Negro Press, was also started in 1919 to provide national news to local black-owned publications.

This was also a period that witnessed the creation and expansion of black voluntary organizations and cooperative societies. Most of these groups, such as the Royal Knights of King David, organized in Durham, North Carolina, in 1884, and the Improved Benevolent and Protective Order of Elks of the World, started in Cincinnati in 1899, provided leadership training and organizational experience to thousands of African Americans, fostering within them a sense of cultural pride and self-respect. They were also informal networks that generated capital that was invested in black neighborhoods. By the early 1920s there were about sixty black fraternal societies in the United States, with a total membership of over two million. On college campuses, African American students created similar organizations, modeled after white Greek-letter fraternities and sororities. The first such fraternity, Alpha Phi Alpha, was founded originally at Cornell University, and chartered in 1906; the first black sorority, Alpha Kappa Alpha, was initiated in 1908. Other fraternities and sororities quickly followed: Kappa Alpha Psi and Omega Psi Phi, both in 1911; Delta Sigma Theta in 1913; Phi Beta Sigma in 1914; and Zeta Phi Beta in 1920. Such groups formed much of the informal cultural and social infrastructure that sustained the development of black civil society.

In rural communities, music was a powerful means of self-expression and survival. In the late-nineteenth and early twentieth centuries in the oppressive rural cotton plantations of the Mississippi delta, a new musical form was born: the blues. The earliest versions of the blues were similar to the field hollers, work calls, and chants of enslaved blacks prior to the Civil War. But the blues also expressed a deep sadness about one's circumstances and environment, as well as folk commentary about unfulfilled love, sexuality, and happiness. In the countryside, the blues assumed a fairly rough musical form, based generally on the guitar and harmonica. The generation of early blues artists, such as Huddie "Leadbelly" Ledbetter and "Blind Lemon" Jefferson, created striking melodies that expressed the bitter pain and hopes of rural blacks struggling to survive the conditions of Jim Crow. But as the blues musical genre made its way to urban areas such as New Orleans, St. Louis, and later Chicago, it acquired a more sophisticated and polished form. W. C. Handy's "St. Louis Blues" appeared in 1914, and within several years blues singers like "Ma" Rainey and the incomparable Bessie Smith established the classic blues form that still is played throughout the world. The blues created the powerful foundation for what would soon evolve as the country's only truly "classical" musical form, jazz, and what would later become American popular music.

During these difficult years, African Americans searched for practical means to find ways to escape from the burden of white supremacy. In the 1880s and 1890s, many suggested the strategy of creating self-contained, all-black communities. Tens of thousands of African Americans fled the Deep South, relocating to Kansas and Oklahoma. Some, such as African Methodist Episcopal Bishop Henry McNeal Turner, championed African American colonization of Africa. Other more conservative black leaders, recognizing the powerful forces that had produced the new Jim Crow system, counseled a strategy of accommodation and cooperation with authorities. The chief architect of the politics of accommodation was Booker T. Washington. Born into slavery, Washington founded the black vocational school Tuskegee Institute in Alabama's rural Black Belt in 1881. He publicly urged African Americans to accept segregation laws and political disenfranchisement, in return for greater economic opportunities and business ownership. Washington's philosophy of "self help," his opposition to trade unionism and advocacy of private enterprise created powerful allies for his institution. With the support of Republican presidents Theodore Roosevelt and William Howard Taft, Washington created the "Tuskegee Machine," a black political organization that controlled federal patronage and access to resources from white philanthropies and corporations. Through Washington's strategy of accommodation, thousands of blacks successfully went into small business and were able to obtain farms and real estate.

Accommodation, however, was never supported by a significant sector of the black community. African Americans in trade unions and in the Socialist Party fought to create alliances with white workers, and organized strikes against corporate domination of labor. In 1905, middle-class intellectuals, educators, and professionals, led by W. E. B. Du Bois and William Monroe Trotter, formed the Niagara Movement to challenge Washington's leadership and to protest against the widespread lynchings and disenfranchisement of black voters. Crusading journalists such as Ida B. Wells publicized the South's racial atrocities and encouraged the collective efforts by blacks to resist white oppression. Black middle-class women such as Mary Church Terrell and Mary McLeod Bethune launched women's groups to encourage the struggle for women's suffrage, civil rights, and an end to legal discrimination. In 1909, a group of white liberals and socialists who were sympathetic to blacks' equal rights initiated the National Association for the Advancement of Colored People (NAACP), which quickly became the major civil rights organization representing the demands of African Americans. In 1915, the NAACP won its first major legal victory against Jim Crow, when the U. S. Supreme Court outlawed the so-called "grandfather clause" restricting black voting in the South, in the *Guinn v. United States* decision. With Washington's death in 1915, the influence of the "Tuskegee Machine" rapidly

disappeared, and the NAACP became the guiding force in the articulation of black issues and interests. In his leadership role as NAACP director of research and editor of the organization's monthly journal *The Crisis*, Du Bois emerged as a central figure in the struggle to overturn legal segregation. By World War I, the NAACP had a national membership of over 40,000, with branch organizations in every southern state.

When the United States entered World War I, many African Americans hoped that the international conflict might create greater opportunities for eliminating racial discrimination. Blacks purchased more than $250 million worth of war bonds and stamps to assist the country's war effort. Nearly 2.3 million African Americans registered for the draft, and 367,000 were enrolled in the armed forces. Thousands of African Americans fought with distinction in the trenches along France's western front in 1918. Yet when the armistice was declared, and the peace was negotiated at Versailles, black interests were largely ignored. The returning black troops encountered the "Red Summer of 1919," a wave of white racist vigilante violence and rioting against blacks that was unparalleled in U. S. history. In dozens of cities, towns, and rural areas, African Americans were publicly executed, in some instances burned alive. Black soldiers sometimes still wearing their uniforms were killed. In Chicago alone during the Red Summer, thirty-eight people were killed, 537 injured, and more than one thousand black families were left homeless. The war that President Woodrow Wilson claimed was being fought to preserve democracy and freedom did little to protect the democratic rights of African Americans who still lived in a separate and unequal society.

026. New Orleans, c. 1884. The next series of photographs (026–032) reflects the character of daily life and labor of African Americans in Louisiana in the years immediately following Reconstruction. After Emancipation, African Americans experienced new-found freedom in civic expression and public life. However, for many, the actual conditions of physical work and daily labor were sometimes only marginally superior to what they had been under slavery.

027. Picking moss, Louisiana, c. 1884.

028. Picking peppers for tabasco, Louisiana, c. 1884 (overleaf).

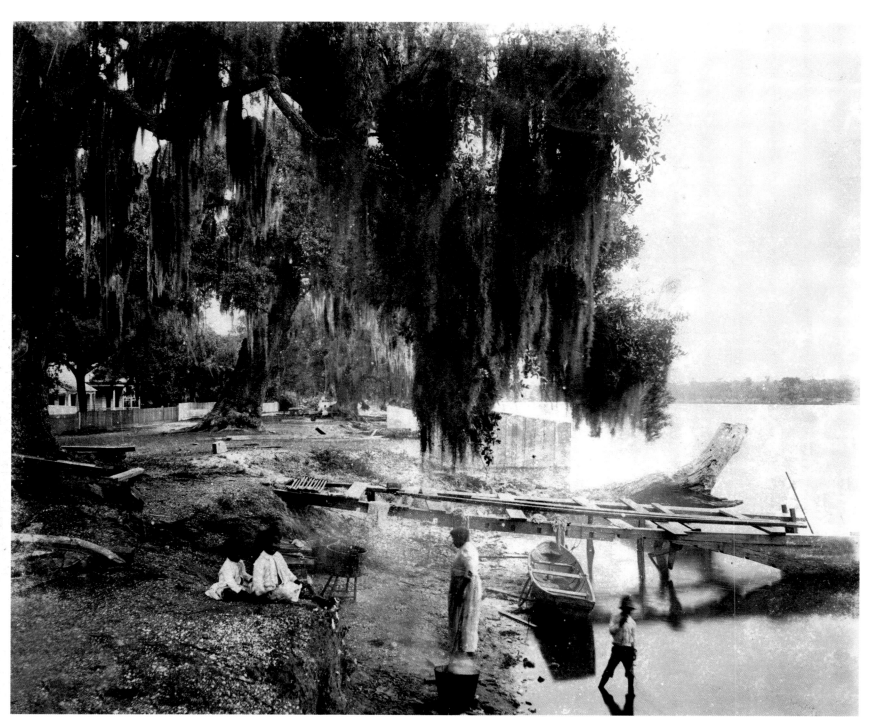

026

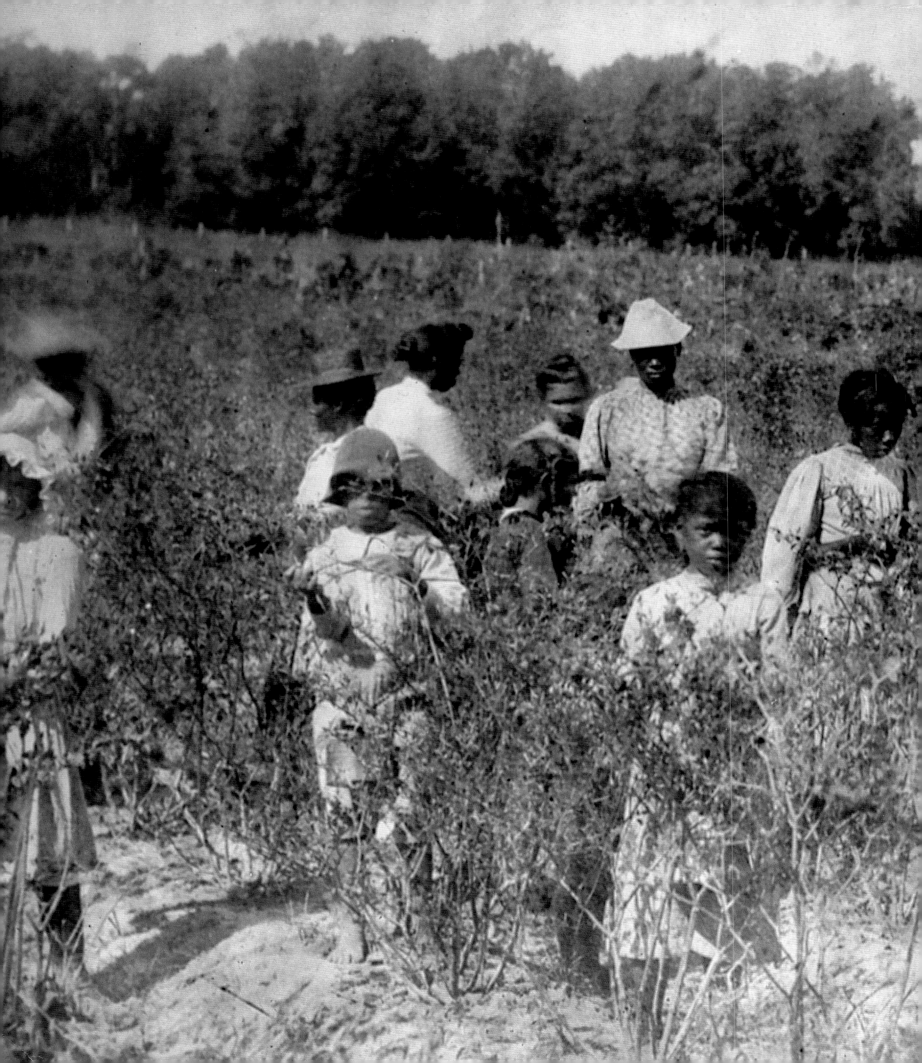

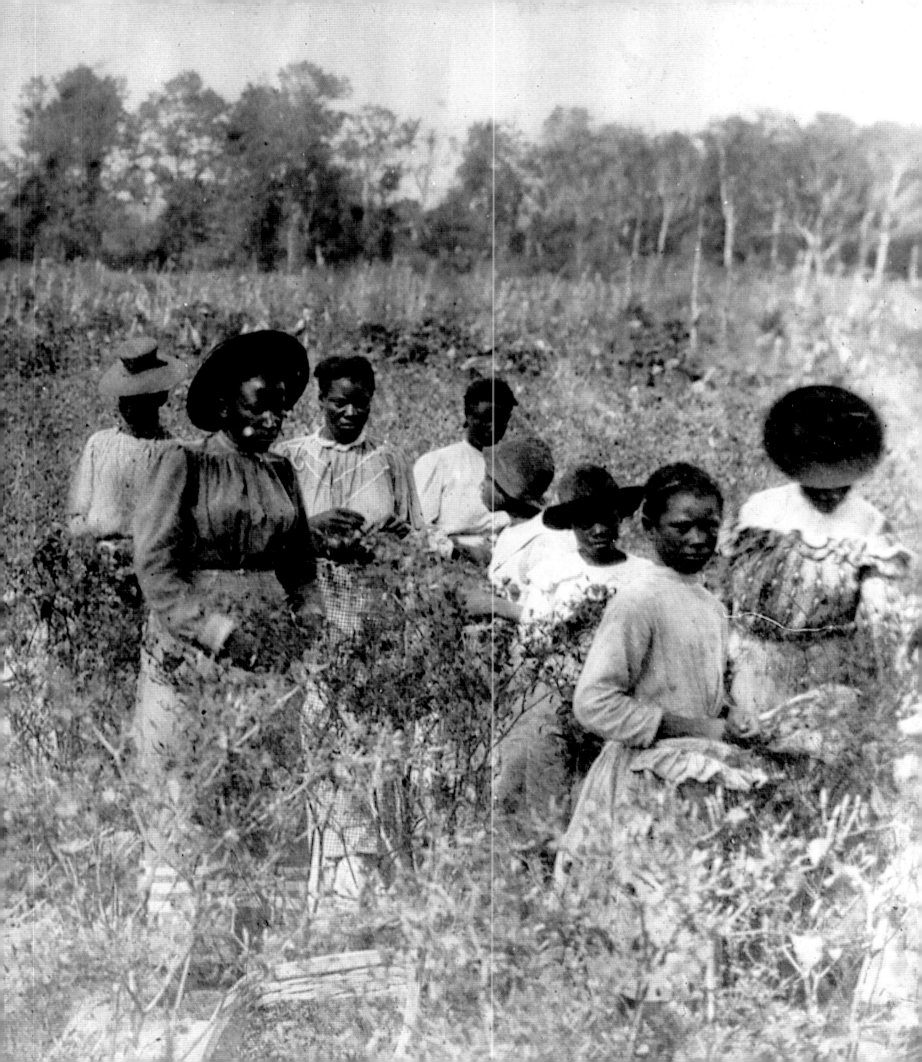

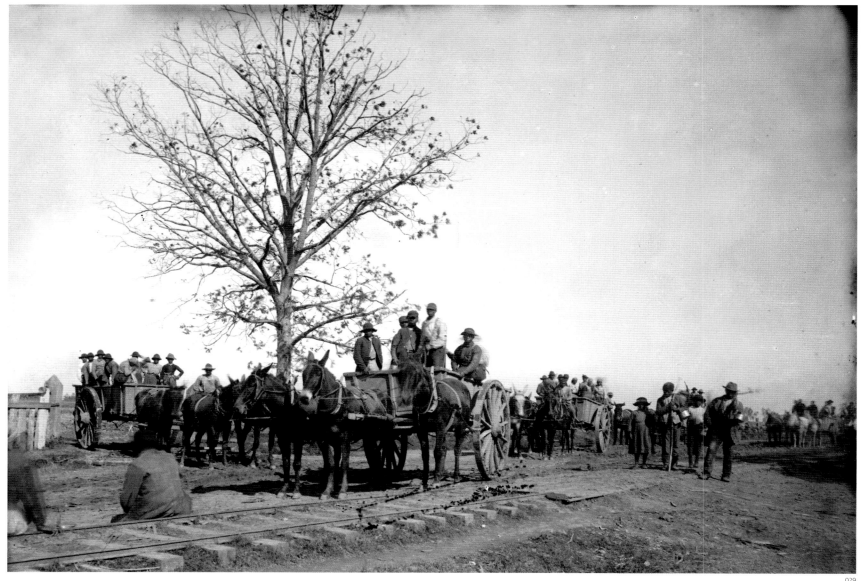

029

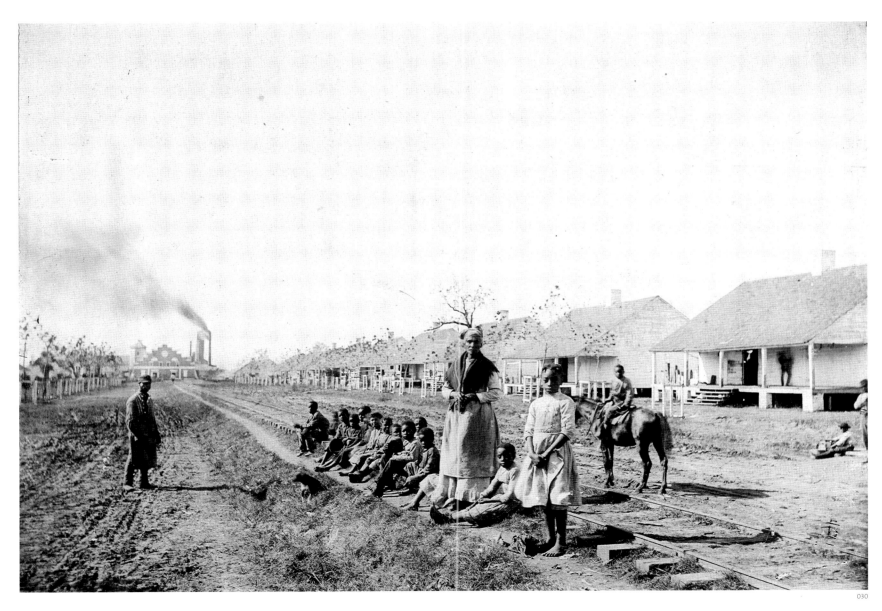

47

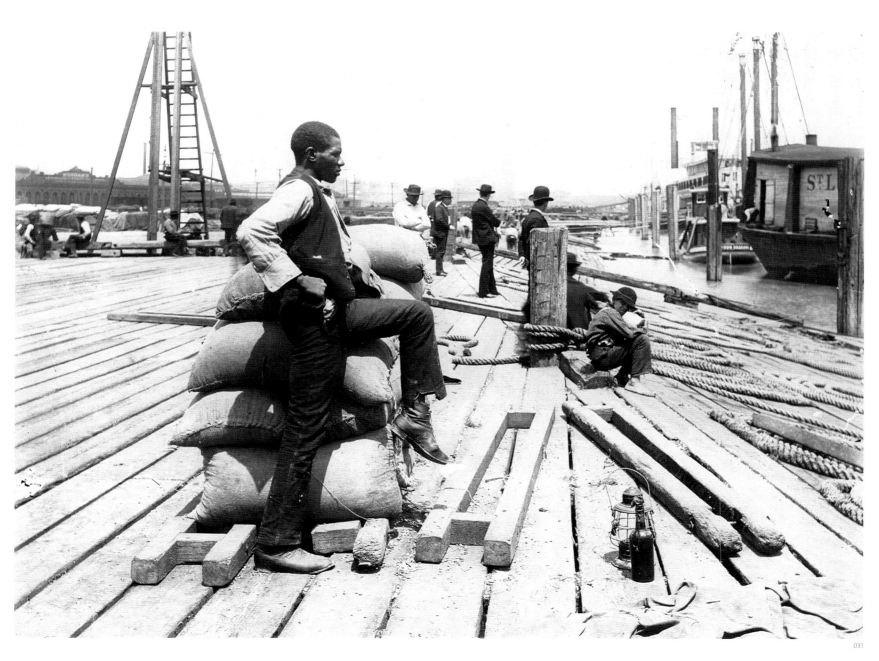

031

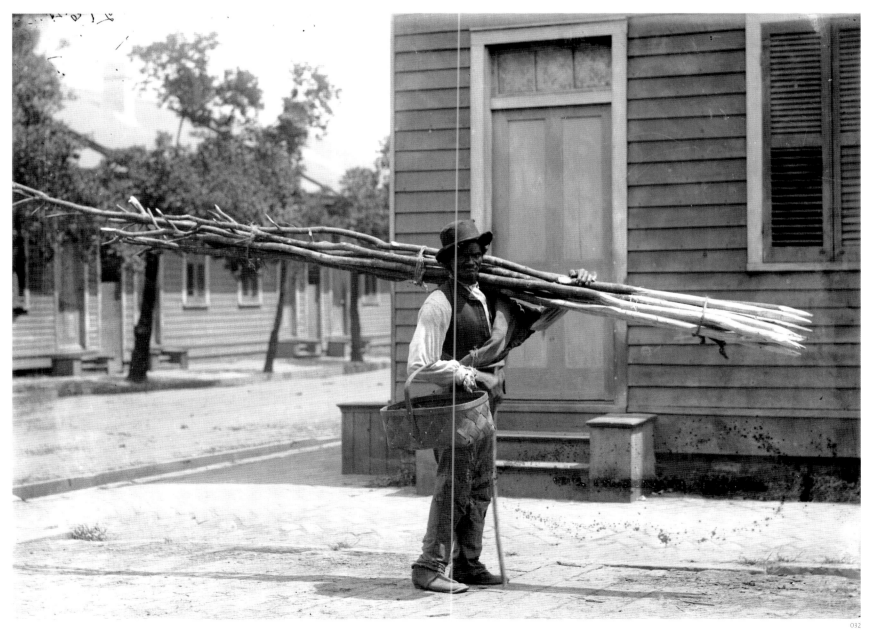

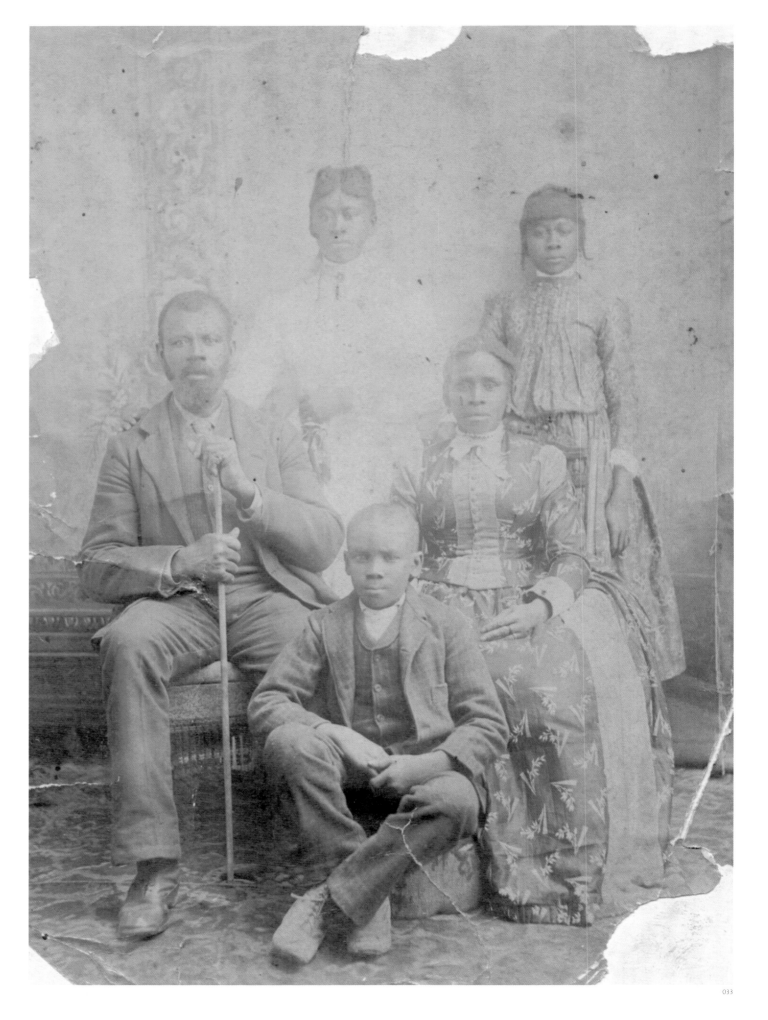

033

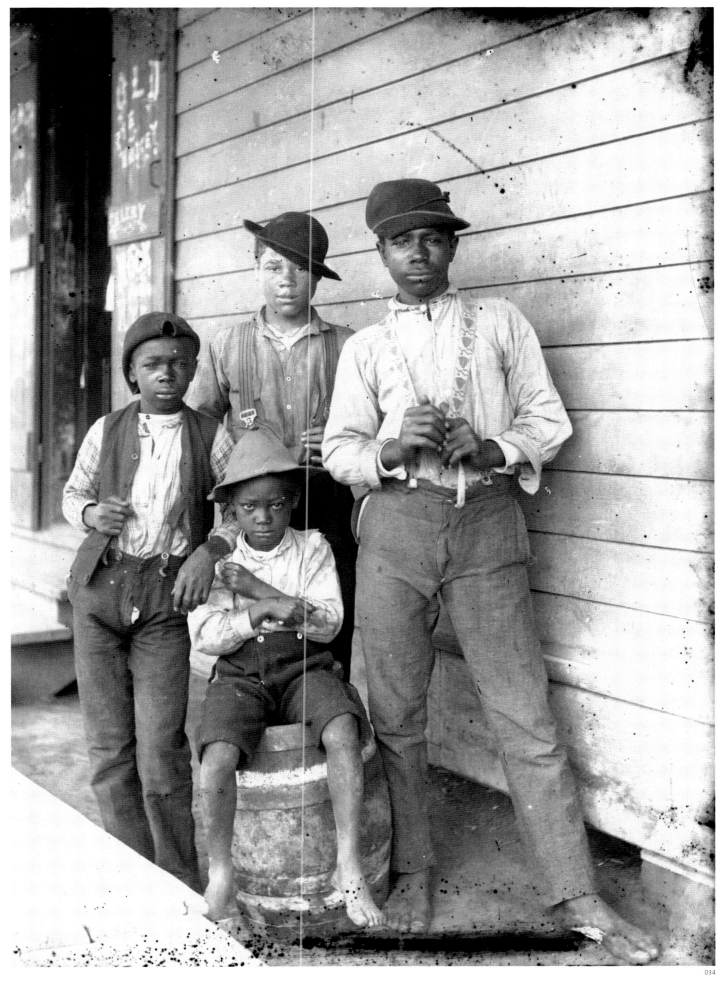

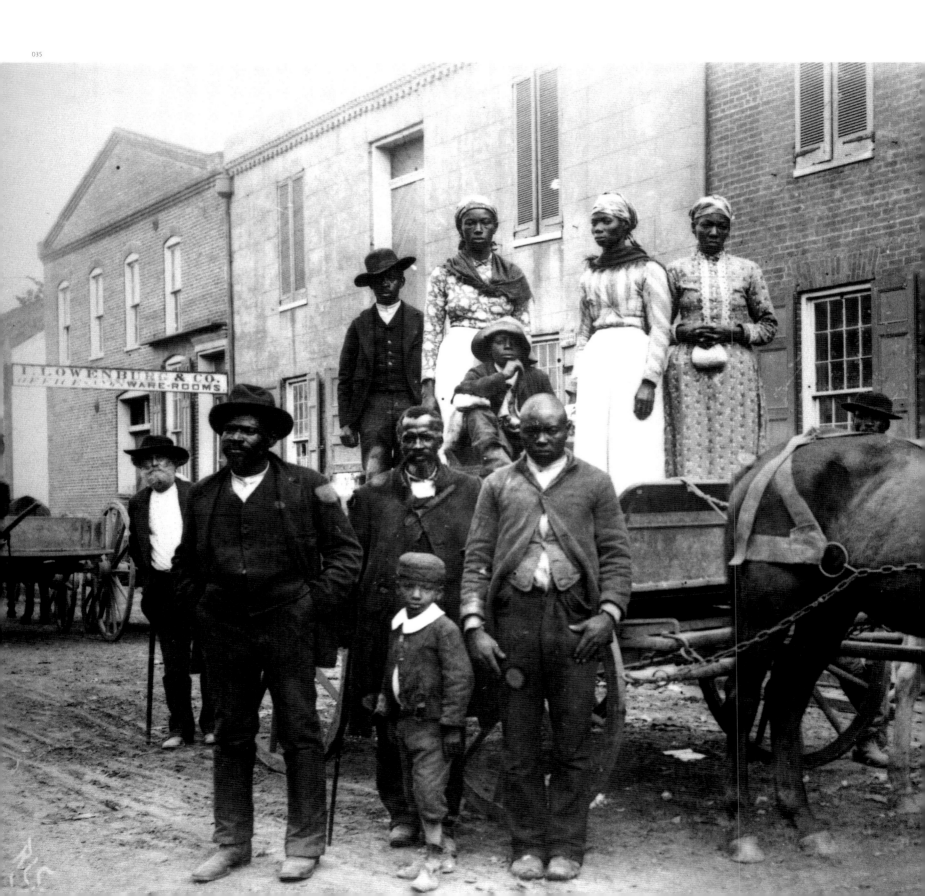

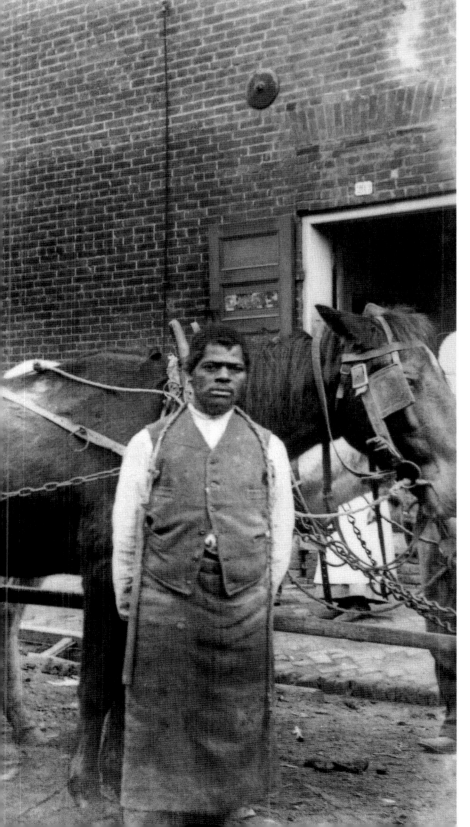

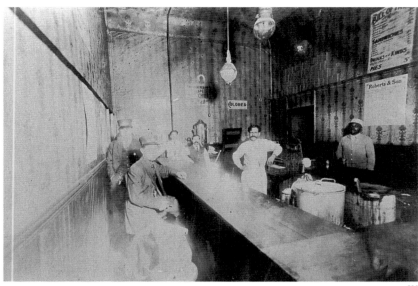

035. "Sunday in Mississippi," c. 1890s. Beginning in 1890 in Mississippi, southern states prohibited nearly all blacks from voting. Within several years, virtually all public settings — schools, churches, government offices, hotels, hospitals, public transportation, parks, and even elevators — were rigidly segregated by race under a system widely termed "Jim Crow" after a minstrel show character. Despite growing legal restrictions on their freedom, however, African Americans continued to establish families, civic associations, and new cultural traditions. It was during this difficult period that many southern black households established the tradition of annual or biannual family reunions.

036. Segregated bar, probably Alabama, c. 1900.

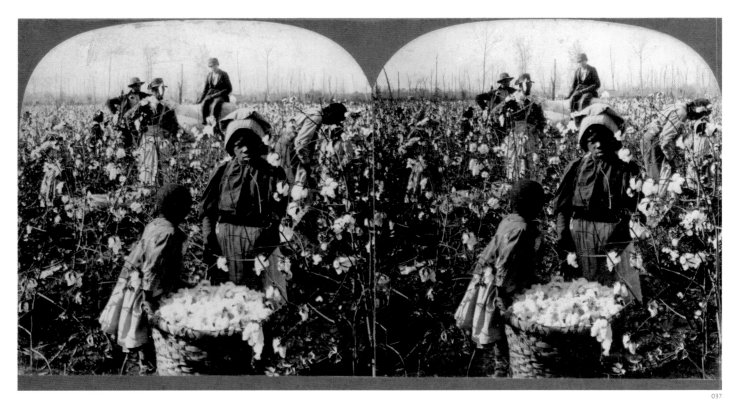

037

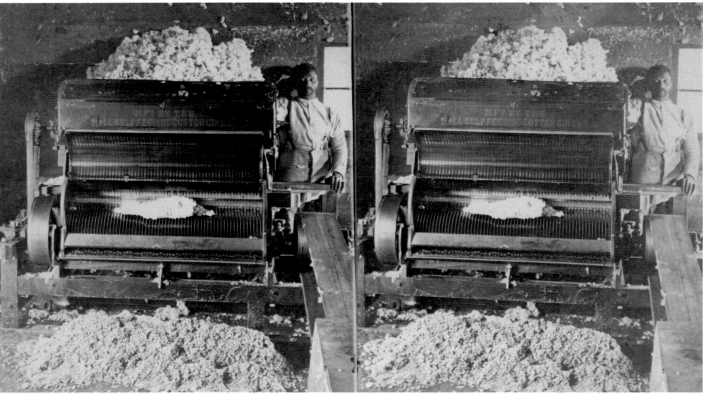

038

037. Cotton picking, Mississippi, c. 1880. For two generations after the Civil War, cotton remained the predominant crop of southern agriculture.

038. Man at the cotton gin, location unknown, c. 1890.

039. Cotton pickers, Louisiana, c. 1890s. In 1880 relatively few African Americans owned their own farms. The vast majority were sharecroppers or tenant farmers, who labored on farms owned by white landowners. Black sharecroppers were pressured to grow cash crops such as cotton and corn and were rarely able to raise sufficient livestock or maintain food gardens. Many survived on credit provided by local white merchants, who often charged 100 percent interest on food supplies and dry goods purchased during the growing season. Especially during harvest, entire families, including small children, were pressed into service. As the price of cotton fell to barely five cents a pound by the late 1890s, thousands of black sharecroppers fell into debt peonage. They became economically and legally tied to the land.

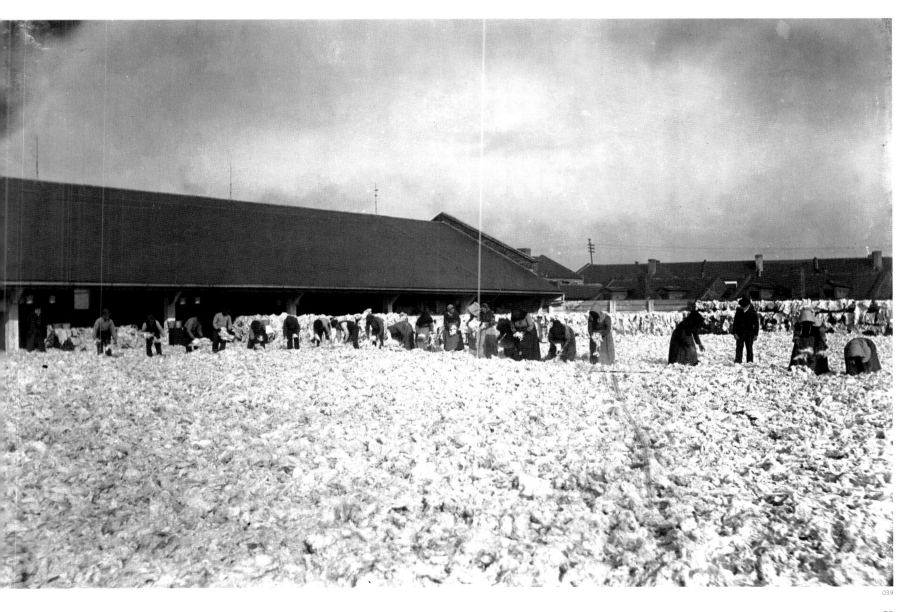

039

040. Mary Church Terrell, c. 1890s. Mary Church Terrell was born in Memphis, Tennessee in 1863. She was educated at Oberlin College, Ohio and completed advanced studies in Europe. In 1895 she became the first African American woman appointed to the District of Columbia school board. From 1896 to 1901, she was the founding president of the National Association of Colored Women (NACW). Until her death in 1954 she remained a prominent activist in the struggle for civil rights and women's equality.

041. Five officers of the Women's League, Newport, Rhode Island, c. 1899. In the 1890s, middle-class black women's associations, known as the Women's Club Movement, blossomed. Middle-class women including schoolteachers, nurses, and journalists formed associations dedicated toward helping less privileged African American women. These clubs raised money to care for children, the sick, and the elderly. They were also particularly concerned with the plight of domestic workers, who were frequently subjected to sexual and physical exploitation in the homes of their employees. In some cases, clubs organized dormitories for these women. Club women opposed lynching and advocated women's suffrage and education.

042. Group photo of early class, Tuskegee Institute, Alabama, c. 1890s.

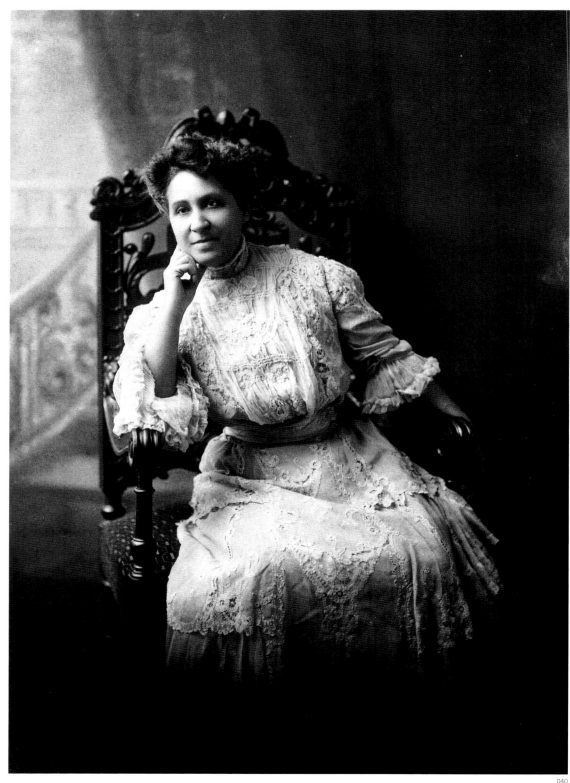

040

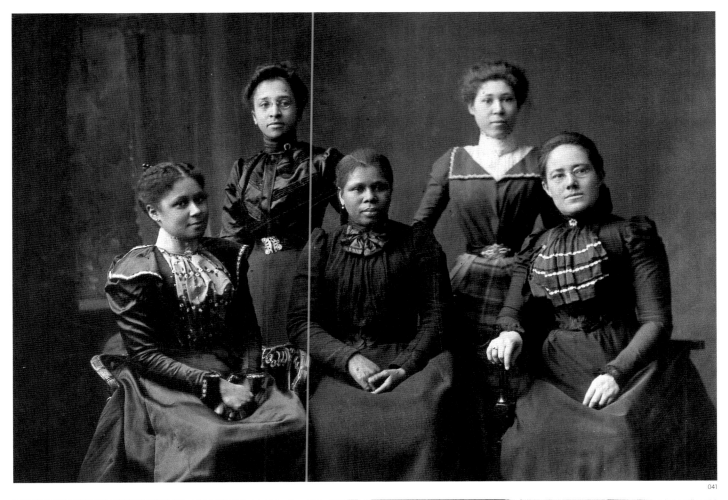

041

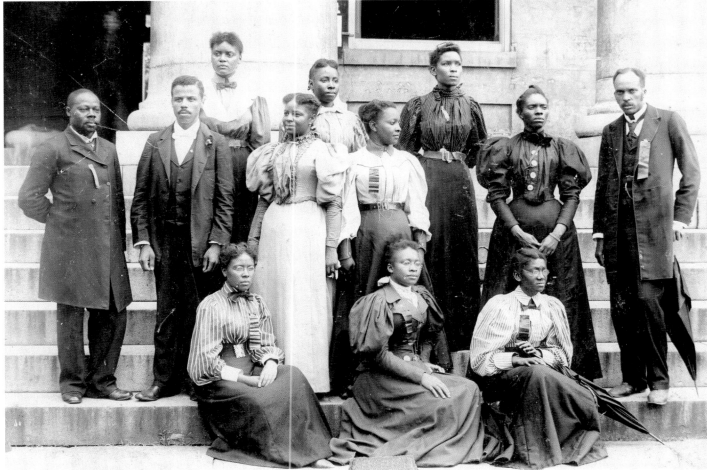

042

57

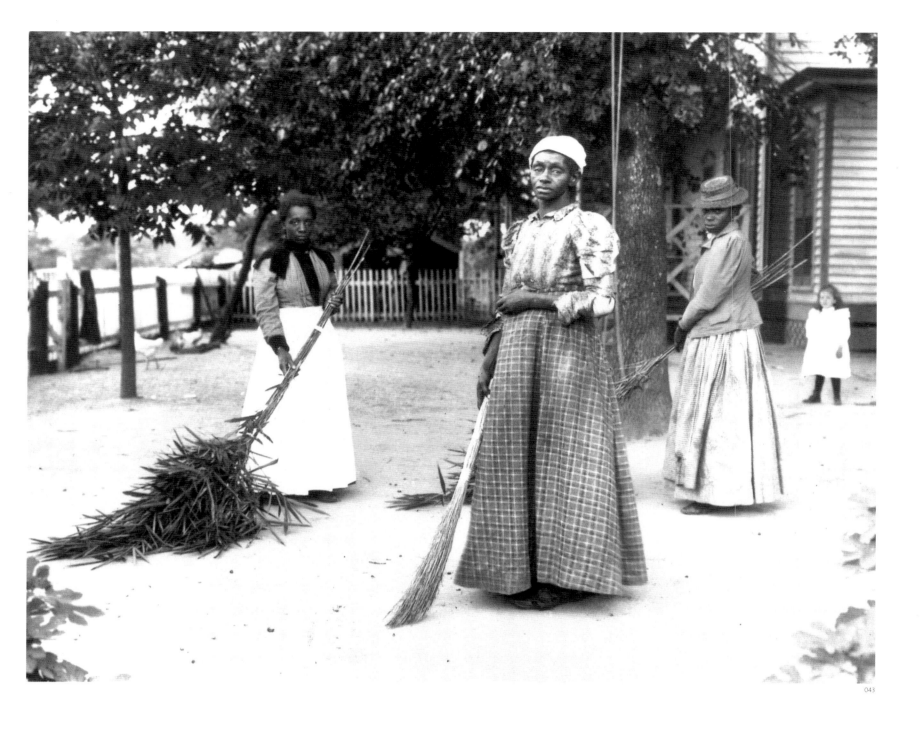

043

043. Latimer Plantation, Belton, South Carolina, 29 October 1899.

044. "On the Way to a Lynching," location unknown, c. 1899–1900. Between 1882 and 1901, 2,060 African Americans were lynched in the United States. During the consolidation of the Jim Crow regime, southern whites devised a variety of methods to assert their social domination over black people. The most effective means was lynching — the use of extra-legal deadly force against a civilian population for the purpose of instilling widespread fear. In many instances, blacks had body parts removed while still alive, or were subjected to other forms of mutilation. A number of African Americans were burned alive at the stake.

By the early twentieth century, lynchings were occasionally advertised in newspapers, and sometimes several thousand whites would festively gather to witness the tortures and executions of black victims. In some cases all stages of a lynching were photographed, and these pictures were made into post-cards and sent to friends and relatives as trophies or souvenirs. Lynchings were

usually justified by southern whites as a form of punish-ment and retaliation for the rape of white women by black men. Statistically, though, accusations of rape — which some journalists at the time, and many historians found to have been largely fabricated — occurred in only approximately one third of all documented cases of lynchings. Another common form of white vigilante

violence often resulting in lynchings was known as "whitecapping," the deliberate destruction of black-owned businesses and institutions, to perpetuate black economic subordination.

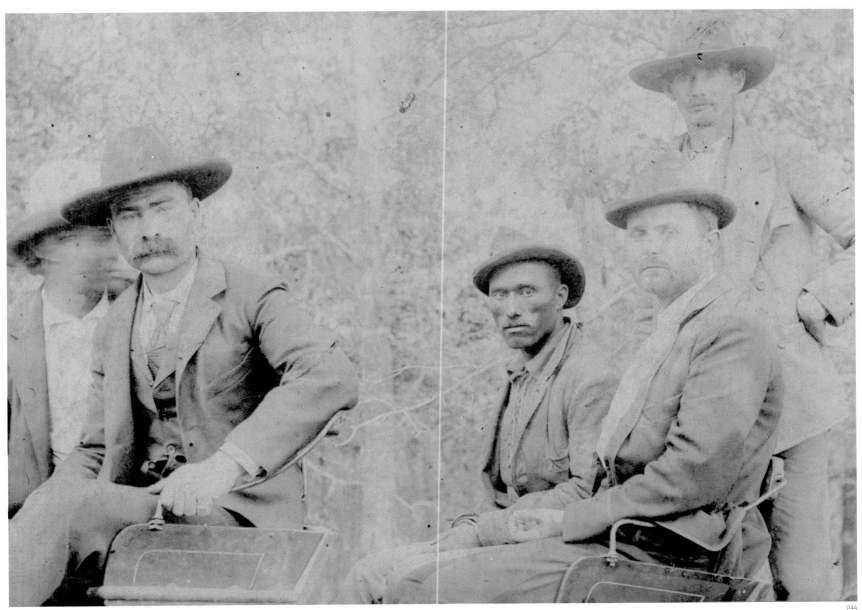

045. W. E. B. Du Bois at the Paris Exhibition, 1900. W. E. B. Du Bois was born in Great Barrington, Massachusetts in 1868. As an undergraduate, he was educated at Fisk University and Harvard College. In 1892–94, Du Bois studied sociology and economics in Berlin and traveled widely throughout Europe. He received his Ph. D. in history from Harvard University in 1895. By 1900 Du Bois was the most prominent African American scholar in the United States — the author of two influential works, *The Suppression of the African Slave Trade*, published in 1896, and *The Philadelphia Negro* in 1899. Du Bois' political thought evolved over a lifetime spanning 95 years. One central idea was that of the "double consciousness" of African Americans. He believed that African American people were culturally and historically connected with Africa and the black diaspora, yet they should also be American citizens, endowed with full liberties and rights. "One ever feels this twoness, — an American, a Negro, two souls, two thoughts, two unreconciled strivings; two warring ideals in one dark body, whose dogged strength alone keeps it from being torn asunder." Du Bois' concept of the "talented tenth" suggested that college-trained middle-class blacks had a moral obligation to uplift the most oppressed members of the community. But he ultimately repudiated this notion and embraced more radical politics, rooted in the activism of the working class.

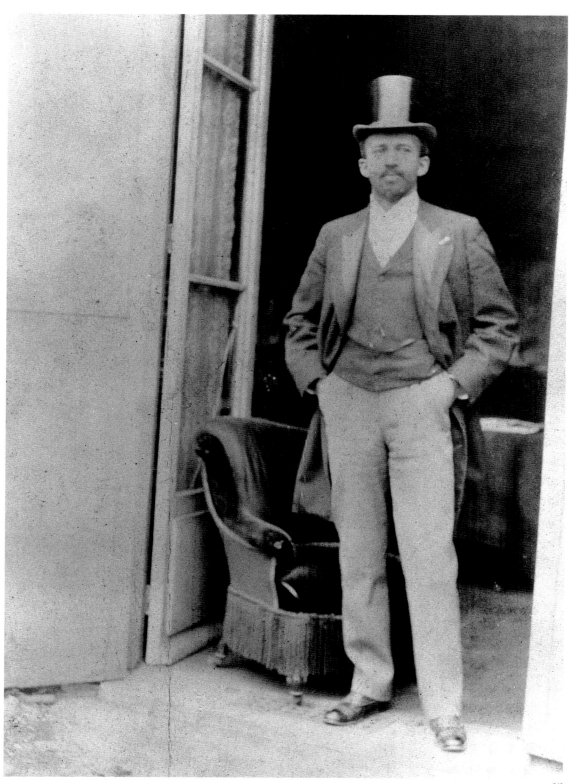

045

046. Booker T. Washington, 1899. First president and principal developer of the Tuskegee Normal and Industrial Institute, Booker T. Washington was black America's most influential leader of the era. In an important 1895 speech in Atlanta, Washington came to national attention by criticizing Reconstruction and appearing to accept Jim Crow restrictions on voting and public accommodations as a means for greater opportunities for African Americans within racially segregated economic markets.

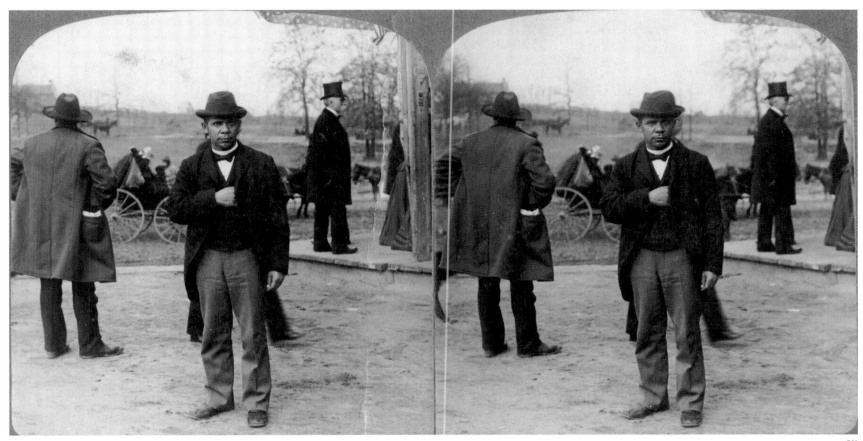

046

047. Simpson Industrial Home at Clafin University, South Carolina, c. 1899–1900. These photographs (047–051), were first presented at the Paris Exposition of 1900 as part of a collection, organized by W. E. B. Du Bois, that depicted the educational and socioeconomic advancement of African Americans in the generation since slavery ended. The exhibition sought to demonstrate, against all odds, the remarkable progress made by African Americans in education, industry, and politics.

048. Pot presses at the T. B. Williams Tobacco Co., Richmond, Virginia, c. 1899–1900.

049. Bricklayers Union, Jacksonville, Florida, c. 1899–1900.

050. Dentistry class at Howard University, Washington, D. C., c. 1899–1900.

051. Officers of the Tobacco Trade Union, Pennsylvania, c. 1899–1900.

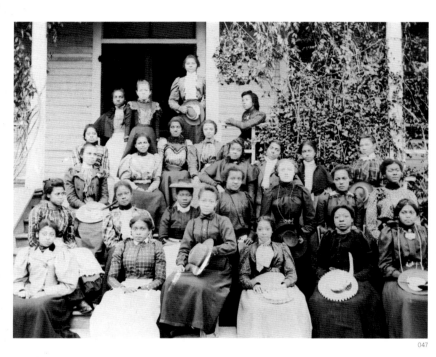

047

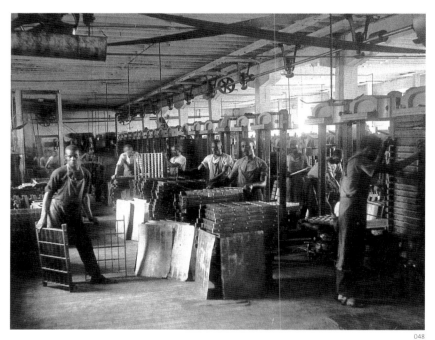

048

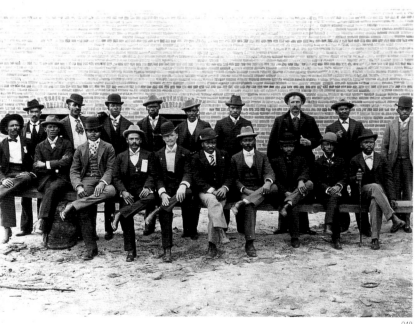

049

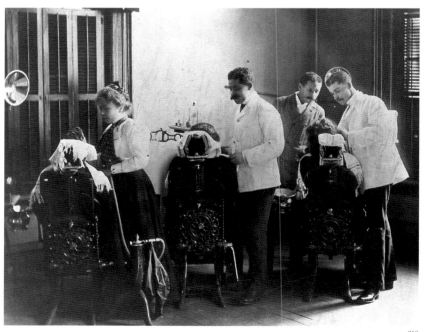

050

052. An unnamed man facing execution by the electric chair at Sing Sing State Prison, New York, c. 1900. In the decades after Emancipation, white authorities increasingly relied on the criminal justice system as a vehicle for the social control of the black community. In capital cases, blacks were significantly more likely to receive the death penalty than whites who had committed the same crimes.

053. Prisoners at Parish Prison at mealtime, New Orleans, c. 1900. The most widespread abuses of black prisoners appeared under the convict leasing system. Blacks convicted of misdemeanors or vagrancy could be assigned to become involuntary, unpaid laborers for private companies or plantations. Due to extreme and inhumane conditions, black convicts under the leasing system were subject to significantly elevated death rates.

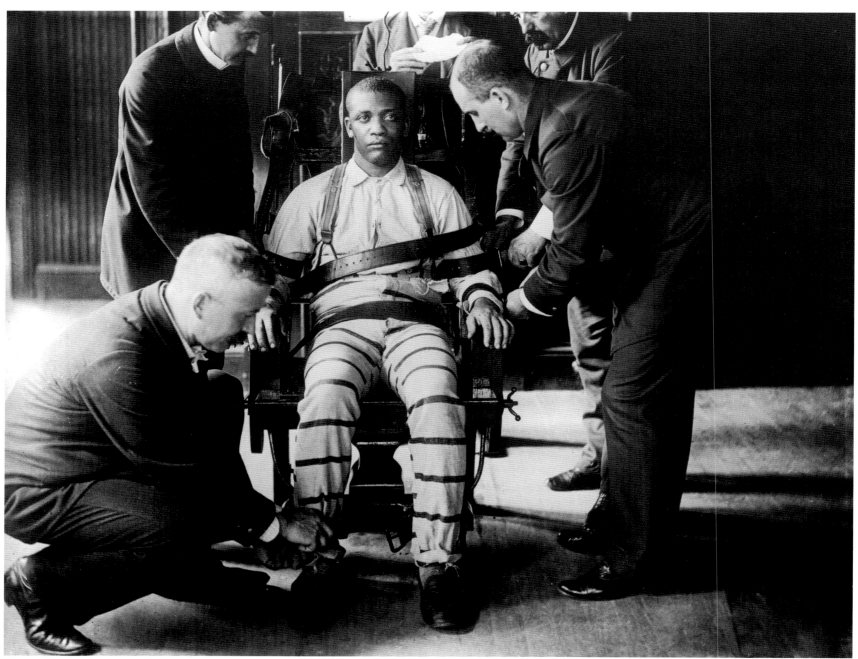

052

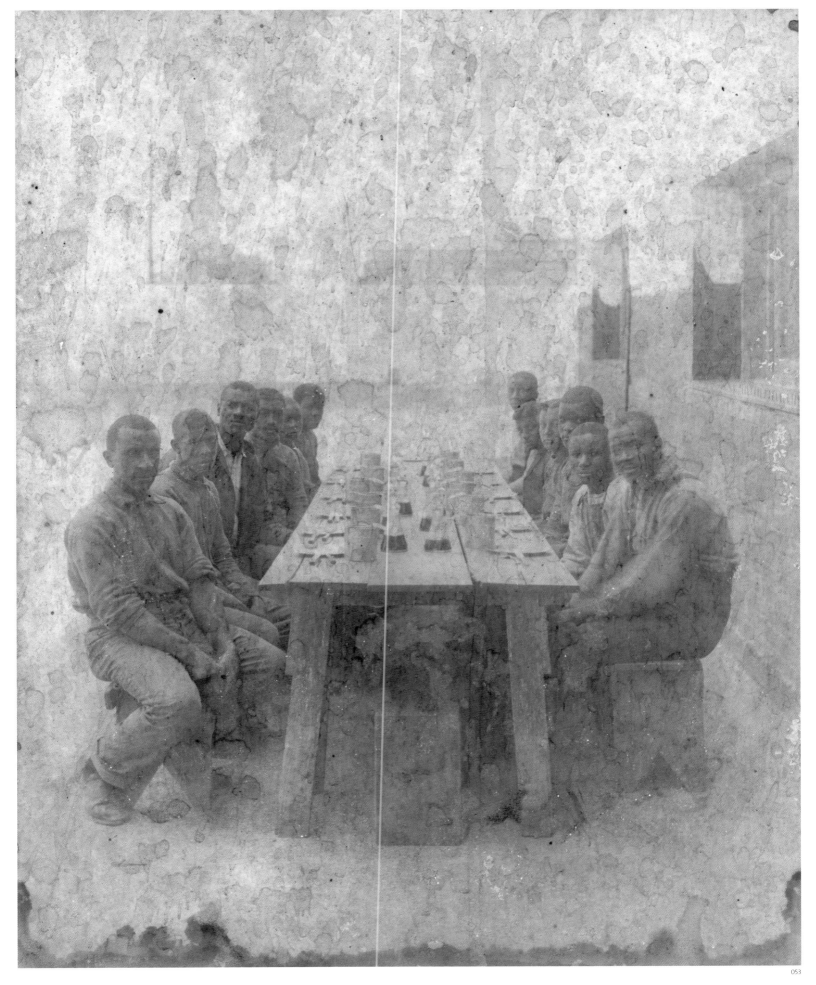

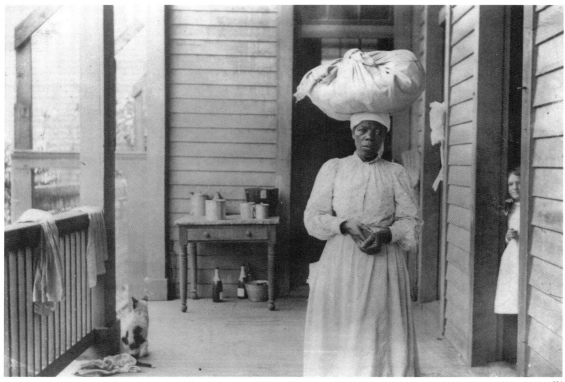

054

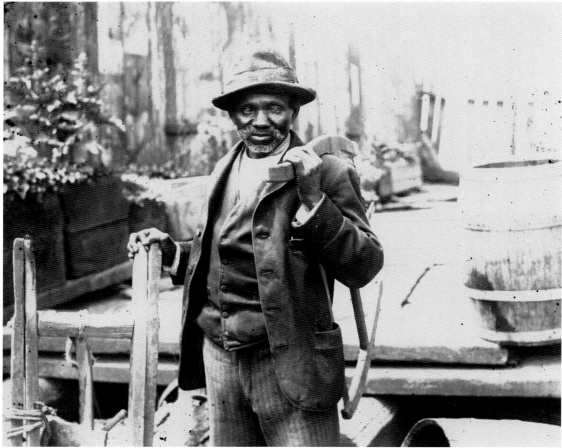

055

054. Domestic worker in the South, c. 1900. For the majority of African American women after Emancipation, non-farm occupations were largely restricted to domestic service. Black women frequently worked around the clock in houses of southern families, caring for their children. They often had only some time on Sunday to spend with their own children. Black married women therefore sometimes chose to work as laundresses rather than as resident domestic servants in order to be able to spend more time with their families.

055. Wood sawyer, Louisiana, c. 1900. During the first decades of the twentieth century virtually all black male adults worked despite the limitations of employment opportunities.

056. Country church and congregation, Louisiana, c. 1900. The center of community and civic life in virtually all southern black communities was the church. These institutions were owned by black people, and blacks themselves selected their leaders and spokespersons. At a time when African Americans were not permitted to vote, the clergy represented the only autonomous representatives of the community who could negotiate with white power. The church was a site of the creation of unique musical forms drawing from both the pain and celebration of the black experience. It was a center for socializing, networking, organizing, and social services, as well as spiritual guidance.

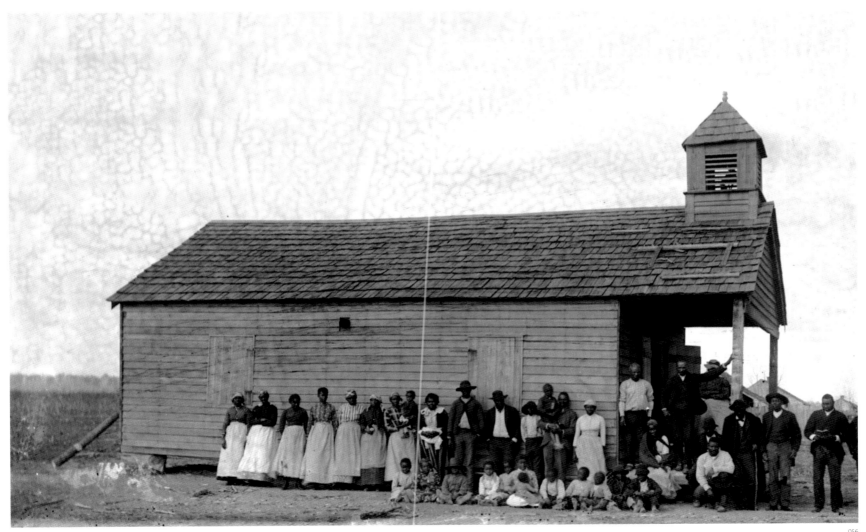

056

057. Bricklaying class, Hampton Institute, Virginia, 1900. Hampton Institute was founded in 1868 by Samuel Chapman Armstrong, a white general who commanded African American troops during the Civil War. The co-educational school trained African Americans and, beginning in 1878, American Indians. Initially, Hampton emphasized elementary and secondary level courses, training non-whites for skilled blue collar, household, and agricultural employment. In the 1920s the elementary and secondary courses were eliminated and the curriculum was transformed to that of a university. Hampton's most famous alumnus was Booker T. Washington, who graduated in 1875.

058. Arithmetic class, Hampton Institute, Virginia, c. 1900.

059. Technical-drawing class, Hampton Institute, Virginia, c. 1900.

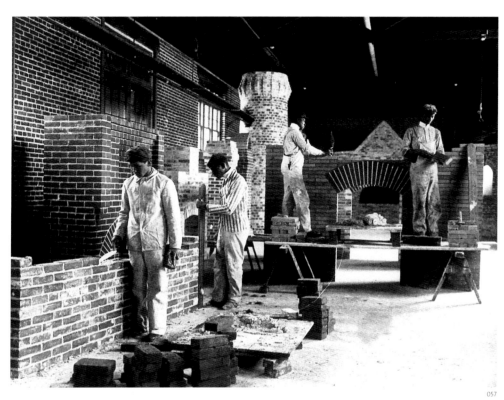

057

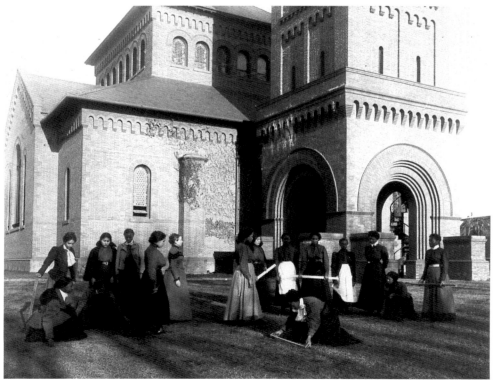

058

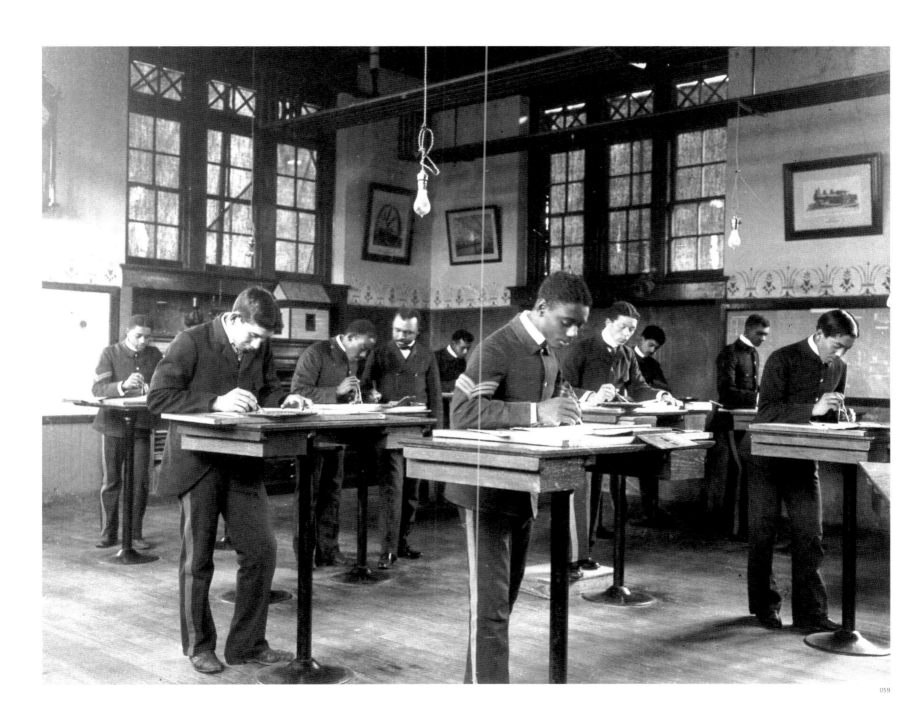

060. A Hampton graduate
at home, location unknown,
c. 1900.

061. Lynching of Garfield
Burley and Curtis Brown,
Newbern, Tennessee,
8 October 1902.

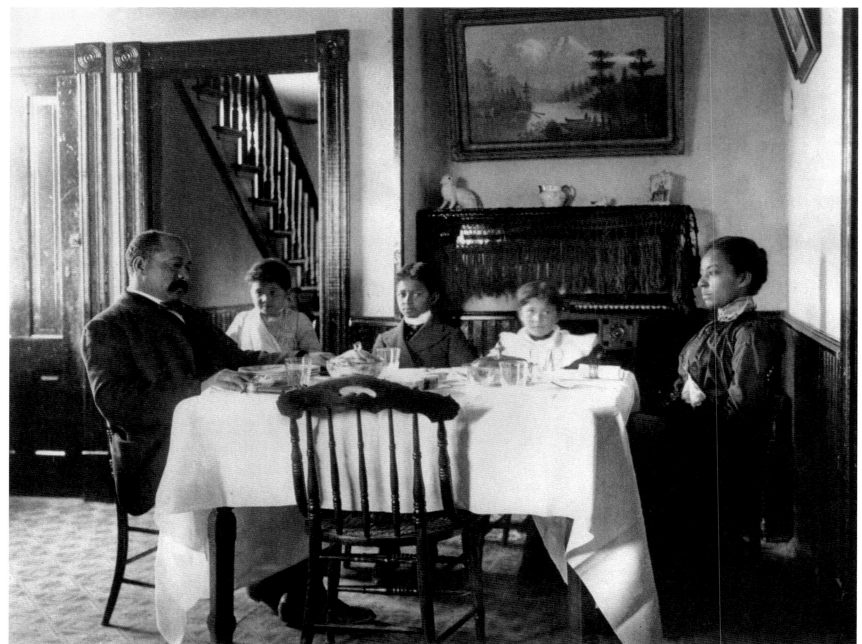

060

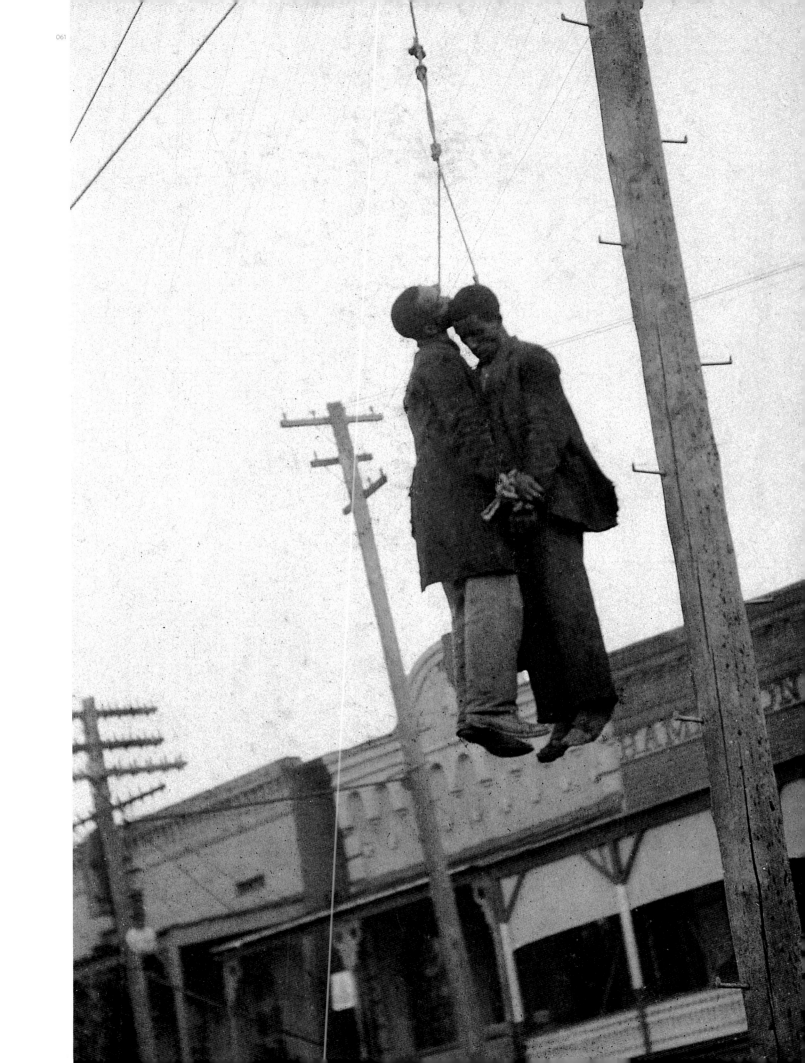

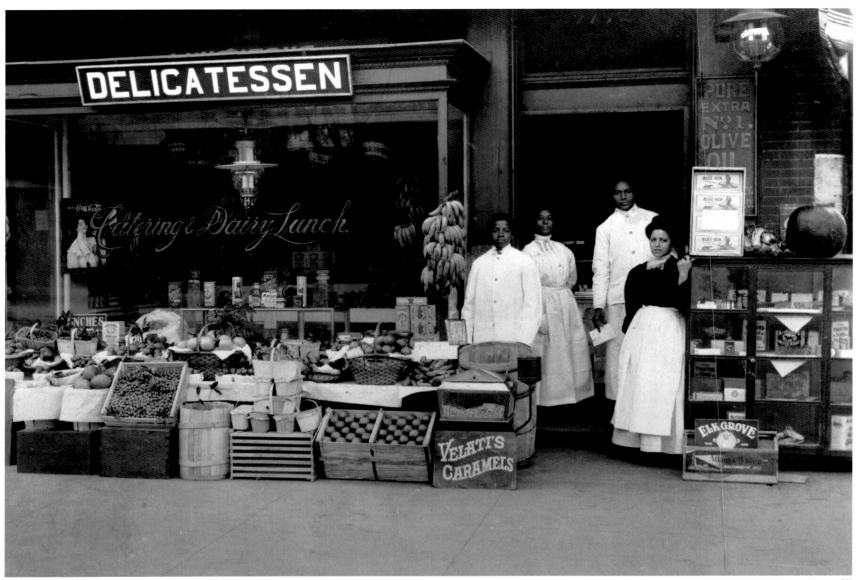

062–063. Underdown family deli, by Addison Scurlock, Washington, D. C., c. 1904. By the beginning of the twentieth century, a small but growing African American middle class had developed in urban centers. This new black elite took special pride in its educational and material achievements. This is well reflected in the photography of the Scurlock studio based in Washington, D. C. Scurlock's photographs celebrated the strivings and accomplishments of a people who, within a generation, moved from being landless migrants to attaining educational and economic success.

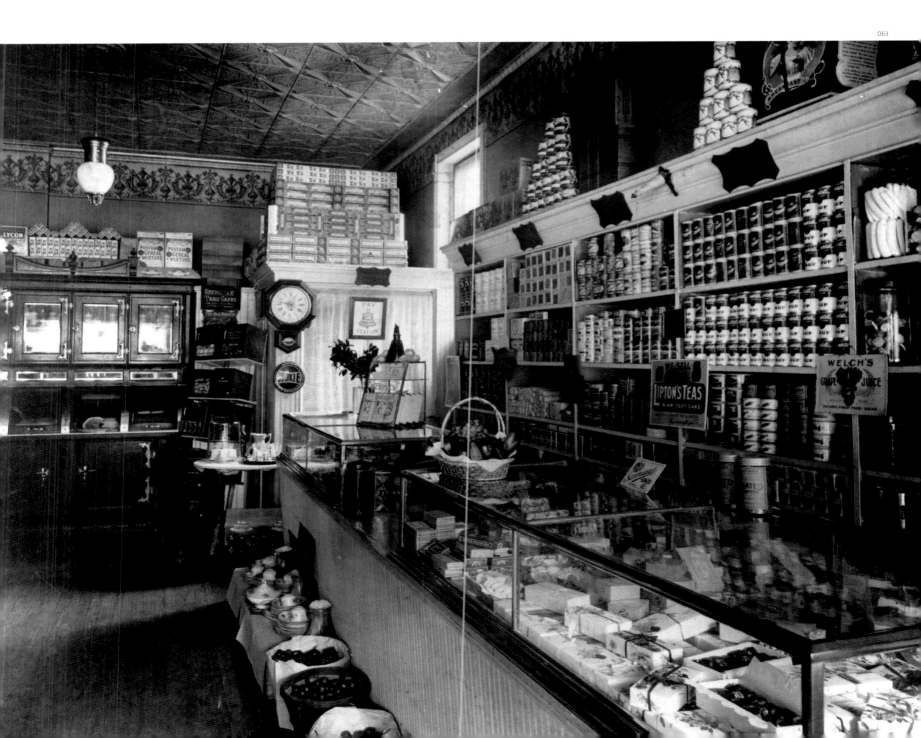

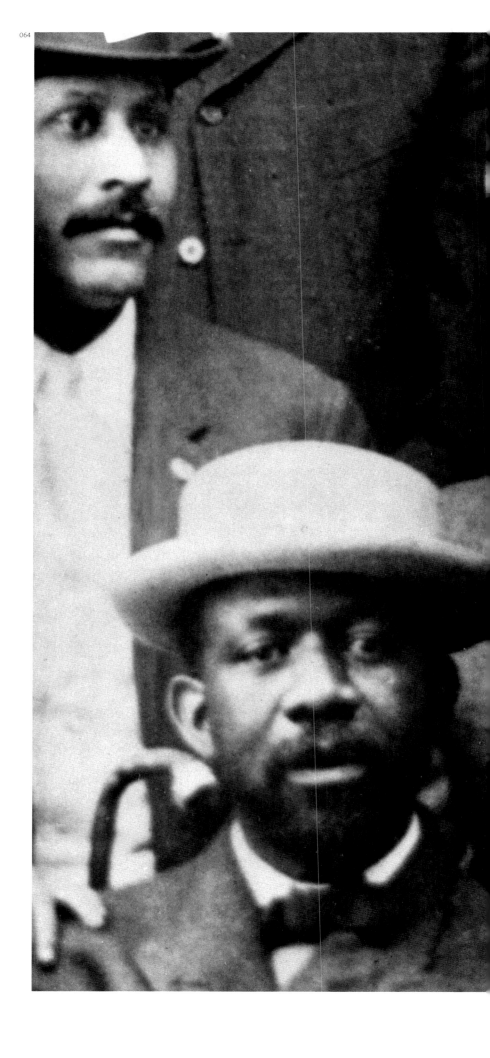

064. Members of the Niagara Movement, Niagara Falls, New York, 1905. In 1905, 29 African Americans led by W. E. B. Du Bois and William Monroe Trotter, editor of *The Guardian*, an African American newspaper in Boston, met at Niagara Falls to initiate a civil rights organization, the Niagara Movement. At its initial meeting the group issued a "Declaration of Principles" that included sharp condemnations of lynching, disenfranchisement, and the segregation of public accommodations and schools. They also called for greater economic opportunity for African Americans, access to higher education and equal justice under the law. Without mentioning Booker T. Washington by name, the Niagara Movement represented a sharp challenge to the political "accommodationism" of the "Tuskegee Machine." The group claimed 170 members by 1906, but conflicts over matters such as the inclusion of women, which Trotter opposed, created serious divisions. Also, Washington used his enormous financial and political influence to harass members of the Niagara Movement, some of whom lost their jobs. By 1909 the group had largely disbanded, and Du Bois agreed to join the National Association for the Advancement of Colored People (NAACP), which had been founded that same year by a group of liberal whites. Du Bois became its Director of Research and the editor of its major publication, *The Crisis*.

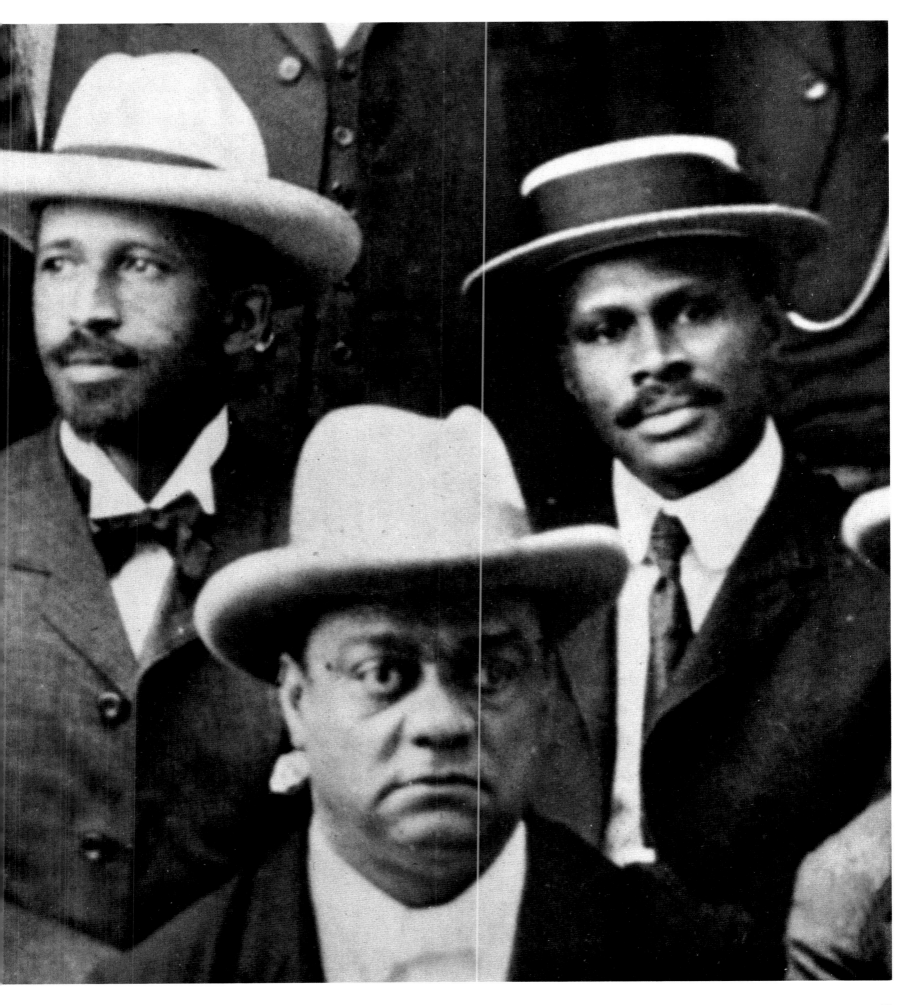

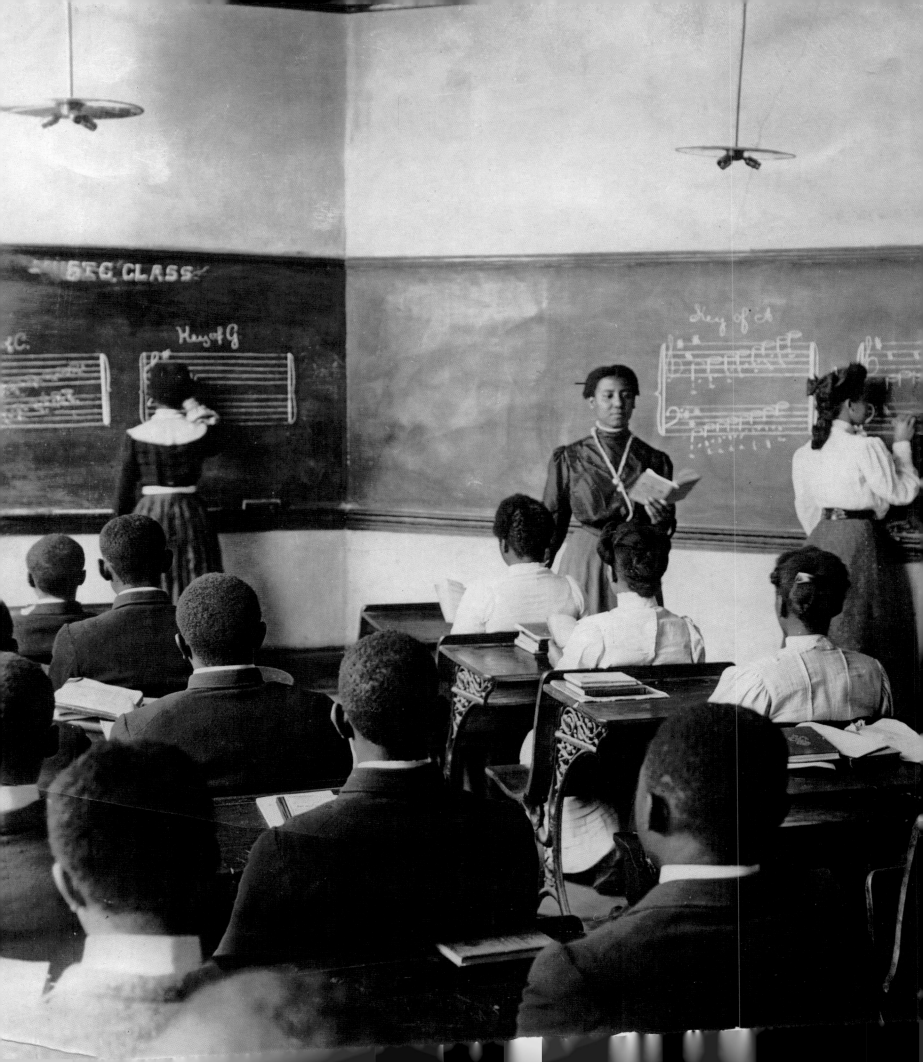

065. Music class, Tuskegee Institute, Alabama, c. 1906. The following photographs (065–070) were part of a third group of pictures commissioned from Frances Benjamin Johnston by Booker T. Washington to illustrate the achievements of the Hampton and Tuskegee institutes. By 1900 Tuskegee Institute had become the most influential model for the training of minorities in the United States. In 1903 Andrew Carnegie gave Tuskegee Institute $600,000 in U. S. Steel bonds, and stipulated that one fourth of this amount be for the personal use of Washington for the promulgation of his conservative educational and political philosophy among African Americans.

Washington used these funds to buy control of several major African American newspapers and to build a political organization, the "Tuskegee Machine" to influence national policies about race. Tuskegee promoted the development of black professional societies and the training of thousands of black entrepreneurs.

066. Booker T. Washington with Theodore Roosevelt at Tuskegee Institute for the twenty-fifth anniversary parade, 24 October 1906. Washington developed a close political relationship with Republican president Theodore Roosevelt, and Washington's lieutenants, such as James Weldon Johnson and Robert Terrell, benefited from patronage appointments within the Republican administrations of Roosevelt and William Howard Taft. Roosevelt's visit to Tuskegee in 1906, only five years after African Americans had been completely disenfranchised in the state of Alabama, represented a remarkable statement of the influence of Washington's policy of accommodation. Most white supporters were not aware that Washington used some of his resources to secretly lobby against Jim Crow laws and the disenfranchisement of black voters in several states.

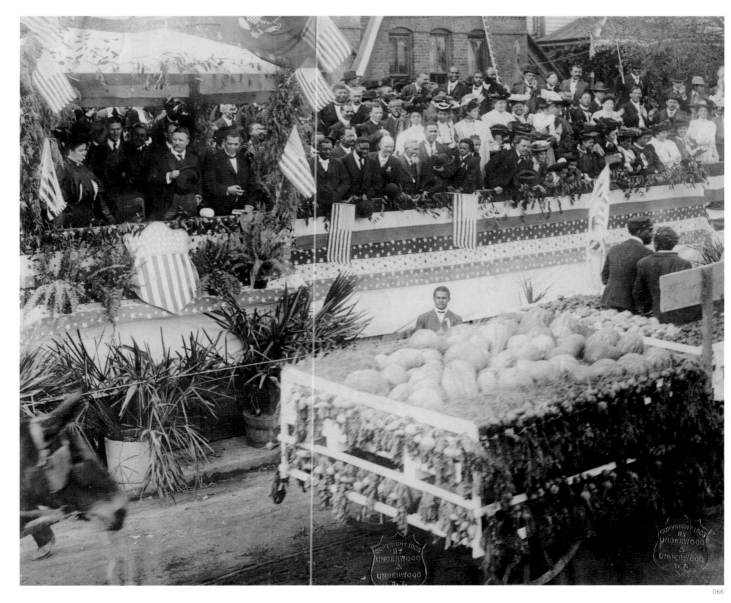

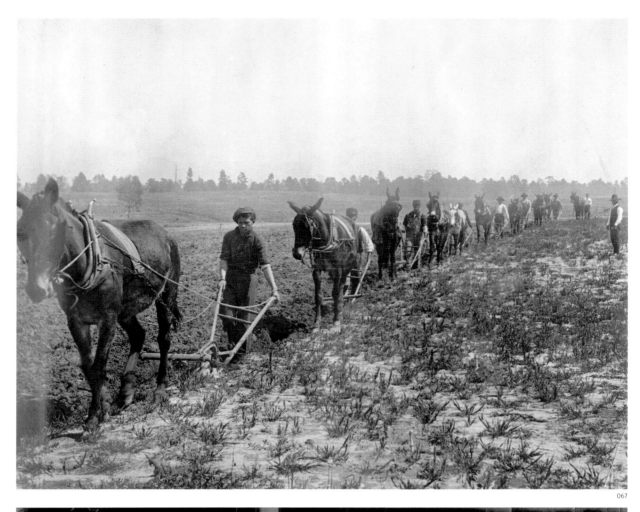

067

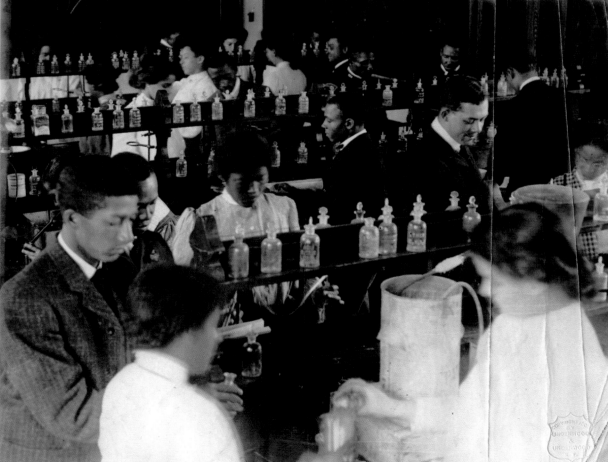

068

067. Field work, Tuskegee Institute, c. 1906. The "Hampton–Tuskegee model" of industrial and agricultural training emphasized manual labor and the acquisition of technical skills rather than a broader liberal arts education.

068. Science laboratory, Tuskegee Institute, c. 1906.

069. Boy's Hall, Tuskegee Institute, c. 1906.

069

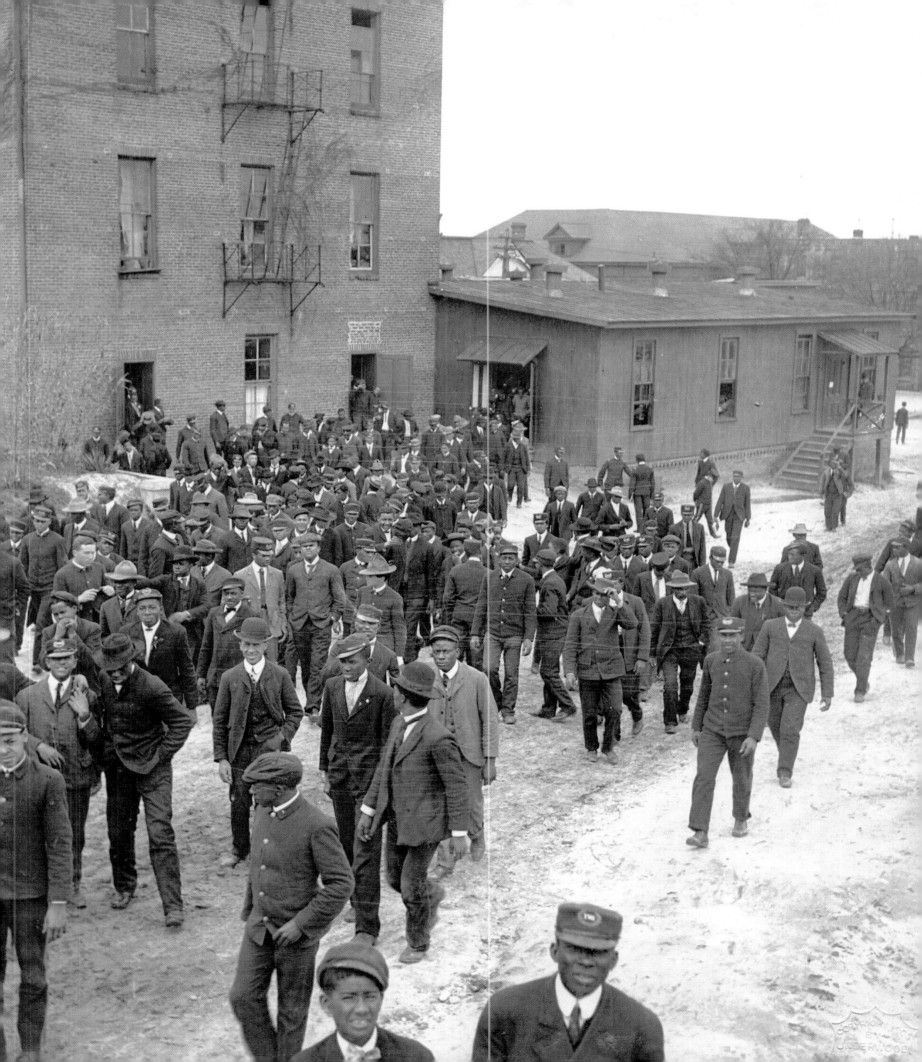

070. Football game at
Tuskegee Institute, c. 1906.

071. The lynching of five
African Americans, Nease
Gillepsie, John Gillepsie,
Jack Dillingham, Henry Lee,
and George Irwin,
Salisbury, North Carolina,
6 August 1906.

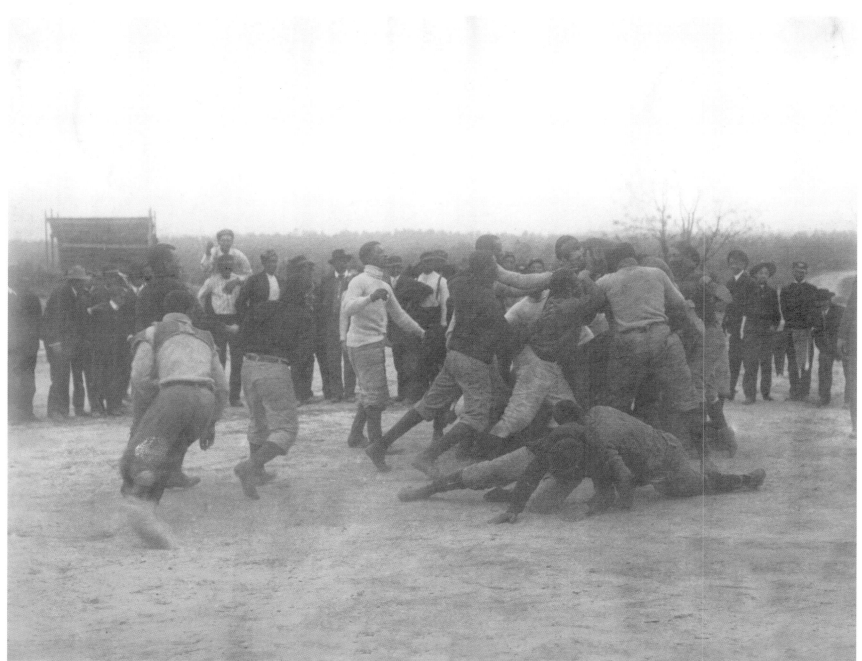

070

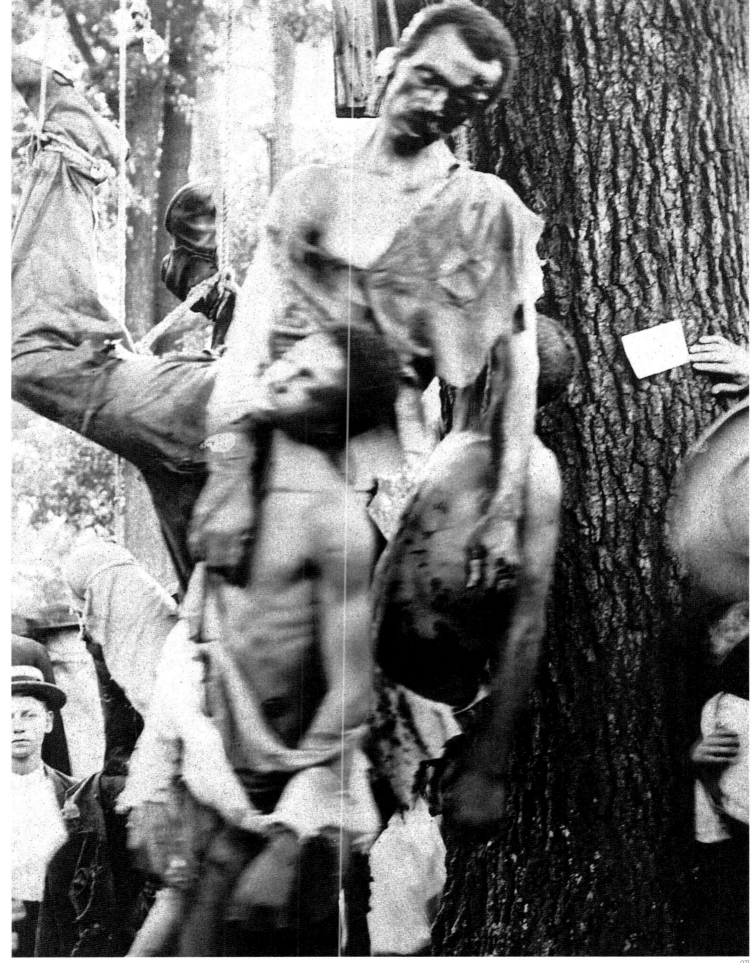

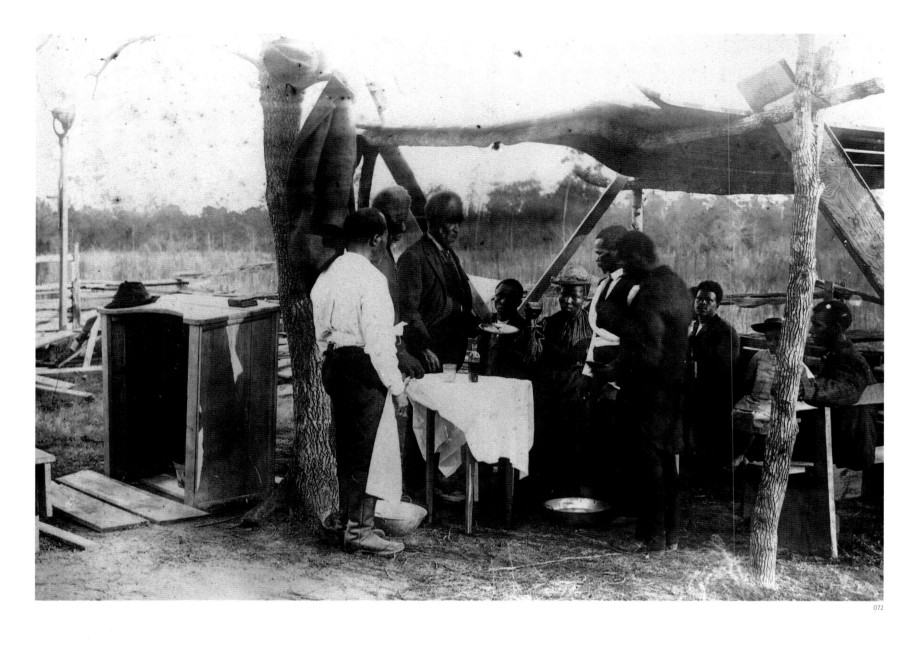

072. Holy Communion, Mount Romus Free Will Baptist Church, Lake Waccamaw, North Carolina, c. 1910. The first convention of black Baptists in North Carolina was held in 1866. For over a century the Baptists have been the largest Protestant denomination of African Americans, and have produced many prominent figures of the African American freedom movement including Adam Clayton Powell, Jr., Martin Luther King, Jr., and Jesse Jackson.

073. African delegates to Tuskegee Institute, Alabama, 1910. An extensive cooperative relationship developed between the Tuskegee Institute and African institutions under colonial rule. The founder of the African National Congress (ANC) in South Africa, John Langalibalele Dube, spoke at Tuskegee's commencement in 1897. Tuskegee graduates were employed throughout Africa, particularly in British West Africa and the Congo Free State; in 1903 Tuskegee graduates, along with a faculty member, established an agricultural project in German West Africa (now Togo). Significant numbers of Africans attended Tuskegee over the years and the Institute became, in many respects, the model for the segregationist "Bantu education system" established by the British in South Africa in the 1920s and 1930s. But these transatlantic links between people of African descent also fostered joint political cooperation in anti-colonial protest movements.

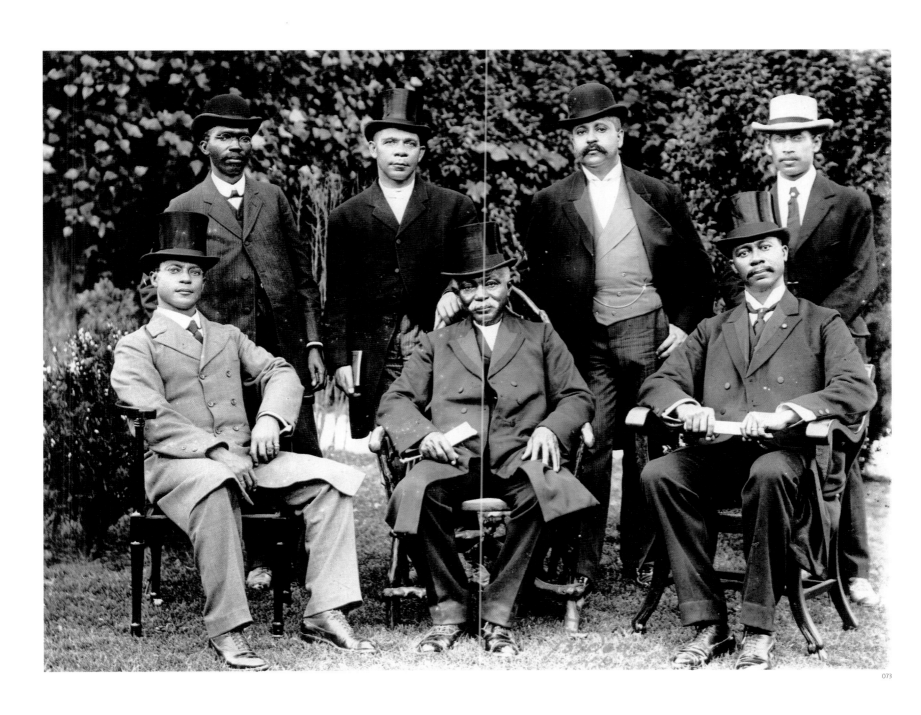

073

074. Jack Johnson (far right) and opponent James J. Jeffries (left) training for the boxing championship fight, location unknown, 1910. During the era of Jim Crow segregation, most professional sports were closed to blacks. One of the few exceptions was boxing. John Arthur "Jack" Johnson, born in Galvesten, Texas in 1878, was the dominant heavyweight boxer for two decades. In 1908 he defeated the world heavyweight champion, Tommy Burns, in Sydney, Australia. Johnson's triumph resulted in widespread outrage among whites and a popular demand for a "great white hope" to take back the championship. James Jeffries, a former champion, reluctantly came out of retirement to challenge Johnson. After Johnson decisively defeated Jeffries in their highly publicized 1910 bout, white vigilantes in over a dozen cities across the United States initiated attacks against blacks. Johnson's controversial personal life, including relationships with white women, generated intense scrutiny by law enforcement officials, until, harassed by federal and state authorities, he was forced to leave the United States and fight abroad. Johnson finally lost the championship when he was defeated by Jess Willard in their 26-round bout in Havana, Cuba in 1915.

075. African American couple, Chicago, c. 1911. Between 1915 and the mid-1920s, as many as one million African Americans left the rural South and migrated to urban areas, particularly to the northeast and midwest industrial regions of the United States. The migrants of the first wave were concentrated in racially restricted residential neighborhoods, which quickly became known as black ghettoes.

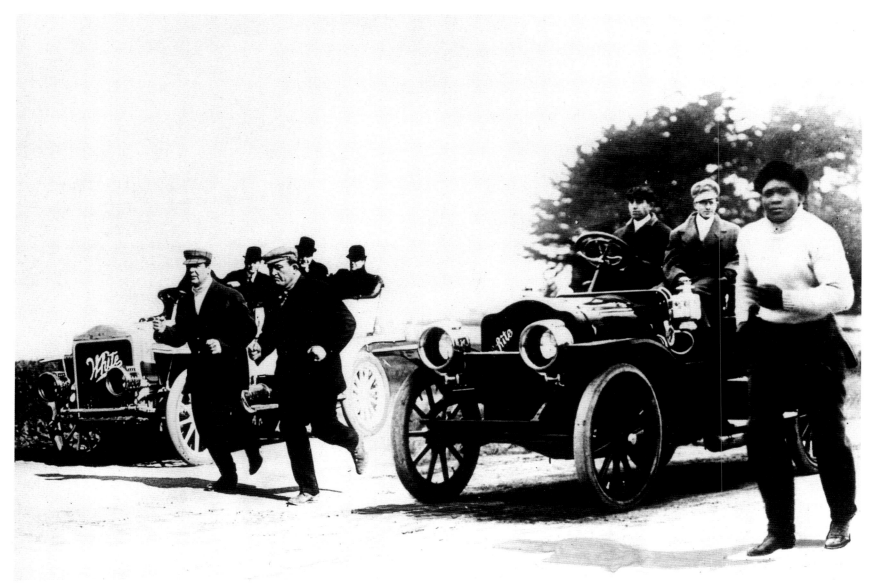

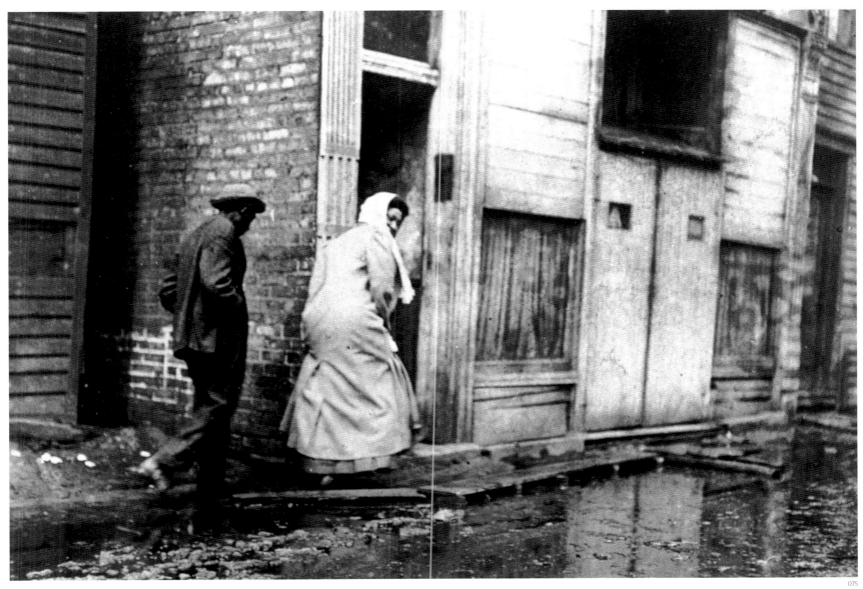

076. "Waterfront" by Addison Scurlock, location unknown, c. 1915.

077. Booker T. Washington in Shreveport, Louisiana, 1915. This photograph was taken by Arthur P. Bedou during Washington's last southern speaking tour, a few months before his death. A popular and effective speaker with black entrepreneurs and farmers, Washington also drew sharp criticism from the educated black middle class for his accommodation to racial segregation and disenfranchisement.

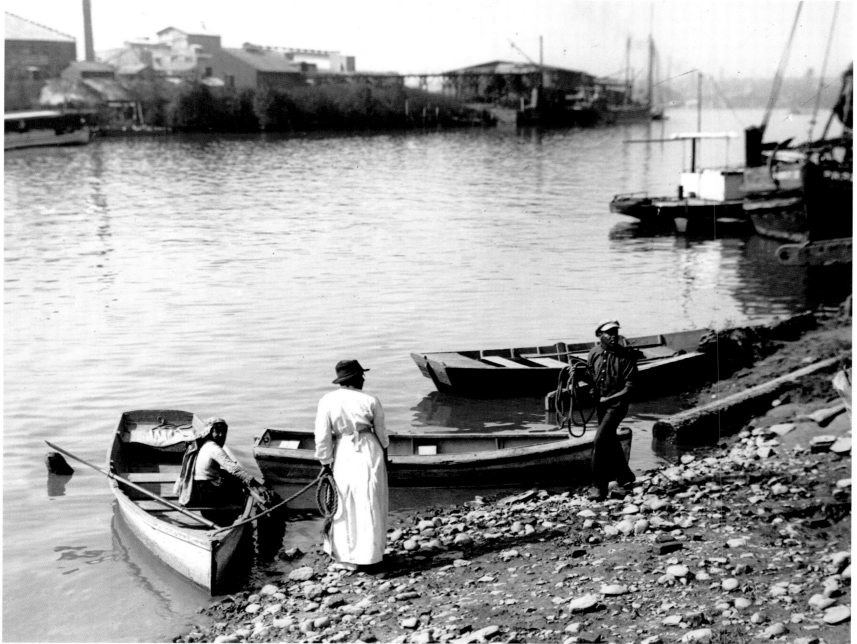

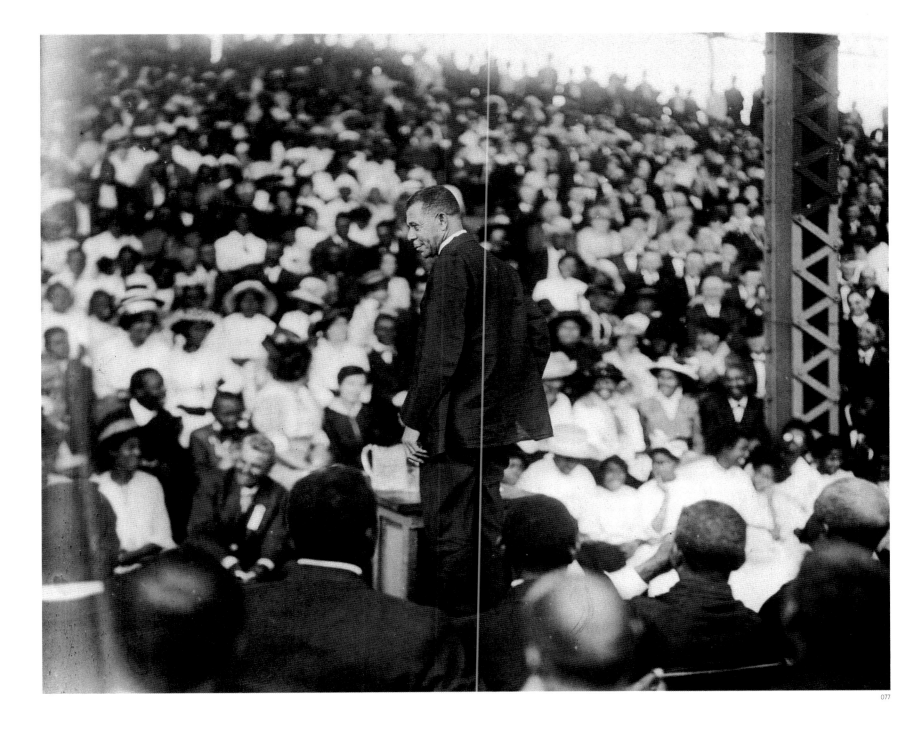

077

078. Silent protest parade organized by the National Association for the Advancement of Colored People (NAACP), New York City, 28 July 1917. When a local packing plant in East St. Louis, Illinois hired black workers, white racist mobs attacked the small black community on 2 July 1917. They murdered dozens of blacks, and several families were burned alive in their homes. In response to the East St. Louis riot and other recent lynchings across the South, 8,000 African Americans, primarily from Harlem and led by the NAACP, marched down Fifth Avenue to a muted drum beat in silent protest. The *New York Age*, a black newspaper, reported, "They marched without uttering one word or making a single gesticulation and protested in respectful silence against the reign of mob-law, segregation, 'Jim Crowism,' and many other indignities to which the race is unnecessarily subjected in the United States."

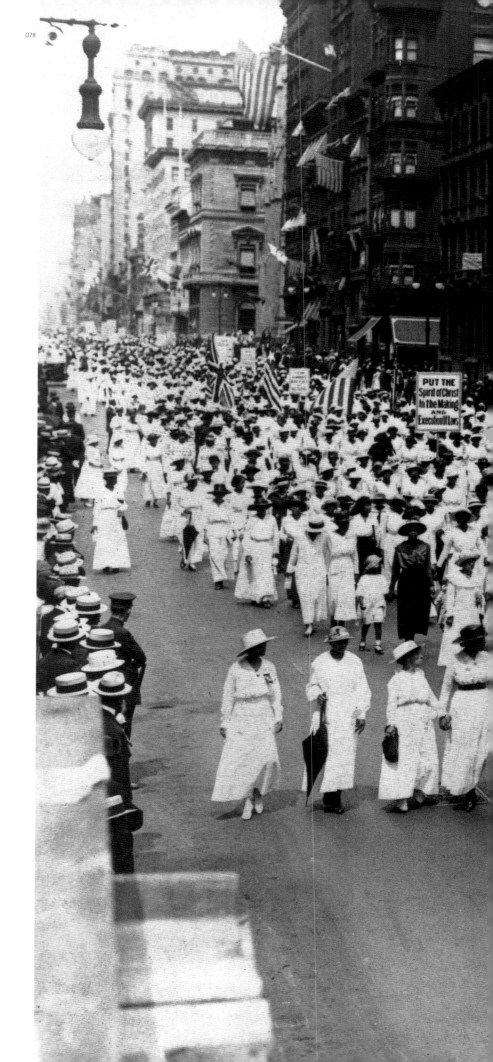

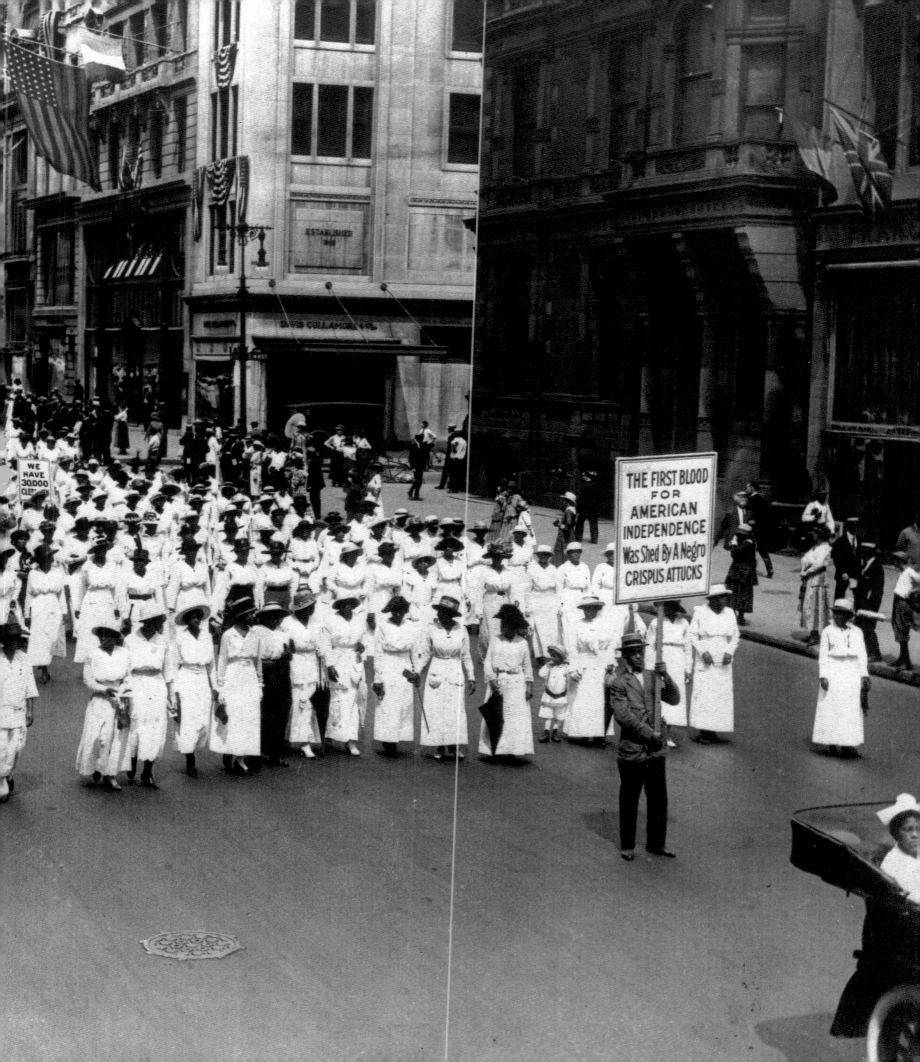

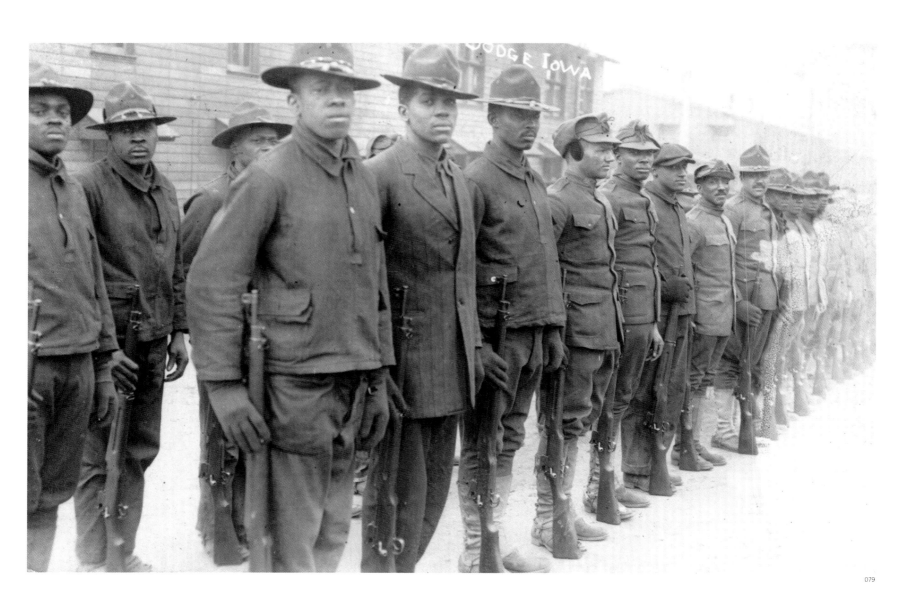

079

079. Soldiers at the head-
quarters of the 88th Division,
Camp Dodge, Des Moines,
Iowa, 1918. For several years
the NAACP had pressured the
administration of President
Woodrow Wilson to create an
officers' training school for
African Americans, as a result
of which the Colored Officers'
Training Camp was created.
On 15 October 1917 at Des
Moines, 639 African American
officers were commissioned.

Although blacks comprised
13 percent of all active duty
soldiers in World War I, they
were restricted to less
than 1 percent of the total
officer corps.

080. Enlisting at the Y. M. C. A.
for the Colored Officers'
Training Camp at Des Moines,
Iowa, February 1918.

081. Berean Colored Officers'
Club, Philadelphia, 1918.

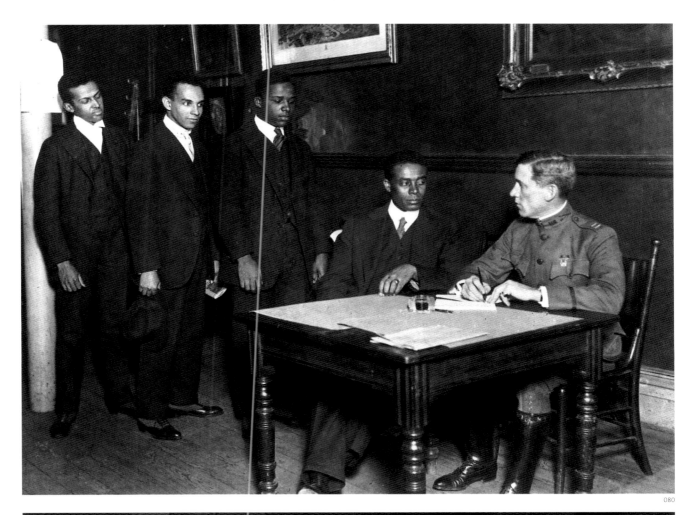

080

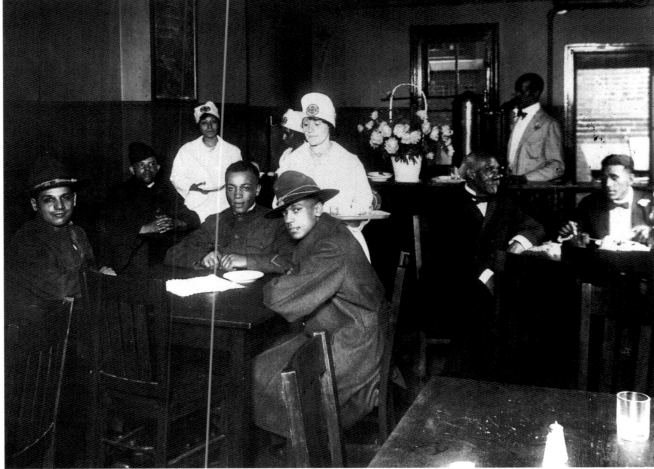

081

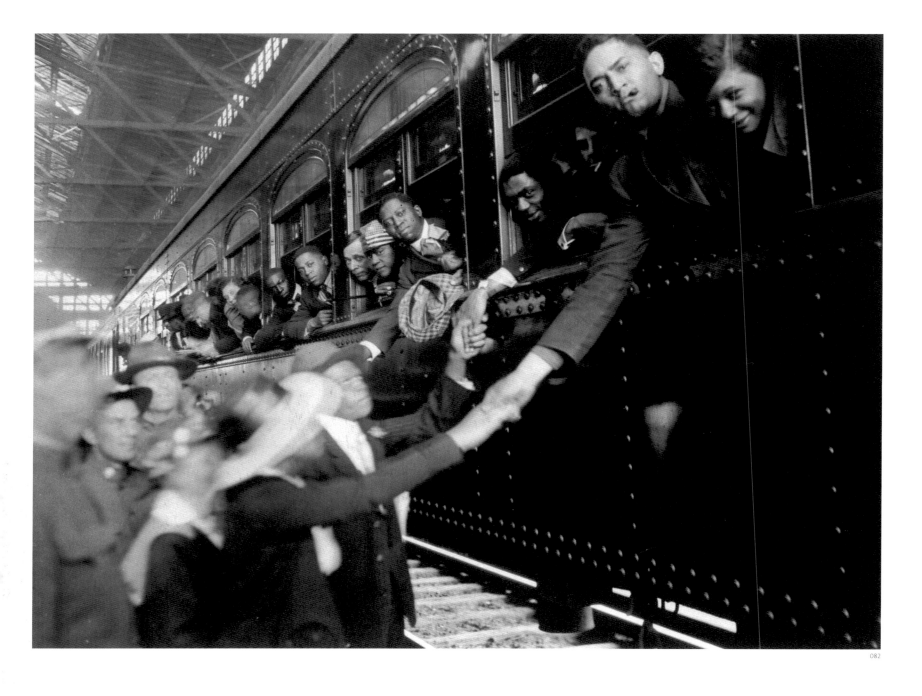

082

082. Men leaving for training camps, Duluth, Minnesota, January–February 1918. During World War I, nearly 2.3 million African Americans registered to serve in the military. 367,000 were enlisted and organized to serve in segregated units. Many of the army's best trained black regiments were assigned to the American Southwest, along the Mexican border, however, because the Wilson administration and army officials were relunctant to send large numbers of African Americans to France for fear that the U. S. policy of strict racial segregation be undermined.

083. The 367th Regiment of Infantry marching in review before being presented with a "strand of colors" by the Union League Club, New York City, 23 March 1918. The 367th Regiment, known as the "Buffaloes," was organized at Camp Upton, New York in late 1917. They were sent to France in June 1918 and achieved great acclaim for their record of heroism. The entire regiment was awarded the *Croix de Guerre*, the distinguished French decoration for bravery.

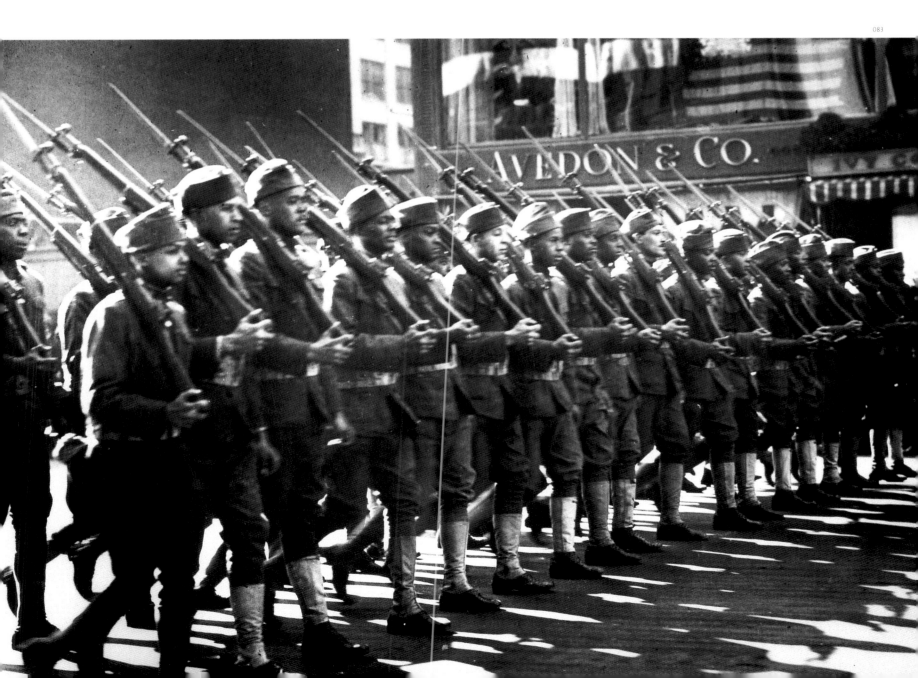

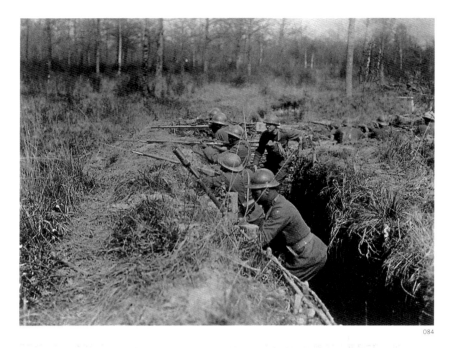

084

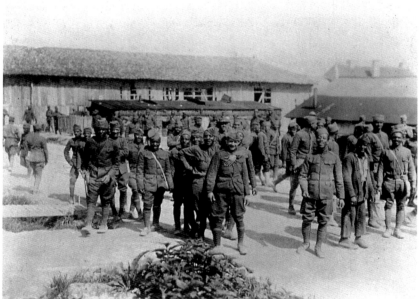

085

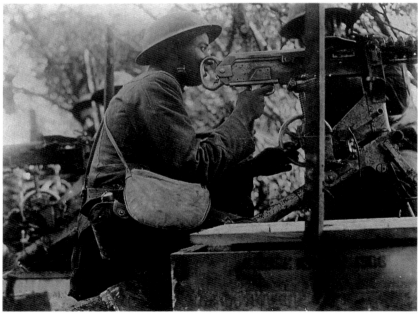

086

084–086. American soldiers in France, June 1918. Forty thousand African American troops in the 92nd and 93rd Divisions were deployed to Europe during the war. But U. S. Commander John "Black Jack" Pershing was sharply opposed to black combat troops fighting side-by-side with white Americans. Black soldiers were therefore assigned to the French, who trained them in combat units.

087. 15th New York Infantry in France, 22 April 1918. These African American soldiers are wearing French helmets.

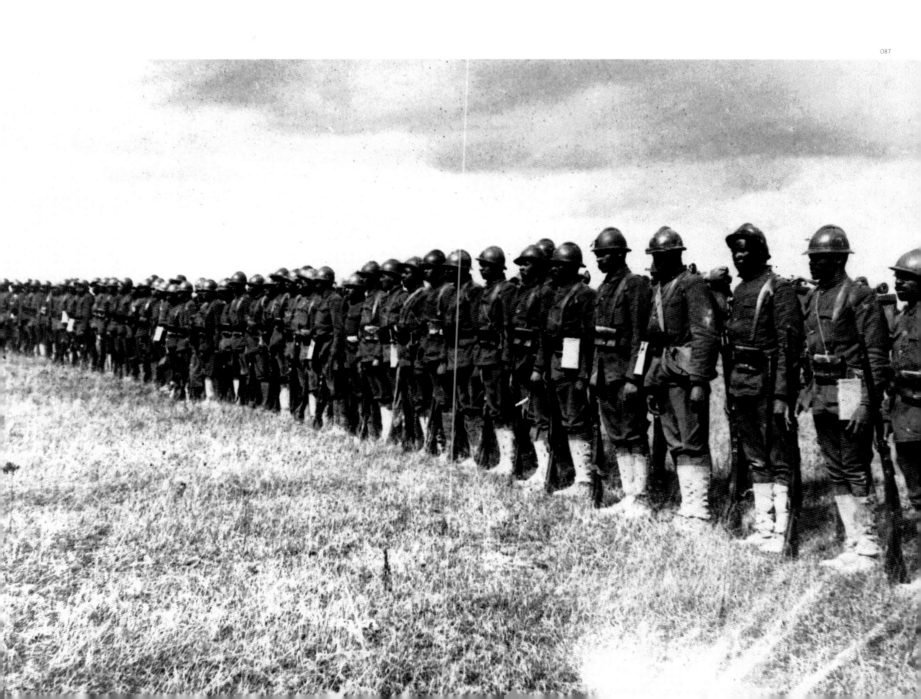

088. Stevedore Regiment consolidated mess, Q. M. C. (Quartermaster Corps) Resident Camp No. 4, France, 1918.

089. The arrival of the 369th Infantry Regiment in New York City after the end of the war, c. 1918. The regiment had arrived in France in early 1918 and was trained for several months in French military camps. By May they were fighting in the front lines, where they spent more than six months — longer than any other American unit during this war. The Germans referred to the 369th Regiment as the "hell fighters." By the end of the war, 171 officers and enlisted men in the 369th Regiment had received medals of bravery from the French government.

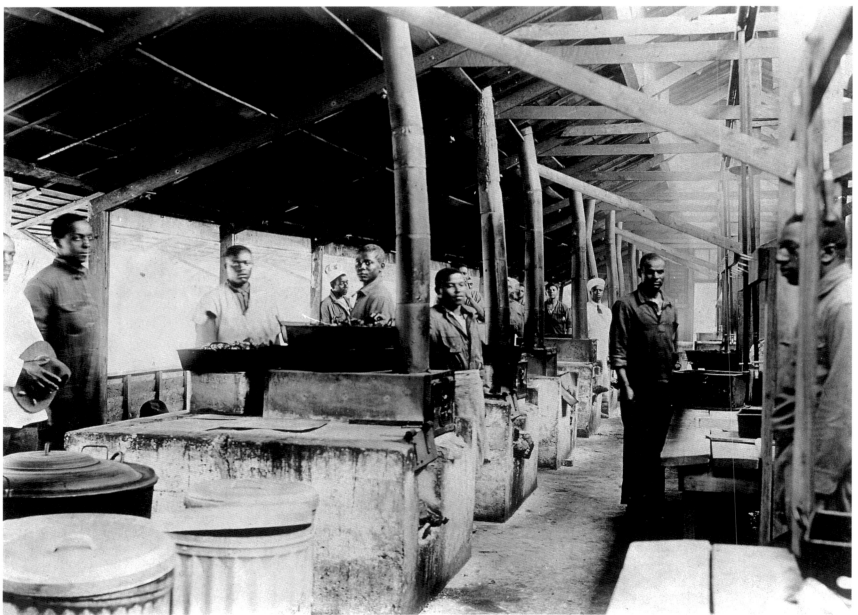

088

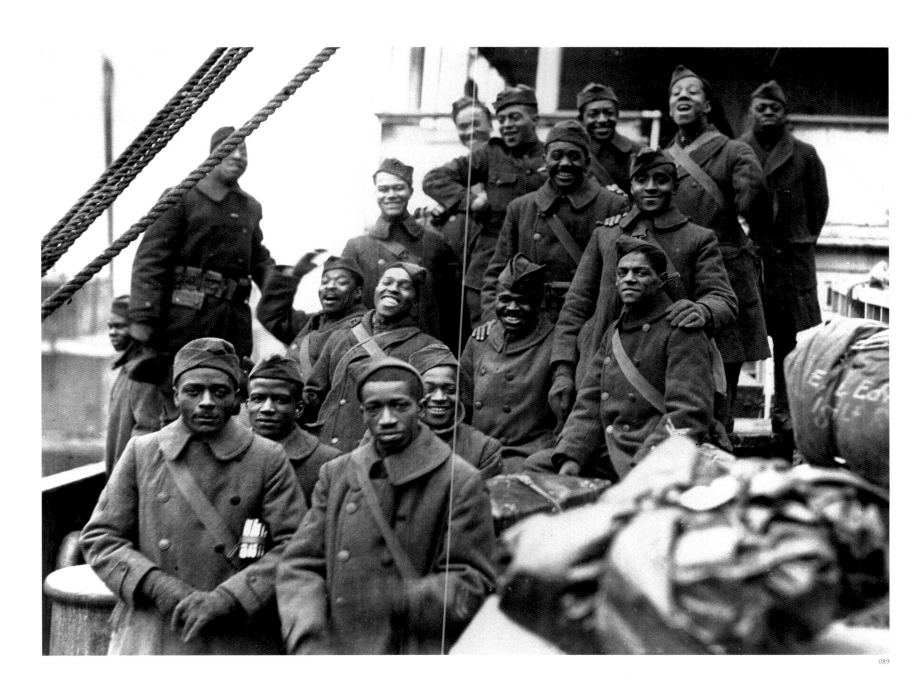

089

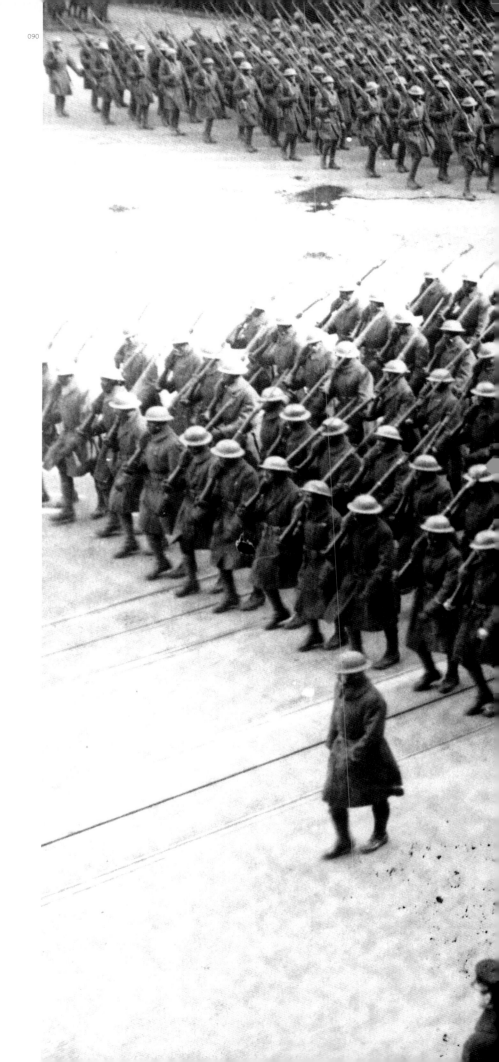

090. The 369th Infantry
Regiment marching in New
York City, March 1919.
The regiment was given a
hero's welcome when it
returned to New York.

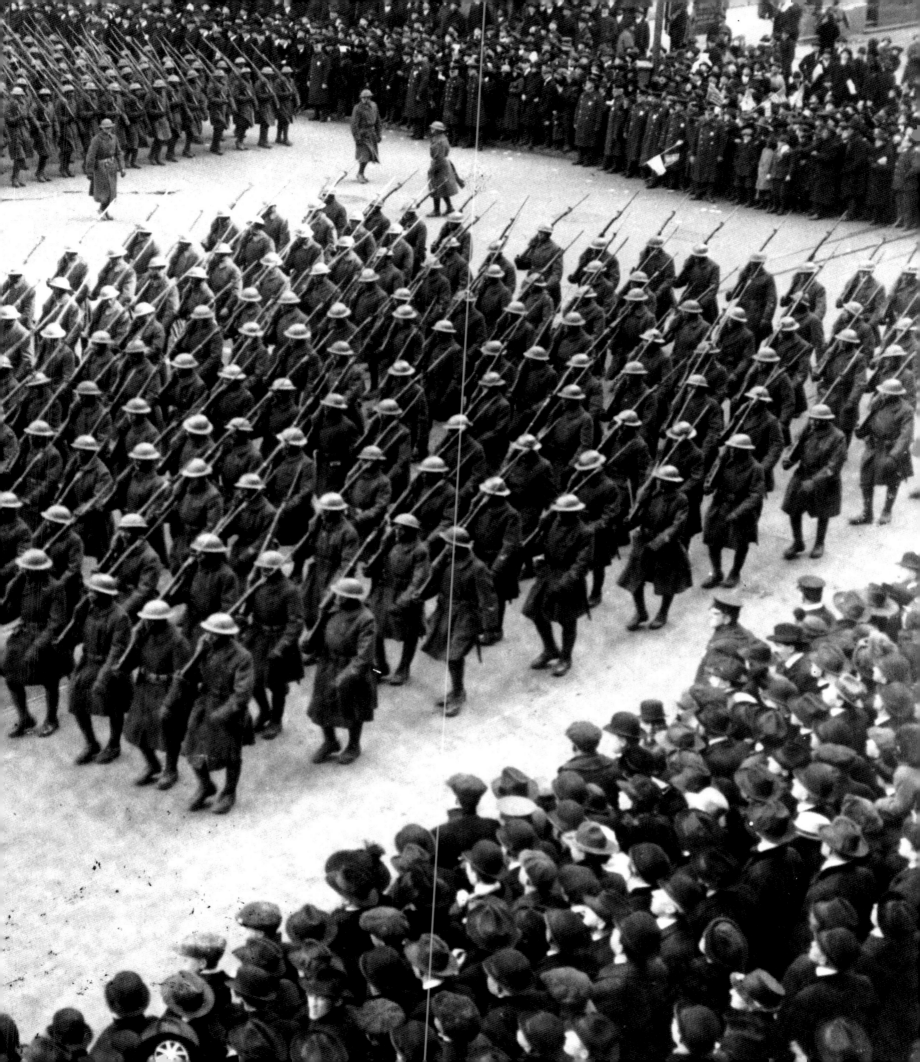

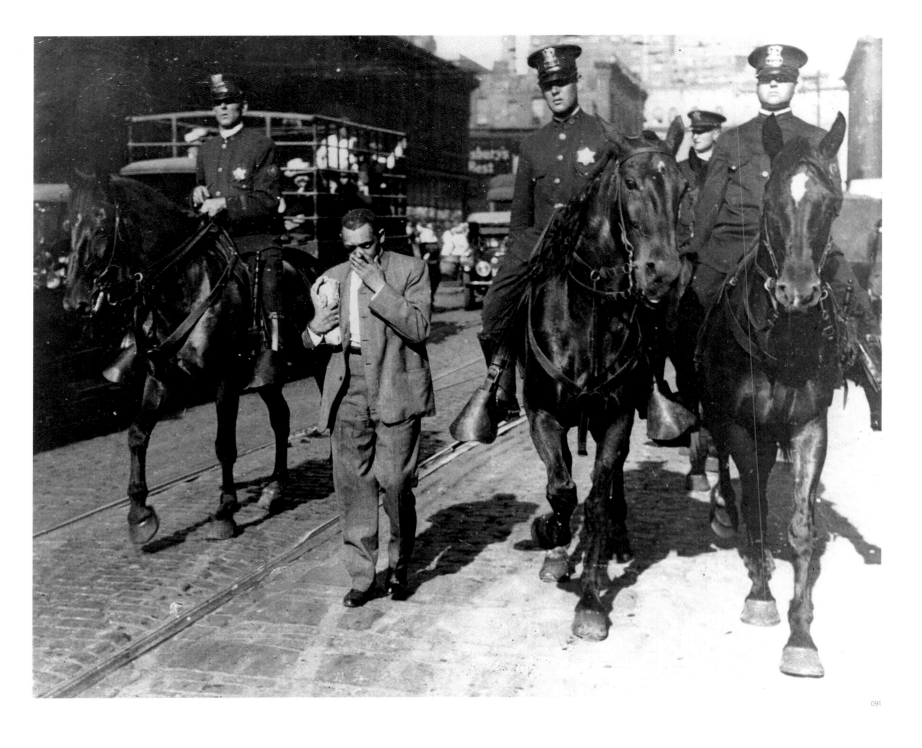

091

091. Chicago race riot, July 1919. Despite the sacrifices and courage displayed by African Americans during the war, they nevertheless encountered a virulent backlash of white racism upon their return to the United States. A number of newly discharged African American soldiers — still wearing their uniforms — were lynched by white mobs.

On 27 July 1919, mobs attacked the African American community in Chicago, which fought back. Two weeks later 38 people had been killed and over 500 injured. More than 1,000 black families lost their homes.

092. Lynching in Omaha, Nebraska, 28 September 1919. A white mob of 5,000 surrounded and attacked the country courthouse to seize an African American accused of assaulting a white girl. The mob mutilated the black man, shooting him over 1,000 times and then burned his body. In the last six months of 1919 there were 25 major race riots in the United States. In response to the carnage of this "Red Summer," poet Claude McKay wrote:

If we must die — let it not be like hogs
Hunted and penned in an inglorious spot,
While round us bark the mad and hungry dogs,
Making their mock at our accursed lot.
...
Like men we'll face the murderous, cowardly pack,
Pressed to the wall, dying, but fighting back!

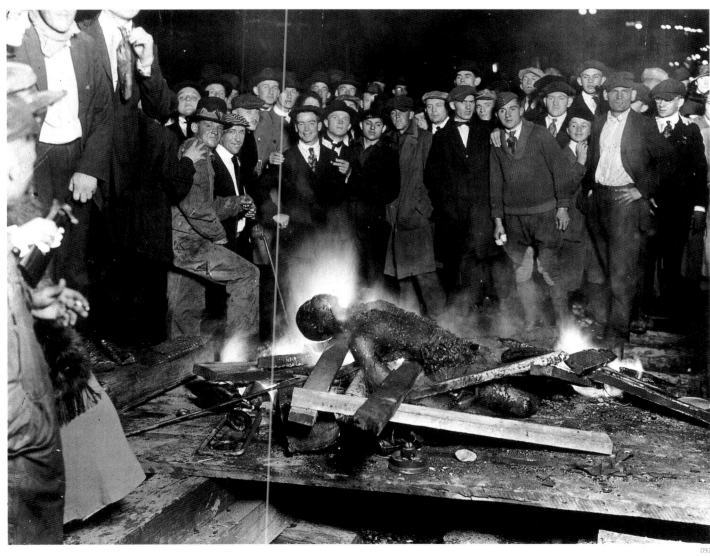

092

1919

1954

A DREAM DEFERRED

A DREAM DEFERRED

What happens to a dream deferred?

Does it dry up
like a raisin in the sun?

— Langston Hughes, "Harlem"

The broad contours of what today is thought of as modern black America were largely produced during the 1920s and 1930s. Prior to World War I, the problem of race was generally confined to the South; by World War II, in the words of sociologist Gunnar Myrdal, it was truly "an American dilemma." In the early twentieth century, African Americans were predominantly a rural people, small farmers, laborers, and domestic servants; by mid-century, they had become largely urban, with more than one-third of the total population living outside the South. During President Woodrow Wilson's administration, blacks had been literally excluded from all aspects of government and civic affairs; by the end of President Franklin Roosevelt's administration, blacks were becoming a significant factor in national politics and a critical constituency in many urban elections outside the South. In professional sports, blacks had virtually disappeared by 1910; a generation later, America's "national pastime," baseball, would be integrated.

The greatest single factor that led to these socioeconomic and political transformations of African American life was the Great Migration. The cotton market collapsed in 1914–15, as U. S. merchants were unable to export goods to Europe during World War I. Thousands of farmers, black and white, went out of business. At the same time, the infestation of the boll weevil destroyed millions of acres of cotton across the Black Belt, reducing production. The mechanization of southern agriculture also reduced the demand for unskilled black labor. All of these economic developments, combined with the daily insults and oppressive conditions on public life imposed by Jim Crow segregation, prompted growing numbers of African Americans to leave their homes and to seek to establish their families and communities elsewhere. With the rapid growth of northern manufacturing and industrial production, blacks understood that new employment opportunities and a higher standard of living would be available to them outside the South.

As early as 1917, W. E. B. Du Bois observed that at least one quarter of a million African Americans had migrated to the North since 1910: "Here we see a social evolution working itself out before our eyes. The mass of the freedmen are changing rapidly the economic basis of their social development." What historians later would term the Great Migration occurred first between 1915 and 1930, represented by two great streams of black population. The first stream came from the southeastern states, Georgia, the Carolinas, and Virginia, resettling in the major northeastern U. S. cities — New York, Philadelphia, Washington, D.C., Baltimore, and Boston. A second migration came from the central Black Belt regions of Alabama, Mississippi, Louisiana, and Arkansas, moving northward into new black urban neighborhoods in Chicago, St. Louis, Detroit, and Cleveland. The racial demographics of urban America were fundamentally altered. By 1930, over 150,000 African Americans were living in New York City. By the late 1950s, over one million blacks resided in New York. Nearly two million blacks had migrated to urban centers before the Great Depression. The migration slowed during the 1930s, dropping to three-quarters of a million people. But the migration resumed, with a second wave of over 1.5 million black migrants in the 1940s, and another two million during the 1950s. Urban communities defined by African American cultural, economic, and social life became part of the nation's major cities: Harlem and Bedford Stuyvesant in New York City, Chicago's South Side, Cleveland's Hough district, North Philadelphia, and Los Angeles' Watts district. African Americans once again encountered fierce discrimination in these cities. White banks carried out informal policies of "redlining," limiting the access of blacks to credit and capital. Real estate firms refused to sell homes to blacks in predominantly white districts, and charged outrageously high rates for apartment rentals even in poor neighborhoods. Blacks were frequently not admitted to white hotels and were sometimes relegated to Jim Crow sections at restaurants and theaters. Despite these restrictions, blacks overall enjoyed a better quality of life. Blacks also had greater access to health facilities and improved sanitary conditions. These striking changes in the material and social conditions of blacks had a direct and measurable impact upon their health and welfare. In 1900, African American life expectancy in the United States was only 34 years; by 1930, life expectancy had increased to 47 years; and in 1950 it was about 58 years, still about nine years less than that of white Americans.

One of the most difficult challenges confronting blacks who had migrated to cities was the struggle for employment. Skilled jobs such as railroad engineers, steamfitters, electricians, machinists, cranemen, plumbers and pipefitters, and many other occupations were designated for whites only. Blacks desperately seeking work sometimes accepted employment as "scabs," in non-union jobs at significantly lower wages, thus undercutting whites-only unions. White workers frequently retaliated with violence, not only against the low-paid black laborers, but also attacking their families and homes. When blacks in small numbers obtained good employment alongside whites, white workers sometimes protested the presence of blacks by initiating "hate strikes." In August 1944, for example, white streetcar workers in Philadelphia organized a strike halting that city's public transportation for six days because eight African Americans had been hired as motormen.

For many years, most unions affiliated with the American Federation of Labor (AFL) either restricted black membership to a minimum, or prohibited blacks from becoming union members at all. However, African Americans understood that union membership would lead to higher wages, benefits, and improved working conditions, and they generally favored unionization at greater rates than whites. In August 1937, the Brotherhood of Sleeping Car Porters, led by socialist A. Philip Randolph, was the first black union to successfully negotiate a labor agreement with a white corporation, the Pullman Company. But it was only with the development of the Congress of Industrial Organizations (CIO) that substantial numbers of African Americans acquired union jobs. The CIO unions had more liberal and egalitarian leadership than the AFL, and approached organizing in basic industries with a strategic effort to bridge color barriers between workers. During the 1930s, blacks increasingly played central roles in a series of important strikes in industries such as steel, auto manufacturing, maritime labor, and tobacco. Communists and other radicals in the CIO's leadership pushed the unions to organize workers in southern industries, bringing black and white workers into cooperative efforts. And the CIO's success in organizing black workers in basic industries prompted the AFL to change many of its exclusionary practices regarding race. By 1946, there were 650,000 black members of the AFL, and about one million African Americans in CIO-affiliated unions. Blacks were always underrepresented in the leadership of these unions, however, and were invariably relegated to the lower-level union jobs. Nevertheless, the making of the black working class in America's manufacturing and industrial sectors was a central factor in the successes of the civil rights movement in the 1950s and 1960s. It was the organized black working class that exerted its influence on both the Democratic Party and white-led unions to push toward desegregation. Black union households with steady paychecks donated millions of dollars to help finance civil rights organizations like the NAACP, black colleges, libraries, and voluntary civic organizations.

The new urban culture of black America fostered an awakening of African American arts and letters. A brilliant literary and artistic movement, the Harlem Renaissance, flourished in the 1920s and early 1930s, bringing to public attention the creative works of poets, novelists, and writers such as Langston Hughes, Countee Cullen, Jean Toomer, Nella Larsen, Zora Neale Hurston, and Claude McKay. The urban age produced a strikingly modern new musical genre, jazz. The foundations and melodic structure of jazz were based on black American musical expression and improvisation. Drawing upon traditional Negro spirituals and especially the blues, jazz became the most popular and creative expression of modern urban life both in America and internationally. The greatest jazz artists of the twentieth century — Louis Armstrong, "Duke" Ellington, Billie Holiday, Charlie Parker, "Count" Basie, John Coltrane, Dizzy Gillespie,

and Miles Davis, as well as many more — developed a musical language whose extraordinary influence became a major creative force in the construction of modern cultural life, affecting theater, art, literature, and virtually all aspects of popular culture.

These developments all had a direct impact on African American women and issues of gender in the black community. Black women had significantly higher labor force participation rates than white women, and they exerted a greater degree of independence financially and socially. Black women's organizations like the National Council of Negro Women generated material resources and provided key leadership in sustaining black civic institutions of all kinds — churches, community associations, school boards, health clinics, social welfare activities, child care, and most essential services that were central to the black community's survival. During World War II, almost one-half of all black women were employed, compared to only 31 percent of all white women. Sixty percent of all black women were still private household workers and domestic servants, but a growing number found employment in the ranks of organized labor. A relatively large number, 16 percent, worked in agriculture as farm laborers. The contributions of black women in many diverse fields, from economic activity to government, from the arts to the sciences, were critical in the construction of modern black America. Black Communist and feminist leader Claudia Jones, writing in 1949, observed that "an outstanding feature of the present stage of the Negro liberation movement is the growth in the militant participation of Negro women in all aspects of the struggle for peace, civil rights, and economic security. . . . Negro women have become symbols of many present-day struggles of the Negro people." Because African American women frequently "had to support themselves and their children" since slavery, and remained "the last to be hired and the first to be fired," the experiences of gender, race, and class oppression fostered a political awareness that went beyond that expressed by most black men. Jones believed therefore that it would only be through these struggles of black women that "the entire Negro people" could achieve freedom.

Despite these real socioeconomic and cultural gains, blacks remained largely a subordinated, marginalized population. The black middle class was growing, but still remained remarkably small. In 1940, of a total African American population of nearly thirteen million, there were only 3,150 physicians. Black representation in other professions was even lower. As of 1940, there were 1,586 black dentists, representing 4 percent of that profession; there were 1,052 lawyers, 238 engineers, and only eighty architects. Black college total enrollment was less than 10,000 through the early 1930s, only reaching 40,000 by the end of World War II. White universities and professional schools in the North severely restricted black enrollment, forcing African Americans to

rely on historically black institutions to produce skilled professionals and technicians who would provide services to their communities. Even as late as 1960, three-fourths of all black college and professional school students were attending predominantly black institutions.

After World War I, as the image of the black metropolis increasingly defined the parameters of black life and culture, new organizations and social movements rooted in the urban milieu emerged. The largest and most dramatic of such movements was Marcus Garvey's Universal Negro Improvement Association (UNIA). Born in Jamaica in 1887, Garvey emigrated to the United States in early 1916. Through his rhetoric flair and organizational skill, in only a few years Garvey inspired hundreds of thousands of blacks to join his black nationalist movement. Based in Harlem in the 1920s, Garvey and his associates established a series of enterprises that provided goods and services to the black community, including the Black Cross Nurses, the African Legion, the Negro Factories Corporation, and the Black Star steamship line. Garvey espoused a militant program of "Africa for the Africans, at home and abroad," and opposed racial integration with whites. Garvey's critics, led chiefly by the NAACP and Du Bois, condemned the UNIA's racial separatist philosophy as counterproductive, and rejected the concept of "Back to Africa." Despite Garvey's support of segregation, white authorities in government feared the militancy of the UNIA's program, and sought to destroy the movement through both legal and extralegal means. In 1923 Garvey was arrested on federal charges of mail fraud; he was found guilty and imprisoned in 1925, and deported from the United States two years later.

To Garvey's left, a generation of black radicals also challenged the middle-class–oriented leadership of the NAACP. Black labor leader A. Philip Randolph established in 1935 the short-lived National Negro Congress, a coalition of over seven hundred black groups, advocating civil rights and economic justice. West Indian immigrant Cyril V. Briggs started the African Blood Brotherhood in 1921, a radical black formation dedicated to "the immediate protection and ultimate liberation of Negroes everywhere." After the Bolshevik Revolution in 1917, the American Communist Party grew in the 1920s and gained support among thousands of black workers and rural farmers. Black Communists organized massive rent strikes and unemployment councils in the economically depressed communities of Harlem, Chicago's South Side, and in other cities. In the early 1930s black Communists established the Sharecroppers' Union in the Black Belt South, assisting tenant farmers and farm laborers to collect decent wages and better working conditions. During the Great Depression and in the 1940s, most black leaders and middle-class organizations worked in coalitions with Communists in local campaigns such as the "Don't Buy Where You Can't Work" boycotts

of white-owned stores in predominantly African American communities. Black Communist attorney and civil rights activist Benjamin Davis was even elected to the New York City Council as Harlem's representative in 1944.

The NAACP also continued to grow during these years, but increasingly reflected a more pragmatic and reformist orientation toward racial change. It was involved in a wide variety of legal efforts, from its unsuccessful attempts to pass federal anti-lynching legislation, to the use of court challenges to attack separate-but-equal policies in public and higher education. The chief architect of the NAACP's legal strategy, attorney Charles Hamilton Houston, successfully planned and won a series of legal victories in desegregation cases. Two of the most important legal victories were related to the important struggles to defend the lives of the "Scottsboro boys," nine young black men who had been falsely convicted of raping two white women in rural Alabama. The Communist Party, and later the NAACP, turned the case into an international human rights campaign, generating worldwide attention. In the case of *Powell v. Alabama* in 1932, the U. S. Supreme Court ruled that defendants in criminal cases must be given the right to legal counsel. In the 1935 *Norris v. Alabama* decision, the Supreme Court found that the deliberate exclusion of African Americans from juries was an unconstitutional denial of an accused's civil rights. In the 1944 Supreme Court decision *Smith v. Allwright*, all-white primary election laws which deliberately excluded black voters were declared unconstitutional. Step by step, the legal basis for racial segregation was being overthrown by the political and legal interventions led by black Americans.

Under the leadership of Walter White, national secretary of the NAACP from 1930 to 1955, the civil rights organization moved toward political measures that would accelerate racial integration without challenging the basic institutional arrangements of society. His pragmatism was vigorously opposed by Du Bois, who challenged the organization to develop black consumer cooperatives and to establish outreach efforts to assist the black rural poor and working class. However, Du Bois now was viewed as too radical by the leaders of the organization that he had helped to create. In 1934 he was pressured to resign his position as editor of *The Crisis* and Director of Research. Ten years later, at the age of seventy-six, he was invited to rejoin the NAACP's national leadership, but in 1948 he was fired, primarily because of his public opposition to the Cold War and the anti-Communist policies of the Truman administration.

Could America's limited definitions of democracy be expanded to incorporate the demands of African Americans for fairness and equality under the law? It was not altogether clear whether American freedom could be reconstructed to include the

freedom of blacks as full partners in a democratic project called the United States. In 1943, sociologist Charles S. Johnson noted that the fundamental and unresolved "contradiction of democracy" was the tension between individual "liberty" versus "equality." Johnson observed: "Liberty is an individualistic notion which gained ascendancy when modern society superseded feudalism. Equality is something else; it is a notion, however, that is implicit in the concept of socialization — socialization of medicine, socialization of industry. . . . [Socialization] seems to be a principle at once ethically sound and politically effective." Johnson was politically no radical — indeed, later during the McCarthy period in the 1950s, as president of Fisk University, he fired several faculty accused of belonging to the Communist Party. Nevertheless, Johnson believed that behind America's racial dilemma was a larger question of class inequality, a hierarchy of white privilege and black subordination that could not be transformed within the existing economic structures of American society. "Unrestrained competition leads to excesses that have seemed to benefit a few but have worked hardships on vast numbers," Johnson observed. "In the logic of this system, freedom of opportunity meant eventually the freedom of the strong to survive at the expense of the weak." A number of black intellectuals such as Du Bois, and especially those connected with organized labor, held Johnson's views about redefining American freedom to mean "equality." In his 1944 essay "My America," poet Langston Hughes predicted that the conclusion of World War II might lead to the re-education of "the South — and all Americans — in racial decency." Hughes warned that the "freedom train can hardly trail along with glory behind a Jim Crow coach . . . "

Many African American artists also understood that expressions of black culture were directly linked with the political and social movement for freedom. The great actor and singer Paul Robeson observed that black culture and "the Negro idiom" formed the basis for most of America's popular music, dance, and the theater. "At another stage of the arts there is no question, as one goes about the world, of the contributions of the Negro folk songs, of the music that sprang from my forefathers in their struggle for freedom — not songs of contentment — but songs like 'Go Down, Moses' that inspired Harriet Tubman, John Brown, and Sojourner Truth to the fight for emancipation," Robeson wrote in 1952. "The culture with which we deal comes from the people . . . in fighting for our cultural heritage [we] fight for our own rights, for the rights of the Negro people, the power of the masses of America, of a world where we can all walk in complete dignity."

The great majority of the black middle class, however, did not share these views. Most black professionals, entrepreneurs, and educators had come to identify their personal and collective goals with their assimilation within the mainstream of American life as it existed. Although the great majority of blacks supported the New Deal and the Democratic administration of Franklin Roosevelt, for example, roughly two-thirds of all black elected officials in the United States in 1946 were Republicans. Nearly 40 percent of the black electorate supported the re-election of Republican President Dwight D. Eisenhower in 1956. Many believed that the "American Dream" of individual upward mobility and material success could be achieved within the existing institutional arrangements of America's social order, once legal segregation was dismantled. And, in many respects, by the 1940s, this moderate approach to social change, the strategy of "integration," appeared to be coming into existence.

Between 1939 and 1950, the median income of non-white wage and salary-earners increased significantly, from 41 percent of white median income to 60 percent. By 1947, 12 percent of all voting-age blacks were registered to vote in the South, up from barely 2 percent in 1940. In 1947, Jackie Robinson broke the color barrier in professional baseball; three years later poet Gwendolyn Brooks' volume Annie Allen was awarded the Pulitzer Prize, and Dr. Ralph Bunche received the Nobel Peace Prize for his service at the United Nations. By 1950, 52 percent of all African Americans lived in urban areas and were beginning to be integrated into major employment sectors throughout the country, even in the South. Given their remarkable accomplishments, it was perhaps not surprising that many African Americans did not actively oppose or protest anti-Communist witch hunts and red-scare tactics that led to a widespread repression of civil liberties in the United States in the late 1940s and 1950s. Thousands of black workers, teachers, and artists who were affiliated with leftist unions or the Communist Party lost their jobs. Black Communist leaders Benjamin Davis and Henry Winston were imprisoned; Du Bois was unjustly charged with being an agent for Soviet interests by the U. S. government in 1951, and even after winning acquittal in court, his passport was seized for seven years. Du Bois, Robeson, and other progressive African Americans were, in effect, barred from civic participation. The NAACP and most black middle-class voluntary associations did little to defend them. The dream of freedom had for so long been "a dream deferred," in Langston Hughes' words, that sacrificing some of its most dedicated leaders seemed necessary to achieve the greater good. Many now had become convinced that their dreams of freedom at last could be won.

093. Linotyper, location unknown, c. 1920. The 1920s marked the emergence of a substantial African American blue-collar working class. Small numbers of African Americans were also employed in white-collar professions.

094. Young boy with violin by James Van Der Zee, Harlem, New York City, c. 1920. Van Der Zee was one of the first black photographers to set up a studio in Harlem. For nearly a half century he was an influential interpreter of urban life, best known for his depictions of the Harlem Renaissance. He specialized in portraits of celebrities, community leaders, and middle-class life.

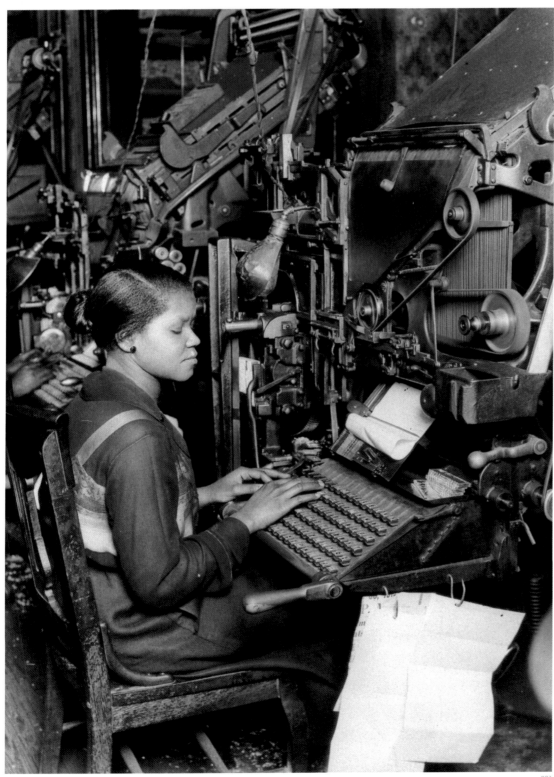

093

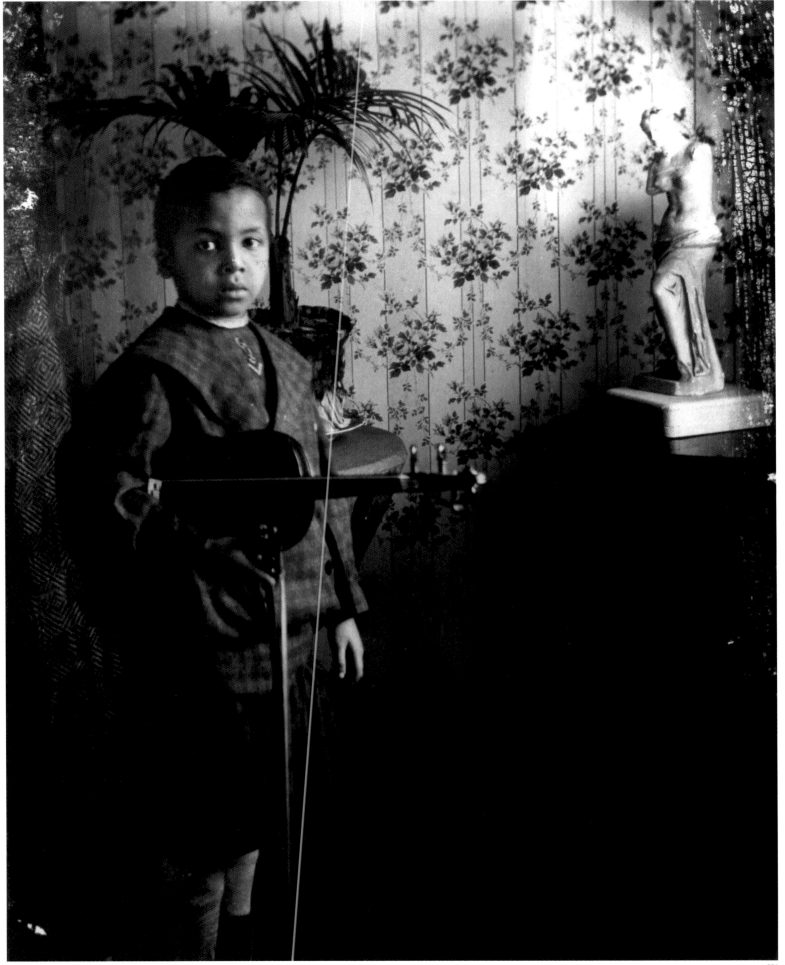

095. Ku Klux Klan meeting, location unknown, 1920s. The Ku Klux Klan, a secret association formed by white vigilantes during Reconstruction, carried out violent attacks primarily against African Americans. By the 1880s, the Klan had largely ceased to exist as a distinct organization. However in 1915, with the release of the popular film, *Birth of a Nation*, white racists reestablished this vigilante organization, which grew rapidly. By the early 1920s, the Klan claimed between two to three million members, and controlled hundreds of elected officials and several state legislatures. The underground society hid behind the anonymity of white sheets to mask their identities. Their symbol, the burning cross, was used to intimidate African American communities. Despite well-documented acts of terror and murder — frequently lynchings and burnings — Klansmen were rarely prosecuted or convicted for their crimes. Between 1920 and 1927, over 300 African Americans were lynched in the United States.

096. W. E. B. Du Bois in the office of the NAACP magazine *The Crisis*, New York City, 1920. Under the leadership of editor W. E. B. Du Bois, *The Crisis* mobilized a national campaign to confront the racist violence against African Americans. The NAACP proposed federal anti-lynching legislation, which was ultimately passed by the House of Representatives, but southern opposition led to its defeat in the Senate. Du Bois' editorials on behalf of civil rights, Pan-Africanism and women's equality helped to define the contours of the best traditions of American liberalism.

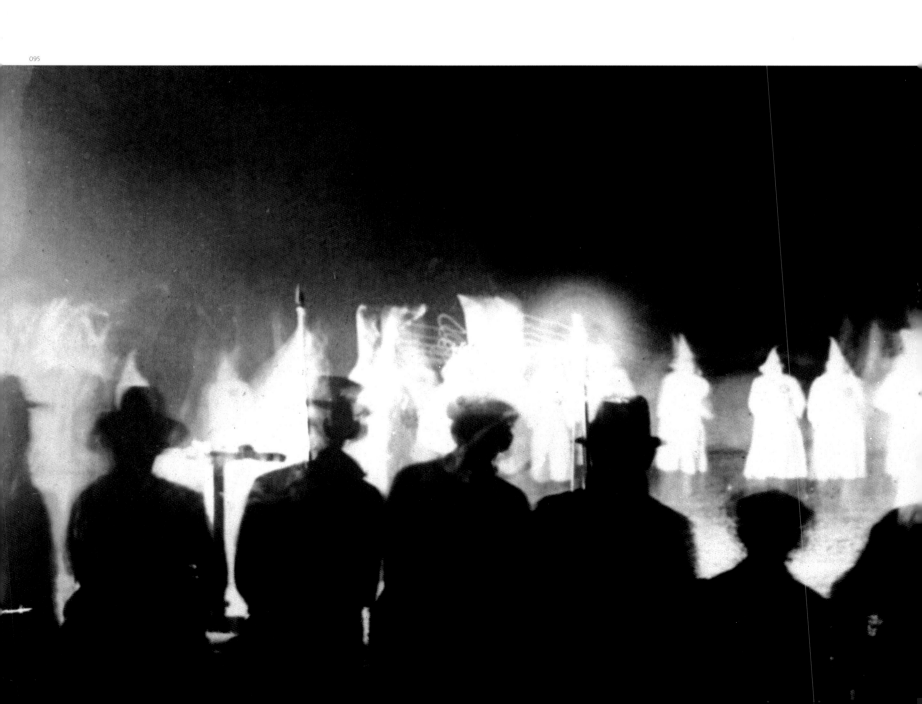

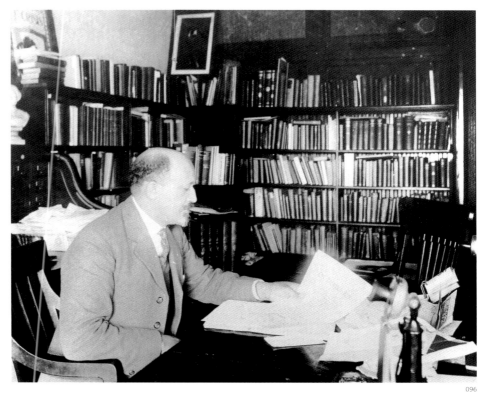

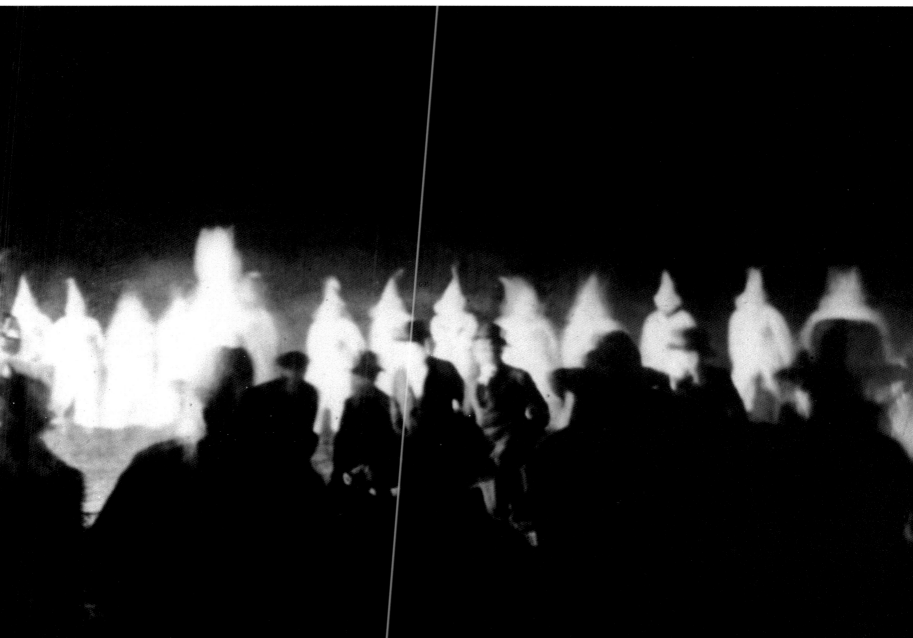

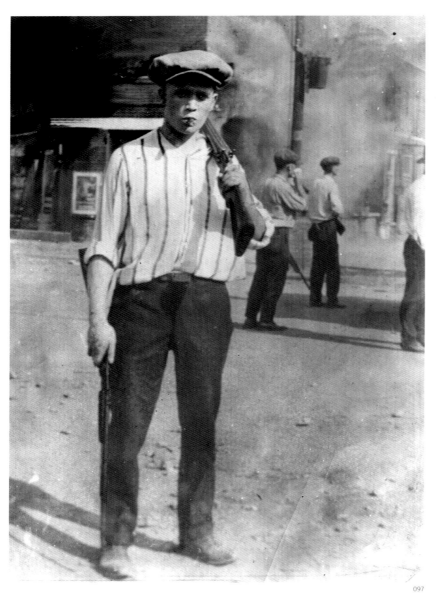

097

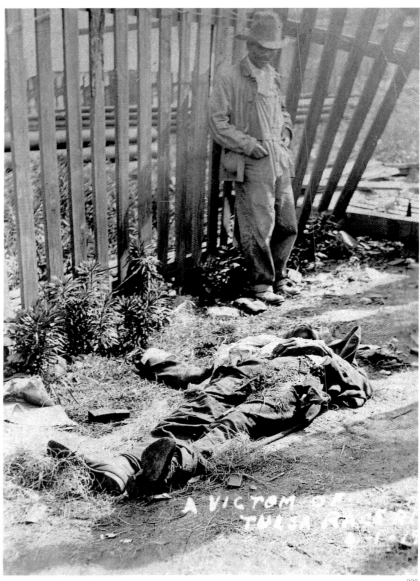

098

097–100. Tulsa, Oklahoma, 1 June 1921. On 31 May 1921 the *Tulsa Tribune*, a local newspaper, published an article and editorial that incited white mob violence against black Tulsans. An estimated five to ten thousand whites, including several hundred deputized by the police department, participated in three days of violent attacks against the black community. Blacks were assaulted with machine guns, airborne gunfire, and incendiary devices dropped from the air. Glenwood, the most affluent section of the African American community, was targeted for destruction. Widely known throughout the nation as the "black Wall Street," Glenwood was famous for its economic and cultural achievements. An estimated six thousand black Tulsans were arrested, and 9,000 became homeless as over 1,200 homes were destroyed. An unknown number, perhaps as many as 300 African Americans, were killed. Many of the victims were buried in mass graves and other corpses were thrown into the Arkansas River. Nearly eighty years later, Oklahoma officials finally took steps to acknowledge the crimes that had been committed against Tulsa's black community and to negotiate claims of compensation for the descendants of the victims.

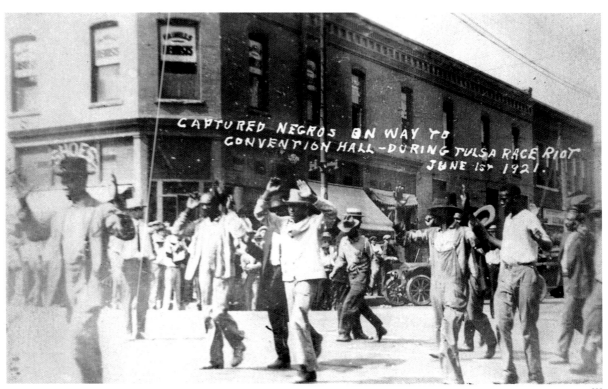

099

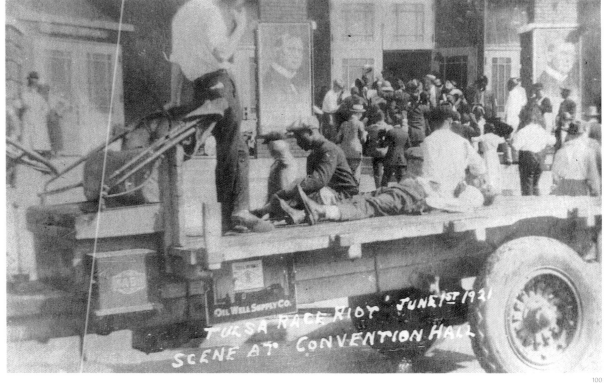

100

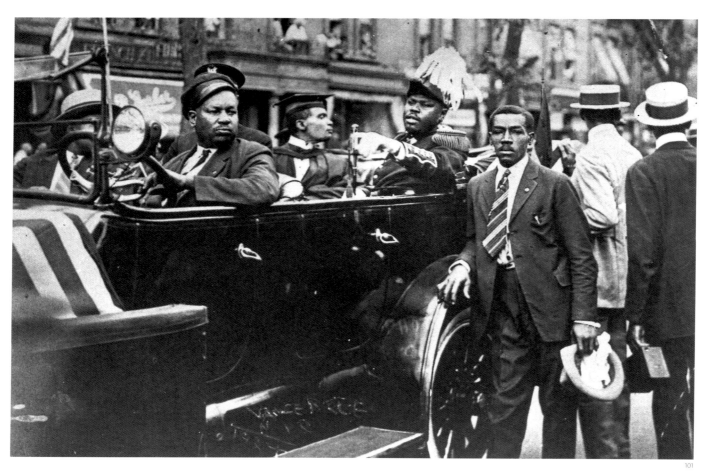

101

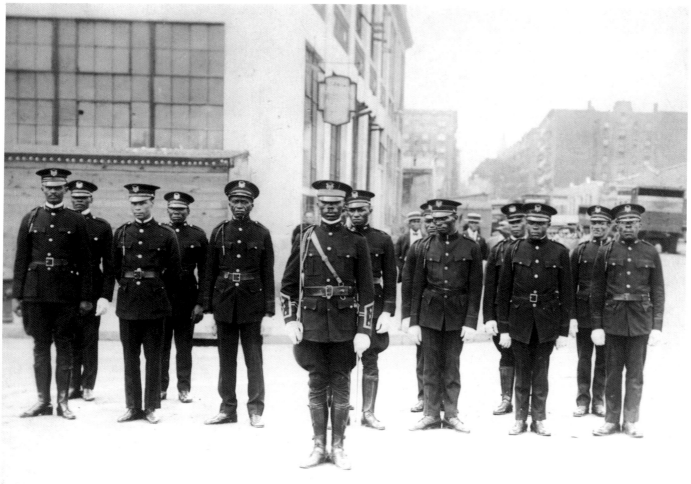

102

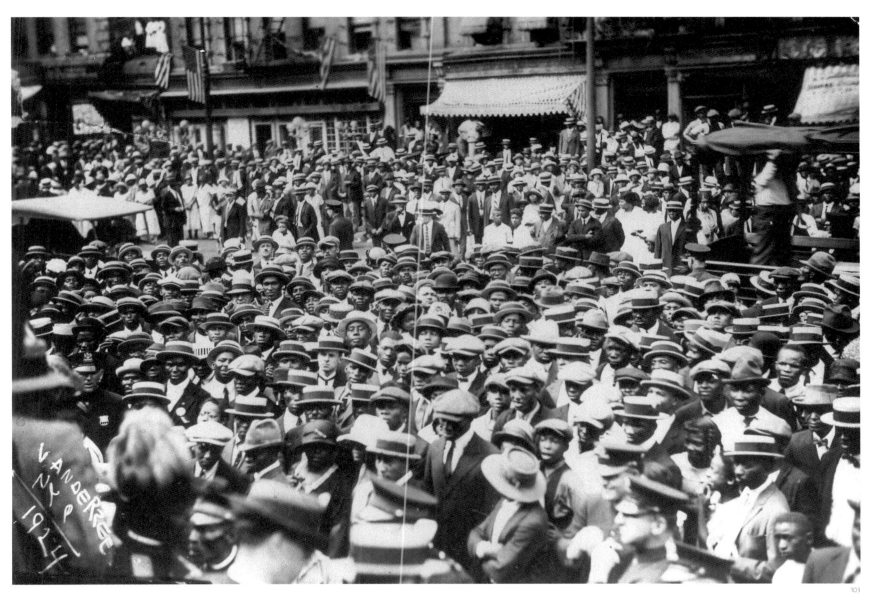

101. Marcus Garvey in a parade of the Universal Negro Improvement Association (UNIA), Harlem, New York City, 1924. The UNIA was perhaps the largest black organization established in the western hemisphere in the twentieth century. Its founder, Marcus Mosiah Garvey, was born in 1887 in St. Ann's Bay, Jamaica. He was employed as a journalist and printer in the Caribbean and England, before returning to Jamaica where he established the UNIA in 1914. Booker T. Washington's philosophy of self-help and black-owned enterprises inspired Garvey to emigrate to the United States in 1916. There, within four years, his program of militant black nationalism had attracted hundreds of thousands of devoted followers. Garvey initiated a series of enterprises that captured the imagination of the black masses: the Black Star Line, a steamship company; the Negro Factories Corporation; the Black Cross Nurses; and the African Legion. His controversial newspaper, the *Negro World*, was translated into several languages, but was banned by British and French colonial officials in Africa and the Caribbean. Garvey advocated racial separatism and championed the slogan: "Africa for the Africans at Home and Abroad."

102. The African Legion, the military arm of the UNIA, in Harlem, c. 1924.

103. Garvey rally in Harlem, 1924.

104. Wedding party by the Scurlock studio, Washington, D. C., 1920s. In the 1920s weddings became a public celebration of the emerging affluence of the African American middle class.

105. Paul Robeson and Mary Blair in *All God's Chillun Got Wings* at the Provincetown Playhouse in New York City, 15 May 1924. Robeson was unquestionably America's Renaissance figure for the first half of the twentieth century. An All-American athlete in college, he received a law degree from Columbia University in 1923. Almost by accident, he became involved in the theater and within a few years had become one of the best known actors in the country. His extraordinary singing voice also won him international popularity. In the 1920s, *All God's Chillun Got Wings* was highly controversial because of its depiction of an interracial couple.

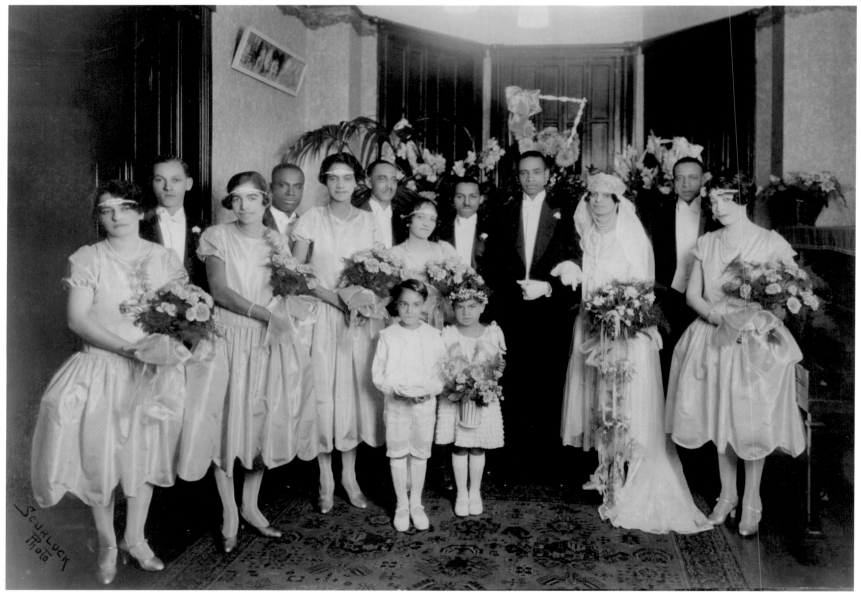

104

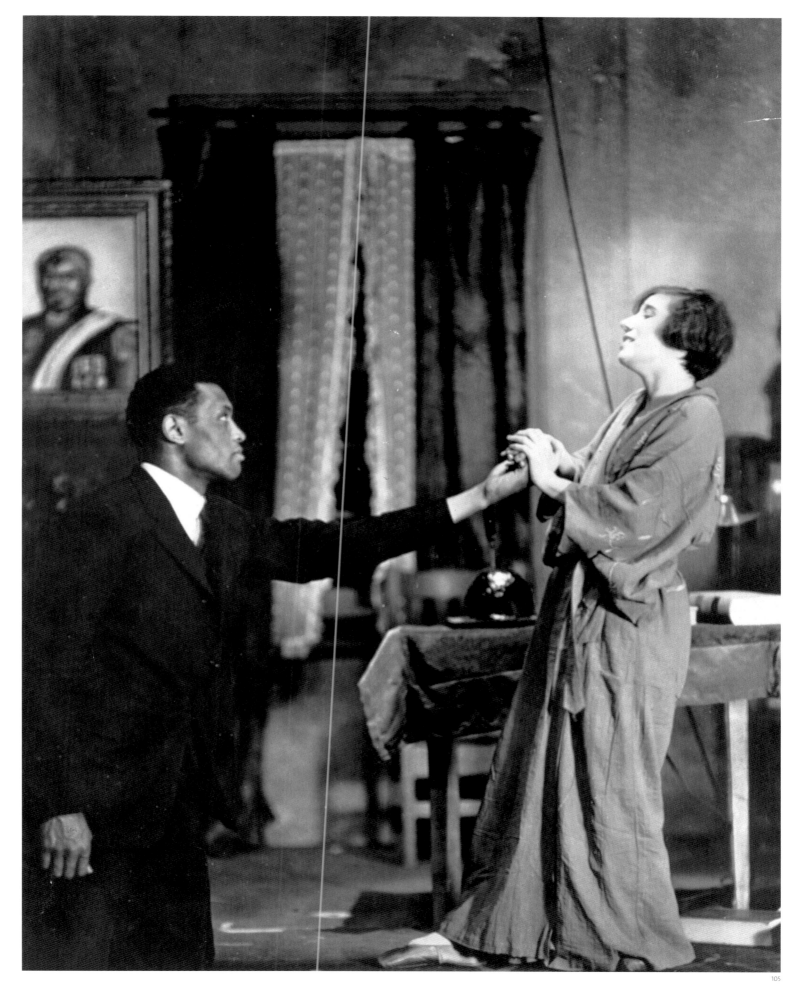

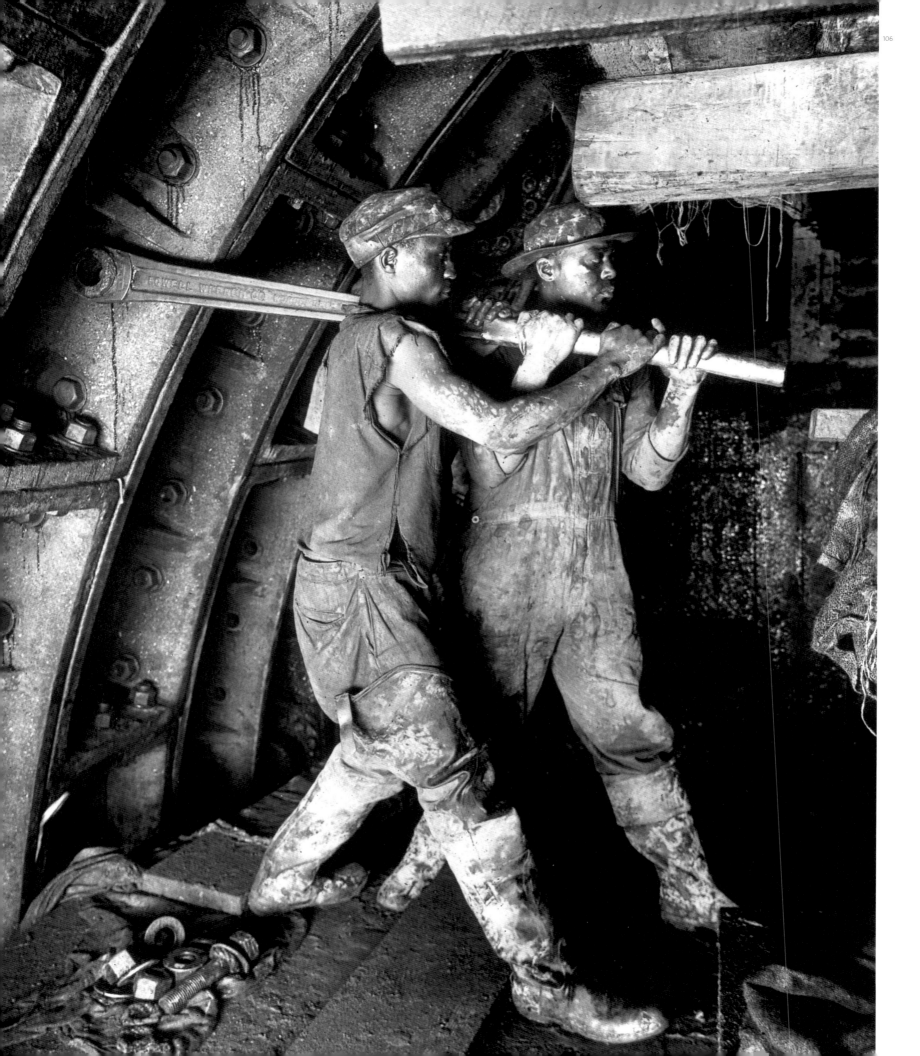

106. Two men tightening a rivet on the Hudson River tunnel, New York City, 20 August 1924. The 1920s witnessed the expansion of the black industrial working class. As black workers entered factories and new areas of industry, the growing class consciousness also had an impact on the writings of young black artists and intellectuals of the time.

107. Langston Hughes, Charles S. Johnson, E. Franklin Frazier, Rudolph Fisher, and Hubert T. Delaney (from left to right) at a party held for Hughes at the home of Regina Andrews and Ethel Ray Nance, 580 St. Nicolas Avenue, Harlem, New York City, 1924. This photograph portrays a group of young intellectuals, several of whom linked their work to the African American freedom struggle. Langston Hughes would later become black America's poet laureate and one of its most popular interpreters of black culture and daily life. Hughes also wrote short stories, plays, and operas. Some of his most famous volumes include *The Weary Blues* (1926), *The Big Sea* (1940), and *The Sweet Flypaper of Life* (1955) in collaboration with photographer Roy DeCarava. Charles Johnson and E. Franklin Frazier would become the two most influential African American sociologists of their generation. In the 1920s, Johnson edited *Opportunity*, the journal of the National Urban League, and sponsored literary prizes that exposed young writers in the Harlem Renaissance literary movement to a national audience. He became the first black president of Fisk University in 1946. Frazier would later teach with Johnson for several years on the faculty of Fisk University, and from 1934 until his retirement in 1959 he was chairman of the Sociology Department at Howard University. In 1949 he became the first black president of the American Sociological Association. Rudolph Fisher was a novelist who later became a physician. Hubert Delaney later became a prominent lawyer and judge.

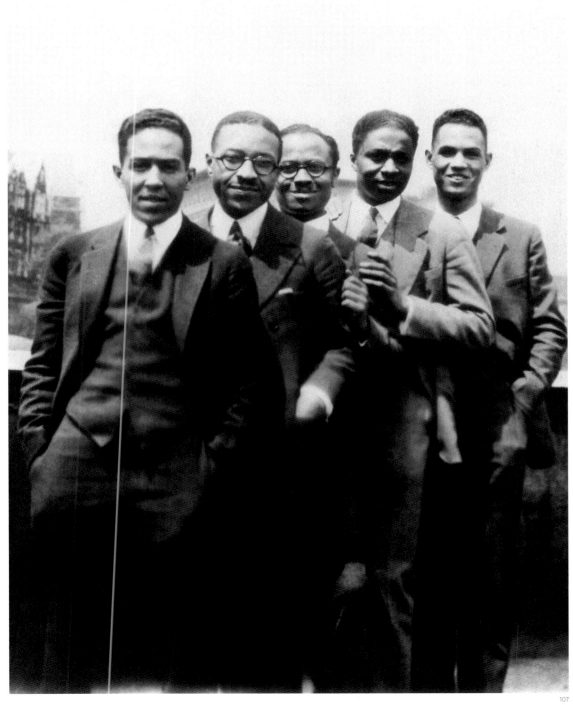

107

108. Marcus Garvey (center) leaves court handcuffed after being sentenced to five years in prison for mail fraud, Harlem, New York City, 6 February 1925. Garvey's militant black nationalism resulted in harassment and surveillance by U. S. and British intelligence agencies. In 1923 he was indicted on charges of mail fraud, generated by complaints about fiscal mismanagement of the Black Star Line. Convicted and imprisoned in 1925, he was deported from the United States two years later. Although he attempted to rebuild his movement, first in Jamaica and later in England, the UNIA never regained its popularity or prominence. In 1940 Garvey died after several severe strokes.

109. Street parade at 135th Street and Lenox Avenue in Harlem, 1925.

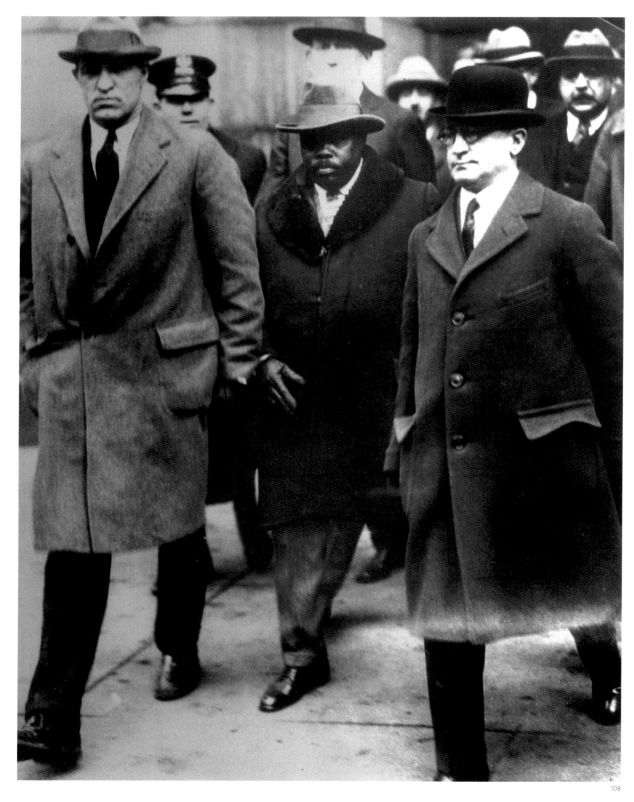

108

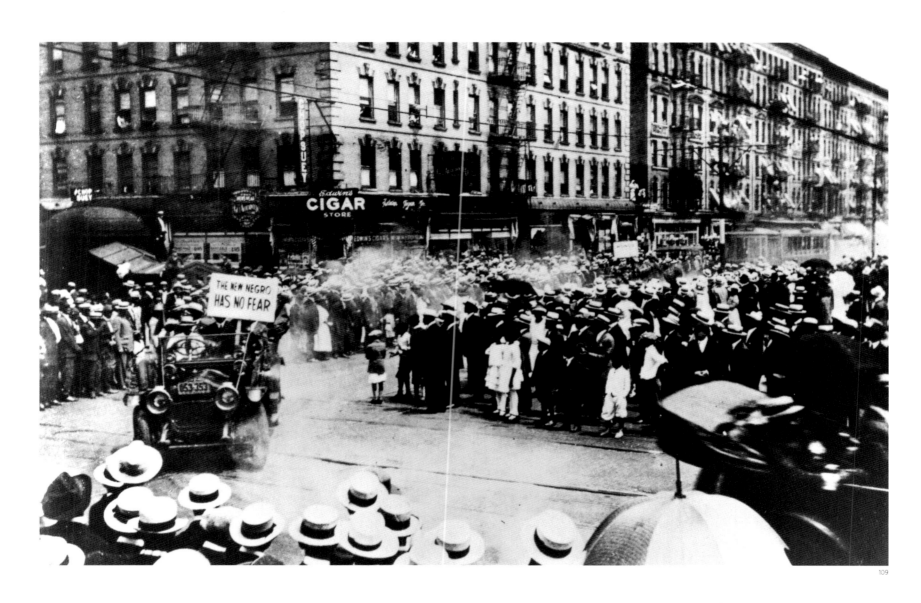

110. Barber shop in Harlem, New York City, 1925. One of the ironies of segregation was that black-owned institutions fostered the creation of free social spaces for African American interaction. Black barber shops and beauty salons were — and remain today — sites for gossip, folklore, information exchange, political debate, and intergenerational camaraderie.

111. The "Hot Five," Louis Armstrong, Johnny St. Cyr, Johnny Dods, Kid Ory, and Lil Hardin (from left to right) in New York City, c. 1925. The musician most responsible for fostering both the artistry and widespread appeal of jazz as an art form was Louis "Satchmo" Armstrong. He was born in poverty in New Orleans in 1901. As a teenager he learned to play the alto horn and the trumpet, working with small bands in his hometown and on steamships traveling up and down the Mississippi River. He moved to Chicago in 1922, joining the celebrated creole jazz band led by King Oliver. In 1925 he organized his most important band, the Hot Five, later expanded to the "Hot Seven." Armstrong could hold a high B-flat on the trumpet for four long measures. His artistic technique astonished other musicians and became wildly popular, first in the United States and then internationally.

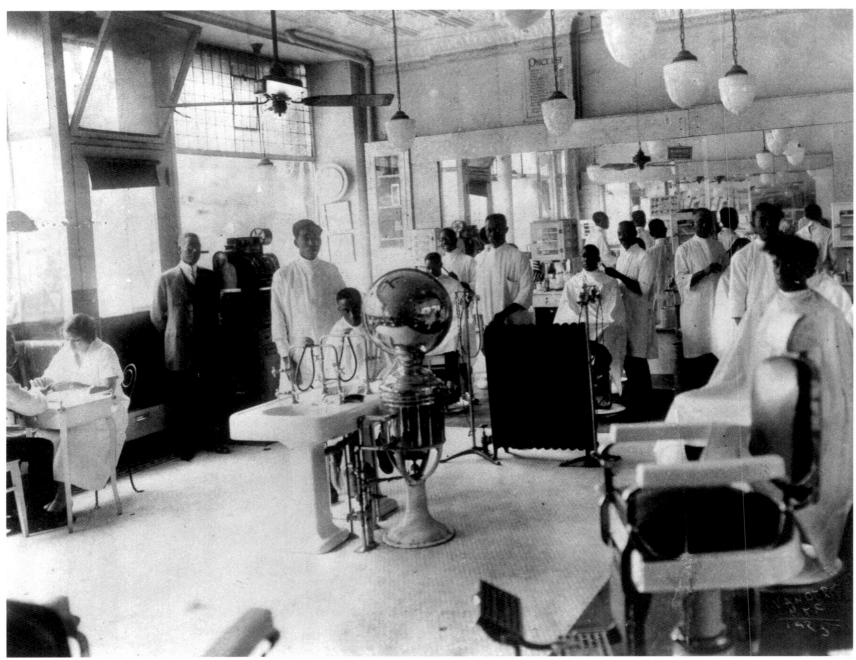

110

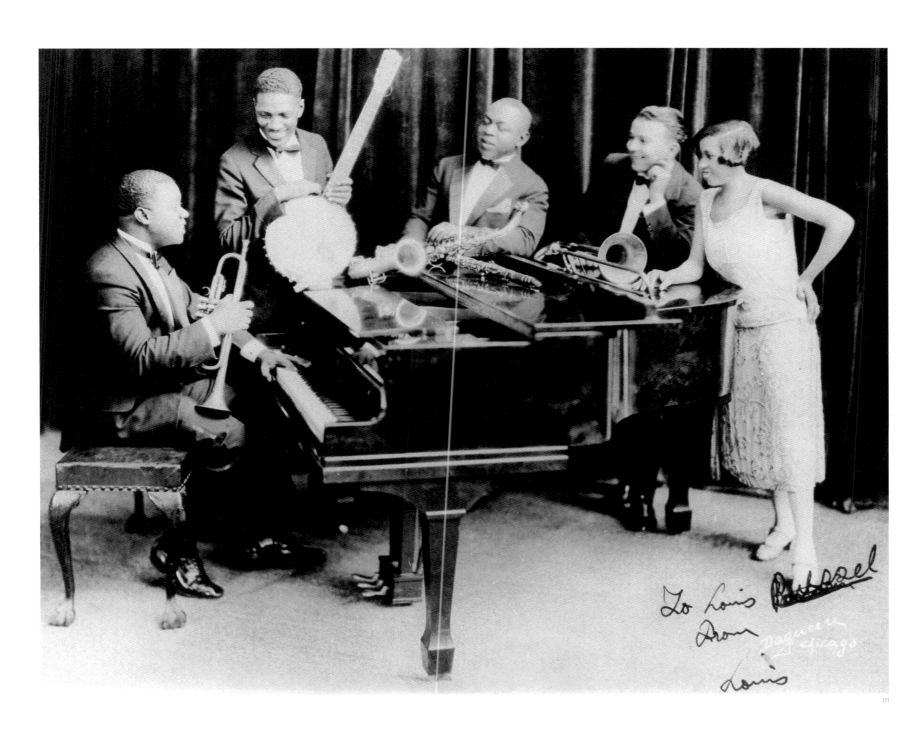

111

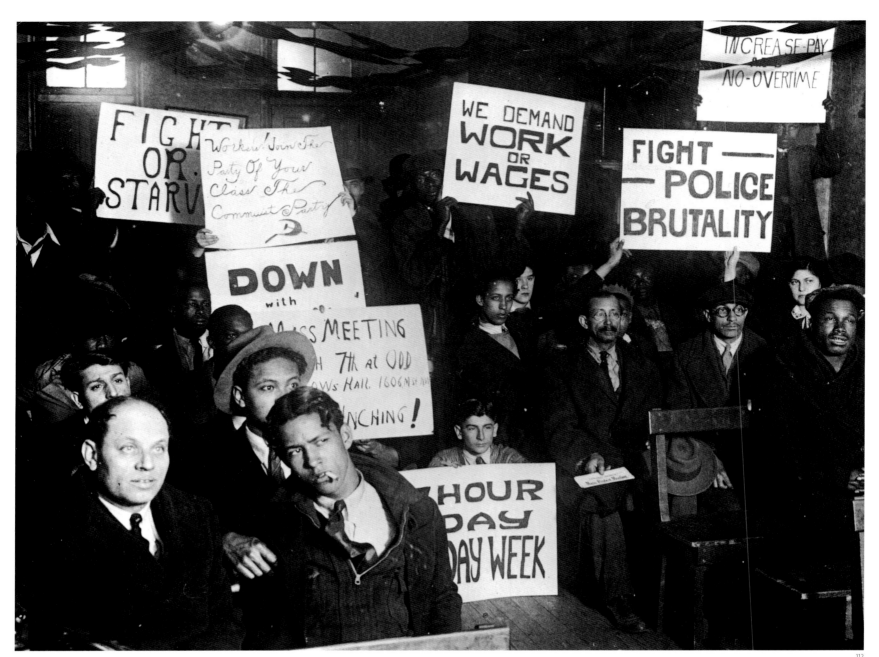

112

112. Demonstration in front of the Communist Party headquarters in Washington, D. C., c. 1920. With the growth of the black urban working class, increasing numbers of African Americans joined the ranks of organized labor and left-wing political organizations. As early as the 1920s, the Communist Party attracted significant numbers of African American political organizers and labor activists, including the militant independent group the African Blood Brotherhood. This photograph shows a mass meeting for the unemployed, after which the participants demonstrated in front of the White House.

113. A. Philip Randolph, probably Harlem, New York City, c. 1925. The first black union to successfully negotiate a union contract with a white-owned corporation was the Brotherhood of the Sleeping Car Porters. The BSCP started in Harlem, in 1925 and was led by socialist organizer A. Philip Randolph and Chicago porter organizer Milton Webster. After twelve years of difficult struggle and fierce resistance, the Pullman Car Company finally agreed to negotiate a contract with the BSCP in 1937. This success was central in underscoring the importance of unions for African Americans, who have historically been significantly more supportive of union-ization than white Americans.

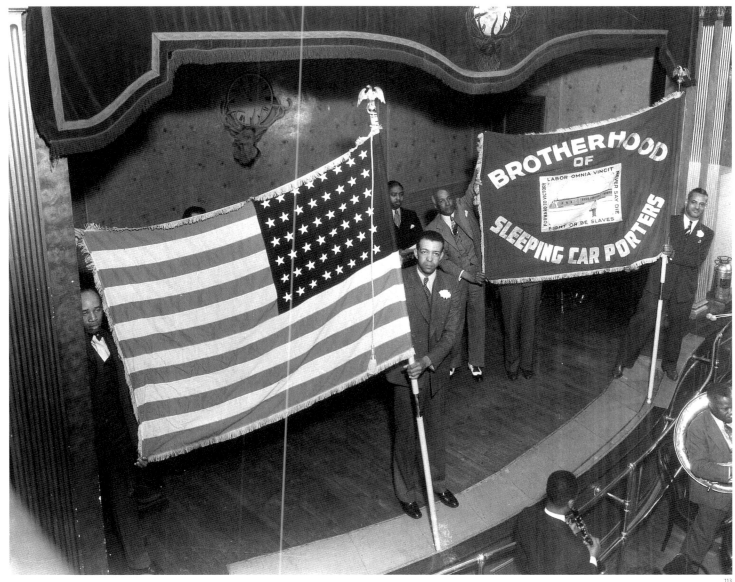

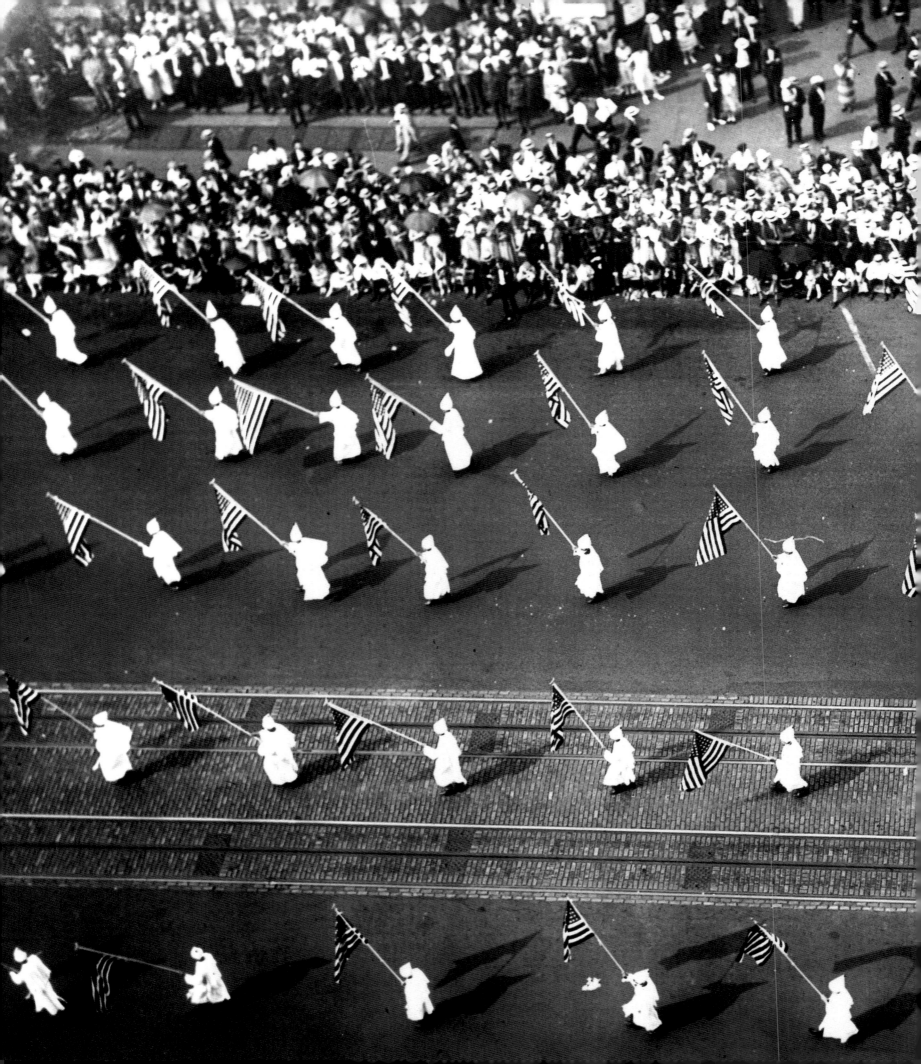

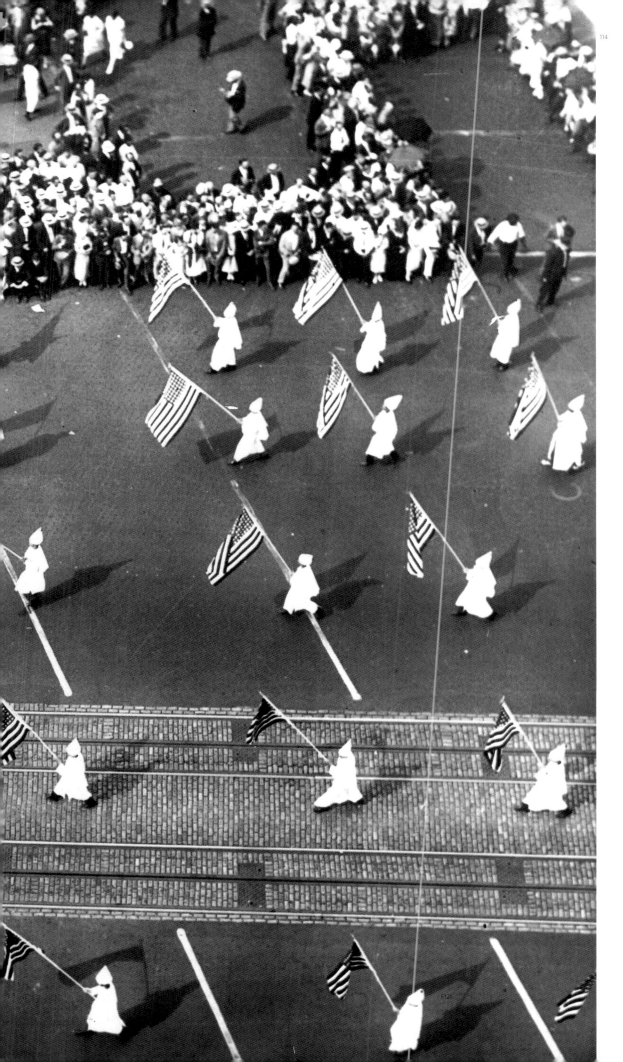

114. Ku Klux Klan demonstration in Washington, D. C., 9 August 1925. By 1925 the Ku Klux Klan had reached the zenith of its influence in American politics, and would quickly decline in membership and power. This march, in which 40,000 Klansmembers participated and thousands of friendly spectators lined the street, demonstrated the strong institutional influence of vigilantism and white supremacy in American politics.

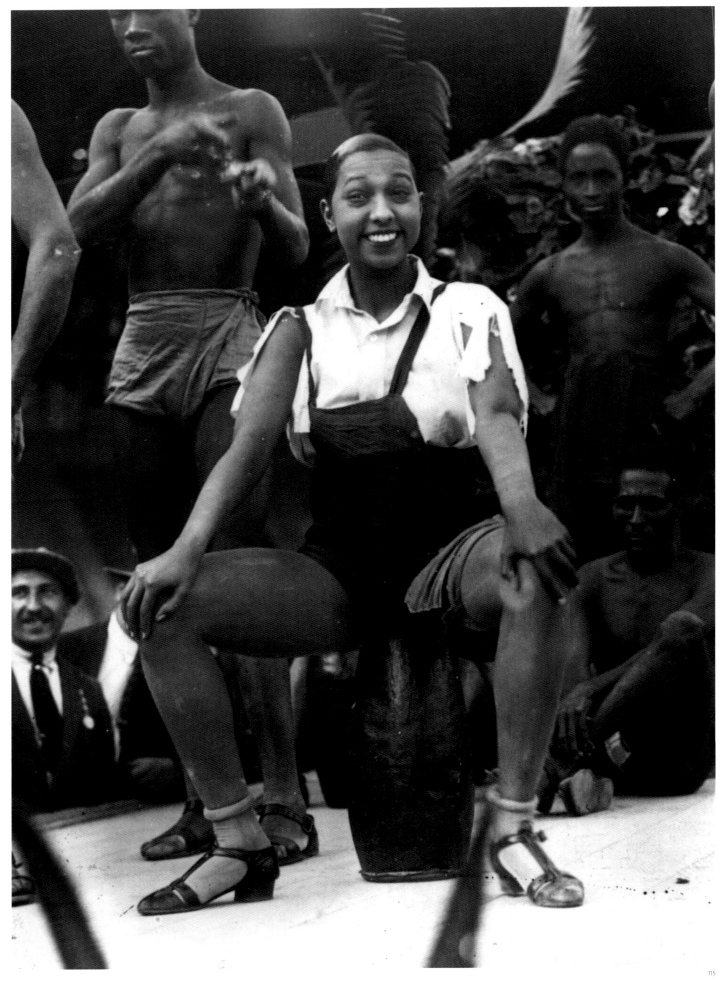

115. Josephine Baker at the Folies-Bergères in Paris, 1926. Born to a very poor family in St. Louis, Missouri in 1906, Josephine Baker became a paid performer before leaving elementary school. At the age of seventeen she joined the chorus line in the popular musical *Shuffle Along*, but it was in Paris that she received international acclaim for her exotic dancing and singing. Her performances in the United States, however, were frequently not well-reviewed. With the outbreak of World War II, Baker worked with the French Red Cross and the resistance movement, for which she was awarded the Resistance Medal and the Legion d'Honneur. She became a strong supporter of the civil rights movement, and during her visits to the United States, her outspoken views and refusal to accept segregation sometimes led to public confrontations. Baker died in Paris in 1975.

116. "The 'Gay Northeasterners' strolling along Seventh Avenue" in Harlem, New York City, c. 1927. The 1920s were years of transformations in gender relations and the roles of women in society both in the United States and western Europe.

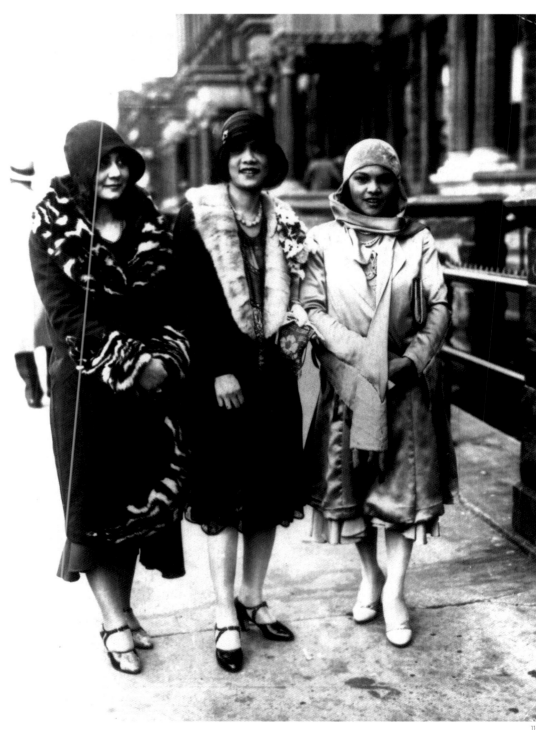

116

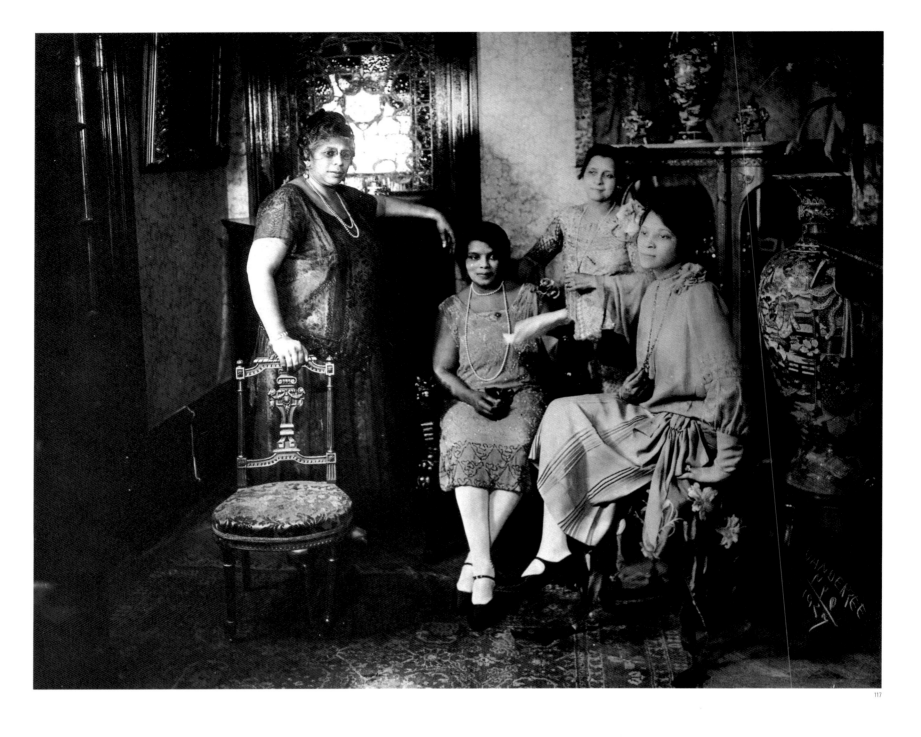

117

117. Society ladies in a home on West 138th Street in Harlem, New York City, 1927. By 1930 over 100,000 African Americans lived in Harlem. Its central boulevards, such as Lenox Avenue, were sites of impressive churches, restaurants, schools, and magnificent brownstone buildings. Striver's Row, two blocks of elegant brown-stones, attracted many of New York's black entertainers, professionals, and civic leaders.

118. Street scene in Harlem, late 1920s.

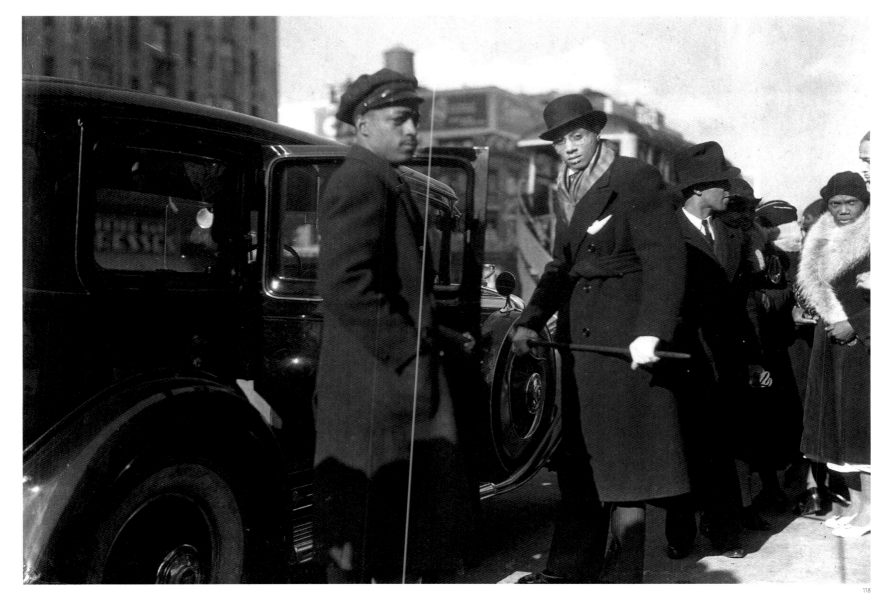

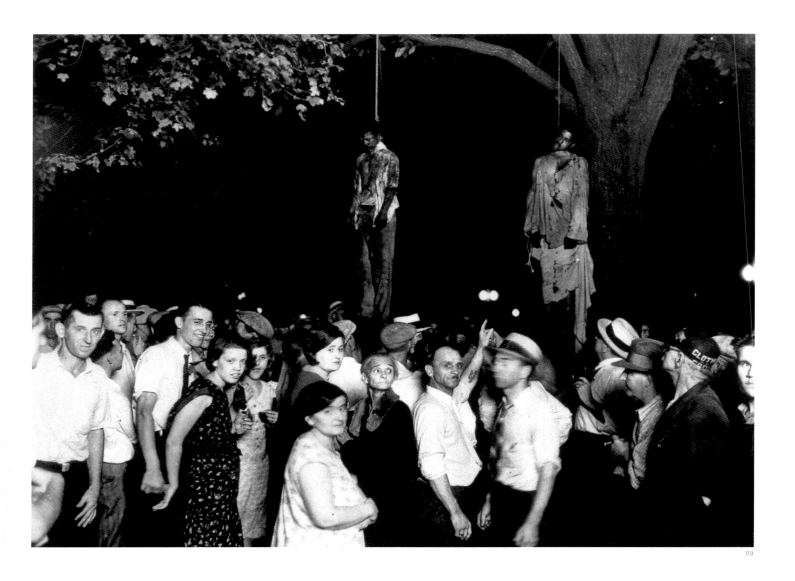

119. Lynching of Thomas Shipp and Abram Smith, Marion, Indiana, 7 August 1930. On 7 August 1930, a white mob seized two black teenagers, Thomas Shipp and Abram Smith, from a jail located in the county court-house. Several thousand whites armed with firearms, baseball bats, crowbars, and other weapons beat the two men to death. During the 1930s, the Ku Klux Klan achieved widespread membership and public endorsement in the Midwest. In Indiana the Klan was a relatively public organization and had the highest rate of per capita membership in the country. The Marion, Indiana lynching illustrates that racial atrocities were not confined to the American South.

120. Segregated bus in Birmingham, Alabama, c. 1930. By 1930 the city of Birmingham was widely known as the "citadel" of southern segre-gation, which permeated every aspect of daily life. In 1931, the Birmingham City Council passed a law prohibiting blacks and whites from playing chess and checkers together.

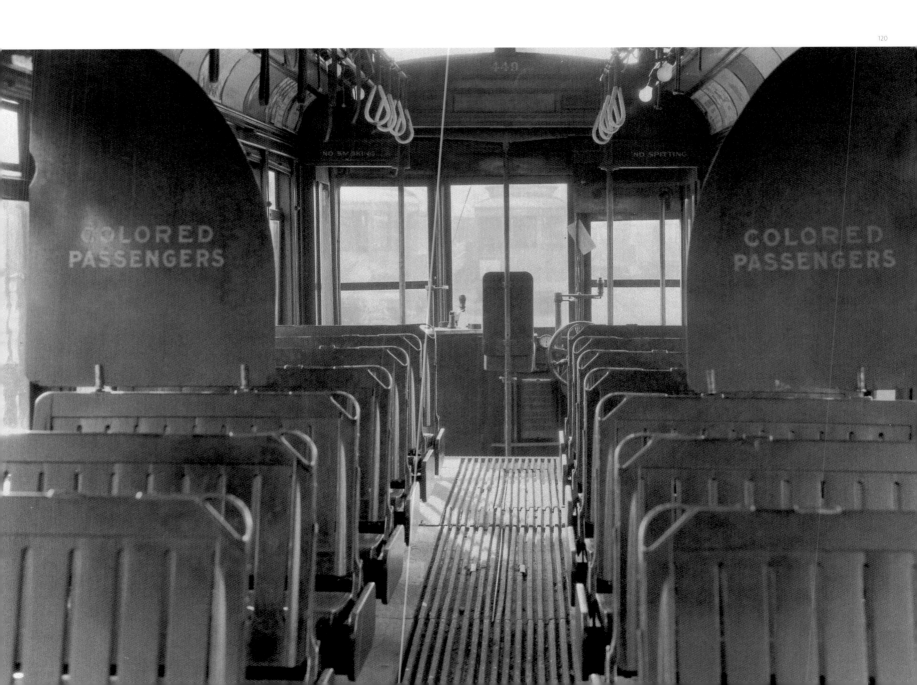

In 1931 nine young African American males were arrested in Alabama on false charges of rape. Blacks were excluded from the hastily formed all-white jury, and the defense attorneys were given only twenty-five minutes to consult with their clients before the trial began. All nine boys were found guilty and eight were sentenced to death in the electric chair; Leroy Wright, who was only twelve years old at the time, was spared the death sentence. A vigorous international defense of the "Scottsboro Boys" was initiated by the Communist Party and subsequently taken up by the NAACP, which led the Supreme Court to order a new trial when the defense lawyers were able to demonstrate that their clients were not provided with adequate counsel. The young men were once again convicted and subsequently given prison terms of 99 years, but all would be released by 1950. These photographs of eight of the "Scottsboro Boys" are believed to have been taken in 1931 on the night they were sentenced to death, which would explain the absence of Leroy Wright, the youngest defendant.

121. Olen Montgomery

122. Andy Wright

123. Eugene Williams

124. Charles Weems

125. Ozie Powell

126. Clarence Noms

127. Haywood Patterson

128. Willie Robertson

121

122

123

124

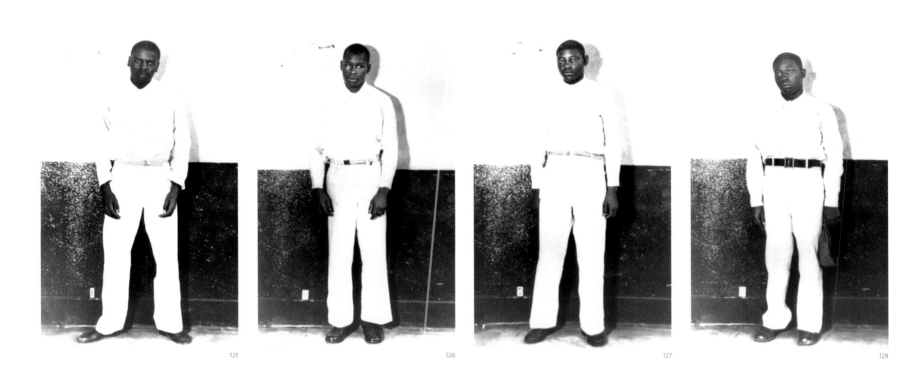

125 126 127 128

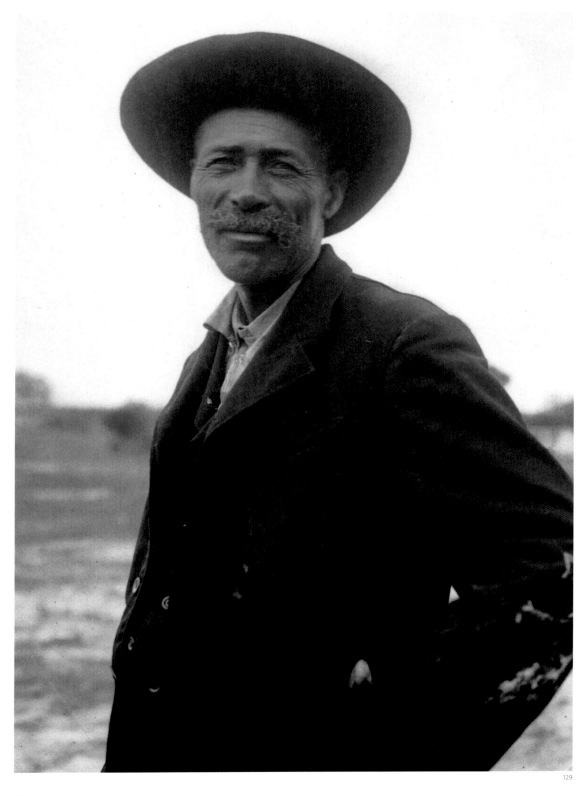

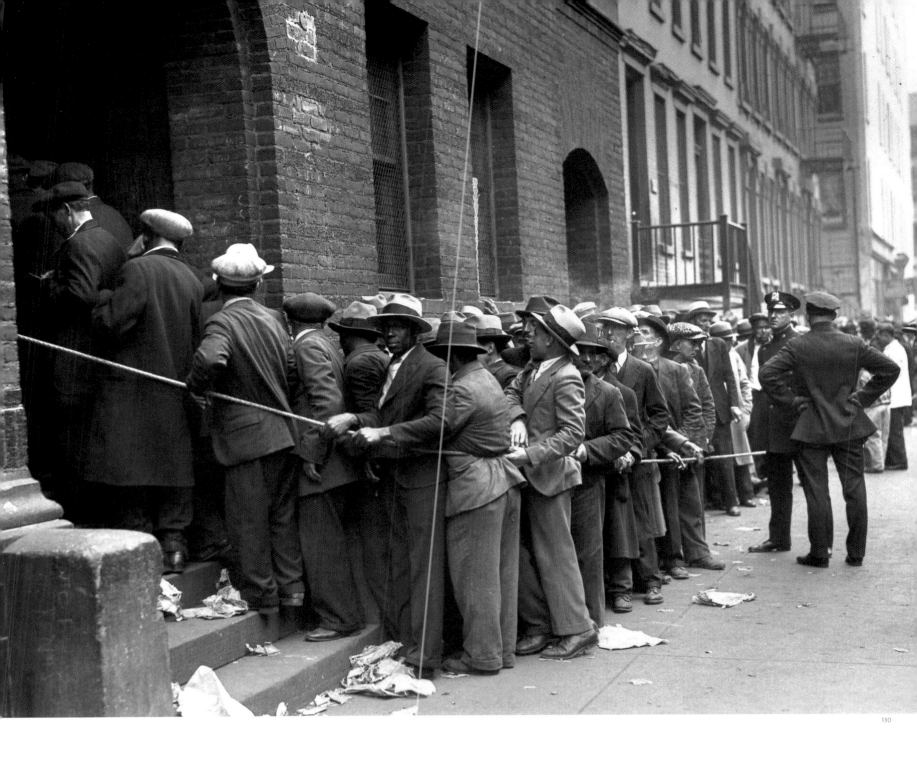

129. A successful farmer from Macon county, Alabama, 1931. Some African Americans were successful in retaining their land and establishing farms, although this became more difficult in the 1920s and 1930s. The economic crisis known as the Great Depression actually began in the rural South with a severe crisis in agriculture. Approximately 150,000 African Americans left the state of Georgia in the decade of the 1920s to escape oppressive economic conditions, as well as vigilante violence. As the price of cotton fell from eighteen cents in 1929 to only six cents a pound four years later, thousands of blacks once again began to migrate to the Northeast and the midwestern states. More militant African American farmers gravitated toward the Sharecroppers' Union, initiated by the Communist Party in 1931. By 1935 the union claimed over 12,000 members in the South.

130. Line of men waiting to register at the Emergency Unemployment Relief registration offices, New York City, 28 October 1931. As people fled the economic devastation of the South, jobs rapidly disappeared in the northern and midwestern cities. Black labor force participation rates fell to barely 50 percent. On 28 October 1931, thousands of unemployed men who had lined up to register at the Emergency Unemployment Relief registration office spontaneously began to protest. The photograph shows the police maintaining the men in line after having quelled the unrest.

131. Duke Ellington (conducting) at the Cotton Club in New York City, 1930s. Edward Kennedy "Duke" Ellington was the most popular jazz band leader and composer. He wrote and performed many of the classical standards that formed the foundation of America's most original music — jazz. For four years Ellington and his band performed at the world-famous Cotton Club, from which popular weekly radio broadcasts brought him national exposure and, eventually, international fame.

132. James Weldon Johnson with his wife Grace Nail Johnson, 1931. As a poet, lyricist, politician, novelist, and civil rights leader, James Weldon Johnson was a central figure in black American life for four decades. He was co-author of the black national anthem, "Lift Every Voice and Sing"; he served as a counsel to Venezuela and Nicaragua; and he was the author of several influential works including the novel *The Autobiography of an Ex-Colored Man*, first published anonymously in 1912. In the 1920s, he served as the national secretary of the NAACP.

133. Ethel Waters (seated) in *Rhapsody in Black*, New York City, 1931. Waters was born in poverty in Chester, Pennsylvania in 1900. As a teenager she appeared in vaudeville and musical shows. She starred in her first Broadway musical, *Africana*, in 1927. Her Broadway performance in *Rhapsody in Black* won popular and critical praise in 1931.

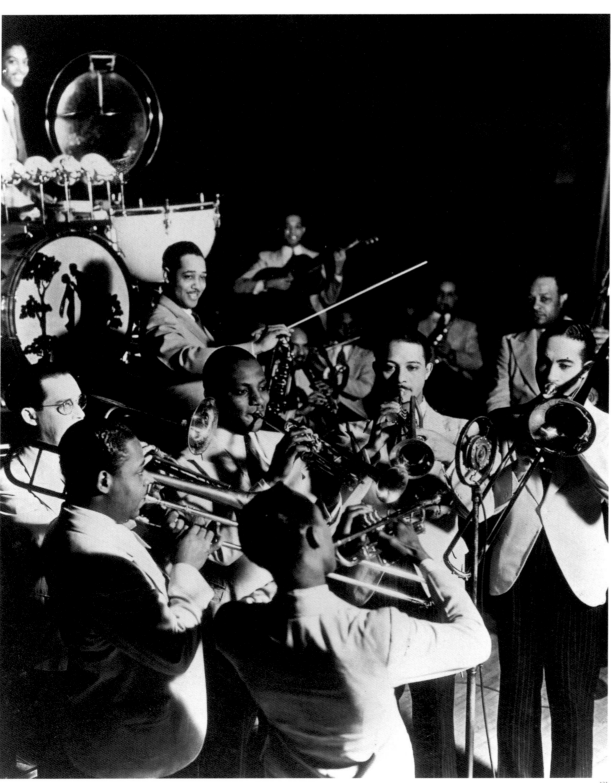

131

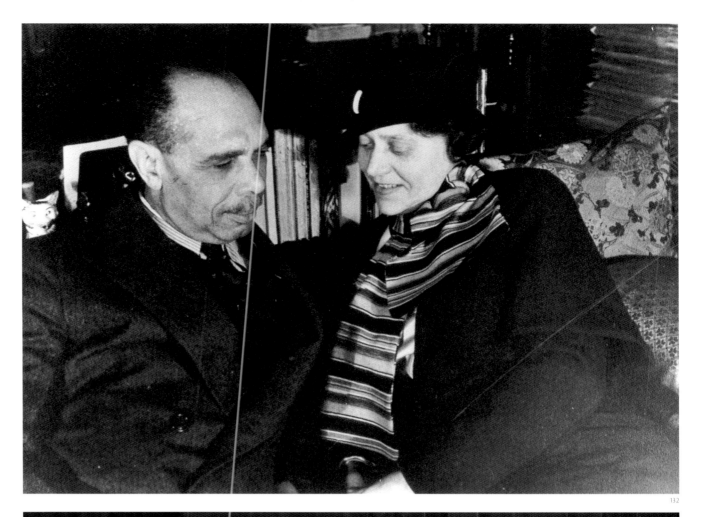

132

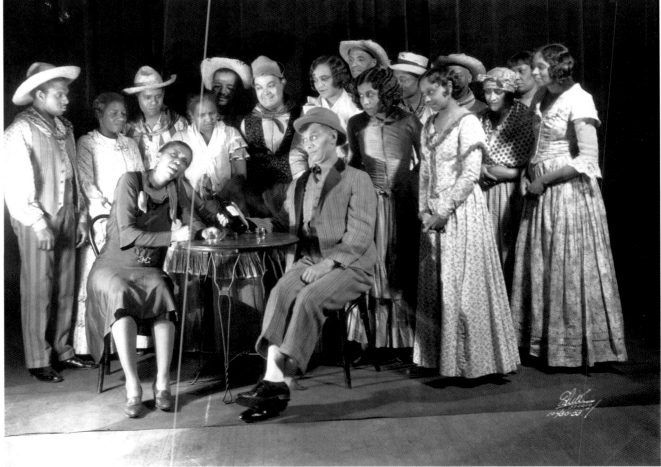

133

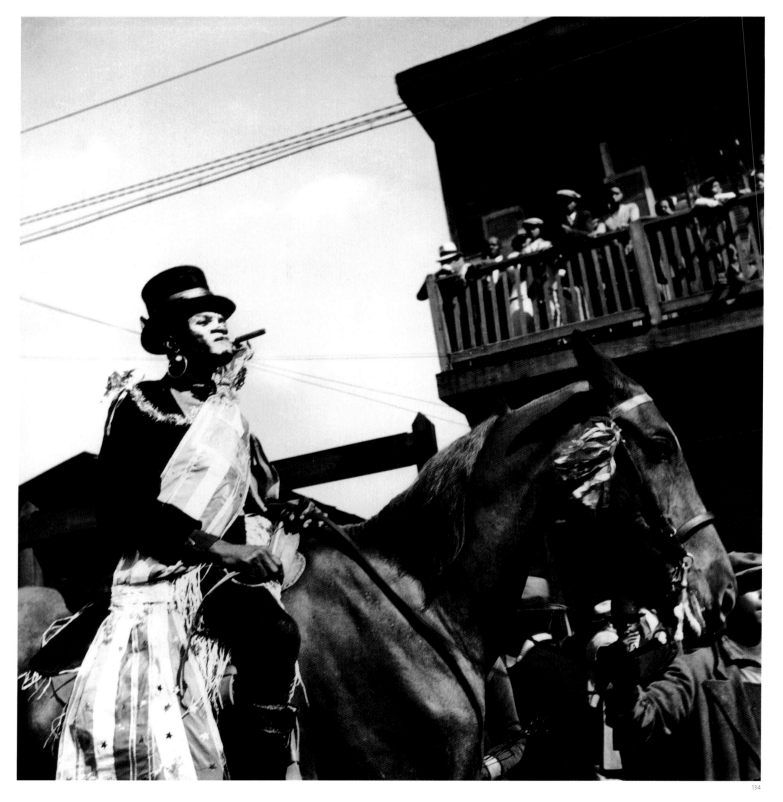

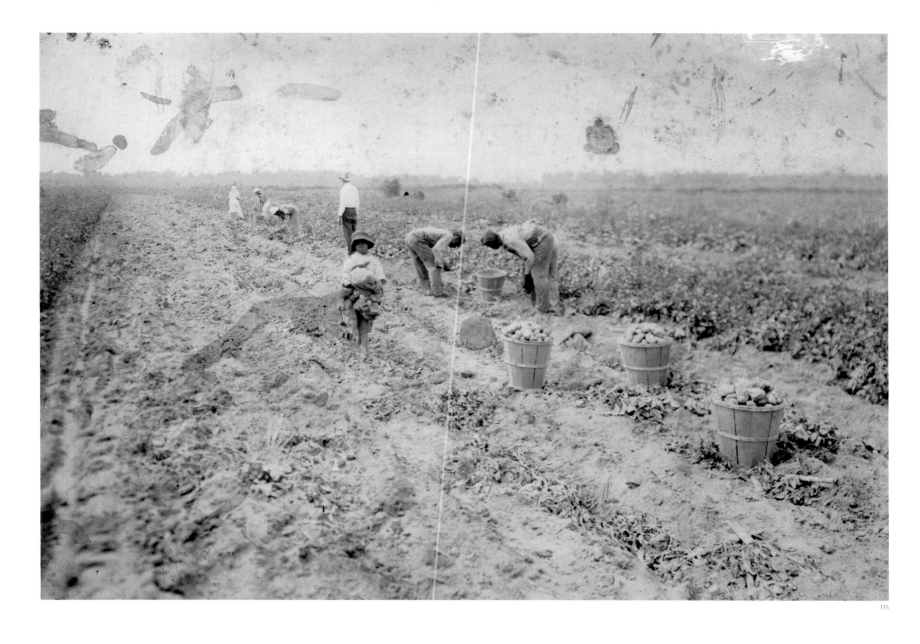

135

134. Zulu King during Mardi Gras, New Orleans, c. 1933. The traditional celebration of Mardi Gras, the day before Lent, is marked with festivities in New Orleans. For several preceding months, "clubs" organize costumes and floats for the festivities. Several of these black clubs, such as the Zulus, evolved from benevolent associations formed by laborers. These networks collected dues and provided financial aid and medical assistance to members as needed. Incorporated in 1916, the Zulus represent an early imagining of the African connection, though in the 1960s, their traditions of applying black face and wearing grass skirts became controversial.

135. Men, women and children digging potatoes in Houma, Louisiana, 18 March 1934.

136. Nancy Elizabeth Prophet in her studio at Atlanta University, 1934. Nancy Elizabeth Prophet was born in Rhode Island in 1890. Unable to find acceptance as a black artist in the United States, she moved to Paris in 1922, where she studied at the Ecole des Beaux Arts. She lived in Paris for the next twenty years, receiving critical acclaim for her life-sized marble sculptures. In 1932 she returned to the United States where her work had by then achieved recognition, and in 1934 she began teaching art, first at Atlanta University and subsequently at Spellman College in Atlanta. She was a friend and associate of W. E. B. Du Bois and of the prominent artist Henry O. Tanner.

137. Meeting of the Brotherhood of Sleeping Car Porters, location unknown, 1932–36.

138. Funeral procession of union members for workers killed during the general strike in San Francisco, 1934. In May 1934, 3,000 longshoremen participated in a general strike to protest wages and working conditions. As a result of racial discrimination within the International Longshoreman's Association, few African Americans were initially involved in the strike. However, as the strike sparked labor insurgence throughout San Francisco and subsequently along the West Coast, larger numbers of African American workers actively participated in the struggle. Though they were organized in separate unions before 1934, black and white cooks and stewards risked their lives by joining picket lines, becoming the strongest supporters of the striking longshoremen. During the labor unrest on the West Coast, thousands of workers and their supporters were imprisoned, hundreds were wounded, and several were killed. As a result of the interracial participation in the strike, the National Union of Marine Cooks and Stewards became integrated. In 1937 Harry Bridges, president of the newly-formed International Longshoremen's and Warehousemen's Union announced, "Negro labor will never again find the doors of the San Francisco longshore locals closed."

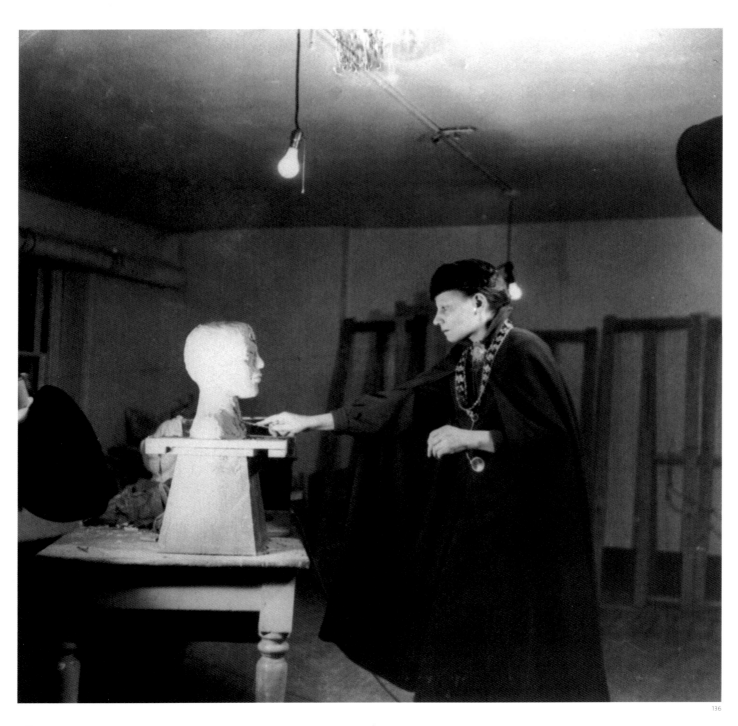

136

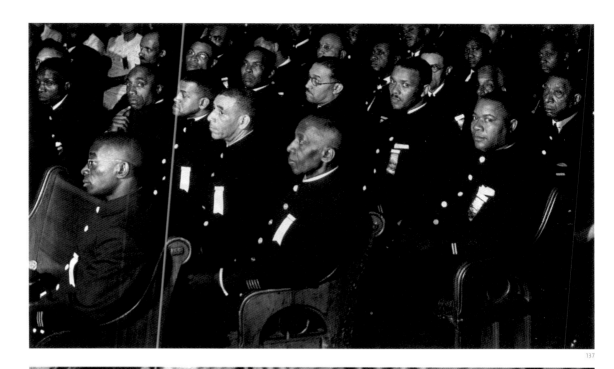

137

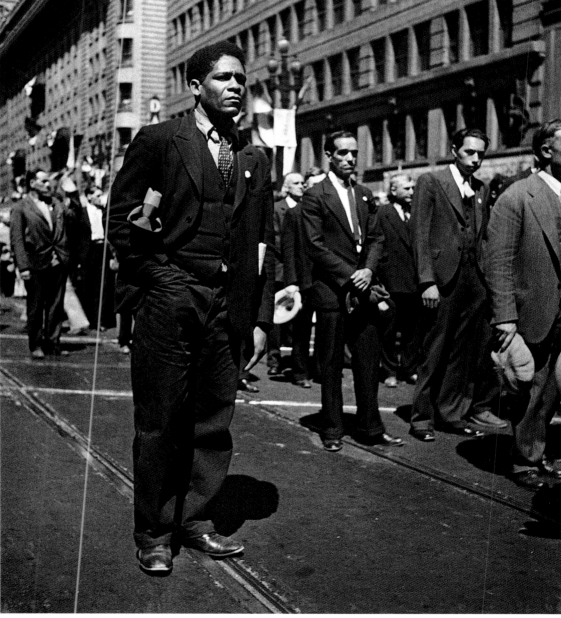

138

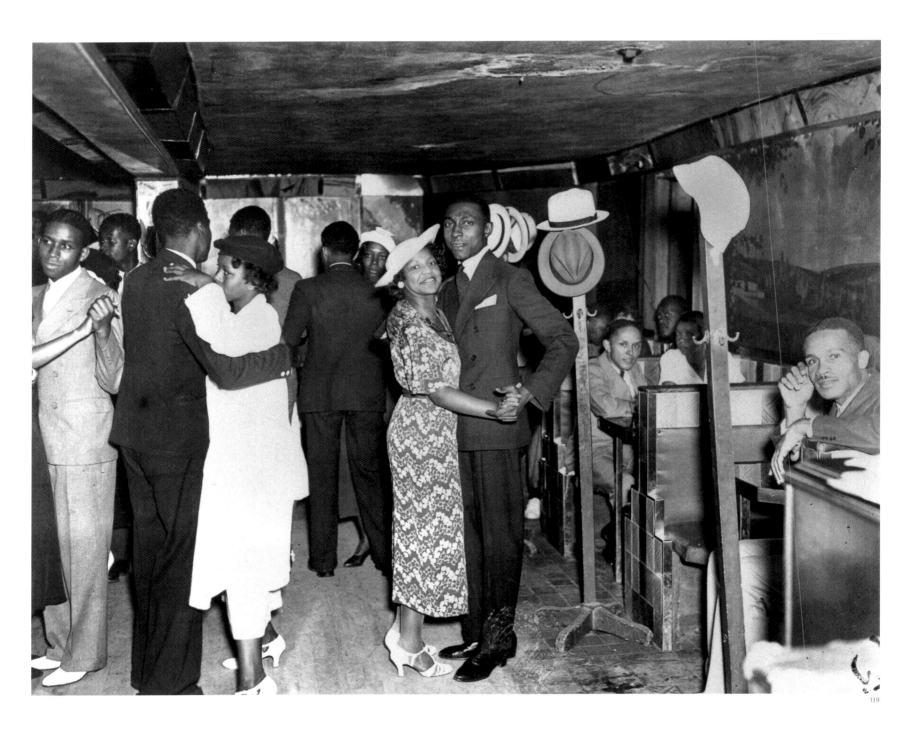

139

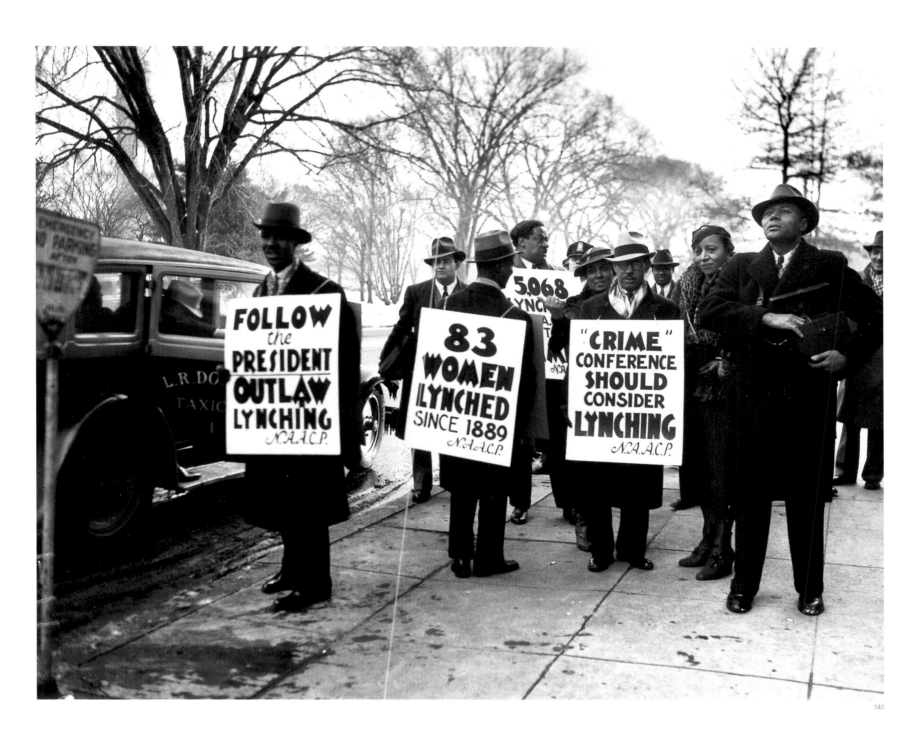

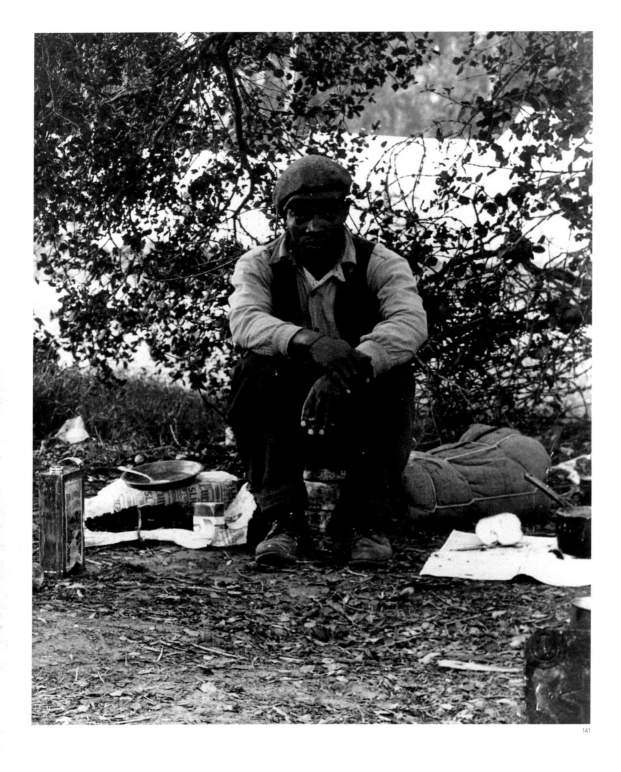

141

141. Man by the roadside on his way to work in the pea fields, Nipomo, California, 1935. This image is one of a series of photographs commissioned by the special photographic section of the Farm Security Administration (FSA). Under the progressive leadership of Will W. Alexander, the FSA loaned money to black and white small farmers without racial discrimination, as a result of which thousands of African Americans were able to purchase land.

142. Man being searched by the police during the Harlem civil unrest, New York City, 19 March 1935. On 19 March 1935 an African American teenager was caught stealing a penknife from a store in Harlem. The police at the scene released the young man, but rumors quickly circulated in the neighborhood that the boy had been killed. A black crowd soon gathered, angered by previous instances of police brutality as well as employment discrimination in white-owned stores along 125th Street. Windows were smashed, and the public demonstration quickly escalated into a general civil disturbance. In less than twenty-four hours, two-million-dollars worth of property damage occurred. Three African Americans had been killed, over one hundred injured, and 125 arrested. New York Mayor Fiorello La Guardia later named a special commission, chaired by prominent sociologist E. Franklin Frazier, to examine the factors contributing to racial unrest. The Harlem civil disturbance of 1935 was one of the first incidents where blacks employed violence to attack symbols of white ownership and civil authority in their own neighborhood.

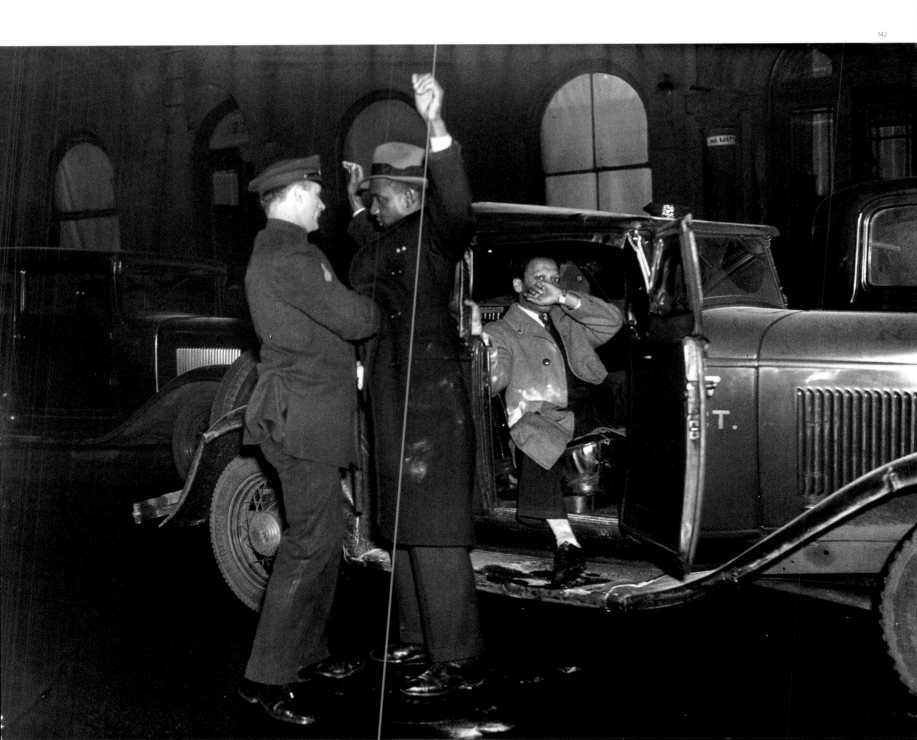

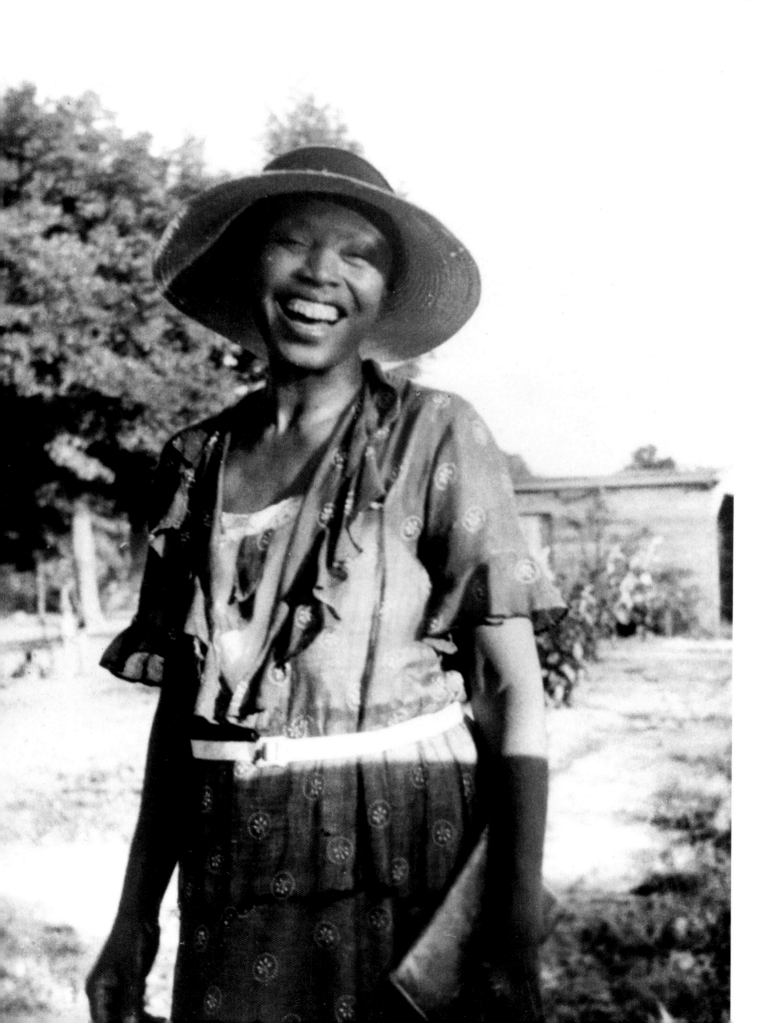

143. Zora Neale Hurston in Eatonville, Florida, 1935. Hurston was a powerful novelist, cultural anthropologist, and folklorist of the black rural experience. Growing up in Eatonville, in the 1920s she became a prominent figure of the Harlem Renaissance literary movement. As a student of Franz Boas she studied social anthropology at Columbia University. Her fieldwork in Haiti, Jamaica, and the American South formed the basis for her creative work during the Great Depression, which included *Mules and Men* (1935), a collection of black folklore, and *Their Eyes Were Watching God* (1938). She pioneered an innovative style of ethnographic writing before the dialogic style came into vogue. Her outspoken opposition to racial integration and support for all-black communities generated criticism from prominent black intellectuals such as Richard Wright. She died in obscurity in 1961 and was buried in an unmarked grave. In the 1970s, novelist Alice Walker helped to reestablish Hurston as one of the first black feminist writers.

144. Children of black sharecroppers doing the washing for a white sharecropper, southern Alabama, c. 1935.

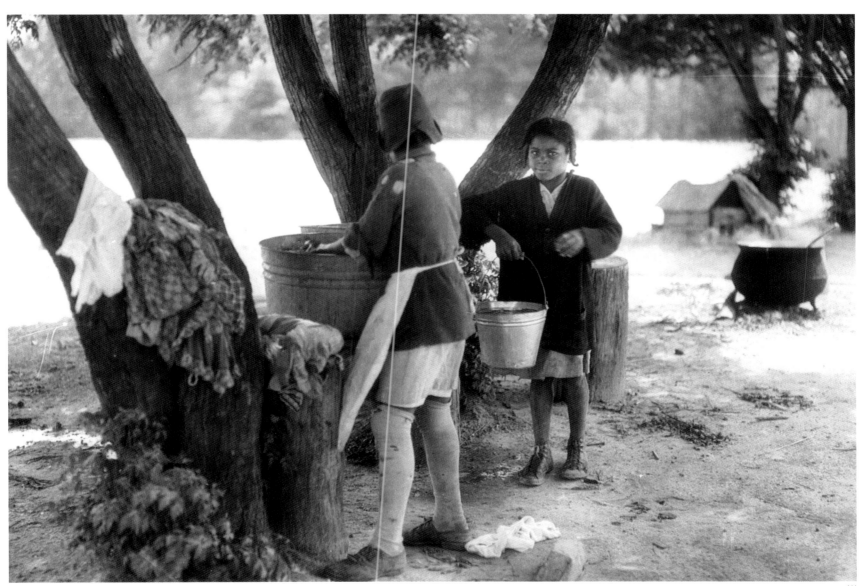

144

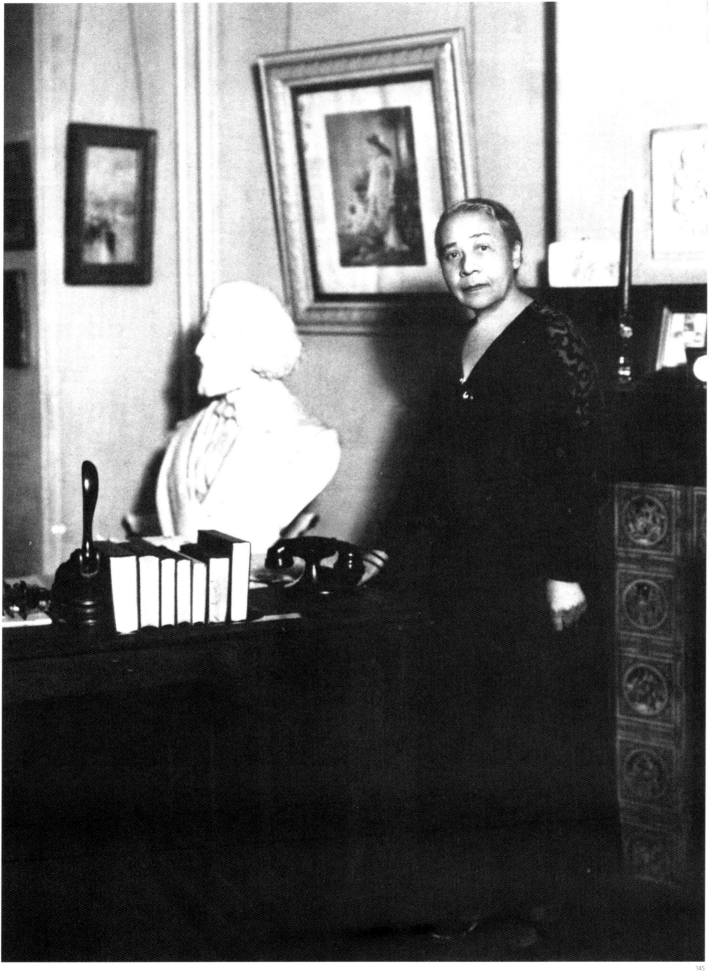

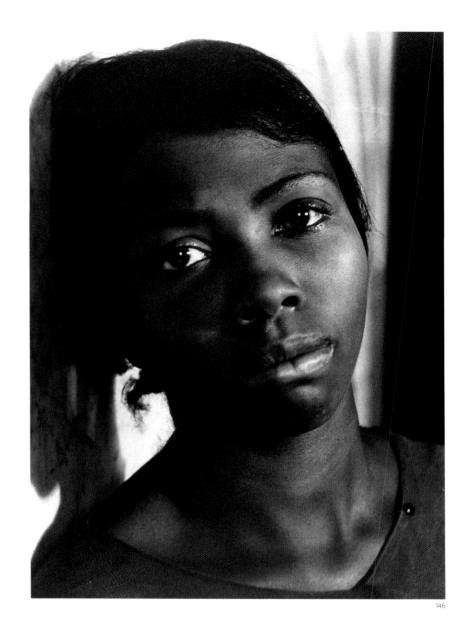

145. Anna Julia Cooper, Washington, D. C., c. 1930s. Cooper was born of a free black woman and a slave father in 1858. She was educated at Oberlin College, Ohio. For nearly forty years she taught mathematics and Latin in Washington, D. C.'s famous M Street High School. She completed graduate studies at Columbia University and received her doctorate from the University of Paris in 1925. Her book, *A Voice From the South*, first published in 1892, was perhaps the first critical study incorporating an analysis of gender, race, and class. She noted, "The colored woman of today occupies, one may say, a unique position in this country. In a period of itself transitional and unsettled, her status seems one of the least ascertainable and definitive of all the forces which make our civilization. She is confronted by both a woman question and a race problem, and is as yet an unknown or an unaknowl- edged factor in both."

146. Portrait of a woman, Annie Mae Merriweather, location unknown, 1935. "The majority of our women are not heroines — but I do not know that a majority of any race of women are heroines. It is enough for me to know that while in the eyes of the highest tribunal in America she was deemed no more than a chattel, an irresponsible thing, a dull block, to be drawn hither or thither at the volition of an owner, the Afro-American woman maintained ideals of womanhood unshamed by any ever conceived. Resting or fermenting in untutored minds, such ideals could not claim a hearing at the bar of the nation. The white woman could at least plead for her own emancipa- tion; the black woman, doubly enslaved, could but suffer and struggle and be silent. I speak for the colored women of the South, because it is there that the millions of blacks in this country have watered the soil with blood and tears, and it is there too that the colored woman of America has made her characteristic history, and there her destiny is evolving." Excerpt from *A Voice from the South* (1892), by Anna Julia Cooper.

147. Cotton pickers, Arkansas, October 1935. The Farm Security Administration (FSA) sponsored educational programs that helped black farmers to implement more productive agricultural techniques. However, the FSA's progressive stance was opposed by conservative members of Congress who were able to significantly cut its appropriations in 1942.

148. Weighing in cotton, Pulaski county, Arkansas, October 1935.

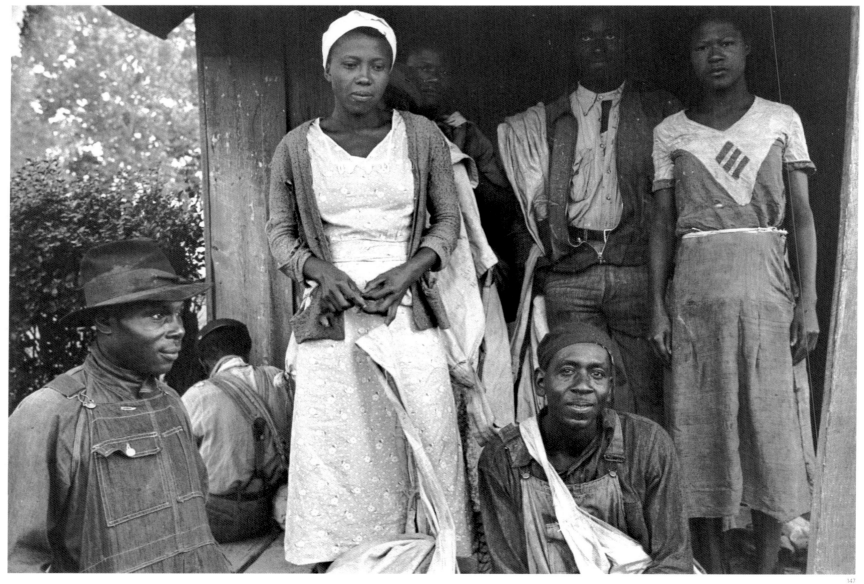

147

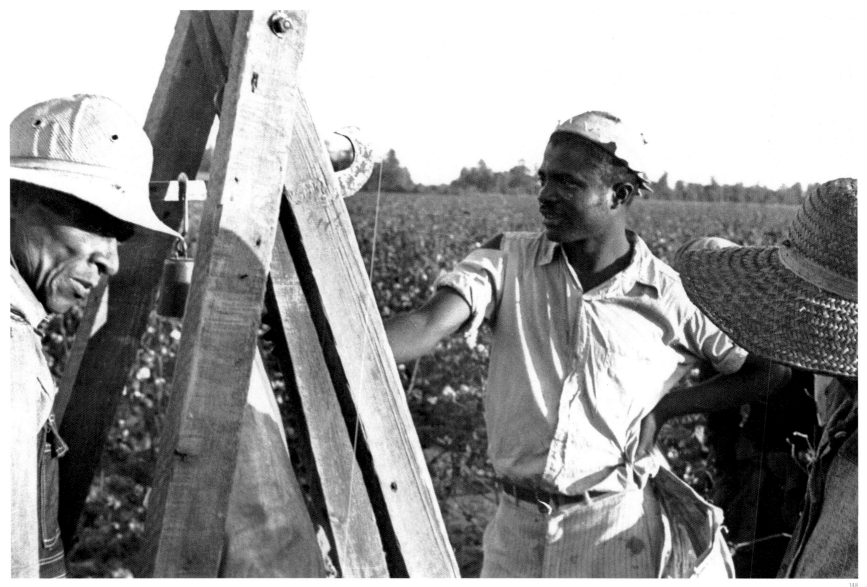

149

149. Claude McKay, c. 1935–36. Poet, novelist, and political militant, McKay was born in Jamaica in 1889. Arriving in the United States in 1912, he quickly became, for a brief period of time, a key figure in American radicalism. An important contributor to the Harlem Renaissance literary movement, McKay produced a series of works documenting the lives of African American working people. His most famous poem, "If We Must Die," was written in response to the epidemic of lynching following World War I.

150. *Porgy and Bess* premiere at the Alvin Theater in New York City, 10 October 1935. For many years, African American culture was represented to white audiences through the works of white writers and composers. George and Ira Gershwin's 1935 opera presented powerful, though controversial, images of black southern life to millions of people throughout the world. *Porgy and Bess* was considered to be the first American opera, and was the first American opera to be staged at La Scala in 1955.

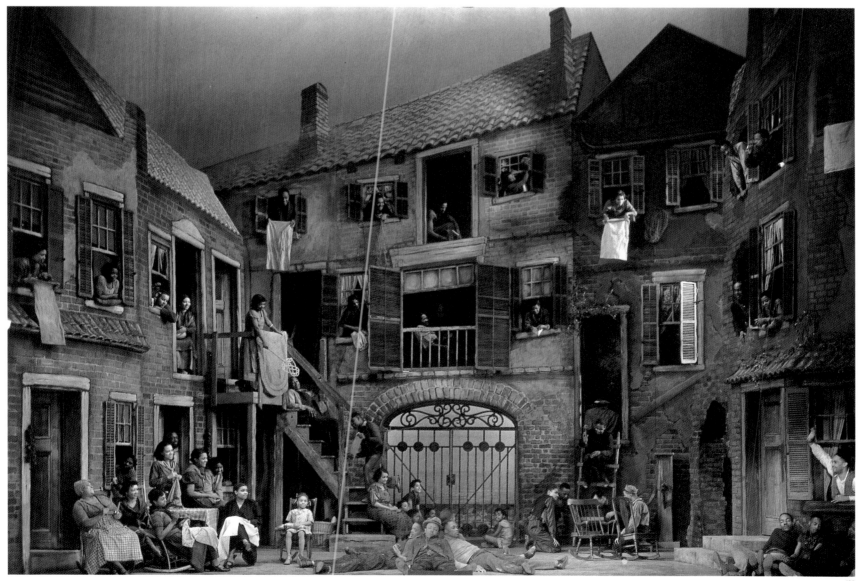

150

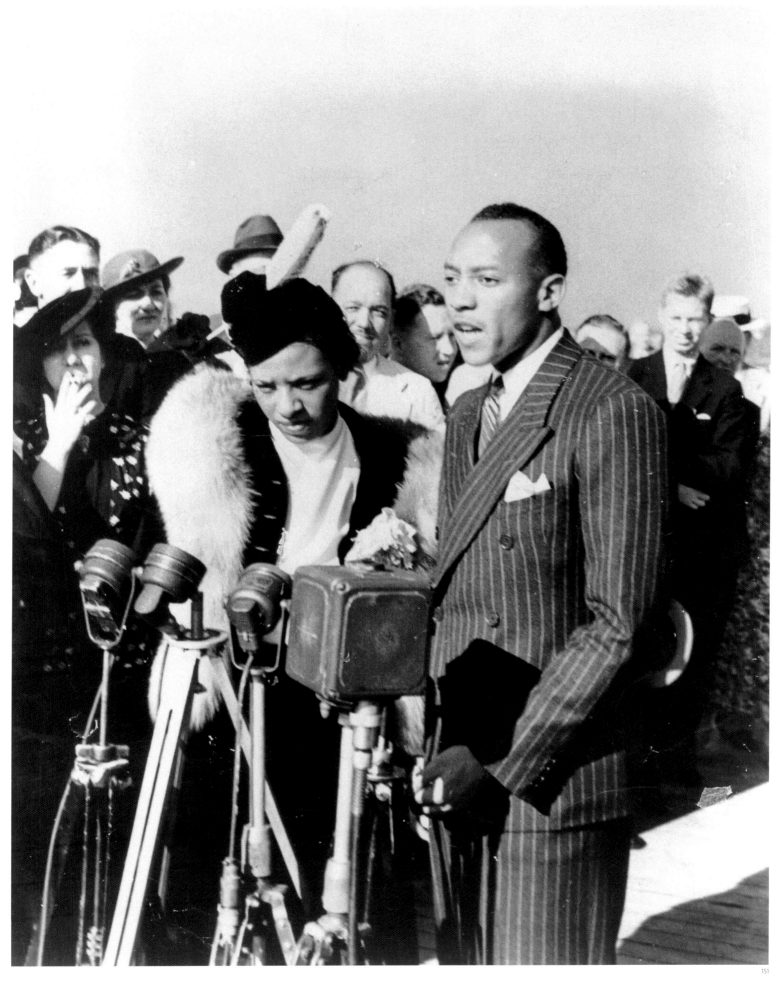

151

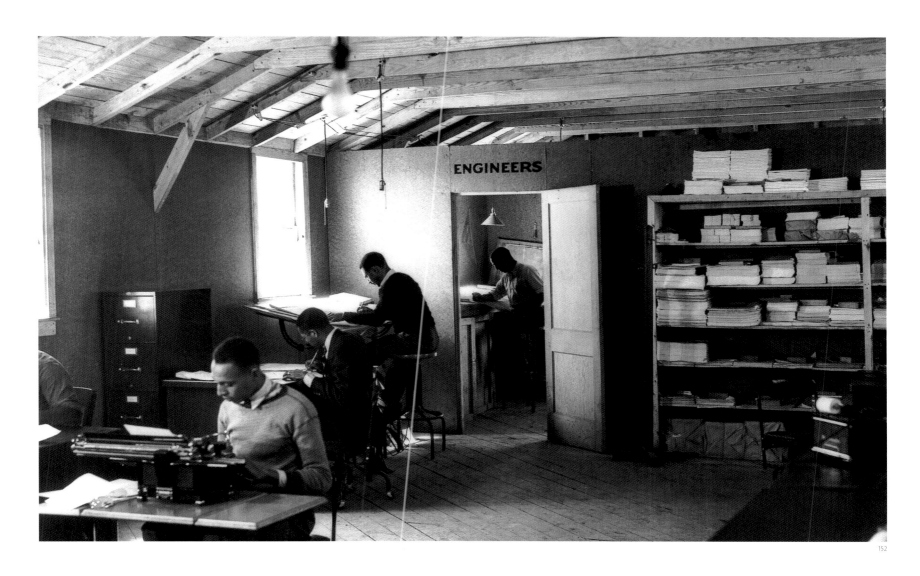

152

151. Ruth and Jesse Owens returning from the Berlin Olympic Games, New York City, August–September 1936. James Cleveland "Jesse" Owens was born in Alabama in 1913, the son of a sharecropper. The Owens family moved to Cleveland, Ohio in 1921 during the Great Migration, and Jesse became a star athlete while still in high school. As a sprinter at Ohio State University he set world records in the 100-yard dash, the 220 dash and the broad jump. At the Big Ten Championships on 25 May 1935, he broke five world records and equaled a sixth in track and field competition — all within 45 minutes. At the controversial Olympic Games held in Berlin in 1936, Owens stunned the world by winning four gold medals. His triumph was a symbolic defeat of the Nazi ideology of a master race.

152. Office staff of the Newport News homesteads, a U. S. resettlement administration housing project, Virginia, September 1936. The New Deal initiated a series of public housing projects that would later radically transform black urban life. Although African Americans benefited from New Deal housing programs, in the South they were implemented strictly along Jim Crow segregation lines.

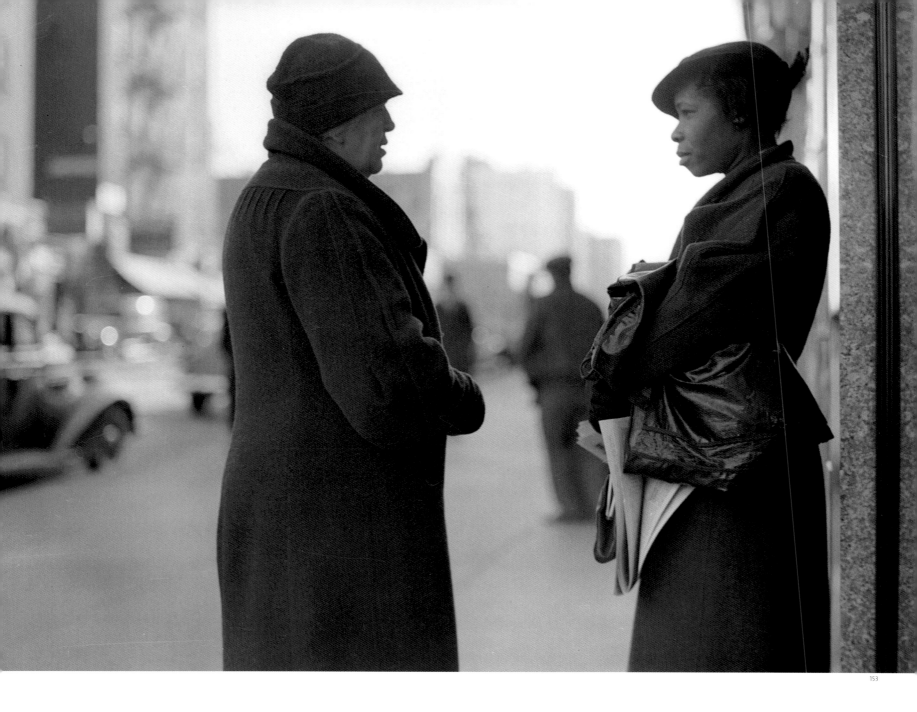

153. The "Bronx slave market," New York City, 1937. In the North, African American women were largely limited to domestic work. During the Depression, black women seeking work would stand on a two-block stretch as white housewives from the suburbs drove by in their cars and negotiated to hire them for domestic service. Because job opportunities for black women were limited by race and gender, many had no other opportunities through which to provide support for their families than to work as domestic servants. For many, the "Bronx slave market" illustrated the race, class, and gender subordination of black women. *The Crisis* magazine journalists Ella Baker and Marvel Cooke related: "Rain or shine, cold or hot, you will find them there — Negro women, old and young — sometimes bedraggled, sometimes neatly dressed — but with the invariable paper bundle [containing their work clothes], waiting expectably for Bronx housewives to buy their strength and energy for an hour, two hours, or even for a day at the munificent rate of fifteen, twenty, twenty-five, or, if luck be with them, thirty cents. . ." This picture was taken by African American photographer Robert McNeill. McNeill worked in the Federal Writers Project and produced extraordinary photographs documenting African American life during this period. Some of his work was so striking in its sensitive and powerful portrayal of white racism that it was censored by his employers. The Federal Writer's Project created in the 1930s was a New Deal enterprise to collect narratives and life histories of formerly enslaved African Americans through-out the United States.

154. Packing celery, Sanford, Florida, January 1937.

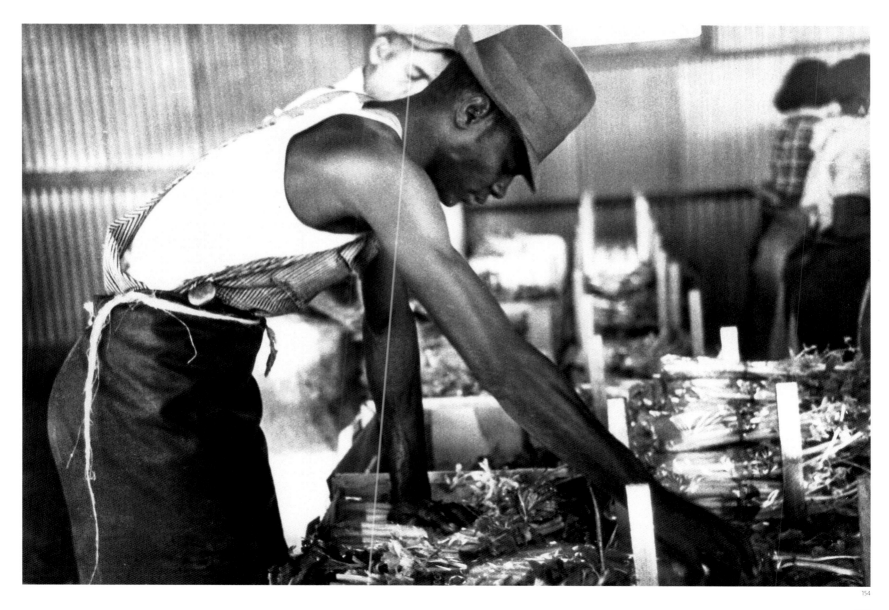

154

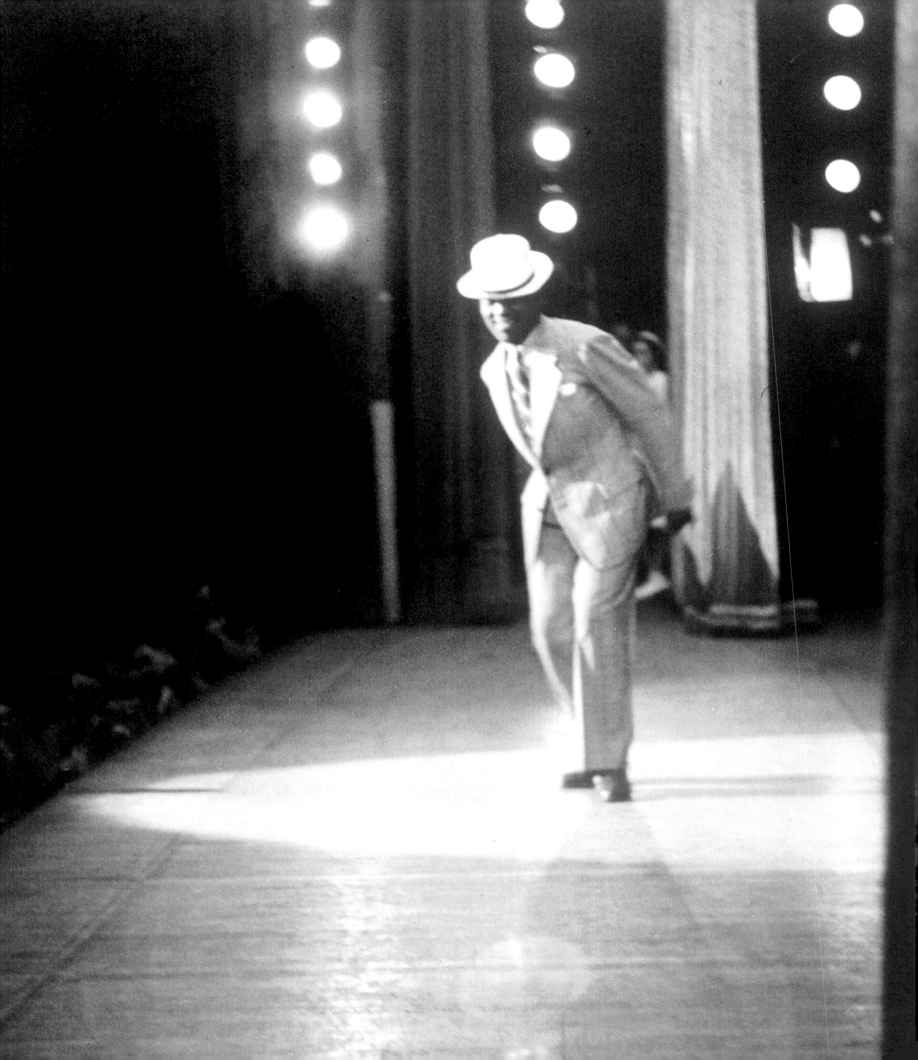

155. Bill Bojangles photographed from the wings of the Howard Theater, Washington D. C., 1937. Luther "Bill Bojangles" Robinson was the most popular tap dancer of his time. He was a veteran vaudeville performer who became an international star by appearing in a series of Hollywood films in the 1930s. Although admired for his dancing skill and perfectly timed performances, he was criticized by many African Americans as an "Uncle Tom" for performing in racially demeaning roles. His career exemplified the dilemma of many African American artists and entertainers whose choices of roles were constrained by racism. Despite his renown as a photographer, segregation laws prohibited Robert McNeill from sitting in the audience of the Howard Theater. Determined to take the picture, McNeill photographed Robinson from the wings of the stage.

156. Augusta Savage in her studio, 1937. Augusta Christine Savage, prominent sculptor and educator, studied at Cooper Union in New York City and later in Paris in 1929–30. She was the first director of the Harlem Community Arts Center. Her artistic work came to national attention in 1939 when she was commissioned by the New York World's Fair to create a sculpture celebrating African American music. Her harp-shaped interpretation of the black anthem "Lift Every Voice and Sing" symbolized the powerful struggle for freedom by African Americans.

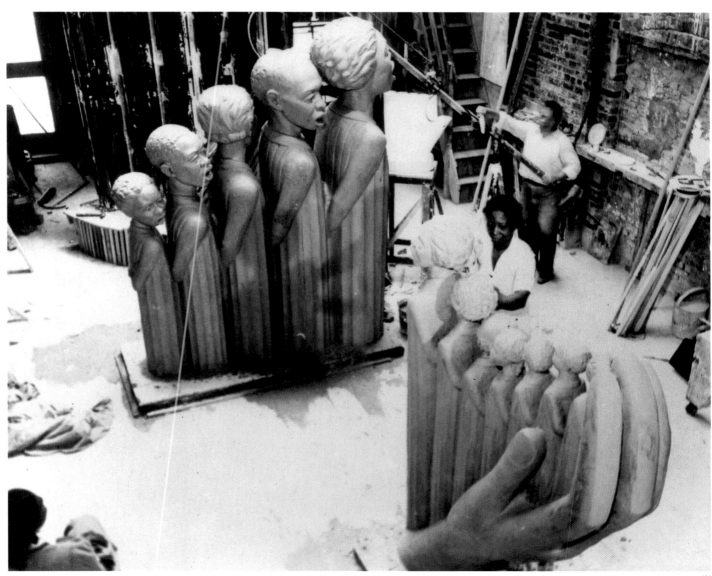

157. Easter Sunday at the zoo, Washington, D. C., spring 1938. During these years many public facilities, even in the North, were segregated. This Robert McNeill photograph portrays a Sunday afternoon at the public zoo, which was open to blacks.

158. Joe Louis–Max Schmelling weigh-in at Yankee Stadium, New York City, 22 June 1938. Louis was the first African American athlete to win widespread popularity within white America. Born in rural Alabama in a sharecropper family, Louis was raised in Detroit. As a teenager he became an amateur boxer and acquired a popular following. In June 1937 he defeated Lou Braddock to become the second African American heavyweight world champion. Before Louis won the championship, he had been defeated by German boxer Max Schmelling. Their 1938 rematch was promoted as a struggle between American democracy and German Nazism. Louis' dramatic first round defeat of Schmelling made him a popular sports icon, but despite his fame and non-controversial persona, he nevertheless encountered the humiliations of segregation. By the end of his career, the "Brown Bomber" had won 68 fights with only three defeats.

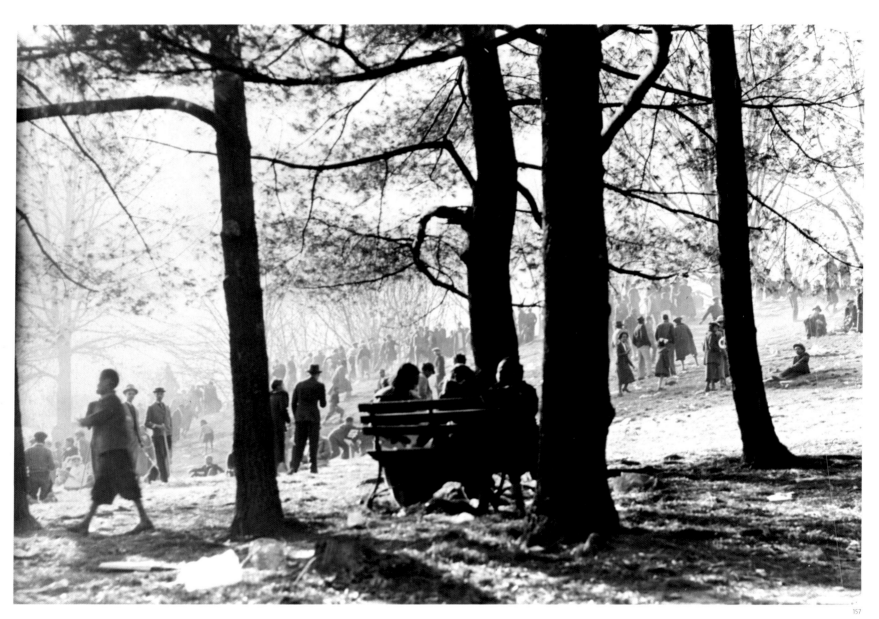

157

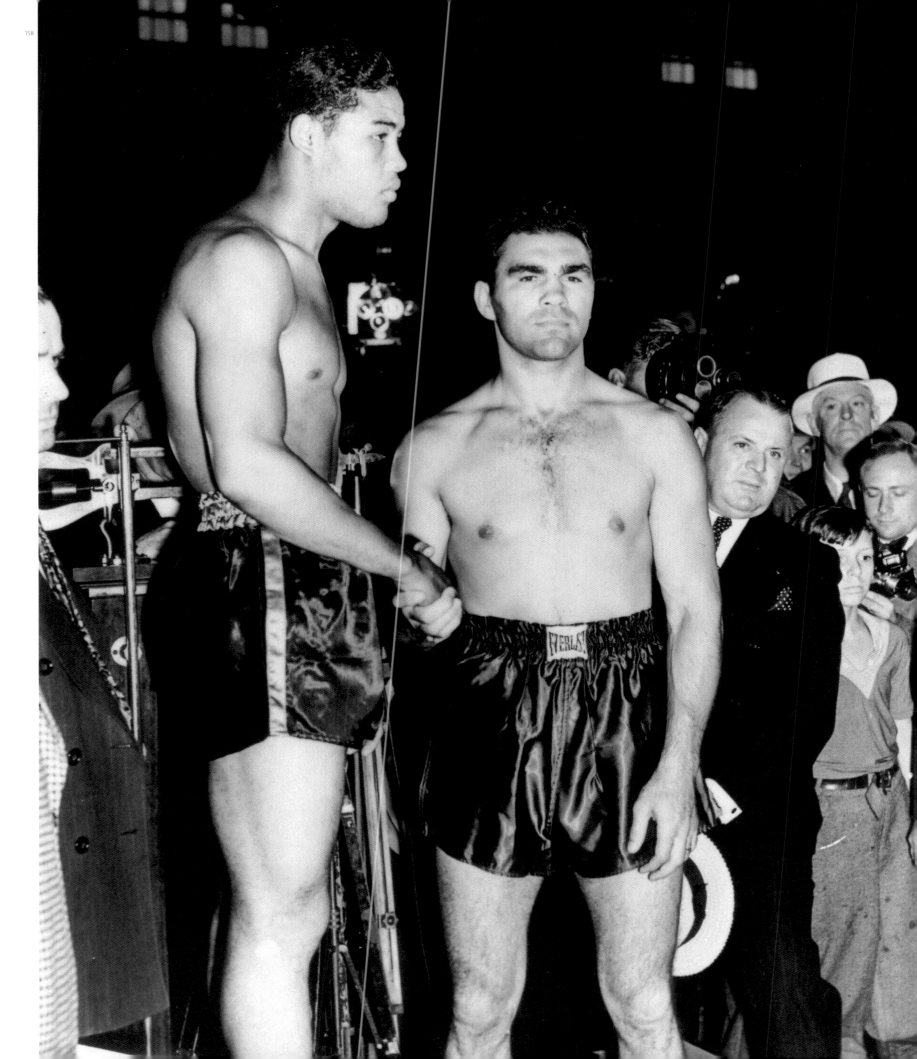

159. East Richmond, Virginia, 1938.

160. Hampton Building and Loan Association, Hampton, Virginia, 1938. Hampton, the home of the Hampton Institute included a large population of college-educated African Americans. The Hampton Building and Loan Association was a financial lending institution, controlled by African Americans, that served the city's black community.

161. Ludlow operator at the *Norfolk Journal and Guide*, Virginia, 1938.

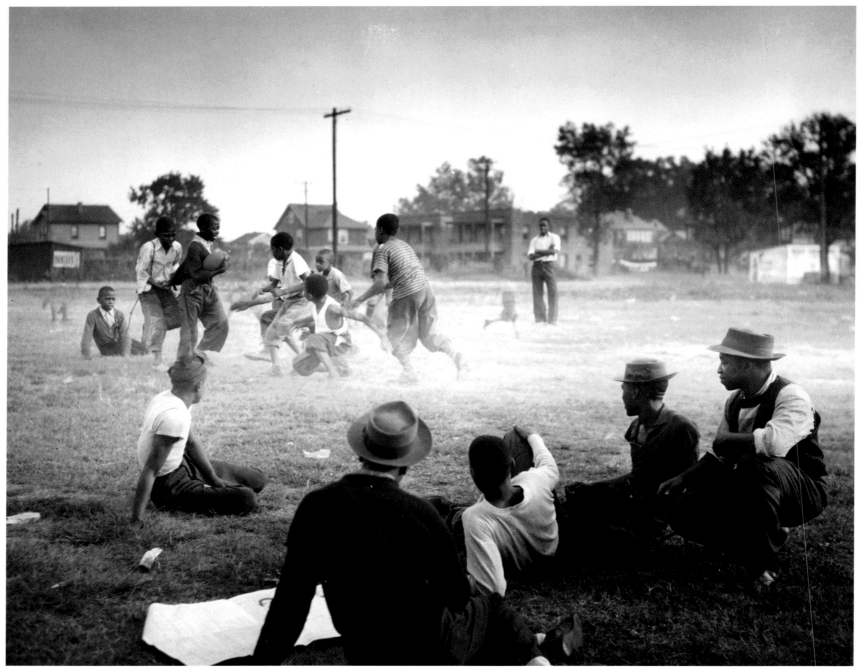

159

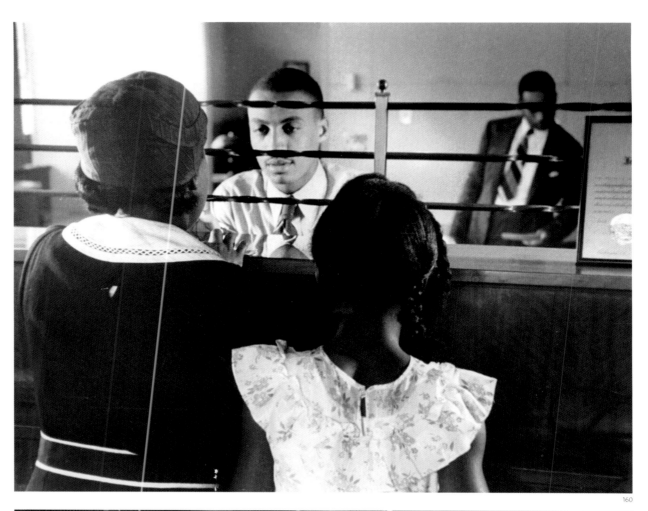

160

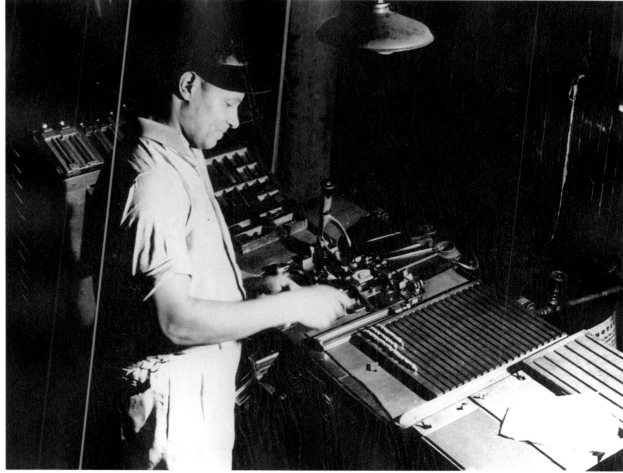

161

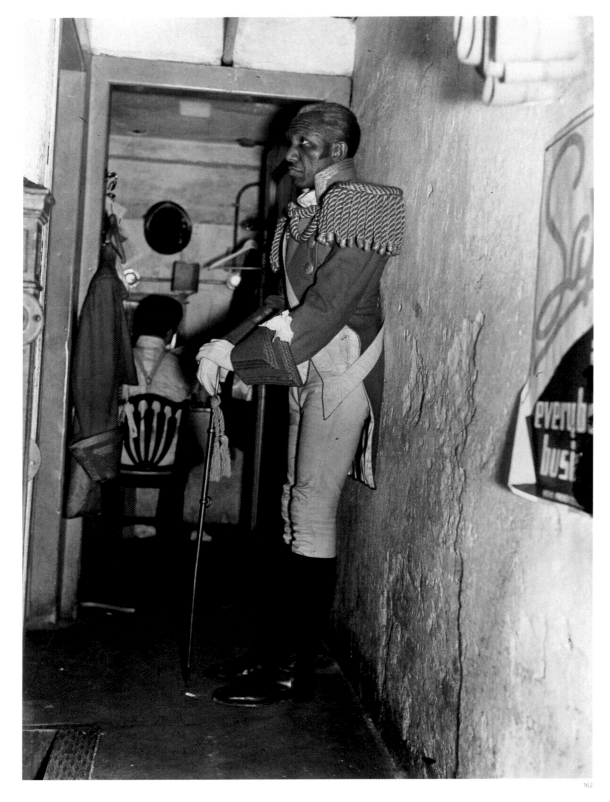

162

162. Actor at the Lafayette
Theater, Harlem, New York
City, 1938–1940.

163. Tobacco workers rolling
a hogshead, Richmond,
Virginia, 1938. In the 1930s,
African American workers
were forcibly ejected
from local meetings of the
Tobacco Workers'
International Union in the
South. Their struggle
against racial exclusionist
policies became part of a
larger effort to desegregate
many unions affiliated

with the American
Federation of Labor (AFL).

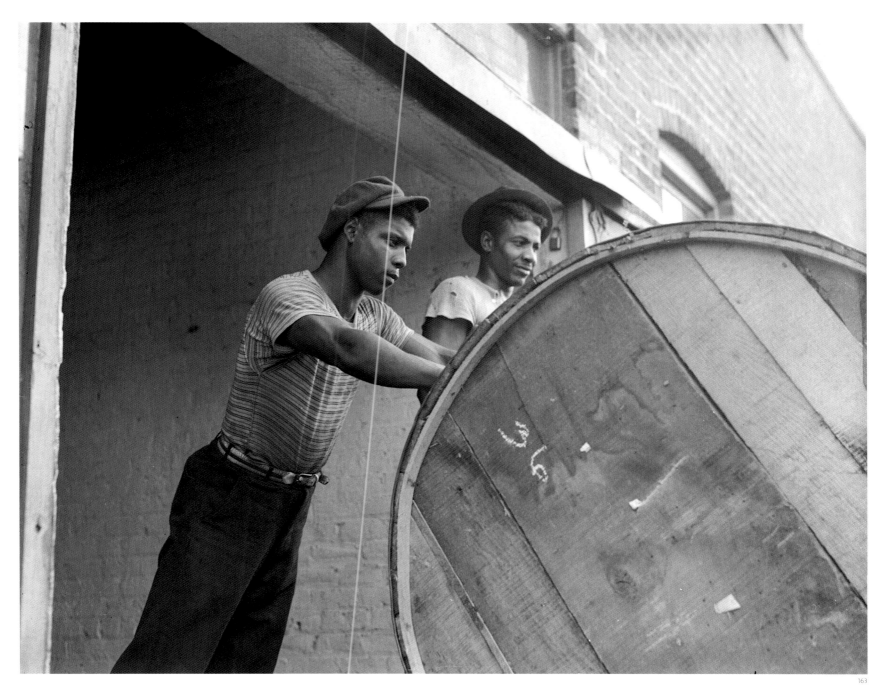

164. Ella Fitzgerald performing with the Chick Webb Orchestra at the Savoy Ballroom in Harlem, New York City, c. 1938. Born in 1918, Ella Fitzgerald first gained attention as a singer in Chick Webb's popular band. Her famous scat style of jazz singing and vocal control made her a favorite among musicians and music enthusiasts.

165. Dancing at the Savoy Ballroom, 1938. Dance has always been central to African American popular culture, and no place was more famous as the site of swing than Harlem's Savoy Ballroom. In the late 1920s the "lindy hop" dance, which is associated with the Savoy, became a national craze. Ironically, because many white Americans readily accepted the stereotype that black people were "natural" entertainers and dancers, ballrooms and jazz clubs during the 1930s and 1940s were among the integrated sites. The Savoy Ballroom located in Central Harlem off Lenox Avenue was opened in 1926, and took up the entire block on the avenue between 140th and 141st streets. The block-long ballroom had two band-stands. Virtually every famous musician of the jazz era played at the Savoy at one time or another.

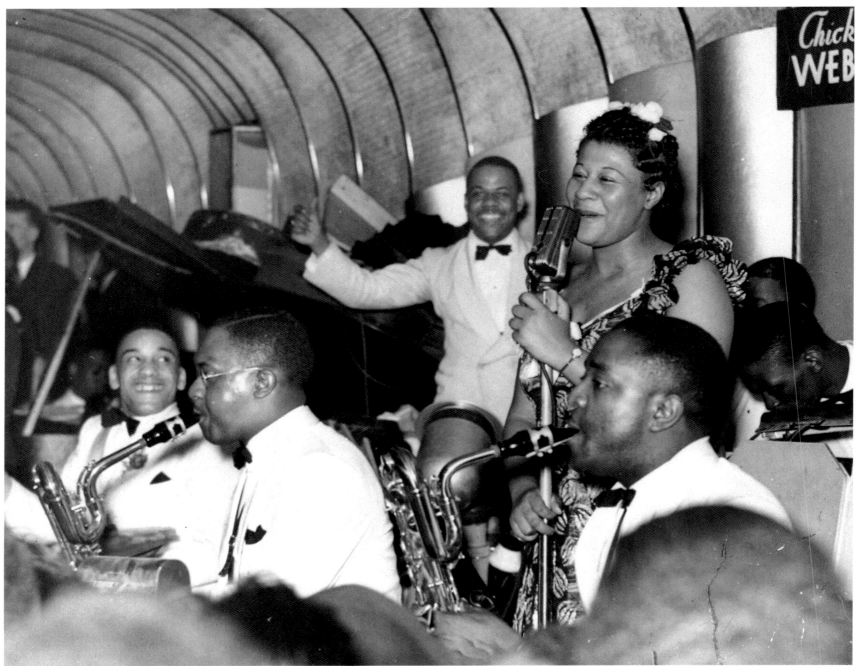

164

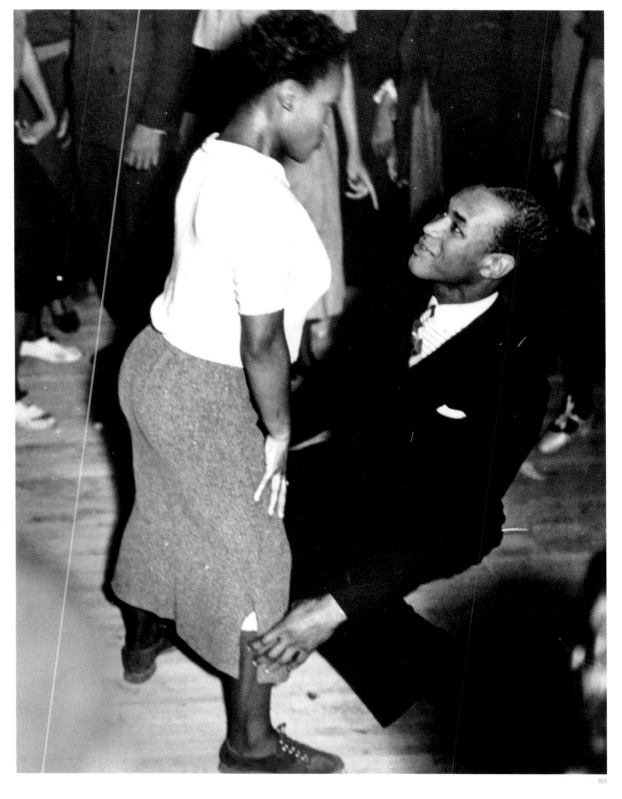

166. Fifth Avenue, New York City, c. 1938. During the 1930s the NAACP flew a flag over its headquarters on Fifth Avenue to report lynchings until, in 1938, the threat of losing its lease forced the association to discontinue the practice.

167–168. Evicted sharecroppers along U. S. Highway 60, New Madrid county, Missouri, January 1939. Hundreds of thousands of farmworkers and sharecroppers were pushed out of southern agriculture by a variety of forces: low wages, mechanization of agriculture, falling crop prices, and racial exclusion in employment. During President Franklin Roosevelt's administration, the Agricultural Adjustment Administration paid farmers to destroy their crops and livestock in order to increase market prices. Most federal funds, which were meant to benefit black sharecroppers and tenant farmers, ended up in the hands of white landlords, and thousands of poor farmers were forcibly evicted every year.

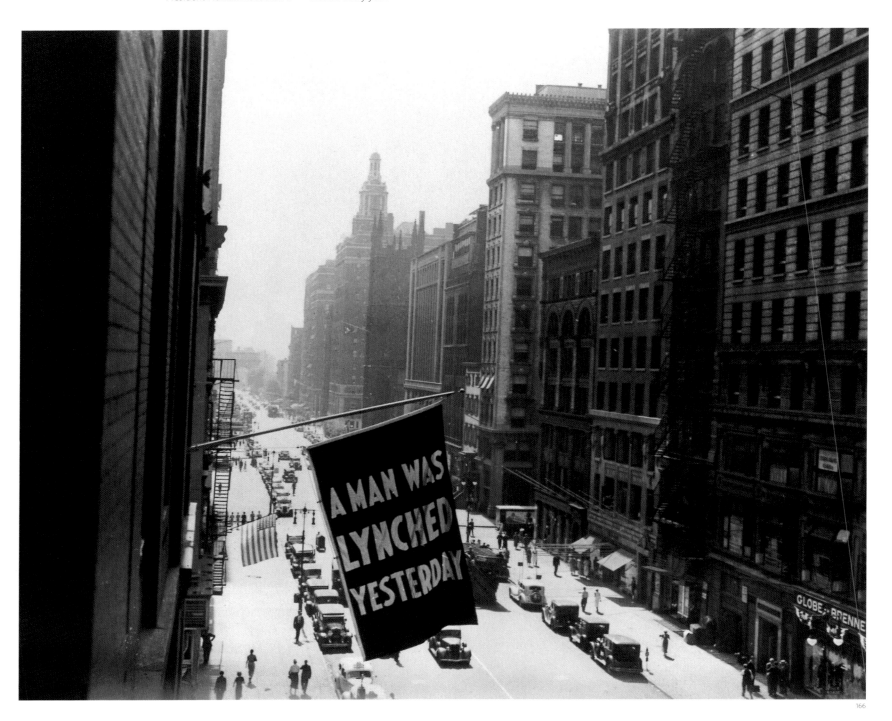

166

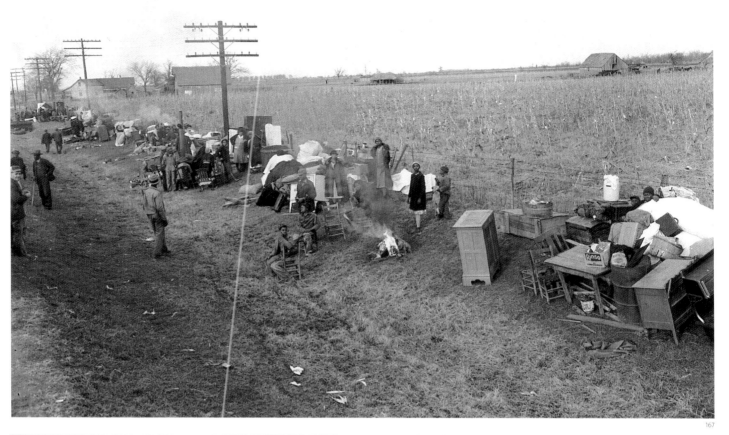

167

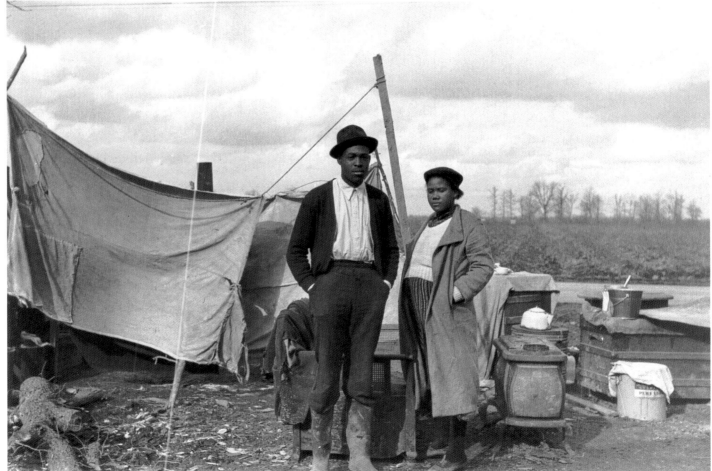

168

169. Marian Anderson singing at the Lincoln Monument, Washington, D. C., 9 April 1939. Born in 1902, Anderson became the first African American singer to be admitted to the Metropolitan Opera Company in New York in 1955. In the 1930s she received international acclaim during a five-year European tour and regularly performed as many as 100 concerts a year. In 1939 the Daughters of the American Revolution, who controlled the facility, prohibited her from performing at Constitution Hall in Washington, D. C. because of her race, upon which First Lady Eleanor Roosevelt publicly resigned from the DAR. As a protest against racial discrimination Anderson gave a concert at the Lincoln Memorial that attracted over 75,000 people and was broadcast nationally. The NAACP gave Anderson its Spingarn Medal, which Eleanor Roosevelt awarded to her. This photograph was taken by the renowned Scurlock studio in Washington, D. C.

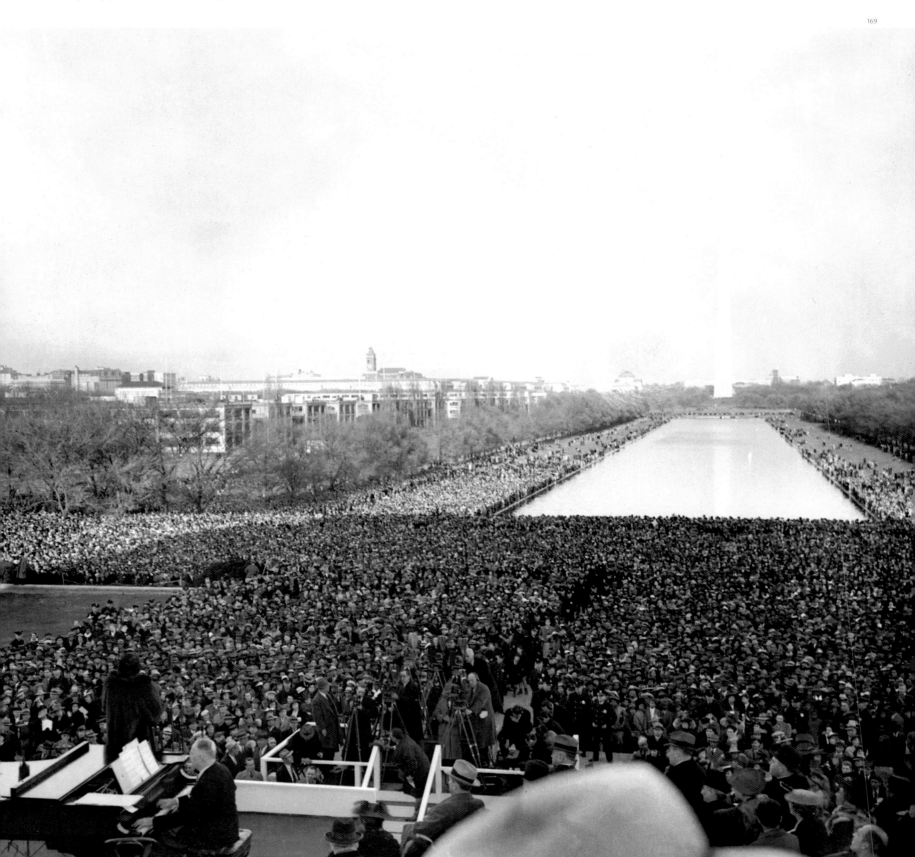

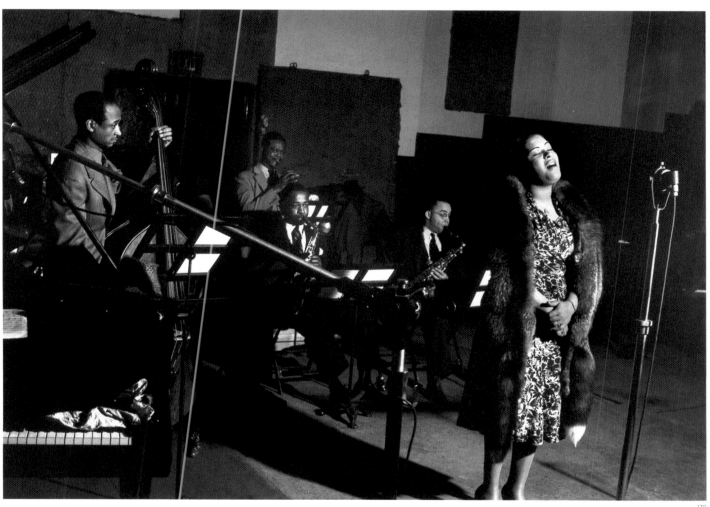

170. Billie Holiday and her band recording "Strange Fruit" for Commodore Records, 20 April 1939. Billie Holiday was a brilliant vocal interpreter of modern American music, as influential, in her own right, as saxophonists Charlie Parker and Lester Young. It was Young who nicknamed Holiday "Lady Day." Her personal difficulties with alcohol and drugs gave her performances an unusual degree of sadness and depth. Although her vocal range was limited, she used various techniques, such as singing behind the beat, that made her singing style unique. Columbia Records refused to release "Strange Fruit," a song about lynching that sharply challenged Jim Crow vigilante violence, for fear of angering the southern record market; it was therefore released by a minor company, Commodore Records. Throughout her career, Holiday earned the respect and admiration of her peers. Her renditions of songs such as *God Bless the Child* and *Good Morning Heartache* became world-famous. Due to years of drug and alcohol abuse, Billie Holiday died at the early age of 44.

170

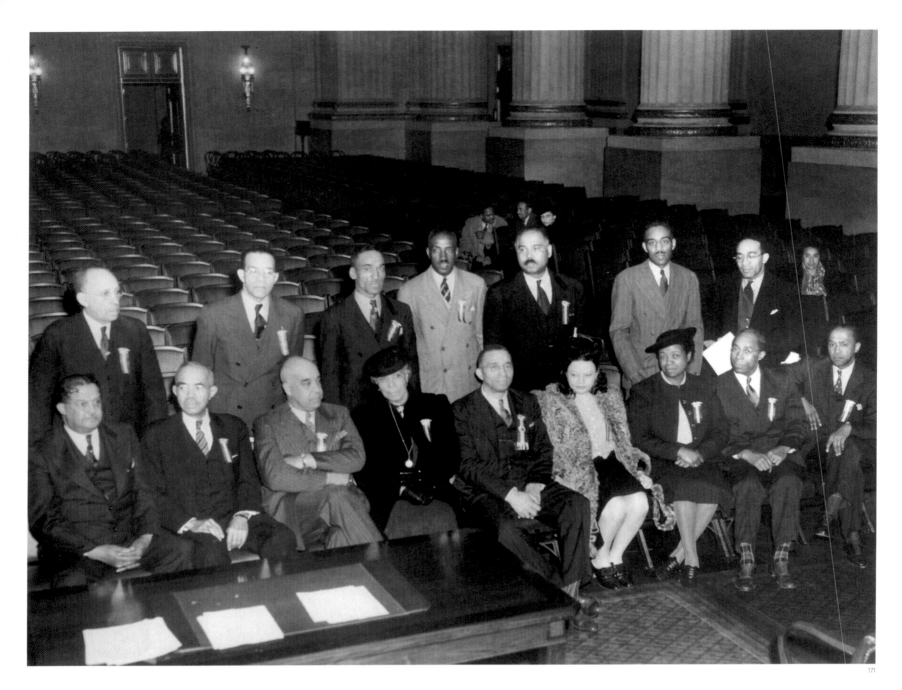

171. Part of what became known as Roosevelt's "black cabinet" at an auditorium on Constitution Avenue, Washington, D. C., c. 1939. As a result of pressure from civil rights organizations and black national leaders such as A. Philip Randolph, Roosevelt's administration appointed a number of African Americans to represent black interests inside the administration. Roosevelt's informal "black cabinet" included intellectuals, officials, and administrators. By 1935, there were a number of African Americans working in various federal agencies. One of the key figures was attorney William Hastie, who served as the assistant solicitor of the Department of the Interior from 1933 to 1937. Hastie was appointed by Roosevelt as the first African American to serve on the federal bench.

172. Mound Bayou, Mississippi, c. 1939. Mound Bayou was founded as an all-black town by political leader Isaiah T. Montgomery in 1887. The town — with its own bank, vocational school, power and light company, and extensive commercial enterprises — became a symbol of black entrepreneurship modeled on Booker T. Washington's philosophy of "accomodation."

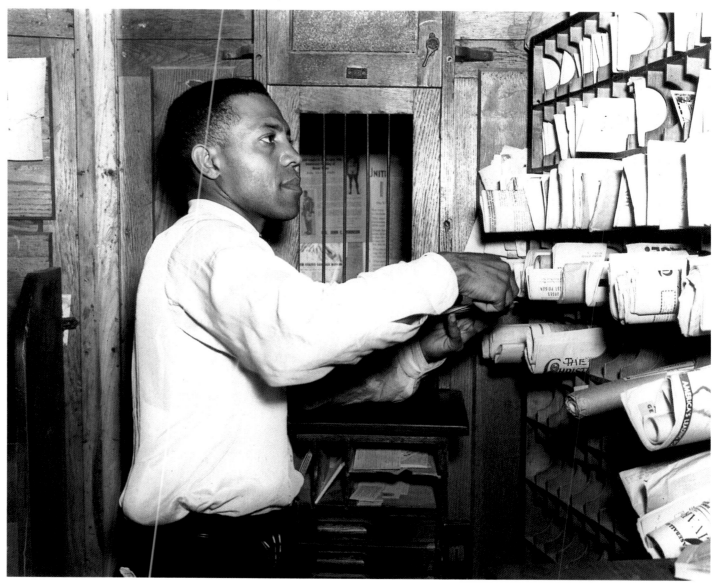

172

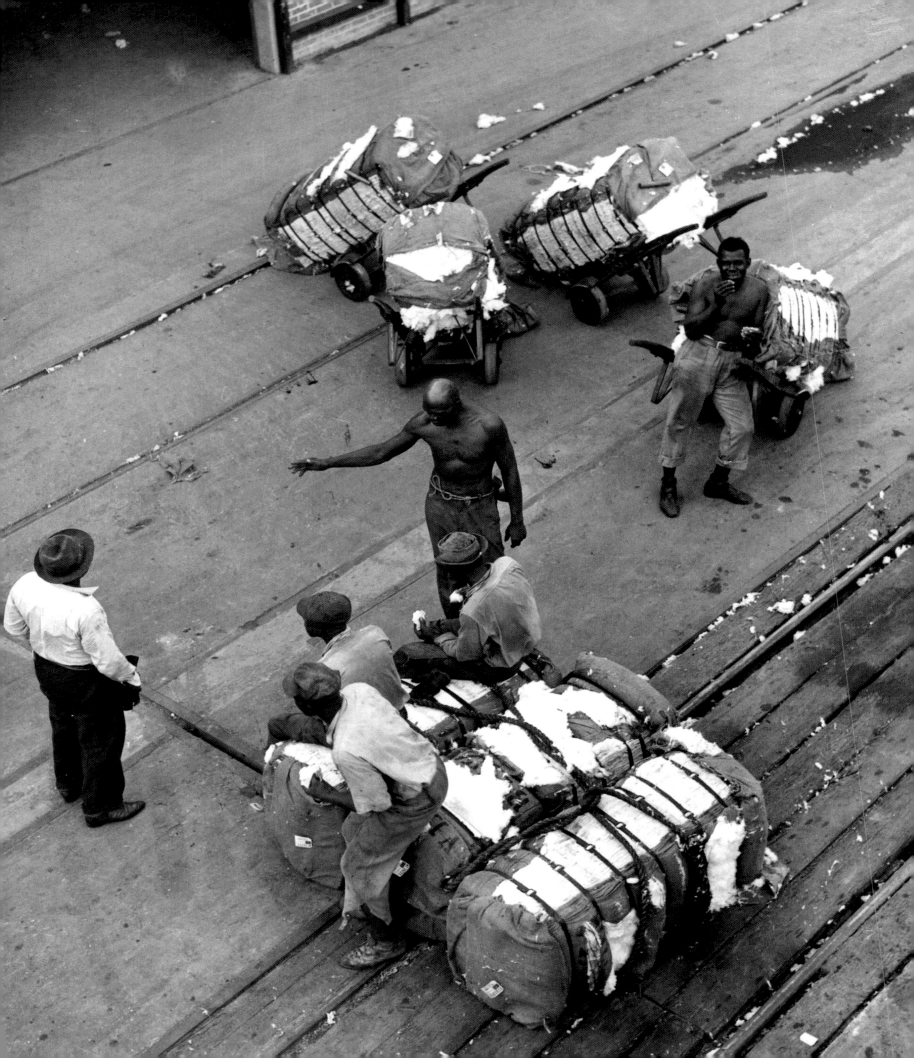

173. Longshoremen on the cotton docks, Houston, Texas, October 1939. There were prominent incidents of black labor militancy among longshoremen along the Gulf Coast of Texas and Louisiana in the early twentieth century. In New Orleans in 1907–8, for example, thousands of black and white dock workers and teamsters joined together to win a major strike. However, legal racial segregation had a powerful effect in dividing workers, and by the 1930s African Americans were almost completely excluded from the better paid blue-collar jobs.

174. Richmond Barthé and Jacob Lawrence registering at the Contemporary Negro Art Exhibition, Baltimore, Maryland, 1939. Barthé and Lawrence were two African American artists who portrayed black workers through their art, and whose work came to define the black aesthetic in the 1940s. Born in Mississippi in 1901, Barthé's first important sculpture exhibition occurred in Chicago in 1927, and in 1935 the Whitney Museum of American Art in New York purchased several of his pieces. Born in 1917, Lawrence emerged in his early twenties as a brilliant and challenging artist. His politics were directly expressed in his paintings, such as the "Harlem Series," "The Migration Series," and "The South Series," which dramatized African American history.

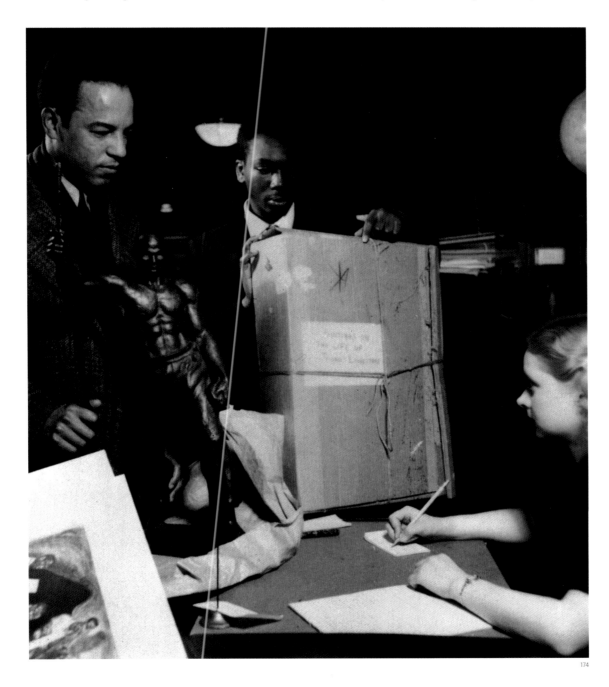

174

175. Beauty parlor, Washington, D. C., 1939. Legal segregation had the ironic effect of creating the necessary space for the development of black businesses and social institutions. Beauty salons, like barber shops, were sites of both economic enterprise and community interaction for African Americans.

176. Journalists leaving to report on World War II, 1939–40. During the first half of the twentieth century, many African Americans acquired most of their information of world events as they related to black interests through African American newspapers. By the early 1940s, major black-owned publications such as the *New York Amsterdam News* from Harlem, *The Pittsburgh Courier*, and *The Chicago Defender* each reached hundreds of thousands of readers every week. Most white newspapers and radio stations drew a rigid color line excluding blacks from virtually all occupations.

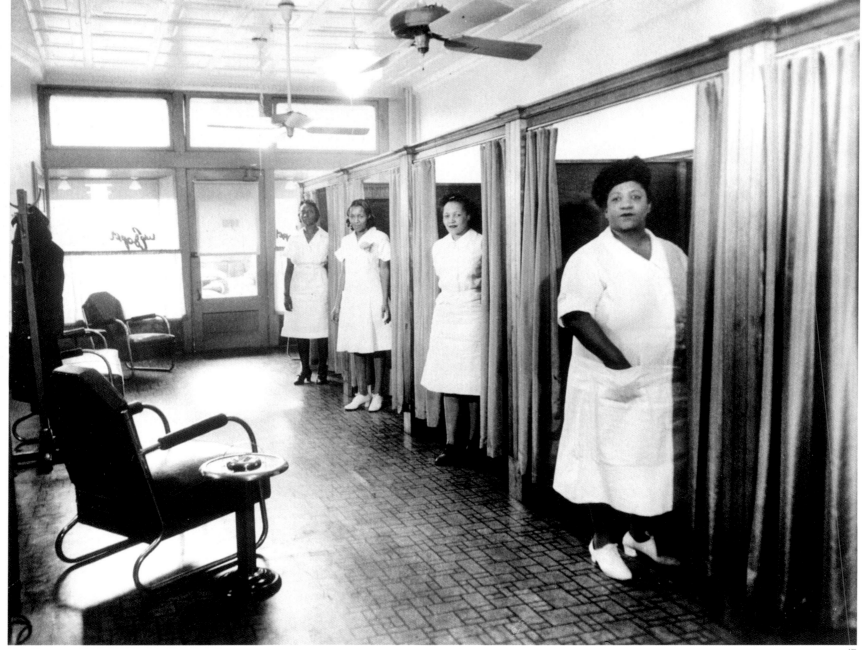

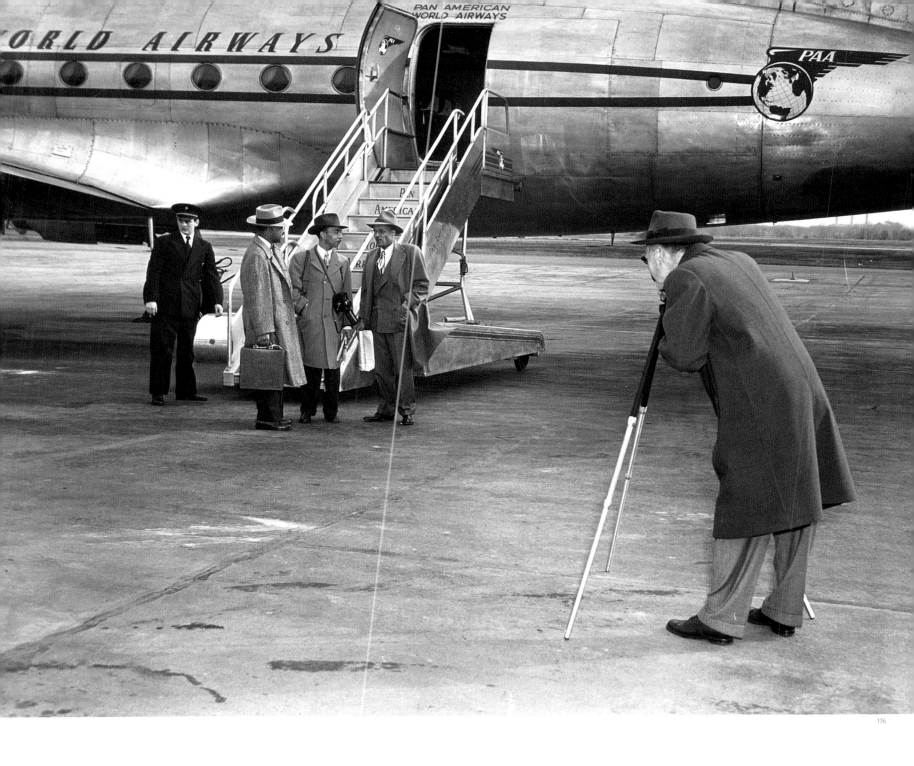

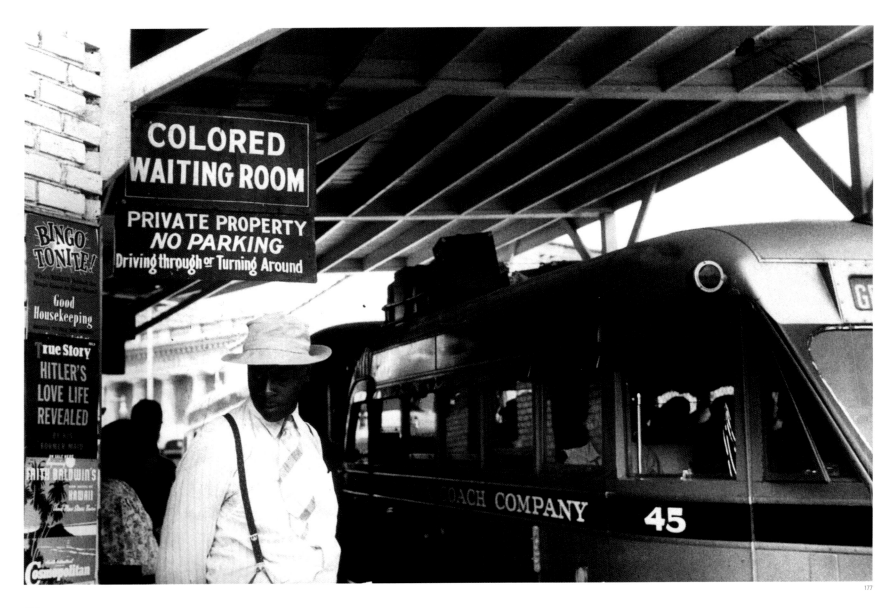

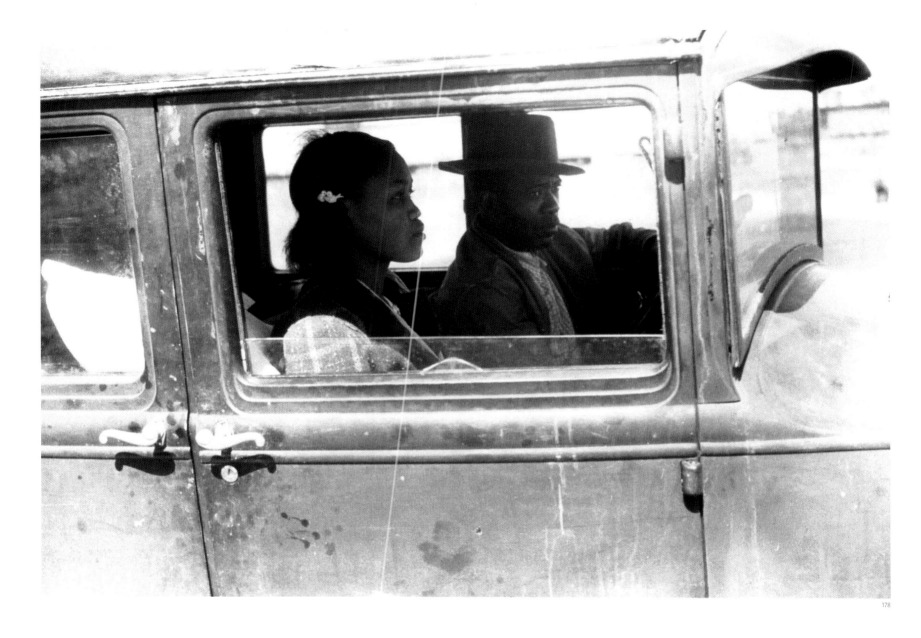

178

177. Bus station, Durham, North Carolina, May 1940. Jim Crow conditions existed in every aspect of public transportation throughout the South in the 1940s. Signs designating segregation were a constant reminder to African Americans of their second class status, even as they traveled abroad to fight for democracy during World War II.

178. Agricultural migrant workers from Florida at Little Creek, the Norfolk end of the Norfolk–Cape Charles ferry, Virginia, July 1940. The New Deal's agricultural policies had the effect of dispossessing hundreds of thousands of black tenant farmers who traveled to areas where the demand for agricultural labor was high; but many ultimately migrated to urban areas.

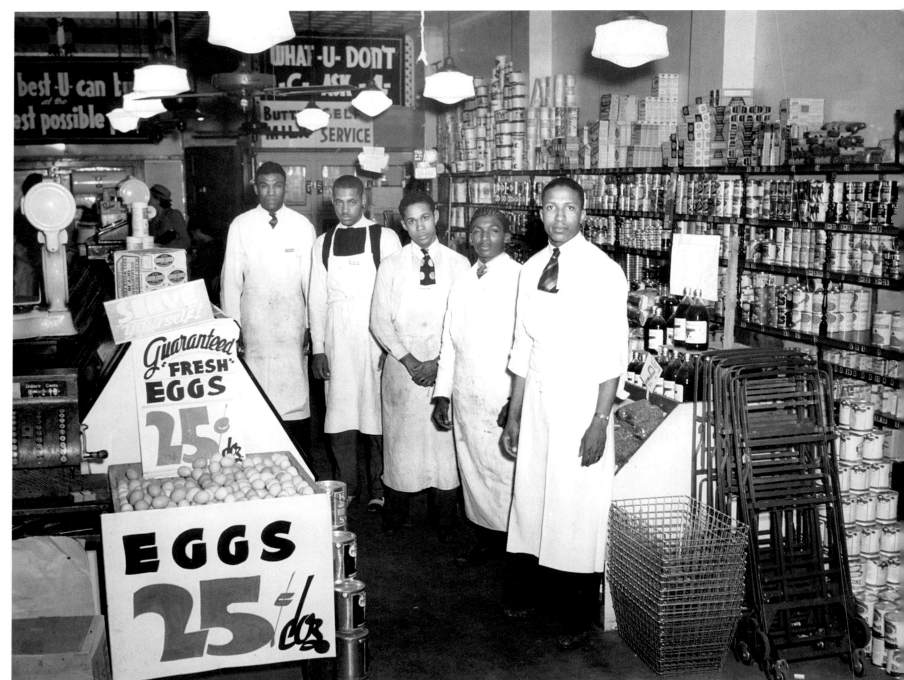

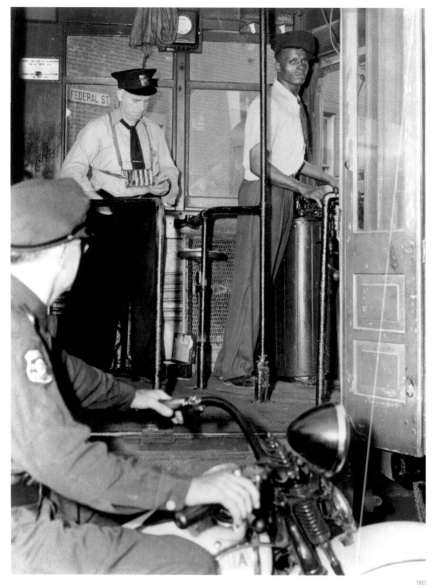

180

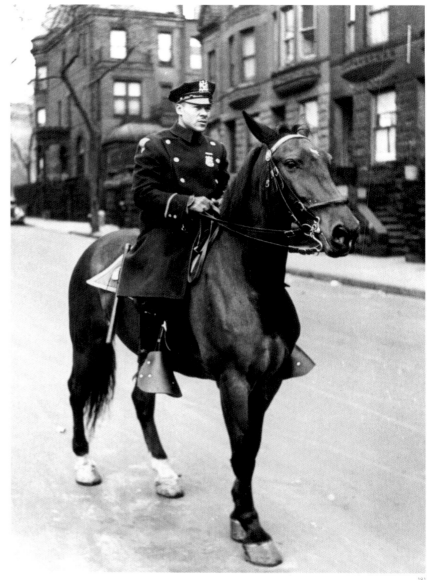

181

179. Grocery store above U Street, Washington, D. C., 1940. Local struggles in urban centers, organized around the concept "Don't Buy Where You Can't Work," often proved successful in generating employment for African Americans. White-owned establishments in all-black neighborhoods increasingly hired blacks to work with customers, although most were reluctant to advance blacks to supervisory positions.

180. First African American streetcar driver under police escort, Philadelphia, c. 1944. During the 1940s some African American men gained positions that had previously been defined as white-only. In several cities, white skilled workers staged "hate strikes" or "sick outs" to protest the employment of African Americans in previously all-white positions.

181. A mounted New York City police officer, 1940.

182. Member of the
Commandment Keepers in
Harlem, New York City, 1940.
In the mid-1920s, several
leaders of Marcus Garvey's
Universal Negro Improvement
Association advocated the
adoption of Judaism as the
"true" religion of black people.
In 1919, West African
immigrant Wentworth Arthur
Matthew founded the first
black Jewish congregation,
the Commandment Keepers,
in Harlem. In 1930, Rabbi
Matthew created the Royal
Order of Ethiopian Hebrews,
the precursor to the Black
Hebrew movement.
By the end of the twentieth
century 100,000 to 130,000
African Americans had
become converts to Judaism.

183. Working class neighbor-
hood, Pittsburgh, Pennsylvania,
January 1941. In the 1940s,
1.6 million African Americans
migrated to the Northeast,
Midwest, and, for the first
time, to the West Coast. As
blacks left the South for
the northern industrial areas,
they were able to considerably
improve their standard of
living through industrial and
manufacturing positions.

Despite frequently being sub-
jected to rigid residential
segregation and occupational
discrimination, the quality
of most black people's lives
improved dramatically.

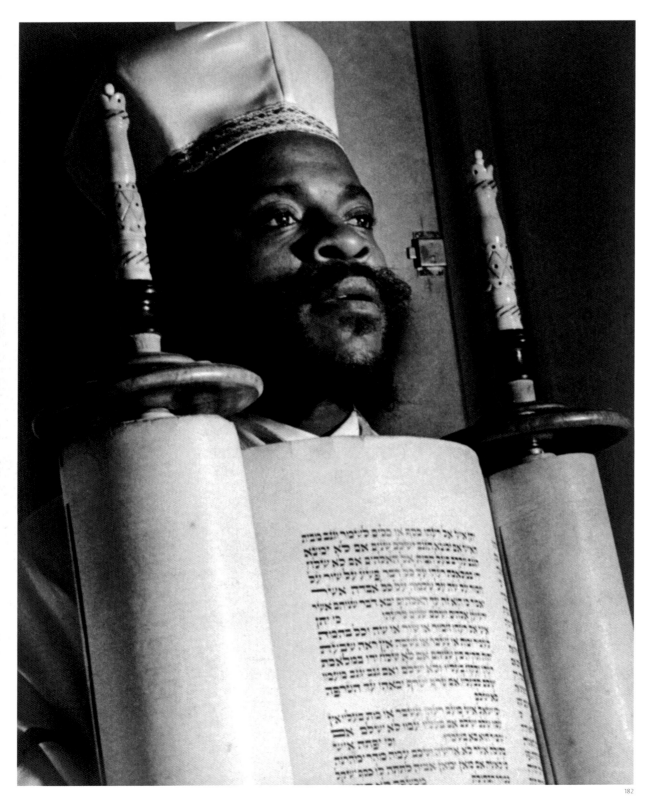

182

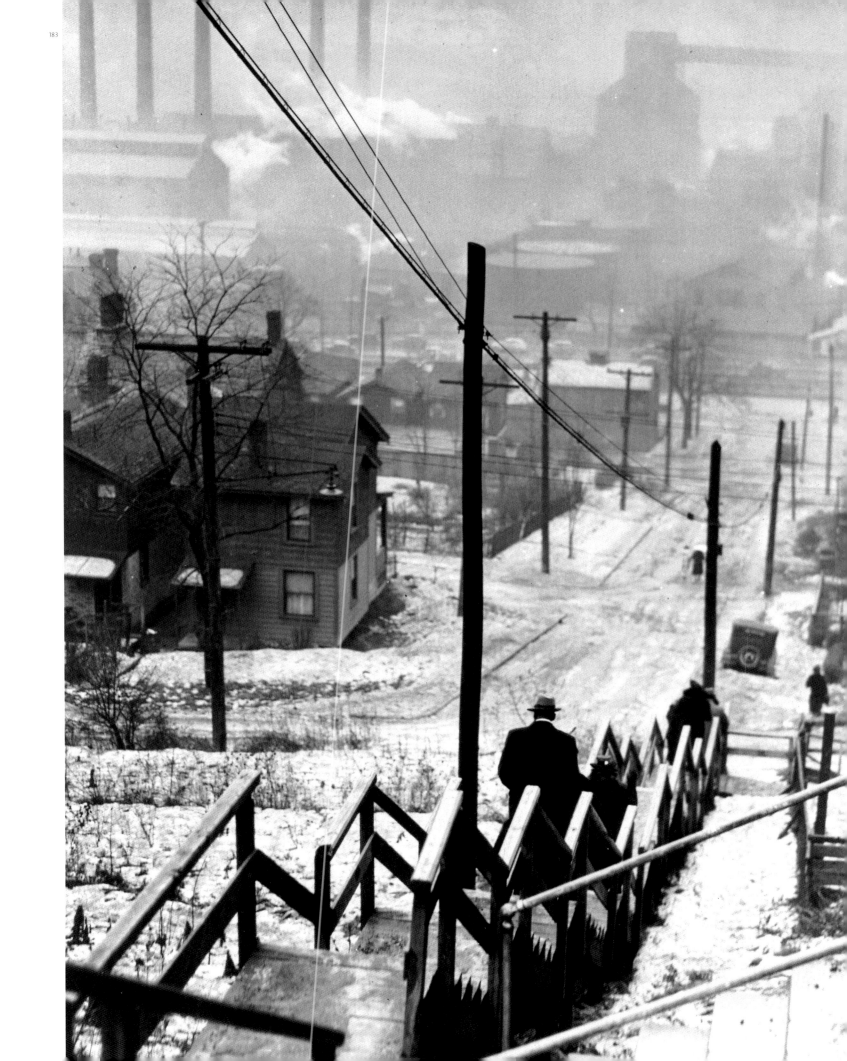

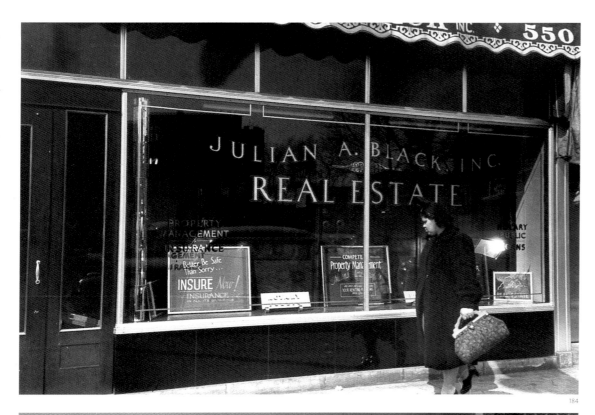

184

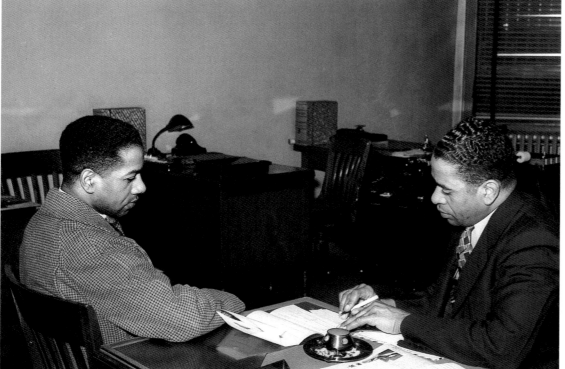

185

184–185. Real estate offices, Chicago, April 1941. Though Harlem in New York City has come to symbolize the black metropolis, black communities in Chicago more closely reflect the dynamics of the construction of twentieth-century black working-class life and culture. In the early 1900s, two thirds of all black men and over 80 percent of all black women in Chicago were employed in the domestic and services sectors. By the 1940s, the majority of black men were employed in blue-collar manufacturing and industrial jobs. For decades Chicago was the most racially segregated city in the United States, more so than any southern town. The extreme residential segregation of most northern cities created racially defined consumer markets, which in turn contributed to the flourishing of black-owned business enterprises.

186. Linotype operators of *The Chicago Defender*, Chicago, April 1941. *The Chicago Defender* was one of the most influential African American newspapers in the United States during the twentieth century. Founded by Robert S. Abbott in 1905, the newspaper championed civil rights and encouraged African Americans in the South to migrate to the North. By 1947 *The Chicago Defender*'s local circulation exceeded 60,000, and it had 131,000 subscribers nationwide.

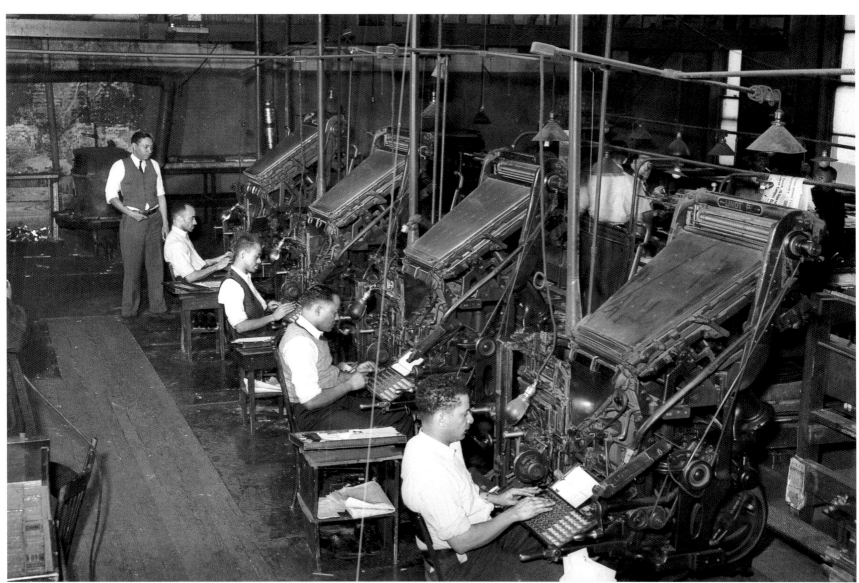

186

187. Lily vendors on Easter Sunday, Chicago, April 1941.

188. Church meeting in Heard county, Georgia, April 1941.

189. Service at a "storefront" Baptist church on Easter Sunday, Chicago's South Side, April 1941. Religious life among African Americans sometimes reflected the emerging class stratification. Storefront churches usually catered to working class populations and recent immigrants and incorporated the more expressive aspects of southern religious life.

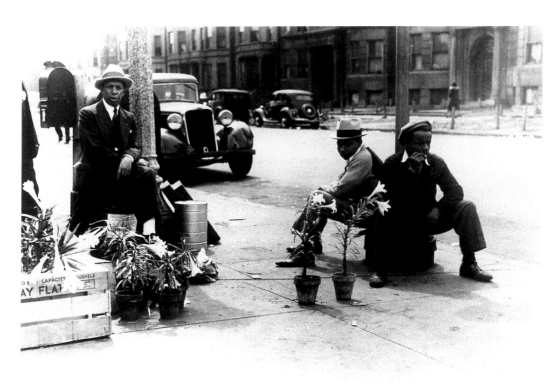

187

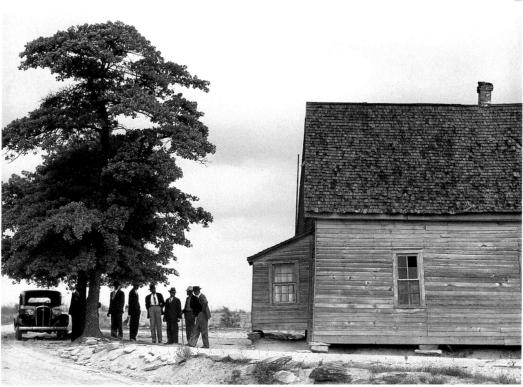

188

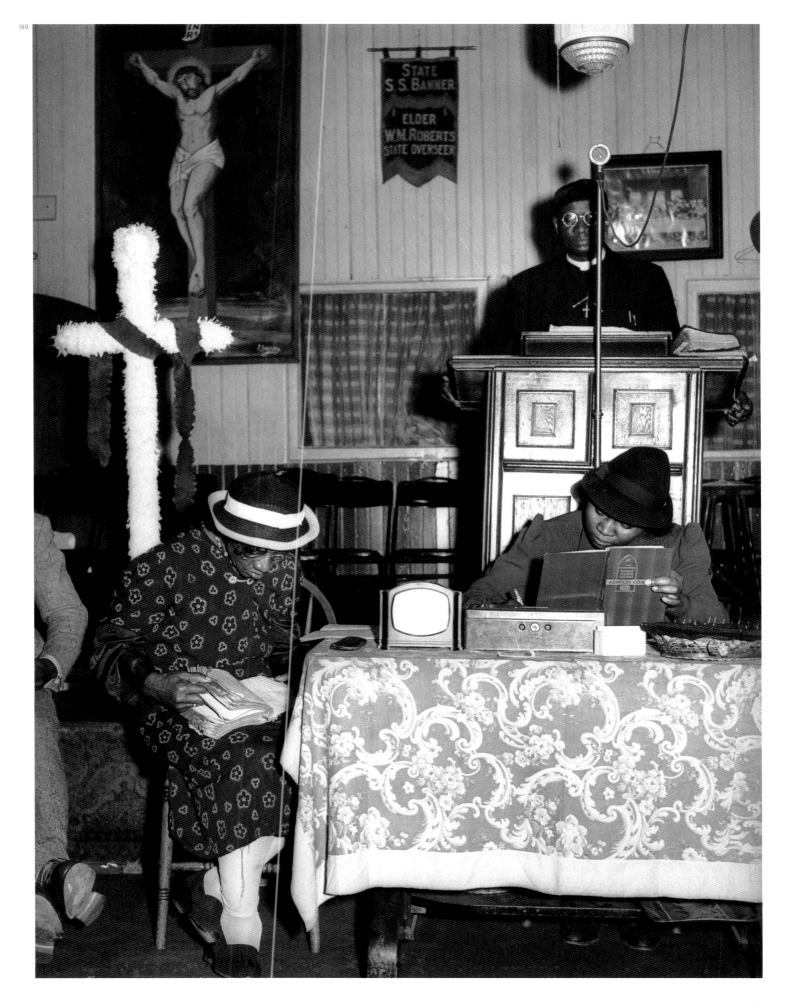

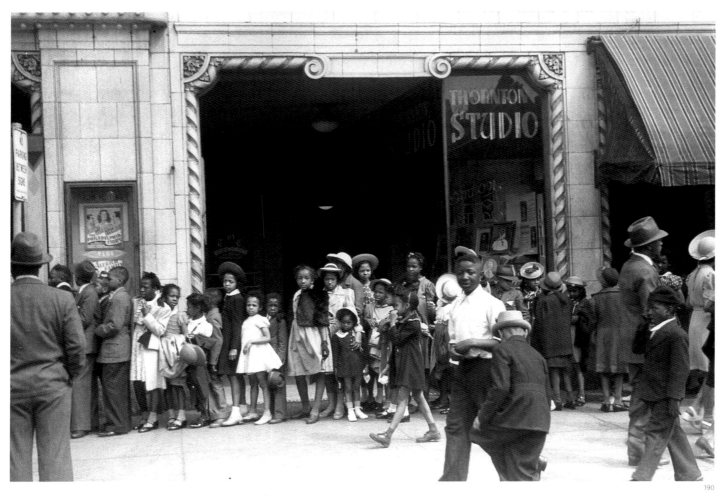

190

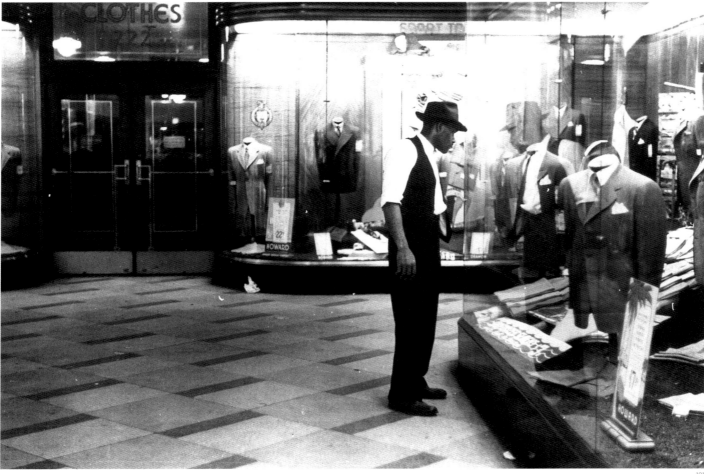

191

190. Children lining up in front of a movie theater for the Easter Sunday matinee, Chicago, April 1941.

190. Children lining up in front of a movie theater for the Easter Sunday matinee, Chicago, April 1941.

191. Window shopping, Chicago, July 1941.

192. Tavern, Chicago, April 1941.

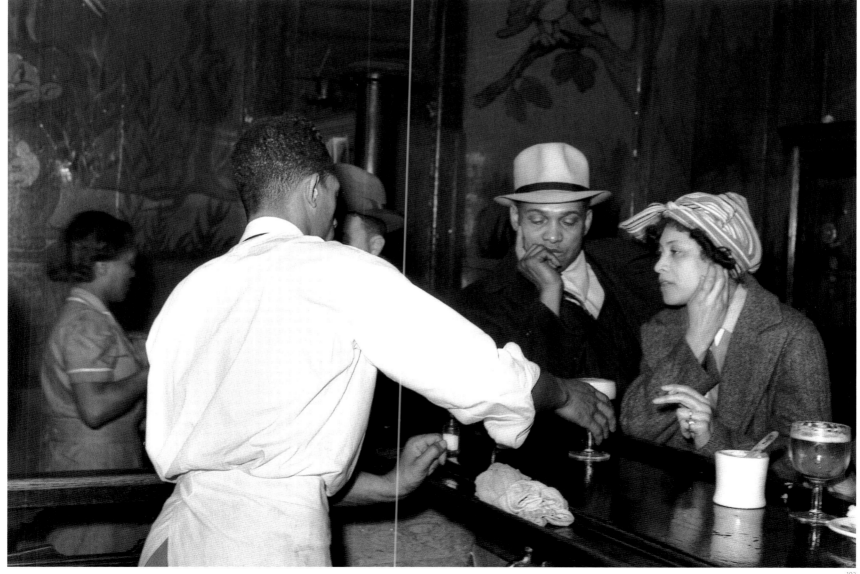

192

193. United Automobile Workers (UAW) organizers at the Ford Motor Company in Detroit, 1941. With the establishment of the Congress of Industrial Organizations (CIO) in the 1930s, tens of thousands of African Americans were allowed into the ranks of organized labor for the first time. During World War II, African Americans entered the UAW union and a number of other progressive and liberal unions. In contrast to the American Federation of Labor (AFL), which included unions that explicitly excluded blacks from membership, the CIO created the Committee to Abolish Discrimination and promoted black and white solidarity among workers. Communists and other leftist organizers in the CIO were largely responsible for popularizing the point of view that racism functioned to destroy working class unity.

194. Leon Bates handing out copies of the UAW newspaper outside the Ford River Rouge Factory, Detroit, 1941. In 1940–41 the UAW attempted to unionize the labor force of the Ford Motor Company in Detroit. A number of black auto workers who had been fired for union activity were hired by the UAW as paid organizers, and racially integrated workers' committees were formed. When a strike started on 1 April 1941, nearly all of Ford's 17,000 black workers honored the picket line, while the NAACP used its influence to convince blacks who had crossed the picket line to reverse their decision and leave the plant. On 11 April 1941, Ford admitted defeat and the UAW was soon recognized as the official bargaining agent for its auto workers. This victory helped to create an important alliance between civil rights organizations and the labor movement.

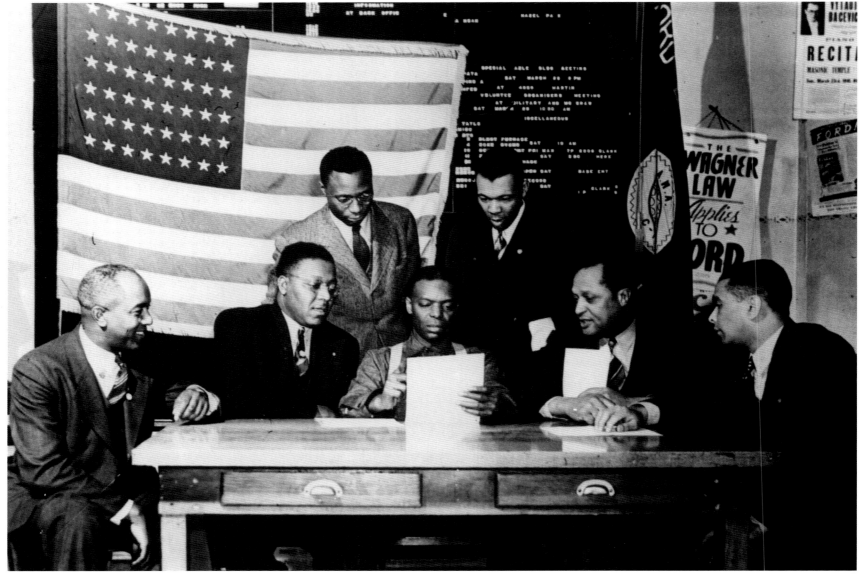

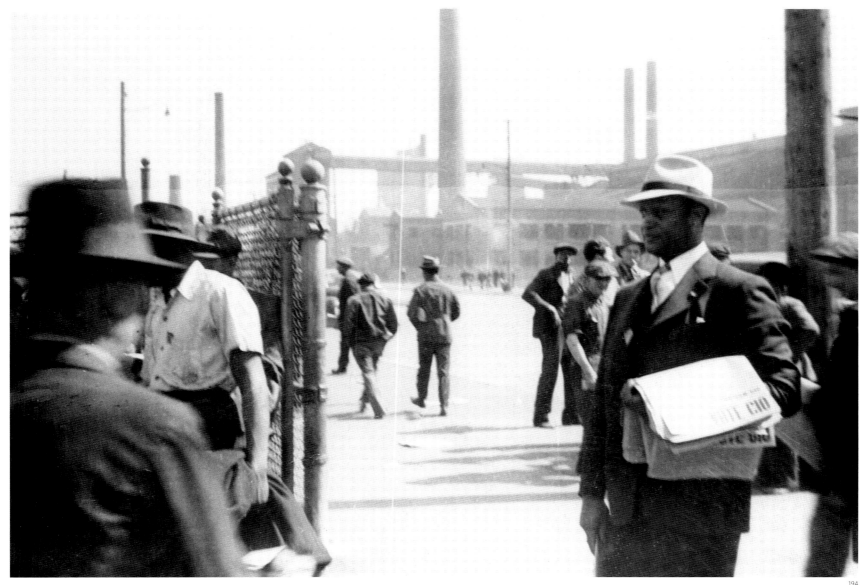

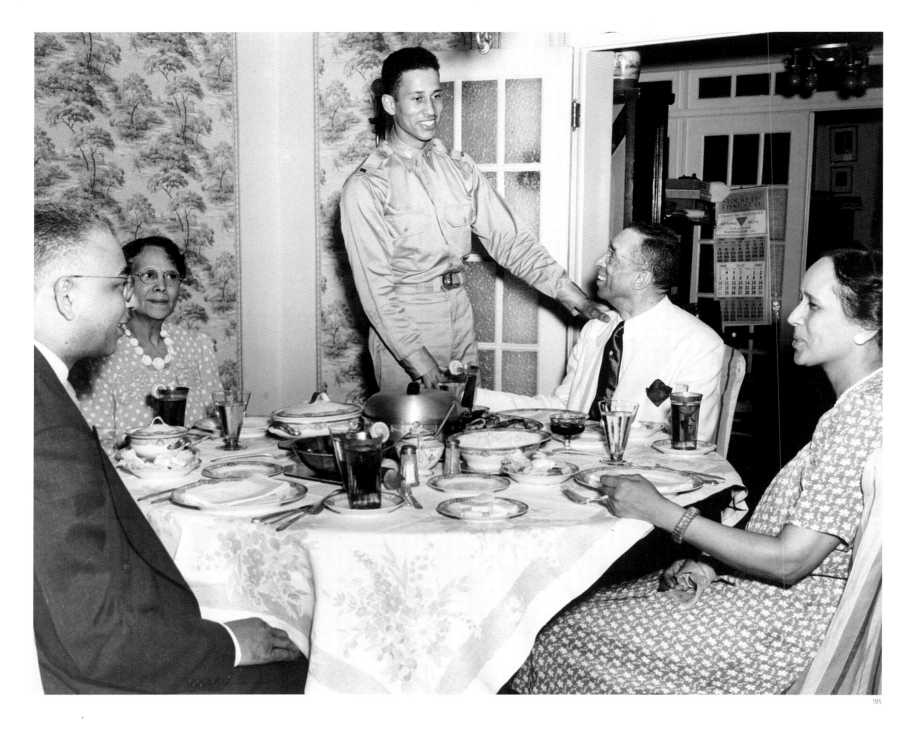

195. Emery Smith's graduation day from Howard University, Washington, D. C., June 1941. On this same day Smith left for the war. By World War II, Howard University had established itself as "the capstone of Negro education." For most of the twentieth century, this university was largely responsible for producing a significant percentage of black professionals.

Even as late as 1980, one fourth of all black attorneys and more than half of all black architects and engineers in the United States were graduates of Howard University. A number of Howard graduates served with distinction during World War II.

196. Members of the Civilian Conservation Corps (CCC) putting up a fence in Greene county, Georgia, May 1941. Initiated by the Roosevelt Administration in 1933, the CCC employed approximately 200,000 African Americans who worked in strictly segregated units.

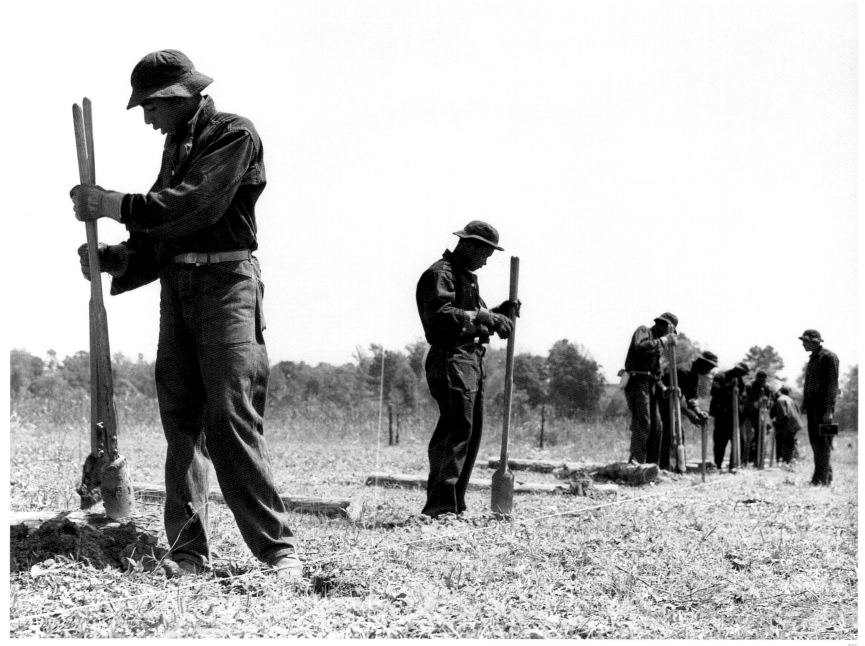

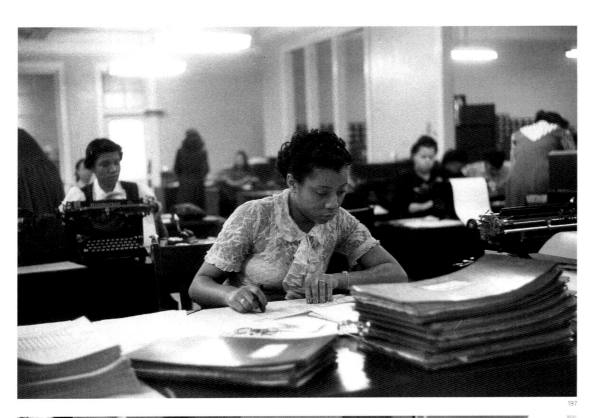

197

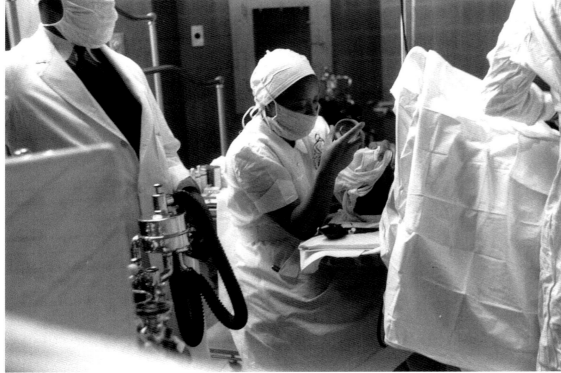

198

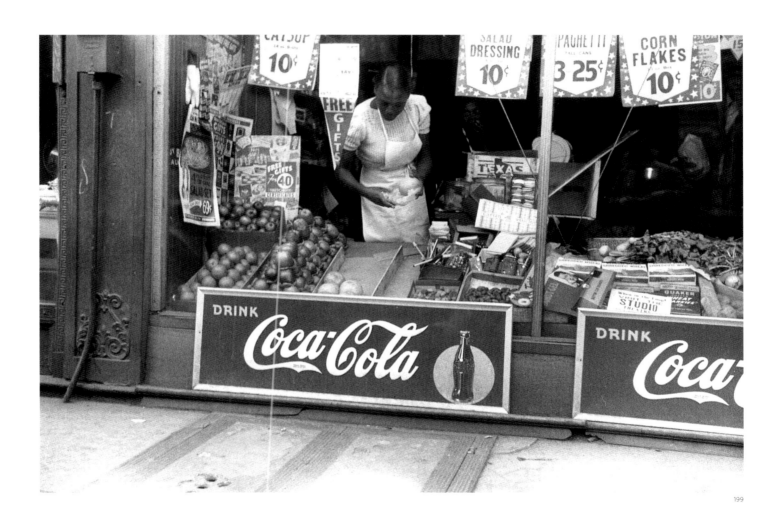

199

197. Insurance company, Chicago, July 1941.

198. Hernia operation at Provident Hospital, Chicago, July 1941. Provident Hospital was one of the major hospitals in the United States with black physicians and medical staff providing health care to the African American community.

199. Grocery store, Chicago, July 1941.

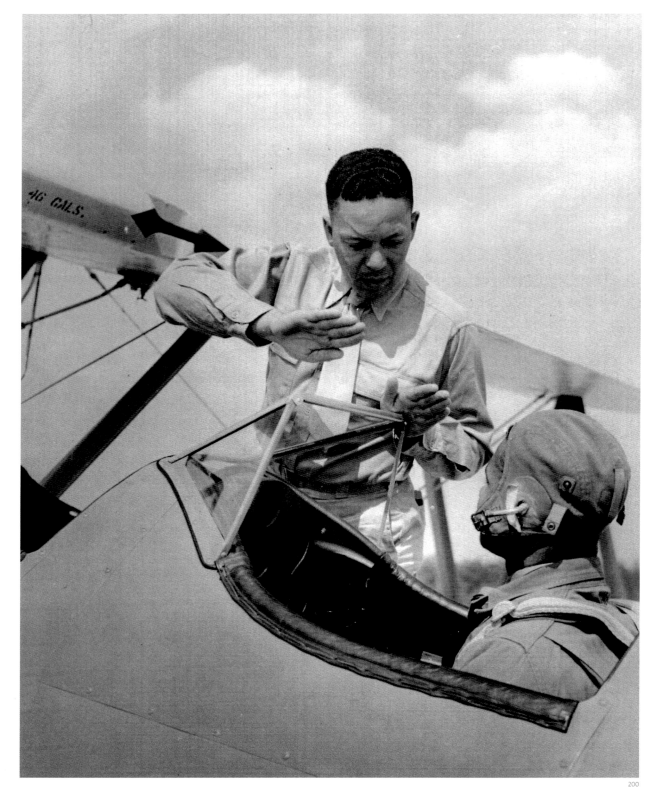

200. Instructor pilot discussing
maneuvers with a student
at Tuskegee Army Air Field,
Alabama, November 1941.
The Tuskegee Army Air Field
was established in July 1941
as the result of a federal
plan initiated in 1940 to create
an aviation school for
African American pilots.

201. Aviation cadets, instruc-
tors, and enlisted men from
the 99th Pursuit Squadron
attending a commander's
call at Tuskegee Army Air Field,
1942. The 99th Pursuit
Squadron, an all-black fighter
unit known as the Tuskegee
Airmen, began training at
Tusgekee Army Air Field in
November 1941. The squadron
was stationed in North
Africa in 1943, from where it

flew bomber-escort, dive-
bombing, and strafing
missions in Europe.

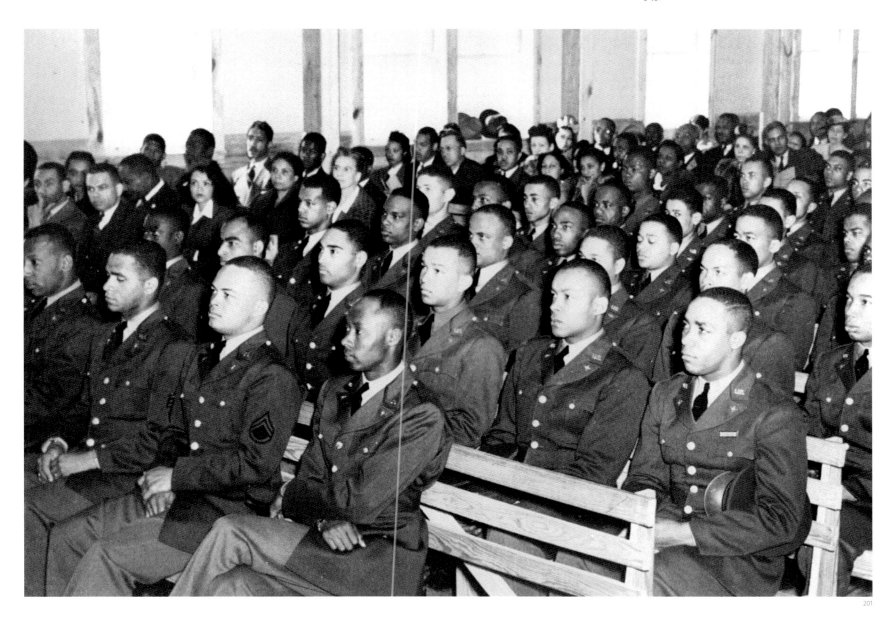

201

202–204. Riot at the Sojourner Truth Housing Project, Detroit, February 1942. The United Automobile Workers' Committee to Abolish Racial Discrimination pressured Detroit officials to establish affordable and accessible housing for workers regardless of race. As a result, the Detroit Housing Commission approved the construction of two major housing projects in June 1941 with the stipulation that one be located in a white area and the other in a black area. However, in an effort to promote integrated housing, the federal government selected a location adjacent to an all-white community for the black project. When the Sojourner Truth Housing Project, named after the renowned nineteenth-century abolitionist, was completed in early 1942, mobs of angry white workers and local residents blocked African Americans from occupying the finished homes. At one point, on 28 February, the crowd reached over 1,200 whites, many of whom were armed. One vice-president of the organization who attempted to block African American residents at the Sojourner Truth project was a UAW member, but after some ambivalence the union supported the principle of integrated housing and publicly opposed the vigilante violence against black home-owners. Finally, in late April 1942, black families moved into the project.

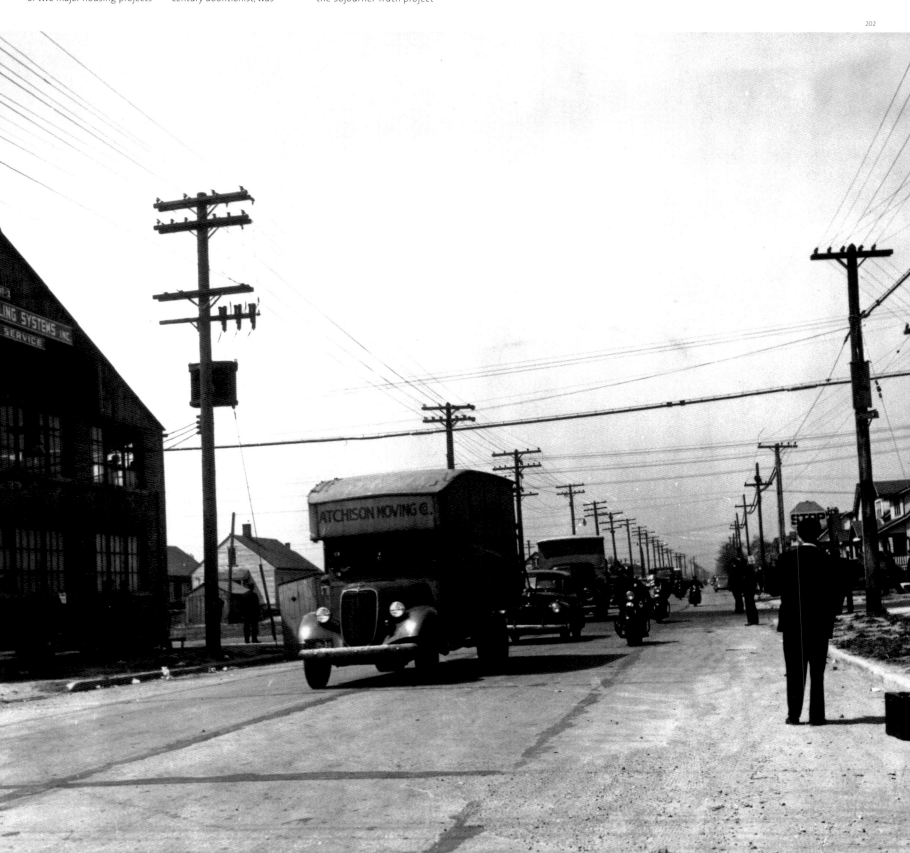

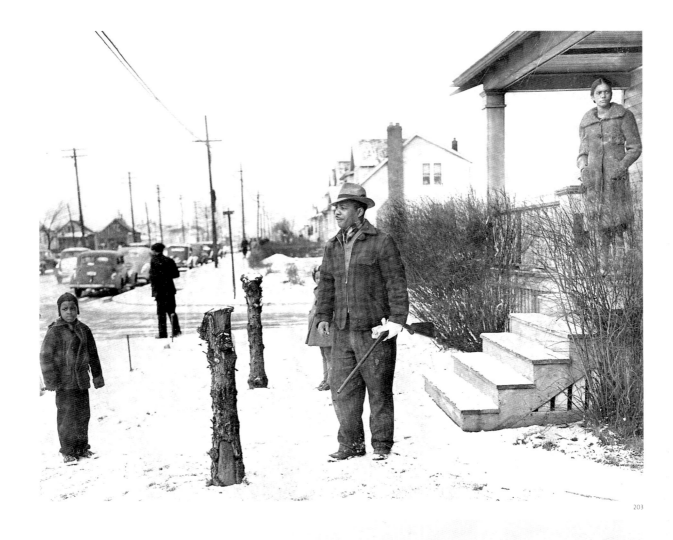

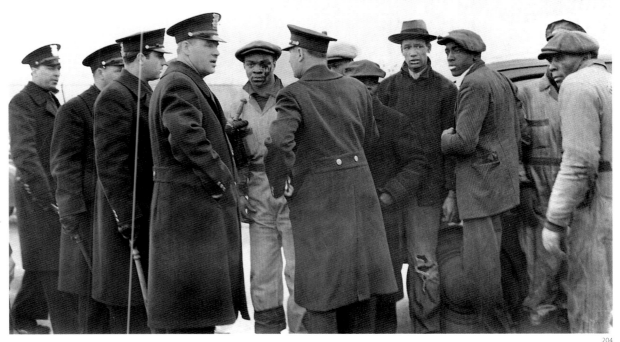

205. Steelworkers at a union meeting at Good Shepard community center, Chicago, March 1942. When steel mills and heavy industrial plants were constructed in the Chicago area after World War I, African Americans were at first relegated to the most menial and dangerous occupations. But the emergence of the United Steelworkers Union in 1936 led to genuine efforts to build solidarity between black and white labor.

206. Pullman porter aboard the Capitol Limited bound for Chicago from Washington, D. C., March 1942.

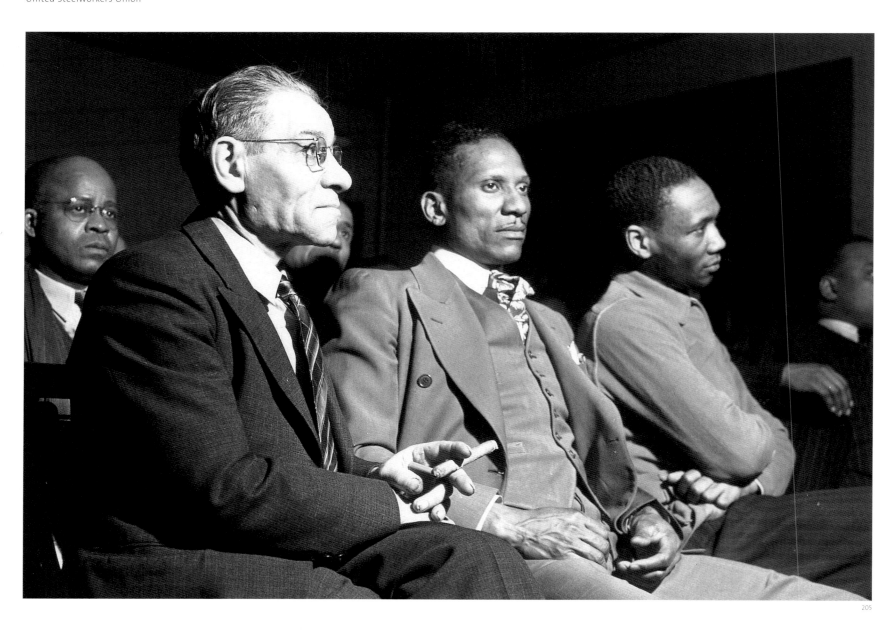

205

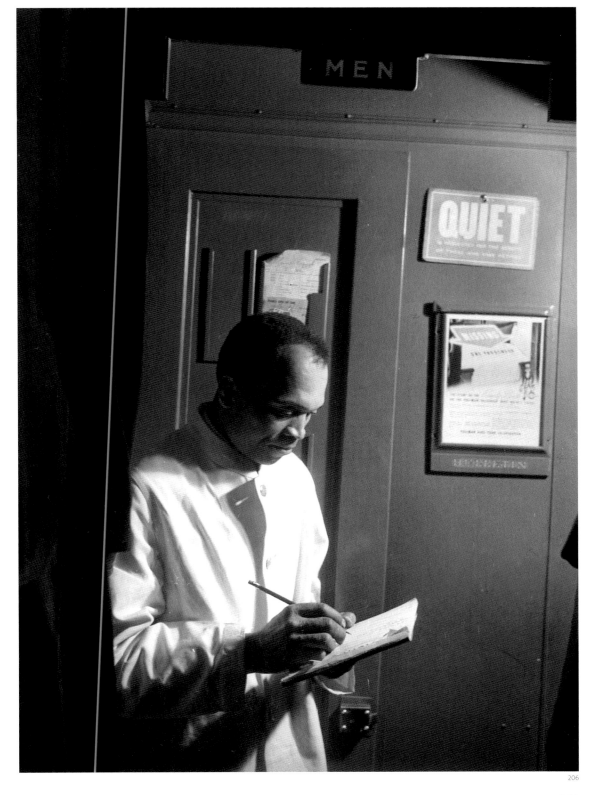

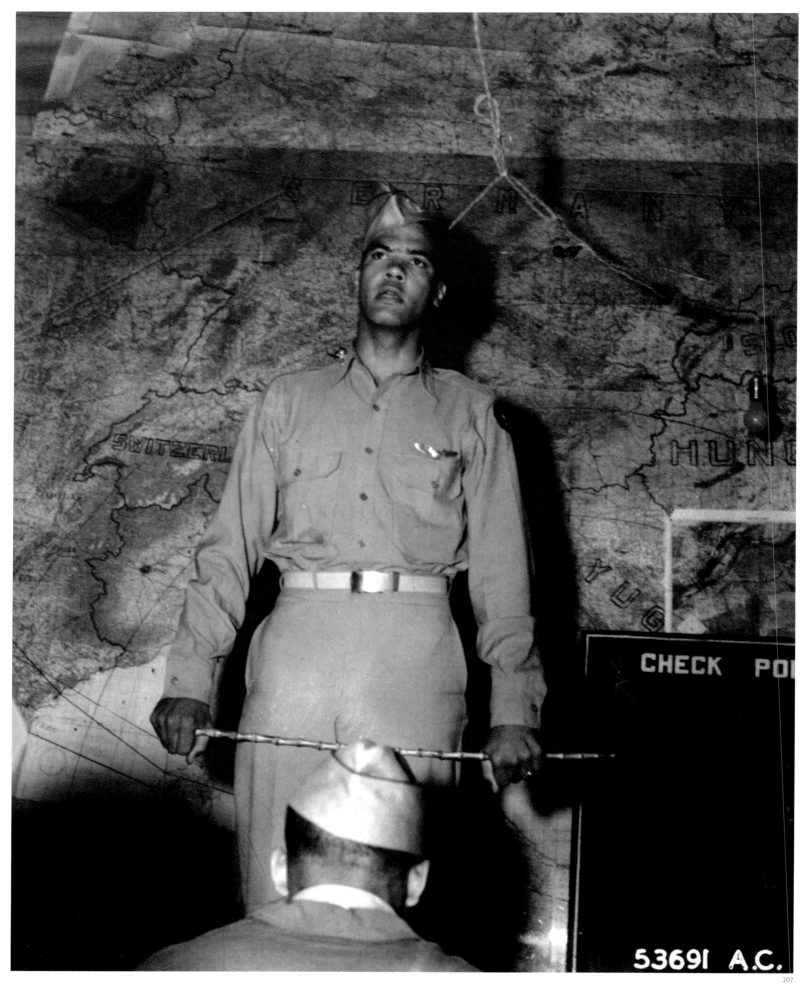

53691 A.C.

207. Colonel Benjamin O. Davis, Jr., commanding officer of the 332nd Fighter Group, briefing aircrews prior to a bomber-escort mission, location unknown, c. 1943–44. Benjamin O. Davis, Jr. graduated from West Point Military Academy in 1936 and earned his wings six years later as an Army Air Corps pilot. During World War II he first commanded the 99th Pursuit Squadron (Tuskegee Airmen) and sub-sequently led the celebrated 332nd Fighter Group. In these two units 82 pilots, including Davis, won the Distinguished Flying Cross. In 1954 Davis was promoted to the rank of Brigadier General, becoming the first African American general in the U. S. Air Force.

208. Red Cross worker, location unkown, c. 1941–45. During World War I, African American nurses were largely excluded from the Red Cross, an auxiliary of the U. S. Army Nurse Corps. Two decades later, however, a somewhat more enlightened policy was implemented and by 1945 there were over 9,000 black registered nurses in the U. S. Army, some of whom were assigned to serve on several European battlefronts. Racial quotas restricting the number of black nurses in the army were not abolished until January 1945, however, and the Navy Nurse Corps appointed its first black registered nurse only in February 1945. The nursing profession became a significant vehicle for mobility for African American women.

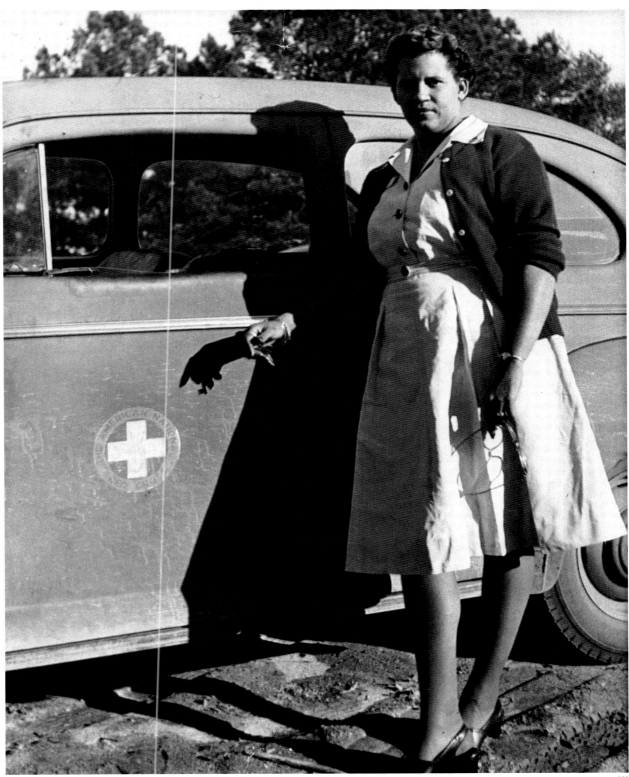

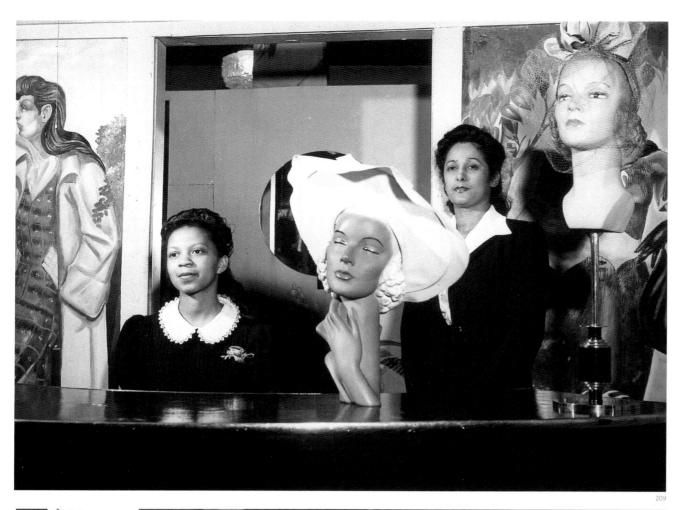

209

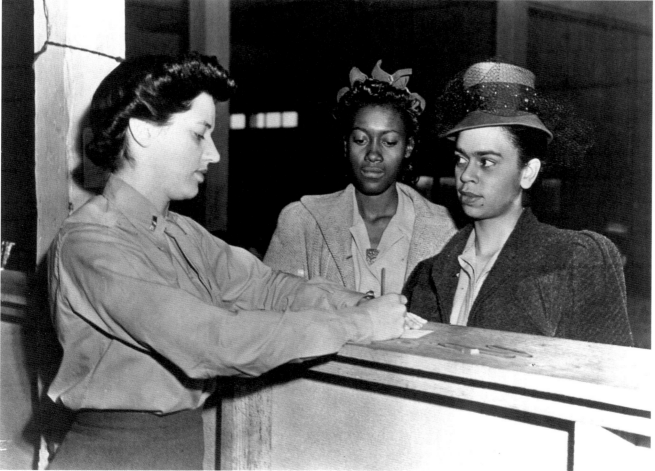

210

209. Clerk (left) and manager (right) of the Cecilian specialty hat shop, 454 East 47th Street, Chicago, April 1942.

210. Checking in for membership in the Women's Army Auxiliary Corps (WAAC), 1942. The WAAC was established in May 1942, and was integrated into the U. S. Army the following year under the name Women's Army Corps (WAC). Eight-hundred black women served in the WAC 688th Central Postal Battalion in England during World War II.

211. Worker in a gas mask factory, Edgewood arsenal, Maryland, June 1942. During the war, African American women moved into manufacturing jobs that had previously been for men only.

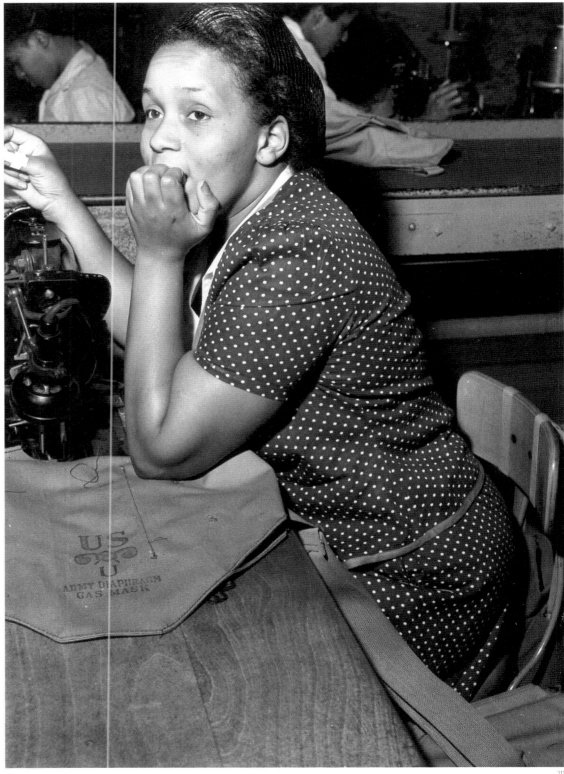

211

212. Lieutenant General Barton K. Young greeting Secretary of War Henry L. Stimson upon his arrival at Tuskegee Army Air Field, Alabama, February 1943. The photograph includes Colonel Benjamin O. Davis (left) although Stimson did not meet Davis during his visit to Tuskegee. The Pentagon ordered Davis' image to be subsequently superimposed onto the photograph.

213. Paul Robeson leading workers in the national anthem at the Oakland docks, California, September 1942. Robeson was one of the most celebrated and widely admired African American leaders during World War II. He lived and worked largely in Europe in the 1930s, where he had better access to opportunities as an actor and singer. He supported trade union activism and campaigned for Third World independence, and in 1938 he traveled to Spain to defend the Spanish Republic in its unsuccessful war against fascism. Returning to the United States in 1939, Robeson became deeply involved in advocating civil rights and trade union struggles throughout the country, which led the FBI to place him under surveillance. During World War II he used his reputation as a public figure and artist to promote interracial cooperation in the conflict against fascism. This photograph captures Robeson's vision of the potential of an integrated American society.

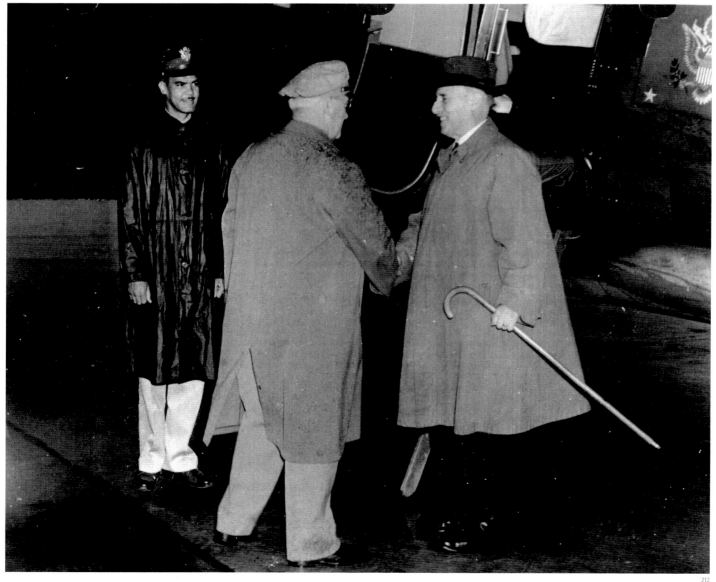

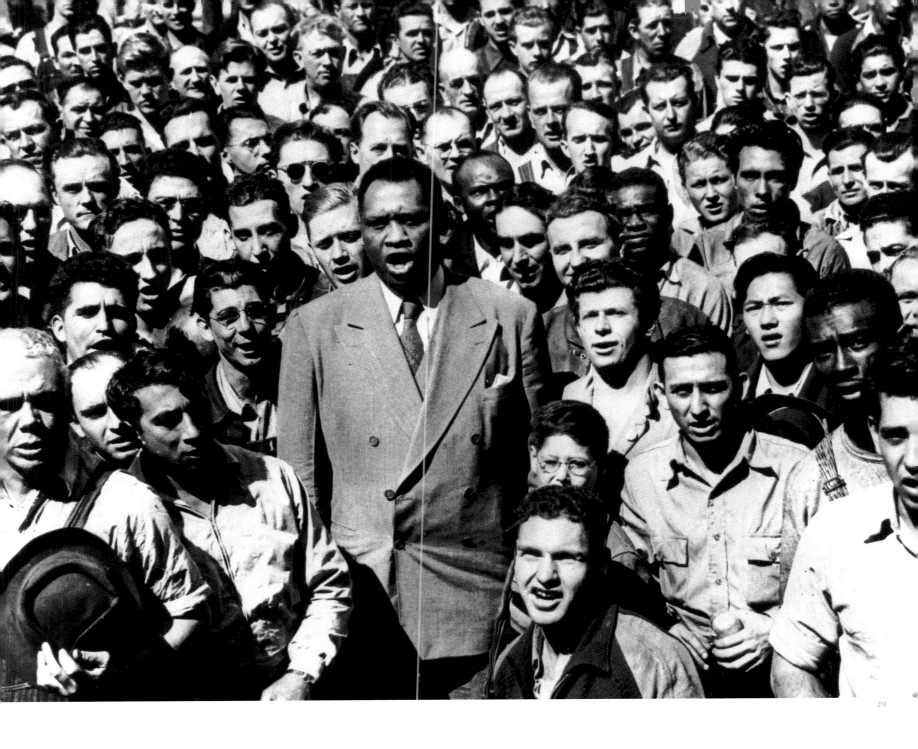

213

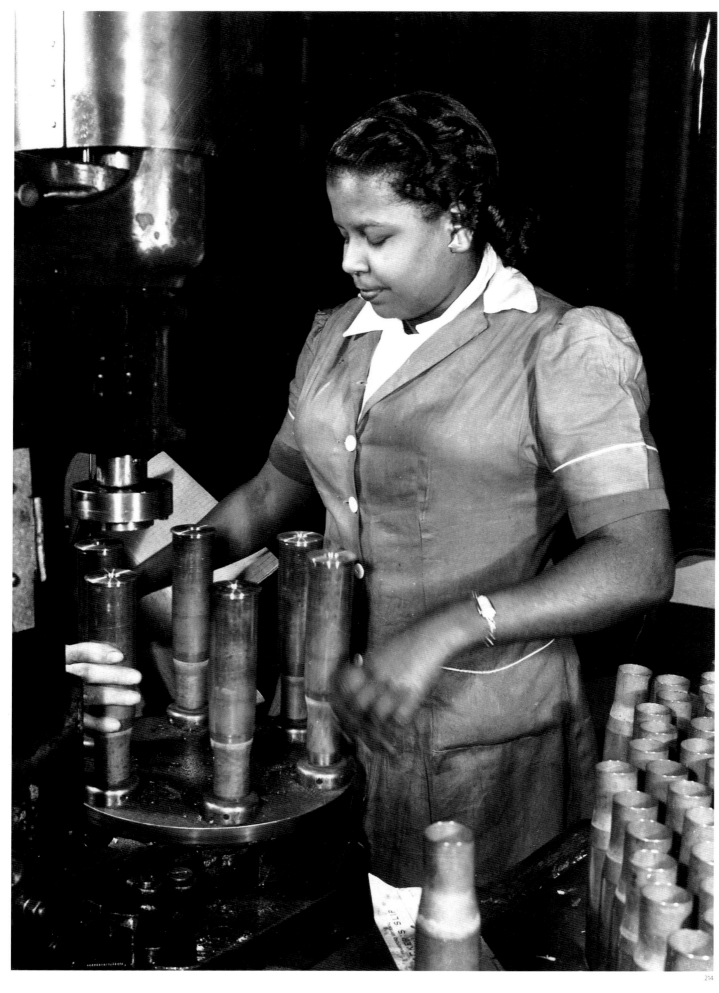

214. Woman feeding a stamp press with 37-millimeter cartridge cases at the Frankfort arsenal in Franklin county, Kentucky, January 1943.

215. Mary McLeod Bethune, Eleanor Roosevelt, and Mrs. Louis Weiss, president of the Board of Directors of the Wiltwyck School for Boys (from left to right), at the opening of a campaign to raise funds for the school, Esopus, New York, early 1940s. Mary McLeod Bethune was a famous member of Roosevelt's "black cabinet." In 1904 she founded a vocational school in Daytona Beach, Florida, which in 1923 became Bethune Cookman College. She was the founding president of the National Council of Negro Women in 1935 and director of the Negro Affairs Division of the National Youth Administration from 1939 to 1943. Bethune used her influence in the Roosevelt Administration, and especially her close friendship with First Lady Eleanor Roosevelt, to promote the desegregation of federal programs and government agencies.

216. Children's Halloween party on 12th Street, by the Scurlock studio, Washington, D. C., 1940s.

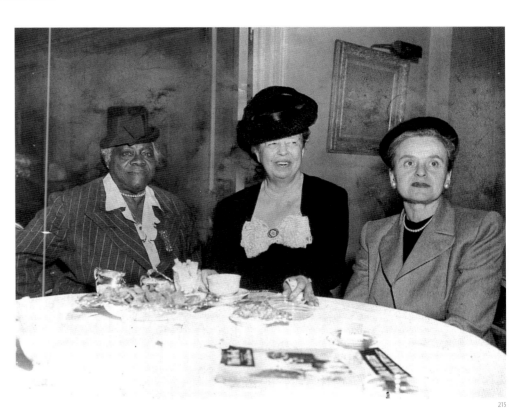
215

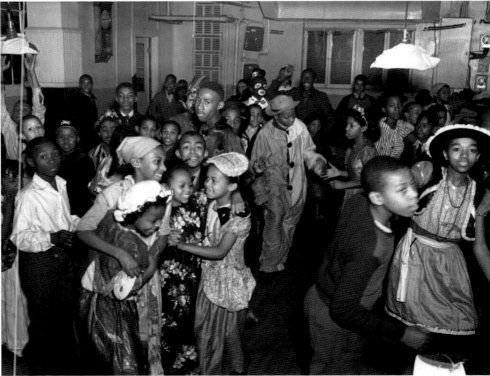
216

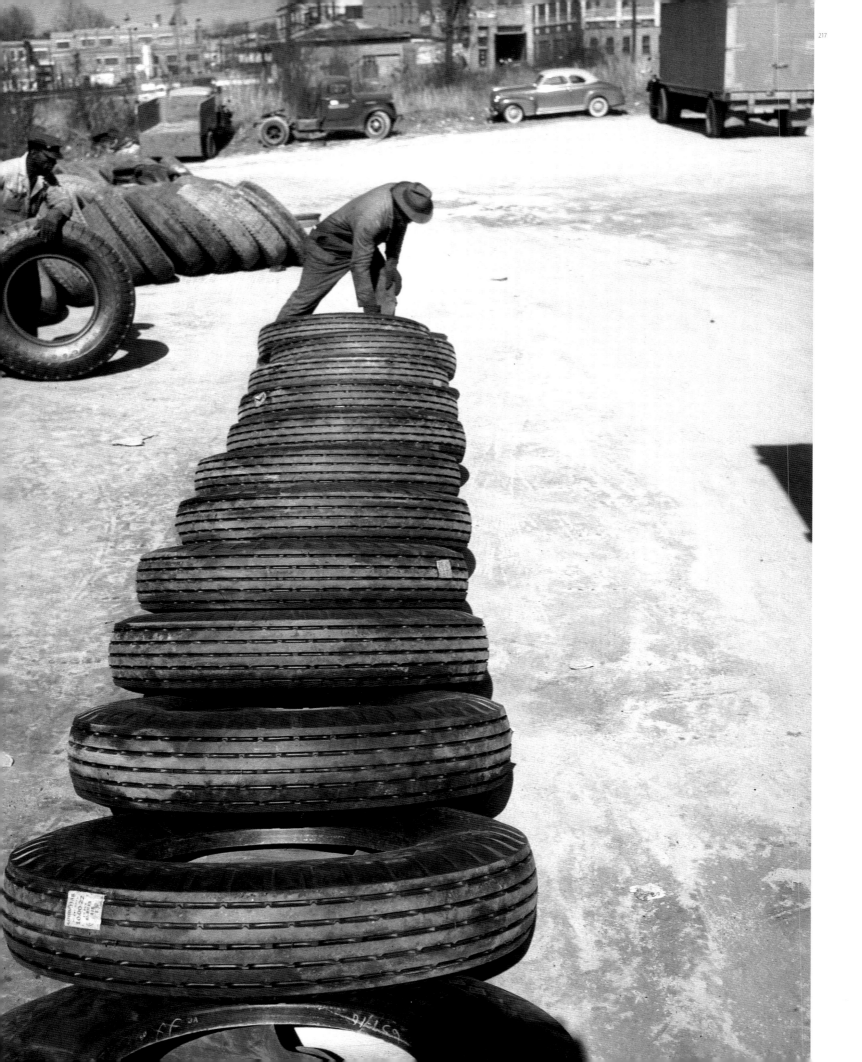

217. Associated transport company, Charlotte, North Carolina, March 1943.
Both the American Federation of Labor (AFL) and Congress of Industrial Organizations (CIO) unions grew significantly in the southern states during the war. Thousands of African American workers joined CIO unions in agriculture, shipbuilding, tobacco, packing, and other sectors, and a number of the more progressive CIO unions in the South took the unprecedented step of holding integrated local meetings of black and white workers. In 1943, because of the growth of black organized labor in the region, the CIO Industrial Union Councils in the South called for the end of whites-only primary elections and the abolition of the poll tax. Key figures in the desegregation drive were communists, socialists, and NAACP activists, many of whom were later purged from the union movement during the repressive years of McCarthyism.

218. Loading trucks, Charlotte, North Carolina, March 1943.

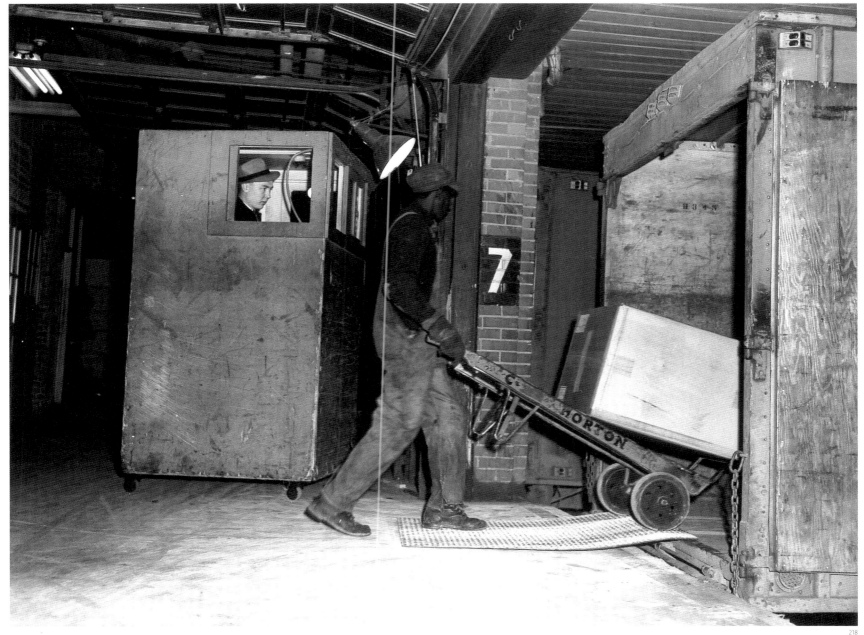

218

219. One of several women
freight handlers at the
Atchison, Topeka, and Santa
Fe freight depots in Kansas
City, Missouri, March 1943.

220. Workers on their way to
catch a conveyance for
work in the early morning,
Baltimore, Maryland,
April 1943.

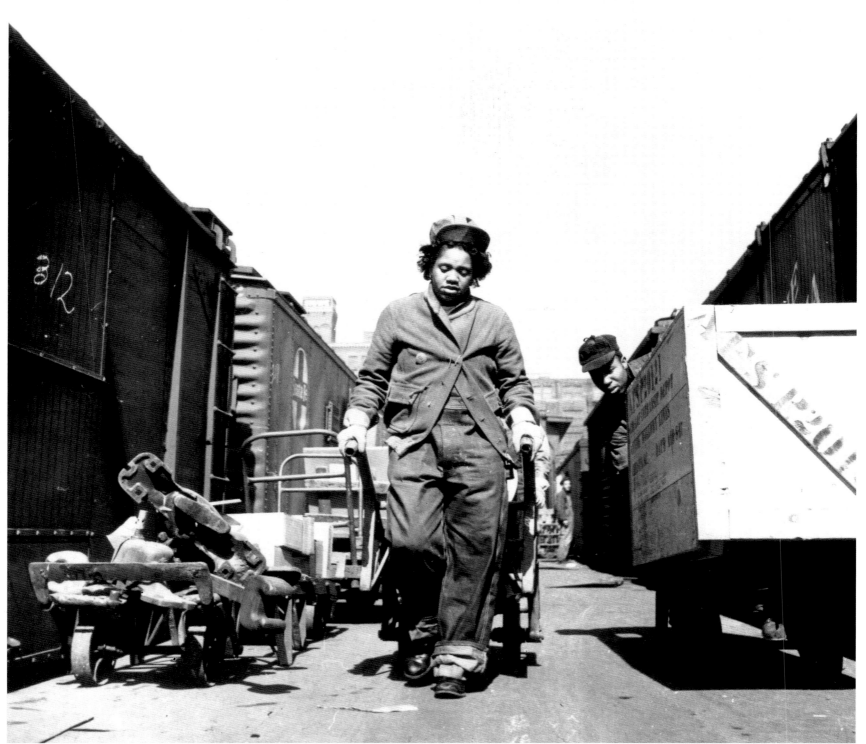

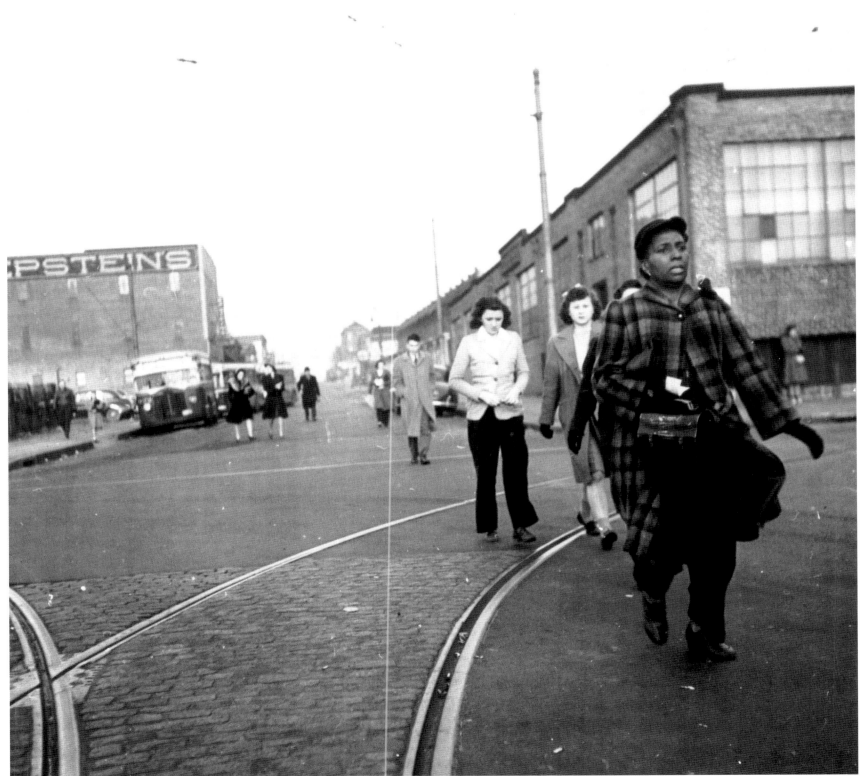

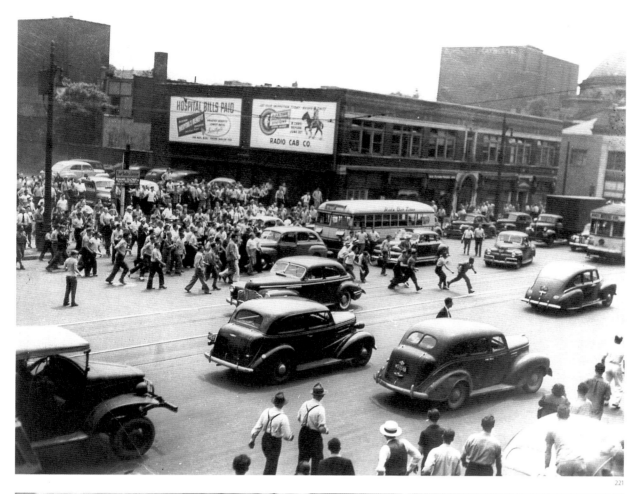

221

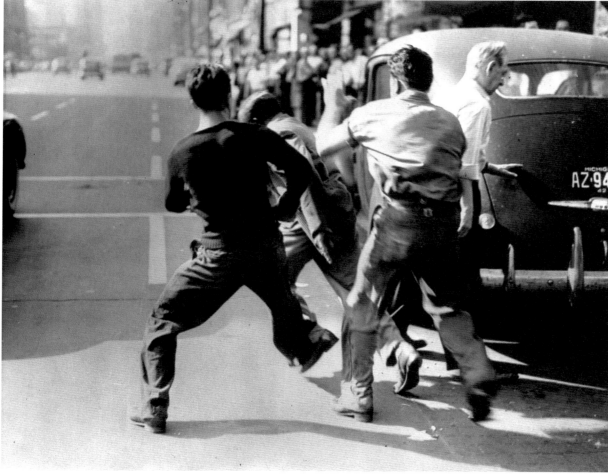

222

221–222. Detroit race riots, late June 1943. On 20 June 1943 several confrontations occurred between blacks and whites at Detroit's Belle Isle Amusement Park. As rumors swept the black community that a women and her baby had been thrown from a bridge, blacks began to attack white-owned businesses in their neighborhood, smashing windows and looting. While white police stood aside, angry white mobs overturned and burned cars belonging to blacks, pulled blacks from buses and street cars, and brutally beat them. The police shot and killed 17 people, all of whom were black, and some of whom were shot in the back. Within 36 hours of conflict, 34 people, including 25 African Americans, were killed. Nearly 1,900 people were arrested, 85 percent of them African Americans. Finally President Roosevelt had to send federal troops to Detroit to restore order. Martin Dies, the chair of the House Un-American Activities Committee (HUAC) attributed the race riot to Japanese Americans who "had infiltrated Detroit's Negro population to spread hatred of the white man and disrupt the war effort."

223. 34th NAACP annual convention, Detroit, 1943. In 1934 NAACP co-founder W. E. B. Du Bois was pressured to resign from the organization in a dispute over policy differences with National Secretary Walter White. By the late 1930s, White had consolidated his leadership of the association by removing several more liberal founders such as Mary Ovington, and appointing allies such as William H. Hastee and Dr. Louis T. Wright to national positions. During these years the organization became much more centralized and, to some degree, removed from the struggles of African American workers which were being waged in the CIO. A. Phillip Randolph largely superseded White as the leading voice for civil rights during World War II.

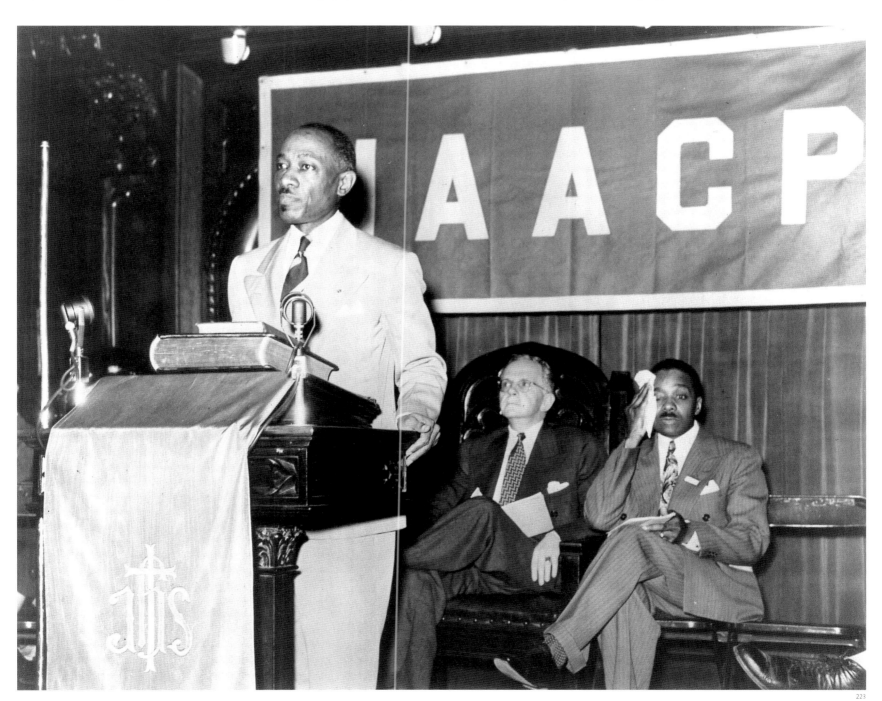

223

217

224. Harlem, New York City, June 1943.

225. People waiting for a shoe store to open on the last day on which war-ration shoe-coupon 17 could be used, Washington, D. C., June 1943.

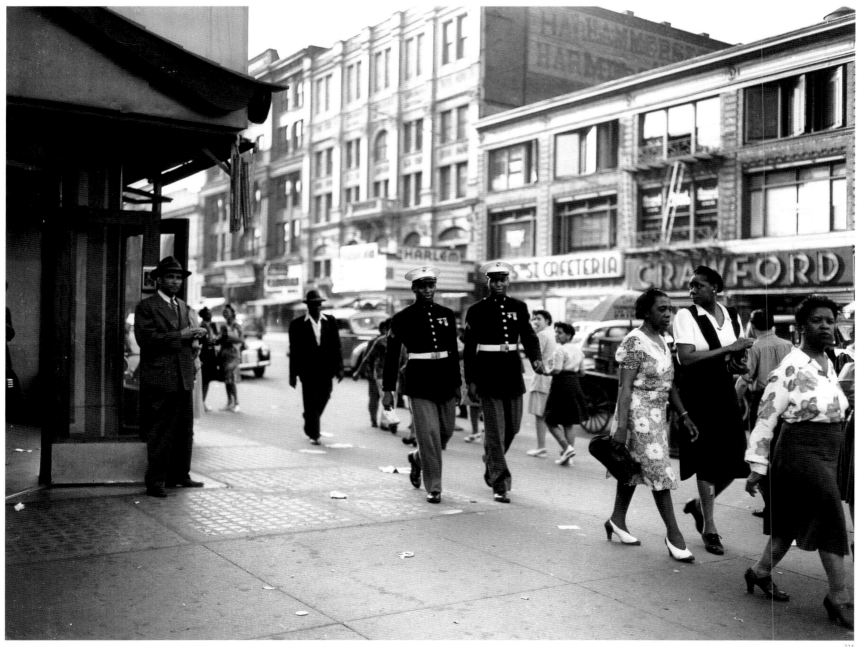

224

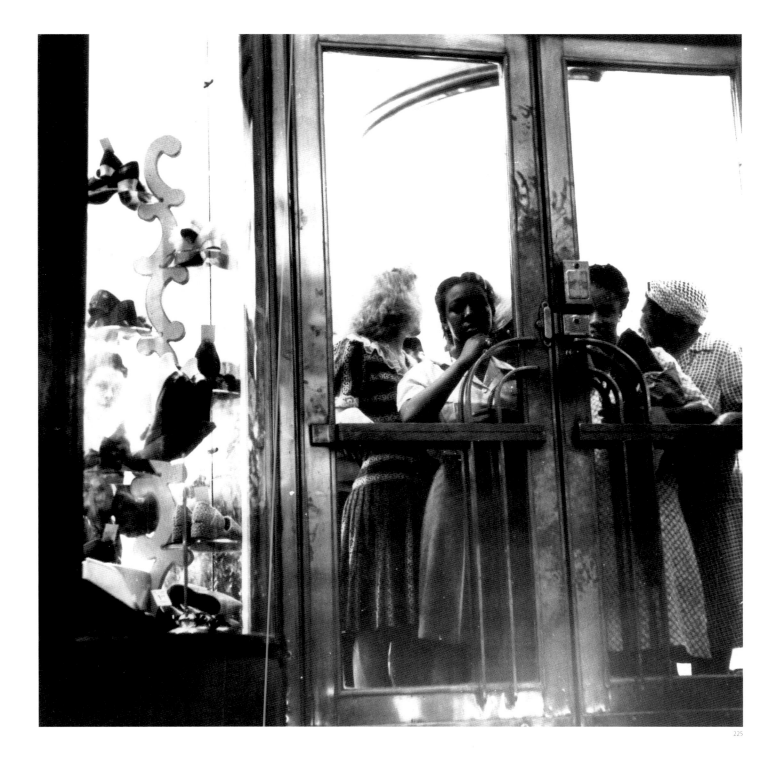

226. New York Mayor Fiorello La Guardia (second from left) with Dr. Max Yergen, former president of the National Negro Congress and a professor at the City College of New York, and Ferdinand Smith, a leader in the Communist Party and the National Maritime Union, near the scene of the Harlem civil unrest, New York City, 2 August 1943. In response to the disturbance in Harlem, La Guardia created the Emergency Conference for Interracial Unity to reduce racial tensions, and initiated an investigation of price gouging by white-owned businesses in Harlem. The unrest also prompted the Office of Price Administration, a federal office with the power to freeze rents and prices in designated areas, to open a branch office in Harlem and begin monitoring rents and prices.

227. Harlem, New York City, 2 August 1943. On 1 August 1943 a police officer shot an African American soldier in uniform in Harlem, sparking an angry reaction among blacks who began to attack white-owned businesses. By the time the police had quelled the disturbance the next morning, six African Americans had been killed, nearly 200 injured and over 500 arrested. Property damage exceeded five million dollars.

228. U. S. troops in Italy, September 1943.

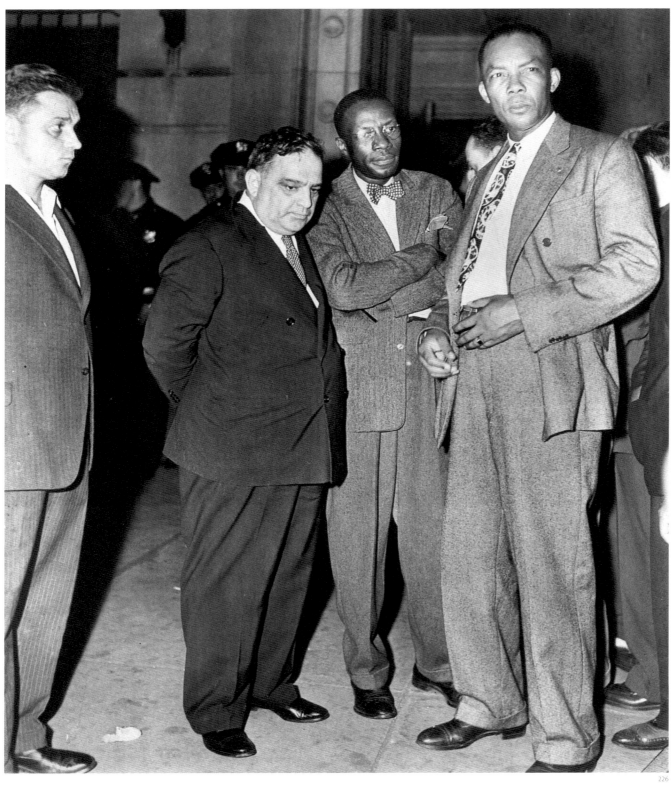

226

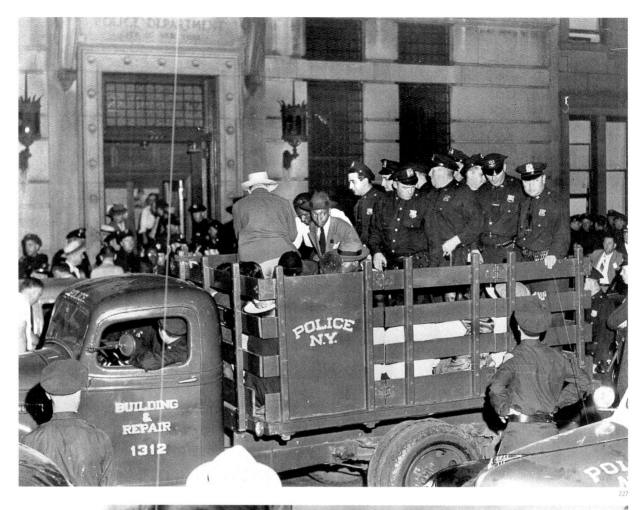

227

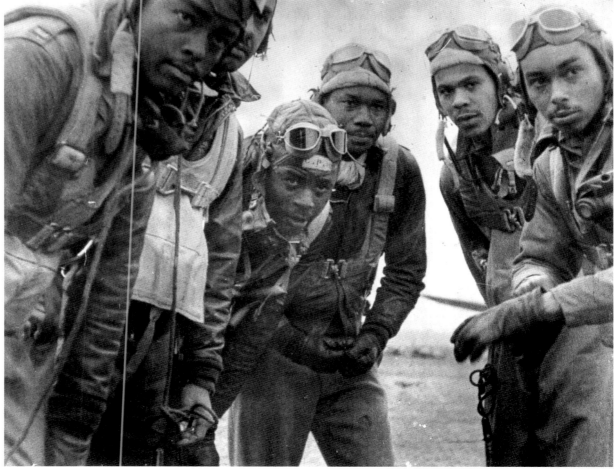

228

221

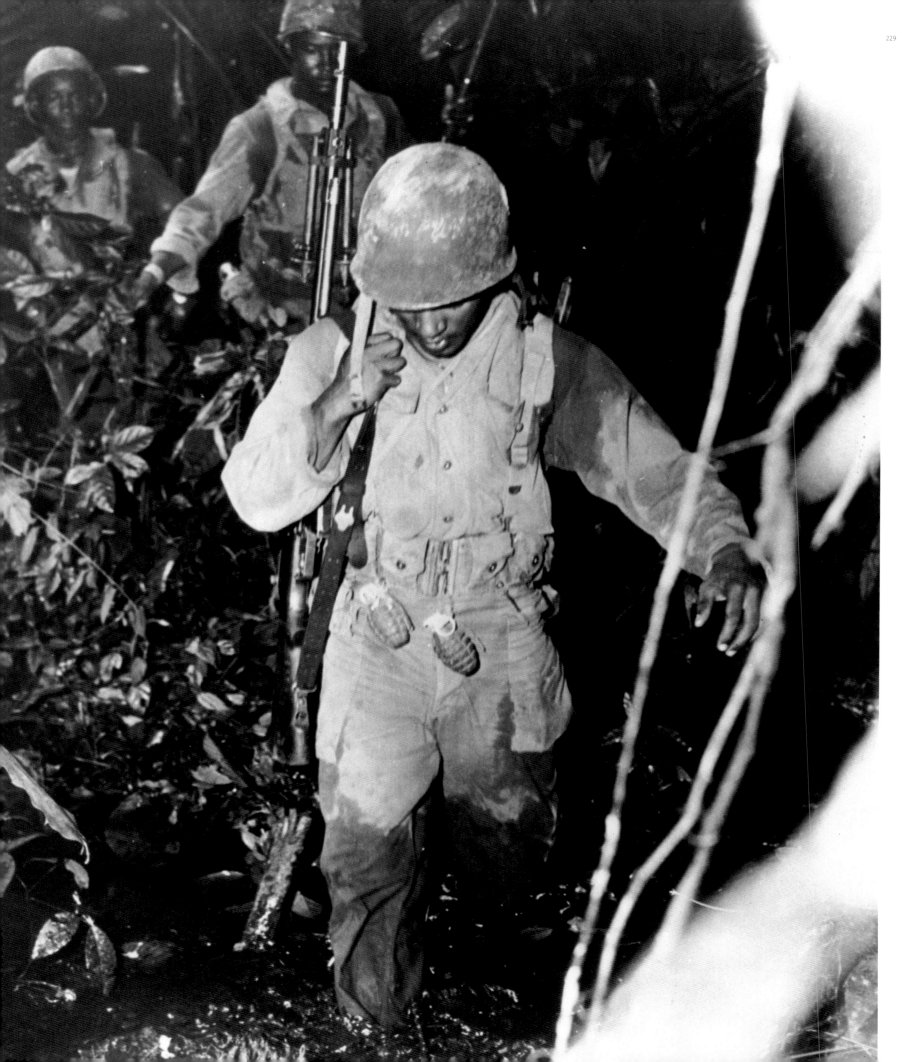

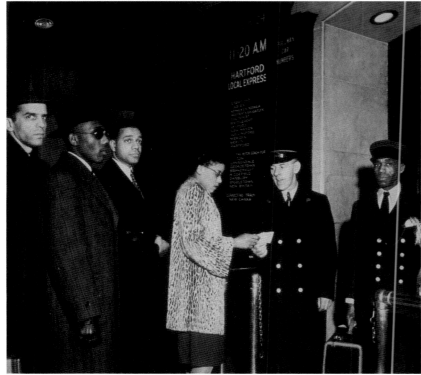

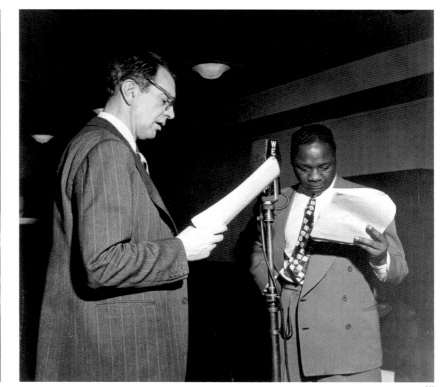

229. Men of the 93rd Infantry Division trudging through the jungle, Bougainville, 1 May 1944. One million African American women and men served in the armed forces during World War II, of which over 700,000 were in the Army. Throughout the war, nearly all military units were segregated, and nearly all African Americans soldiers were stationed overseas. Twenty-two black combat units were involved in military operations in Europe.

230. Issac Woodward leaving New York City with his wife after having received funding from the NAACP, c. 1945. Similar to the aftermath of World War I, African American military veterans returning from fighting in Europe and the South Pacific frequently experienced the brutality of racist violence in the United States. Hours after his discharge from a three-year tour of military service, black veteran Issac Woodward, traveling home to South Carolina from Atlanta, Georgia had an altercation with the bus driver who called the police and ordered him out of the bus. Linwood Shull, the Chief of Police of Batesburg, South Carolina, struck him with a billy club and threw him in jail. While in jail, Shull gouged out Woodward's eyes, blinding him for life. After deliberating for less than half an hour, an all-white jury acquitted the white policeman. The NAACP established a fund to assist Woodward in carving out a new life as a blind man.

231. Raymond Massey and Canada Lee making a transcription of *Two Men on a Raft* at the NBC studios in New York City, April 1945. After brief stints as a jockey, boxer, and musician, Canada Lee began his acting career as part of a Works Progress Administration (WPA) project during the Great Depression. In 1941 director Orson Wells cast Lee as the character Bigger Thomas in his production of Richard Wright's *Native Son*. Winning critical acclaim, Lee performed in a series of successful plays and theatrical performances. In 1944, he appeared in a radio series, *New World A-Coming*, that documented the heritage of African Americans. Lee also began to advocate civil rights, participating in a delegation that urged Congress to adopt the federal ballot for soldiers, and campaigning for the passage of federal legislation to extend the Fair Employment Practices Committee (FEPC). As he became more out-spoken, Lee was falsely charged with being a communist and blacklisted. Though he had a successful run in *Cry, the Beloved Country*, which was produced in England, Lee continued to be blacklisted in the United States. He died of a heart attack in 1952.

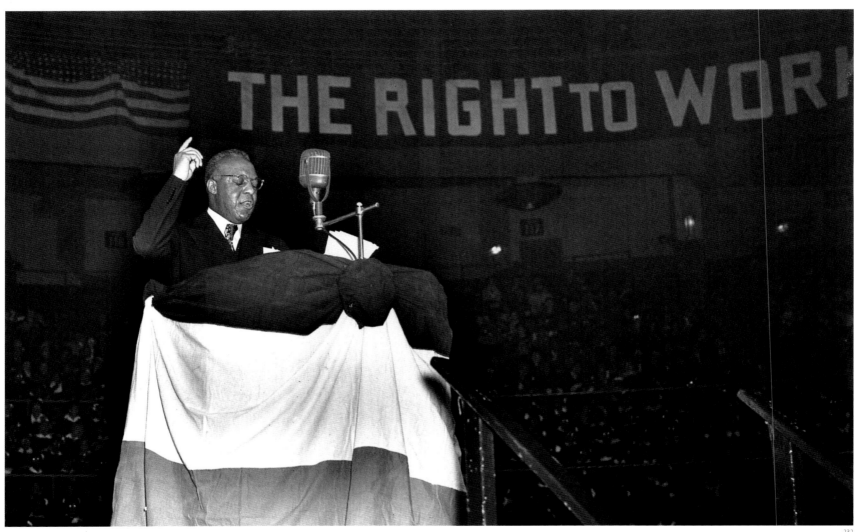

THE RIGHT TO WORK

232. A. Philip Randolph, president of the Brotherhood of the Sleeping Car Porters (BSCP), speaking at a Fair Employment Practices Committee (FEPC) rally at Madison Square Garden, New York City, 28 February 1946. The FEPC, established during the Roosevelt Administration in July 1941, held hearings throughout the United States to promote the employment of African Americans in the war industry and to eliminate all barriers to vocational training. Under the Truman Administration, however, the FEPC's ability to influence policy was severely restricted. When in 1946 Truman prohibited the committee from issuing an order to hire black workers on streetcar lines in Washington, D. C. committee-member attorney Charles Hamilton Houston resigned in protest, declaring that there was "a persistent course of conduct on the part of the administration to the matter of eliminating discrimination in employment on account of race, creed, or national origin since V-J Day, while doing nothing substantial to make the policy effective." The FEPC was abolished by the Senate later that year.

233–234. Nurses and emergency medical personnel, location unknown, 1940s. During World War II, civil rights organizations called for the "Double V" — a double victory: the defeat of fascism abroad and the realization of democracy at home. This campaign helped to desegregate a number of professional vocations and industries during and immediately following the war. In 1948, for example, the American Nurses Association was integrated and appointed a black nurse as Assistant Executive Secretary in its national headquarters.

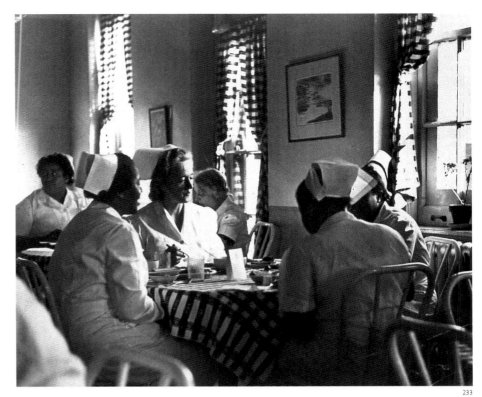

233

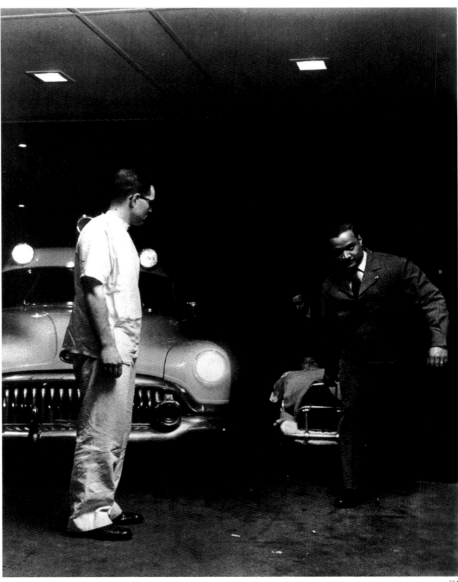

234

225

235. Billy Eckstein in Naylor's record shop around the corner from the Howard Theater, 7th Street, Washington, D. C., 1946. Eckstein was one of the most popular vocalists in the 1940s and 1950s. Between 1944 and 1947 he led one of the best known big bands of the bebop era.

236. Colored entrance of a movie theater, c. 1946. Although African American entertainers and artists had begun to achieve great popularity with white audiences, blacks continued to be forced to sit in segregated sections of movie theaters and other public venues.

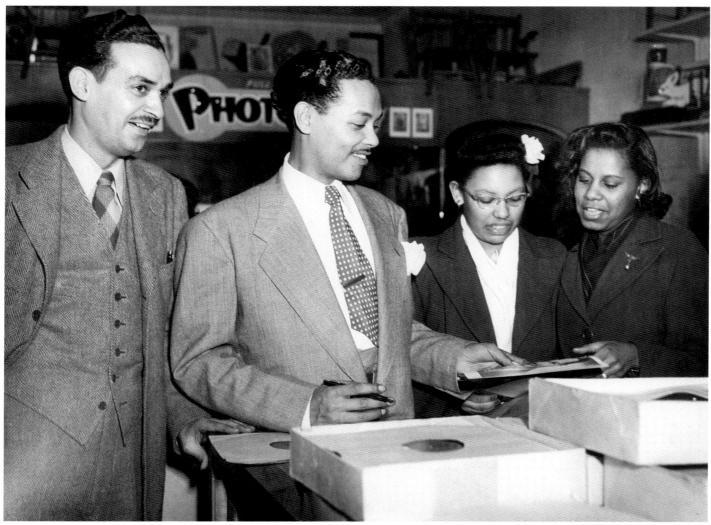

235

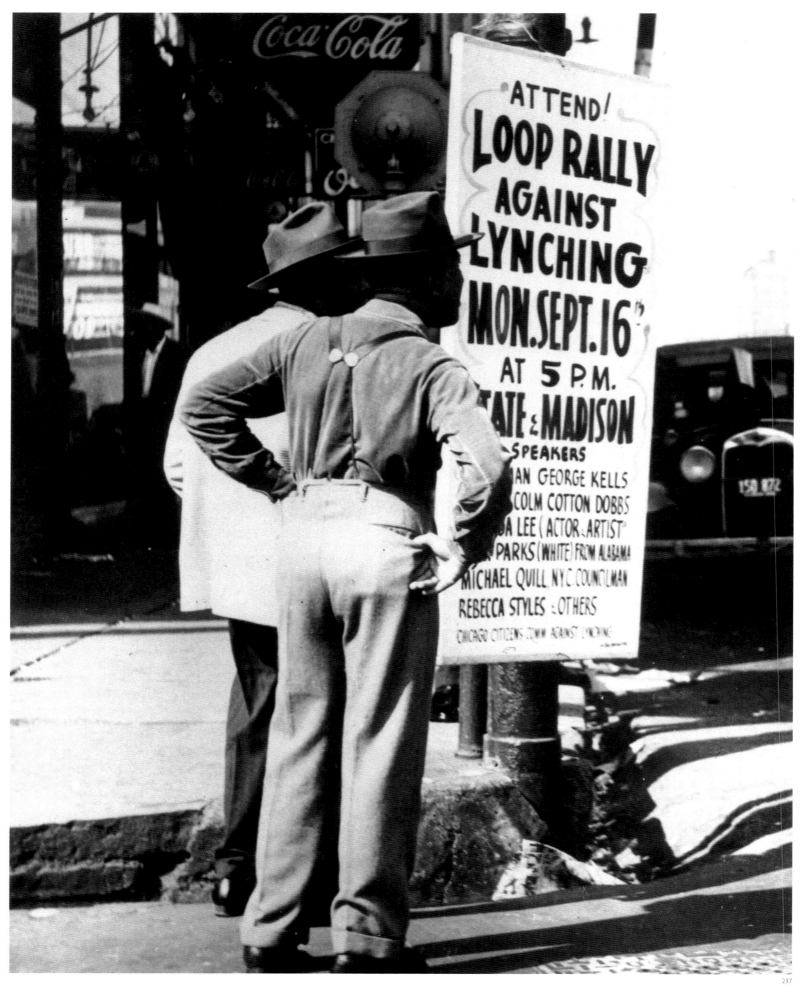

The poster text reads:

ATTEND!
LOOP RALLY
AGAINST
LYNCHING
MON. SEPT. 16TH
AT 5 P.M.
STATE & MADISON
SPEAKERS
...AN GEORGE KELLS
...COLM COTTON DOBBS
...A LEE (ACTOR-ARTIST)
...PARKS (WHITE) FROM ALABAMA
MICHAEL QUILL, N.Y.C. COUNCILMAN
REBECCA STYLES & OTHERS
CHICAGO CITIZENS COMM. AGAINST LYNCHING

237

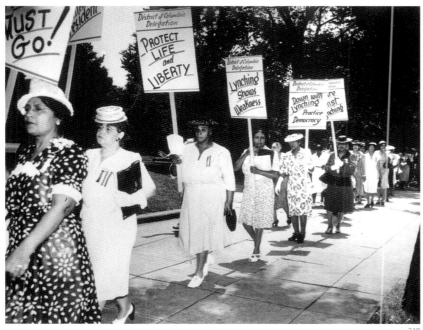

238

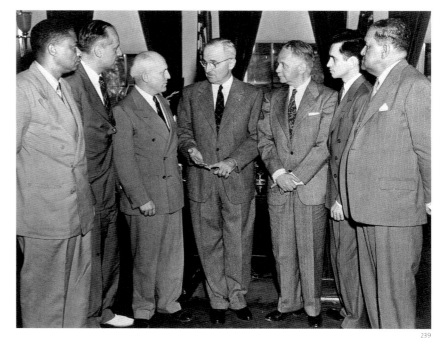

239

237. Poster advertising a Loop rally against lynching, Chicago, August 1946. The end of World War II brought a new wave of vigilante attacks against black communities, including the murder of African American veterans. Federal authorities did little to halt the series of lynchings and firebombings of African American homes throughout the South.

238. Anti-lynching protest organized by the National Association of Colored Women (NACW), Washington, D. C., c. 1946. The NACW was founded in 1896 by Mary Church Terrell through a merger of several large African American women's organizations. Predating the efforts of the NAACP, the NACW was in the forefront of struggles to confront both race and gender discrimination.

239. Members of the Washington Bureau calling on President Truman (center) for a special congressional session to enact new laws against mob violence, 19 September 1946. Responding to the criticism of the civil rights community, the Truman Administration took some meaningful steps to address racial discrimination. Truman established the first Civil Rights Commission,

which in 1947 issued an important report, "To Secure These Rights," calling for an end to segregation in the armed forces and federal guarantees to protect African American voting rights.

240. Howard University students lined up for a publicity shot, Washington, D. C., fall 1946. Despite overwhelming obstacles, African Americans continued to pursue education and to become professionals in a variety of fields. In this picture, Howard students pose for a publicity photo to depict examples of the students' future professions — the military, musical or engineering fields, general studies, and law.

241. Poster advertising civil rights and equal opportunities, c. 1946.

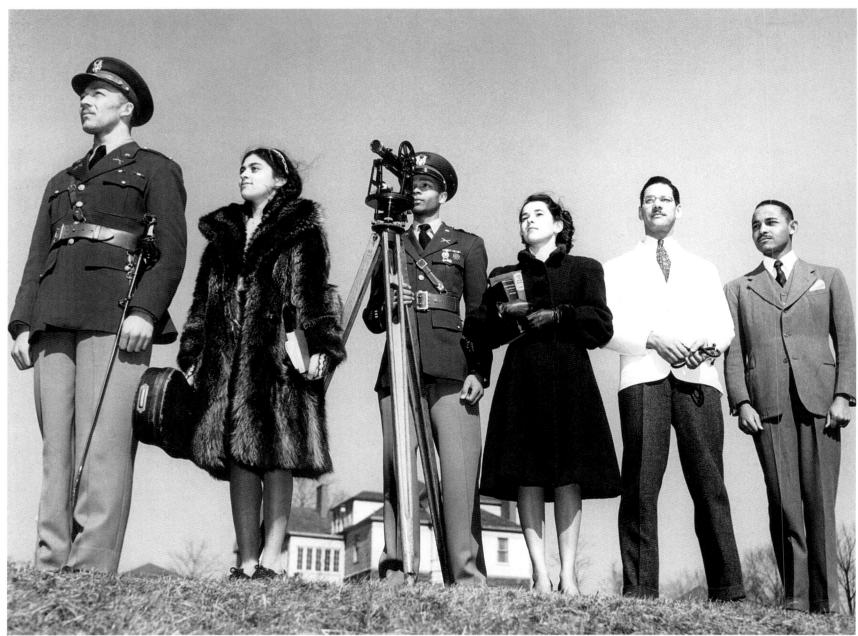

240

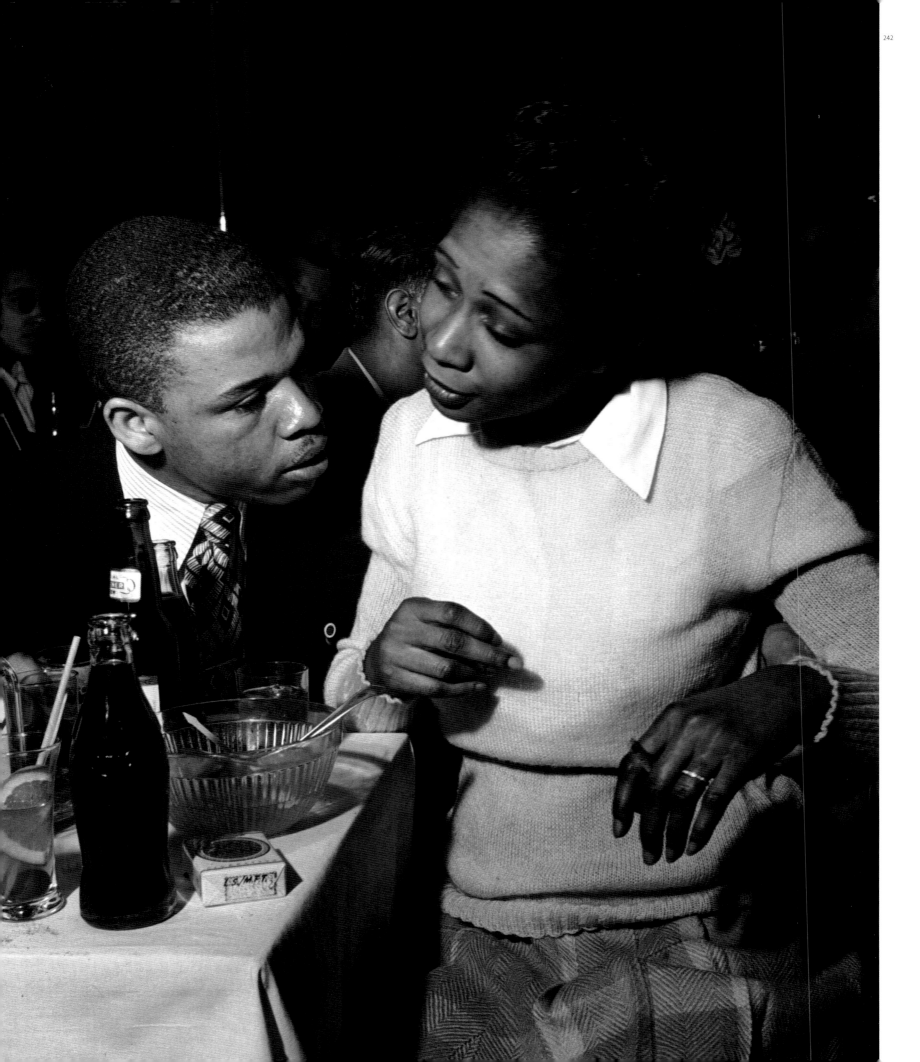

242. Young couple in a night club, Chicago's South Side, 1947.

243. Richard Wright at his home in Paris, 1947. Richard Wright was born in 1908 near Roxie, Mississippi. Growing up in the Deep South, in 1927 he moved to Chicago, where he held a series of menial jobs for several years, from digging ditches to working at the post office. In 1931 Wright began attending public meetings of the Communist Party, which he joined three years later. Through the communist-sponsored John Reed Club, Wright developed important social and literary relationships, earning a reputation as promising poet and essayist. Wright's provocative novel *Native Son*, published in 1940, established his national reputation. During the years of World War II he broke with the Communist Party and relocated permanently to Paris. A productive author, Wright produced a series of challenging works including *Black Boy* in 1945, *The Outsider* in 1953, *Black Power: A Record of Reactions in a Land of Pathos* in 1954, and *White Man, Listen!* in 1957. Wright died of a heart attack in Paris in 1960 at the age of 52. His critical insights into the character of American racism and his strong writing style influenced a generation of African American novelists and essayists, including Ralph Ellison and James Baldwin.

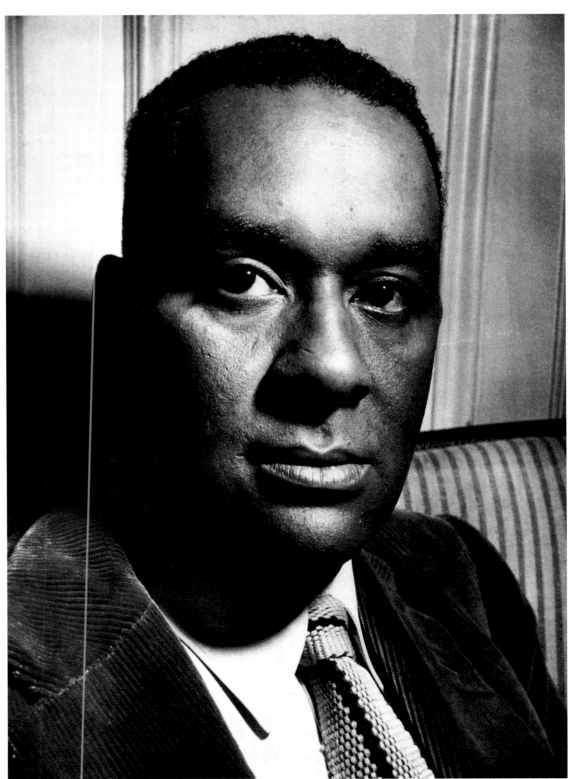

243

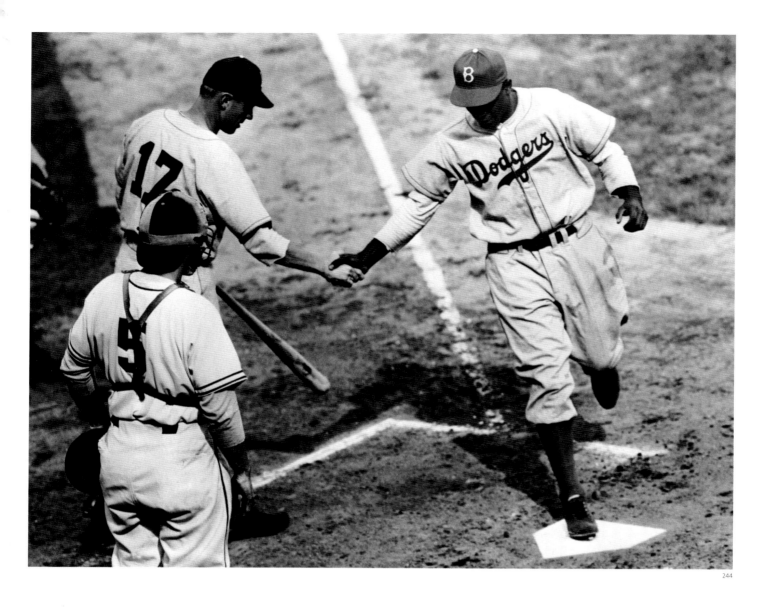

244

244. Jackie Robinson (right) hitting a home run for the Brooklyn Dodgers, 18 April 1947. Contrary to popular belief, Robinson was not the first African American to play in professional baseball. In the nineteenth century, professional baseball admitted black players until Moses Fleetwood Walker was forced out in the 1890s. In the 1930s and 1940s, the success of the Negro Baseball League proved that African Americans could perform at a level at least equal to that of white athletes. For several decades civil rights groups and leftist organizations pressured professional baseball to desegregate until finally, in April 1947, Robinson began his career with the Brooklyn Dodgers. For three years he was harassed by racist fans and players, but with grim determination and courage, he refused to respond to their racial provocations. Despite the constant intimidation, he earned Rookie of the Year honors and led the league in stolen bases. Two years later, he was named the National League's Most Valuable Player. Robinson's success paved the way for thousands of African Americans to enter professional sports.

245. Paul Robeson (second from left) in an NAACP picket line in front of Ford's Theater in protest of the theater's policy of racial segregation, Baltimore, 1947. Robeson's involvement in civil rights activities became even more extensive in the years following the war. He sacrificed considerable commercial success to participate in public demonstrations for racial justice, civil rights, and workers' rights. He was a strong supporter of the National Negro Labor Council, formed after the war to promote the rights of black workers and abolish segregated hiring policies.

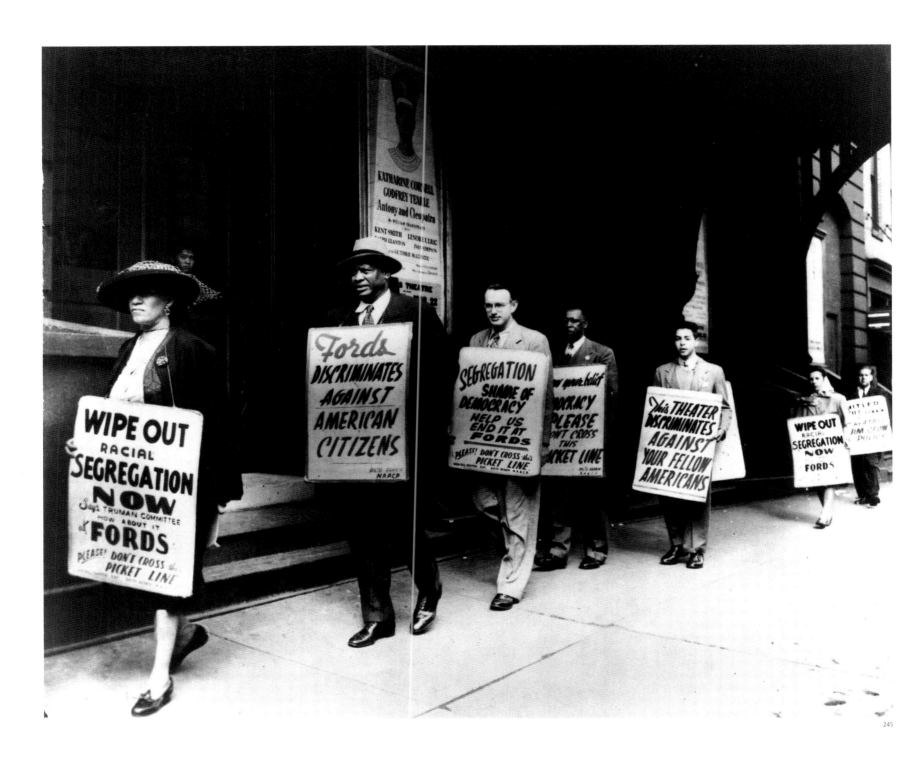

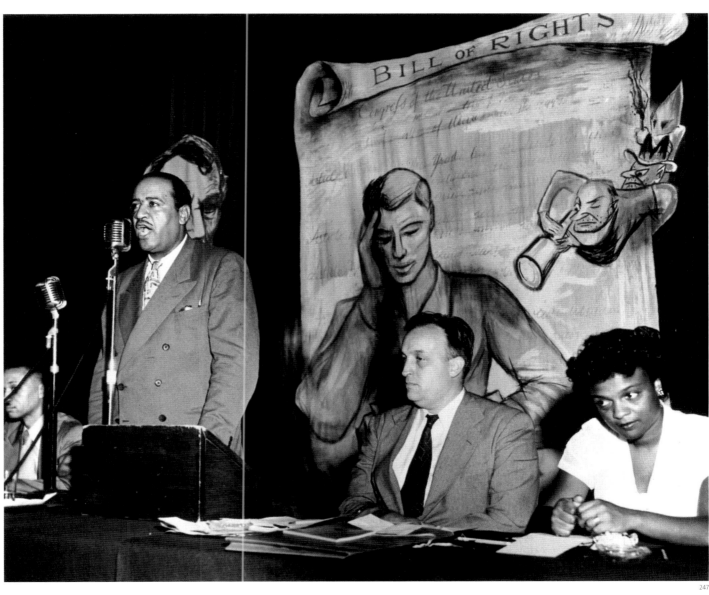

247

246. William L. Patterson, location unknown, c. 1948–49. Patterson was one of the leading civil rights attorneys in the first half of the twentieth century. Born in San Francisco in 1891, Patterson established a law firm in Harlem, New York City immediately after World War I. He developed close political and personal relation-ships with leaders such as W. E. B. Du Bois and Paul Robeson. Joining the Communist Party in 1927, he was elected to its Central Committee five years later. He was a central figure in organizing the legal defense of the "Scottsboro Boys" in 1931 and was co-founder and executive director of the Civil Rights Congress, a coalition of activists fighting for desegregation and the rights of black workers. Patterson played a key role in the campaign to desegregate professional sports, which led to Jackie Robinson's admission to professional baseball. In 1951, Patterson wrote "We Charge Genocide," a petition submitted to the United Nations Genocide Convention presenting evi-dence of the systematic violations of the human rights of African Americans in the United States. The peti-tion was signed by Robeson, Du Bois, Mary Church Terrell, and many others. Patterson refused to answer questions before the House Un-American Activities Committee (HUAC) and in 1954 was imprisoned for three months on the grounds of contempt. He was ultimately vindicated in a successful appeal to the contempt citation. Patterson died in 1980.

247. Benjamin Davis, Jr. at a Civil Rights Congress meeting in New York City, c. 1948–49. Davis was the first black communist elected to legisla-tive office in the United States. Born in Dawson, Georgia in 1903, he later moved to New York, where he became active in civil rights and labor struggles, particularly in advocacy for tenants rights, rent control, and public housing in Harlem. He was twice elected to the City Council in the 1940s to represent Harlem. In 1950 he was convicted under the infamous Smith Act and was incarcerated for five years in a federal prison. After his release he continued to be active in the civil rights and labor movements until his death in 1964.

248. A. Philip Randolph (right) and Grant Reynolds testifying to the Senate Armed Services Committee, Washington, D. C., March–April 1948. By the late 1940s African Americans in the northern states had become an important constituency in the Democratic Party. By 1952 the national black electorate numbered almost two million voters, but millions of others, especially in the South, were barred from voting. Randolph and other civil rights leaders pressured the Truman Administration to implement desegregation measures. Recognizing the importance of the black vote to his electoral success, Truman implemented measures to desegregate the armed forces that same year.

249. Five southern Democratic governors air their grievances against President Truman's Civil Rights program to senator J. Howard McGrath (seated), chairman of the Democratic National Committee, Washington, D. C., 23 February 1948. White southern Democrats led by South Carolina governor Strom Thurmond bitterly opposed the tepid steps of the Truman Administration toward civil rights. Many bolted from supporting Truman's reelection campaign in 1948. Thurmond ran for the presidency on the ticket of the States' Rights Party, also known as the "Dixiecrats," a white supremacist political party based in the South.

250. Relief pickets on 124th Street, New York City, 1949.

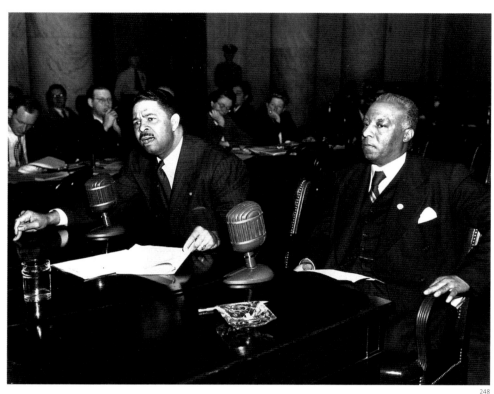

248

249

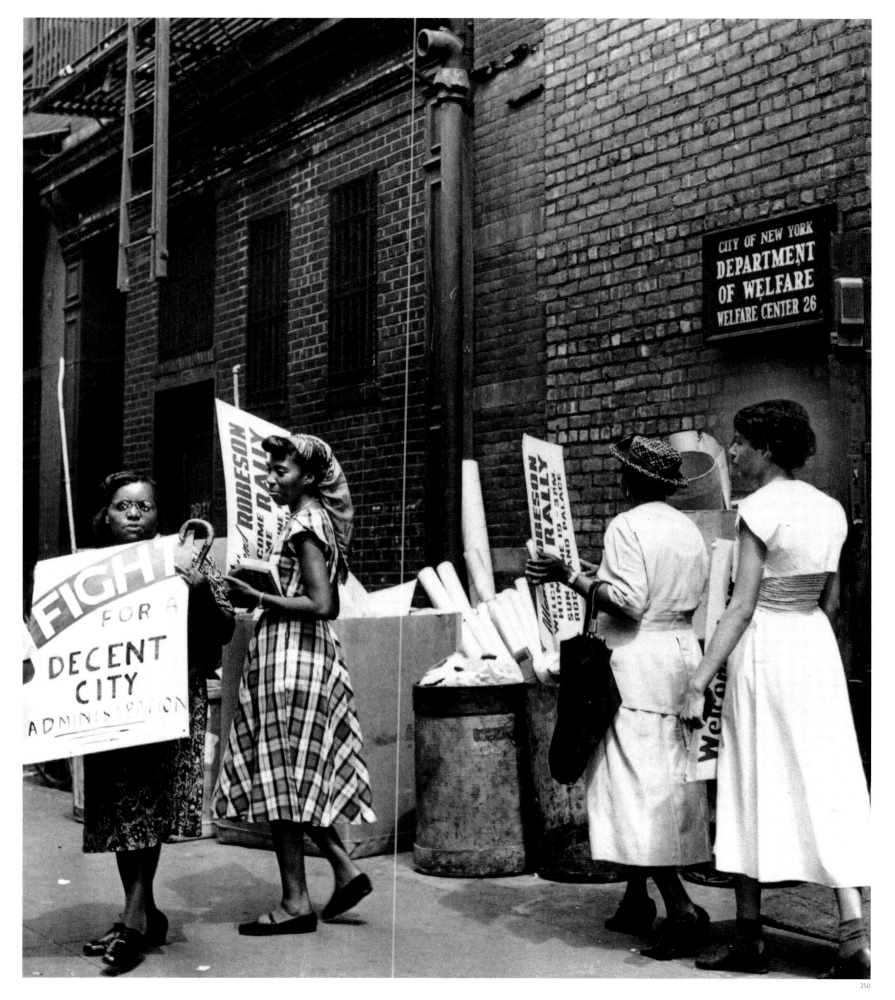

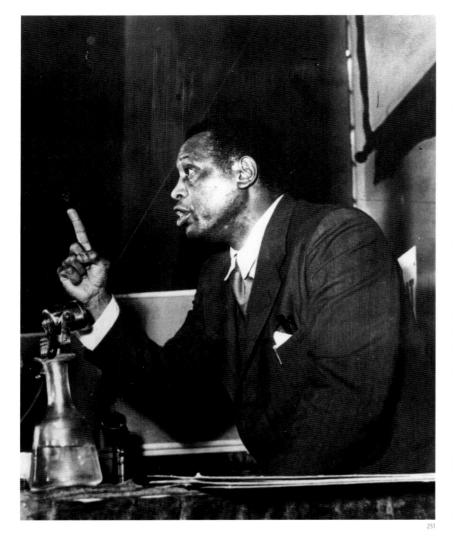

251

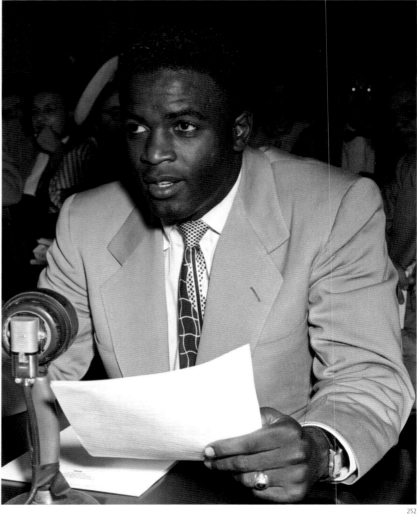

252

251. Paul Robeson, Paris, 19 April 1949. In April 1949 at the World Peace Conference in Paris, Robeson stated that "It is unthinkable that American Negroes will go to war on behalf of those who have oppressed us for generations . . . against a country [the Soviet Union] which in one generation has raised our people to the full dignity of mankind." The American press distorted this quotation, claiming that Robeson had stated that African Americans would not fight for the United States. Several prominent African American leaders including Harlem congressman Adam Clayton Powell, Jr., NAACP National Secretary Walter White, and baseball star Jackie Robinson, issued public statements critical of Robeson. In 1950 Robeson's passport was seized by the U. S. State Department and he was prohibited from traveling abroad. He was banned from appearances on television, radio, and at concert halls. Subpoenaed by the House Un-American Activities Committee (HUAC) in 1956, Robeson defiantly refused to give names of American communists and challenged the committee members about their racism. In 1958 the Supreme Court finally restored his passport and he immediately went abroad. For several years he performed in Europe and Australia, but the pressures of political harassment took their toll; in 1961 Robeson had a mental breakdown and for his remaining years suffered from bouts of depression. Largely retired from public life, Robeson died in 1976.

252. Jackie Robinson testifying, Washington, D. C., 18 July 1949. Although Robinson strongly supported racial integration, his views became increasingly conservative and, in July 1949, he agreed to testify against Paul Robeson before the HUAC. He later became a prominent member of the Republican Party, and in 1962 was inducted into the National Baseball Hall of Fame. He died in 1972.

253. Peekskill riot, New York, 27 August 1949. On 27 August 1949 Paul Robeson was scheduled to sing at a concert in Peekskill organized to raise funds for the Civil Rights Congress. Robeson's identification with the left and with peace activists who opposed military confrontation with the Soviet Union generated a backlash by political conservatives across the country, and mobs of white vigilantes disrupted the concert and physically assaulted conference organizers and participants. Robeson was unharmed, but more than a dozen concert goers were hospitalized, some with serious injuries. On 4 September 1949 a second concert was organized as a show of defiance against those who had disrupted the first event. Several thousand war veterans and hundreds of workers from District 67, the Garment and Fur Workers Union, provided security for the concert. Mobs of white counter-demonstrators hurled rocks and bottles. State and local police did little to protect concert participants, and some were even reported to have participated in the mob violence. A grand jury subsequently blamed Robeson and his supporters for creating the conditions for the riot. The disturbances at Peekskill made headlines around the world.

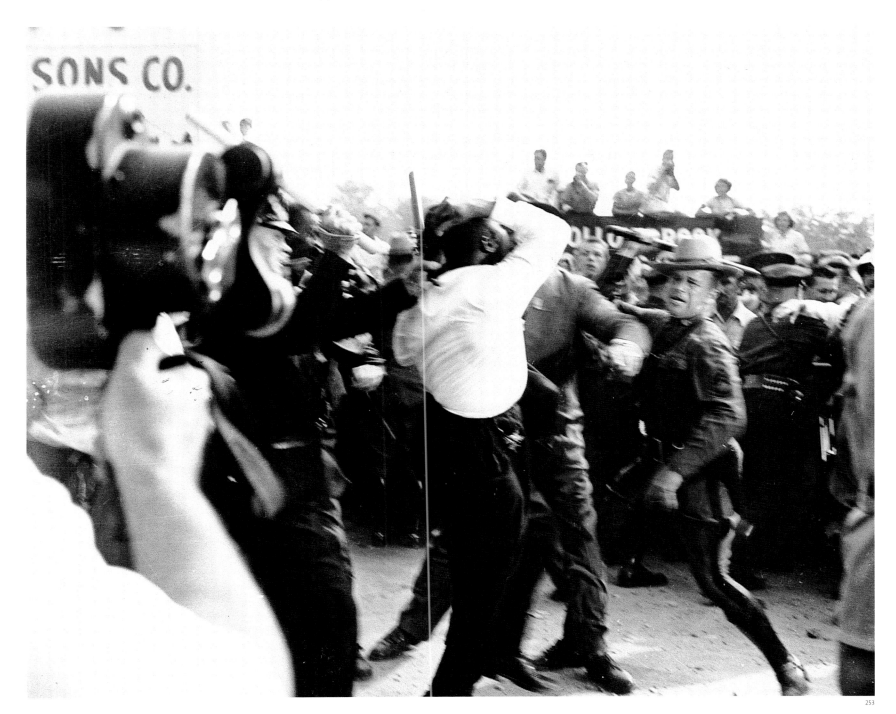

253

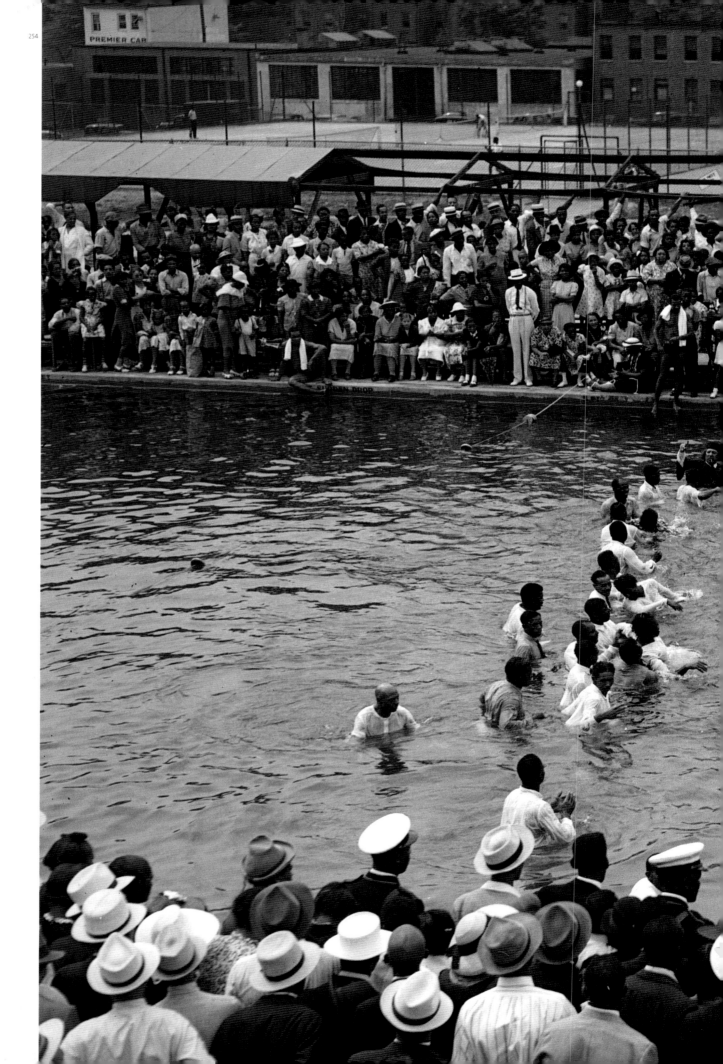

254. Pentecostal baptism by leader Daddy Grace, Washington, D. C., 1949. Pentecostalism is an evangelical Christian sect, founded by African Americans. It has a particular appeal among the poorest and most disadvantaged sectors of American society, regardless of race, and has attracted millions of non-black followers around the world. Pentecostals emphasize the perfectibility of human nature and the possession of the body by the Holy Ghost. Many elements of traditional African American religious rituals have been incorporated into Pentecostal mainstream practices, including dancing, music, and speaking in tongues. Mass baptisms were a well-known feature of this movement. Daddy Grace, who had thousands of devoted followers, was one of the most prominent Pentecostal leaders after World War II.

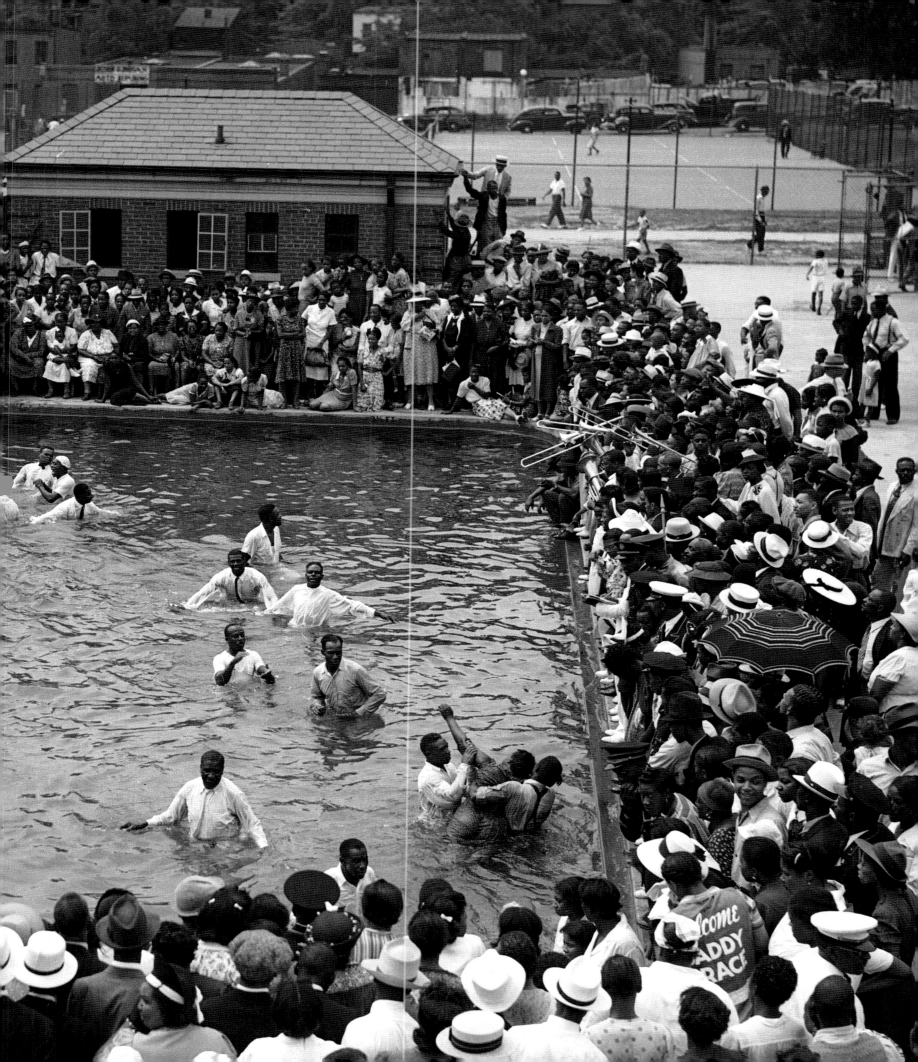

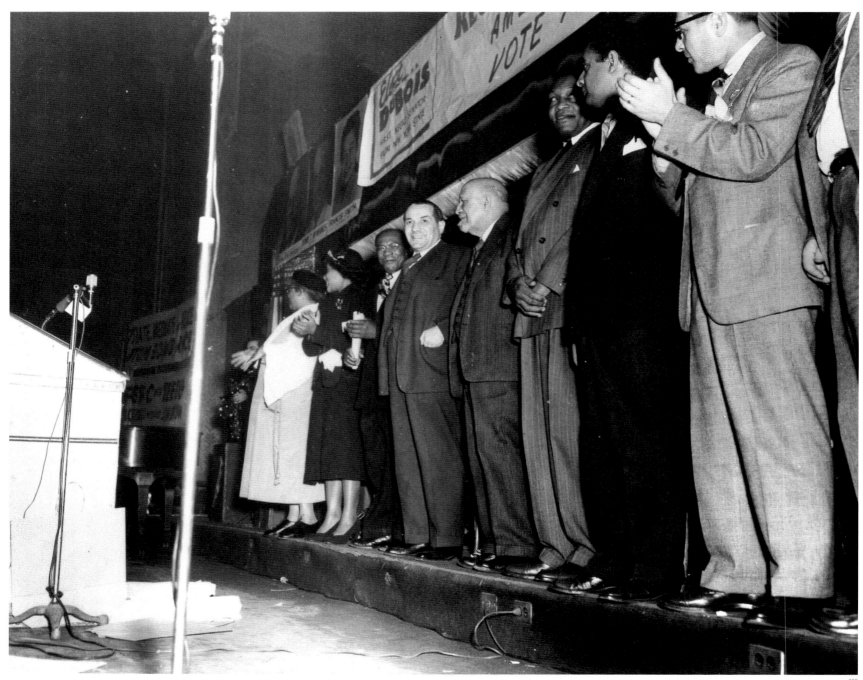

255

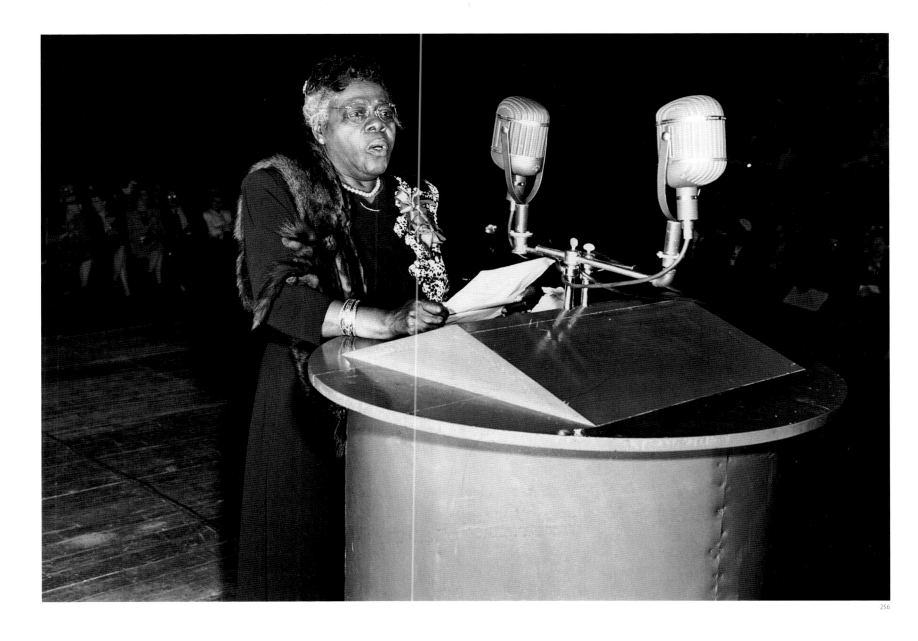

256

255. W. E. B. Du Bois' electoral campaign, New York City, 1950 (Du Bois is fifth from the left, with Paul Robeson to his right). In 1950 Du Bois reluctantly accepted the American Labor Party's nomination as New York candidate for the U. S. Senate. Despite fierce attacks by the media and government surveillance, he managed to win over 200,000 votes in the election. Just several months after his electoral campaign, he was indicted by the U. S. government for being "an unregistered agent of a foreign country," and the massive legal defense organized in his defense was not supported by the NAACP. He was subsequently acquitted of the charges, but the State Department seized his passport, denying him the right to travel outside of the United States. His books were removed from public libraries and frequently burned, and he was largely prohibited from speaking in public venues, and experienced constant surveillance by the FBI.

256. Mary McLeod Bethune speaking at Madison Square Garden, New York City, c. 1950.

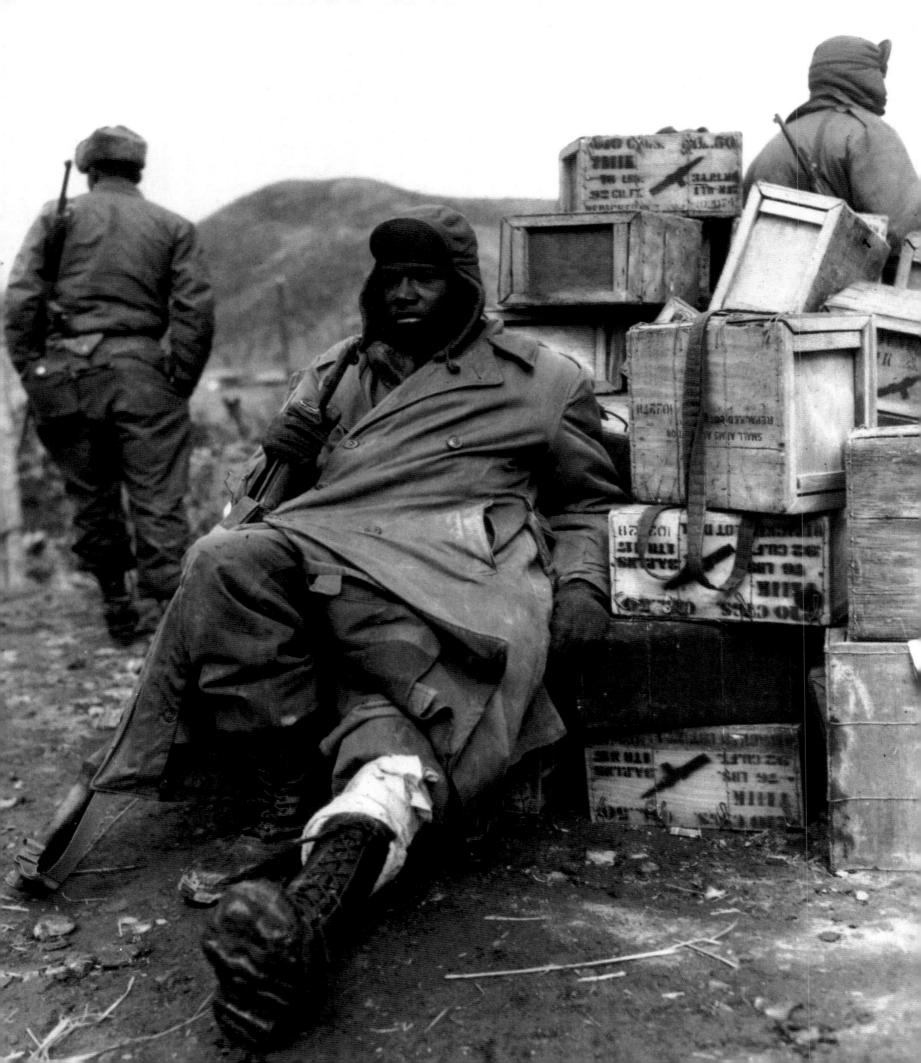

257. Wounded man of the 24th Infantry Regiment waiting to be evacuated away from the front lines, Korea, 16 February 1951. Although President Truman ordered the desegregation of the U. S. armed forces in 1948, compliance was extremely slow. The Navy assigned most of its African American recruits to be waiters and cooks; the Army resisted efforts to desegregate and blacks continued to be trained in segregated units. With the outbreak of the Korean conflict in June 1950, the all-black 24th Infantry Regiment was one of the first American units to engage in the conflict. The Commander of the United Nations forces, U. S. General Douglas MacArthur, resisted efforts to desegregate his troops, but the integration of African Americans in the Far East began to be implemented under the command of General Matthew Ridgeway, appointed in 1951. By August of that year approximately 30 percent of U. S. combat troops were integrated. One year later the last all-black unit was finally disbanded. A study by the NAACP found that a disproportionately high number of black soldiers were court-martialed or subjected to military punishment in these newly integrated units.

258. Ku Klux Klan meeting in South Carolina, early 1950s.

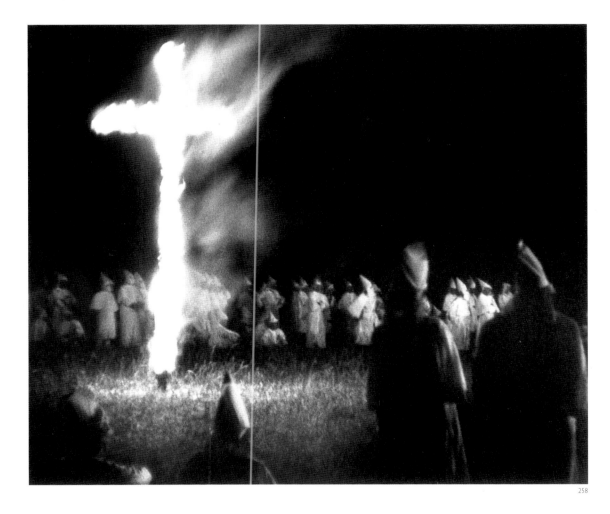

258

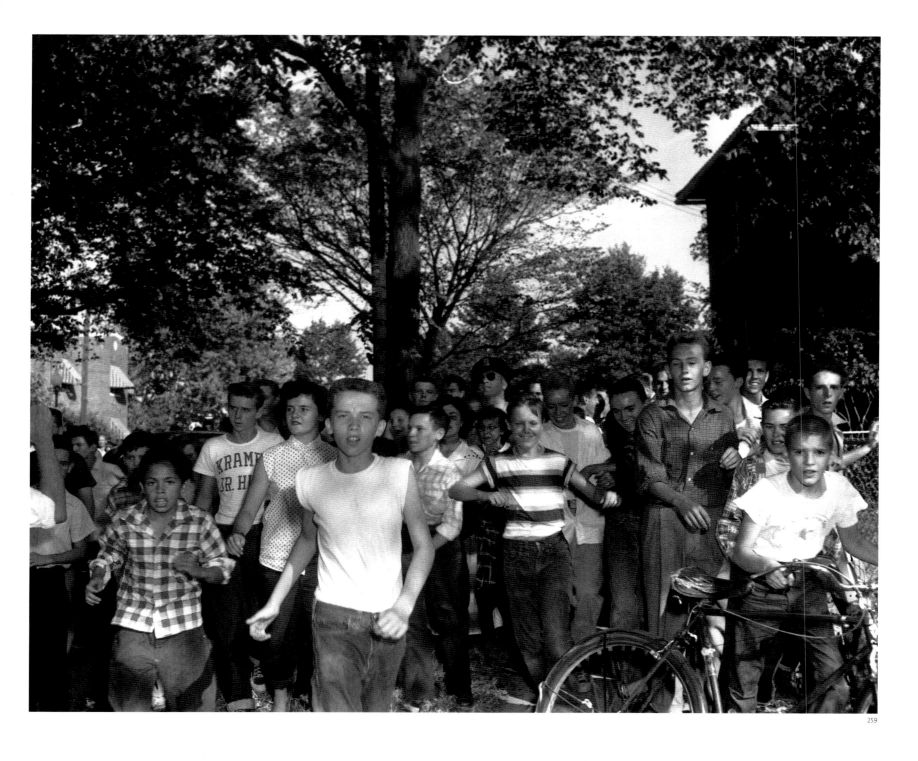

259

259. Students of the Anacostia High School running after African American school children, Washington, D. C., 4 October 1954.

260. Little girl in Mississippi, c. 1954. In 1950 approximately 2.2 million African American children were enrolled in racially segregated elementary schools, mostly in the South. The segregated school system operated under the legal doctrine established by the Supreme Court in its *Plessy v. Ferguson* decision of 1896, which held that racially segregated schools were constitutional as long as equal accomodations were established for blacks. However, separate was never equal and all black schools were inadequate in virtually every respect. There were vast disparities in terms of access to textbooks, recreational facilities, teachers' salaries, and length of the school year.

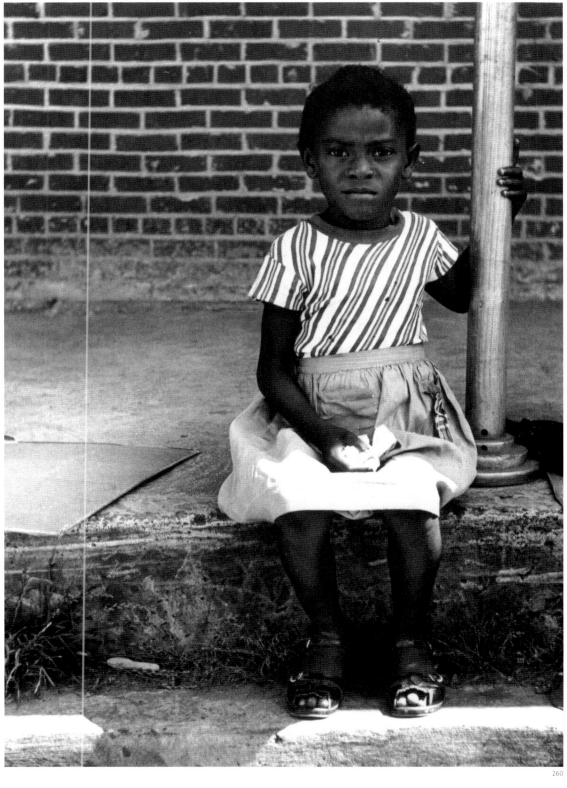

1954

1975

WE SHALL OVERCOME

We shall overcome, we shall overcome,
We shall overcome someday.
Oh, deep in my heart, I do believe,
We shall overcome someday.

— Black freedom movement anthem, 1960s

Contemporary African American history really begins with two events. On 17 May 1954, in a unanimous decision, the U. S. Supreme Court overturned the legality of racially segregated schools in the *Brown v. Board of Education* decision. The high court declared in its ruling that "in the field of public education the doctrine of 'separate but equal' has no place." The following year, the Supreme Court urged the adoption of desegregation plans by public schools "with all deliberate speed." The *Brown* victory was the culmination of decades of legal and political efforts by the NAACP and other civil rights groups.

On 1 December 1955, Rosa Parks, a respected seamstress and NAACP activist, refused to relinquish her seat to a white man while riding on a segregated public bus in Montgomery, Alabama. Local black leader E. D. Nixon, outraged by Parks' arrest, urged the African American community to stage a one-day boycott of Montgomery's buses. A black professional women's group, the Women's Political Council led by educator Jo Ann Robinson, was largely responsible for initiating the successful city-wide mobilization to protest Jim Crow regulations in public transportation. On Monday, 5 December, over 95 percent of all blacks refused to ride the buses. That night six thousand black people gathered at Montgomery's Holt Street Baptist Church and reached a consensus to continue the non-violent protest indefinitely. A black coalition, the Montgomery Improvement Association, was created, which selected a young, little-known Baptist minister as its chief spokesperson — Dr. Martin Luther King, Jr. The boycott continued for nearly one year, despite the hundreds of blacks who were fired from their jobs for supporting the civil protest. The homes of King and other African Americans were firebombed; local police harassed and jailed boycott organizers. Finally, on 13 November 1956, the U. S. Supreme Court ruled in favor of the boycott and struck down the city's segregation ordinance for public transportation. The modern black freedom movement had achieved a decisive victory, and the struggle had found a new spokesperson in the powerful and charismatic Dr. King.

History is often told from the vantage point of "great" people's (usually men's) lives. Indeed, an unusual number of talented and extraordinary black women and men came into the public arena to push forward measures to outlaw American apartheid: King; the Reverend Ralph David Abernathy, King's closest friend and confidant; the brilliant tactician Bayard Rustin; Medgar Evers, the leader of Mississippi's NAACP branch, who was brutally assassinated in front of his home and family in 1963; Septima Poinsette Clark, who created the Citizenship Education Program that taught thousands of poor and illiterate blacks to read, write, and register to vote; Robert Moses, a young mathematics teacher, who went to Mississippi to organize voter education and registration campaigns; the Vanderbilt University divinity student James Lawson, who trained civil rights activists in civil disobedience techniques and taught them the philosophy of non-violence of Mohandas Gandhi; the courageous Ella Baker, veteran of civil rights organizations who inspired the creation of the Student Nonviolent Coordinating Committee in 1960; the legendary Fannie Lou Hamer, a former cotton-field laborer who co-founded the Mississippi Freedom Democratic Party and challenged the whites-only state delegation at the 1964 Democratic National Convention; John Lewis, who in his early twenties participated in "freedom rides" to desegregate interstate bus routes and led non-violent sit-in demonstrations at whites-only lunch counters; Thurgood Marshall, lead attorney of the NAACP Legal Defense Fund and later the first black U. S. Supreme Court Justice; and Gloria Hayes Richardson, who led the desegregation campaign in Cambridge, Maryland.

Creative and talented individuals may help to define a moment in history, yet the substance of daily life is fundamentally set by ordinary people, who work every day, sacrifice for their children, and find social meaning through their contributions to their communities, voluntary organizations, and religious institutions. The struggle for freedom was always expressed in collective terms for the African American people. The spirit of freedom was expressed in their celebrations of what was first termed "Negro History Month" held every February; through celebrations such as "Juneteenth," honoring the date of 19 June 1865, when blacks in Texas first learned of their emancipation from slavery; in the popular national liberation flag of the Negro masses inspired by Marcus Garvey, a flowing colorful banner of "red, black, and green." The fierce and unrelenting character of white racism, and the structural barriers that inhibited the flourishing of full democratic life, constructed a national black consciousness and political culture that expressed itself through myriad institutional and organizational forms. Black people, regardless of their social class, deeply felt a sense of linked fates, which bound them to one another as well as to their collective history of resistance. The successes of any one member of a disadvantaged community were, in many ways, shared and experienced by all. When boxers such as Joe Louis and Muhammad Ali dominated their opponents and were acclaimed heavyweight champions of the world, blacks throughout the nation to some degree found common pride in and through their accomplishments in the ring.

The modern black freedom movement was successfully constructed, and was able to transform America's political and social institutions, because it reflected this national consciousness, a collective identity born of triumphs as well as tragedies, the fruit of deferred dreams and democratic aspirations. During the desegregationist phase of the struggle for civil rights, from roughly 1954 to 1965, voluntary organizations supported a number of national political groups, all of which espoused civil rights but disagreed sharply over the appropriate strategies and tactics to be used to achieve the common goal. The small professional class usually favored the moderate approaches of the NAACP and the even more conservative National Urban League. The African American religious community and faith-based institutions provided the necessary resources to King's Southern Christian Leadership Conference (SCLC), founded in 1957. Unlike the NAACP, which emphasized litigation and legislation, the SCLC practiced civil disobedience mass campaigns, designed to mobilize church congregations to pack the jails, in order to pressure authorities to eliminate discriminatory laws. The SCLC used economic boycotts and the tactics of peaceful civic disruption to force local business and political leaders to change their policies toward blacks. To their left politically were the Congress of Racial Equality (CORE), founded by James Farmer and Bayard Rustin in 1941, and the Student Nonviolent Coordinating Committee (SNCC), launched from the sit-in student protests during the winter and spring months of 1960. Throughout most of its history, CORE was a racially integrated organization that actively used civil disobedience tactics, such as sit-ins and "freedom rides," to challenge Jim Crow laws. SNCC activists also desegregated lunch counters and initiated voter education and registration drives in many of the most poverty stricken and dangerous areas of the rural South. They described themselves, with youthful élan, as the "True Believers," absolutely dedicated to placing "their bodies on the line" in the struggle to outlaw Jim Crow.

The mass democratic movement for desegregation, over a period of many years, finally convinced white Americans to end their longstanding commitment to legal segregation. The Civil Rights Act, passed by Congress and signed into law by President Lyndon Johnson in 1964, prohibited the exclusion of blacks from all public facilities and accommodations: restaurants, parks, swimming pools, hotels, and theaters. It outlawed the use of federal funds to maintain or support educational institutions that practiced segregation. That same year, the twenty-fourth amendment to the U. S. Constitution was passed, abolishing the poll tax on voting throughout the country, a restrictive provision that had been extensively used to deny black and poor people the right to vote. On 6 August 1965, President Johnson signed into law the Voting Rights Act. The new law established direct federal examination of local voting registration processes. The Voting Rights Act almost immediately changed the political landscape of the

South. In every southern state, the percentages of black adults who were registered to vote rose above 60 percent by 1969. That same year, 1,200 black elected officials were in office, with more than one third of that number from the South.

The economic changes derived from the desegregation of American society led to the opening of employment sectors that had largely excluded blacks in the past. Between 1960 and 1970, the number of African American white-collar workers grew significantly, from 1,457,000 to 2,356,000. The number of blacks employed in professional and technical positions more than doubled, from 331,000 to 766,000 employees. In the skilled and highest paid sectors of labor — craftsmen and foremen — the numbers of African Americans grew in these same years from 415,000 to 692,000. At the other end of the wage scale, the overall numbers and percentages of blacks in the worst jobs declined. The percentage of the African American total labor force employed as farm laborers fell from 6 percent to 2.9 percent; the percentage of all blacks working as private household workers also fell, from 12.6 percent to 7.7 percent. In the late 1960s especially, there were unprecedented gains in household income and living standards, especially in two-income families. In 1969, black male jobless rates dropped to only 5.3 percent.

In the field of higher education, the changes for blacks were even more extraordinary. In 1960, only 7 percent of all black young adults were attending college. However, the political and social pressures of the black freedom movement forced white administrators of major academic institutions to finally open their doors to blacks, as students, faculty, and as administrative personnel. By 1970, over 410,000 African Americans aged 18 to 24 were in colleges, 15.5 percent of their age group — but still well short of equity with whites, of whom 34 percent of all males and 21 percent of females were enrolled. As demands for the adoption of African American Studies departments, minority-based scholarships and needs-blind admissions programs escalated, the racial composition of higher education continued to change. By 1974, about 750,000 blacks were enrolled at all levels of post-secondary education. Three years later, the major milestone of one million African American post-secondary students was achieved. From 1968 to 1975, about 350 predominantly white colleges started African American Studies departments, programs, and research centers, and more than one thousand institutions had initiated at least one course devoted to the black experience in its standard curriculum.

The general conditions of health and social conditions for most African Americans also improved markedly. The black population by 1970 exceeded 22.5 million. Eighty-one percent of all blacks now lived in cities, making them the most urban population of any ethnic group in the country. The life expectancy of black people continued to

improve, with black women actually outliving white males (though not white females) by 1970. Black infant mortality rates also fell, but remained more than twice as high as those for white infants. Real changes also occurred in housing. Throughout the first half of the twentieth century, at least 80 percent of all black families lived in what the federal government defined as "substandard housing," dwellings that typically lacked indoor plumbing facilities, electricity, and/or heat. Under Democratic administrations, and particularly under the presidency of Lyndon Johnson from 1963 to 1969, the federal government initiated the construction of several million public housing units and allocated billions of dollars to improve existing housing stock in central cities. The passage of "open housing" legislation in 1968 made it somewhat easier for black working- and middle-class families to purchase homes in largely segregated, white suburbs and in more affluent urban districts. However, blacks tended to be relegated to the purchase or rental of older properties; due to pervasive residential segregation, the market value of blacks' homes was far less than that of whites. According to a 1968 presidential commission on housing, blacks were routinely charged up to 30 percent more than whites to rent the identical type of residential properties. Less than one third of all African American families even owned their own homes, compared to a homeownership rate of over 60 percent among whites.

The very successes of the legal, political, and social reforms related to the status of blacks in U. S. society, however, obscured other very real social problems that the government had failed to address. Millions of upper- and middle-class whites fled America's central cities and relocated to predominantly white suburbs. The populations of the country's major cities had become increasingly African American. As of 1970, New York City was home to 1.7 million African Americans; other major cities included Chicago (1.1 million blacks in 1970), Detroit (660,000), Philadelphia (654,000), Washington, D. C. (537,000), Los Angeles (504,000), Baltimore (420,000), Houston (317,000), Cleveland (288,000), New Orleans (267,000), and Atlanta (255,000). In urban neighborhoods like South Central Los Angeles, one quarter of all dwellings were substandard, without plumbing, heat, or electricity. About 30 percent of adult blacks were jobless. Blacks in Los Angeles' ghetto were confined to an area four times more congested than the rest of the city. As of 1970, one-fifth of all black homes had a person-per-room ratio of above 1.1 persons per room, a clear indication of overcrowding. Particularly in inner cities, blacks suffered disproportionately higher rates of hypertension, tuberculosis, diabetes, and other illnesses. Black women's mortality rates in childbirth were six times that of white women in 1970. Such intolerable conditions convinced many African Americans that the victories of the desegregation movement were largely irrelevant to the masses of urban poor blacks. Sociologist Kenneth Clark, a key contributor to the legal arguments behind the 1954 *Brown* decision,

observed in 1968: "The masses of Negroes are now starkly aware that the recent civil rights victories benefited primarily a very small percentage of middle class Negroes while their predicament remained the same or worse. . . . [T]okens of 'racial progress' are not only rejected by the masses of Negroes but seem to have resulted in their increased and more openly expressed hostility toward middle class Negroes."

The disparities between the urban ghetto and affluent middle-class America finally produced a series of urban uprisings drawing their energy from the alienation and anger of the most marginalized sectors of society. From 1964 to 1972, hundreds of urban rebellions erupted, leaving a total of 250 deaths, 10,000 serious injuries, and over 60,000 arrests. In the first nine months of 1967 alone, there were 164 civil disorders across the country. In the aftermath of King's assassination on 4 April 1968, thousands of blacks protested by destroying white-owned businesses and private property in black neighborhoods, and targeted symbols of white authority, such as the police. In Chicago, 11,000 members of the U. S. Army and the Illinois National Guard were deployed to suppress the civil disorders. In Baltimore, ghetto violence only subsided after 8,000 federal troops and National Guardsmen implemented a military occupation of predominantly black districts. Rioting in Cleveland's East Side on 5 July 1968 resulted in twenty-two casualties, including fifteen police officers, in only one hour. Traditional civil rights leaders now began to question whether their emphasis on abolishing legal segregation had led them to ignore the social crises of poverty and despair in the inner cities. CORE leader Floyd McKissick, speaking at the National Black Power Conference held in Newark, New Jersey, in July 1967, declared that "in this country, the ghetto is not defined by barbed wire: the ghetto follows the black man wherever he goes. . . ."

The second significant phase of the black freedom movement, commonly termed "Black Power," dominated African American politics and social activism from 1966 to 1975. As in the desegregationist coalition in the previous decade, the Black Power movement was an amalgam of conflicting organizations and constituencies, all dedicated to the ideal of enhancing black empowerment — such as through building black institutions, black ownership of their own neighborhoods, and electing blacks to positions of public authority. A short list of some of the major tendencies within Black Power would include: black economic nationalists, such as CORE's McKissick, who favored the development of black businesses, banks, and private enterprise with separate, all-black communities; black religious nationalism, reflected in the Nation of Islam, led by Elijah Muhammad, which preached a conservative, patriarchal creed of racial separation and selective elements of traditional Islam; black cultural nationalism, emphasizing the central role of African identity and heritage among black Americans, the creation of a new "black aesthetic" through the production of a

black militant theater and literature, such as that reflected in the creative writings of Amiri Baraka (Le Roi Jones); revolutionary black nationalism, which combined a Marxist political critique of both class and racial inequality, favoring solidarity with Third World countries and the Vietnamese liberation struggle against the United States, which was best represented by the Black Panther Party and the League of Revolutionary Black Workers; and black political nationalism, reflected in the collective efforts by thousands of black activists who ran for elective office on political platforms promising to channel resources and economic benefits to inner-city neighborhoods. "Black militancy" came to be interpreted in an almost inexhaustible number of ways: "afro" hairstyles; African-inspired dress; selecting Swahili, Hausa, Yoruba, or Arabic names; soul music, such as James Brown's hit "Say It Loud, I'm Black and I'm Proud"; the creation of black-oriented neighborhood schools, cultural centers, civic associations, and agencies that preached black self reliance, self respect, and a rejection of racial assimilation into the white world.

The fountainhead of Black Power was in many respects embodied in the charismatic figure of Malcolm X. Born Malcolm Little in 1925, he joined the Nation of Islam while in prison during his twenties. His powerful speaking style and organizational abilities helped to propel the Nation of Islam from a narrow religious sect to a significant social force within black America. Impatient with the social conservatism of the black group and its refusal to participate in anti-racist efforts, Malcolm X broke away in March 1964. In May 1964, he established the Organization of Afro-American Unity, with the objective of building a broad coalition of black groups to work jointly to empower the most oppressed sectors of the black community. Although many white Americans condemned Malcolm X as dangerous and anti-white, his political philosophy toward the end of his short public life was broadly humanistic and internationalist. Malcolm X reached the conclusion that America could indeed have a "bloodless revolution," if whites could transcend their historic prejudices against people of color, and if the socio-economic and political institutions of the country could fully reflect the nation's true diversity. Malcolm X insisted that he and his supporters were not "anti-white," but they were "anti-exploitation . . . anti-degradation . . . anti-oppression." "The political philosophy of black nationalism," Malcolm X declared, "means that the black man should control the politics and the politicians in his own community. . . . We want freedom now, but we're not going to get it saying, 'We Shall Overcome.' We've got to fight until we overcome."

The two central figures produced by the black freedom movement, Martin Luther King, Jr., and Malcolm X, were both thirty-nine years old when they were assassinated. Although both had different political styles and espoused conflicting philosophies, in many respects they symbolized the rich spectrum of political culture within black civil society in the 1960s: an impatience with racial discrimination; a determination to improve the physical conditions and quality of life for their people; a commitment to the achievement of democratic rights and the elimination of systemic poverty and class inequality. Both men, and more generally the political movements that they represented, were perceived by elements within the U. S. government as threats to national security. King, Malcolm X, and virtually the entire public leadership of the black freedom movement was constantly subjected to illegal wiretaps, surveillance, and overt harassment by the Federal Bureau of Investigation. Prominent activists such as Fred Hampton, Mark Clark, and George Jackson were murdered by federal, state, and/or local law enforcement agencies. The Black Panther Party was subjected to police raids, mass arrests, and in several instances political assassinations, orchestrated by the FBI's Counterintelligence Program. The most prominent political prisoner of the period, Communist activist and philosophy professor Angela Davis, was placed on the FBI's "Ten Most Wanted List" and was incarcerated for nearly two years before being acquitted of all charges in court. The FBI circulated false information and documents between black organizations to deliberately provoke them to assault each other. Very few prominent African Americans escaped some type of legal and governmental harassment, even those who had no connections with militant politics, such as retired boxer Joe Louis and actress Eartha Kitt.

The suppression of the most radical elements of the black freedom movement, combined with the elimination of many of its most articulate and popular leaders, left African Americans in a paradoxical situation. Blacks were, by the mid-1970s, more firmly represented at all levels of American society than at any previous moment in their history. Blacks had begun to dominate several professional sports; black popular music, whether expressing itself as "rhythm and blues" or "disco," set the pace for all musical trends; black actors were more widely apparent in films and television; and by 1976, nearly one-third of all black households earned $15,000 or more annually, a figure achieved by only 2 percent of all black families in 1966. African Americans were widely elected as mayors of many of the nation's major cities: Wilson Goode in Philadelphia, Coleman Young in Detroit, Kenneth Gibson in Newark, Carl Stokes in Cleveland, Maynard Jackson in Atlanta, and Thomas Bradley in Los Angeles. Despite such victories, the pace of racial change remained agonizingly slow. The total number of black families below the federal poverty level actually rose from 1.3 million in 1969 to 1.5 million in 1976. Non-white youth unemployment rose to 39.6 percent by 1977. Poverty rates for black young adults who did not finish high school as of 1977 were a staggeringly high 53 percent. For millions of black people, the American Dream still remained a dream deferred.

261. Roy Wilkins (standing), executive secretary of the NAACP, speaking on the topic of the Supreme Court decision *Brown v. Board of Education* on the desegregation of public schools (Thurgood Marshall is seated immediately to his right), 31 May 1955. The 1954 *Brown v. Board of Education* Supreme Court decision outlawing racial segregation in public schools marked a major turning point in the struggle for civil rights. In a May 1954 editorial on the decision, the *Washington Post* commented: "It is not too much to speak of the Court's decision as a new birth of freedom. . . . America is rid of an incubus which impeded and embarrassed it in all its relations with the world." The following September, public schools in Washington, D. C. and Baltimore, Maryland began to implement desegregation plans. On 31 May 1955, the Supreme Court reinforced the *Brown* decision by declaring that desegregation of the nation's public schools must be implemented "with all deliberate speed."

The NAACP used a number of cases including that of Linda Brown of Topeka, Kansas to challenge the legality of racially segregated public schools. Linda Brown, an African American third-grader, was denied enrollment in an all-white elementary school near her home. She was forced to walk one mile through a railroad switch-yard to attend the all-black elementary school farther away. In support of segregation the Topeka Board of Education argued that segregated schools simply prepared African Americans for their lives in a separate society and that there was no evidence that Jim Crow conditions fostered any damage to blacks. However on 17 May 1954, in a vote of 9–0, the U. S. Supreme Court sided with the NAACP by outlawing the "separate, but equal" doctrine that had for many years justified legal segregation. Chief Justice Earl Warren declared: "We conclude that in the field of public education, the doctrine of separate but equal has no place. Separate educational facilities are inherently unequal. Therefore, we hold that the plaintiffs and others similarly situated for whom the actions have been brought are, by reason of the segregation complained of, deprived of the equal protection of the laws guaranteed by the Fourteenth Amendment."

The triumph of *Brown v. Board of Education* symbolically marked the emergence of a new generation of civil rights leaders. With the deaths of Mary Church Terrell in 1954 and Walter White and Mary McLeod Bethune in 1955, new spokespeople began to emerge. On 11 April 1935, Roy Wilkins had become Executive Secretary of the NAACP. In 1938, Thurgood Marshall had succeeded celebrated attorney Charles Hamilton Houston as the lead council of the NAACP. In that position, Marshall was the chief architect of a legal strategy that won a series of decisions before the Supreme Court, which outlawed all-white primary elections, racial segregation in interstate transportation, and segregated housing convenants, and brought down the legal barriers to the admission of blacks to law and professional schools. However, these legal successes would require a tremendous social movement to implement them.

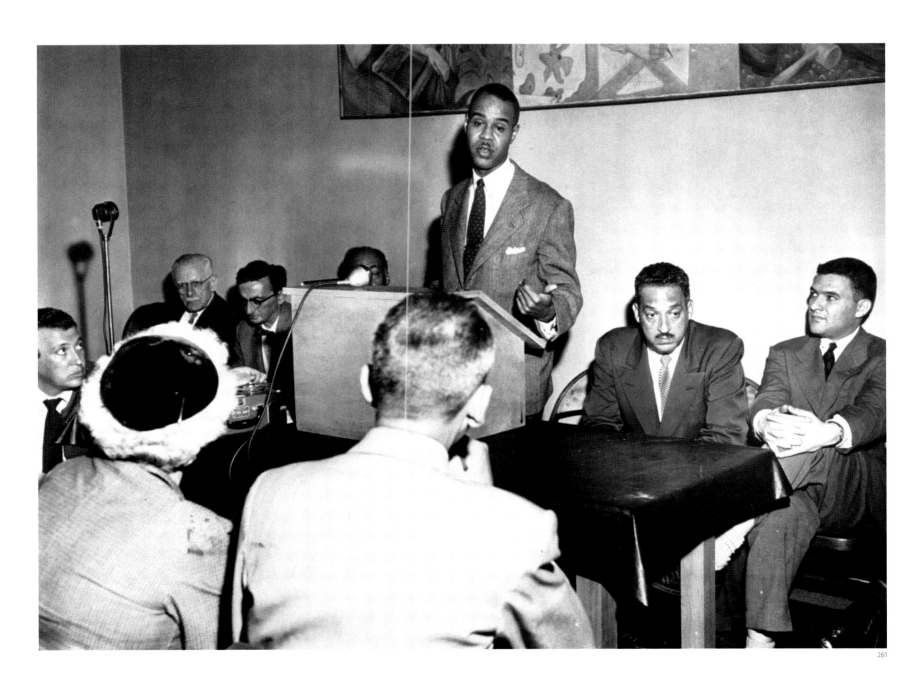

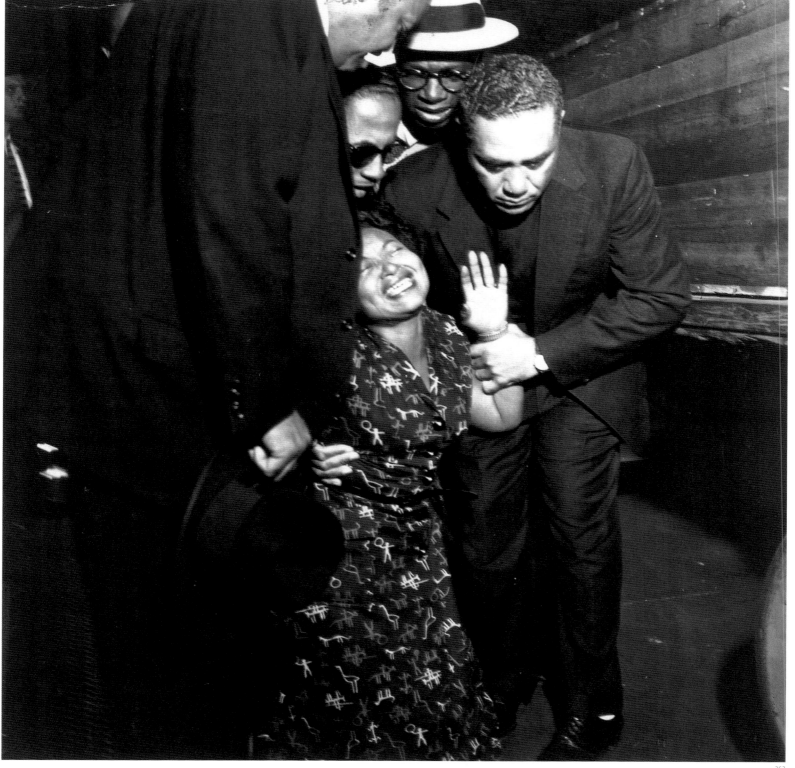

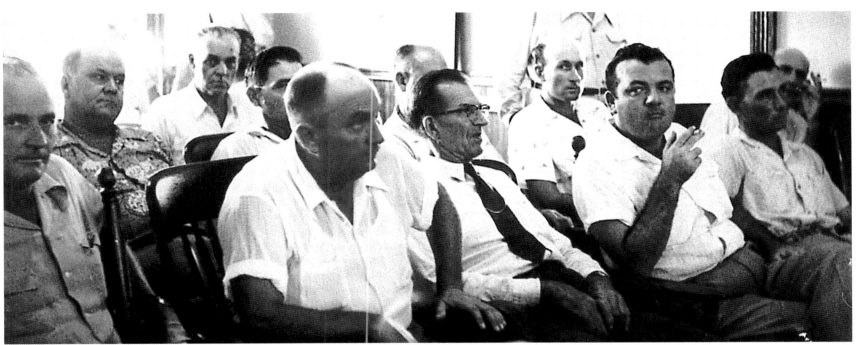

263

262. Mamie Till, Emmett Till's mother at her son's funeral in Chicago, August 1955. Born in 1941, Emmett Louis Till had been raised in Chicago. In the summer of 1955, his mother sent him to visit his uncle, Moses Wright, who lived in rural Mississippi. Unfamiliar with the strict racial and sexual codes of the segregationist South, fourteen-year-old Emmett either whistled or spoke familiarly to a 21-year-old white woman named Carol Bryant. On 28 August 1955, Bryant's husband and his half brother abducted Till. Three days later his mutilated, naked body was found in a nearby river. Overwhelmed by the brutality meted out against her son, Mamie Till refused to allow a closed casket at the funeral. Photographs of Emmett's body were published in newspapers across the United States and civil rights organizations sharply protested the atrocity.

263. Jury of the Emmett Till trial, Mississippi, September 1955. Till's killers were tried one month later by an all-white jury and were promptly acquitted. Later the two murderers admitted their responsibility for the murder in an interview published in Look magazine.

264. The Louis Armstrong *All Stars* (Louis Armstrong, Edmond Hall, Velma Middleton, Billy Kyle, Arvell Shaw, and Trummy Young) in Amsterdam, 29 October 1955. During the 1950s and 1960s Armstrong traveled widely throughout the world as an unofficial ambassador of American culture. He performed frequently on television programs and appeared in films such as *The Glenn Miller Story* in 1953 and *Hello Dolly* in 1969. His song "Hello Dolly" replaced a Beatles selection as the nation's top popular recording in 1964. Toward the end of his life, however, Armstrong was frequently criticized for his failure to take a stronger stance against white racism in the United States.

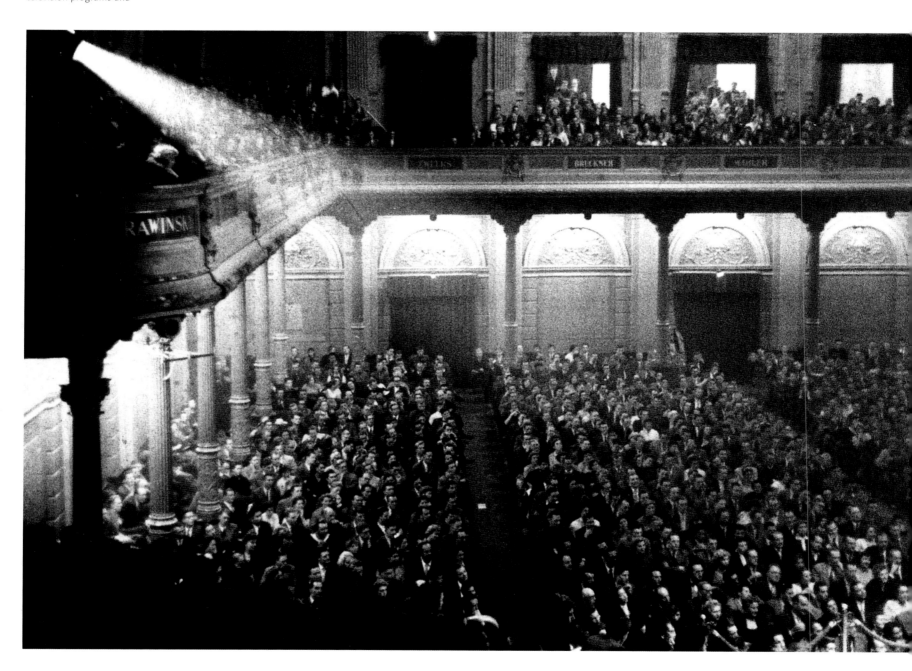

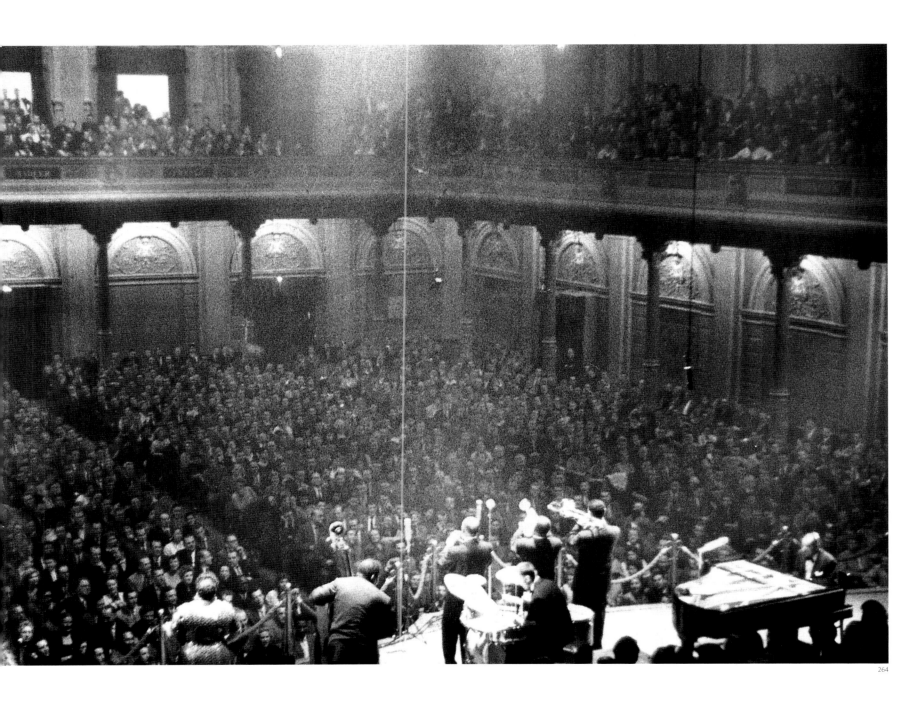

264

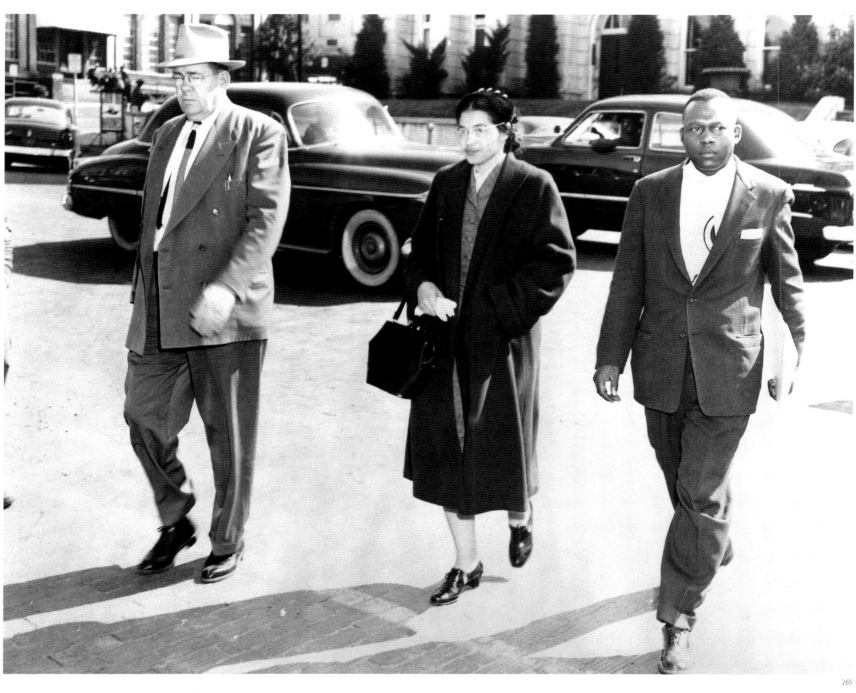

265. Rosa Parks on her way to jail, with her attorney Charles D. Langford (right) and a deputy police officer, Montgomery, Alabama, 1–5 December 1955. One of the greatest indignities that African Americans had to endure in the South was segregation in public transportation. In many southern cities, the majority of riders on public buses were African Americans, yet they were forced to sit in the back of the bus and to give up their seats to white people on demand. In 1953, civil rights activists in Baton Rouge, Louisiana initiated a successful boycott against the city's racially segregated public buses. In a compromise agreement, Baton Rouge buses were largely desegregated with seating on a first come, first serve, basis. However, whites retained the privilege of reserving two front seats for themselves, with the last seats reserved exclusively for blacks. In Montgomery the Women's Political Council, a black women's civic organization chaired by college professor Jo Ann Robinson, and the local NAACP, planned to initiate a similar campaign in their city. On Thursday, 1 December 1955, Rosa Parks, a highly respected seamstress and NAACP activist, was arrested for refusing to surrender her seat to a white man. When news spread of Parks' arrest, Robinson and local NAACP leader E. D. Nixon decided to implement a boycott of the city's public buses the following Monday. Overnight Robinson mimeographed 35,000 handbills urging blacks to support the boycott.

266. Woman boycotting the Montgomery buses, December 1955. On 5 December, over 95 percent of African Americans refused to ride the buses in Montgomery. Later that afternoon, boycott leaders formed the Montgomery Improvement Association (MIA) and elected a twenty-six year old minister, Dr. Martin Luther King, Jr., as its president. At a mass rally that evening, the decision was made to continue the boycott indefinitely. Many African American workers walked to work and hundreds, including Parks, were fired from their jobs in retaliation for the boycott.

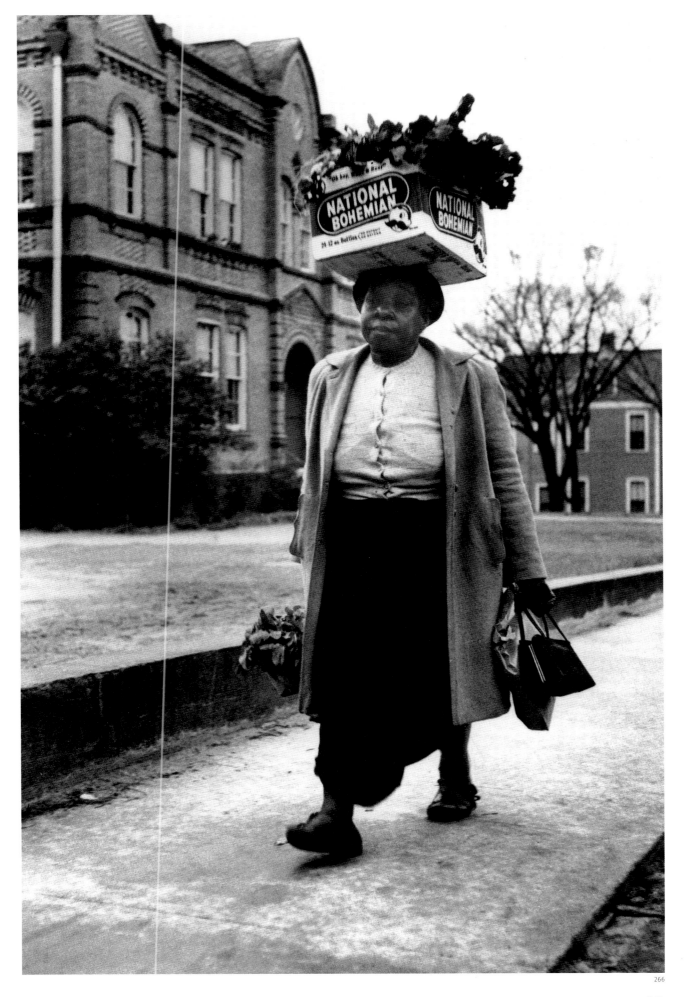

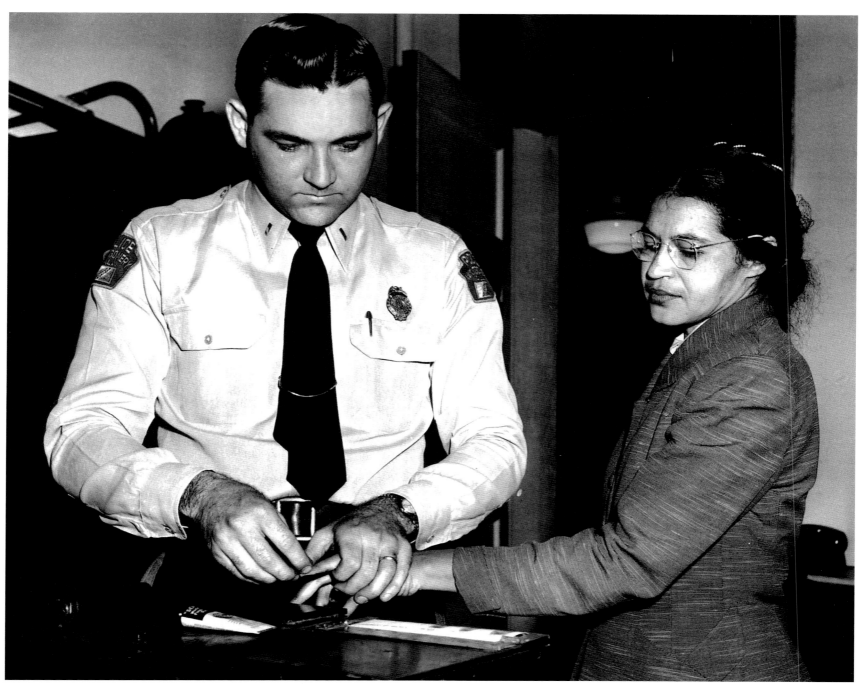

267

267. Rosa Parks being finger-
printed after her arrest,
Montgomery, 22 February
1956.

268. Dr. Martin Luther King,
Jr. arrested for his participa-
tion in the bus boycott in
Montgomery, 24 February 1956.
On 30 January 1956, Martin
Luther King, Jr.'s home was
firebombed. Two days later,
E. D. Nixon's home was also

firebombed. City leaders
attempted to convince several
black ministers to accept a
"compromise" that consisted
of reserving ten seats in the
front of each bus for whites,
ten seats in the back for
blacks, and the rest on a first
come, first serve basis.
When King and other leaders
rejected this proposal, city
leaders decided to use the full
weight of the criminal

justice system to destroy
the boycott. On 13 February
1956, a grand jury met to
consider indictments against
leaders of the MIA.
On 21 February, 89 African
Americans, including King,
were indicted for conspiring
to boycott. King was found
guilty, sentenced to a
$500 fine and court costs, or
386 days of hard labor.
He was released on bond.

The philosophy of non-violent
protest in the African
American freedom movement
is today largely associated
with King. However, it first
appeared as a distinct element
within the black freedom
movement in the early 1940s.
In Chicago in 1942, a small
integrated group of young
radicals led by Bayard
Rustin and James Farmer
created the Congress of Racial

Equality (CORE), which by
the mid-1940s was a loose
network of social justice
activists in cities scattered
across the Midwest and
the northeastern states.
CORE members, who were
influenced by Mohandas
Gandhi and the Indian
struggle for independence
against British colonialism,
employed techniques
of passive resistance to

demonstrate against racial
segregation. King's personal
commitment to non-violence
drew heavily from biblical
teachings and his Christian
faith, and his appreciation
of Gandhi's ideas were rein-
forced by Bayard Rustin,
among others. Non-violent
direct action became the
guiding strategy for the civil
rights movement.

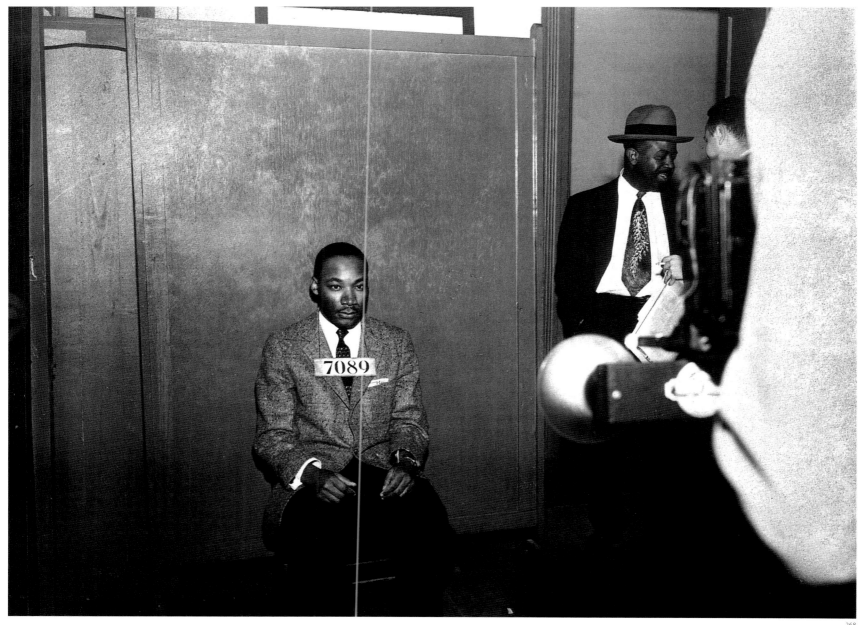

269. Congregation of boy-cotters at a rallying meeting led by Martin Luther King, Jr., Ralph Abernathy, and other leaders of the movement, Montgomery, February–March 1956.

270. Member of the Montgomery Improvement Association, 1956. The MIA organized extensive carpools to transport thousands of African Americans to work every day.

271. Line of parked, unused buses in Montgomery, 1956. An estimated 50,000 African Americans boycotted the Montgomery buses during the year-long protest until, on 13 November 1956, the U. S. Supreme Court finally out-lawed segregation on the city's buses. On 20 December, federal injunctions were served on Montgomery officials ordering them to halt the enforcement of segre-gationist policies. On 21 December, Montgomery's buses were integrated and the boycott was terminated. The black community had won a major victory, although whites continued to retaliate. Snipers periodically fired into buses, and the home and church of the Reverend Ralph Abernathy, a local leader of the boycott, were bombed several weeks later. However, the successful Montgomery boycott inspired similar efforts in Tallahassee, Florida and Birmingham, Alabama.

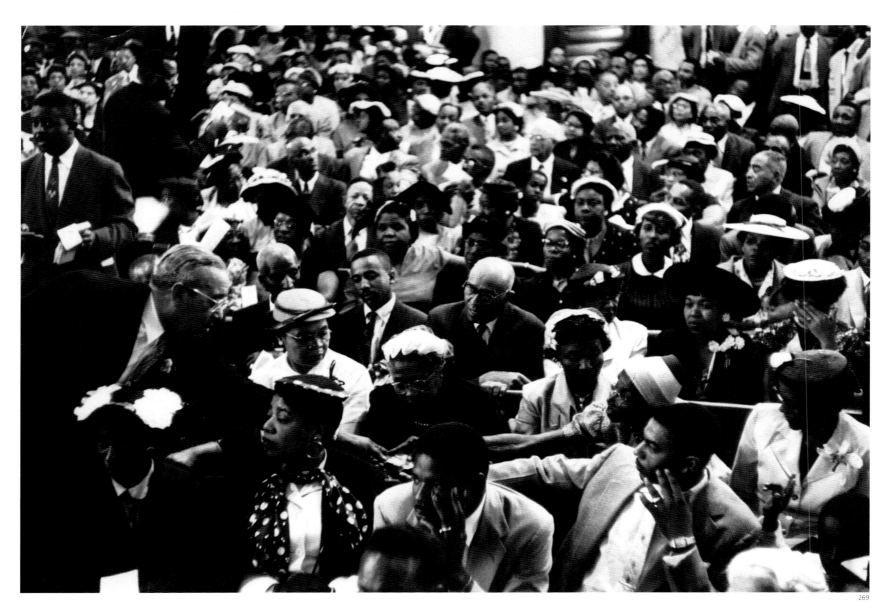

269

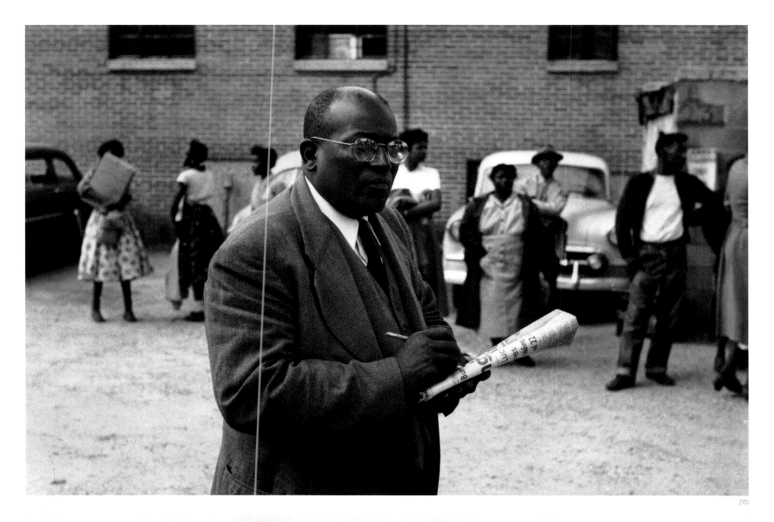

270

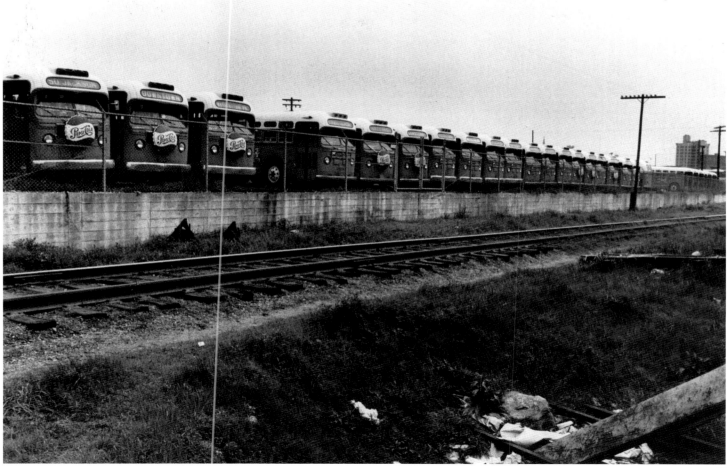

271

272. Autherine Lucy (left), an African American woman briefly enrolled in the University of Alabama, with NAACP attorney Thurgood Marshall (center, next to Lucy), February 1956. Despite the legal successes of the NAACP in desegregating major universities in the 1940s, the University of Alabama refused to admit black students, and this policy of exclusion came under increased pressure in the mid-1950s. In July 1955, Marshall and other lawyers of the NAACP Legal Defense Fund finally won a court decision requiring the University of Alabama to admit an African American woman, Autherine Lucy, along with "all similarly situated" applicants. In February 1956, when Lucy attempted to attend classes, hundreds of protesting whites yelling "lynch the nigger" and "keep 'Bama' white" overwhelmed the campus. After three days of threats and harassment Lucy withdrew from the university.

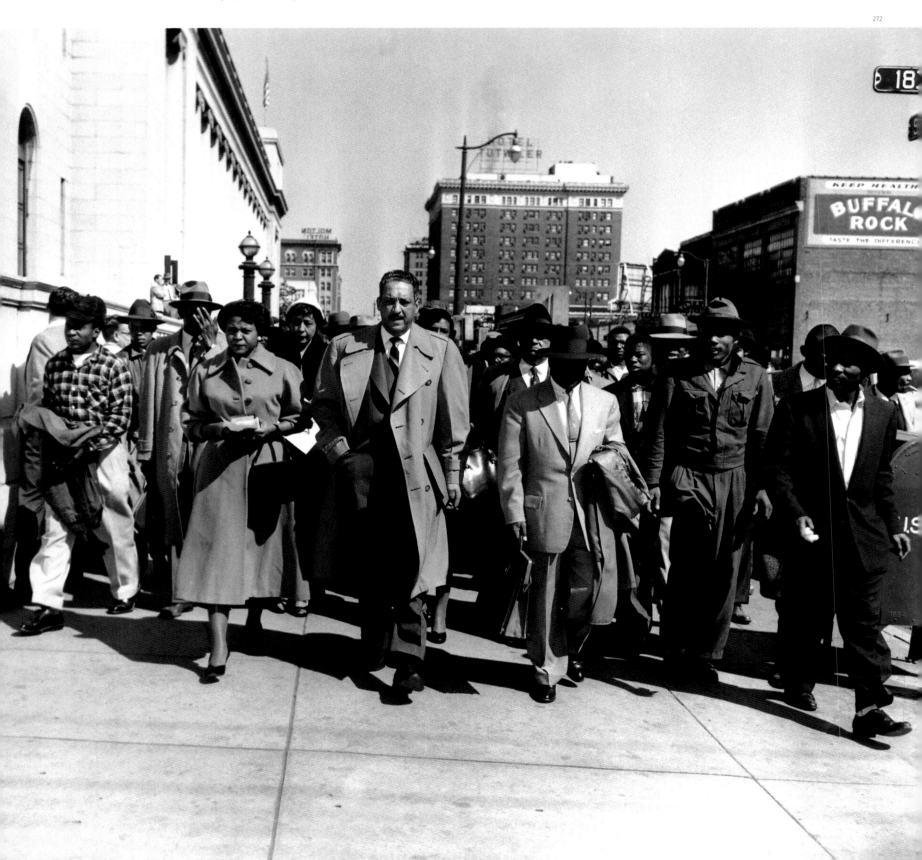

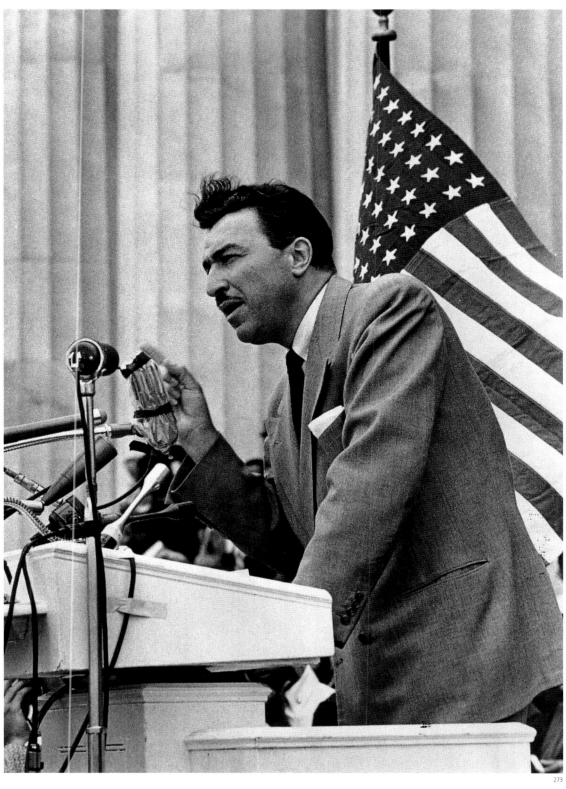

273. Adam Clayton Powell, Jr. speaking at the "Prayer Pilgrimage for Freedom" in Washington, D. C., 17 May 1957. In February 1957, Martin Luther King, Jr., Ralph Abernathy, T. J. Jemison and other civil rights leaders founded the Southern Christian Leadership Conference (SCLC) in New Orleans. King was selected as the organization's first president. Three months later, civil rights activists including Bayard Rustin and Ella Baker coordinated the "Prayer Pilgrimage for Freedom." The event marked the third anniversary of the *Brown v. Board of Education* decision, and was designed to pressure President Dwight Eisenhower's administration and Congress to support the enforcement of civil rights. Twenty thousand people attended the public demonstration. Speakers included actor Harry Belafonte, Birmingham civil rights leader Reverend Fred Shuttlesworth, Roy Wilkins, King, A. Phillip Randolph, and Harlem Congressman Adam Clayton Powell, Jr. Powell was the most influential black elected official in the country during the two decades after World War II. His father, Reverend Adam Clayton Powell, Sr. had served from 1908 to 1937 as head pastor of Abyssinian Baptist Church, one of the largest black churches in the United States. Powell Jr., who took over his father's ministry of Abyssinian, earned a reputation as a community activist, leading campaigns against job and housing discrimination in Harlem. In 1944 he was elected to Congress where he would serve for a quarter of a century.

273

269

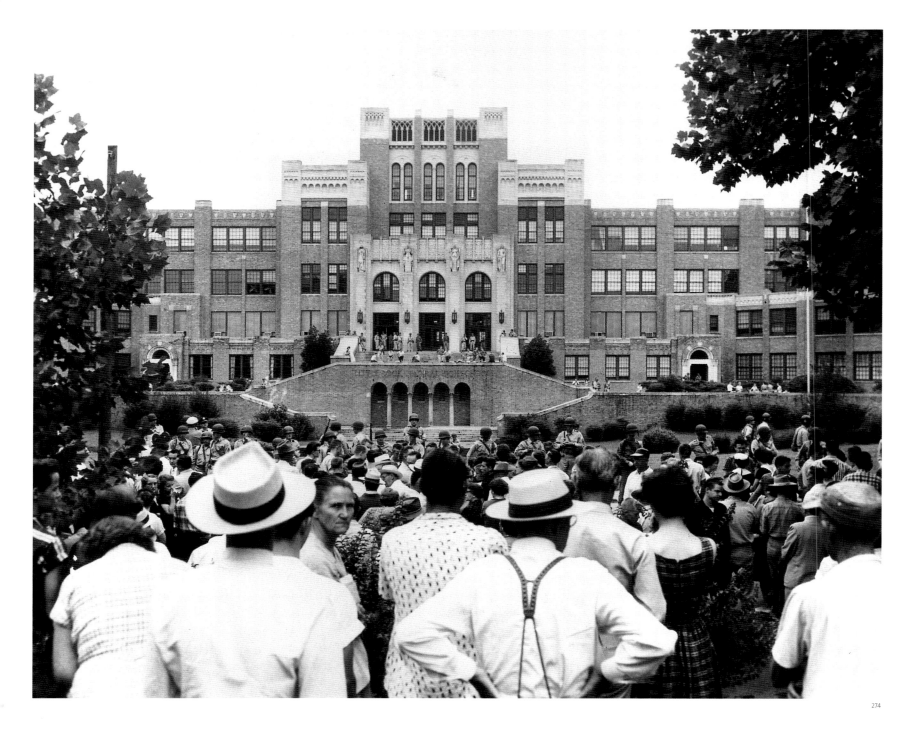

274. Crowd of spectators in front of Little Rock Central High School watching as National Guardsmen prevent African American students from registering, Little Rock, Arkansas, 3 September 1957. After the U. S. Supreme Court demanded school integration "with all deliberate speed" in 1955, a white backlash rapidly developed throughout the South. In 1956 white mobs in Mansfield, Texas, Clinton, Tennessee, and other southern towns demonstrated against the enrollment of blacks in all-white public schools. In Clay, Kentucky black students were able to enter public schools only with National Guard protection in September 1956. In Nashville, Tennessee an elementary school was destroyed by a bomb. In Birmingham, Alabama, the Reverend Fred Shuttlesworth was attacked when he attempted to enroll his daughters in a white school. In January 1956, twenty-seven African Americans attempted to enroll in Little Rock public schools but were refused admission. The NAACP subsequently filed a suit against the school system on the grounds that it had failed to enforce the *Brown v. Board of Education* decision. But when a federal district judge ordered the gradual integration of Little Rock schools, to become effective 3 September 1957, Arkansas Governor Orville Faubus ordered the Arkansas National Guard to surround Little Rock Central High School to prevent the registration of black students. On 3 September, a white mob of three hundred people gathered to heckle the young African American students.

275. Elizabeth Eckford in front of Little Rock Central High School, 4 September 1957. Forty years later, in a speech honoring the "Little Rock Nine," President Bill Clinton remarked, "Forty years ago, a single image first seared the heart and stirred the conscience of our nation; so powerful most of us who saw it then recall it still. A fifteen-year-old girl wearing a crisp black-and-white dress, carrying only a notebook, surrounded by large crowds of boys and girls, men and women, soldiers and police officers, her head held high, her eyes fixed straight ahead. And she is utterly alone. On September 4th, 1957, Elizabeth Eckford walked to this door for her first day of school, utterly alone. She was turned away by people who were afraid of change, instructed by ignorance, hating what they simply could not understand. America saw her, haunted and taunted for the simple color of her skin, and in the image we caught a very disturbing glimpse of ourselves."

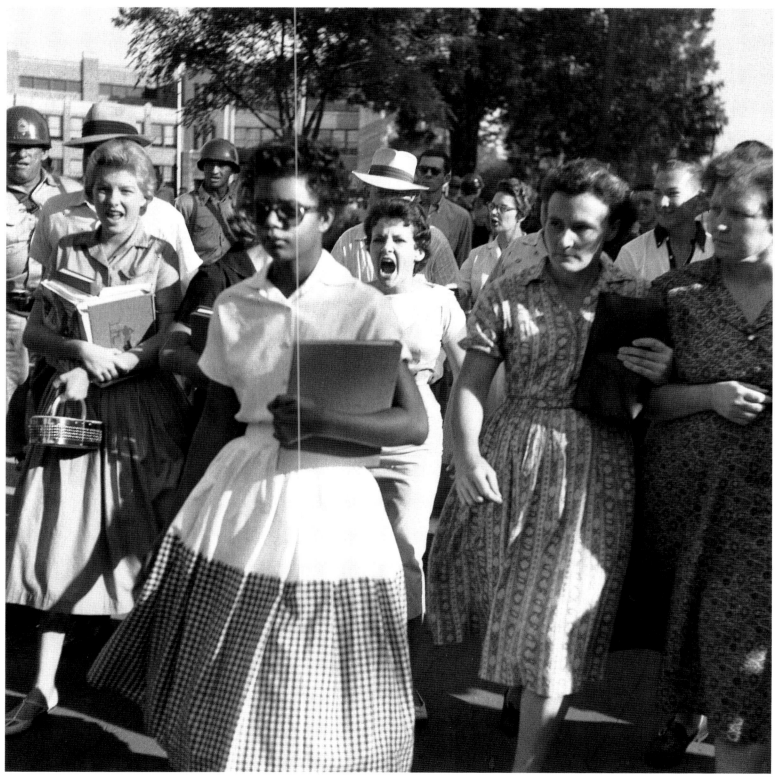

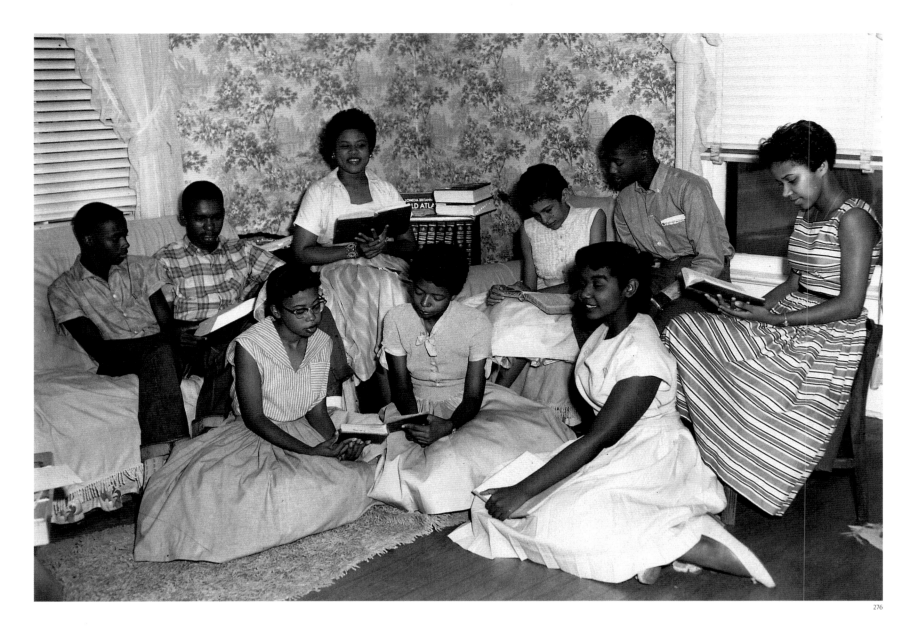

276. The nine students who were prevented from entering Little Rock Central High School created their own study circle, early September 1957. Seated on the floor from left to right: Thelma Mothershed, Elizabeth Eckford, and Melba Pattilo; above from left to right: Jefferson Thomas, Ernest Green, Annie Jean Brown, Carlotta Walls, Terrence Roberts, and Gloria Ray.

277. Troops escorting the nine black students into Little Rock Central High School, 25 September 1957. On 20 September the federal court demanded that Arkansas Governor Faubus enforce the law. Faubus removed the National Guard and ordered the Little Rock police to take their place. On 23 September, when the nine black students entered the building, a crowd of 1,000 whites surrounded the school demanding their removal. The black students were taken out of the school through the side door. The following day, President Eisenhower federalized the Arkansas National Guard and sent 1,000 federal troops to Little Rock to restore order. On 25 September, under heavy escort by Army troops, the nine black students finally entered the school. Most of them remained there throughout the school year and one of the students graduated with 600 white classmates at the May commencement. However, in a special session of state legislature in August 1958, Governor Faubus demanded that public schools be closed to prevent desegregation. By an overwhelming majority of 129,500 to 7,600, a statewide referendum endorsed the opposition to integration, and for the entire 1958–1959 school year, Little Rock's public high schools were closed. In June 1959 federal courts declared Arkansas' school closing law unconstitutional. Finally in August 1959 schools were reopened and small numbers of black students enrolled, but Little Rock schools were not fully integrated until 1970.

278. Little Rock Central High School, 25 September 1957. Three men from the mob are escorted away by soldiers of the 101st Airborne Division.

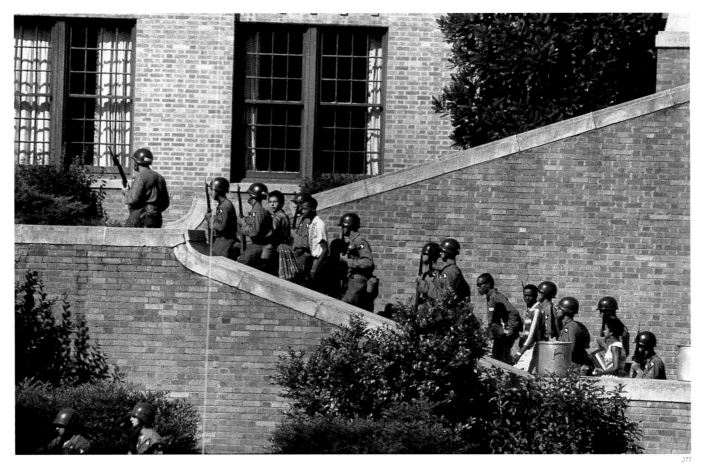

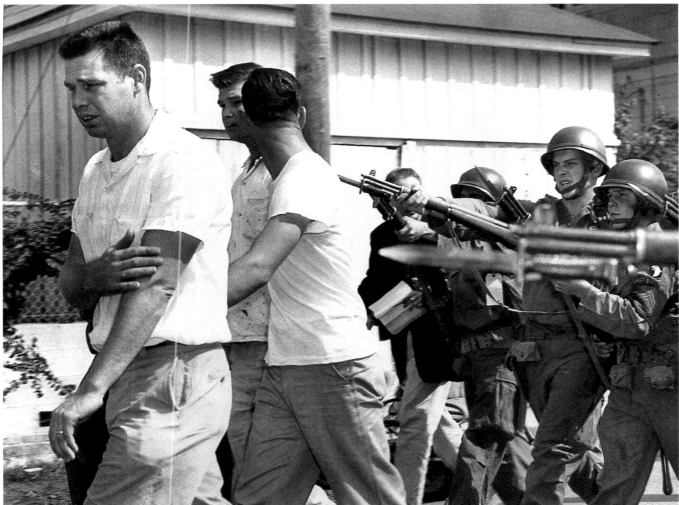

279. Septima Clark (seated, center) leading a citizenship-education class, John's Island, South Carolina, 16–23 January 1959. Septima Poinsette Clark was born in South Carolina in 1898 and was educated at Benedict College and Hampton Institute. Like W. E. B. Du Bois, Clark was committed to using education for empowerment. As a young school-teacher, she became convinced that adult literacy programs and lifelong learning courses could empower working-class and low-income African Americans. In the 1950s, she initiated "citizenship schools," teaching rural and poor blacks how to register to vote, as well as basic consumer skills. In 1961 Clark's project was adopted by the Southern Christian Leadership Conference (SCLC). Tens of thousands of those who participated in her program became involved in desegregation efforts across the South.

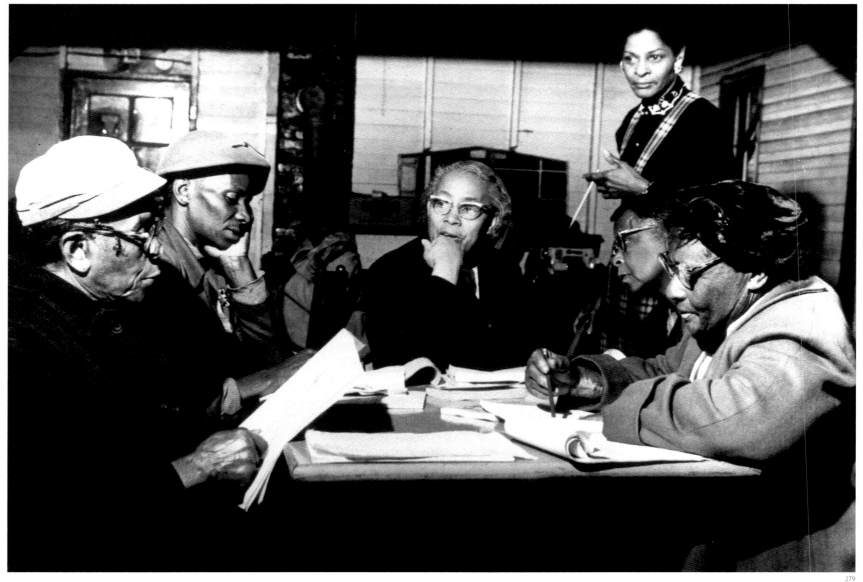

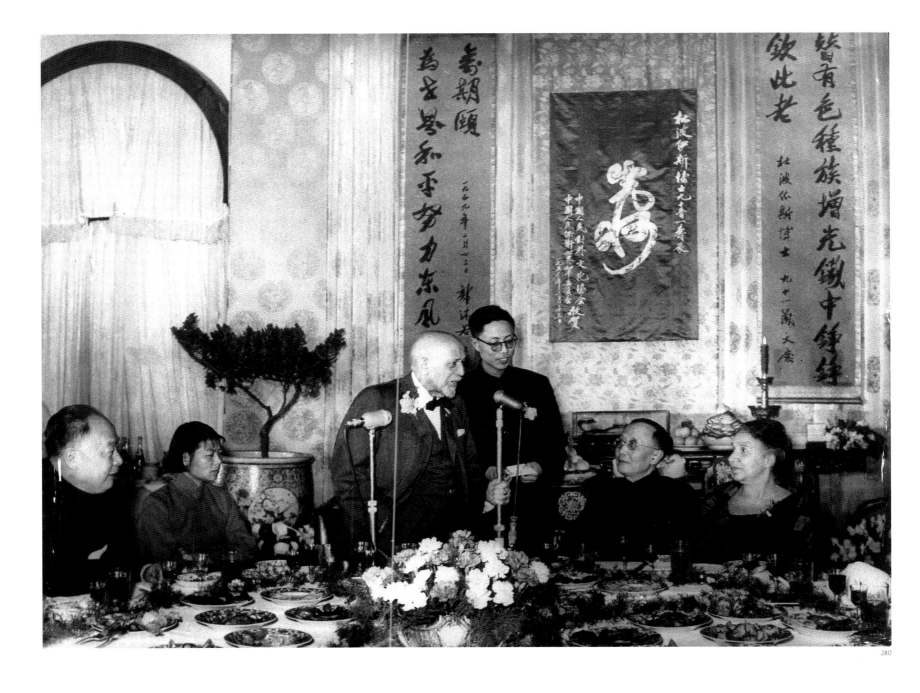

壽期頤 為至善和平努力東風

一九五九年二月廿三日 郭沫若

杜波伊斯博士九青一壽辰

中國人民對外文化協會 中國人民保衛世界和平委員會敬賀

賢育色種族增光鐵中鏗鏘

杜波依斯博士 九十一壽 文慶

欽此老

280. W. E. B. Du Bois celebrating his ninety-first birthday in Beijing, 23 February 1959. Throughout the 1950s Du Bois was subjected to surveillance and harassment by the federal government. When the Supreme Court ordered the State Department to release his passport which had been confiscated, Du Bois used the opportunity to travel extensively abroad. He was enthusiastically welcomed in the People's Republic of China, where his ninety-first birthday was marked by an official ceremony. At this event, which was broadcast across the country, Du Bois stated, "I speak with no authority; no assumption of age nor rank; I hold no position, I have no wealth. One thing alone I own and that is my own soul. Ownership of that I have even while in my own country for near a century I have been nothing but a 'nigger.' On this basis and this alone I dare speak, I dare advise." On 1 December 1961 Du Bois joined the Communist Party of the United States, and four days later departed permanently for Ghana. Well into his nineties, he remained intellectually and politically active. He revived his project to create an Encyclopedia Africana, and was an informal advisor to Ghanaian President Kwame Nkrumah. Du Bois died in Ghana at the age of 95, only hours before the historic 1963 March on Washington. The United States embassy refused to send a representative to the state funeral organized in Du Bois' honor by President Nkrumah.

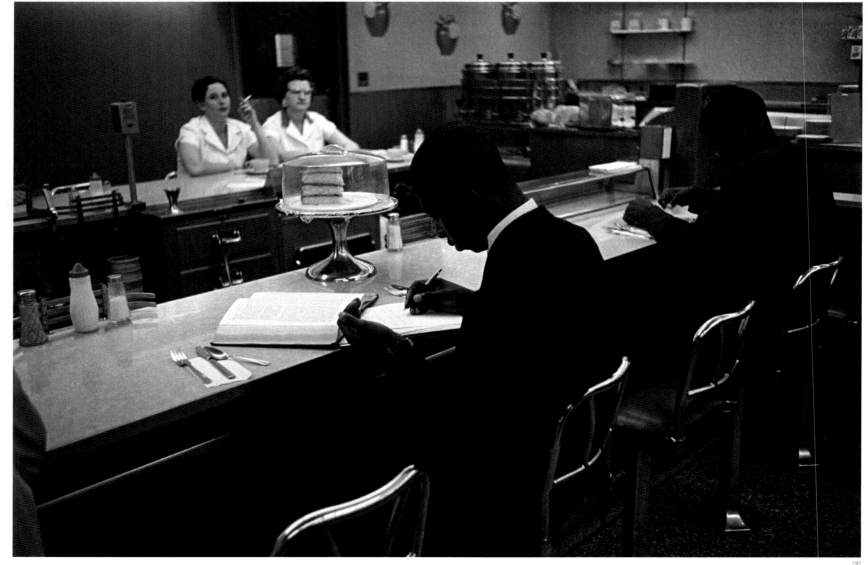

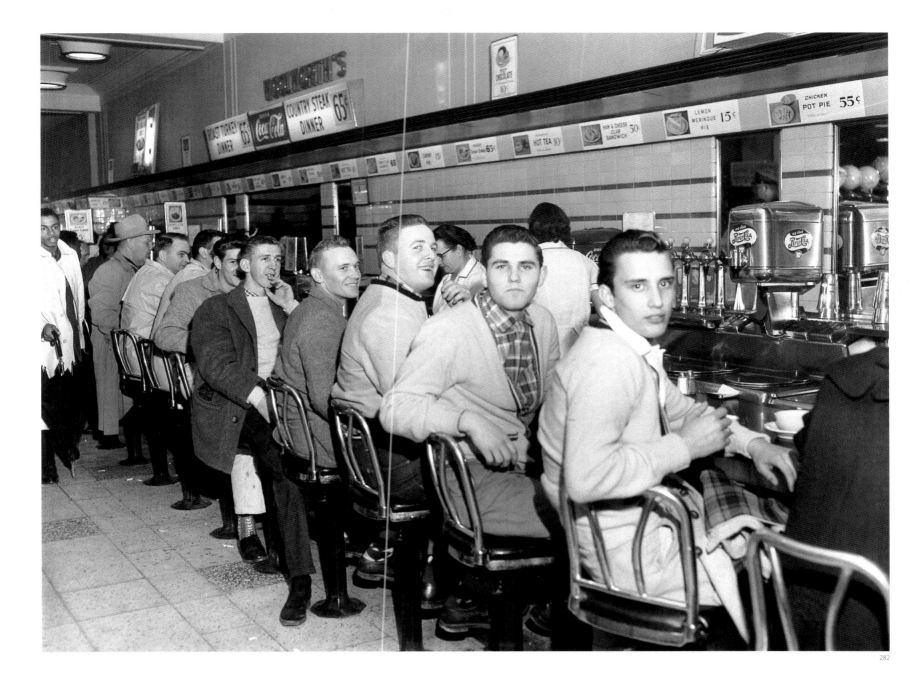

281. Sit-in demonstration in Raleigh, North Carolina, 10 February 1960. On 1 February 1960 four African American college students initiated a non-violent protest at the Woolworth's store segregated lunch counter in Greensboro, North Carolina. Over the course of several days, hundreds of students participated in what would be known as "sit-in" demonstrations, which, within weeks, spread to other cities. White officials pressured administrators at black colleges to discipline or expel students and faculty participating in the demonstrations. Over 140 students and at least 58 professors were dismissed. Nevertheless, black students initiated sit-ins in Durham and Winston Salem, North Carolina; in Nashville, Tennessee, Fisk University student Diane Nash and theology student James Lawson organized a successful desegregation campaign. Students at St. Augustine's College and Shaw University in Raleigh sat in at the lunch counters of many stores throughout the state capital, in response to which a number of them closed their lunch counters and one store removed the stools, permitting black and white customers to eat together while standing. Although demonstrators were non-violent in their acts of protest and did not respond to provocations, angry whites frequently assaulted them. Students at Shaw University created the Student Nonviolent Coordinating Committee (SNCC) to organize these sit-in demonstrations and publicize their activities.

282. White youths taking up counter space at Woolworth's to block sit-in demonstrations, Greensboro, North Carolina, February 1960. Woolworth's in Greensboro was the site of the first protest. It was desegregated in the summer of 1960.

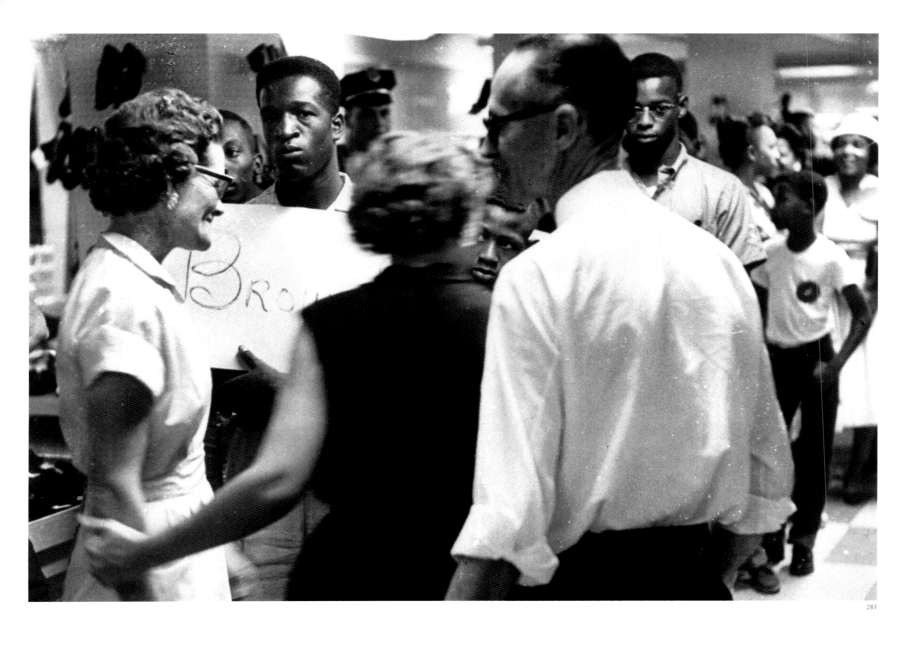

283

283. Sit-in demonstration in Oklahoma City, 6 August 1960. Under the leadership of sixteen-year-old Barbara Posey, the NAACP Youth Council initiated what became year-long demonstrations at several major eating places in down-town Oklahoma City. In this picture, employees at a local lunch counter are admitting whites, but barring the entrance to African Americans.

284. Demonstration against segregation in Baton Rouge, Louisiana, 1960.

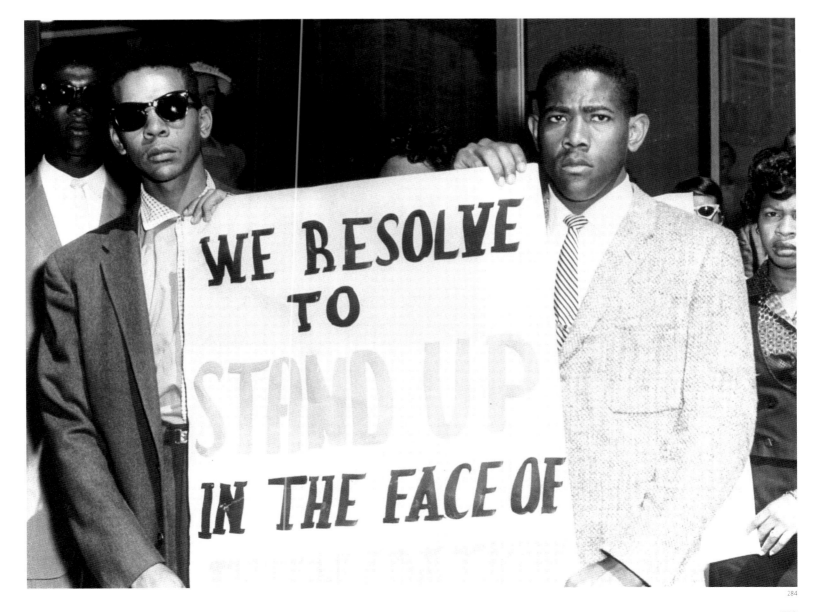

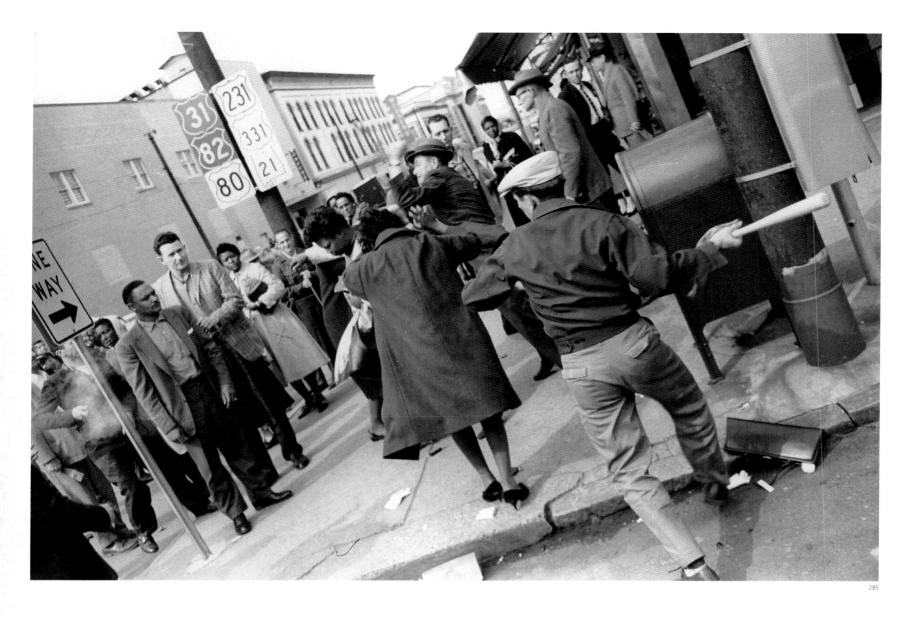

285

285. Two white men attacking black students on the day after the students were refused service in an all-white cafeteria in Montgomery, Alabama, 1960. In a series of demonstrations, Alabama State College students held sit-in protests throughout Montgomery, including at the courthouse building on 25 February. On 1 March over 1,000 students marched on the capitol building demanding an end to segregation. The next day, nine student leaders were expelled from the college for their involvement in the sit-ins.

286. Duke Ellington in concert, New York City, 1960.

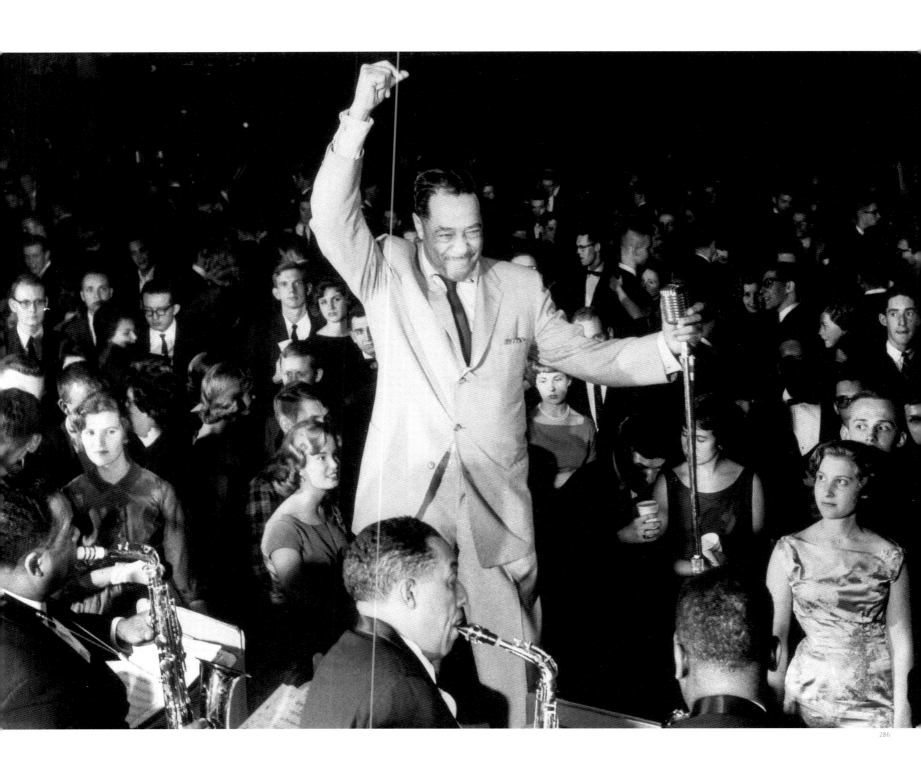

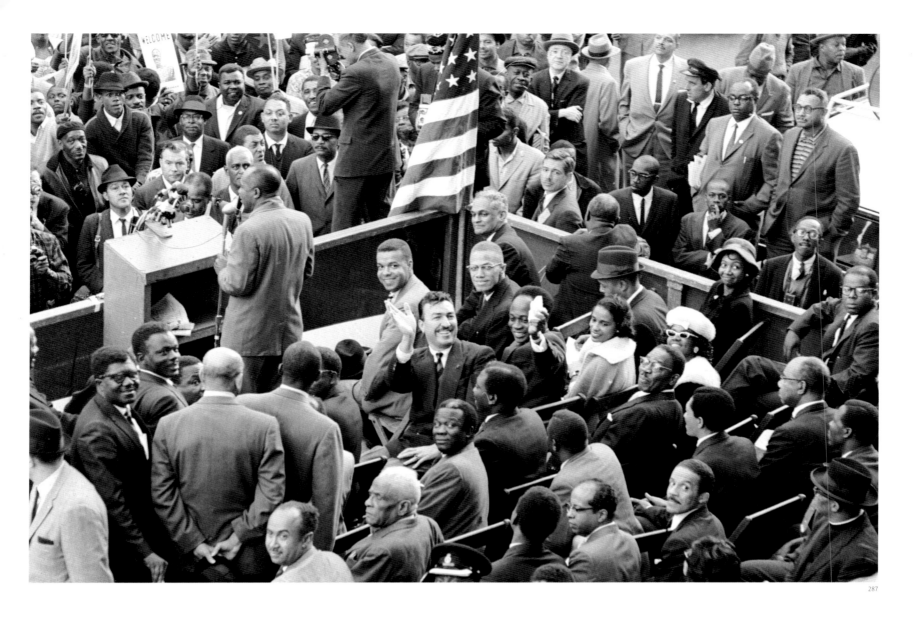

287. "American Committee on Africa" rally in Harlem in honor of Kwame Nkrumah, leader of the newly independent Ghana, New York City, 5 October 1960. Malcolm X (in the center with glasses) is seated right in front of Kwame Nkrumah and Adam Clayton Powell, Jr. (with raised hands). Nkrumah was born in what was then known as the Gold Coast in 1909. He attended both Lincoln University in Pennsylvania and the University of Pennsylvania, and spent several years in the United States. Returning to the Gold Coast in 1947, he became the Secretary General of the United Gold Coast Convention, a party of middle-class Africans who advocated home rule, and subsequently created a more militant political organization, the Convention Peoples' Party, that promoted mass protest and boycotts against British rule. He was arrested and imprisoned, but in 1951, while in prison, Nkrumah's party achieved a majority of seats in the legislative assembly election and he became the head of the government. When the Gold Coast became an independent state — Ghana — in 1957, Nkrumah became its prime minister. Nkrumah was very knowledgeable about race in the United States and was extremely popular among African Americans. His appeals to Pan-Africanism and Third World solidarity had a profound impact upon African American civil rights activists. His popularity also reflected the long relationship of African Americans with Africans and people of the African diaspora.

288. Counter-demonstration by members of the Nation of Islam during NAACP rally in Harlem, 1961. African Americans were profoundly affected by the independence movements that spread across Africa in the 1950s and 1960s. The charismatic prime minister of the independent Congo, Patrice Lumumba, was especially popular among black nationalists in the U. S. When Lumumba was assassinated, with American involvement, in 1961, many black Americans protested.

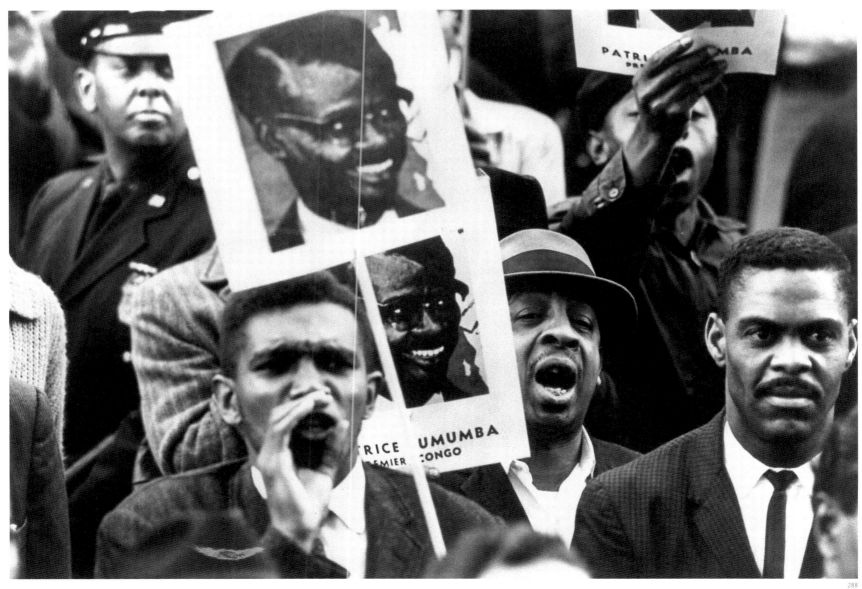

288

283

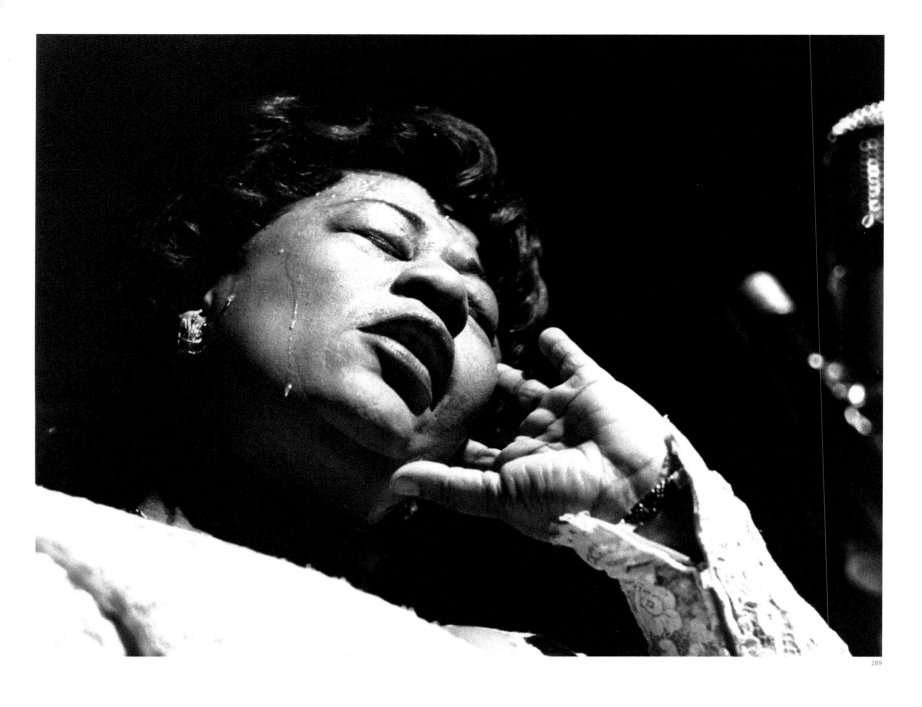

289

289. Ella Fitzgerald at the
Olympia theater in Paris, 1960.

290. Elijah Muhammad (left), patriarch of the Nation of Islam (NOI), and NOI minister Malcolm X, head of the Harlem-based Mosque #7, conferring before a public rally in New York City, 1961. The Nation of Islam was established in Detroit during the Great Depression. A marginal religious sect initially, it drew on elements of traditional Sunni Islam and the black nationalism of Marcus Garvey. For forty years, the patriarch of this religious movement was Elijah Poole, who became known a Elijah Muhammad. During World War II, many NOI members refused to join the military and Muhammad spent several years in prison as a draft resister. While incarcerated, he recognized the vast potential for recruiting prisoners and the most disadvantaged members of black society into his organization. In the 1950s, the NOI grew at least ten-fold, claiming as many as 100,000 members by 1960. The leader most responsible for the organization's powerful influence within African American society and in the national media was the charismatic Malcolm X. He was born Malcolm Little in Omaha, Nebraska in 1925, to parents who were active members of Garvey's Universal Negro Improvement Association. When Malcolm was a young boy, his father was brutally murdered, probably by white racists. After his mother was institutionalized for mental illness, Malcolm and his siblings were placed in foster care. Later he moved to Boston to live with his half-sister. During World War II, Malcolm became a hustler and petty criminal, known in New York's Harlem and Boston's Roxbury section as "Detroit Red." In 1946 he was arrested, charged with burglary, and sentenced to a ten-year prison term. While in prison, Malcolm was attracted to the teachings of Muhammad, and after some initial resistance became a member of the NOI. Following the organization's tradition, Malcolm Little discarded his "slave" surname, and was renamed Malcolm X — the "X" standing for the unknown African heritage that had been lost during the slave trade. Upon his release from prison in 1952, Malcolm X quickly became an important lieutenant of Muhammad and was rapidly given a series of responsible positions. In 1954 he became the head of Harlem's Temple #7, a position he would hold for almost ten years. Travelling extensively throughout the country, Malcolm X recruited thousands of new members annually through his powerful public appearances and outreach efforts to the poorest and most oppressed sectors of the black community. He attracted the attention of the white national media through his quick intellectual engagement and his outspoken views about white racism. In 1961 Malcolm X founded the publication *Muhammad Speaks,* which became one of the most widely read African American newspapers in the United States.

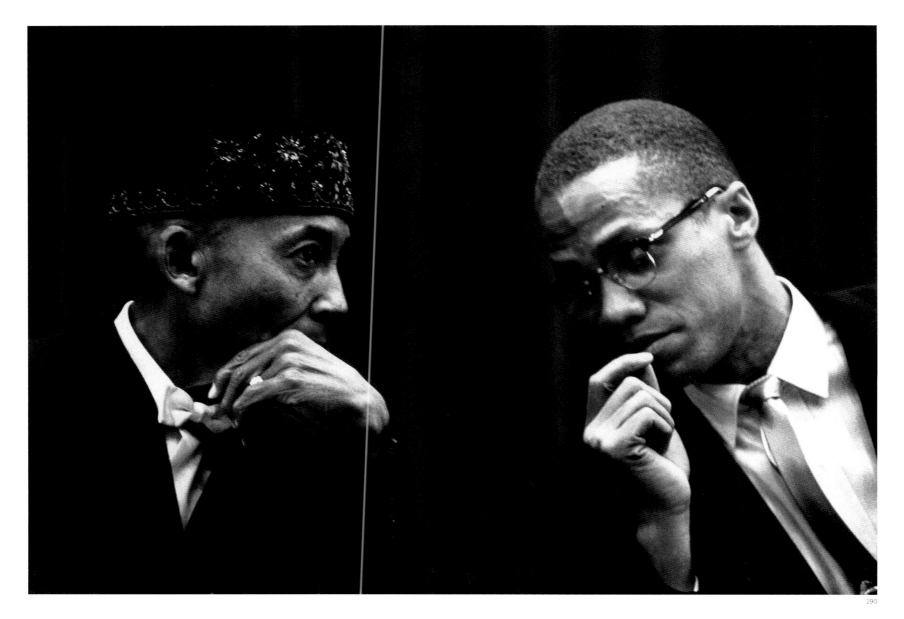

290

291. Bus transporting "Freedom Riders" set on fire by a white mob in Anniston, Alabama, 14 May 1961. In the late 1940s, the Congress of Racial Equality (CORE) had organized a series of non-violent protests to challenge racial segregation on interstate bus routes. These protests, called "the journeys of reconciliation," had brought teams of whites and blacks to challenge segregation laws together by sitting in white sections of buses. Nearly fifteen years later when the Supreme Court ruled that segregation on bus and railroad transportation was unconstitutional, CORE revived this form of nonviolent protest under the new name of "Freedom Rides." Starting on 4 May 1961, groups of black and white protestors traveled from Washington, D. C. to Atlanta, and then to cities and towns in the Deep South. Whites deliberately sat with blacks in white-only waiting rooms and restaurants to challenge local segregation codes. Freedom Riders were frequently harassed, arrested, and assaulted. In one incident, when Freedom Riders reached Anniston their buses were overrun by an angry mob of at least 200 whites. On one bus the tires were slashed, and when the driver left the vehicle to change them, the bus was firebombed. The second bus was overwhelmed by the mob and the riders were forcibly removed and viciously beaten. One rider was paralyzed for life and another was subject to permanent brain damage from the attack.

292. Man from the mob kicking a news photographer in Montgomery, Alabama, 20 May 1961. Despite assurances from Alabama Governor John Patterson that they would receive protection upon their arrival in Montgomery from Birmingham, when the Freedom Riders arrived neither police nor state highway patrolmen were present in the bus terminal. Mobs of whites attacked them, focusing their anger on Jim Zwerg, a white Freedom Rider, who was brutally beaten. John Lewis, a seminary student who later became head of SNCC, and two decades later a congressman from Georgia, was knocked to the ground and beaten unconscious. A U. S. Justice Department official was also beaten unconscious.

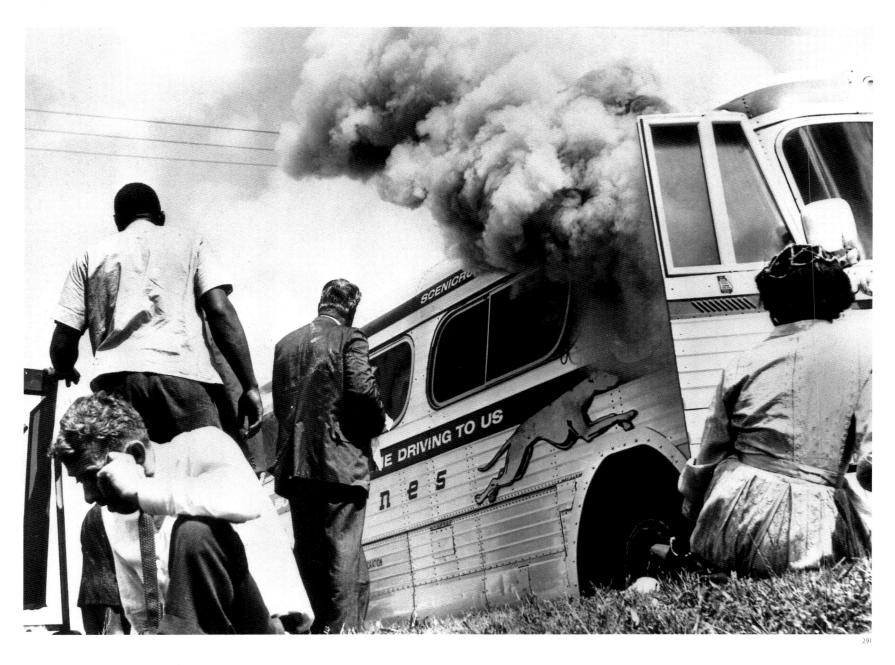

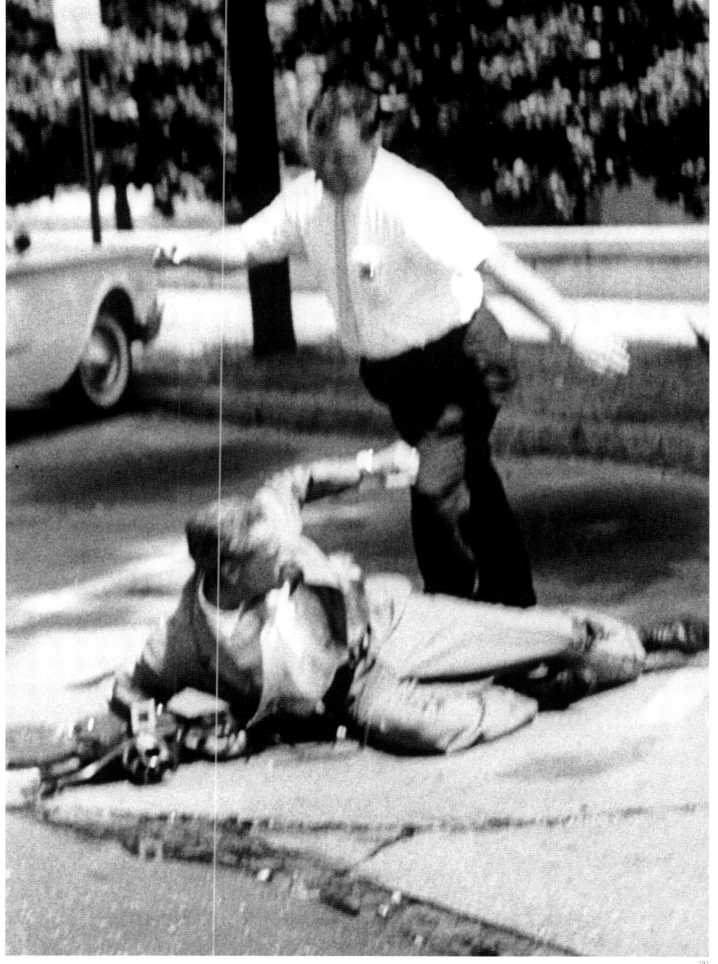

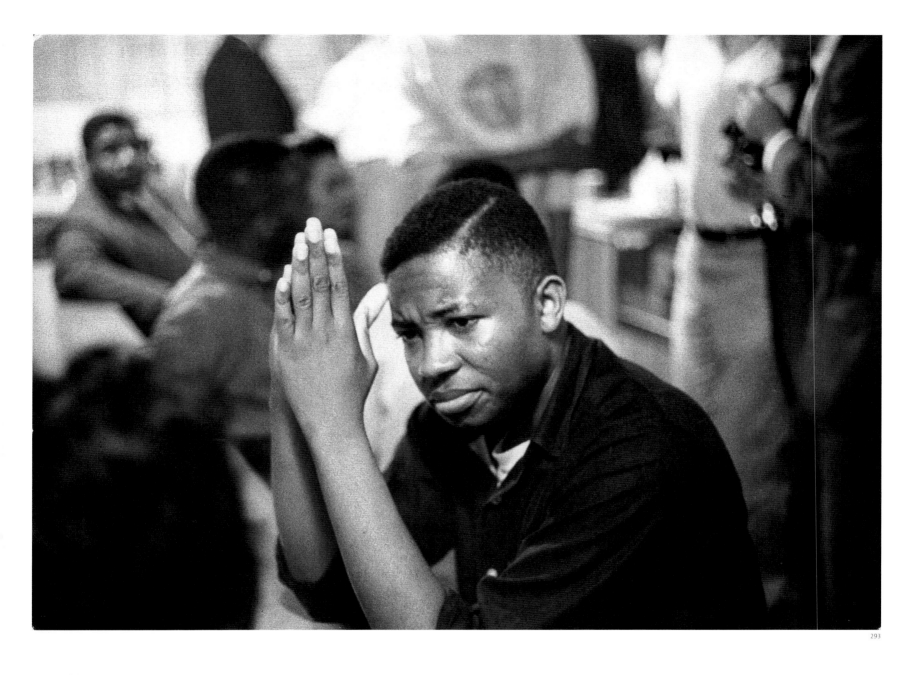

293

293. Freedom Rider in
Montgomery, Alabama, 1961.

294. First Baptist Church in
Montgomery, 21 May 1961.
In response to the violence
carried out against Freedom
Riders, Martin Luther King, Jr.
went to Montgomery to
show his support. During his
address at the First Baptist
Church, a white mob
surrounded the building. The
governor of Alabama
declared a state of martial
law. At 4 am the troops
arrived at the church and
escorted the parishioners
safely to their homes. As
state police and the National
Guard were called into
Montgomery, the crowds of
white vigilantes disappeared.

295. Attorney General Robert
F. Kennedy (right) with
Harold F. Reis, first assistant
in the office of legal counsel,
considering the course of
action to be taken about the
situation in Montgomery,
21 May 1961. The morning
after the mob violence at the
Montgomery church,
U. S. Attorney General Robert
Kennedy urged Freedom
Riders to declare a "cooling-
off period." But after CORE
leader James Farmer and
other activists refused,
Kennedy approached
Mississippi senator James O.
Eastland to guarantee the
safety of Freedom Riders
traveling through Mississippi.

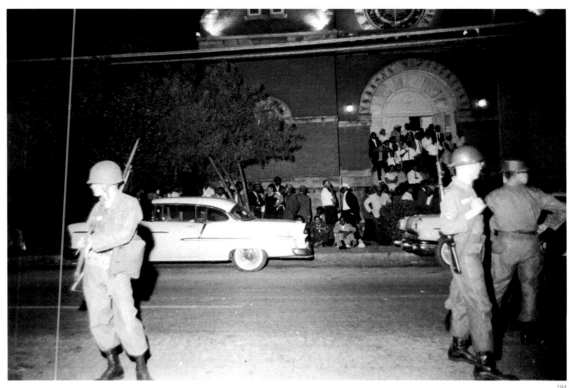

294

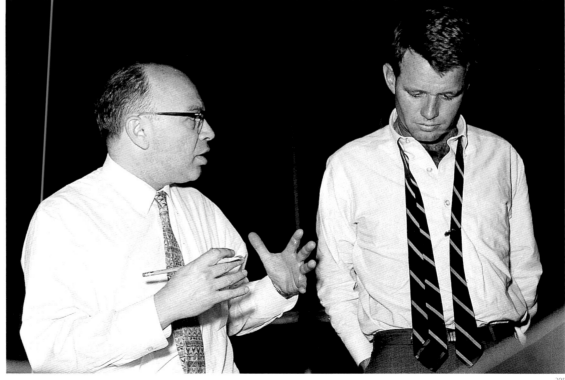

295

296. Freedom Riders in Montgomery, Alabama, on a bus to Jackson, Mississippi, 24 May 1961.

297. Freedom Riders arrive in Jackson, 26 May 1961. When the Freedom Riders arrived at the Jackson bus depot, there were no white mobs ready to assault them as there had been in Montgomery. However, when they entered "white-only" waiting rooms they were immediately arrested by local police officers on charges of disturbing the peace. They were tried, convicted, and sentenced to sixty days in the state prison.

298. Bus depot, Jackson, 26 May 1961. The ordeals of the Freedom Riders were widely publicized throughout the world and generated significant support for the cause of racial desegregation in the South. During the first two years of his administration, President John F. Kennedy attempted to placate white southern Democrats by not aggressively supporting a civil rights agenda. However, the bloody events in Alabama convinced Attorney General Robert Kennedy that greater action on behalf of desegregation activists was needed. Based on his urging, the Interstate Commerce Commission finally banned racial segregation on inter-state bus transportation on 22 September 1961.

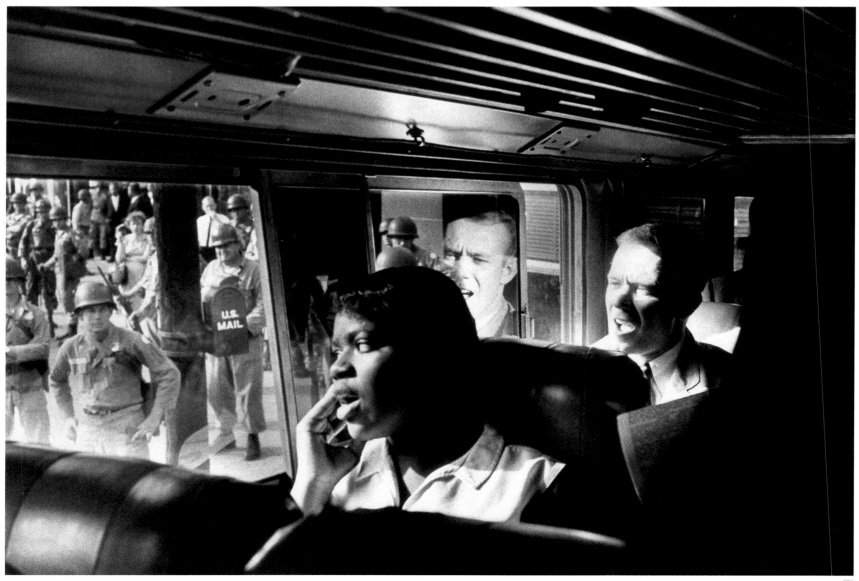

296

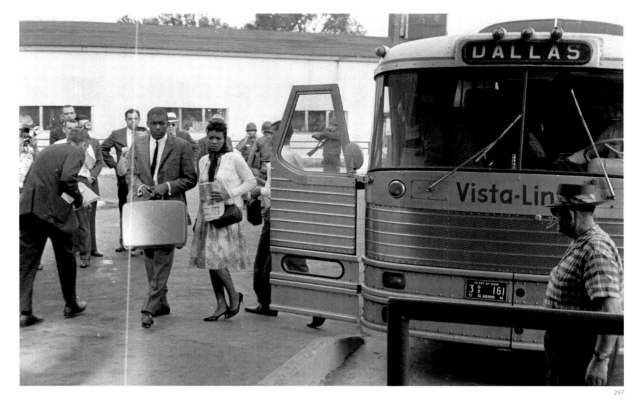

297

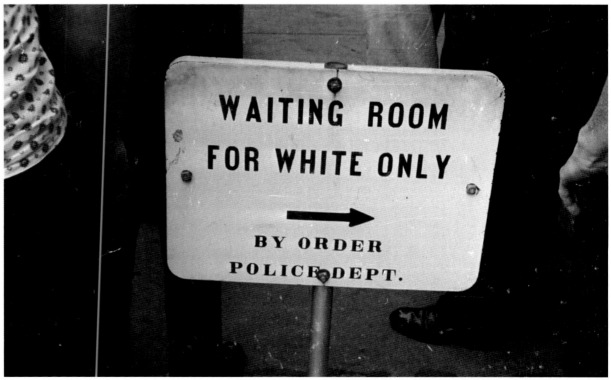

298

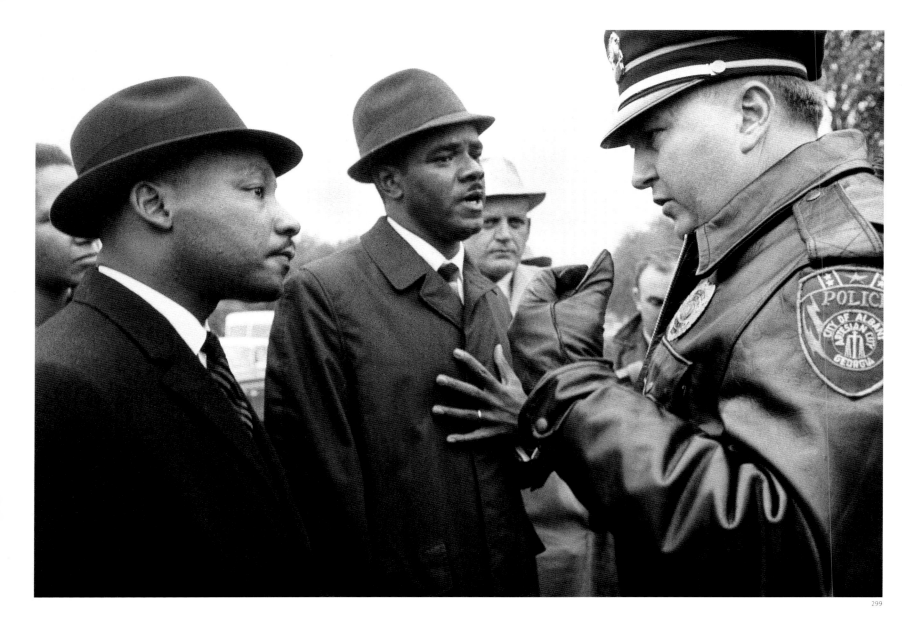

299

299. Police chief Laurie Prichett arresting Martin Luther King, Jr. (left) and W. G. Anderson in Albany, Georgia, 16 December 1961. A series of desegregation campaigns were organized in 1961 in the small southern town of Albany, largely by African American college students and a coalition of local black ministers. After the initial wave of demonstrations, local leaders invited King and other SCLC leaders to the town, primarily to provide moral support and to attract national media attention to their campaign. Against the advice of most of his aides, King personally led a non-violent protest march and was promptly arrested. The desegregation campaign dragged on for months throughout 1962, frustrated by the counter-protest tactics of Albany's police chief, Laurie Prichett. Prichett and town officials provoked divisions among local black leaders, creating tensions within the civil rights coalition, and protesters by the hundreds were deliberately shipped miles away from Albany to neighboring county jails. In late 1962, when King withdrew from the Albany campaign, the town remained largely segregated, and full integration would not occur for several years. Despite its relative failure, the Albany campaign provided an important lesson for the civil rights movement. It proved the need to first develop strong local leadership and coalitions before calling for the involvement of national organizations.

300. James Meredith being escorted by U. S. marshals to register at the University of Mississippi, 1 October 1962. Perhaps the greatest resistance to the dismantling of legal racial segregation occurred in Mississippi. In the state's "Black Belt," African Americans significantly outnumbered whites, and any shift in political power would have threatened the white political and economic establishment. Racist rhetoric and vigilante violence were frequently used to divide the poor and to prevent African Americans from asserting their civil rights. The state's segregationist policies were decisively challenged, however, when James Howard Meredith, a 28-year-old African American, applied for admission to the University of Mississippi in 1961. Officials rejected Meredith's application, and a suit was filed in federal court on his behalf. The U. S. Supreme Court ruled in Meredith's favor, ordering that he be admitted to the university, and U. S. marshalls were deployed to escort him to class after the governor of Mississippi personally attempted to block his entry. President Kennedy was forced to station federal troops at the campus as white rioters destroyed automobiles and campus property. By the end of the rioting, two people had been killed and hundreds were injured. Twelve thousand federal troops remained on campus for a short time to keep order. Despite personal abuse and racist intimidation, Meredith completed his studies at the university, successfully graduating in 1963, after which he moved to Nigeria to further his studies.

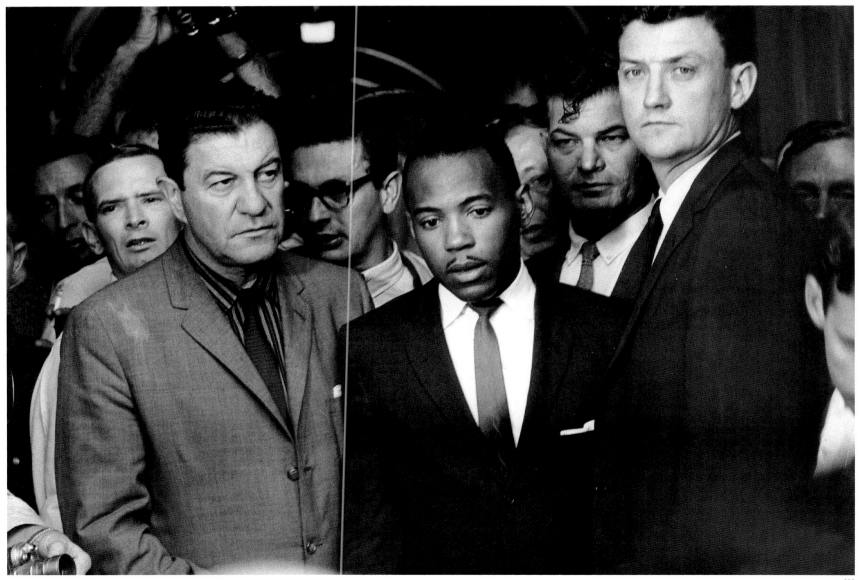

300

301. Troops deployed to the University of Mississippi to guarantee the registration of James Meredith, early October 1962.

302–303. The University of Mississippi during the registration of James Meredith, early October 1962.

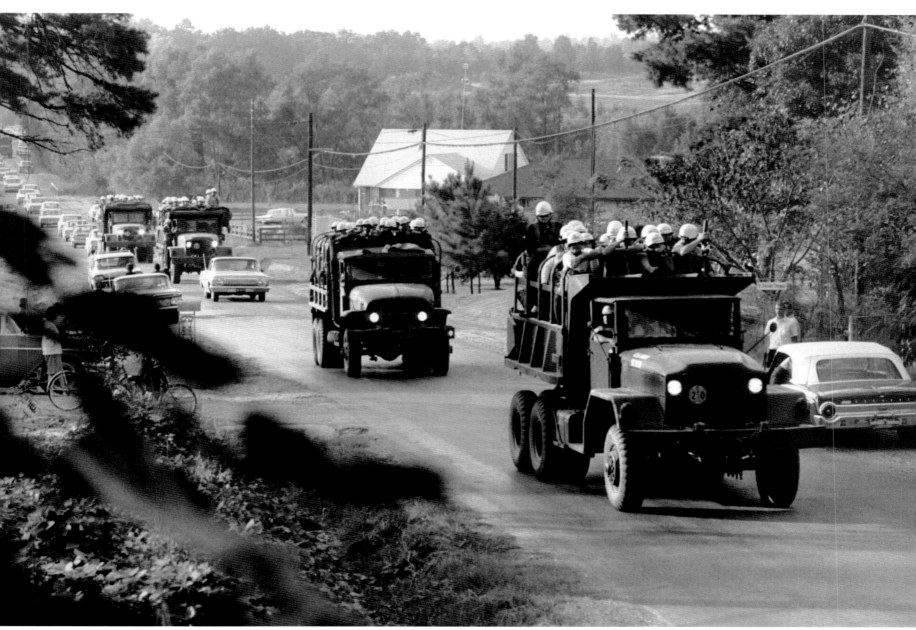

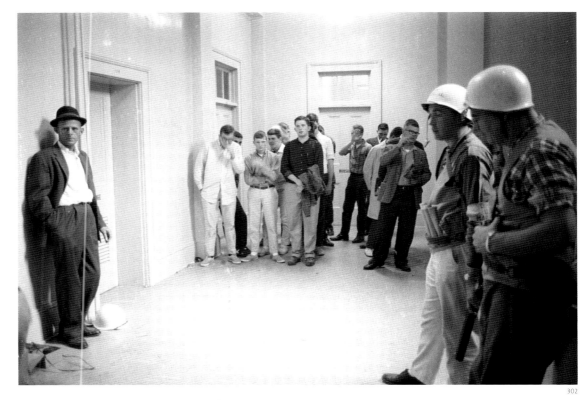

302

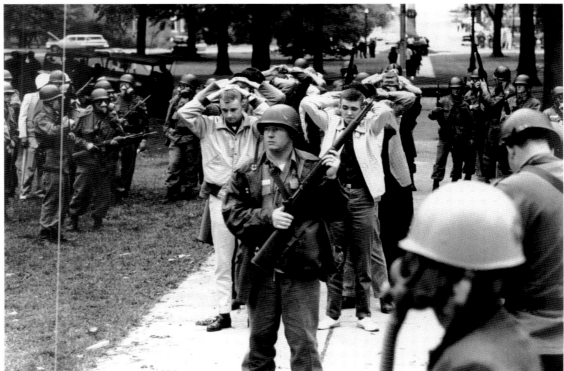

303

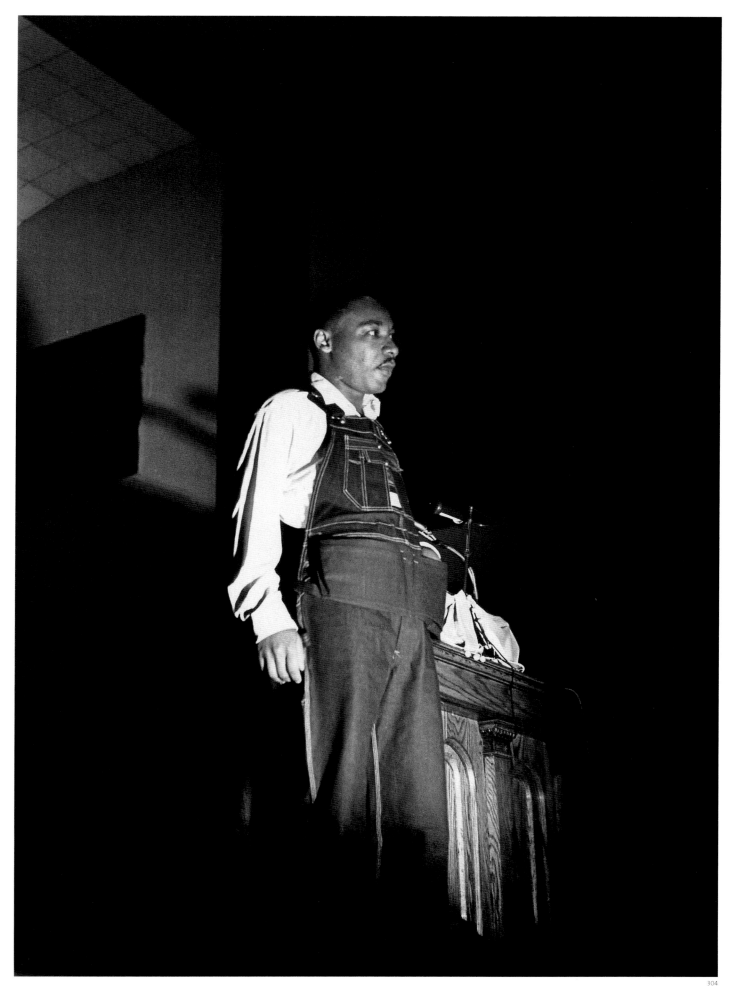

304. Martin Luther King, Jr. speaking to a rally of over 500 supporters and desegregation activists in Birmingham, Alabama, 6 April 1963. King urged male protestors to don overalls as a symbol of solidarity with the struggles of the working poor. In the 1960s, Birmingham, widely considered the citadel of racial segregation in the Deep South, was an industrial, steel-producing town, with a large blue-collar working class. 40 percent of the city's population of 350,000 was African American. Incidents of racial harassment, police beatings and occasional lynchings were a routine part of life for its black community. In his inauguration speech in January 1963, Alabama Governor George C. Wallace defiantly declared: "Segregation now! Segregation tomorrow! Segregation forever!" At the same time, SCLC leaders Fred Shuttlesworth, Wyatt T. Walker, Ralph Abernathy, and King began to organize a deliberate strategy on the one hand to desegregate restaurants, lunch counters, and all public facilities, and on the other hand to ensure greater employment opportunities for the city's black community. The headquarters of this campaign was the city's Sixteenth Street Baptist Church.

305. Martin Luther King, Jr. and Ralph Abernathy being arrested in Birmingham, 12 April 1963. On 6 April 1963, Fred Shuttlesworth initiated a sit-in campaign against whites-only facilities. The Birmingham police responded to the non-violent demonstrators with attack dogs, firehoses, and nightsticks. King was arrested on Good Friday, 12 April and placed in solitary confinement in the Birmingham jail. While incarcerated, he wrote a letter to the local white clergy who had criticized civil rights activists in the city. King's "Letter from the Birmingham Jail" became a central document, not only for the desegregation campaigns of the 1960s, but also as a classic statement about the pursuit of freedom in America. He wrote: "We waited for more than 340 years for our constitutional and God-given rights. . . . Perhaps it is easy for those who have never felt the stinging darts of segregation to say 'Wait.' But when you have seen vicious mobs lynch your mothers and fathers at will and drown your sisters and brothers at whim; when you have seen hate-filled policemen curse, kick and even kill your black brothers and sisters; when you see the vast majority of your twenty million Negro brothers smothering in an airtight cage of poverty in the midst of an affluent society. . . . When you are harried by day and haunted by night by the fact that you are a Negro, living constantly at tiptoe stance, never quite knowing what to expect next, and are plagued with inner fears and outer resentments; when you are forever fighting a degenerating sense of 'nobodiness' — then you will understand why we find it difficult to wait."

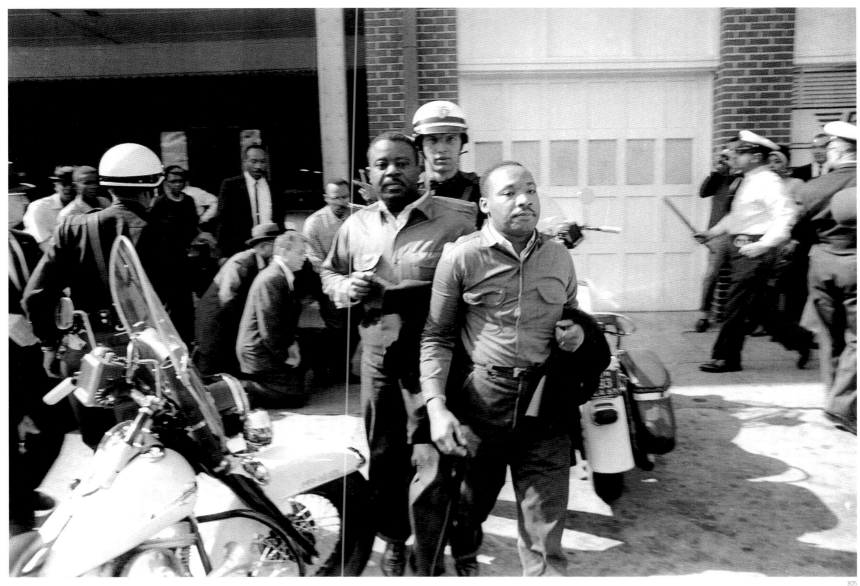

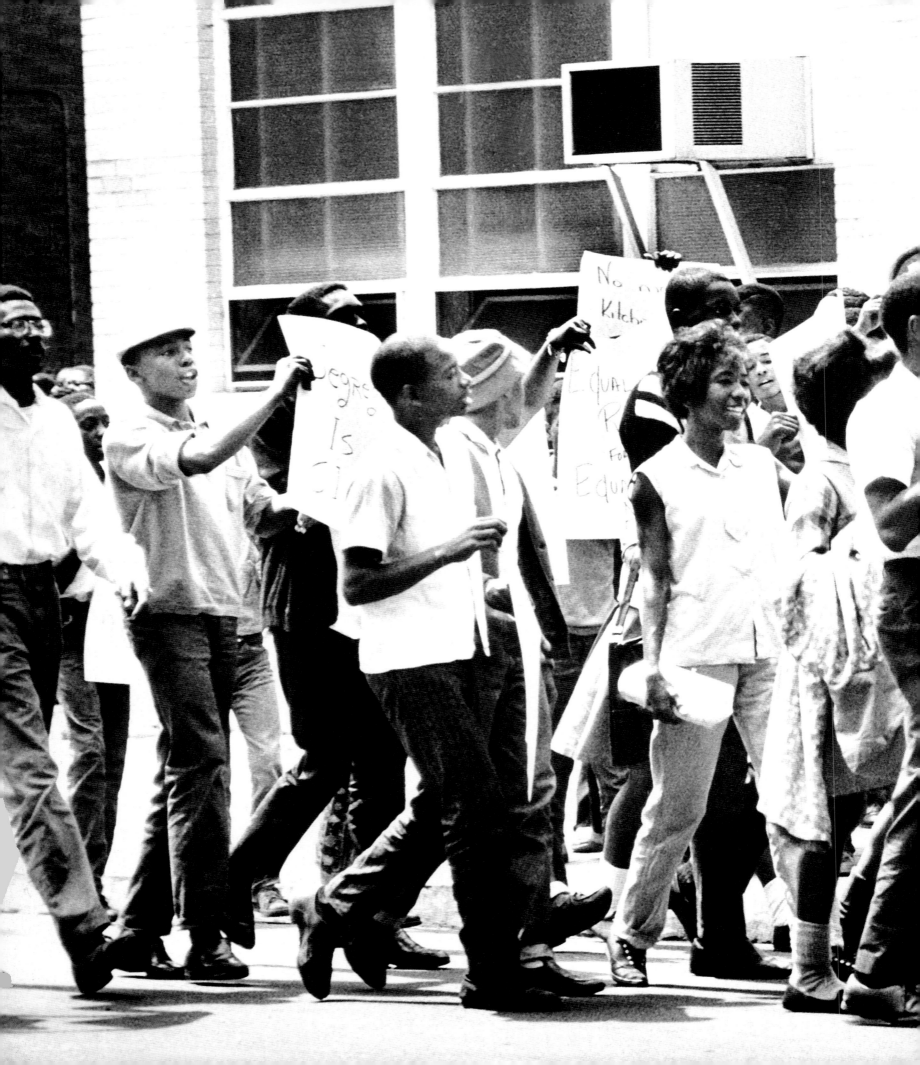

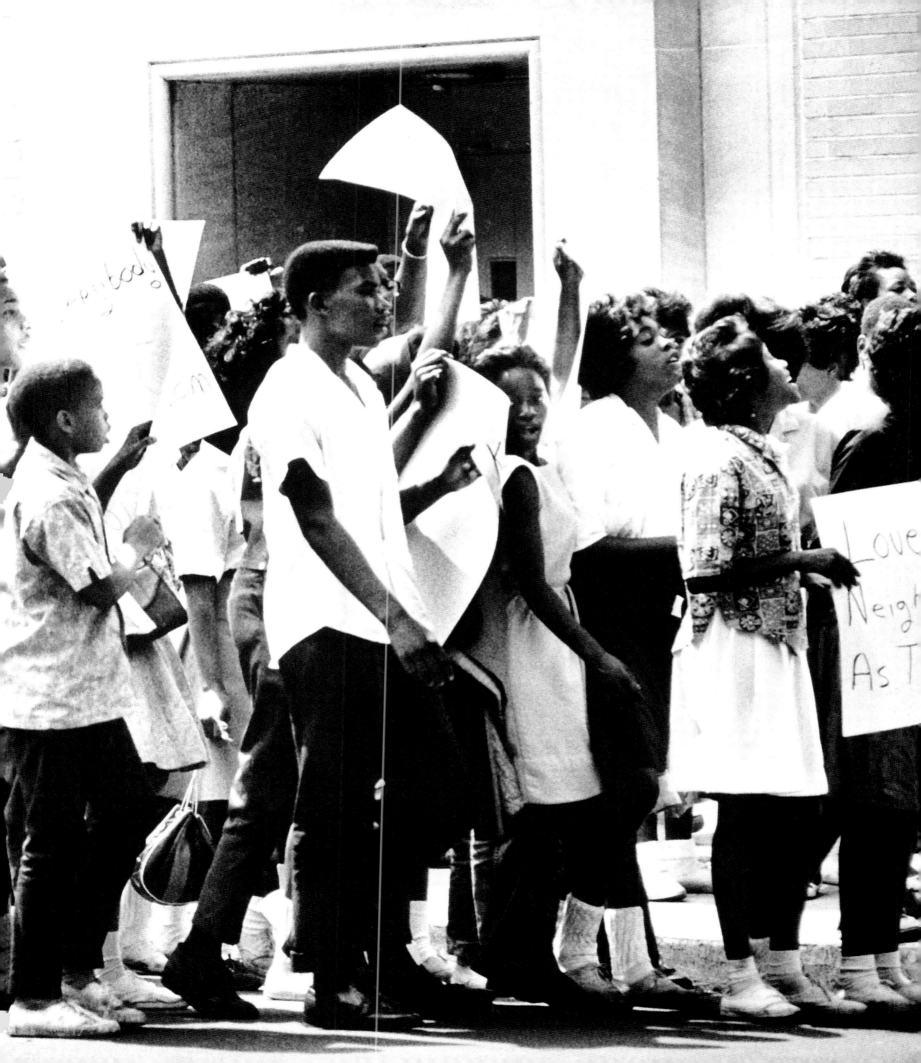

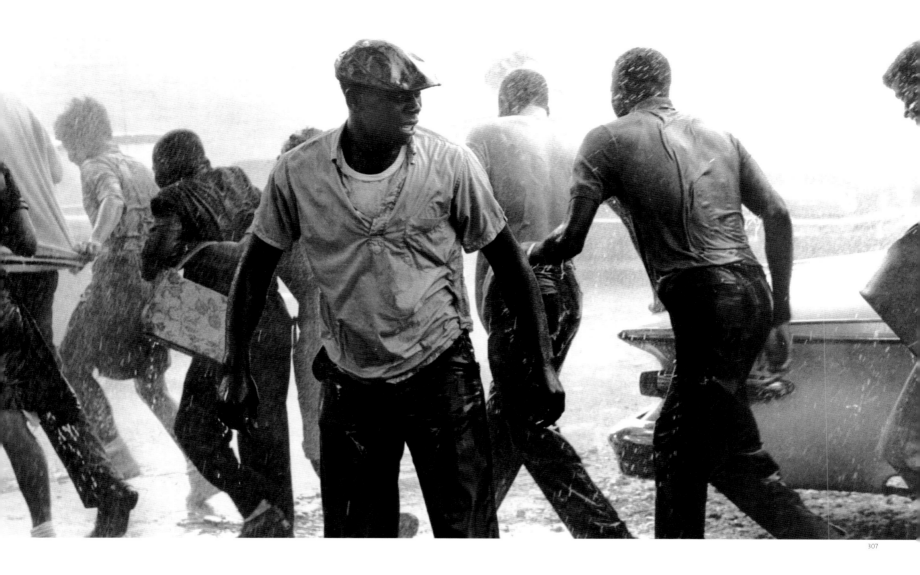

307

306. Birmingham, 2 May 1963
(previous spread). On 2 May
1963, thousands of children
between the ages of six
and eighteen gathered at the
Sixteenth Street Baptist
Church and began marching
toward downtown
Birmingham, singing freedom
songs and chanting to
reinforce their courage.
Birmingham's commissioner
of public safety, Theophilus
Eugene "Bull" Connor ordered

firehoses to be blasted at the
children, who were knocked
to the ground, some uncon-
scious. Some police dogs
were also unleashed against
the children. At the end
of the day, 959 children were
jailed. The next day the
peaceful opposition in
Birmingham built momentum,
and was heavily repressed
by the police.

307–310. Birmingham, 3 May
1963. Firehoses, which had
a pressure of 100 pounds per
square inch, were used
to disrupt the non-violent
protests.

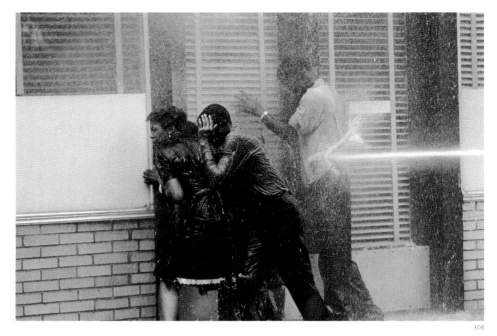

308

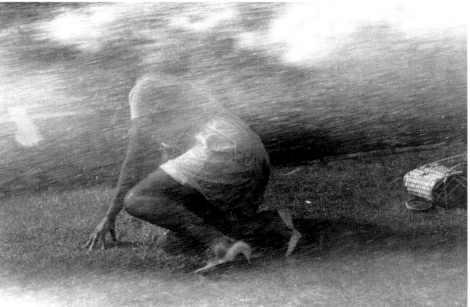

309

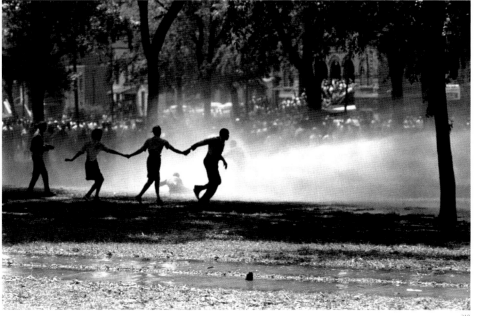

310

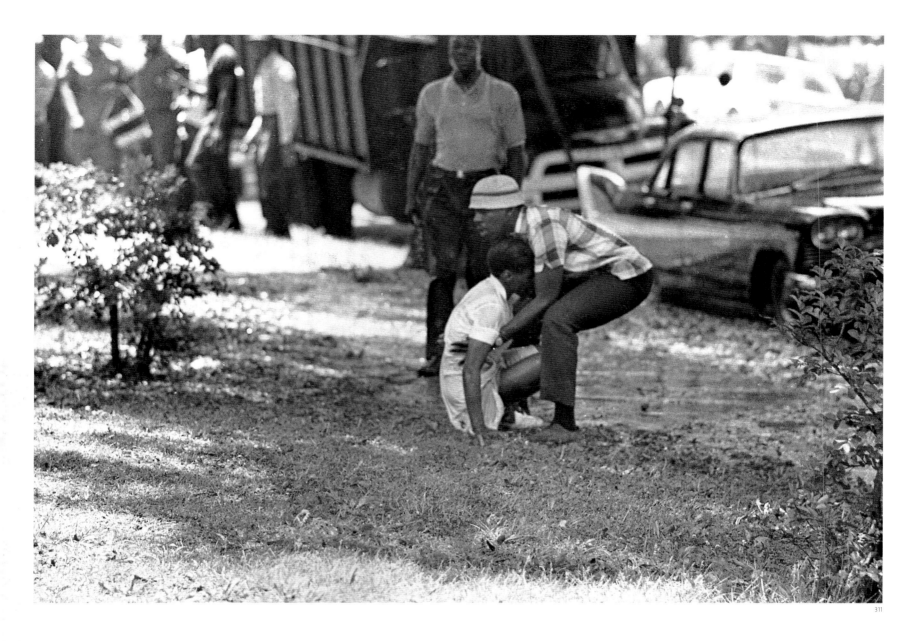

311. Woman being helped
to her feet after having been
knocked to the ground
by firehoses, Birmingham,
3 May 1963.

312. William Gadsdan being
attacked by K–9 units
outside the Sixteenth Street
Baptist Church, Birmingham,
3 May 1963.

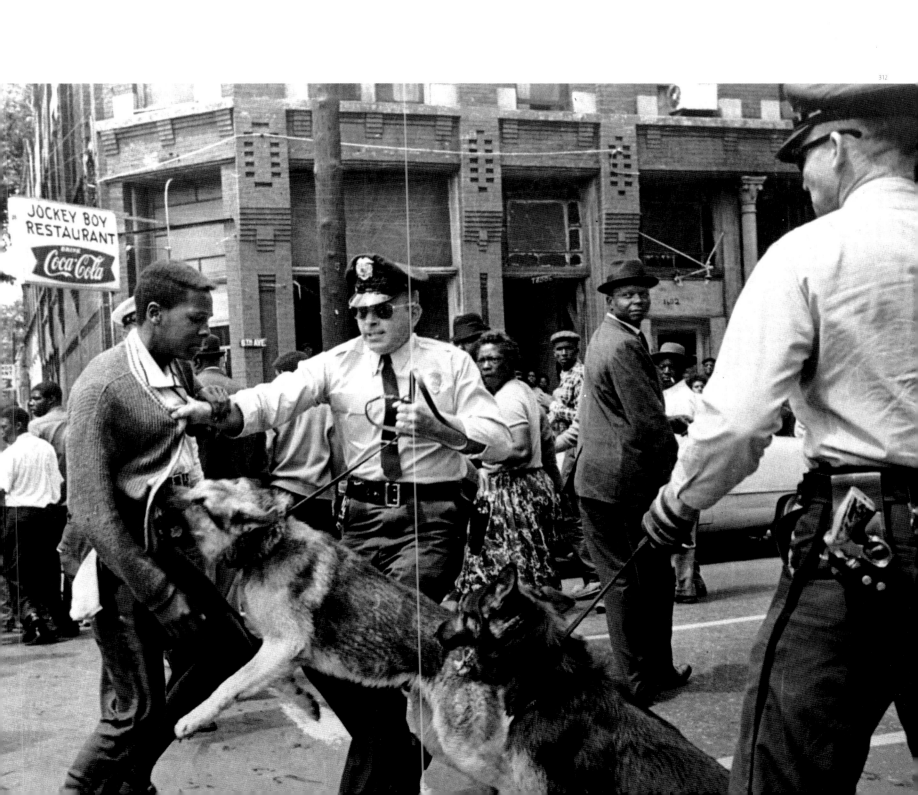

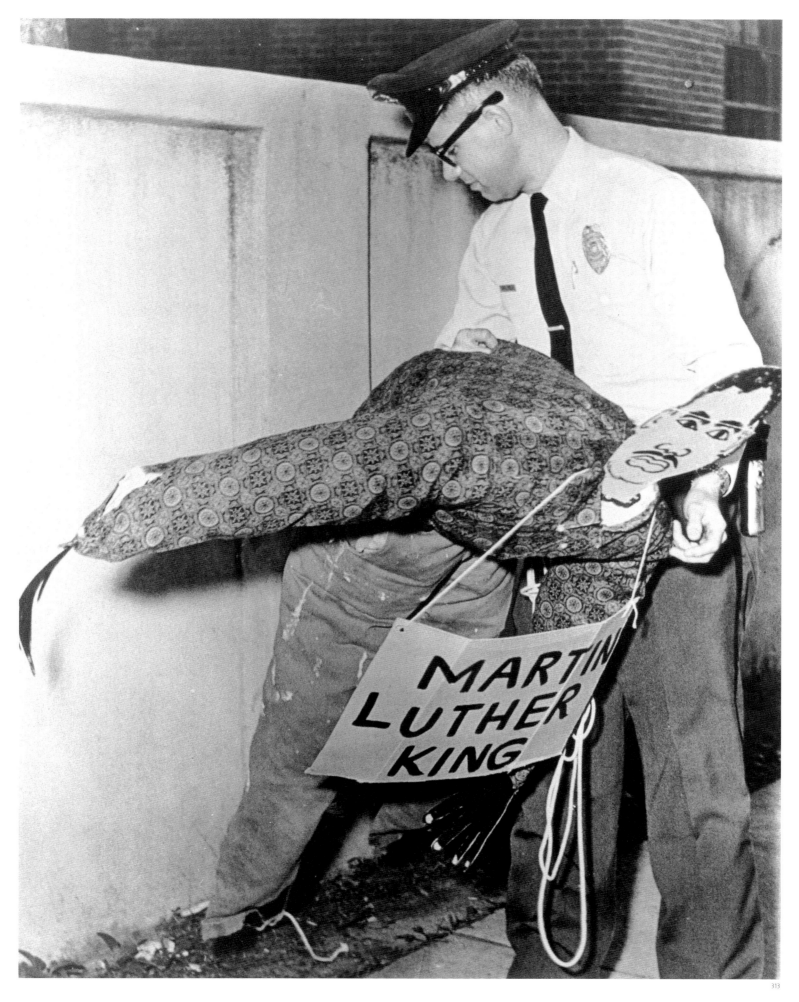

313. Birmingham police officer with effigy of Martin Luther King, Jr. found on the sidewalk in front of a local high school, 3–6 May 1963.

314. Woman arrested by the police, Birmingham, 6 May 1963.

315. Marchers being loaded into the back of police wagons, Birmingham, 6 May 1963.

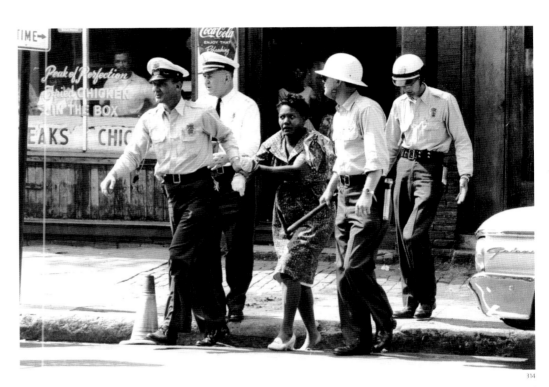

314

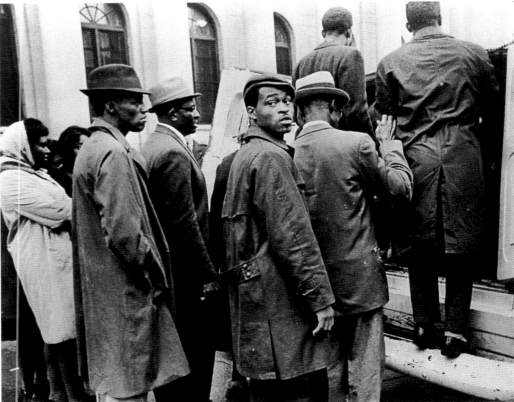

315

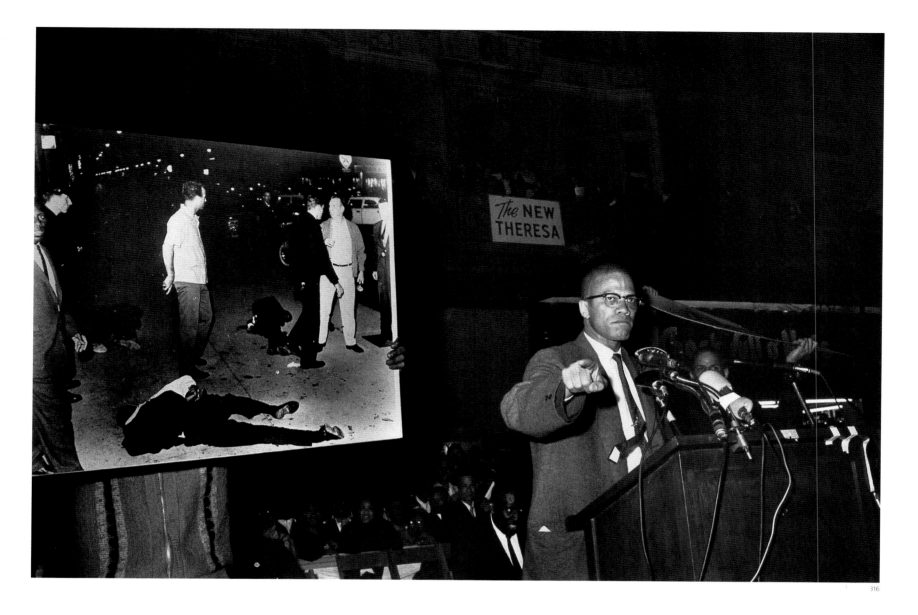

316. Malcolm X addressing a
Black Muslim rally in Harlem,
New York City, 14 May 1963.
For many black nationalists,
the carnage in Birmingham
was one more example that
integration was not a viable
solution to the problems
of black people. The Nation
of Islam taught that African
Americans should establish
their own separate state and
they created businesses and
organizations that provided

goods and services to blacks.
Appointed as the organiza-
tion's national spokesperson,
Malcolm X gained national
prominence as the most out-
spoken critic of the civil rights
leadership and the strategy
of non-violence. For several
years, he had attempted to
establish a black united front,
which was to include a
broad spectrum of African
American leaders and
opinions. However, repeatedly

rebuffed by Martin Luther
King, Jr. and most of the
other civil rights leaders,
and personally criticized by
Thurgood Marshall and
Bayard Rustin, Malcolm X
ridiculed and condemned the
cause of integration. In the
early 1960s, he aggressively
pushed the NOI to play a
more active role in efforts
to challenge police brutality
and to fight for African
American political empower-

ment. Elijah Muhammad
and other conservative NOI
leaders opposed this new
political militancy and began
to undercut his position
in the organization. During
1962 and 1963, the newspaper
Muhammad Speaks barred
any mention of Malcolm's
name. At this Harlem rally
held in defense of the
African American struggle in
Birmingham, Malcolm X
displays a photograph of a

man injured after a police
altercation in front of the
NOI mosque in Los Angeles.

317. Fred Shuttlesworth, Ralph Abernathy, and Martin Luther King, Jr. (from left to right), walking to a press conference in Birmingham, 16 May 1963. After the May 2nd Children's March there was tremendous international pressure on the Kennedy administration to act decisively to end the racist violence against demonstrators in Birmingham, and government officials helped to negotiate a compromise agreement between civil rights leaders and local businessmen. The businesses agreed to desegregate lunch counters and to employ African Americans in sales and clerical positions from which they had traditionally been excluded. Birmingham's commissioner of public safety "Bull" Connor denounced the agreement as a capitulation to blacks and urged whites to boycott all white-owned stores that had agreed to desegregate. On 11 May, the home of Reverend A. D. King, the brother of Martin Luther King, Jr., was bombed. On the same day the Gaston motel, the major black-owned hotel in the city was also bombed. On 20 May the Birmingham public school board suspended or expelled one thousand African American children who had participated in the demonstrations.

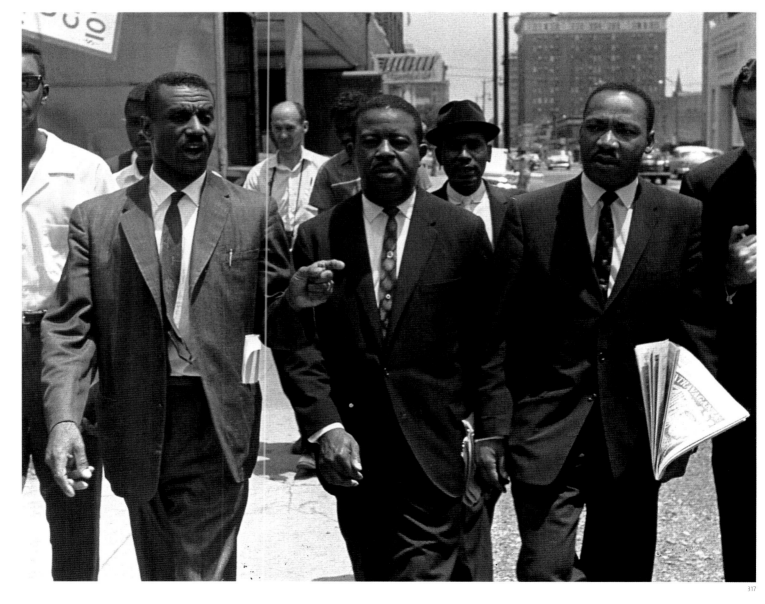

317

307

318–319. Demonstration in
New York City, 1963. The
brutality against non-violent
protesters in Birmingham
outraged African Americans
across the country, and
hundreds of local solidarity
marches and religious services
were organized in support
of the struggle for desegre-
gation.

320. Nation of Islam mosque
in Harlem, New York City,
1963.

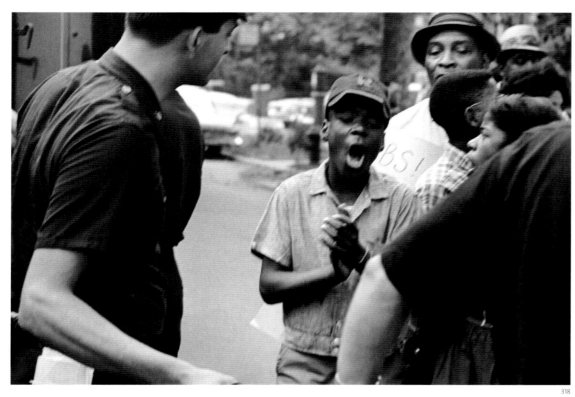

318

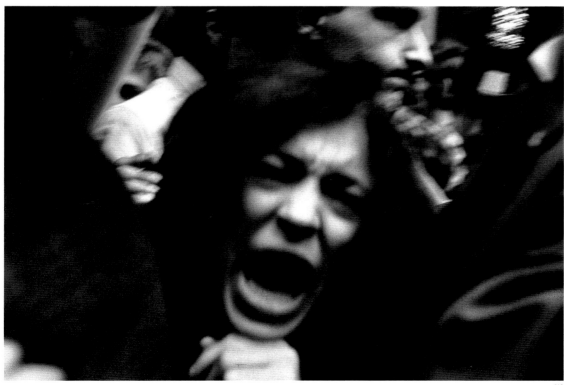

319

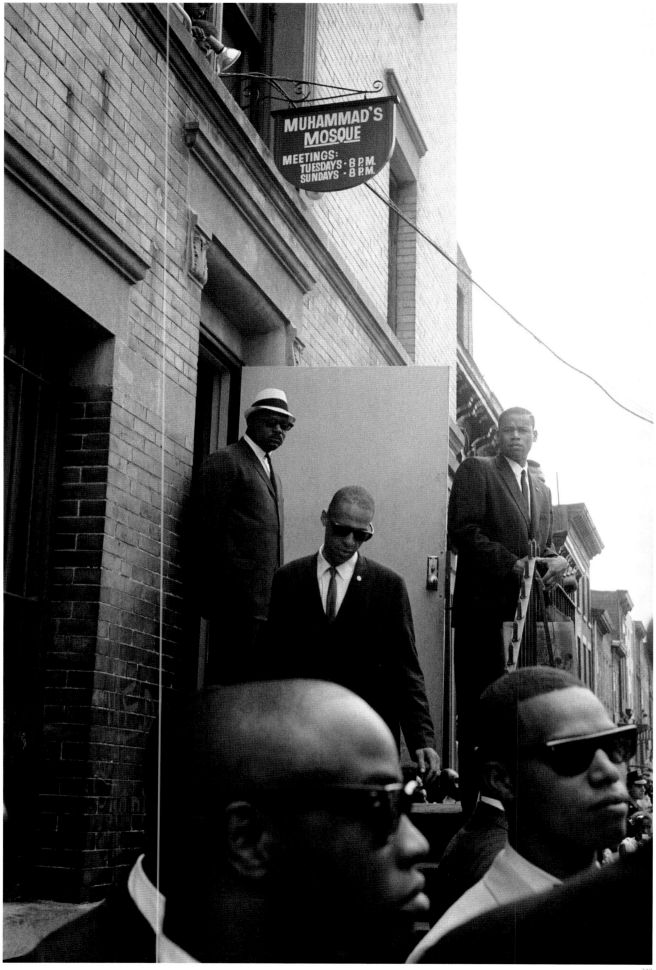

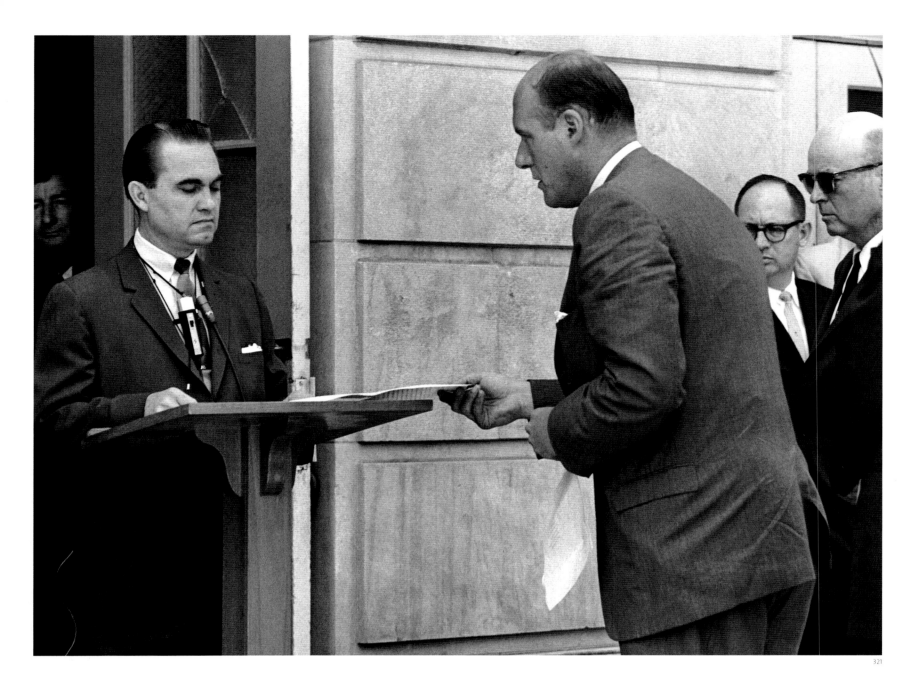

321. Governor George Wallace confronted by U. S. Deputy Attorney General Nicolas Katzenbach at the University of Alabama, 11 June 1963. On 11 June 1963, Alabama Governor George Wallace stood defiantly at the entrance of a University of Alabama building, symbolically blocking the entrance of two African American students, Vivian Malone and James Hood. Directly confronting him, Deputy Attorney General Nicolas Katzenbach informed Wallace that the federal government intended to guarantee the desegregation of the university. That afternoon, federal marshals and the federalized Alabama National Guard occupied the campus, ousted the governor, and escorted Malone and Hood into the university. That evening in a national address, President Kennedy used the moral authority of his office to come out forcefully in support of federal legislation to abolish racial segregation in public accommodations throughout the United States, and on 19 June, Kennedy introduced the civil rights bill to Congress. Wallace's conflict with the federal government over racial policy made him a popular national figure among white racists and extreme conservatives across the country almost overnight. In 1968 he ran for president on a third party ticket, challenging both Republican candidate Richard Nixon and Democratic candidate Hubert Humphrey. Wallace received 13.5 percent of the popular vote. In 1972 during his campaign to win the Democratic Party's presidential nomination, he was severely wounded and paralyzed in an assassination attempt. In his later years, he presented an emotional apology at a black church in Montgomery, expressing deep remorse for his role in establishing the racist environment in which civil rights workers had been killed.

In an ironic twist of political fate, Wallace was reelected governor of Alabama in 1982, due to the political support of the African American electorate.

322. Vivian Malone and James Hood being interviewed at the University of Alabama, 11 June 1963.

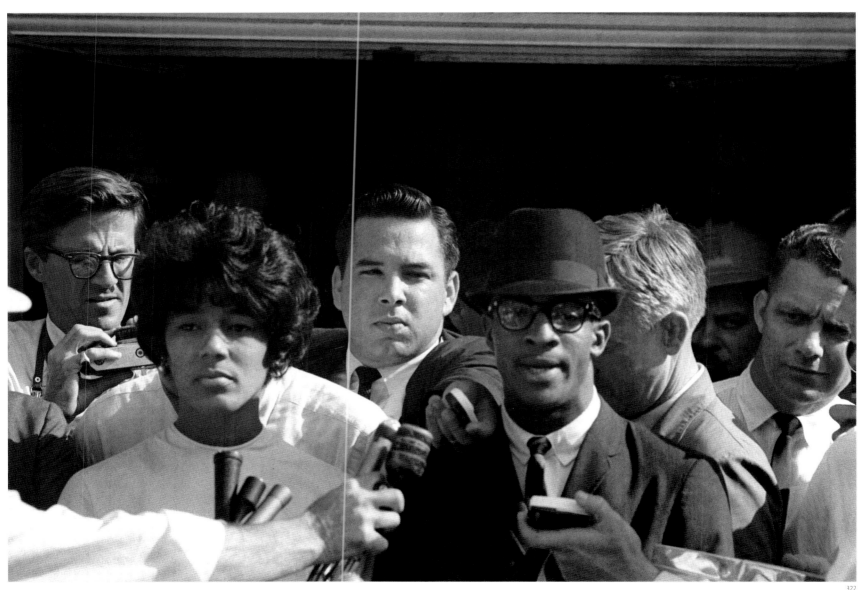

322

323. Myrlie Evers at her husband's funeral, Jackson, Mississippi, 15 June 1963. Medgar Wylie Evers was born in Decatur, Mississippi in 1925 and served in the Army during World War II. After the war he attended Alcorn A & M College in Mississippi, a historically black institution, and subsequently became an insurance salesman. In 1954 he accepted an appointment as NAACP field secretary on a full-time basis. Evers organized across the entire state, recruiting new members and investigating instances of racial violence against African Americans. A month before he was assassinated, his garage was firebombed. Just after midnight on 12 June 1963, Evers was shot in the back and killed as he left his car to enter his home. Two all-white juries refused to convict Evers' murderer, a white supremacist named Byron de la Beckwith, despite overwhelming evidence that he had committed the crime. However, 31 years after Evers' murder, de la Beckwith was at last convicted and sentenced to prison due to the persistence of the civil rights leader's widow, Myrlie Evers-Williams. Charles Evers, Medgar's older brother, assumed his post as field director of the NAACP in Mississippi.

324. Medgar Evers' funeral procession, Jackson, 15 June 1963.

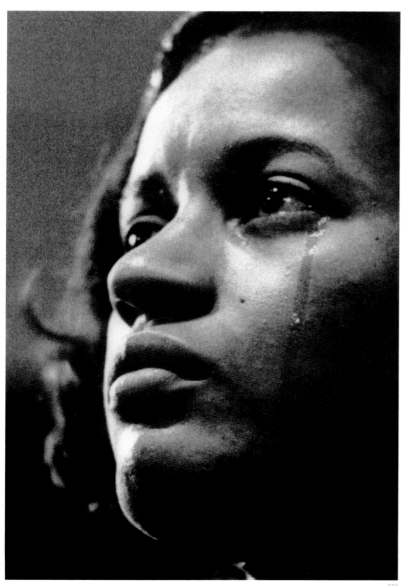

323

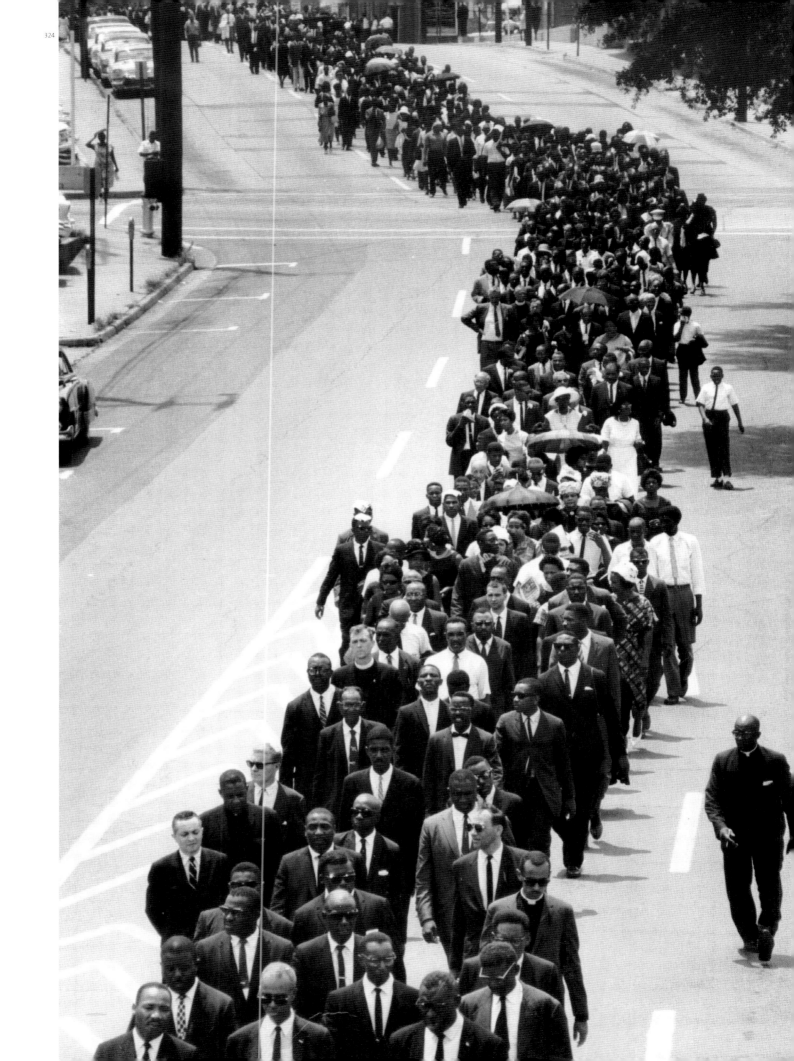

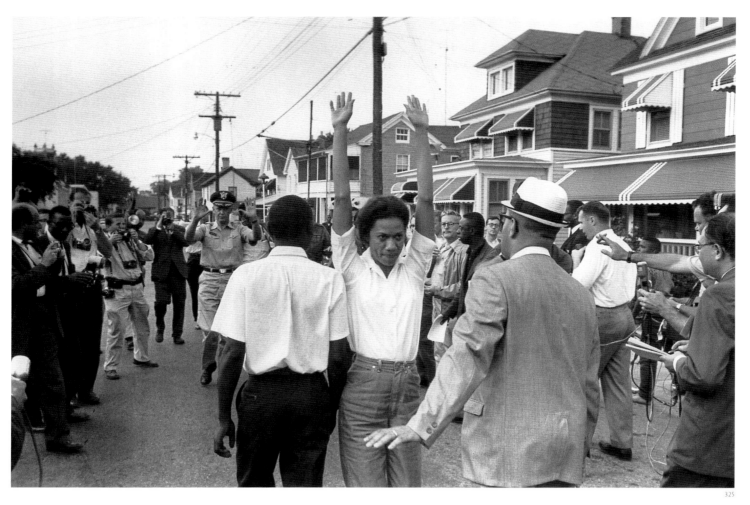

325

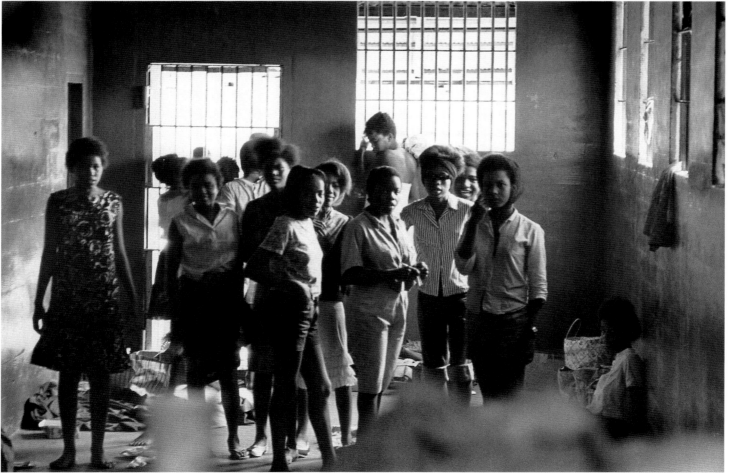

326

325. Gloria Richardson, head of the Cambridge Non-Violent Action Committee, and General George Gelston, of the Maryland National Guard (both with their arms raised), making signs to halt a demonstration march, Cambridge, Maryland, 12 July 1963. In the Spring of 1963, under the leadership of Gloria Richardson, civil rights activists held a series of non-violent demonstrations in Cambridge, calling for the desegregation of the town's public schools and restaurants. Impatient with the pace of social change, and harassed by local police, young activists fought back, sparking a general civil disturbance. The Maryland National Guard was called into the town to restore civil order. A compromise agreement was achieved when local officials consented to end segregation in all public accommodations and schools and to construct affordable housing that would be accessible to African Americans.

326. Teenage demonstrators from Americus, Georgia being kept in an insanitary stockade a mile away from the town, near Leesburg, Georgia, 14 July 1963.

327. CORE demonstration in New York City, 1963.

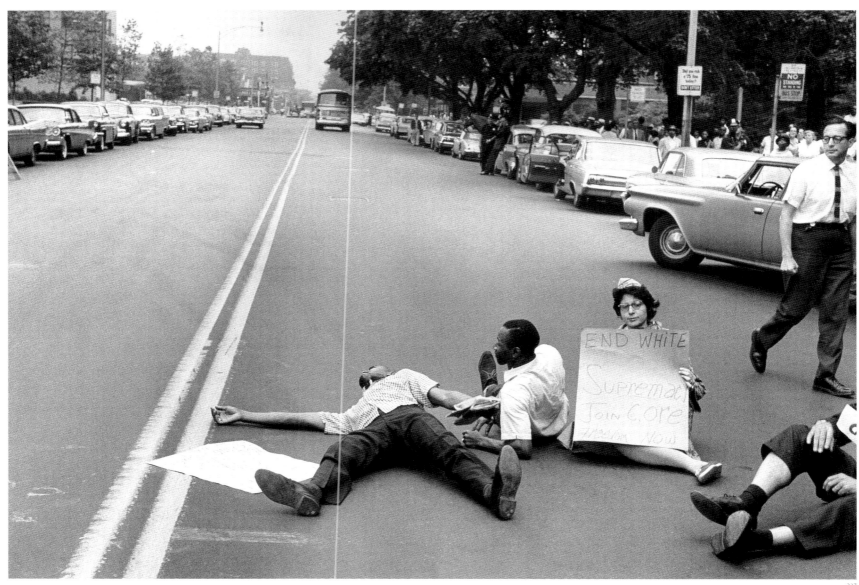

327

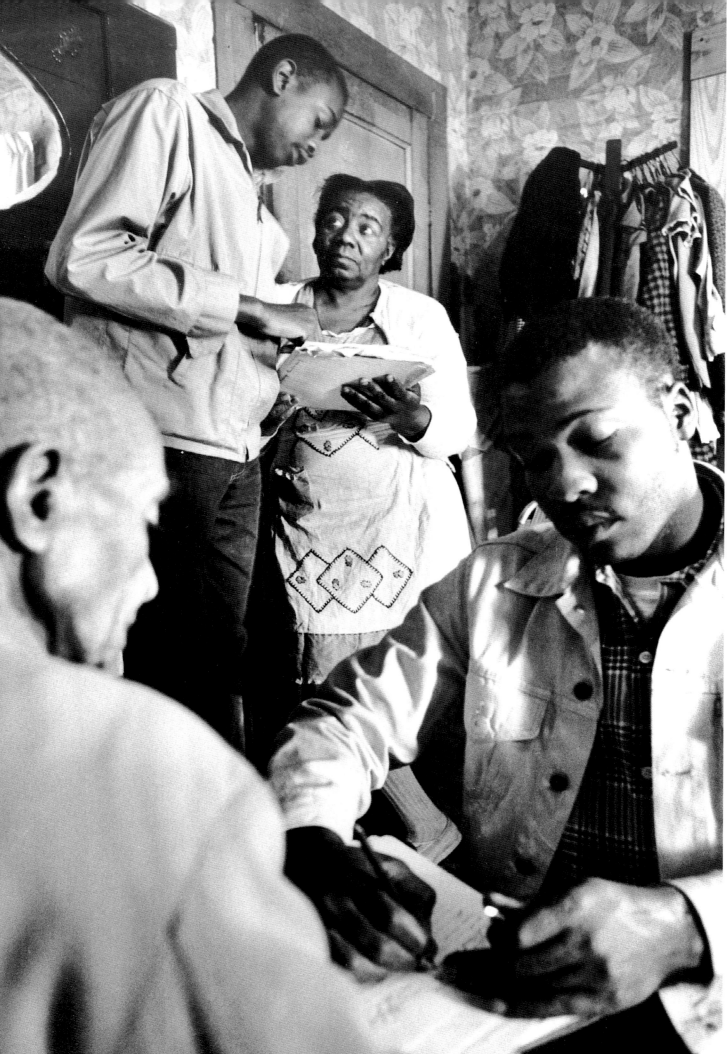

328. Voter registration campaign, Mississippi, 1963. For more than seventy years the state of Mississippi required eligible voters to demonstrate that they could both read and interpret sections of the state's constitution to the satisfaction of a local voting registrar. This narrow interpretation of voting rights was used to eliminate African Americans, and a substantial proportion of poor whites, from the state's electorate. The goal of the NAACP was to mobilize rural blacks to demand their right to vote. It required tremendous patience and committed organizing to convince black sharecroppers and farmworkers, whose livelihood depended upon white landlords and businessmen, that it was in their interests to assert this right. A key figure in the attempt to organize Mississippi's black electorate was SNCC leader Robert Parris Moses. In the summer of 1961, Moses and a team of other SNCC workers began a campaign to register black voters in concert with local leaders of the NAACP. Although the NAACP was opposed to the idea of other civil rights organizations such as CORE and SNCC taking the lead, or the credit, for the success of desegregation campaigns, Medgar Evers accepted the assistance and support of other groups. In early August 1963, Moses was arrested while taking several black people to register to vote. A week later he was beaten by a cousin of the local sheriff in the town of Liberty, Mississippi.

329. George Ball (center) assists rural blacks in completing voter registration applications, Mississippi, 1963.

330. CORE members organizing a march on Plaquemine, Iberville Parish, Louisiana, c. August 1963. On 19 August 1963, a CORE-led demonstration was held to denounce the lack of voting rights for African Americans in Iberville Parish, located just south of the state capital, Baton Rouge. James Farmer, the national director of CORE, was ordered to spend ten days in jail in Ascension Parish and over 200 civil rights demonstrators were arrested.

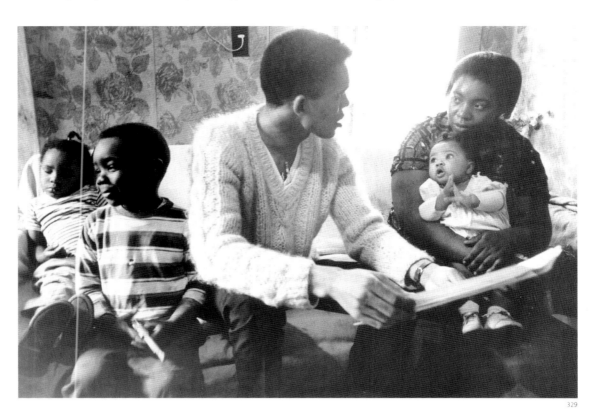

329

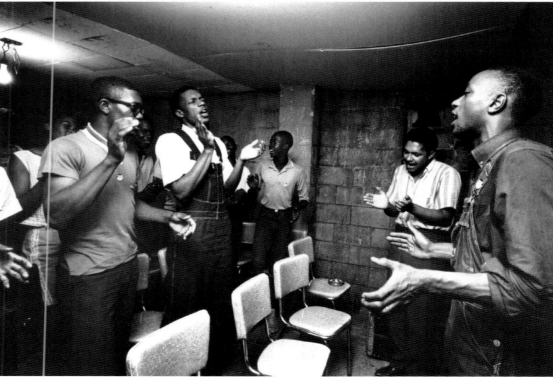

330

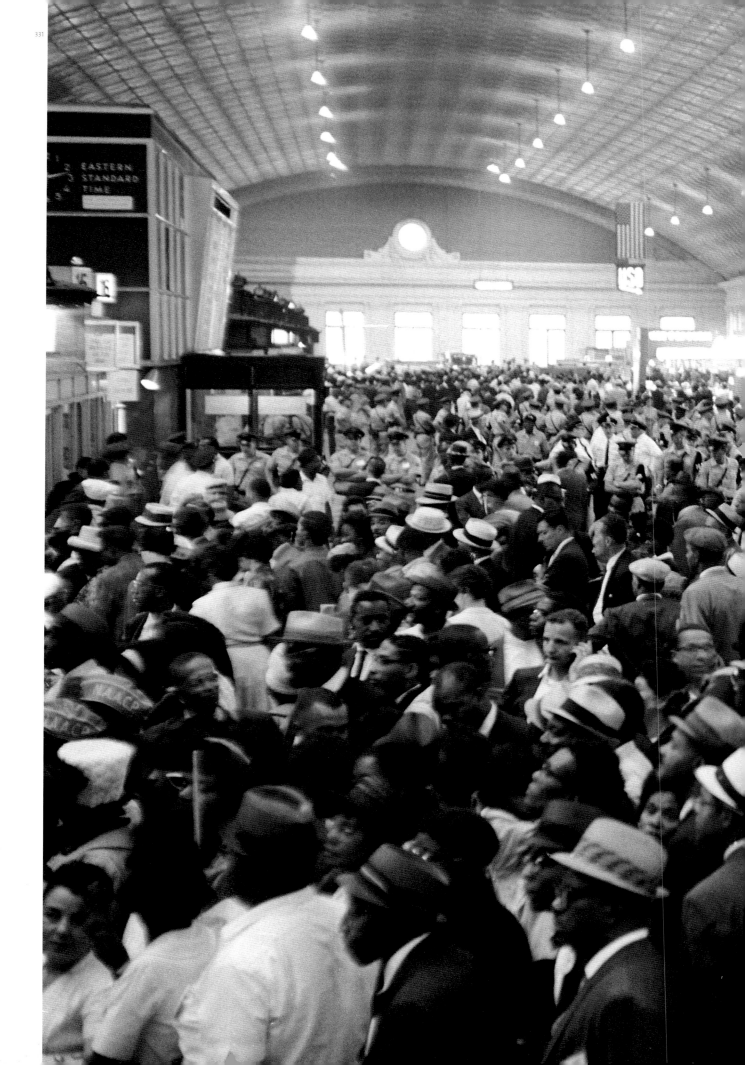

331. Arrival of the marchers at Union Station, Washington, D. C., 28 August 1963. Throughout 1962 a number of civil rights activists began talking about the need for a major national demonstration to force the adoption of a new civil rights bill by Congress. The aborted 1941 Negro March on Washington provided a suitable model for the event. Labor activists and socialists such as Bayard Rustin and A. Phillip Randolph also favored incorporating demands for job training and an end to employment discrimination. Appointed deputy director for the mobilization, Bayard Rustin was its chief architect and logistical planner. Martin Luther King, Jr. was also in favor of the march and the SCLC began to organize its members to participate. The more radical sectors of the desegregationist coalition, especially SNCC, and many elements within CORE, were deeply disappointed that plans for the mobilization did not include acts of mass civil disobedience at federal buildings, protesting the Kennedy Administration's relative lack of support for civil rights. Throughout the summer, communities across the United States mobilized to take people to the march. "Freedom buses" were organized in hundreds of cities and towns to transport people to Washington D. C. The Kennedy Administration at first attempted to persuade King, Randolph, and other leaders to cancel the event, but then reluctantly allowed the march to proceed, provided that the demonstration's focus be on the civil rights bill that was currently being considered in the Senate. On the evening of 27 August 1963, thousands of people began arriving in the District of Columbia, by foot, rail, and bus. By mid-morning on 28 August, approximately one quarter of a million Americans, about 60,000 of whom were white, stood before the Lincoln Memorial on the Mall. It was, at the time, the largest single public gathering of Americans supporting civil rights in the country's history.

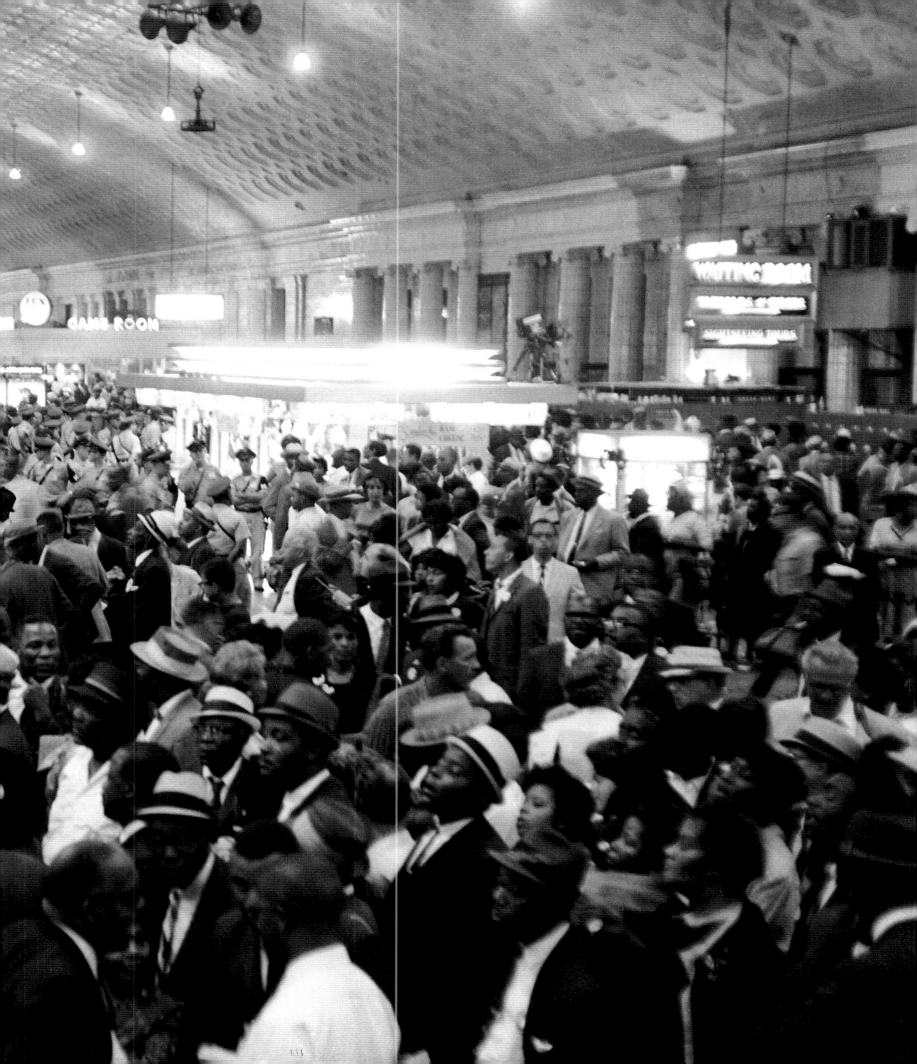

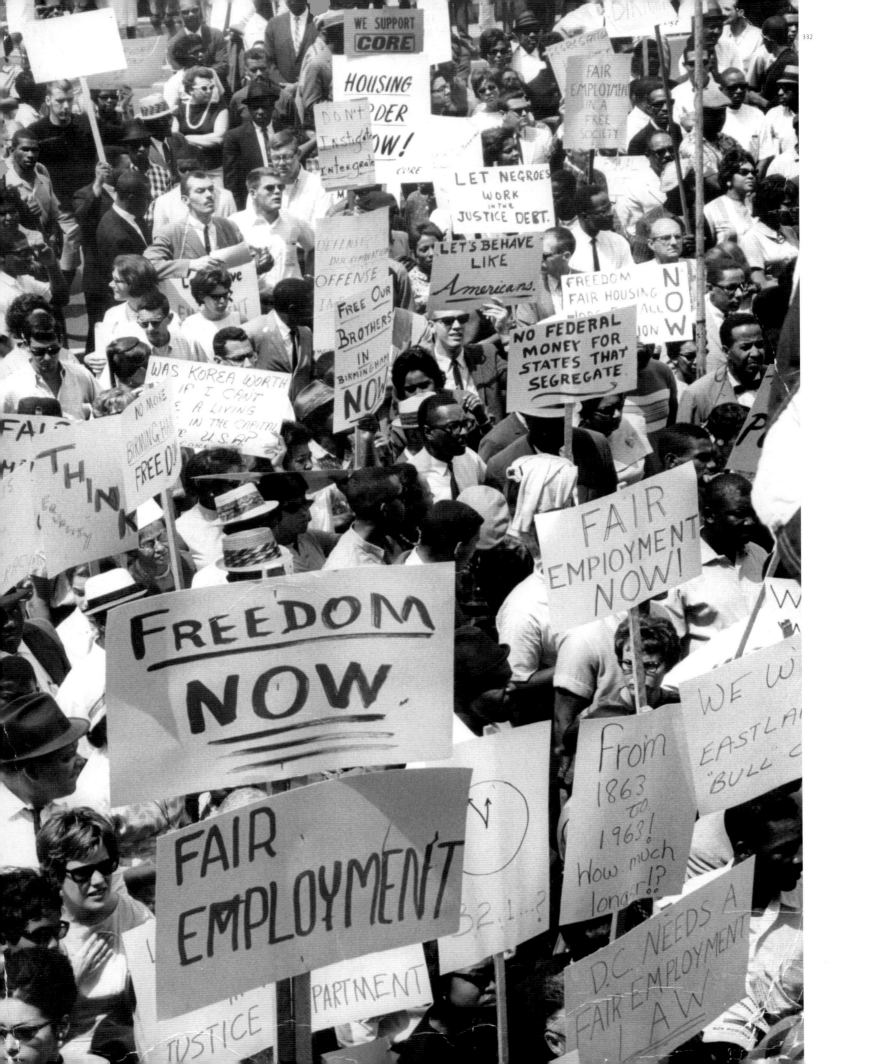

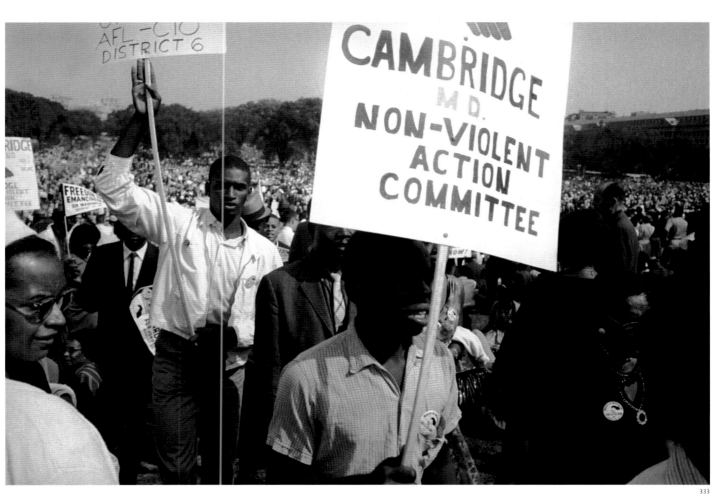

332. March on Washington, D. C., 28 August 1963.

333. SNCC members at the March on Washington, D. C., 28 August 1963. By the time of the march, many SNCC activists felt that the resources and effort used to orchestrate the mass event in Washington, D. C. could have been better used to organize hundreds of small towns and cities throughout the South. John Lewis, the chairman of SNCC, prepared a speech that included pas-

sages critical of the Kennedy Administration. Cardinal Patrick O'Boyle, who had learned about Lewis' speech, warned that he would not participate unless the speech was changed. Martin Luther King, Jr., A. Philip Randolph, and other civil rights leaders demanded that Lewis' speech be revised using alternative language that was deemed less provocative. The original

version of Lewis' speech was a ringing challenge to the nation's political establish-ment: "The revolution is at hand, and we must free ourselves of the chains of political and economic slavery. The nonviolent revolution is saying, '. . . We will not wait for the President, nor the Justice Department, nor Congress, but we will take matters into our own hands, and create a great source of

power, outside of any national structure that could and would assure us victory.'. . . We all recognize the fact that if any radical social, political, and economic changes are to take place in our society, the people, the masses must bring them about. In the struggle we must seek more than mere civil rights; we must work for the community of love, peace, and true brotherhood."

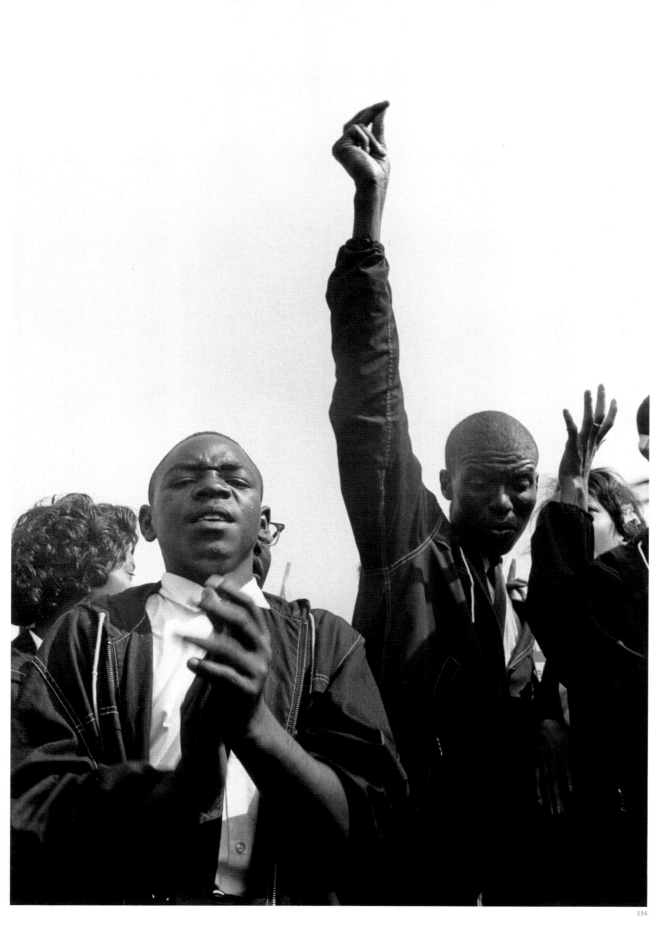

334

334–335. March on
Washington, D. C., 28 August
1963.

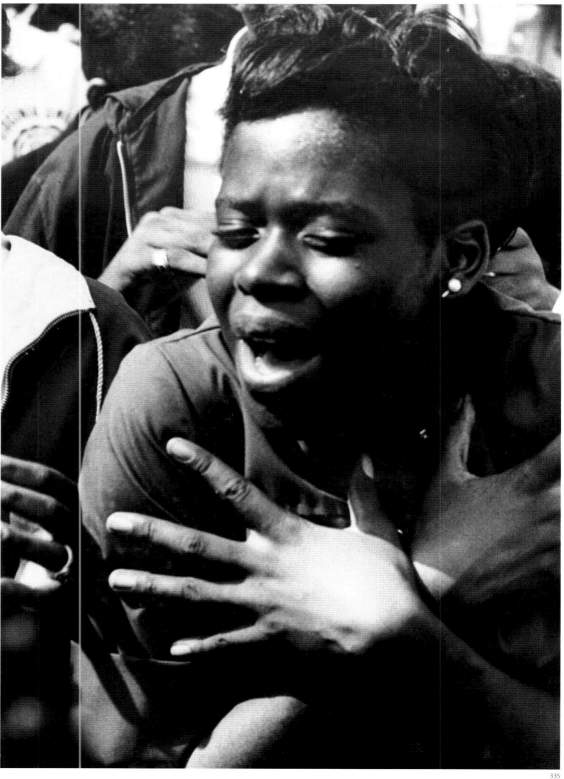

336–338. March on
Washington, D. C., 28 August
1963.

337. Mahalia Jackson singing
at the March on Washington,
D. C., 28 August 1963.
Mahalia Jackson preceded
Martin Luther King, Jr.'s
famous "I Have a Dream"
speech with the spiritual
"I've Been 'Buked and I've
Been Scorned."

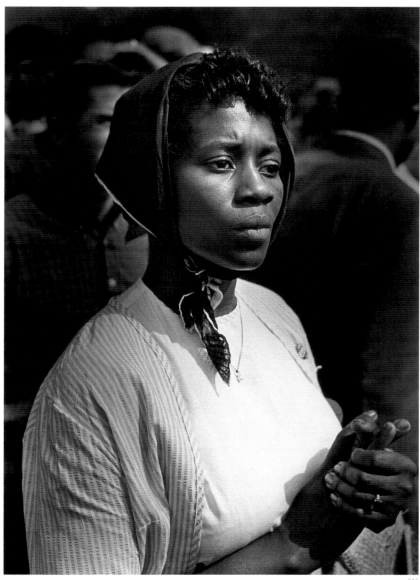

336

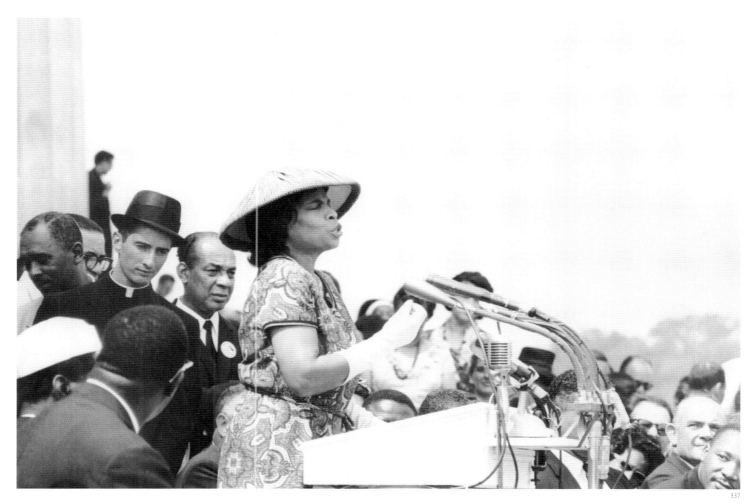

337

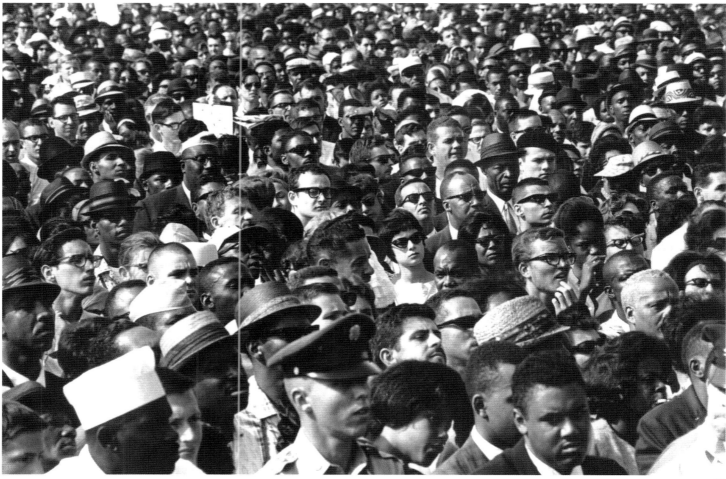

338

325

339. March on Washington, D. C., 28 August 1963.

340. Martin Luther King, Jr. during his famous "I Have a Dream" speech, March on Washington, D. C., 28 August 1963. For several months prior to the historic march on Washington, many of the ideas and much of the language that would become later known as the "I Have a Dream" speech, had been delivered by King at various demonstrations and rallies throughout the country. As he came to the podium as the final major speaker of the march, King captured the spirit of democratic resistance that had motivated so many thousands of his fellow Americans to take a public stand in favor of freedom. The speech carefully wove together appeals to classical American values of liberty and equality under the law that white Americans could accept. It spoke to a racially integrated future for the country, but in a language that was carefully crafted not to generate a racial backlash against the African American cause. Stamped on public memory and now part of the national narrative about the meaning of American democracy, it is important to recall the truly challenging elements of King's thesis: "I say to you today, my friends, that in spite of the difficulties and frustrations of the moment I still have a dream. It is a dream deeply rooted in the American dream. I have a dream that one day this nation will rise up and live out the true meaning of its creed: 'We hold these truths to be self-evident; that all men are created equal.' I have a dream that one day on the red hills of Georgia the sons of former slaves and the sons of former slave owners will be able to sit down together at the table of brotherhood. . . . I have a dream that my four little children will one day live in a nation where they will not be judged by the color of their skin but by the content of their character."

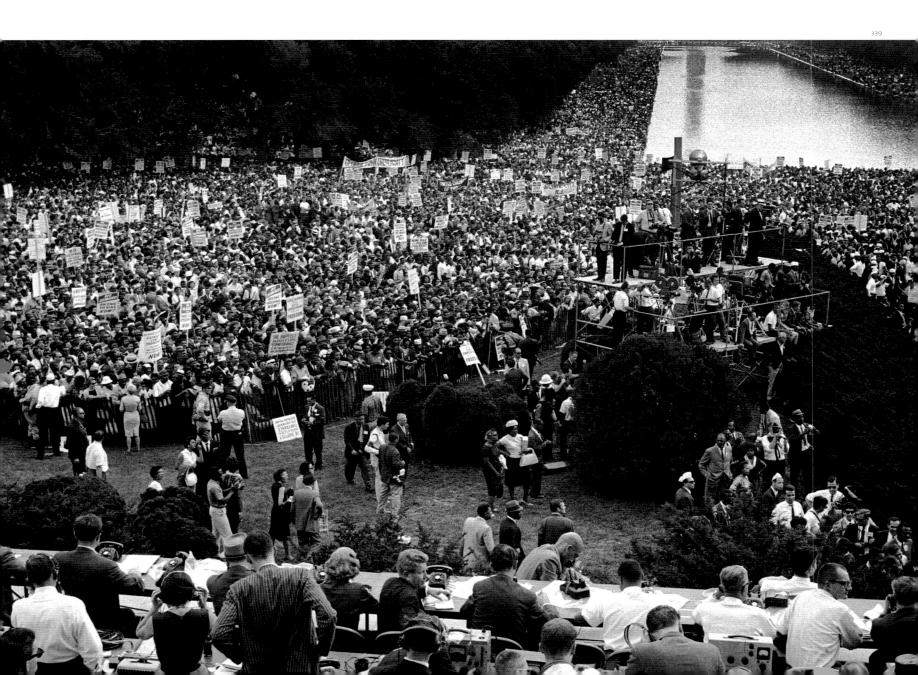

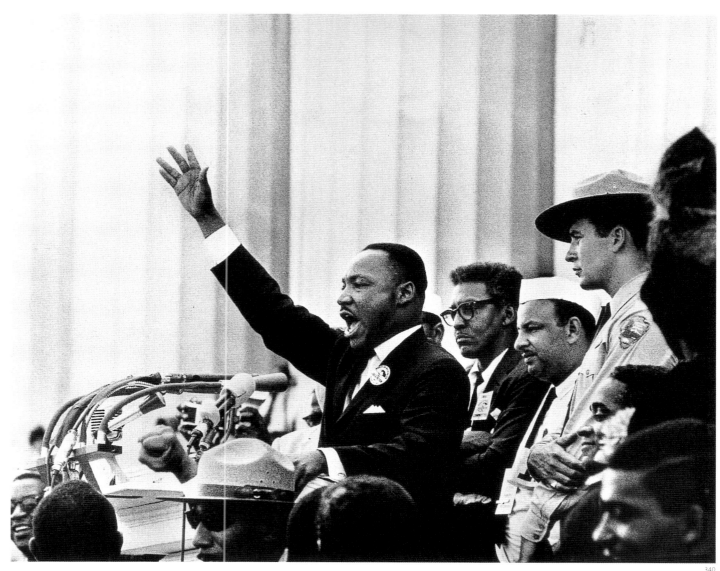

341. Meeting at the White House with (from left to right) Martin Luther King, Jr. (SCLC), John Lewis (SNCC), Rabbi Joachim Prinz (American Jewish Congress), Dr. Eugene Carson Blake (National Council of Churches), A. Philip Randolph, President Kennedy, Vice President Lyndon B. Johnson (hidden), Walter Reuther (United Auto Workers), and Roy Wilkins (NAACP), Washington, D. C., 28 August 1963. Pleased with the absence of violence and the relative moderation of the demands presented by the speakers during the March on Washington, President Kennedy invited key participants to the White House. However, certain critics of the civil rights movement, both black and white, were largely unimpressed by the march. In the following days, not a single vote in the United States Senate was changed, and southern senators continued their filibuster and demands to preserve white supremacy. African American critics, such as Malcolm X, dubbed the mobilization "the farce on Washington," and accused black leaders of selling out the interests of the black masses to the Kennedy Administration. Despite these criticisms, the march assumed global significance, effectively presenting the cause of the African American freedom movement to an international audience.

342. Whites demonstrating against the registration of blacks at Woodlawn High School, Birmingham, Alabama, 4 September 1963. Millions of white Americans remained implacably opposed to racial integration. A number of them were prepared to use violence as a means of preserving this normal feature of their daily life.

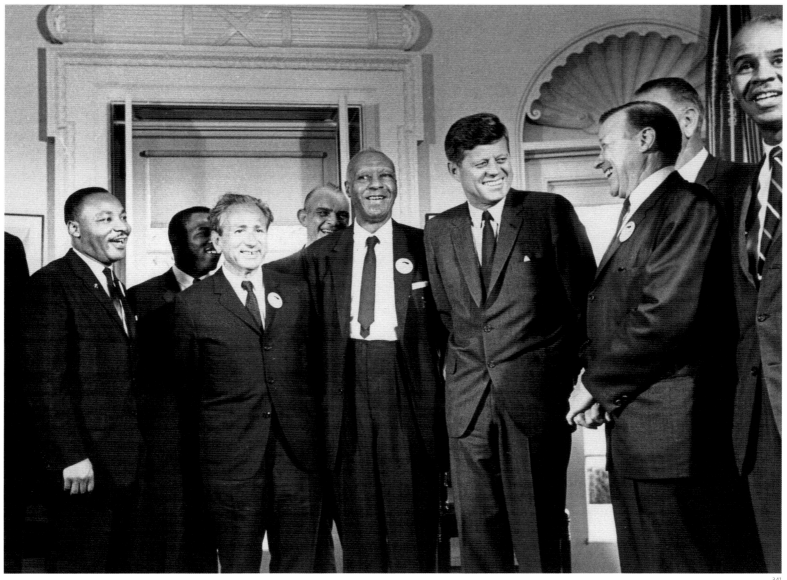

341

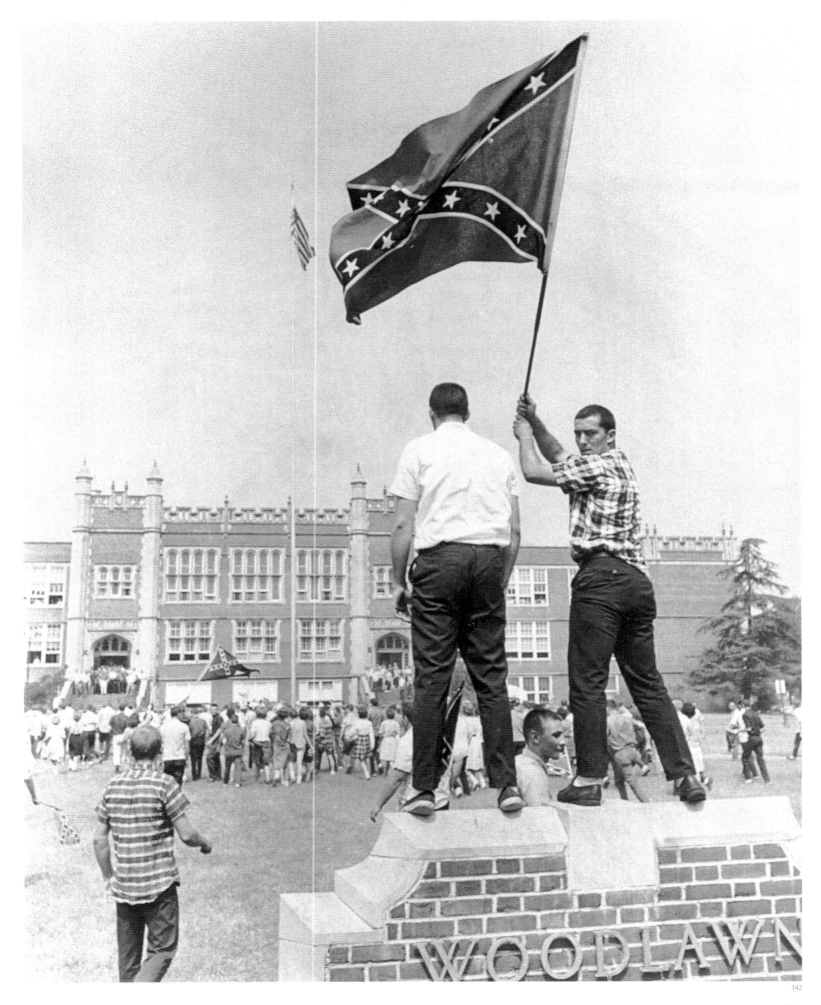

343. Floyd and Dwight Armstrong integrate Graymont Elementary School, Birmingham, Alabama, 10 September 1963. School integration ordered by the federal court was imposed in several Alabama cities in early September 1963. At Graymont Elementary School on 4 September, whites protested when two black children enrolled. Governor George Wallace ordered state troops to shut down the school. On 9 September, Wallace defied a federal district court order for school desegregation by ordering the Alabama National Guard to surround several schools, including Graymont, in order to prevent the enroll-ment of black students. The National Guard were federalized and the two students were admitted to the elementary school.

344. Students of the Montgomery High School protesting against the enrollment of black students, Montgomery, Alabama, September 1963. White students at Montgomery High School adamantly opposed the enrollment of blacks, and walked out of the school as federal author-ities escorted a few black students to enroll.

345. Anti-segregation protest at a black high school, Birmingham, early 1960s.

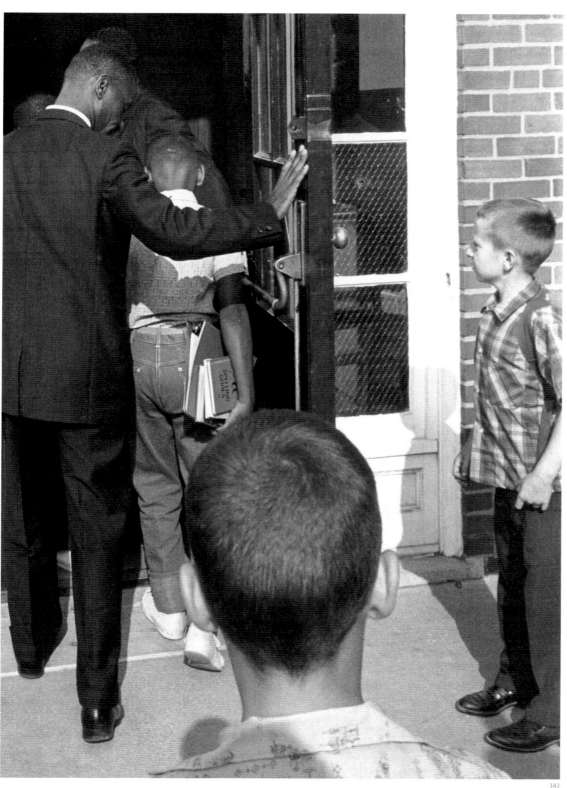

343

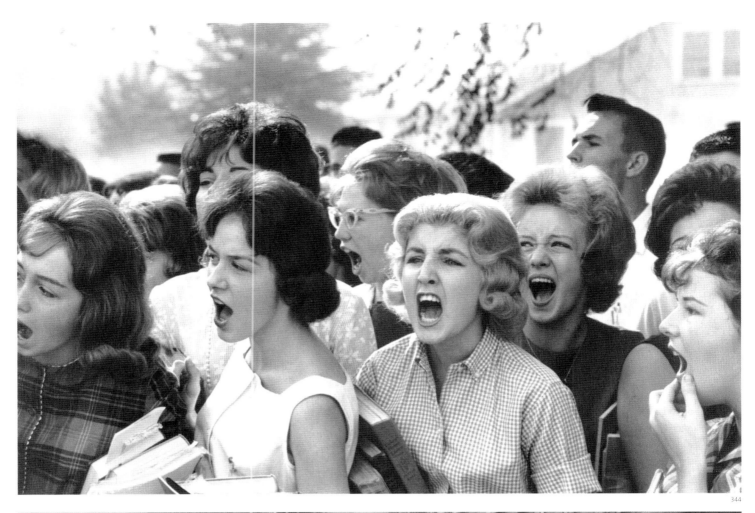

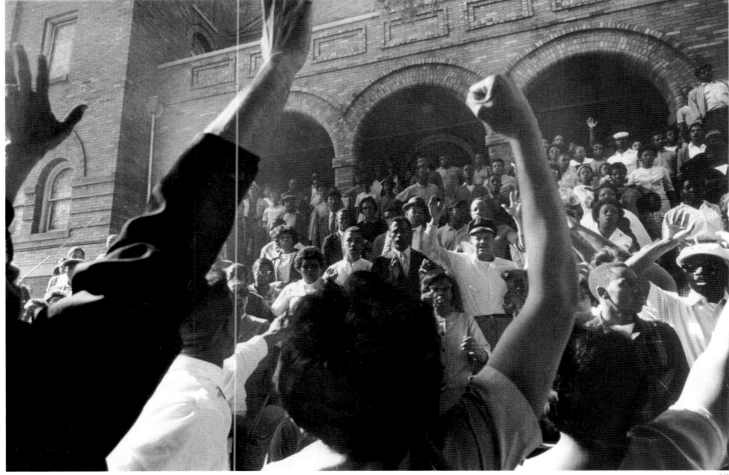

346. Sixteenth Street Baptist Church, Birmingham, Alabama, September 1963. On Sunday morning, 15 September 1963, approximately four hundred worshipers had gathered at the Sixteenth Street Baptist Church in Birmingham. At about 10:30 A.M., a bomb planted in the church basement exploded. Twenty people were injured and four little girls, ages eleven to fourteen-years old — Denise McNair, Addie Mae Collins, Cynthia Wesley, and Carole Robertson — were killed. The bombing was the third in Birmingham since elementary and secondary school integration had been initiated two weeks before. Blacks in Birmingham, and across the country, were outraged by this atrocity. King told Governor Wallace: "The blood of four little children . . . is on your hands. Your irresponsible and misguided actions have created in Birmingham and Alabama the atmosphere that has induced continued violence and now murder."

347. Family members at the joint funeral held for Denise McNair, Addie Mae Collins, and Cynthia Wesley, Birmingham, 18 September 1963.

348. Mr. and Mrs. Alvin C. Robertson at their daughter Carole's funeral, Birmingham, 17 September 1963.

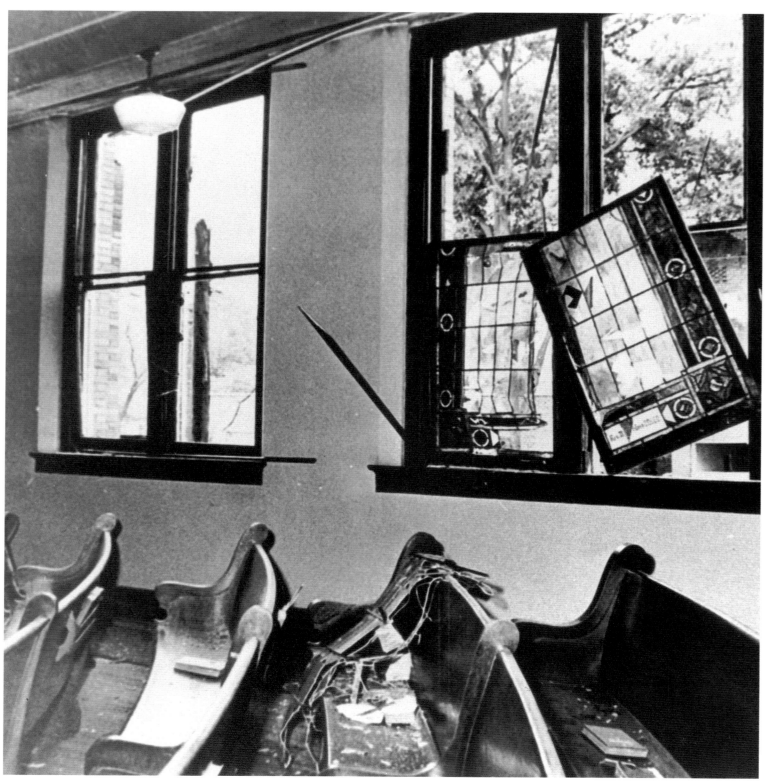

346

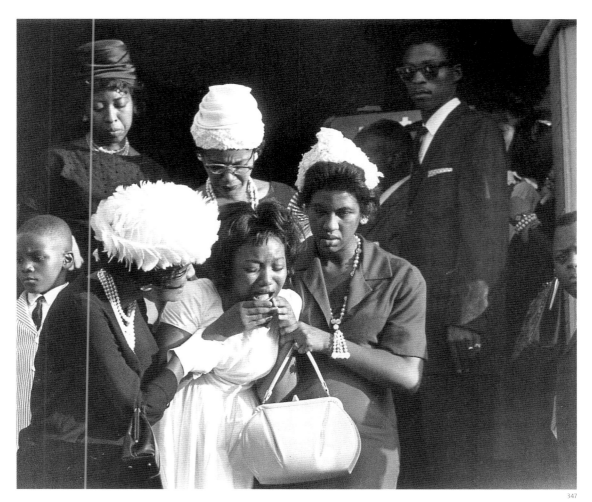

347

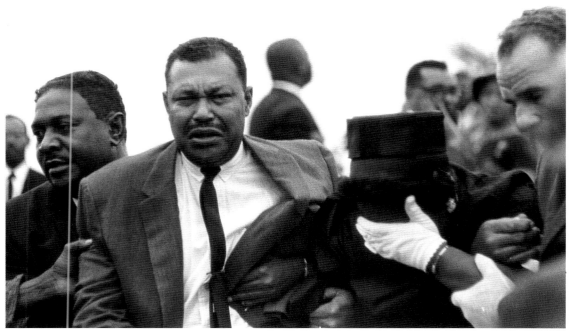

348

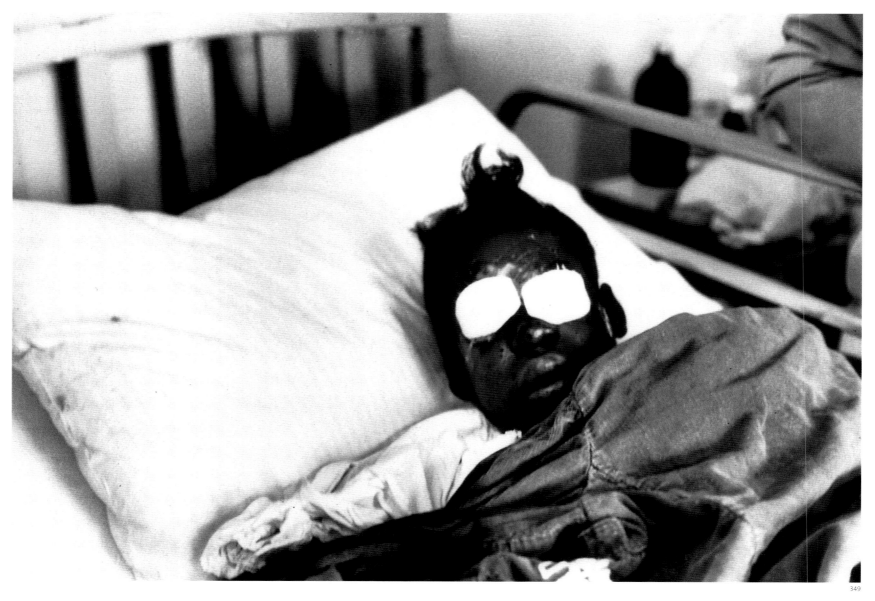

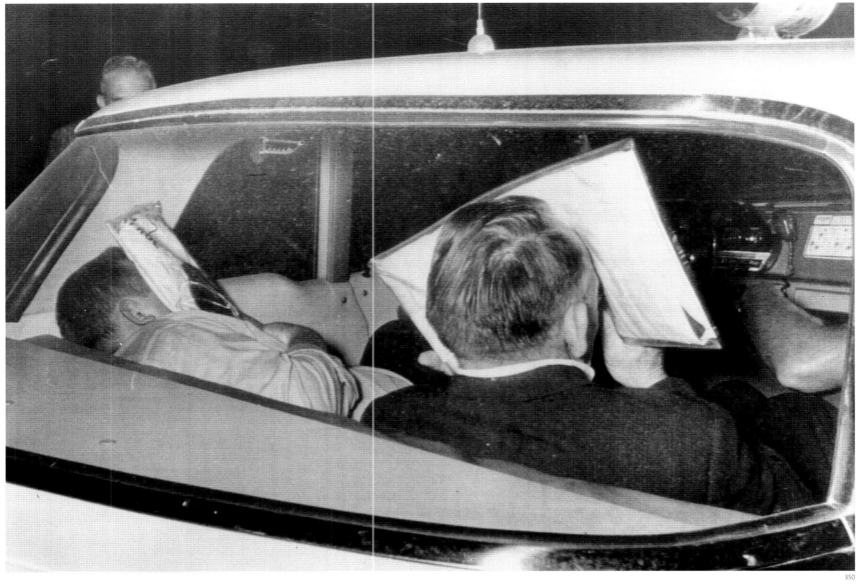

350

349. Young girl injured in the Sixteenth Street church bombing, Birmingham, September 1963.

350. R. E. Chambliss and Charles Cagle arrested for questioning in connection with the Sixteenth Street church bombing, Birmingham, 30 September 1963. Three men were arrested on 30 September for possessing dynamite, but they were not indicted. For several years white enforcement officials and city and state leaders refused to conduct an investigation of the bombing until the case was reopened in 1970 by the attorney general of the Nixon Administration. Seven years later, in 1977, one of the murderers, Robert E. Chambliss was convicted and sentenced to life in prison, where he died. Herman Frank Cash died in 1994. Thomas Blanton Jr. was found guilty in 2001. It would not be until May 2002 that the last living defendant, Bobby Frank Cherry, was sentenced to life in prison at the age of seventy-one.

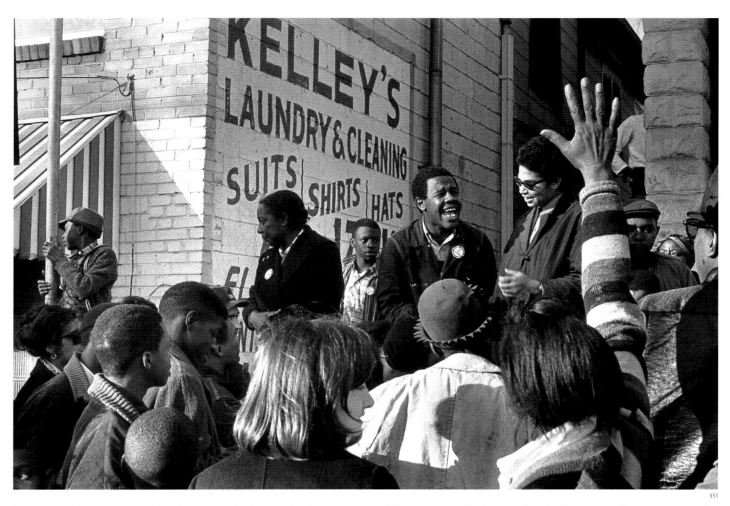

351

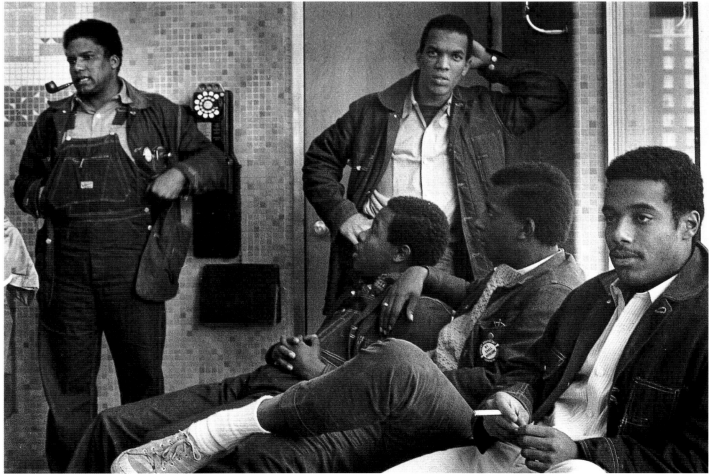

352

351. Willie Ricks haranguing the crowd, Atlanta, 1963. Willie Ricks was a key grass-roots organizer in SNCC. Later, in 1966, he was instrumental in popularizing the slogan "Black Power" calling for the black freedom movement to emphasize self-defense and black independent politics.

352. James Forman (left), Atlanta, 1963. Born in 1928, James Forman served in the U. S. Air Force during the Korean War. He became involved in the civil rights movement as a participant in a CORE–sponsored project assisting African American farmers in the South. In 1961 he participated in the Freedom Rides and several months later began working with SNCC. By 1964 Forman had become SNCC's executive secretary, responsible for training staff and directing fundraising. He left SNCC in 1968 and became involved in the emerging campaign for black reparations. In 1967 Forman read the controversial Black Manifesto at Riverside Church in New York, demanding that faith-based institutions contribute millions of dollars to black institutions as compensation for racism.

353. Restaurant-owner John Furrow (pointing at the camera) threatens a UPI photographer during a sit-in in Atlanta, 30 December 1963. Seated on the right is comedian and social activist, Dick Gregory, whose wife had recently been jailed for refusing to leave the same restaurant. Standing, right is Stokely Carmichael.

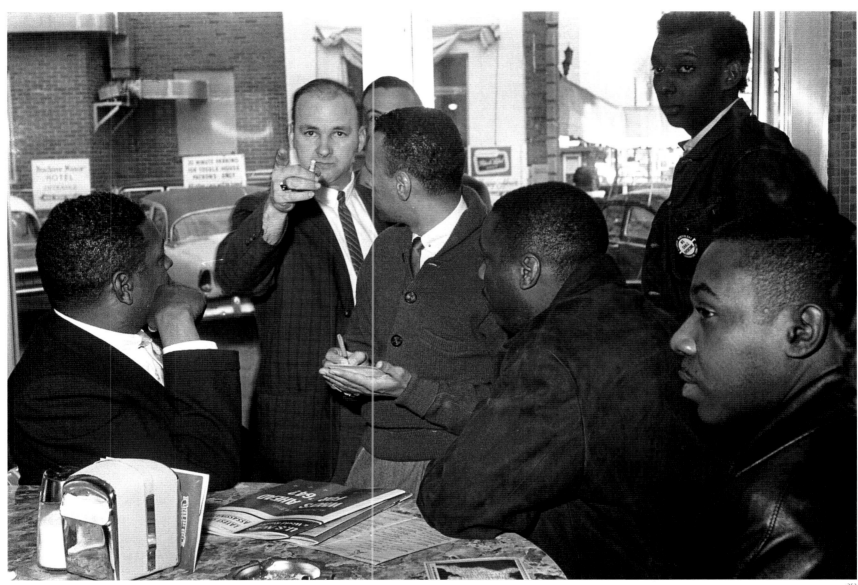

353

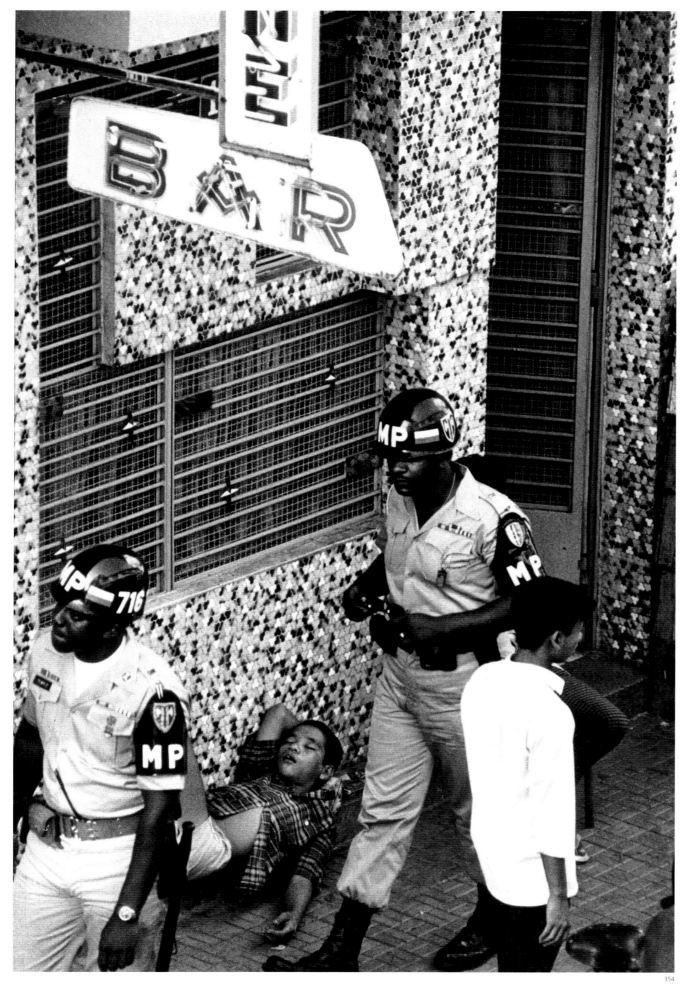

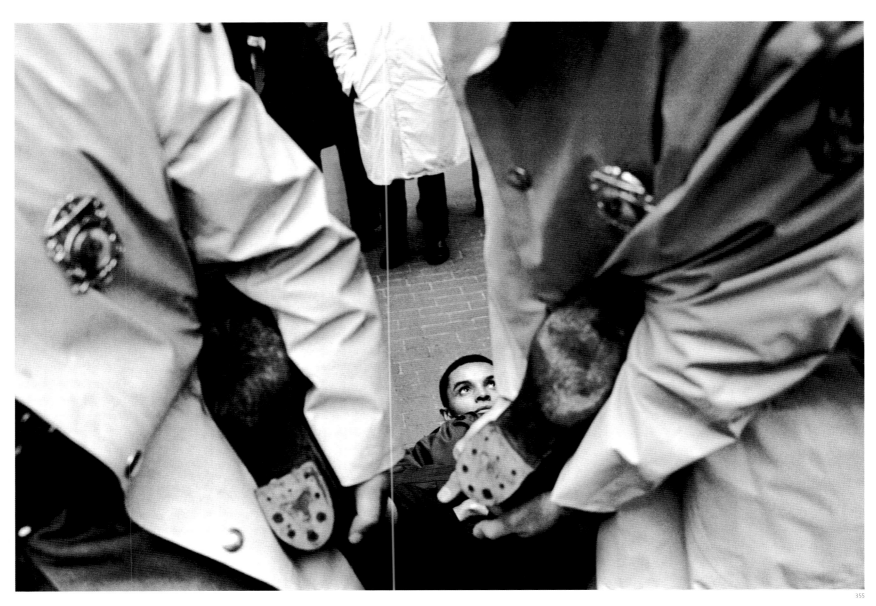

354. South Vietnam, early
1960s. During the Cold War
the Eisenhower and Kennedy
administrations stationed
U. S. military advisors
in South Vietnam. In the
months immediately following
Lyndon Johnson's landslide
presidential victory in
November 1964, he authorized
the expanded deployment
of U. S. troops in that country.
By January 1965, 25,000
U. S. troops were stationed in

Vietnam and were directly
involved in combat against
both the National Liberation
Front, a guerrilla movement
in South Vietnam, and North
Vietnamese army troops.
In 1966, 184,000 U. S. troops
were in Vietnam, with
thousands more arriving
every week.

355. Man dragged away
during a CORE demonstration
in New York City, 1964.
In 1964 CORE had two major
initiatives in New York City
against segregation. On
3 February 1964, it initiated a
city-wide boycott of public
schools, demanding desegre-
gation. Nearly half of the
students stayed at home and
thousands of CORE activists
picketed the Board of
Education. A month later,

several dozen members
of Harlem's CORE chapter
blockaded the roadway
across the Triborough Bridge.

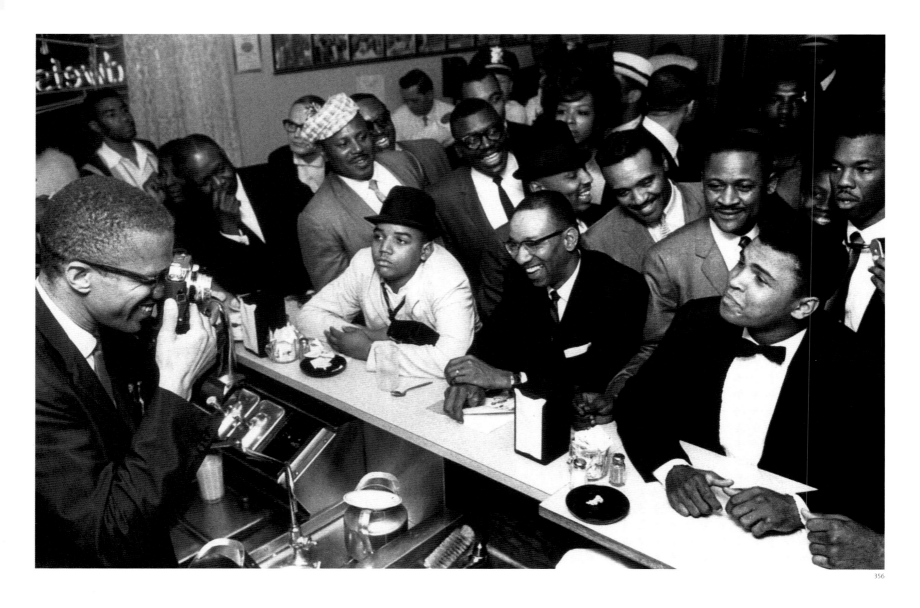

356. Malcolm X photographing Cassius Clay (aka. Muhammad Ali, seated, right) celebrating his championship victory over Sonny Liston in a restaurant in Miami, 26 February 1964. On 3 July 1963, two former secretaries of Nation of Islam leader Elijah Muhammad filed paternity suits against him claiming that the 67-year-old patriarch had fathered their four children. Malcolm X found it difficult to justify his leader's private behavior, and was increasingly at odds with the political conservatism of the organization. Following the assassination of President Kennedy, Malcolm had commented to the media that the chief executive's death was a case of "the chickens coming home to roost . . . that the hate in white men had not stopped with the killing of defenseless black people, but that

hate, allowed to spread unchecked, finally had struck down this country's chief of state." Most major media took Malcolm's words out of context, implying that he supported the murder of the president. Elijah Muhammad used this public controversy as a rationale for removing Malcolm X from his organization. He was "silenced" for 90 days, but was not subsequently reinstated as an NOI leader. During this period of suspension, Malcolm and his family visited Miami Beach for one of the few family vacations. In a shocking upset, Clay defeated Sonny Liston to become the world's heavyweight champion. Almost immediately after winning the title, he announced his membership in the NOI and proclaimed that he would change his name to Muhammad Ali. Malcolm had been largely

responsible for recruiting Cassius Clay, the young boxer from Louisville, into the NOI.

357. Martin Luther King, Jr. and Malcolm X at the Capitol during a debate on the civil rights bill, Washington, D. C., 26 March 1964. On 8 March 1964 Malcolm X announced his departure from the Nation of Islam and the foundation of the religious Muslim Mosque, Inc. He was now "prepared to cooperate in local civil rights actions in the South and elsewhere and shall do so because every campaign for specific objectives can only heighten the political consciousness of the Negroes and intensify their identification against white society." Traveling to Washington, D. C. to observe the Senate debate over the stalled Civil Rights Act, Malcolm X accidentally encountered King in the hallway of the Capitol building on 26 March. Several weeks after their only meeting, Malcolm X completed his

spiritual hajj to Mecca and returned to the United States in May as El Hajj Malik el Shabazz. In the course of his travels through the Middle East and Africa, Malcolm X met Muslims of many different skin colors and cultures, gaining a more complex perspective on America's racial dilemma. He later wrote "I was no longer less angry than I had been [sic], but at the same time the true brotherhood I had seen had influenced me to recognized that anger can blind human vision." Malcolm's new political views included the necessity for African Americans to develop an independent political strategy regarding the U. S. electoral system. He also emphasized the parallels between the African American movement for equality and social justice and the African and Asian

struggles for independence against European colonialism. El Hajj Malik el Shabazz founded the Organization of Afro-American Unity in May 1964, a secular, progressive formation dedicated to coalition-building throughout the black community.

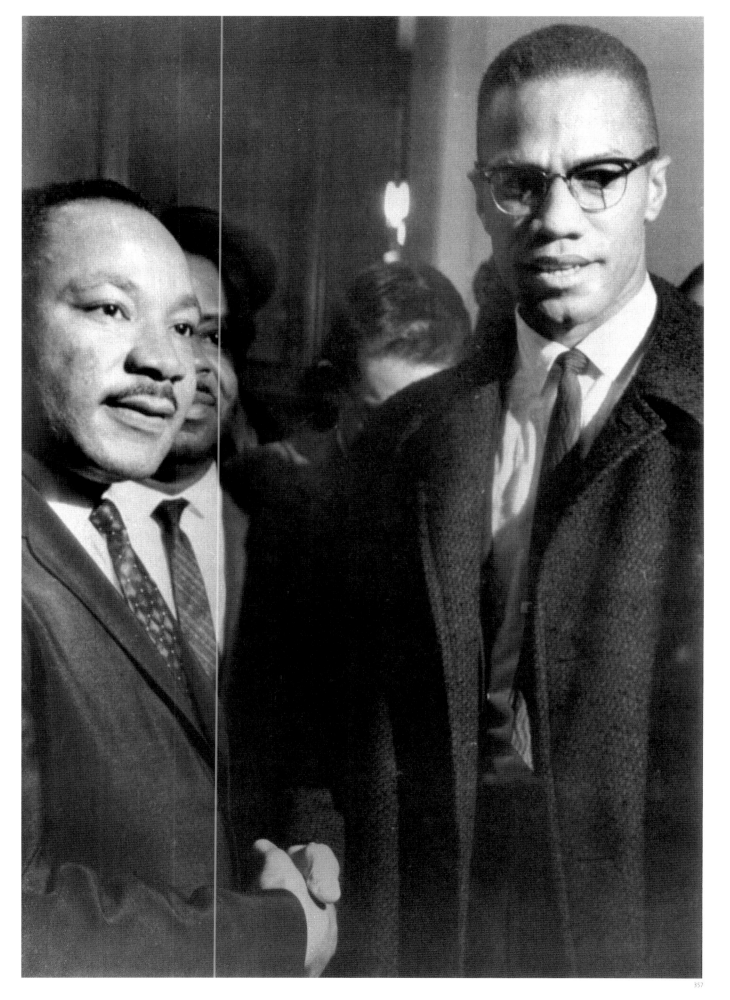

358. Members of CORE blocking the Triborough Bridge during a sit-in demonstration in New York City, 6 March 1964. Some demonstrators arrived at the Triborough Bridge — connecting Manhattan, the Bronx, and Queens — with bags of garbage to dramatize the unequal living and school conditions of African Americans. A second school boycott was called for on 16 March, which Bayard Rustin and mainstream civil rights leaders in the NAACP, and the Urban League immediately denounced as disruptive. Even James Farmer, the national leader of CORE, disavowed the protests. However, militant local CORE leaders accelerated confrontational tactics with city police and public officials.

359. Nashville, Tennessee, 27 April 1964. With the civil rights bill stalled in the U. S. Senate there was still no national law prohibiting racial segregation in public accommodations such as restaurants, theaters, and other public establishments. In the state capital on 27 April 1964, several hundred civil rights protesters marched toward downtown to protest racially segregated restaurants. Wielding a nightstick, a Nashville police officer grabbed one of the demonstrators and ordered him into custody. When the man refused he was beaten and subdued by officers who forcibly pushed him into the police wagon with other arrested demonstrators.

360. National Guard arresting SNCC photographer Clifford Vaughs in Cambridge, Maryland, 2 May 1964. Cambridge was, for several years, an important site for desegregation campaigns in the border state of Maryland. This image of struggle and the use of police power to suppress dissent was taken by photographer Danny Lyon, another staff member of SNCC.

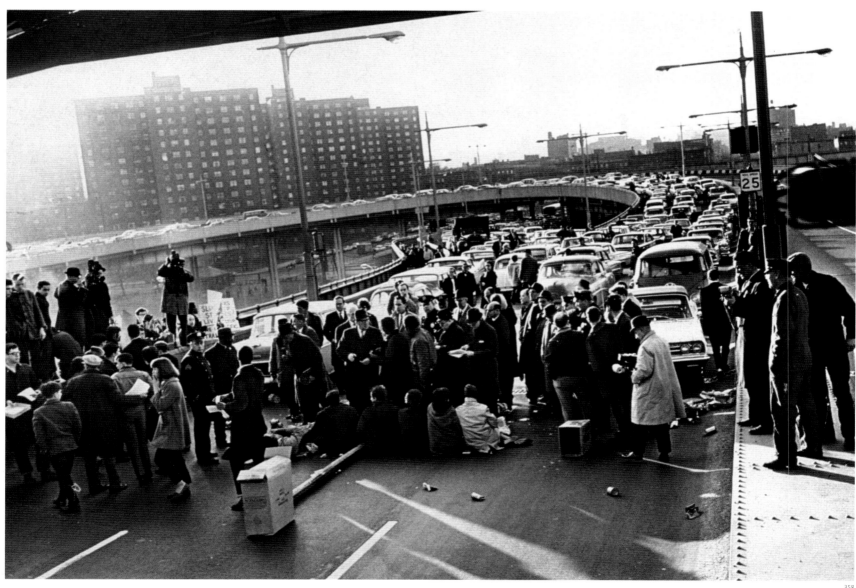

358

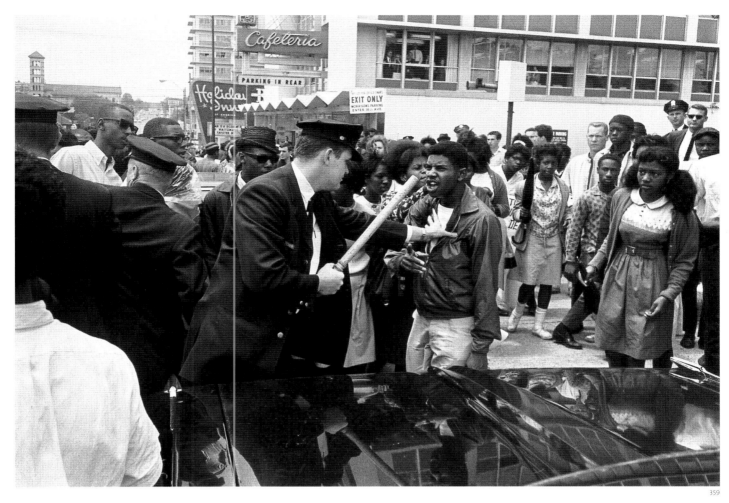

359

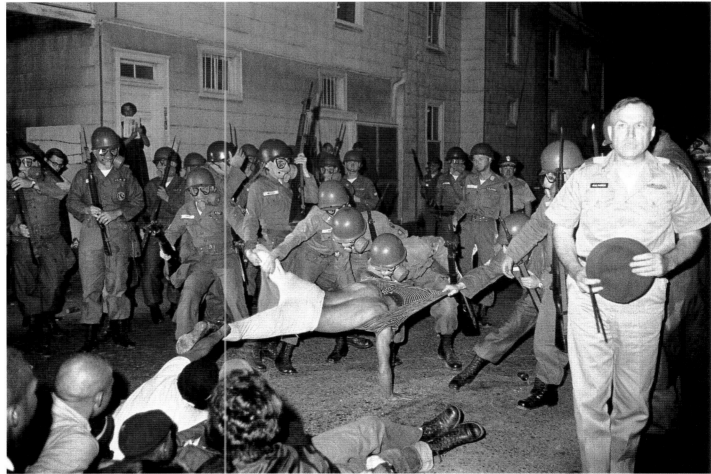

360

343

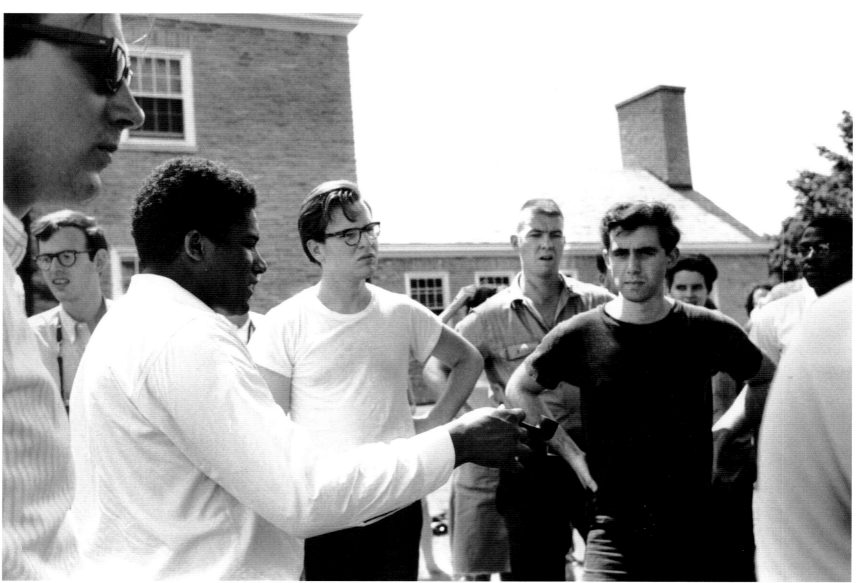

361. Andrew Goodman (right) training with other civil rights workers for the Mississippi project, Oxford, Ohio, June 1964. In 1962 less than 7 percent of the African American electorate in the state of Mississippi was registered to vote — the lowest percentage in the United States at the time. For this reason, SNCC, CORE, and the NAACP targeted that state for intense political organizing. Recognizing that

white Americans would be more sympathetic to the cause of civil rights if whites became involved in the effort to build democracy across the South, black leaders recruited white college students to train in the techniques of nonviolent direct action with the objective of registering thousands of new African American voters. Andrew Goodman, a twenty-year-old drama major at the

Queens College of the City University of New York, was a volunteer to participate in the Mississippi "Freedom Summer," the state-wide mobilization that involved over 1,000 volunteers, three quarters of whom were white.

362. Robert Moses training Freedom Summer volunteers, Mississippi, 1964. Robert Parris Moses was the central figure in organizing the 1964 Freedom Summer. The son of a Harlem laborer, Moses approached his task with unusual pragmatism: "We can organize the people and present a challenge," Moses informed the press in early August 1964, "somebody else has to make the decision to

get the Negro on the voter registration books. We can take him to the courthouse and stand in line with him, but that is as far as we can go."

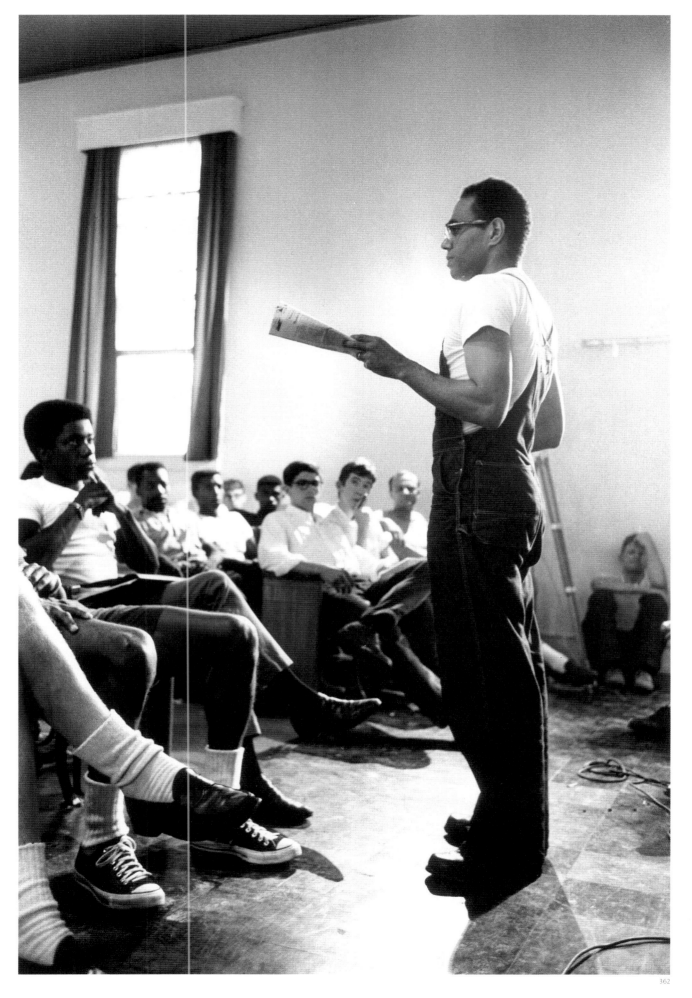

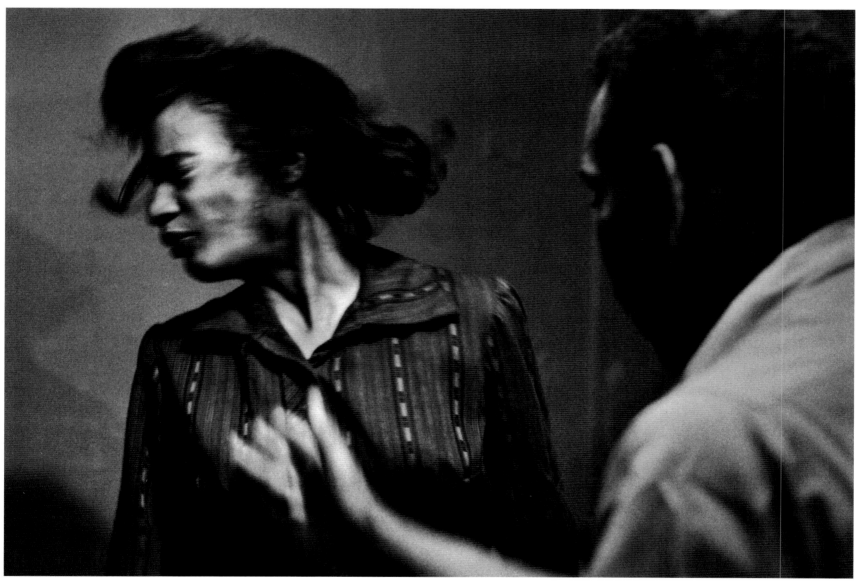

363, 365. Civil rights workers in training, Mississippi, summer 1964. Preparing middle-class college students for the physical abuse and vigilante violence that frequently occurred in civil rights organizing efforts in the Deep South was extremely difficult. Such idealism within SNCC was characterized by the expression "true believers": those activists who embodied a deep faith in the possibility of human transformation through peace and love. Civil rights workers were trained not to respond to the most extreme provocation.

364. Freedom School pupils, Hattiesburg, Mississippi, 11 July 1964. The Freedom Summer project organized thirty "Freedom Schools" throughout Mississippi, which focused on leadership training with a curriculum including reading, mathematics, and African American history. Over three thousand young blacks attended the Freedom Schools. These educational institutions, spawned by social protest, became models for alternative grassroots educational programs throughout the United States. The schools also played a role in the development of the Mississippi Freedom Democratic Party, an independent political movement that challenged the hegemony of the white supremacist Mississippi Democratic Party.

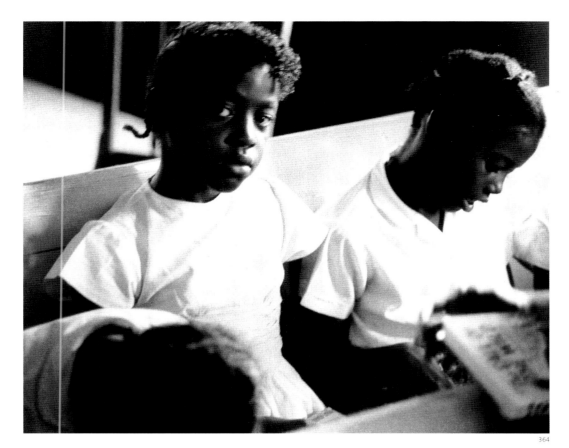

364

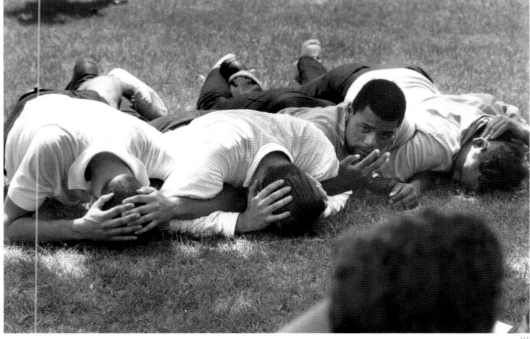

365

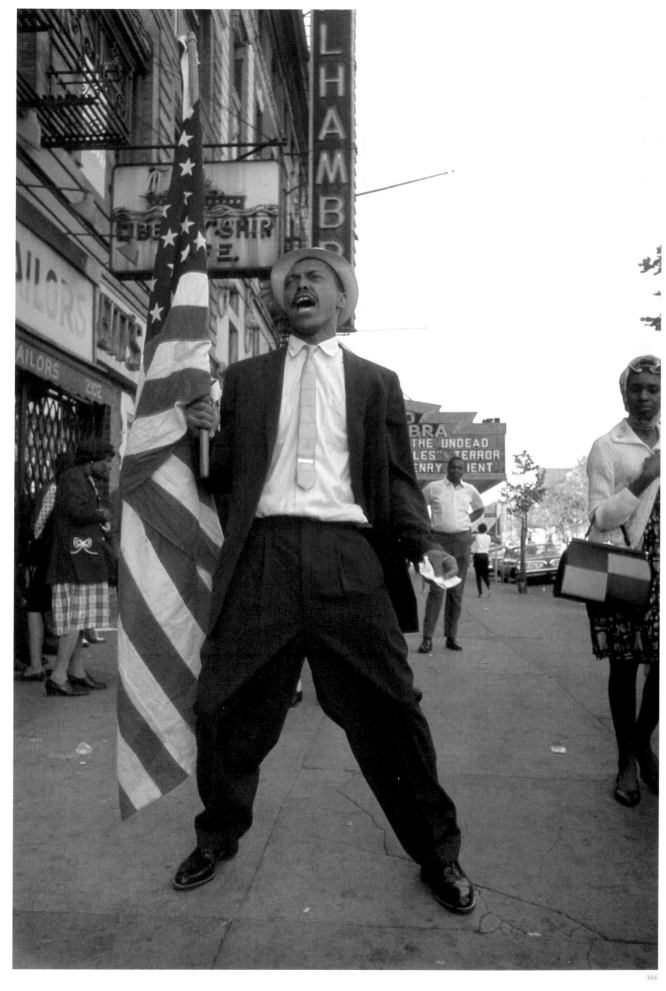

366

366. Civil rights demonstrator outside the Alhambra Theater in Harlem, New York City, 1964.

367. President Lyndon B. Johnson (seated) shaking hands with Martin Luther King, Jr. at the signing of the Civil Rights Act, 2 July 1964. On 10 June 1964, by a vote of 73 to 27, the U. S. Senate ended the filibuster blocking the passage of the civil rights bill that President Kennedy had originally proposed. The Civil Rights Act of 1964 was signed by President Lyndon Johnson on 2 July 1964. The law empowered the Attorney General to defend the rights of citizens against racial discrimination in all aspects of public life, from hotel accommodations to the use of public facilities and public education. The law created a new federal agency, the Equal Employment Opportunity Commission (EEOC), which had the authority to enforce civil rights in workplaces across the country. The United States Office of Education was granted the power to extend financial assistance and technical support to aid cities in the integration of their public schools. Millions of white southern Democrats began to abandon the Democratic Party over the issue of race.

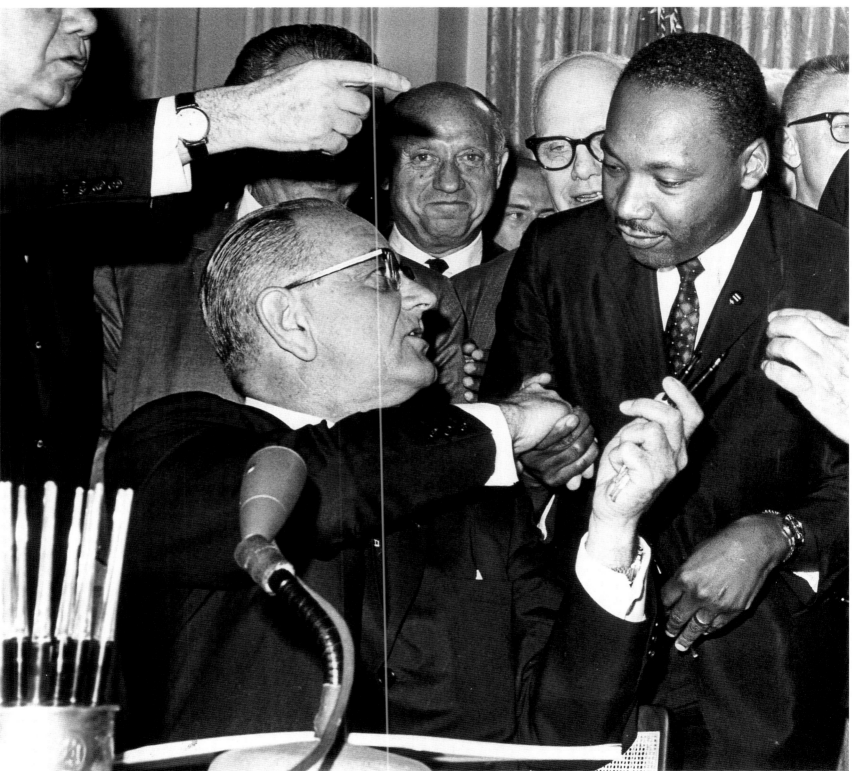

367

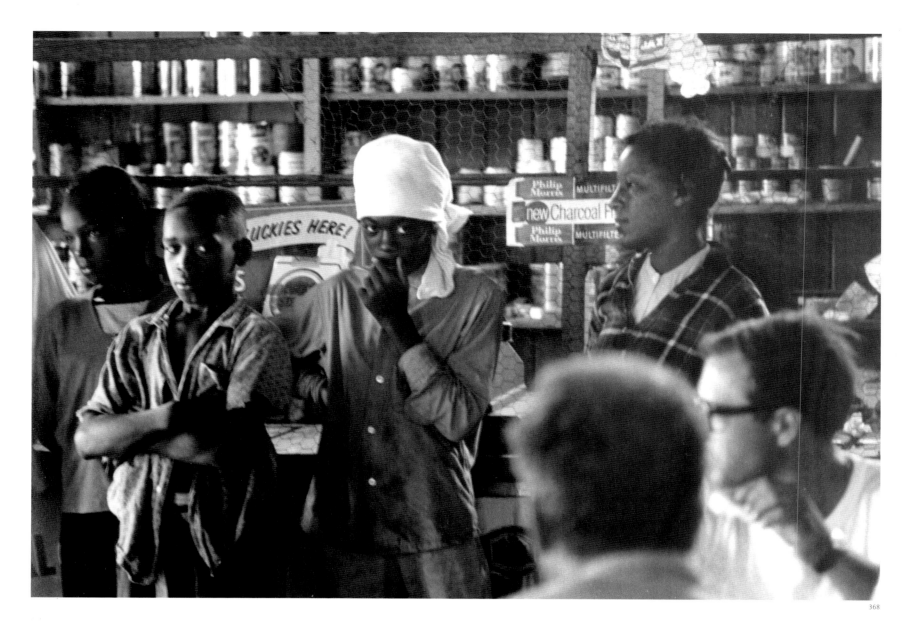

368

368. Teenagers and Freedom Summer volunteers (right, seated) at Beddingfield's store near Mileston, Mississippi, summer 1964.

369. Civil rights workers calling on a family for the voter registration project, Mississippi, 1964. Freedom Summer activists for the most part lived in the homes of rural black families and avoided white establishments. Nevertheless, white racist vigilantes and law enforcement officials made a concerted attempt to intimidate and expel the civil rights workers. Freedom Schools were frequently the targets of attack. Throughout the summer of 1964, thirty black homes and more than three dozen African American churches were firebombed or destroyed in Mississippi.

370. Woman registering to vote in Baton Rouge, Louisiana, 1964.

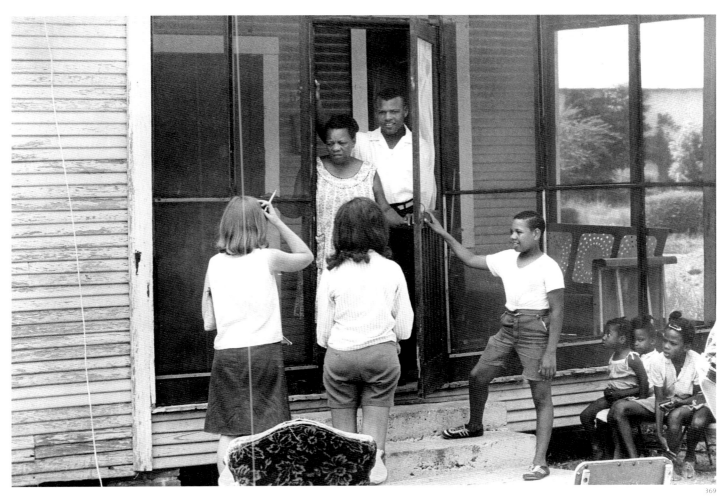

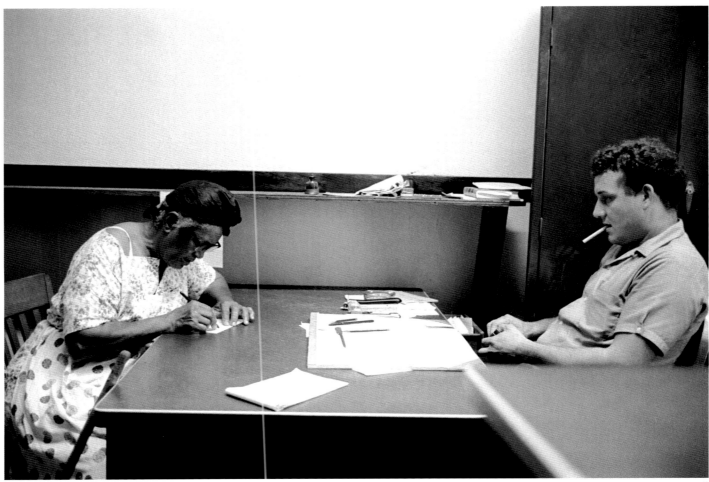

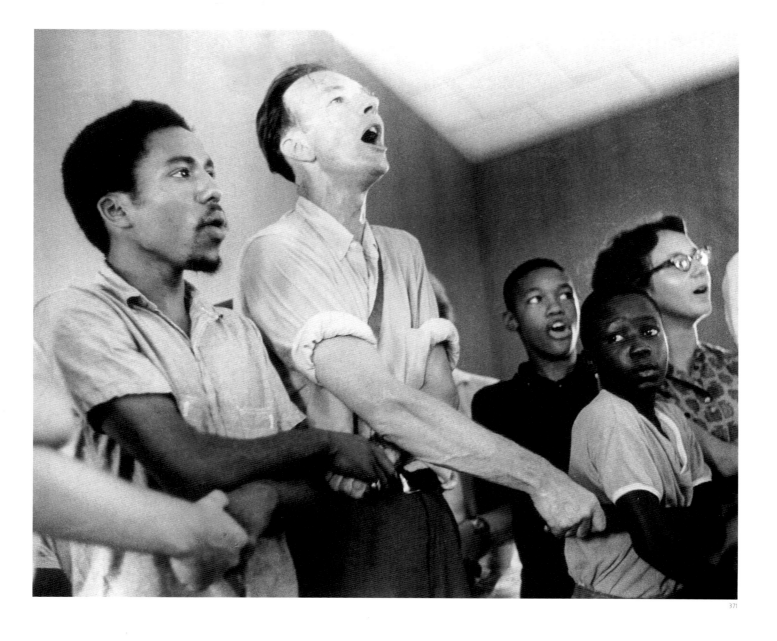

371. Pete Seeger (second from left) at a community center meeting, Mississippi, 4 August 1964. Seeger was a legendary folksinger, song writer, and political activist. He became a musician during the Great Depression and began performing with folksinger Woody Guthrie. In the 1950s he was blacklisted during the McCarthy period, and was subpoenaed before the House Un-American Activities Committee (HUAC) in 1955. He was indicted for contempt by Congress, and sentenced to serve ten years in prison, but was later freed when his conviction was reversed. Seeger was the author of numerous songs that became standards in American folk music. His version of an old spiritual, which he called "We Shall Overcome," became the anthem of the civil rights movement.

372–373. Men observing the towing of the car in which civil rights workers James Earl Chaney, Michael Schwerner, and Andrew Goodman were murdered, Mississippi, 4 August 1964. James Earl Chaney, born in Meridian, Mississippi in 1943, joined CORE at the age of twenty. He became involved in the mobilization of the 1964 Freedom Summer with white activists such as Andrew Goodman and Michael Schwerner, a 24-year-old Cornell University graduate who had just opened the CORE office in Meridian with his wife Rita. On 21 June 1964, Chaney, Schwerner, and Goodman were driving from Meridian to Lawndale, Mississippi, when the police stopped them in Philadelphia, Mississippi, for speeding. They were taken to jail but were subsequently released. The three men disappeared and for six weeks nothing was heard of them. On 4 August 1964, three decomposed bodies were uncovered beneath an earthen dam. The autopsy revealed that Goodman and Schwerner had been killed by single gunshots to the head. Chaney had been brutally beaten to death before being shot. The Justice Department subsequently indicted nineteen people, including police officers and member of the Ku Klux Klan for their involvement in the murders. Only seven of those indicted were found guilty.

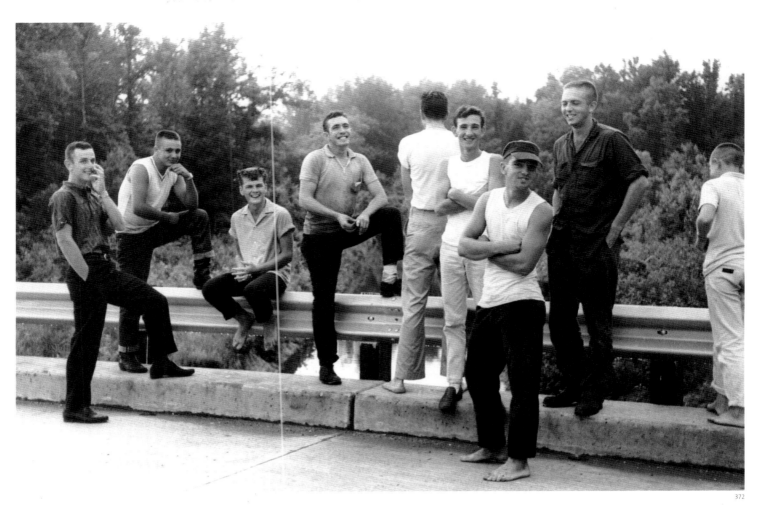

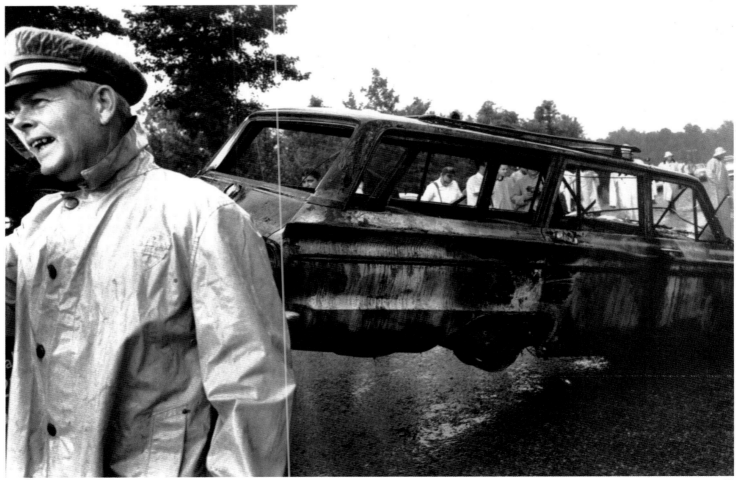

374. James Earl Chaney's family at his memorial service, Mississippi, August 1964.

375. Participants at the Democratic National Convention in Atlantic City holding banners in memory of James Earl Chaney, Michael Schwerner, and Andrew Goodman, Atlantic City, New Jersey, 24–27 August 1964. By the summer of 1964, 80,000 African Americans had joined an independent political movement, the Mississippi Freedom Democratic Party (MFDP), to challenge the state's pro-segregationist Democratic Party. The MFDP sent its representatives to the Democratic National Convention in Atlantic City, demanding the right to represent the people of their state in the proceedings. Unwilling to alienate white southern Democrats, President Lyndon Johnson proposed a compromise agreement according to which the all-white delegation would remain intact and only two MFDP delegates would be credentialed to vote as official delegates. All other MFDP representatives would be classified as observers only. Most of the mainstream civil rights leadership, including Martin Luther King, Jr. and Roy Wilkins, urged the MFDP to accept the compromise, but they refused. To many progressives in the civil rights movement, the Democratic Party's leadership had betrayed the principles of democracy.

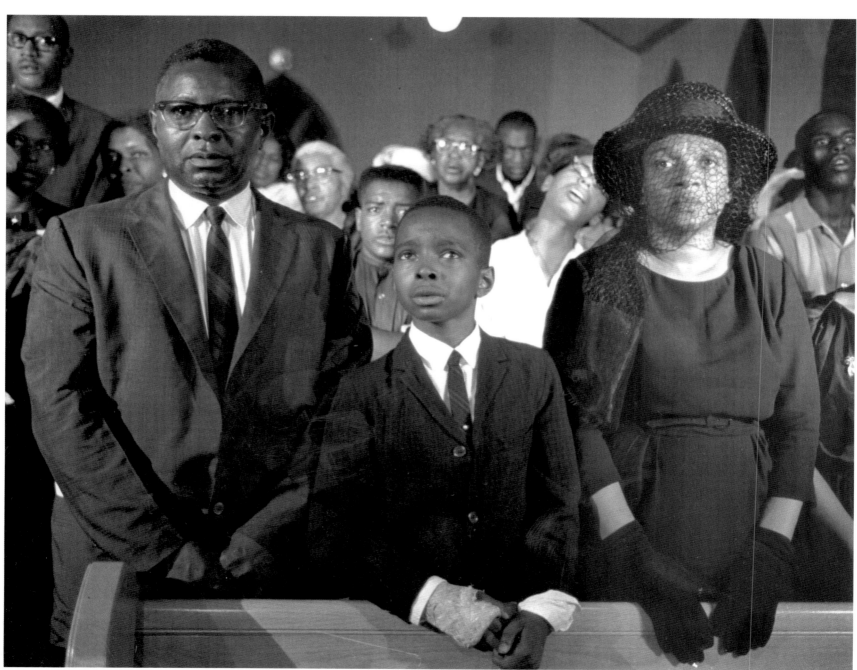

374

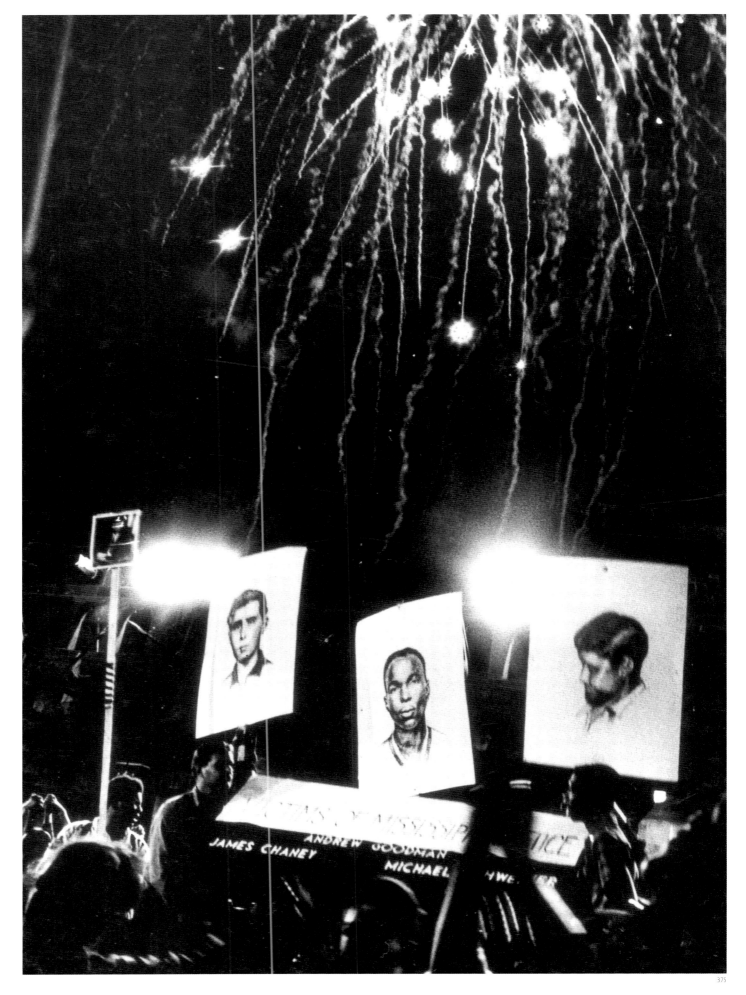

376. Fannie Lou Hamer testifying before the Democratic National Convention Credentials Committee, Atlantic City, 22 August 1964. Born on 6 October 1917 in rural Mississippi, Fannie Lou Hamer was the youngest of twenty children in a sharecropper family. At the age of six she began picking cotton in the fields. She was only able to complete six years of primary school education. In the early 1960s, Hamer became involved in voter registration efforts led by SNCC and the SCLC. After attempting to register to vote at Indianola, Mississippi, Hamer and others were jailed. Her landlord ordered her off his property and her career as a full-time organizer began. She became a field secretary for SNCC, organizing grassroots constituencies across the state. On 9 June 1963 in Winona, Mississippi, Hamer and other SNCC workers were brutally beaten while in police custody. Hamer's injuries from the beating gave her serious health problems through the remainder of her life. In 1964 she became a leader of the MFDP and attended the Democratic National Convention in Atlantic City. Confronting the convention's Credentials Committee, Hamer passionately challenged the exclusionary policies of the Democratic Party, asking, "Is this America, the land of the free and the home of the brave, where we are threatened daily because we want to live as decent human beings?" In 1969 Hamer established the Freedom Farm Cooperative, helping thousands of poor black farmers to grow their own food. Hamer died in 1977.

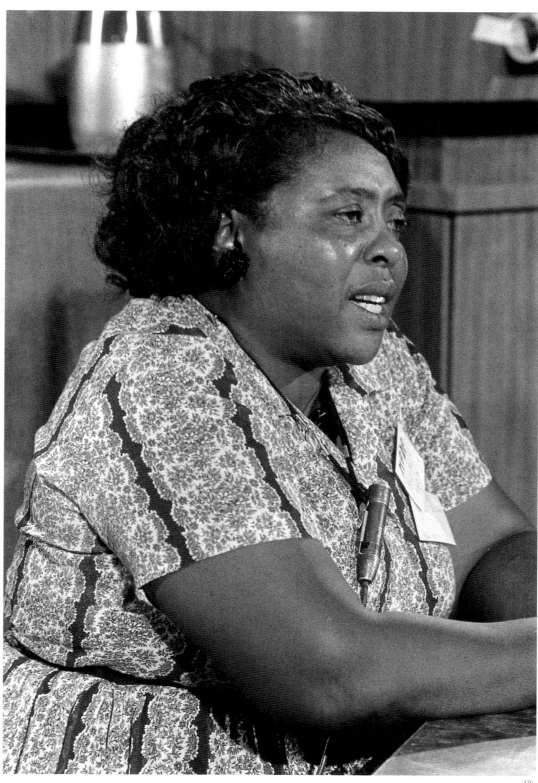

376

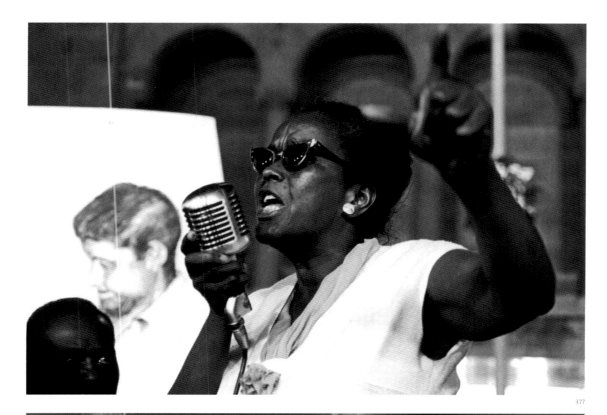

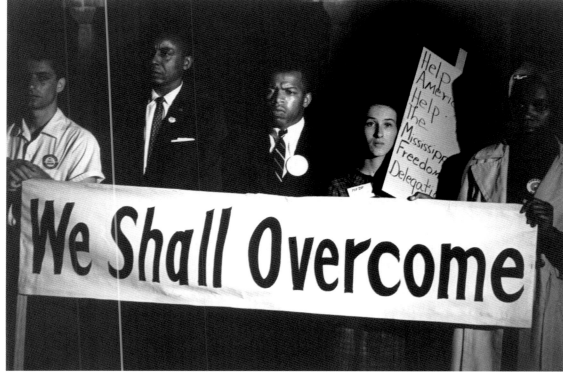

377. Ella Baker addressing a rally of the MFDP outside the Democratic National Convention, Atlantic City, 24–27 August 1964. Born in Norfolk, Virginia in 1903, Ella Baker attended Shaw University in Raleigh, North Carolina, graduating as valedictorian in 1927. She worked for several years in Harlem as the national director of the Young Negroes Cooperative League, which was involved in building black economic capacity through the development of consumer cooperatives. Joining the NAACP in 1940, Baker was soon promoted to director of branches. She criticized the hierarchical structure of the organization and its emphasis on legal reforms at the expense of grassroots organizing. Baker resigned her position in 1946. In 1958 she moved to Atlanta as a key administrator for the SCLC. She was central in the creation of SNCC, believing in an independent, non-hierarchical organization that focused on direct action. She noted that students "showed willingness to be met on the basis of equality, but were intolerant of anything that smacked of manipulation or domination. This inclination toward group-centered leadership . . . was refreshing indeed to those of the older group who bear the scars of the battle, the frustrations and the disillusionment that come when the prophetic leader turns out to have heavy feet of clay." In 1964 Baker helped to organize the Freedom Summer and the MFDP. She died in 1986.

378. Civil rights activists at the Democratic National Convention, Atlantic City, 24–27 August 1964. The debate over civil rights at the 1964 Democratic National Convention sparked an exodus of white segregationists from the party. In November 1964, conservative Republican presidential candidate Barry Goldwater was defeated soundly by Democratic candidate Lyndon B. Johnson throughout the country, but carried electoral majorities in Mississippi, Louisiana, Alabama, Georgia, and South Carolina. The so-called solid South, the electoral corner-stone of the Democratic Party for a century, fell apart because many southern whites were unable to accept integration and equal rights. This new Republican majority throughout much of the South became the core constituency of Reaganism in the 1980s.

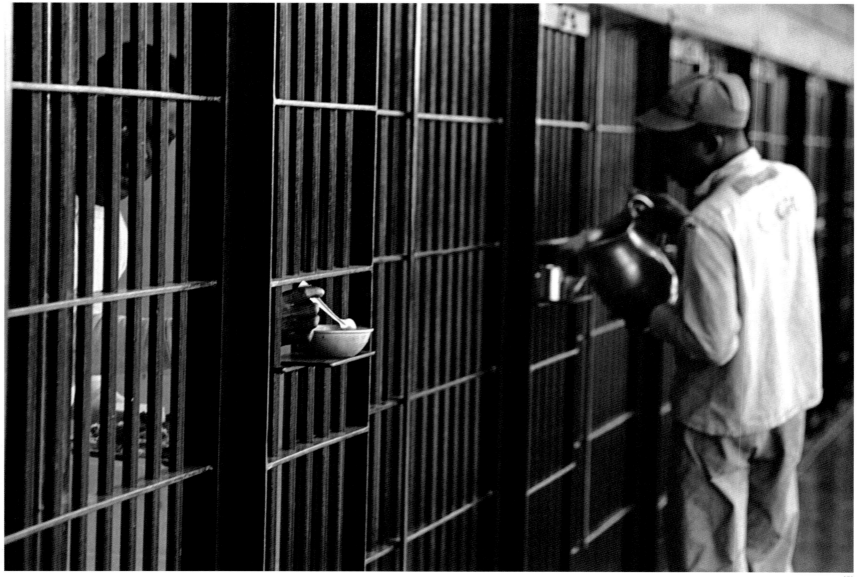

379

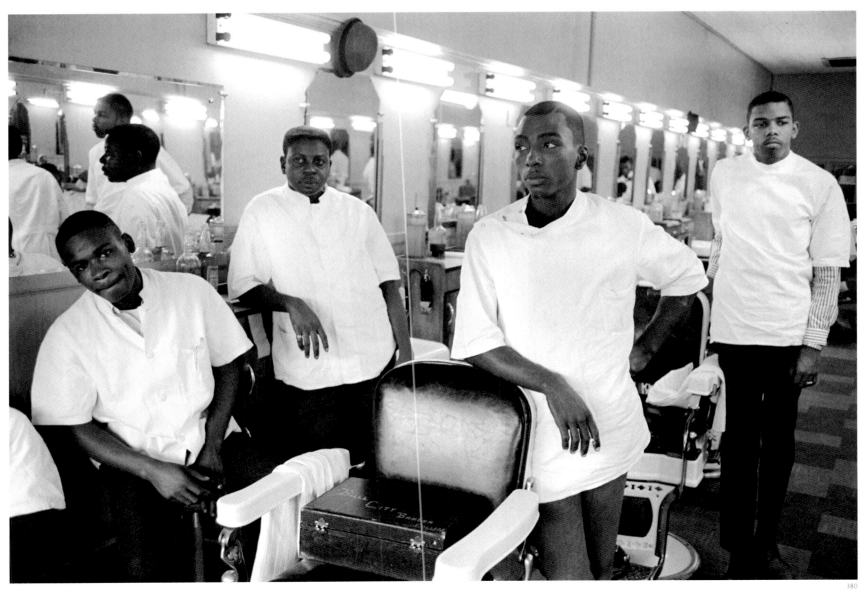

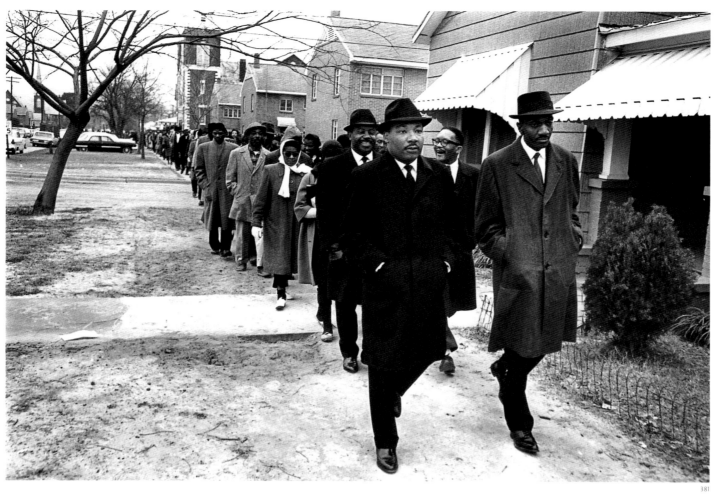

381

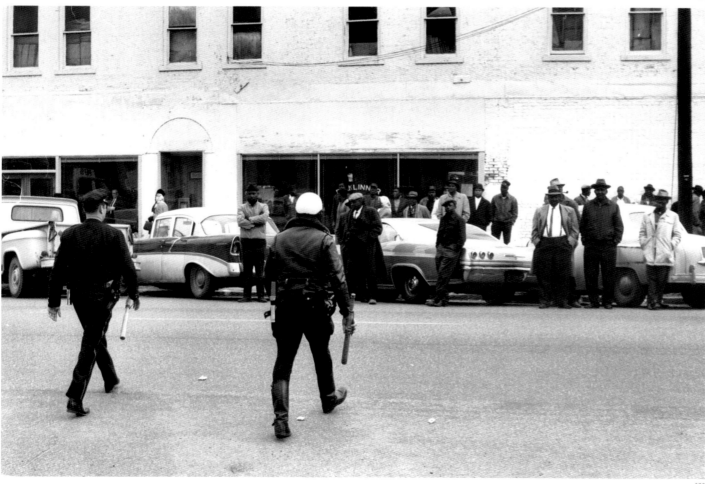

382

360

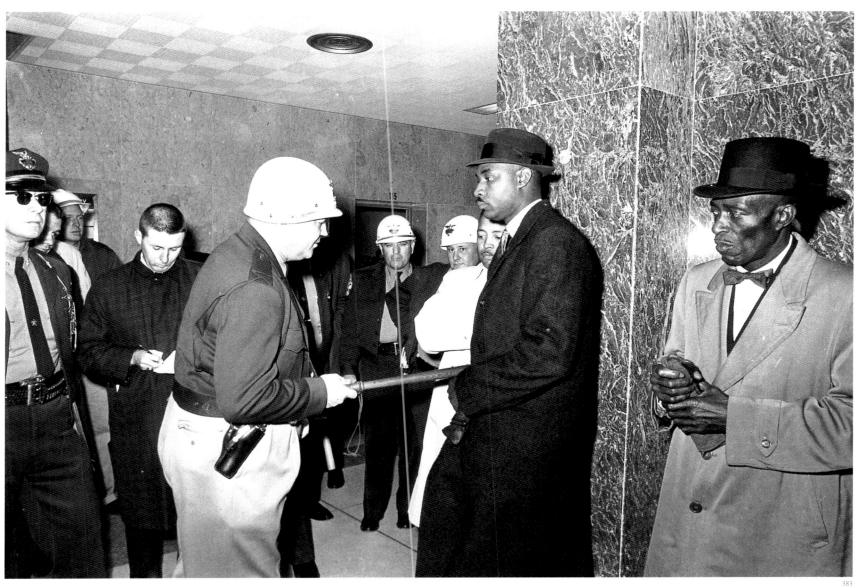

381. Martin Luther King, Jr. leading the march on the Dallas County Courthouse, Selma, Alabama, 1 February 1965. On 10 December 1964, King was awarded the Nobel Peace Prize in Oslo, symbolizing the international recognition of the African American civil rights movement. With the passage of the 1964 Civil Rights Act, the new focus for civil rights workers in the South shifted to the enforcement of voting rights. SNCC organizers had been working in rural Black Belt Alabama for several years attempting to register African American voters, and had encountered extreme resistance from white authorities. A series of demonstrations took place in Selma in early 1965, and on 22 January, more than 100 African American schoolteachers protested at the local courthouse, helping to spark the wide-scale participation from different groups. King and other SCLC leaders came to Selma to generate media attention around the local campaign for voting rights. On Monday, 1 February, King was arrested with 250 marchers. Upon learning about King's arrest, more than 500 public-school students marched to the courthouse and were also arrested.

382. March on the Dallas County Courthouse in Selma, 1 February 1965.

383. Sheriff Jim Clark attempting to intimidate marchers at the Dallas County Courthouse in Selma, 2 February 1965. At the courthouse the demonstrators were told that the Board of Registrars was not in session, and approximately 100 marchers were arrested. On 4 February, Malcolm X visited Selma at the request of SNCC activists. Speaking to an overflowing audience at a local black church, he expressed his solidarity with the Selma campaign. Privately, he met with King's wife, Coretta Scott King, and informed her that his goal was not to undercut the good work her husband was accomplishing, saying, "If the white people realize what the alternative is, perhaps they will be more willing to hear Dr. King."

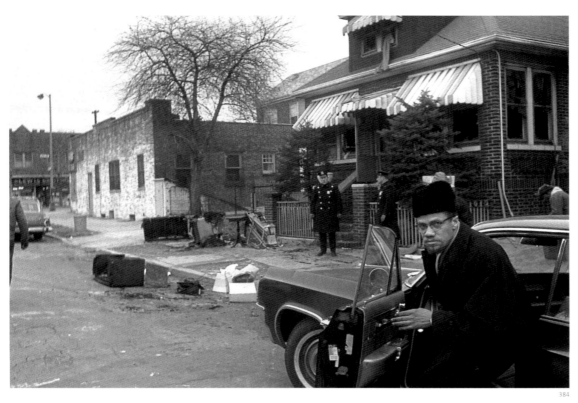

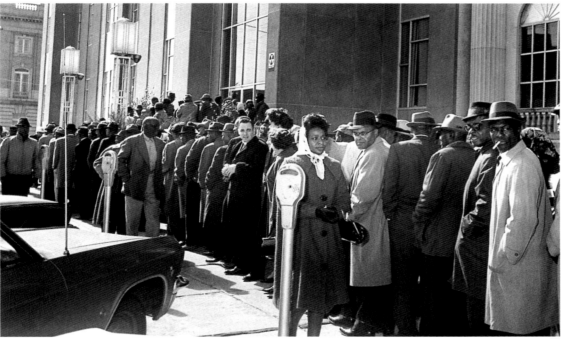

384. Malcolm X stepping out of his car in front of his home after Molotov cocktails were thrown into the house, 14 February 1965. During the second half of 1964, Malcolm X took a second trip to Africa and the Middle East. In many countries he was welcomed with the ceremony of a head of state. He met with leaders of anti-colonial movements and spoke publicly before African legislatures and the Organization of African Unity. Upon his return to the United States in late 1964, the level of harassment and death threats against him and his family dramatically increased. His former protégé, Louis X (later Louis Farrakhan), publicly attacked Malcolm X as being a man "worthy of death." Historians have subsequently learned that Malcolm X was also under close surveillance by the FBI and law enforcement authorities, who implemented tactics of disruption against his new political group, the Organization of Afro-American Unity. In the days before his assassination, Malcolm X informed his biographer, Alex Haley, that the level of harassment was so extensive that he no longer believed that the Nation of Islam was primarily responsible for it. In the early morning hours of 14 February, Malcolm's home in Elmhurst, Queens in New York City was firebombed. His pregnant wife, Betty Shabazz, and their four small children were unharmed. The Nation of Islam had previously sued Malcolm X to recover ownership of the house. Malcolm secured safe lodgings for his family and traveled the same day to Detroit to deliver an important address.

385. Outside the Dallas County Courthouse, Selma, Alabama, 15 February 1965. On 4 February, a federal judge had ordered the Selma registrar's office to process a minimum of 100 voters' applications a day. Almost immediately registrars created new obstacles for black voters. Officials required prospective voters to sign a ledger and those who did would be served first, but only on days when the registrar's office was open — two days a month. On 15 February, the last day of the month when registration was possible, Martin Luther King, Jr. led 500 African Americans who patiently waited in line to register to vote.

386. Malcolm X wheeled away on a stretcher after having been shot, Harlem, New York City, 21 February 1965. On the afternoon of 21 February 1965, just before he was due to deliver a speech at the Audubon Ballroom in upper Manhattan, Malcolm X was assassinated by three gunmen, in front of his wife and three of his four children. The perpetrators were later identified as members of the Nation of Islam. The crowd that had gathered for the address overwhelmed one of the assailants before the police took him into custody. Malcolm, who had suffered more than twenty bullet wounds, was transported on a stretcher to the hospital across the street, where he was pronounced dead. In apparent retaliation, the Nation of Islam's Mosque #7 in Harlem was firebombed hours later.

387. Mourners paying their respect to the deceased Malcolm X at the Unity Funeral Home in Harlem, 23–26 February 1965 (overleaf). In the last year of his life, Malcolm X successfully completed a spiritual journey from the separatism of the Nation of Islam, to the internationalism of orthodox Islam. Unfortunately, he did not have sufficient time to complete his political journey. He remained committed to black nationalism, which he defined as the effort to build strong black-controlled institutions for empowering the African American community. But in the last months of his life he also spoke about the need for African Americans to challenge the capitalist system. He denounced U. S. involvement in Vietnam and urged African Americans to build solidarity movements with Third World countries. At Malcolm X's funeral, African American actor and activist Ossie Davis eulogized him: "Malcolm was our manhood, our living, black manhood! This was his meaning to his people. And, in honoring him, we honor the best in ourselves. And we will know him then for what he was and is — a Prince — our own black shining Prince! — who didn't hesitate to die, because he loved us so."

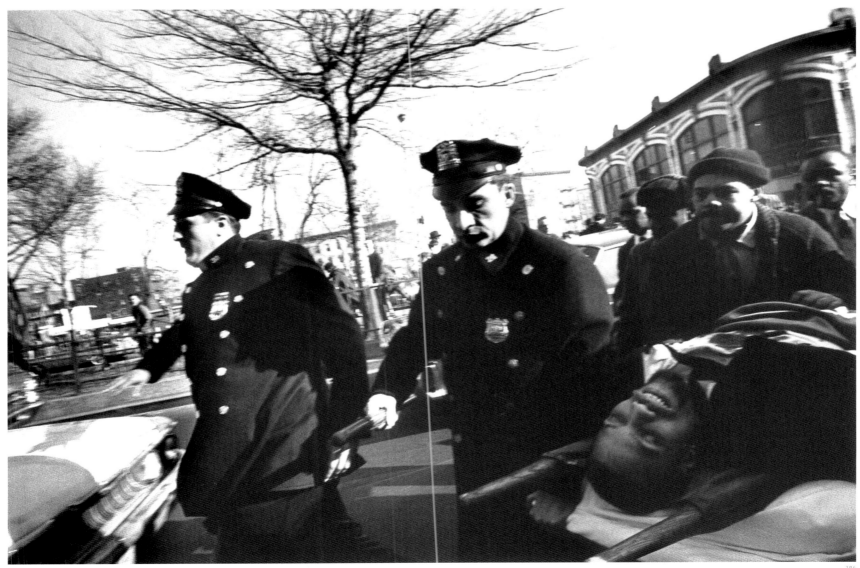

386

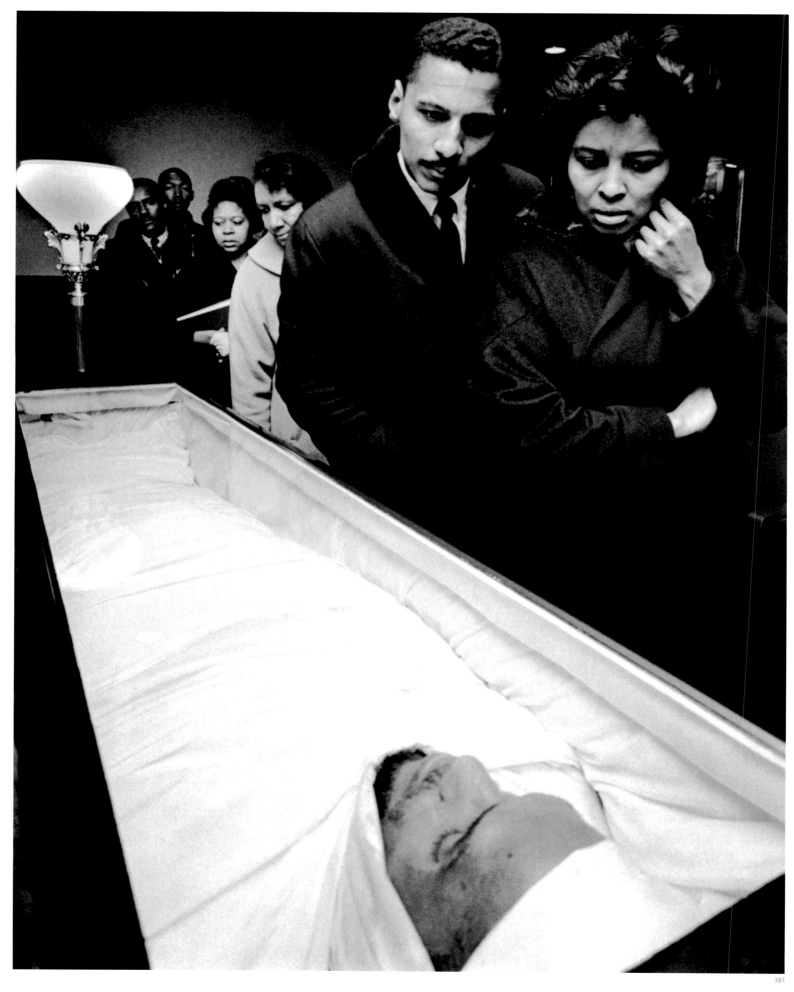

387

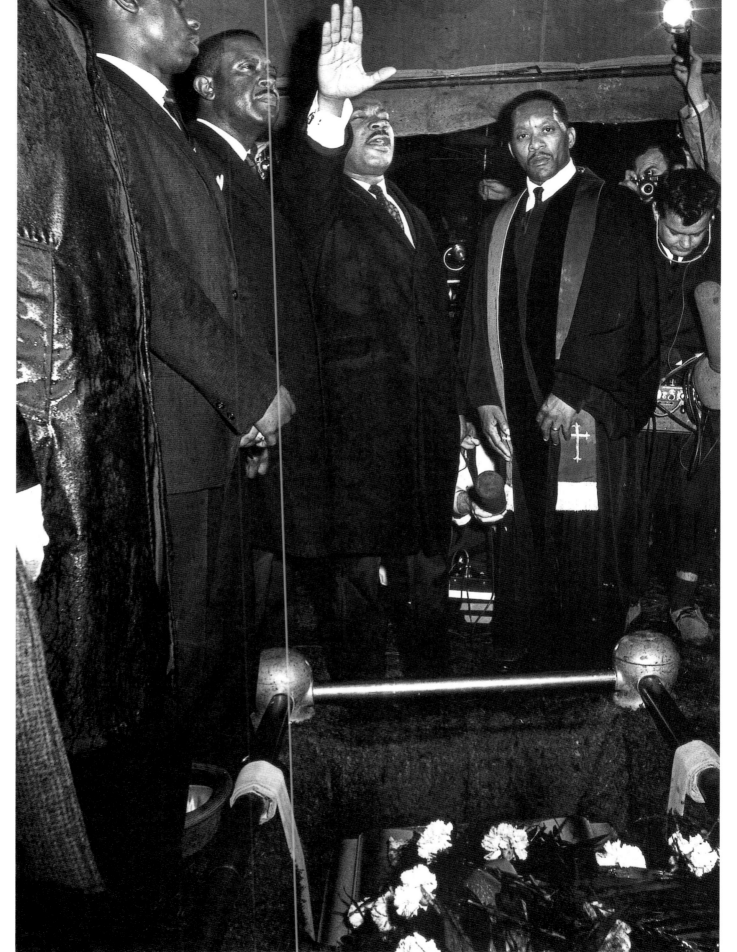

388. Martin Luther King, Jr.
(with raised hand) speaking
at the funeral of Jimmy
Lee Jackson, Selma, Alabama,
3 March 1965. In Marion,
Alabama, not far from Selma,
SCLC executive staff member
Reverend C. T. Vivian led
a peaceful march in the early
evening of 18 February. The
marchers were assaulted by
white vigilantes and law
enforcement officers. Cager
Lee, an 82-year-old man, was
brutally beaten. His grandson,
26-year-old Jimmy Lee Jackson,
helped him to escape, but
both men were followed by
the white mob. When Jackson's
mother was also attacked,
and Jackson attempted to
defend her, one state trooper
struck him in the face with
a nightstick and another shot
him in the stomach. Jackson
died seven days later.

389. "The two-minute warning," confrontation at the Edmund Pettus Bridge, Selma, 7 March 1965. After the murder of Jimmy Lee Jackson, the SCLC was determined to hold a nonviolent march demanding voting rights that would capture the attention of the national media. The plan was to walk along the highway from Selma to the state capital of Montgomery fifty miles away. SNCC was opposed to the march, but permitted their members to participate as individuals. On Sunday 7 March, Martin Luther King, Jr. was speaking at his church in Atlanta, so SCLC leader Hosea Williams was selected to lead the march. He was joined by Andrew Young, James Bevel, other SCLC organizers, and SNCC leader John Lewis. As marchers crossed the Edmund Pettus Bridge leading from Selma to Montgomery, they encountered police armed with shotguns and automatic weapons. Governor George Wallace had ordered the use of force, if necessary, to halt the march. The Alabama troopers, determined to stop the marchers, pressed forward in readiness to attack.

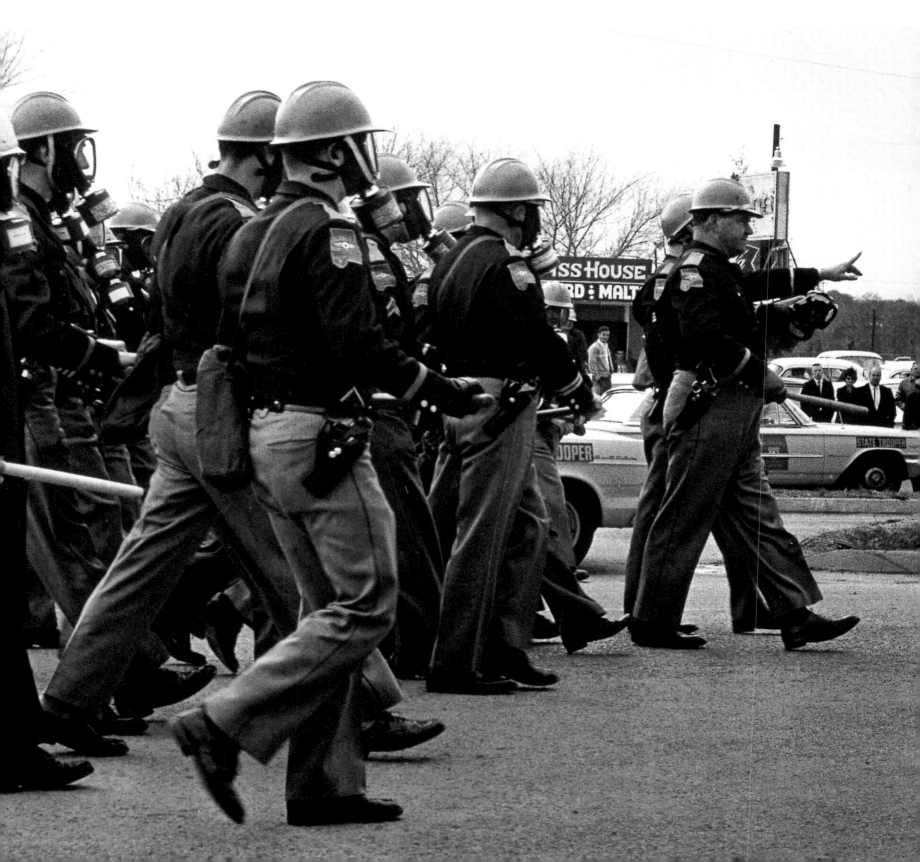

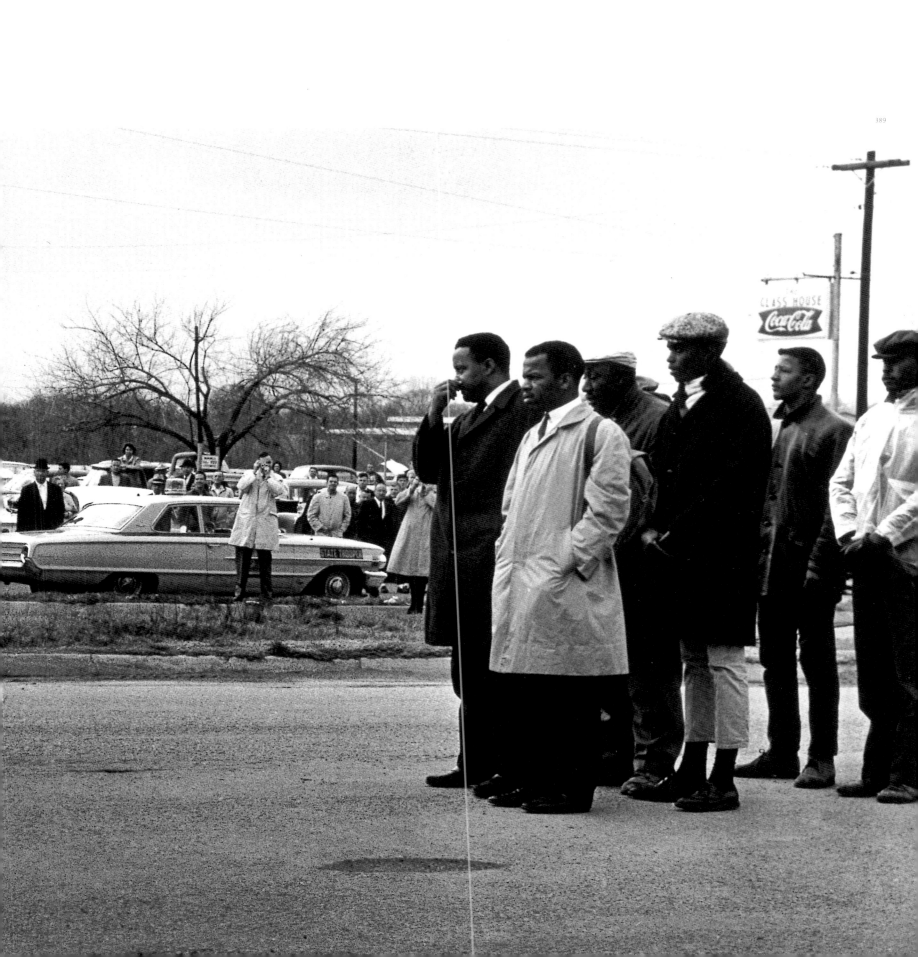

390, 392. Selma, 7 March 1965. The police attacked with tear gas and nightsticks. The shocking images of what became known as "Bloody Sunday" were shown across the world.

391. Selma, 7 March 1965. Amelia Boynton, a highly respected Selma resident and activist, being helped to her feet after being knocked unconscious by a trooper. As she later recounted, "The horses . . . were more humane than the troopers: they stepped over fallen victims. As I stepped aside from a trooper's club, I felt a blow on my arm . . .

another blow by a trooper as I was gasping for breath, knocked me to the ground and there I lay, unconscious."

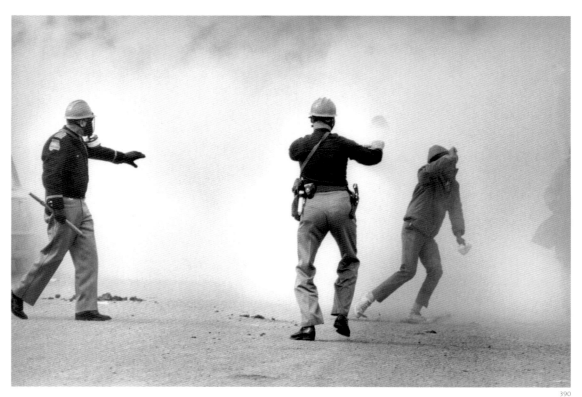

390

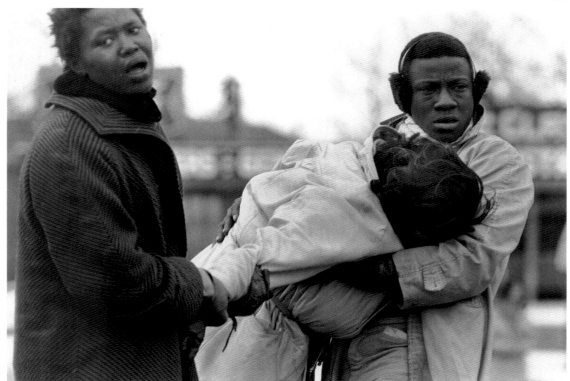

391

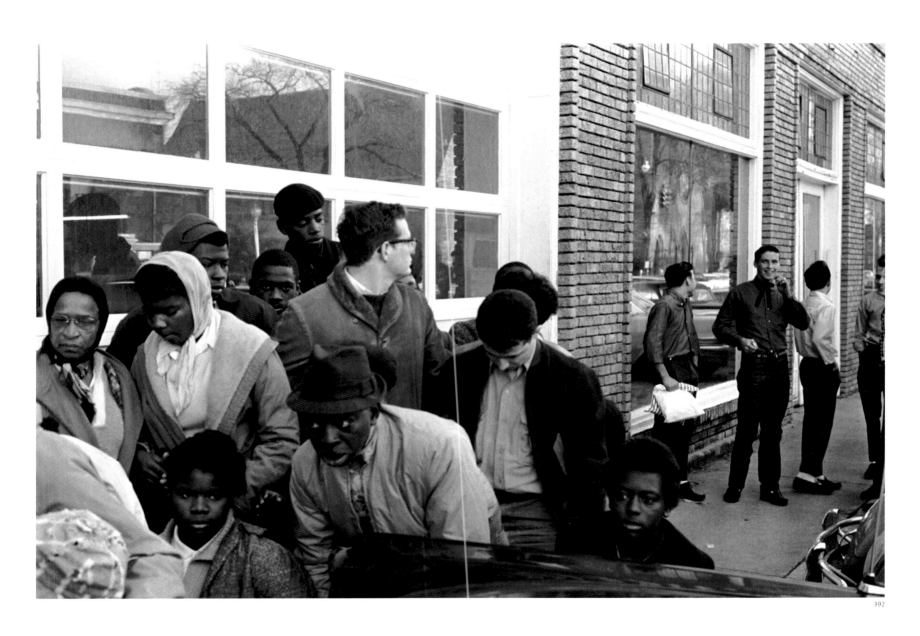

392

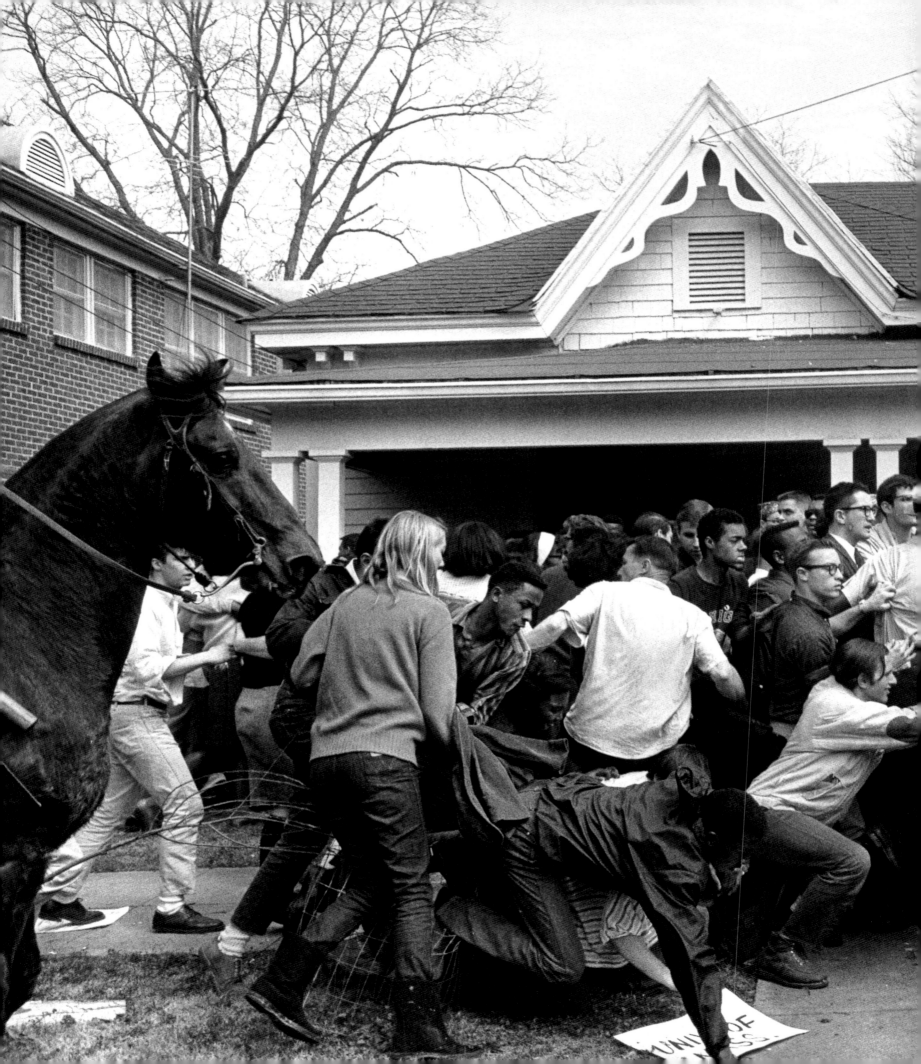

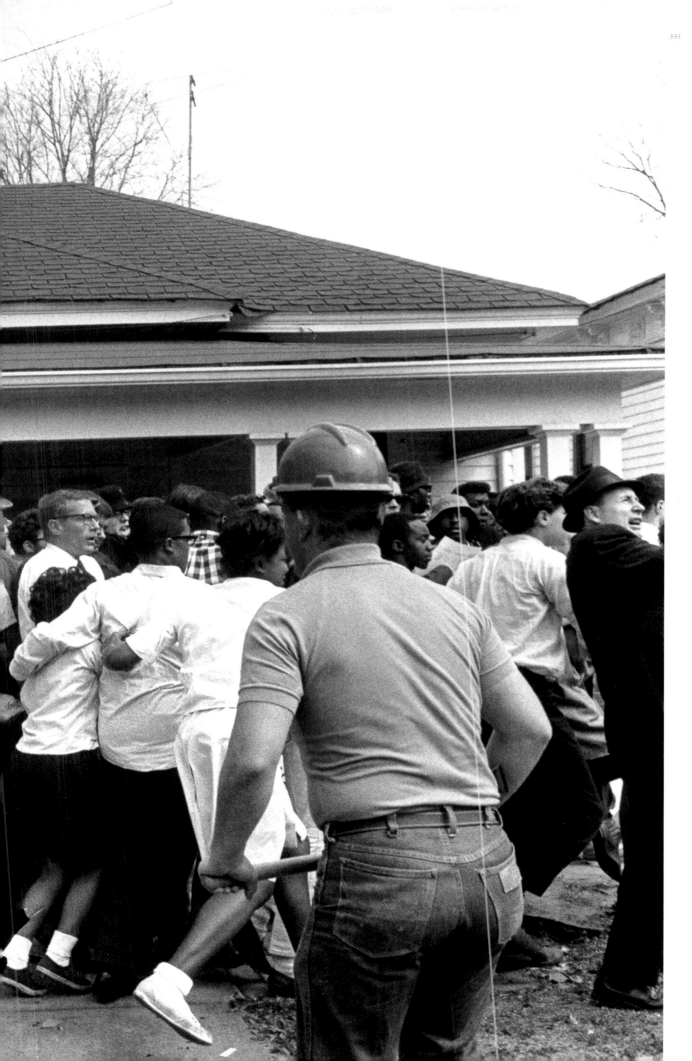

393. Selma, 7 March 1965.
The Alabama State police
and sheriff's deputies on
horseback rode through the
marchers swinging ropes,
nightsticks, and canes. They
later blamed a "mixup
in signals" for the panic that
ensued.

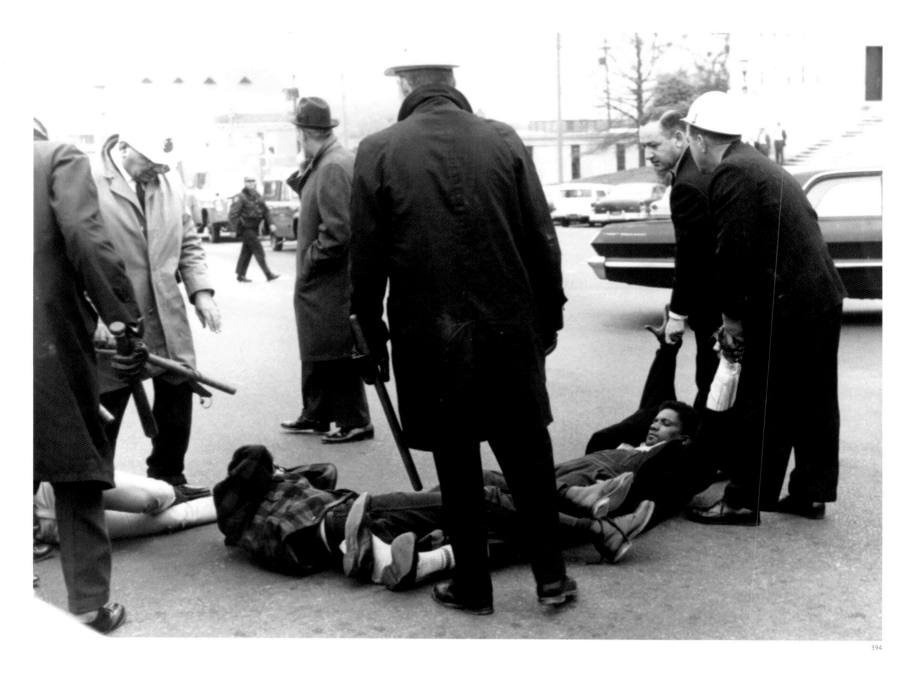

394

394. Selma, March 1965.
There were three attempts
to cross the Edmund Pettus
Bridge. After the first unsuc-
cessful attempt on 7 March,
when 600 marchers were
assaulted with tear gas and
clubs, and turned back,
King returned from Atlanta
to Selma. On the second
attempt on Tuesday, 9 March,
King personally led 1,500
marchers to confront
Wallace's state troopers on

the other side of the bridge.
After kneeling to pray,
as the marchers sang the
civil rights anthem "We Shall
Overcome," King rose and, to
the surprise of almost every-
one, ordered the marchers
to turn back. He later claimed
that the use of force by
the police was imminent and
that the symbolic point
of walking across the bridge
had already been made.
SNCC activists, and even

some of the SCLC leadership,
were very disappointed with
King's decision. Later that
evening several white minis-
ters who had participated
in the march were attacked
by racists. Reverend James
Reeb, a Unitarian minister,
was clubbed in the head, and
died of his injuries two days
later. These events outraged
President Lyndon Johnson
and prompted him to submit
a strong Voting Rights Act

to Congress. In his speech,
Johnson affirmed his support
for the goals of the civil
rights movement, noting:
"We shall overcome."

395. Selma, March 1965.
Hosea Williams (SCLC); James
Forman (SNCC); Martin
Luther King, Jr. (SCLC); Ralph
David Abernathy (SCLC); and
James Farmer (CORE) (from
left to right) strategizing
during the Selma campaign.

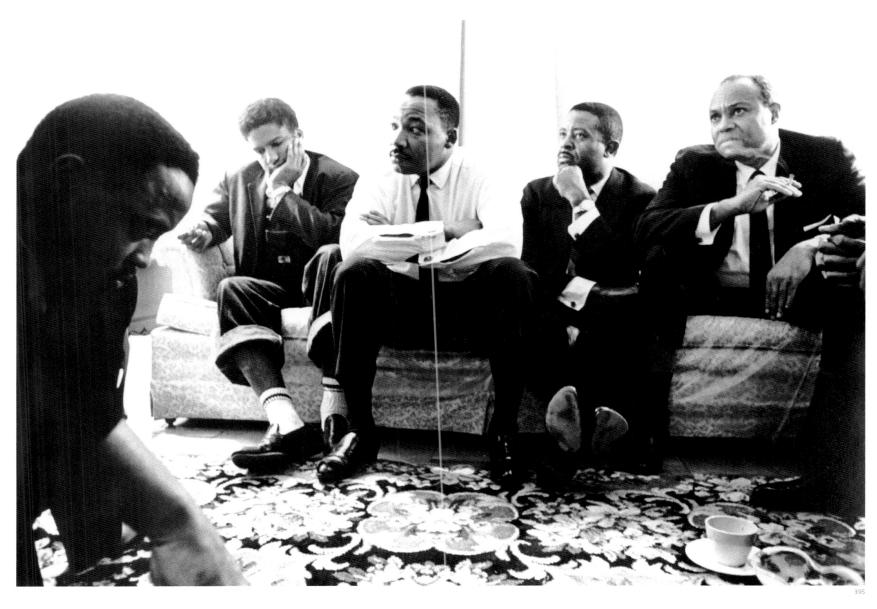

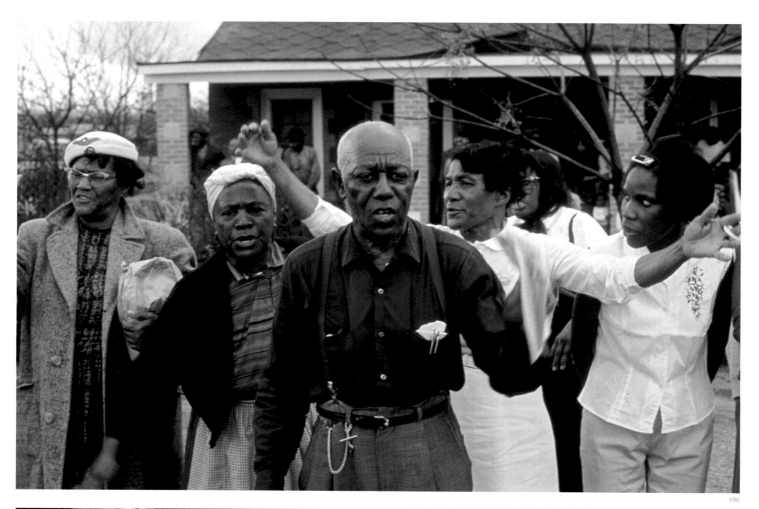

396

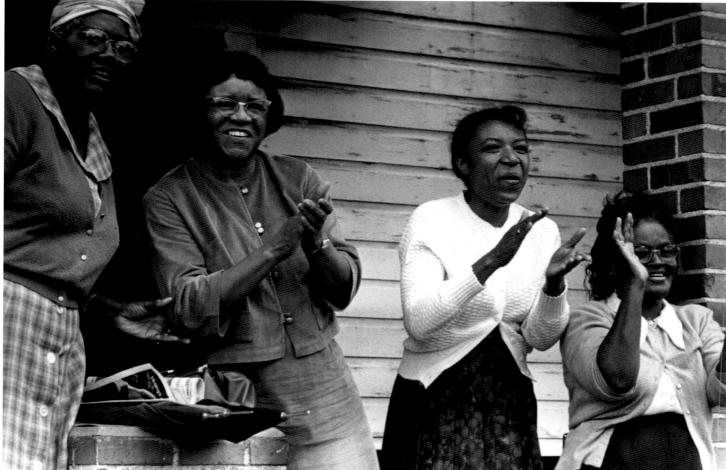

397

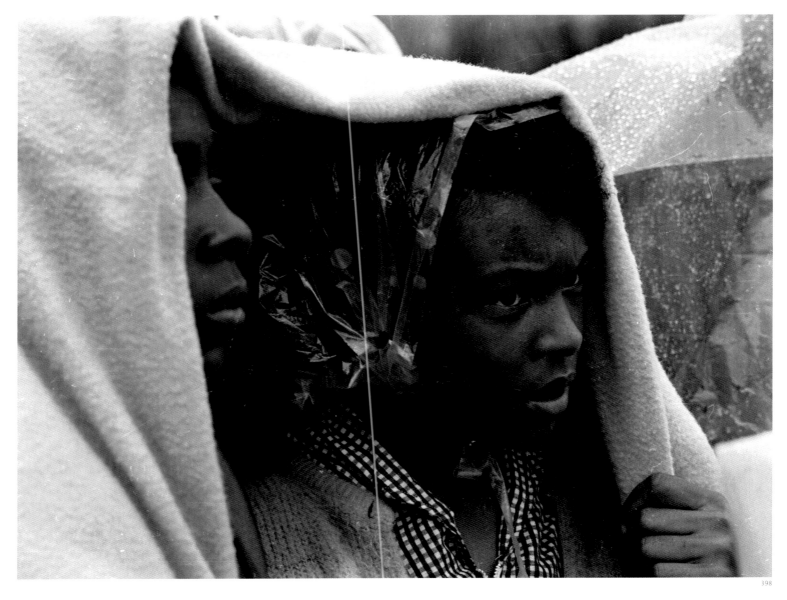

396–397. Onlookers supporting the marchers from Selma to Montgomery, 21–25 March 1965. By the third attempt to cross the Edmund Pettus Bridge, on Sunday 21 March, President Johnson had federalized the Alabama National Guard and had ordered 2,000 army troops and several hundred federal agents to protect the civil rights marchers.

398. Young marchers on the road from Selma to Montgomery, 21–25 March 1965.

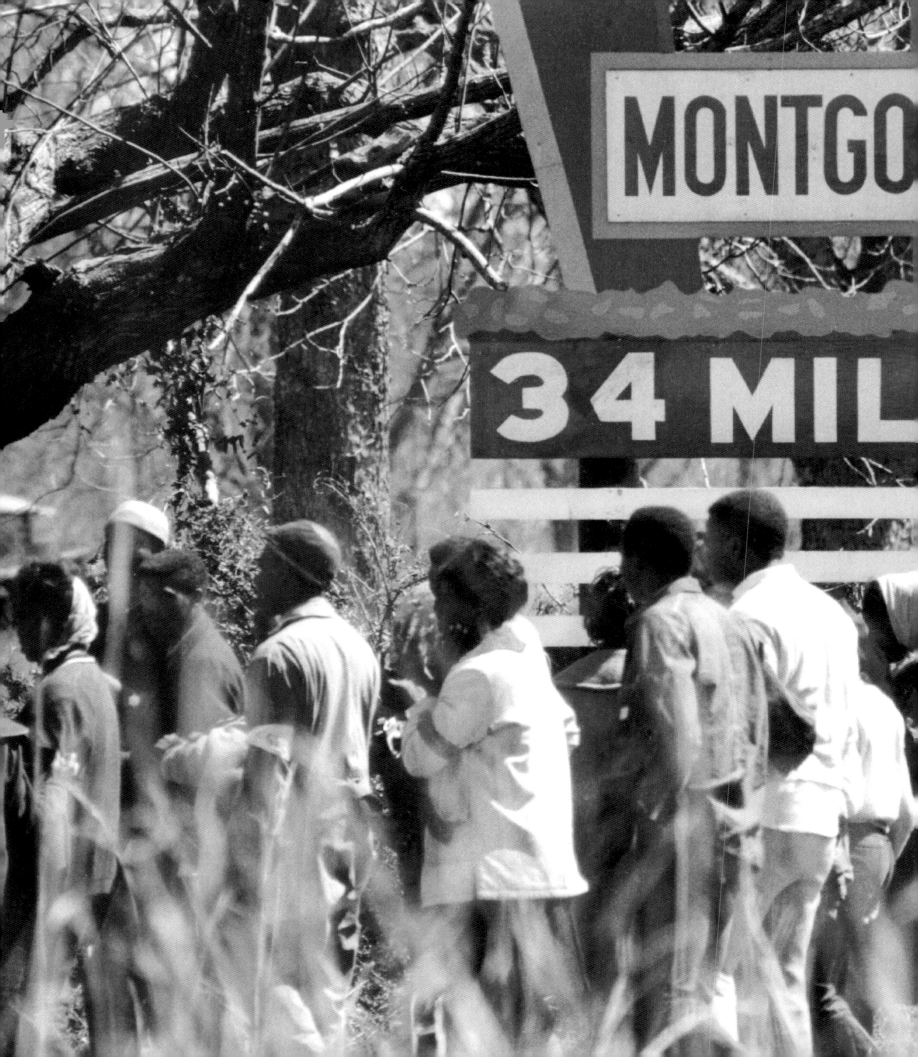

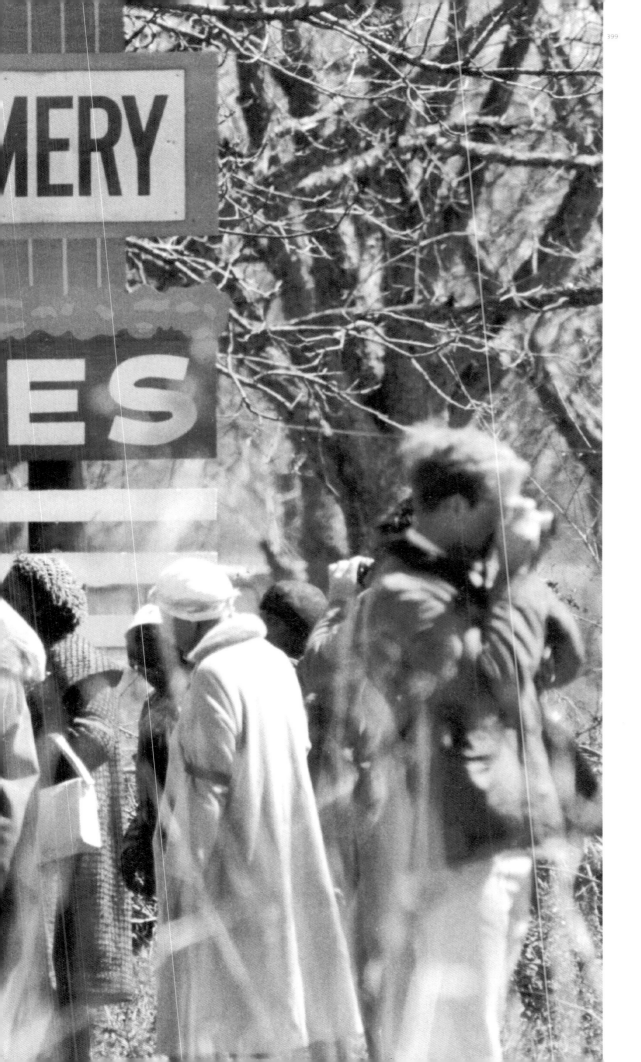

399. Selma to Montgomery
March, 21–25 March 1965.

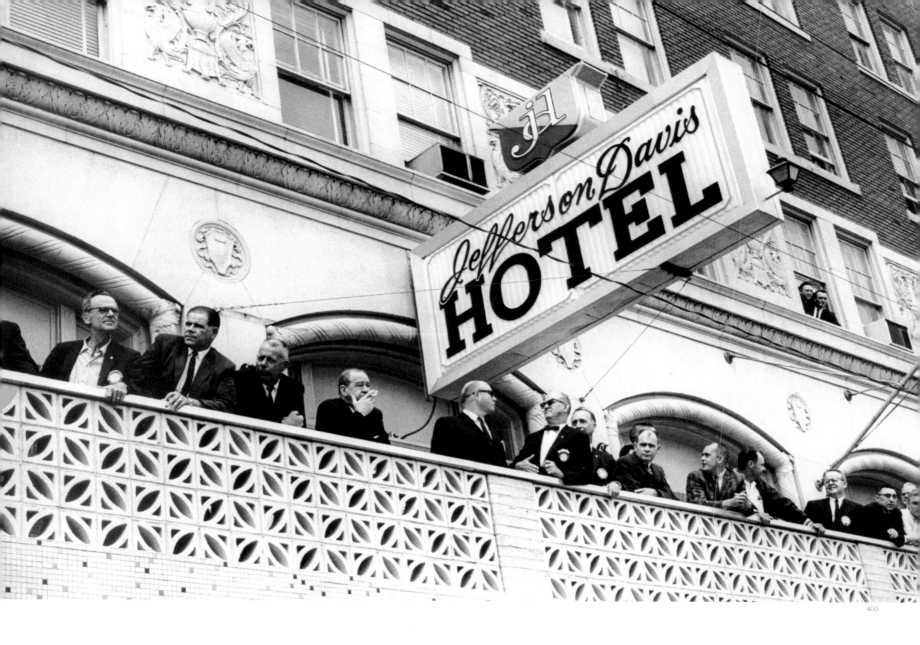

400. Onlookers on Main Street in Montgomery watching the marchers arrive in town, 25 March 1965.

401. Montgomery, 25 March 1965. Four thousand marchers began the march in Selma and they were 25,000 by the time they arrived in Montgomery. As they reached the state capitol building, which still flew the Confederate battle flag, tens of thousands of marchers celebrated their victory. The Selma campaign created the necessary political support for Congress to pass the 1965 Voting Rights Act. Millions of African Americans who had been denied the right to vote for nearly a century finally had a federal guarantee to exercise the electoral franchise.

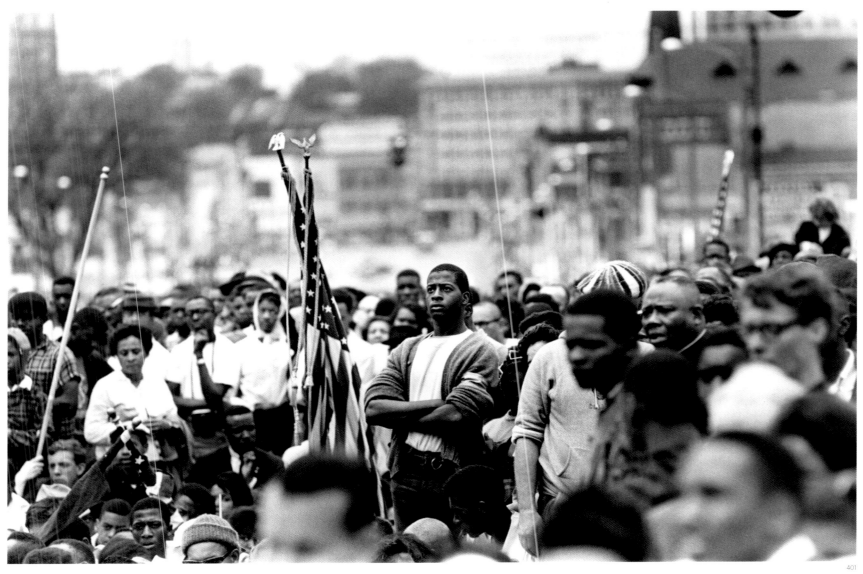

402. Henry Winston on May Day, Union Square, New York City, 1965. During the era of McCarthyism, many Communist Party leaders were forced to go "under-ground" or were imprisoned. One of the most prominent black leaders to be jailed was Henry Winston. Born in 1911 in Mississippi into a sharecropper family, Winston's first political involvement was with an Unemployed Council in Kansas City during the Great Depression. He soon joined the Communist Party, and by 1936 he was the National Secretary of the Young Communist League. During World War II he helped to organize and enlist thousands of communists to join the armed forces, and he himself served in Europe. In 1947 Winston was impris-oned under the Smith Act on the basis of his membership in the Communist Party. While incarcerated, a prison guard encouraged another prisoner to physically attack Winston. After a blow to the head, he developed a brain tumor. Prison officials did not allow him adequate medical treatment, which ultimately led to his blindness. On his release from prison in 1961, he stated, "I return from prison with the unshaken conviction that the people of our great land, Negro and white, need a Communist Party fighting for the unity of the people for peace, democracy, security, and socialism. I take my place in it again with deep pride. My sight is gone, but my vision remains." In 1966, Winston became National Chairman of the Communist Party and was active in organizing antiwar efforts, solidarity for African liberation movements, and the campaign to Free Angela Davis. Winston died in 1986.

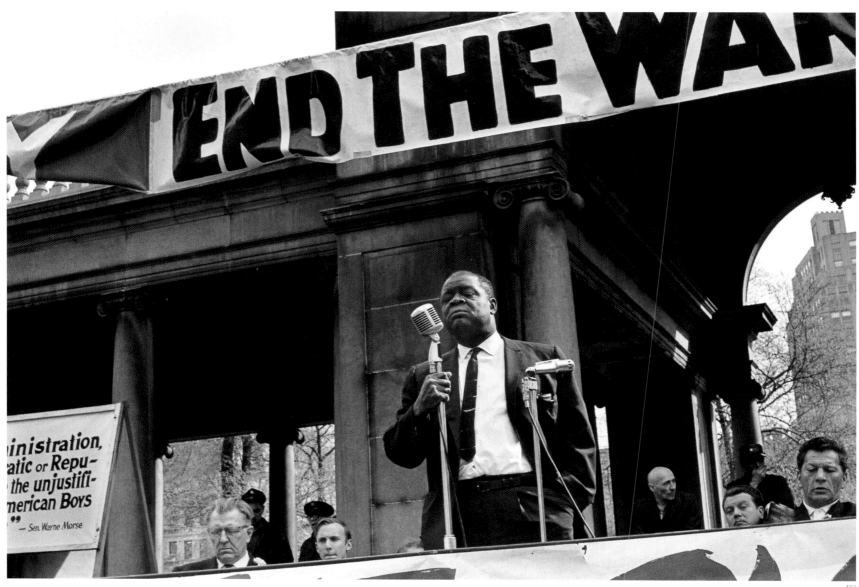

402

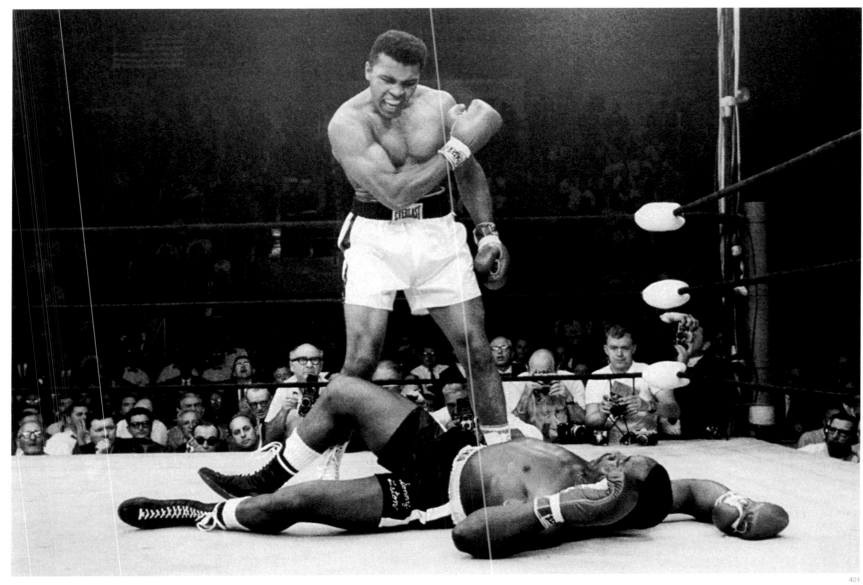

403

403. Muhammad Ali (standing) and Sonny Liston, Lewiston, Maine, 25 May 1965. In his first heavyweight championship title defense, Muhammad Ali stunned the sports world with a controversial first round knockout of former champion Sonny Liston. Ali would soon become the center of even greater controversy by refusing to be inducted into the U. S. Army because of his opposition, as a conscientious objector, to the Vietnam War. Boxing officials immediately stripped Ali of his championship title and for three and a half years, during the prime of his career, he was unable to box professionally. Although Ali was a prominent member of the Nation of Islam, he became an icon to millions of Americans of all races who opposed the Vietnam War. He was also tremendously popular throughout the Third World, both as a Muslim and because of his opposition to the war.

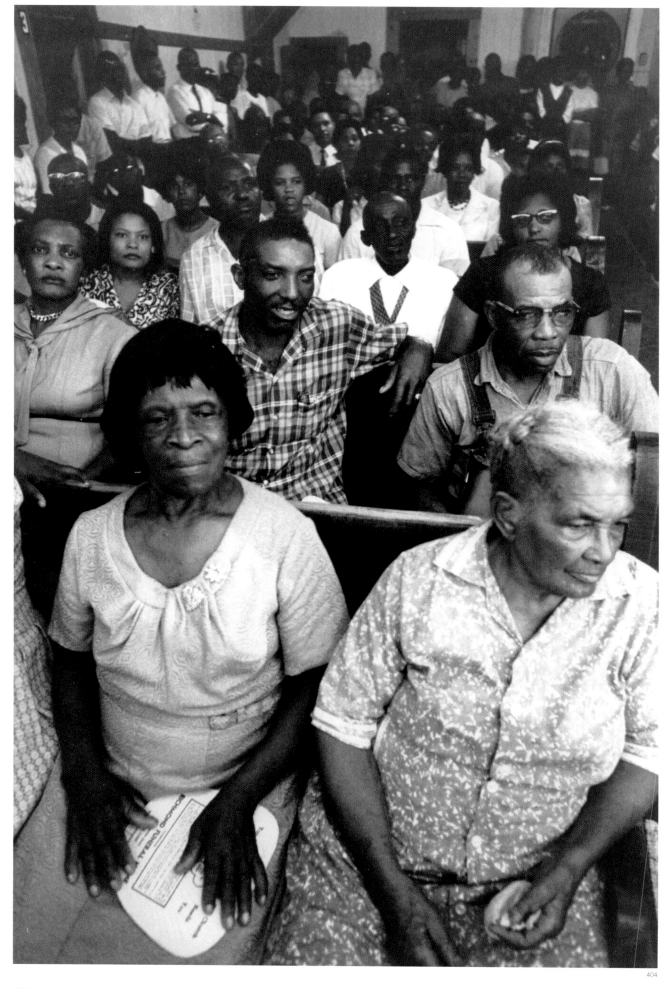

404. Church rally before a march by the Deacons of Defense, Bougalousa, Louisiana, 1965. The Deacons of Defense was established in July 1964 by African American World War II and Korean War veterans in rural Louisiana. Their objective was to provide security and support for CORE civil rights organizers registering African Americans to vote.

The Deacons of Defense provided security at mass meetings and patrolled African American communities to provide protection from the Ku Klux Klan and other racist vigilantes. The FBI launched an investigation of the group, placing it under surveillance until it became inactive by the early 1970s.

405. President Lyndon B. Johnson (left) and Martin Luther King, Jr., 6 August 1965. The Voting Rights Act removed the right of states to set arbitrary restrictions on the exercise of the electoral franchise. Since the end of Reconstruction, southern states had used a variety of schemes — from poll tax to all-white primaries — to eliminate black electoral participation. Under the terms of this new law, the attorney general now had the power to send federal examiners into areas where black voters had been deliberately denied the right to register and vote. The act also suspended all literacy tests in states where less than 50 percent of the voting-age population had been registered or had voted in the 1964 presidential election. Within five months, over 250,000 new African American voters were registered. Between 1964 and 1969, the number of black adults registered to vote increased in Mississippi from 6.7 percent to 66.5 percent. By 1966, there were six African American representatives in Congress and nearly 100 black members of state legislatures.

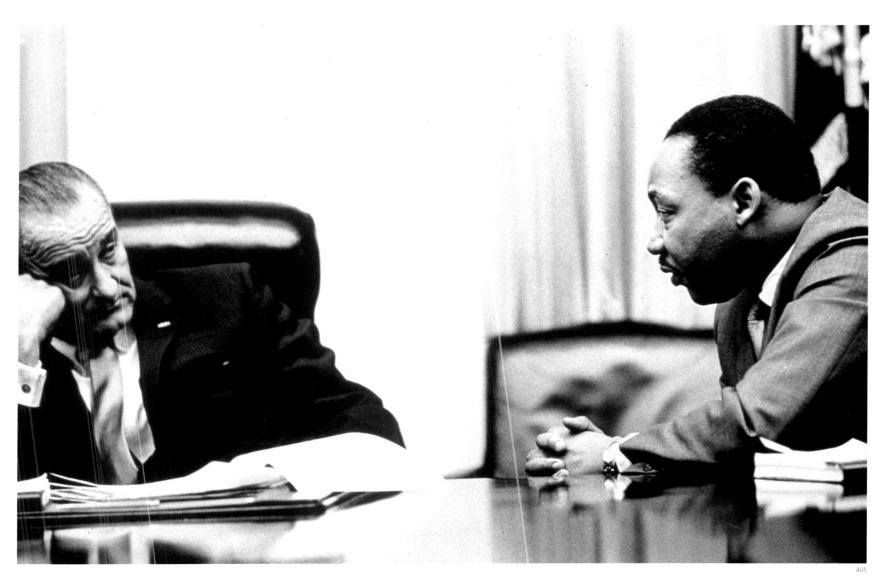

405

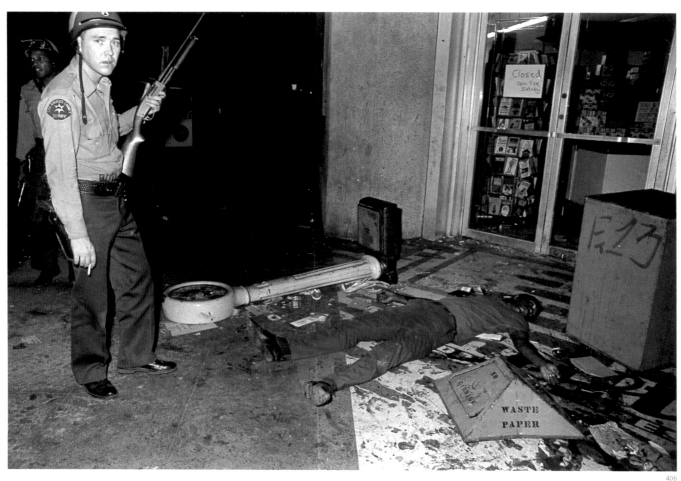

406

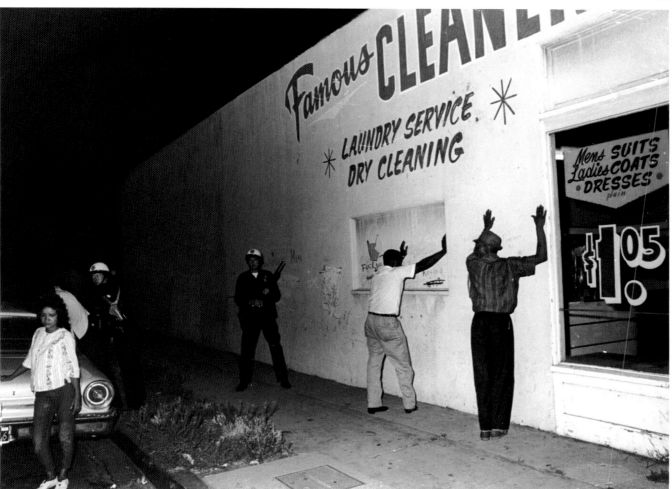

407

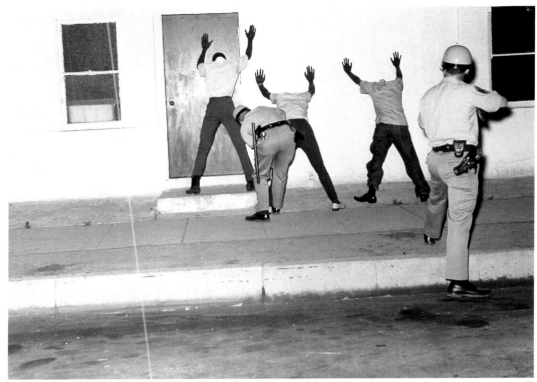

408

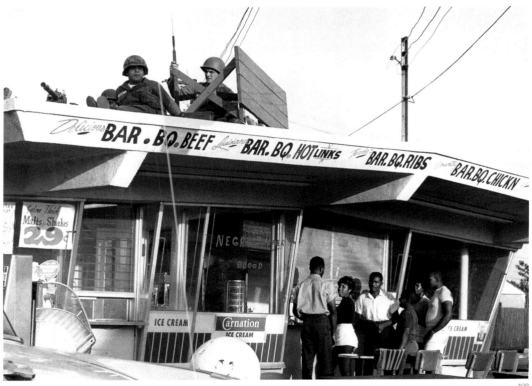

409

406–407, 409. Watts, Los Angeles, 11–16 August 1965. On 11 August 1965 a white police officer stopped African American motorist Marquette Frye, whom he suspected of driving while drunk. As a crowd gathered, a second officer was called in. An altercation broke out when Rayna Frye, the motorist's mother, arrived at the scene. According to eyewitness accounts, a second officer struck onlookers with his baton, which generated an outpouring of anger and resentment against symbols of white authority. Over the next five days, African American residents of South Central Los Angeles attacked white-owned property. Thirty-four people were killed, over 1,000 were injured, and almost 4,000 were arrested. California Governor Pat Brown ordered the National Guard to patrol the city of Los Angeles. Sixteen thousand police, national guardsmen, and other law enforcement officers were called in to restore the peace. Over the objections of Governor Brown, Martin Luther King, Jr., Bayard Rustin, and other civil rights leaders came to Los Angeles to encourage an end to the violence. Governor Brown later named John McCone to chair a state commission to examine the factors that culminated in the urban uprising. The McCone Report cited high rates of unemployment, substandard public education, poor housing, and the use of excessive force by the police, as the underlying causes. In California, conservatives charged that liberal permissive attitudes and civil rights advances had contributed to black unrest. These disturbances were a factor in the defeat of Pat Brown, the liberal Democratic governor, by Ronald Reagan in 1966. The Watts disturbances were a harbinger of the urban unrest that would sweep across the United States in the mid- and late 1960s.

408. Long Beach, California, 15 August 1965.

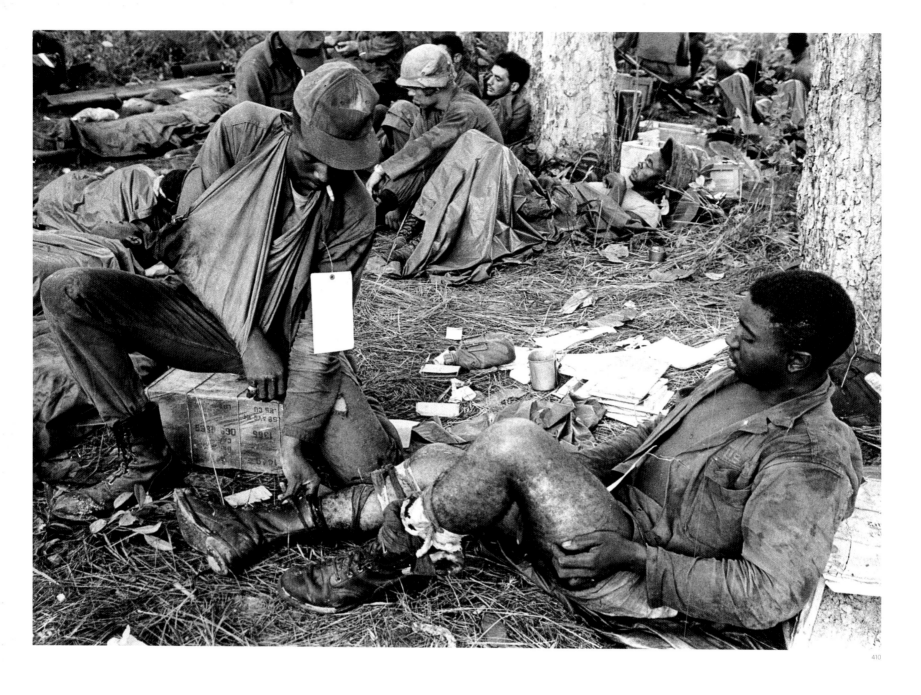

410. Plei Me, South Vietnam, 24 November 1965. The war in Vietnam was the first American conflict where all branches of the U. S. armed forces were racially integrated. From the outset, the burden of the conflict was borne disproportionately by African Americans and working-class and poor whites. During the 1960s, the early years of the war, students enrolled in college could obtain deferments from military service. Many middle- and upper-class whites were also able to fulfill military obligations by joining the Army Reserve or the National Guard. As a result, in 1967, 64 percent of all eligible African Americans were drafted, but only 31 percent of eligible whites. During 1965–66, the casualty rate for blacks was twice that of whites. Malcolm X was the first prominent African American leader to denounce the Vietnam War, and others soon followed his lead. In January 1966 SNCC issued a strong statement. SNCC activist Julian Bond, who was elected to the Georgia state legislature in 1965, announced his support for Americans who burned their draft cards and refused to serve in the U. S. military. Georgia legislators responded by illegally refusing to seat Bond. In December 1966 the Supreme Court ruled in Bond's favor and ordered the legislature to seat him. However, leaders such as Bayard Rustin and A. Phillip Randolph warned that the civil rights movement should be publicly neutral regarding the Johnson Administration's pursuit of the war in Southeast Asia, fearing that taking a position would jeopardize the liberal coalition that had successfully passed civil rights and anti-poverty legislation. Although Martin Luther King, Jr. privately had grave reservations about America's war, he did not initially voice his opposition.

411. The women's section of the Nation of Islam celebrating Savior's Day, its annual gathering, Chicago, 26 February 1966. After the assassination of Malcolm X in 1965, many African American activists became more critical of the NOI, which was still led by its patriarch, Elijah Muhammad. Nevertheless the NOI did continue to appeal to a sector of the African American community and during these years it successfully developed several new initiatives. Its national newspaper, *Muhammad Speaks*, devoted extensive coverage to Third World liberation movements and strongly opposed black participation in Vietnam. By 1970, *Muhammad Speaks* had a national subscriber base of 600,000, making it the largest black paper in the United States. A former protégée of Malcolm X, charismatic minister Louis Farrakhan emerged as a popular figure with a following that extended beyond the religious sect. The NOI was a patriarchal organization that defined distinctly separate gender-based roles for women. However, NOI women such as Elijah Muhammad's wife Clara were effective leaders and made significant contributions to building the organization.

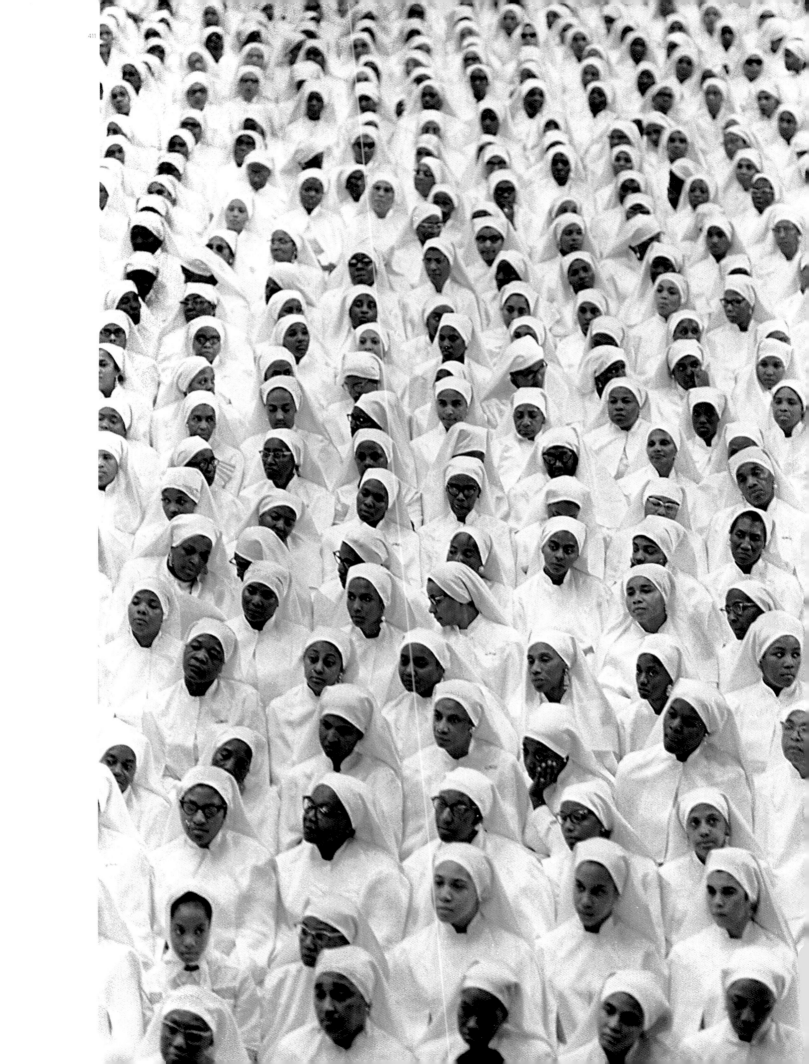

412. Woman sitting outside the National Memorial African bookstore, Harlem, New York City, 1965.

413–414. Selma, Alabama and Atlanta, Georgia, 1966. Blacks voting for the first time after the successful voter-registration campaigns. Between 1964 and 1969, the percentage of the African Americans electorate registered to vote increased from 27.4 percent to 60.4 percent. The huge increase in the black electorate quickly altered the political landscape in Georgia. A 30-year-old African American attorney, Maynard Jackson, ran for the U. S. Senate against incumbent senator, Herman Talmadge, losing narrowly. Several years later, Jackson was elected the first black mayor of Atlanta. In 1972, Martin Luther King, Jr. lieutenant Andrew Young was elected to Congress from Atlanta, becoming the first black member of the Georgia congressional delegations since Reconstruction.

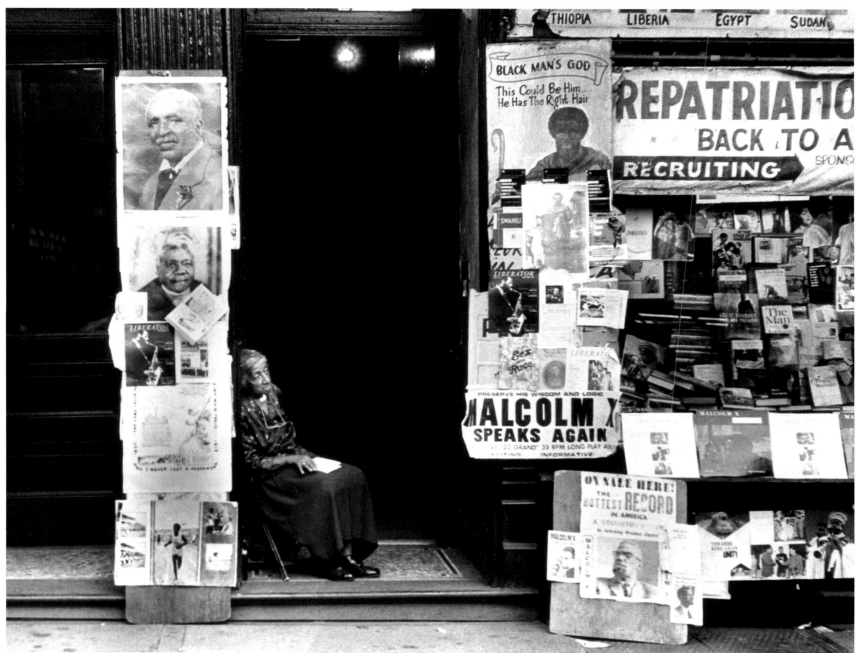

412

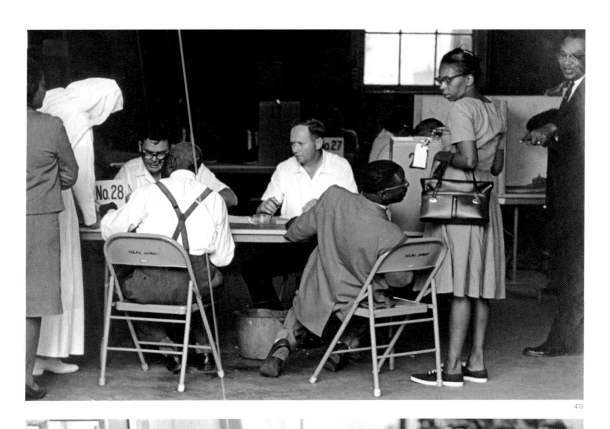

413

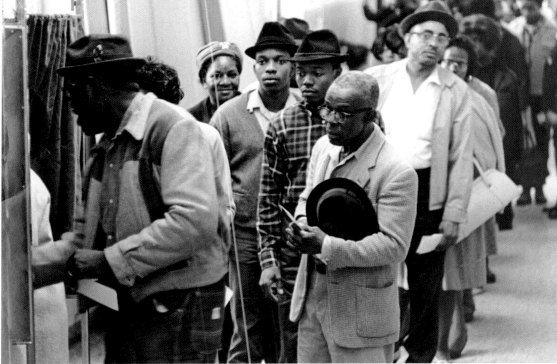

414

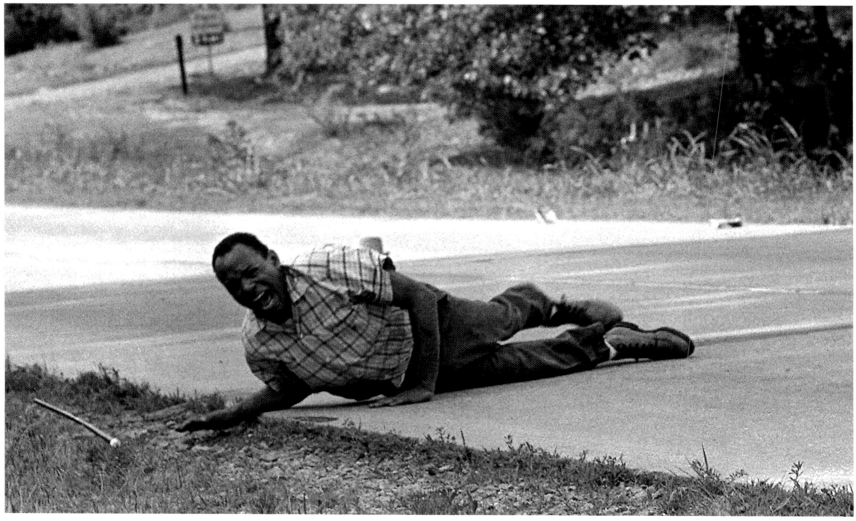

415. James Meredith just after having been shot during his March Against Fear, Hernando, Mississippi, 6 June 1966. After studying abroad in Nigeria and at Columbia Law School, James Meredith returned to the Deep South in early 1966. In a symbolic gesture to encourage African Americans not to be afraid to register to vote, he decided to walk the 225-mile distance between Memphis, Tennessee and Jackson, Mississippi. On the second day of his "March Against Fear," Meredith was shot; he was hospitalized and unable to complete the walk.

416. Coretta Scott and Martin Luther King, Jr. at the James Meredith March Against Fear, June 1966. Prominent civil rights leaders vowed to complete Meredith's symbolic march.

417. Stokely Carmichael (right) at the James Meredith March Against Fear, June 1966. Following the passage of the 1965 Voting Rights Act, the pragmatic political consensus that had held together the civil rights coalition began to weaken. Moderates such as Bayard Rustin urged civil rights activists to move "from protest to politics," by running for elected office and working within the Democratic Party. Martin Luther King, Jr. and the SCLC concluded that the desegregationist struggle had to be moved to the North to challenge residential segregation and problems of urban poverty and unemployment. Radicals in SNCC, and increasingly in CORE, felt that the civil rights movement had been betrayed by the Johnson Administration's pursuit of the Vietnam War and increasingly questioned the role of whites in the black freedom movement. In early 1966, James Farmer was replaced as head of CORE by Floyd McKissick, a black attorney from North Carolina who favored the development of all-black institutions and economic initiatives. At about the same time, Stokely Carmichael replaced John Lewis as the head of SNCC. A veteran of non-violent political organizing in the Deep South, Carmichael had experienced physical brutality and incarceration. He eventually concluded that the strategy of nonviolence could not, in the long run, transform white racism. He had grown impatient with the slow pace of change and believed that blacks had to repudiate alliances with white liberals and establish their own independent all-black political organizations and institutions.

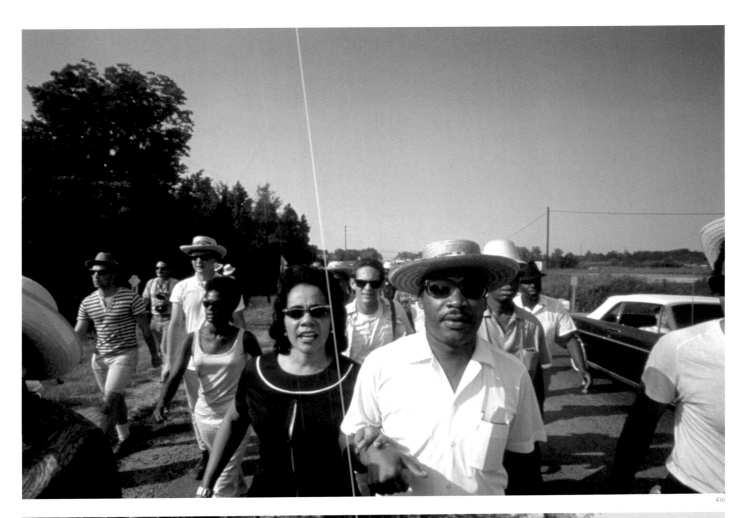

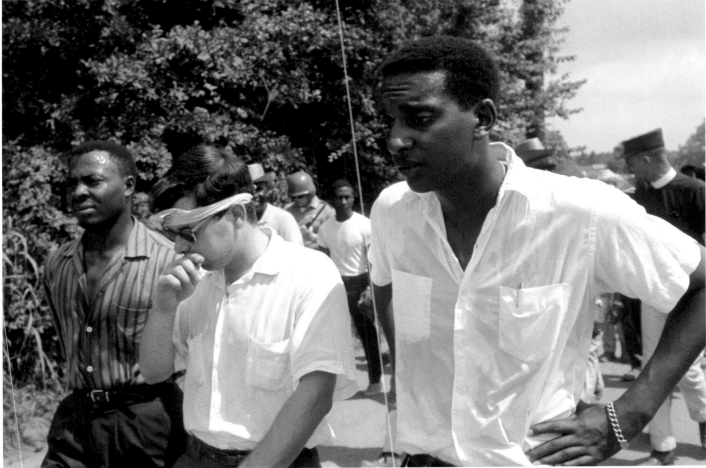

418. Stokely Carmichael (on the microphone) calling for "Black Power" in Greenwood, Mississippi, 16 June 1966. During the Meredith march, activist Willie Ricks began a chant among demonstrators for "Black Power." The phrase caught on despite admonition from Martin Luther King, Jr. and other moderate leaders that it might be misunderstood by white participants in the demonstration, and by the media. However Carmichael, in several highly publicized events during the march, used the term "Black Power," projecting a new direction for the freedom movement — one that moved away from the goal of integration and commitment to non-violence. Within a month a major debate had erupted within Black America about the meaning of "Black Power" and whether the tools of civil disobedience and the objective of integration were still relevant. Malcolm X had popularized the expression "by any means necessary." Many young blacks interpreted this to mean that in the face of the violence experienced by nonviolent demonstrators and others, armed self-defense, and even acts of retaliatory violence, were necessary.

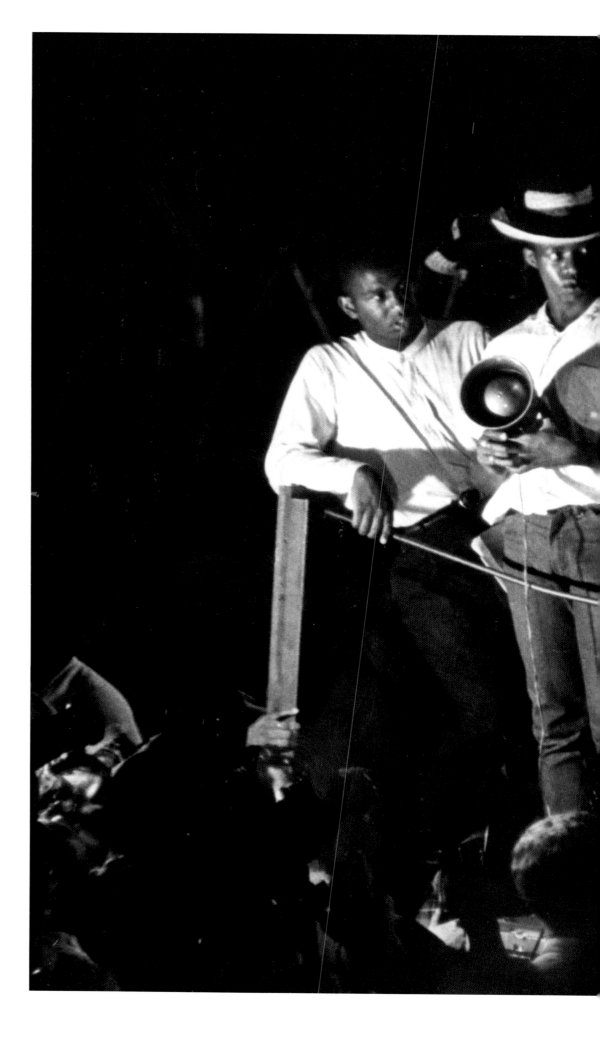

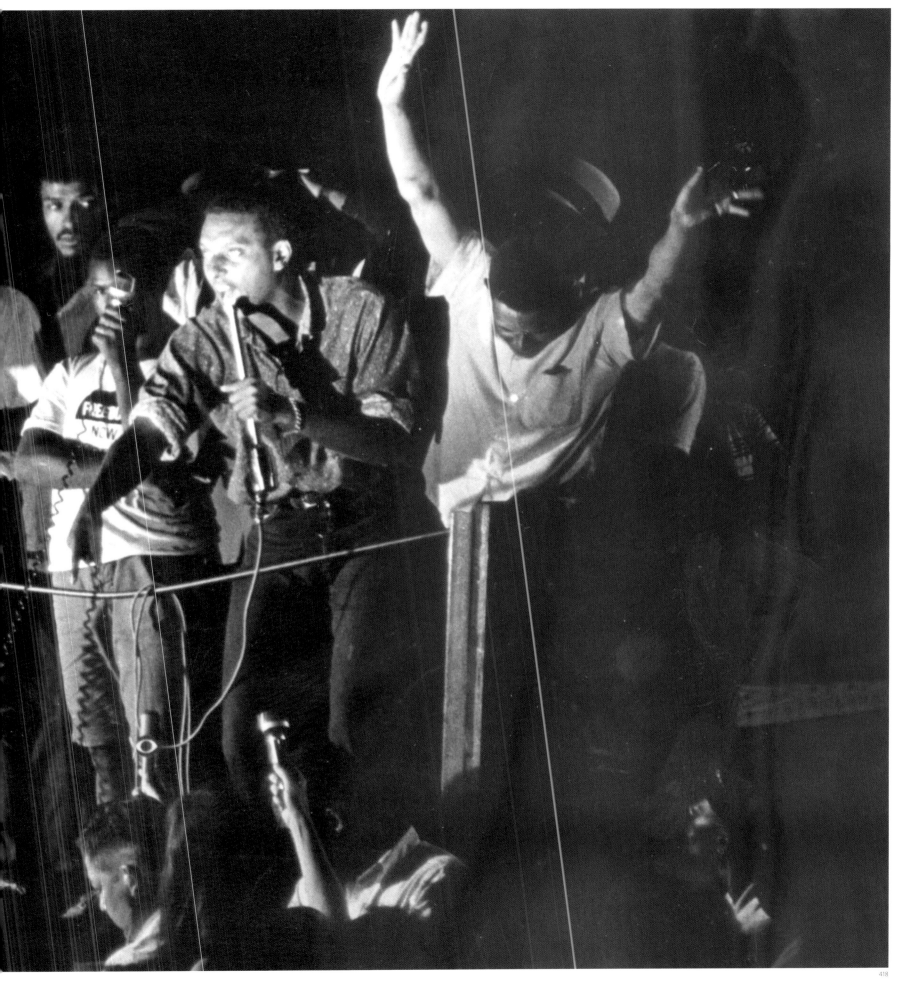

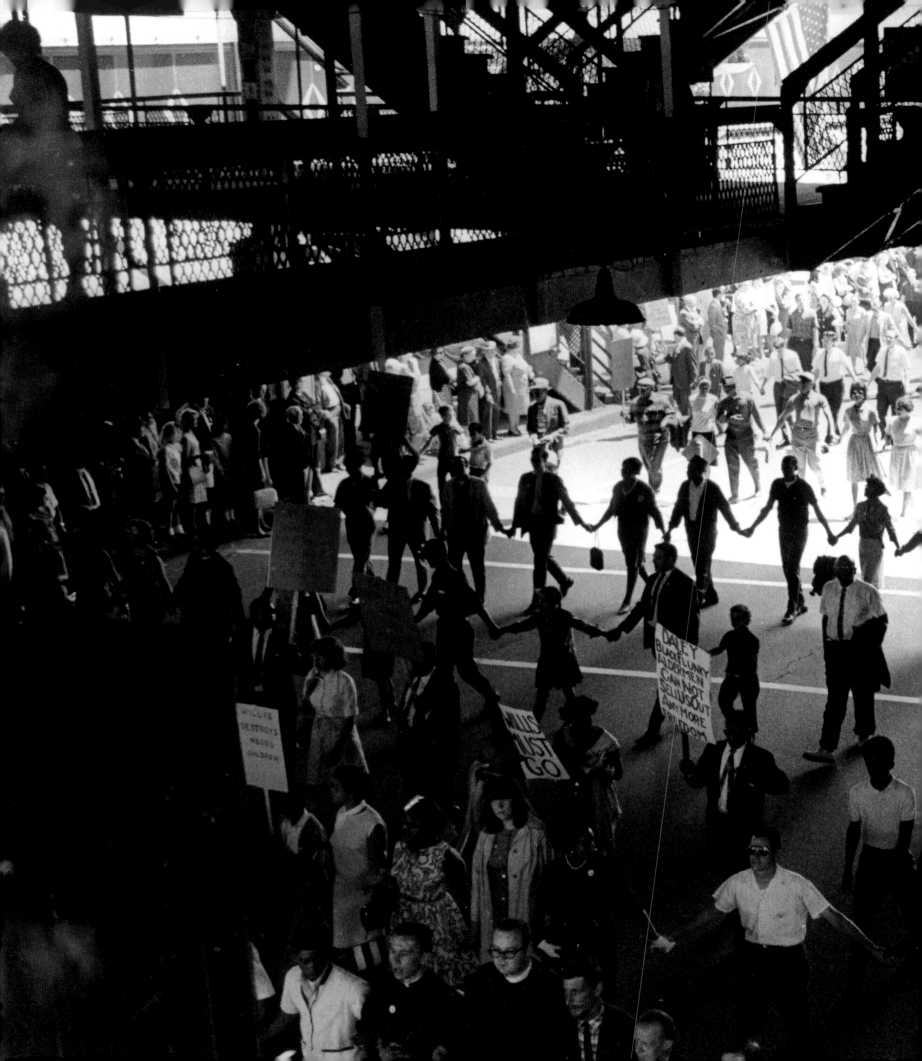

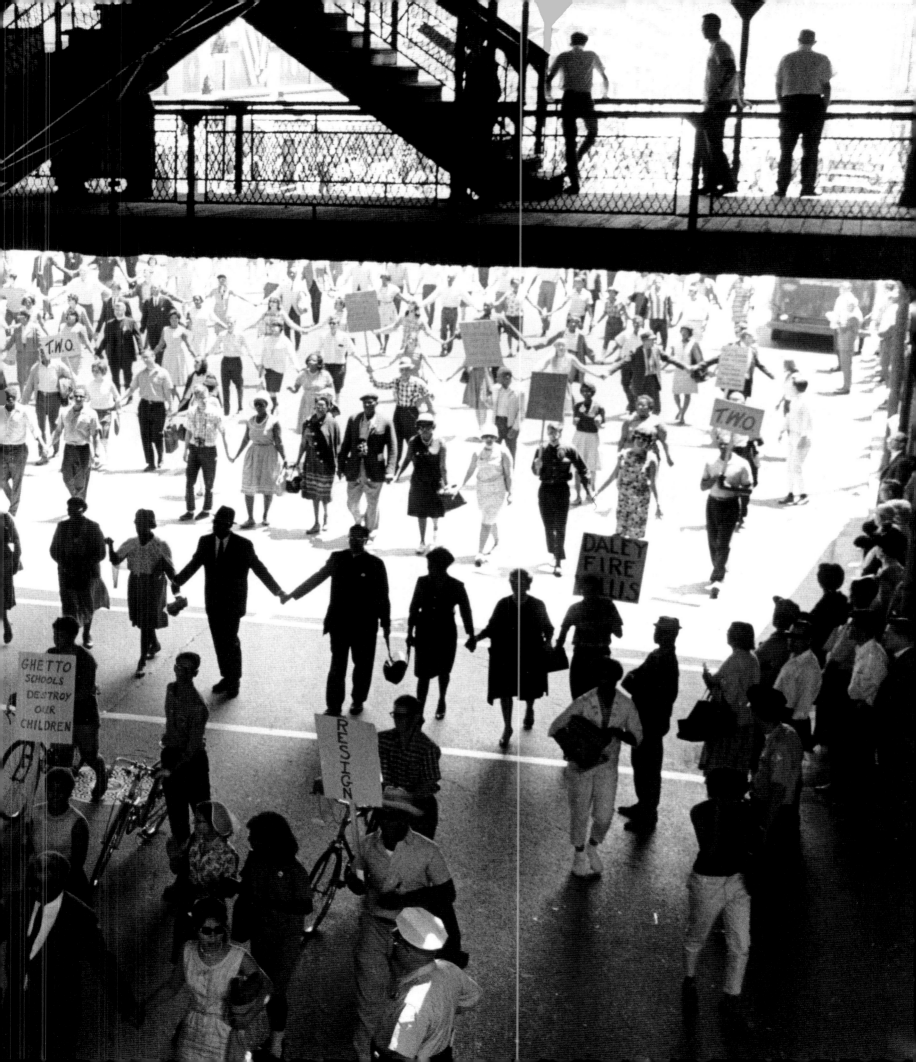

419. March led by Martin Luther King, Jr. through downtown Chicago to protest de facto school segregation, 1966 (previous spread). In the wake of the Watts civil unrest, King concluded that the civil rights movement had to make a strategic shift away from its focus on the rural South toward increased efforts to desegregate America's northern ghettos. The SCLC concentrated its resources in Chicago to attempt to achieve the desegregation of its suburbs, as well as enhancing job opportunities, housing, and education in the city's black neighborhoods.

420. The car from which two young boys, Lamar Talley and his brother, had just escaped after being trapped when it was attacked by forty youths, Chicago, 1966. Lamar, who was injured by rocks hurled through the car windows, was visiting from Fort Wayne, Indiana, when their car was attacked. In a series of non-violent demonstrations, the advocates for open housing encountered fierce resistance and open hostility from racists in all-white ethnic enclaves in and around the city of Chicago. In Cicero, an all-white working class suburb, Martin Luther King, Jr. was struck and would later remark that the hatred and racism he encountered in this white suburb was even more extreme and threatening than the racism he had encountered in the Deep South.

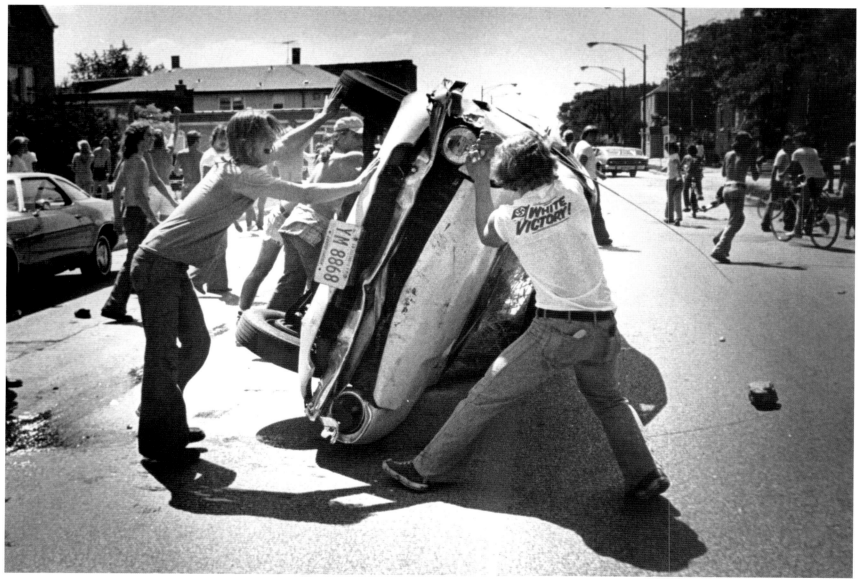

420

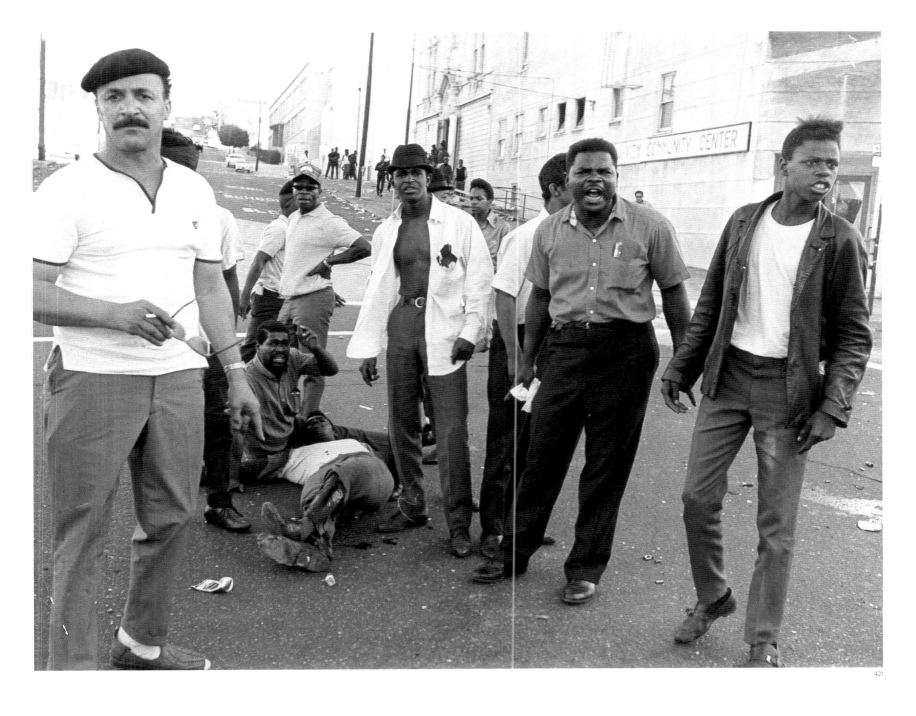

421

421. Hunter's Point, San Francisco, 12 December 1966. Residential racial segregation was more entrenched and pervasive in many northern and western cities than in the Deep South. In San Francisco, nearly all African Americans were confined to the Bayview–Hunter's Point neighborhood and the Fillmore district. African Americans lived in substandard housing and encountered job discrimination and incidents of police brutality. In September 1966, after police shot a black man allegedly running from a stolen car, community residents responded by attacking white-owned businesses, smashing windows, and starting fires. The San Francisco mayor imposed a curfew and 12,000 California National Guardsmen were stationed in black areas to impose order. Over a six-day period, over 350 people were arrested and 51 were injured. The Hunter's Point disturbance symbolized the unresolved problems of racial discrimination in the North and West.

422–423. Harlem peace march, New York City, 27 April 1967.

424. Peace march, New York City, 1967. Although African Americans were not always present in large numbers in the official peace movement, opinion polls showed that opposition to the Vietnam War was stronger among blacks. Many African Americans saw the Vietnamese as a Third World people who had experienced the same racism and colonialism as had African Americans and other peoples of African descent. Some were also concerned that, because of discriminatory draft policies, blacks bore an unfair burden of the combat duties and suffered a disproportionate share of the casualties. Yet another factor was the recognition among civil rights and black labor leaders that the federal government could not fulfill its promises to pursue a war on poverty or finance a domestic Marshall plan unless military expenditures were reduced. Furthermore, many of the men who served in the Southeast Asia theater between 1962 and 1975, returned home dependent on heroin or other drugs. The real number of war casualties cannot be measured solely by battlefield fatalities. On 4 April 1967 King delivered a speech at New York City's Riverside Church that sharply condemned the war in Vietnam, "As I have walked among the desperate, rejected, and angry young men [of northern ghettos] I have told them that Molotov cocktails and rifles will not solve their problems. . . . maintaining my conviction that social change comes most meaningfully through nonviolent action. But they asked — and rightly so — what about Vietnam? I knew that I could never again raise my voice against the violence of the oppressed in the ghettos without first having spoken clearly to the greatest purveyor of violence in the world today — my own government. For the sake of those boys, for the sake of this government, for the sake of the hundreds of thousands trembling under our violence, I cannot be silent." King's antiwar position was criticized by prominent black public figures, including Roy Wilkins and Bayard Rustin.

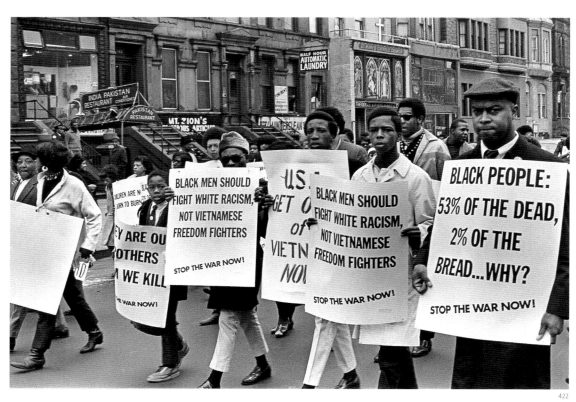

422

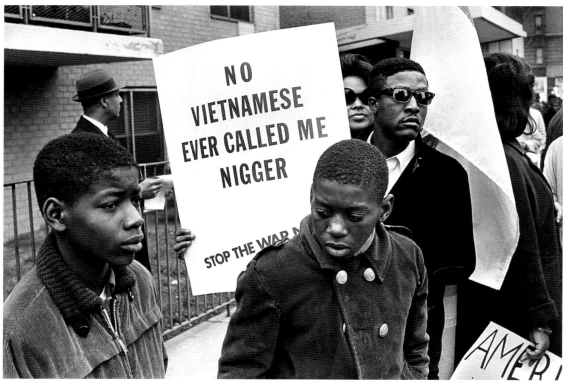

423

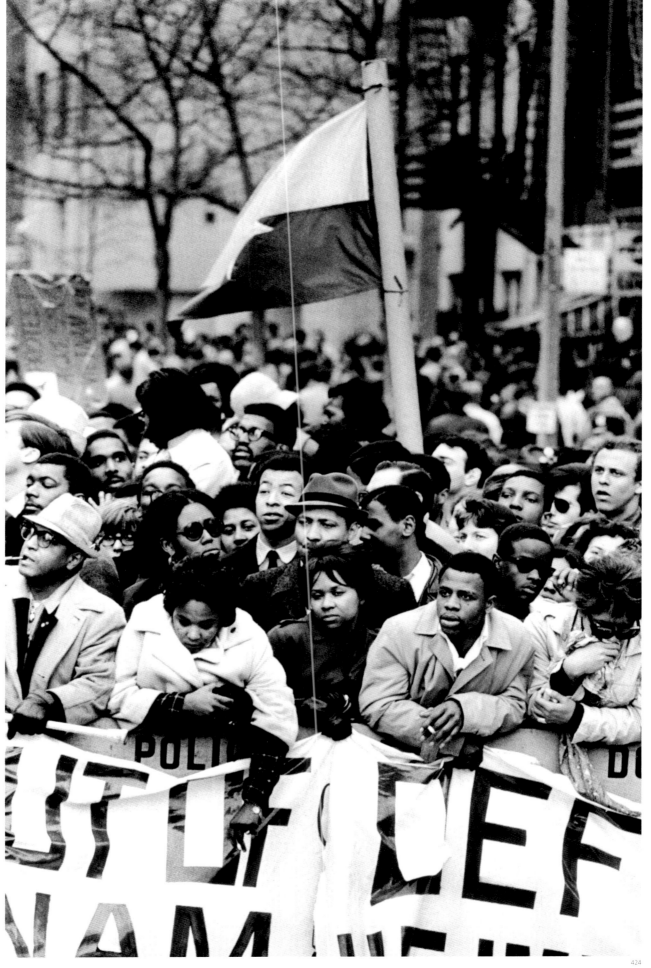

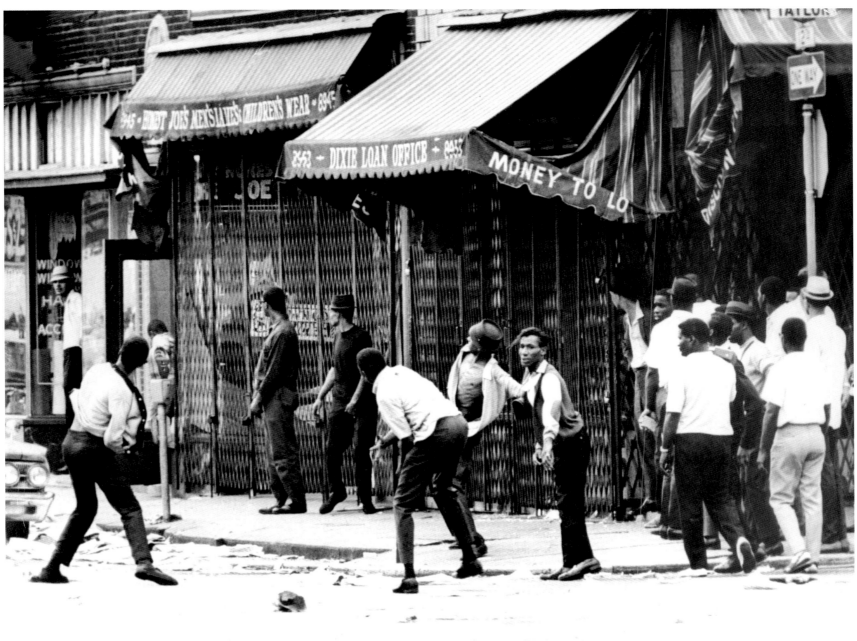

425–426. Detroit civil unrest, July 1967. The "long, hot summer" of 1967 witnessed the largest number of black urban uprisings in the country's history. In cities throughout the United States young African Americans, frustrated by high rates of unemployment, rampant discrimination, poor housing, inadequate social services, and police brutality, resorted to acts of public protest and retaliatory violence against symbols of white authority. Younger African Americans felt that the liberal integrationist strategy of nonviolence was meaningless in the face of the routine use of excessive force by white police officers in their own neighborhoods. As of 1967 Detroit had among the highest rates of substandard housing, infant mortality and crime in U. S. cities. On 23 July 1969, police raided an unlicensed black-owned business serving alcohol, handcuffed the patrons, and forced them outside. As crowds of local residents surrounded the police, and the police called in backup, the confrontation dramatically escalated. Blacks initiated sporadic violence against white-owned property, burning white stores to the ground. The National Guard was called in to impose civil order. After three days of unrest, 43 African Americans had been killed, nearly 1,200 were injured and over 7,200 had been arrested.

427. Civil unrest in Newark, New Jersey, 29 July 1967. In the summer of 1967, major uprisings occurred in several northern New Jersey cities, including Newark, Elizabeth, Jersey City, and New Brunswick. In the wake of the numerous urban uprisings, President Johnson appointed Illinois Governor Otto Kerner to head a national advisory commission on civil disorders. The Kerner Commission later reported that in the first nine months of 1967, the United States had experienced uprisings in 128 cities. The report warned that "Our nation is moving toward two societies, one black, one white — separate and unequal."

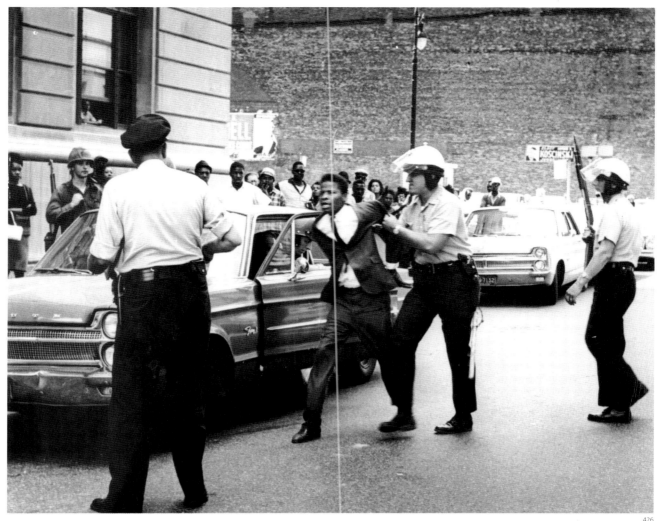

426

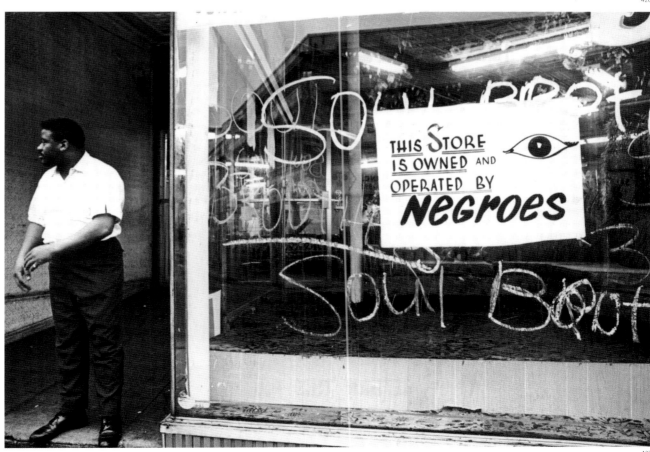

427

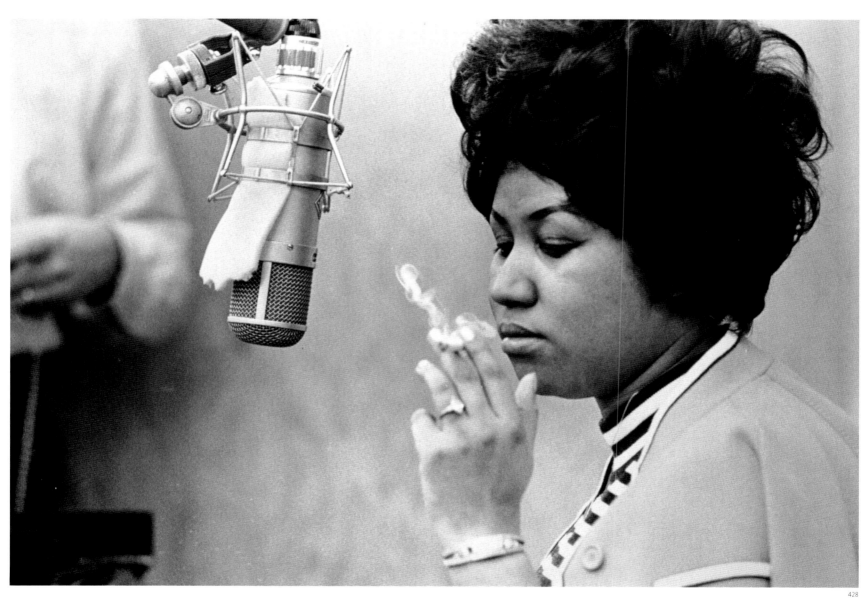

428. Aretha Franklin recording "Respect," 1967. Born in 1942, Aretha Louise Franklin was the daughter of influential Baptist preacher in Detroit Reverend C. L. Franklin. Trained in the classics of gospel music, as a teenager she began to record popular music and jazz ballads. Her first popular release, "I Never Loved A Man (The Way I Love You)," sold over one million copies and her career began to soar.

Franklin blended the power of gospel music into the framework of rhythm and blues, producing a powerful sound described as "soul music." Her most influential recording, "Respect," a rallying cry for social progress, resonated widely among African American women. Franklin was supportive of the civil rights movement and later sang at Martin Luther King, Jr.'s funeral.

429. Amiri Baraka (aka. LeRoi Jones) with his wife, Amina, and child in Newark, New Jersey, January 1968. LeRoi Jones was one of the most influential American intellectuals in the 1950s and 1960s. Born in Newark, New Jersey in 1934, Jones attended Howard University in Washington, D. C., and, in the late 1950s, relocated to New York's Greenwich Village where he became widely

known as an avant-garde poet, jazz critic, and playwright. His provocative and powerful plays including *The Dutchman*, *The Slave*, and *The Black Mass*, as well as his books, *Blues People* and *Home*, established a new aesthetic and cultural explosion of black creativity called the Black Arts Movement. Breaking his ties with the Bohemian beat poets and avant-garde writers, Jones

adopted an African cultural identity, changing his name to Amiri Baraka. Deeply influenced by Malcolm X, Baraka first moved to Harlem and subsequently back to Newark where he established a local political organization and helped to elect Kenneth Gibson as the city's first African American mayor. In 1970, he established the Congress of African People, a black nationalist

formation dedicated to the principles of self-determination and cultural empowerment. In 1972 he was instrumental in organizing the National Black Convention in Gary, Indiana, which led to the creation of the National Black Political Assembly. In the mid-1970s, Baraka repudiated cultural nationalism and identified himself as a Marxist.

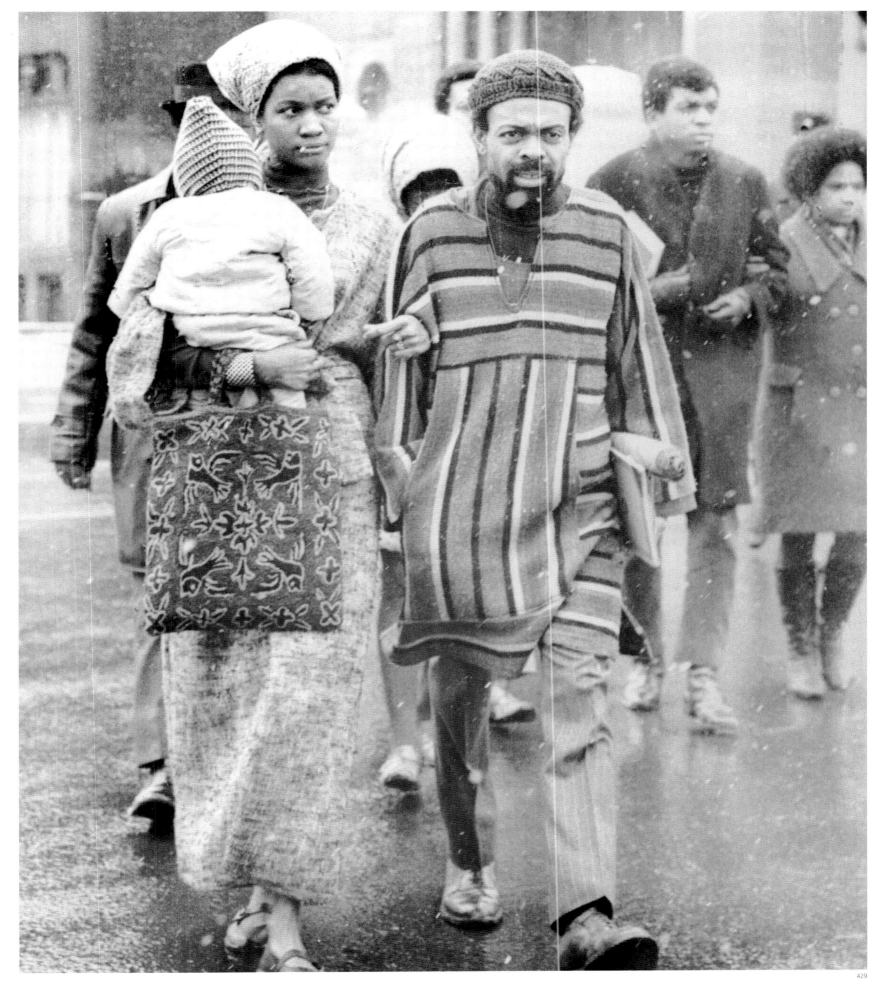

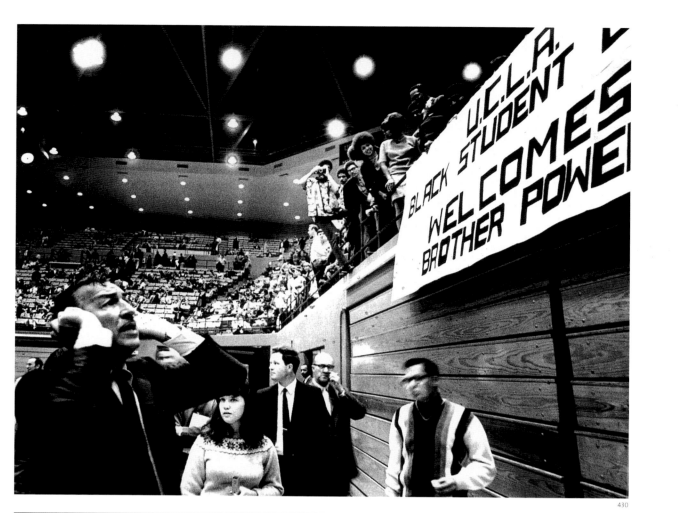

430

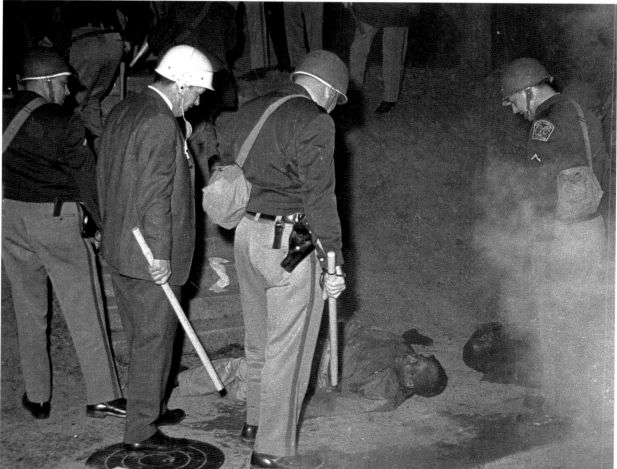

431

430. Adam Clayton Powell, Jr. talking with students from the University of California, Los Angeles, 11 January 1968. Serving in Congress for over two decades, Powell, as Chairman of the House Committee on Education and Labor, successfully led the passage of much of the anti-poverty and education legislation produced during the Kennedy and Johnson administrations. Powell's confrontational style and his role as a powerful black leader in Congress earned him the hostility of many white Congressmen. His 1966 commencement address at Howard University emphasizing "Black Power" as the new direction for the African American freedom movement was picked up a month later by Stokely Carmichael and other black activists during the Meredith March. In 1967,

Powell was censured by the House and stripped of his congressional seat, but Harlem voters responded by reelecting him to Congress. Subsequently, the Supreme Court overturned the censure decision and Powell recovered his back pay, but not the powerful chairmanship of his committee. In 1970 Powell was narrowly defeated by Democrat Charles Rangel. Powell died in 1972.

431. Police riot, Orangeburg, South Carolina, February 1964. Although the Civil Rights Act of 1964 had outlawed racial segregation in all public establishments, the All Star Bowling Lane of Orangeburg, South Carolina, still refused to admit African Americans. On 6 February 1968, students from the all-black South Carolina State College held a sit-in demonstration at the bowling alley. The next

night, fifteen demonstrators were arrested. On 8 February, during a protest rally and bonfire on the campus, local police confronted the student demonstrators and began firing indiscriminately into the crowd. Three students were killed and 27 were wounded. News reports erroneously described the incident as a shootout between students and police officers. However, physical evidence confirmed that many students were shot while lying on the ground. Nine officers were indicted in the shootings and all were acquitted. While the Kent State shootings and the death of four white college students at an antiwar demonstration two years later created a national debate, the assault and murders of African American college students at Orangeburg was largely ignored.

432. Eldridge Cleaver (arm outstretched), at a rally for the liberation of Black Panther Huey Newton at the Oakland auditorium, California, 17 February 1968. In October 1966, two student activists, Huey P. Newton and Bobby Seale, established the Black Panther Party for Self-Defense in Oakland, California. The original purpose of the party was to create a security force for the surveillance of the local police in their dealings with black residents. The Black Panther Party (BPP) interceded in conflicts and attempted to protect black residents from the police. Its Ten-Point Program included demands for full employment, decent housing, universal education, an end to police brutality, and the freedom of black men held in federal and state prisons. Significantly, the tenth point in the BPP's

program demanded: "Land, bread, housing, education, clothing, justice and peace. And as our major political objective, a United Nations–supervised plebiscite to be held throughout the black colony in which only black colonial subjects will be allowed to participate, for the purpose of determining the will of black people as to their national destiny." One of the "Eight Points of Attention" required of party members was to "not take liberties with women." In May 1967, BPP co-founder Bobby Seale, and a group of party members marched into the California State Capitol building in Sacramento, fully armed, to read a protest statement. The police immediately arrested all thirty Panthers in the demonstration, and the BPP became the target of extensive surveillance

and disruption from the FBI and local law enforcement agencies. In February 1968 Stokely Carmichael joined the BPP, becoming the organization's prime minister. Radical journalist Eldridge Cleaver became the BPP's minister of information and later its international secretary. Later that year, Cleaver was nominated by the Peace and Freedom Party of California to run as an independent candidate for the presidency. Cleaver's controversial book *Soul on Ice* became a national best-seller. The Panthers influenced the development of similar militant formations among other racial minority groups including the Puerto Rican Young Lords Party, the Mexican American La Raza Unida, the American Indian Movement (AIM) and, in India, the Dalit (untouchables) Black Panthers.

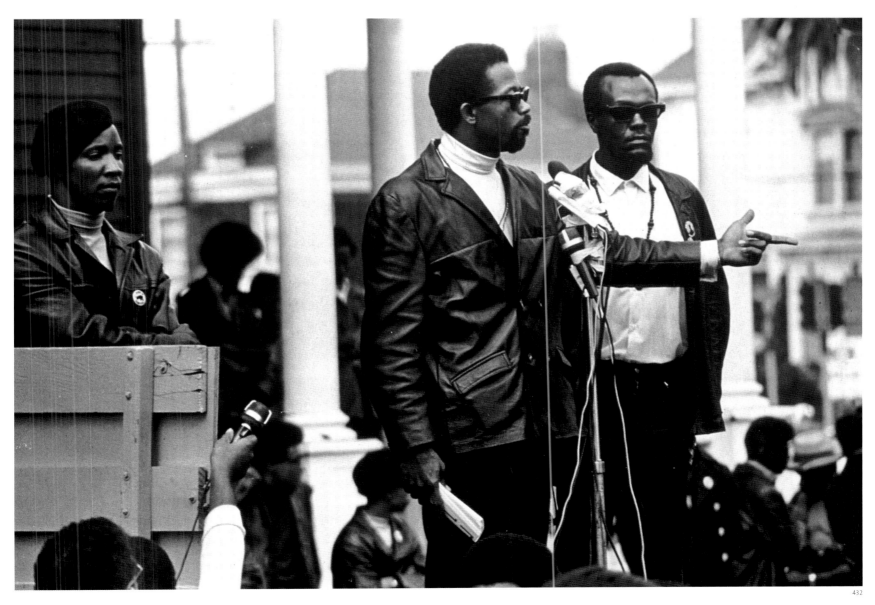

432

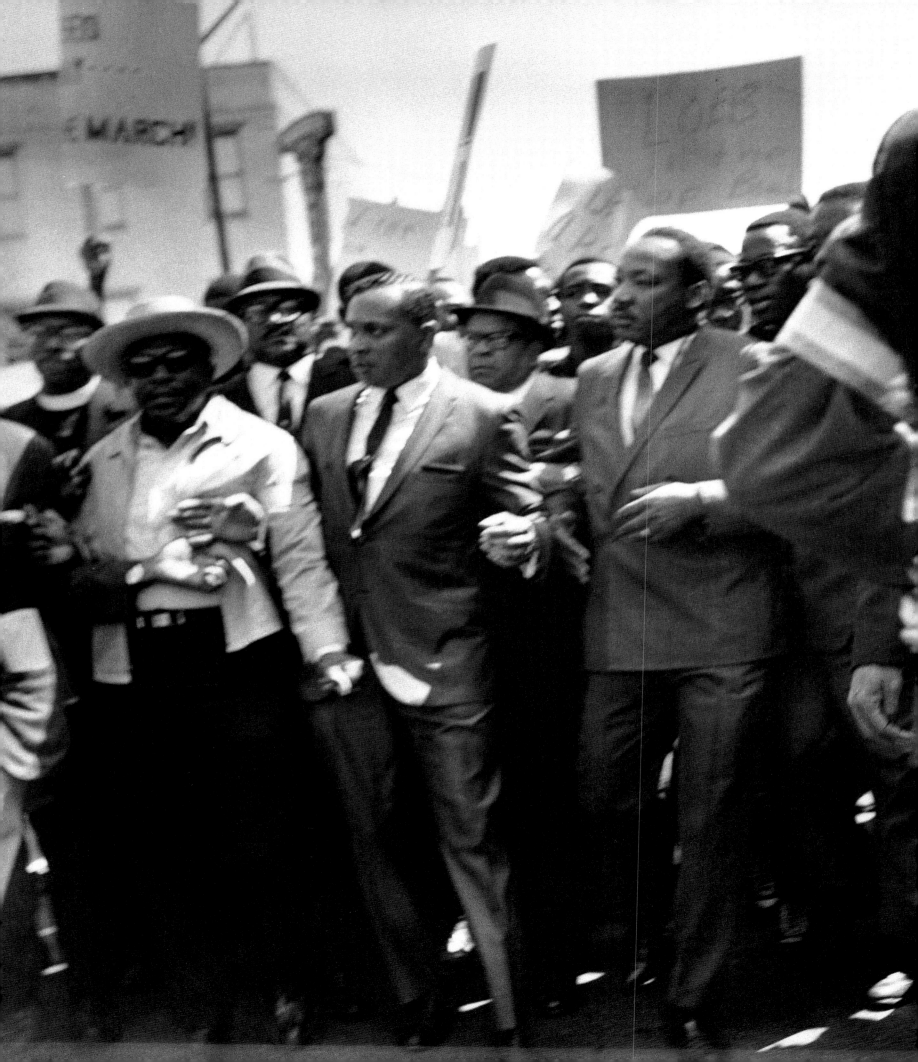

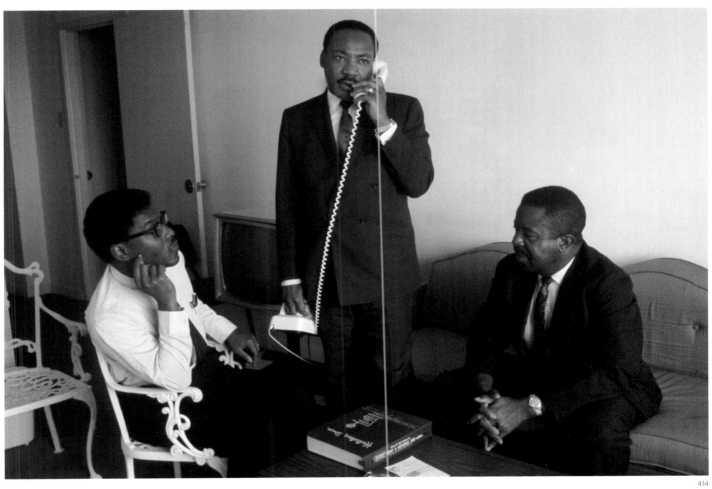

434

433. Martin Luther King, Jr. (right) leading the sanitation workers' strike in Memphis, Tennessee, 28 March 1968. Photograph by Ernest C. Withers. By 1967 King had begun to recognize the limitations of his earlier political philosophy of political reform. A White House study on poverty released in November 1967 showed that 41 percent of all non-whites still lived in poverty and that black unemployment remained twice as high as that of whites. In some cities such as New York, the percentage of families in poverty had actually increased in the 1960s, a period of unprecedented economic expansion. King believed a dual approach was necessary: first, vigorous opposition to the war in Vietnam and the reallocation of the federal budget toward human needs; second, building an interracial poor people's movement with the goal of achieving a guaranteed annual income and full employment for all. As the SCLC prepared to launch a Poor People's March on Washington, D. C., black labor leaders in Memphis asked King to come to the city to provide support for a sanitation workers' strike. The local sanitation workers' union had 1,300 members, all but five of whom were black. By the time King arrived in Memphis on 18 March 1968, the sanitation workers had been on strike for over one month. Many had been jailed and demonstrators had been assaulted with tear gas and clubs by local police. The working conditions for sanitation workers were substandard: the hourly wages averaged $1.60 to $1.80 per hour; they had no pensions or benefits; there was no protective clothing, bathrooms, nor shower facilities. On 28 March, King led 6,000 demonstrators on what was initially a peaceful march in downtown Memphis. Fighting erupted between several hundred black youth and police, and police responded by shooting tear-gas into the ranks of all demonstrators, creating a panic. Thirty-eight hundred National Guardsmen were immediately called into the city and martial law was declared.

434. Martin Luther King, Jr. (on the telephone) and Ralph Abernathy (right) making plans with labor union leaders to organize a more successful and peaceful march, Memphis, March 1968.

435. Sanitation workers' strike in Memphis, 29 March 1968. On 29 March the demonstrators marched peacefully past the National Guard. Martin Luther King, Jr. left the city for several days and the national staff of the SCLC and local labor leaders coordinated the details for a second major march in support of the strike.

436. On the balcony of the Lorraine Motel in Memphis, associates point in the direction of the gunshots that have just struck Martin Luther King, Jr., 4 April 1968. Returning to Memphis on 3 April, King delivered an address at an evening rally in support of the strike. During the speech he abruptly began to talk about himself in the past tense: "I don't know what will happen now. But it really doesn't matter to me now. Because I've been to the mountaintop. I won't mind. Like anybody, I would like to live a long life. Longevity has its place. But I'm not concerned about that now. I just want to do God's will. And he's allowed me to go up to the mountain. And I've looked over, and I've seen the promised land. . . . I may not get there with you, but I want you to know tonight that we as a people will get to the promised land." The next evening, 4 April, at 6:08 P.M., while on the balcony of the Lorraine Motel in Memphis, Reverend Dr. Martin Luther King, Jr. was assassinated by a white man named James Earl Ray.

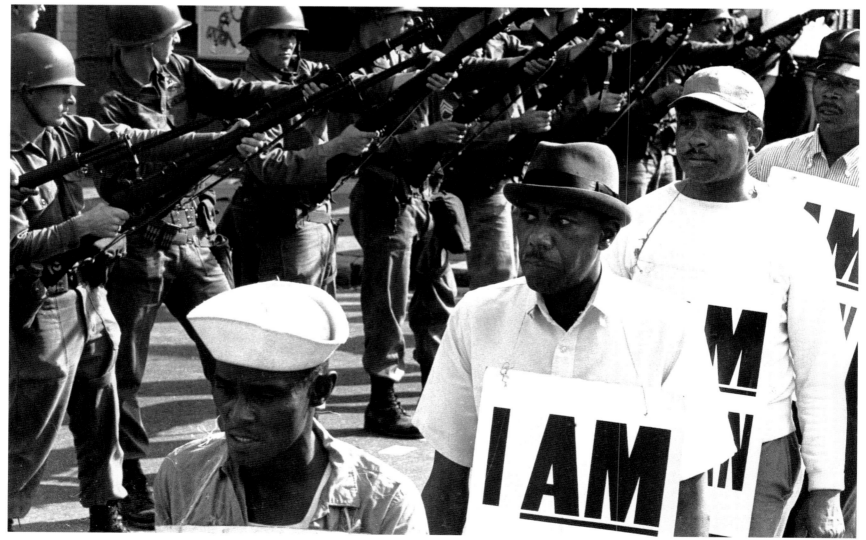

435

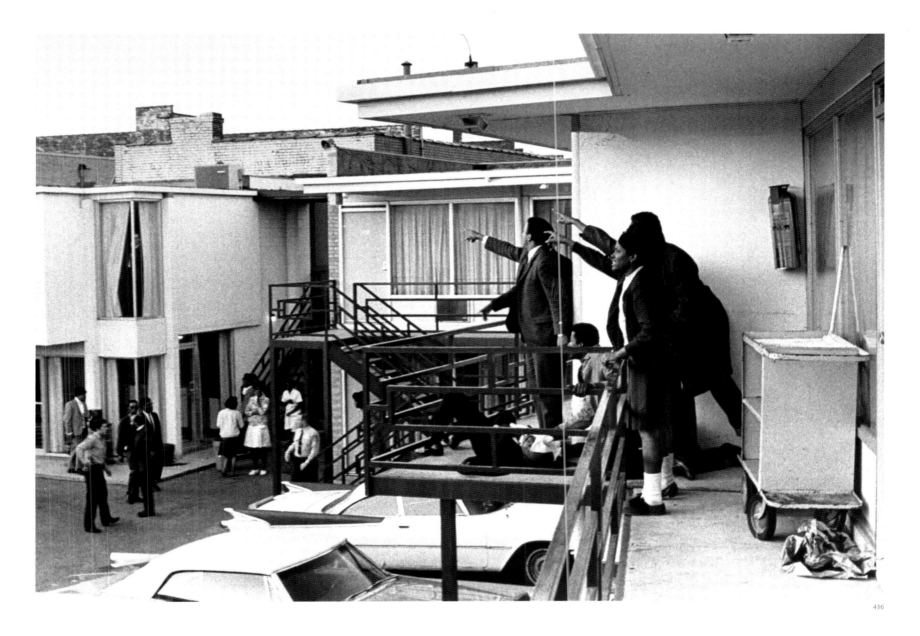

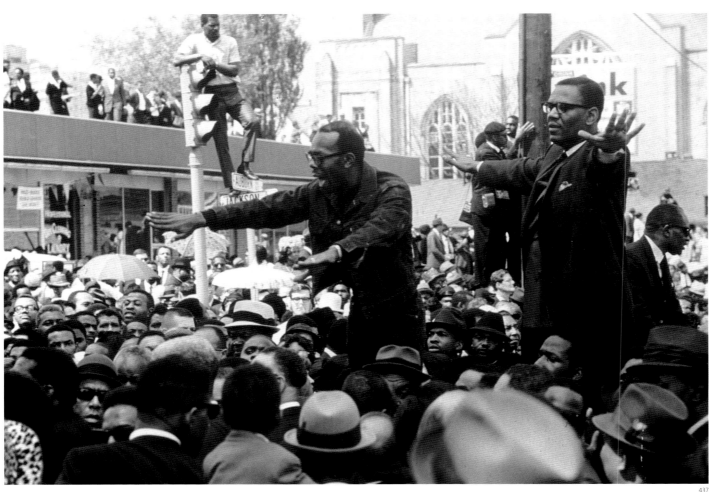

437

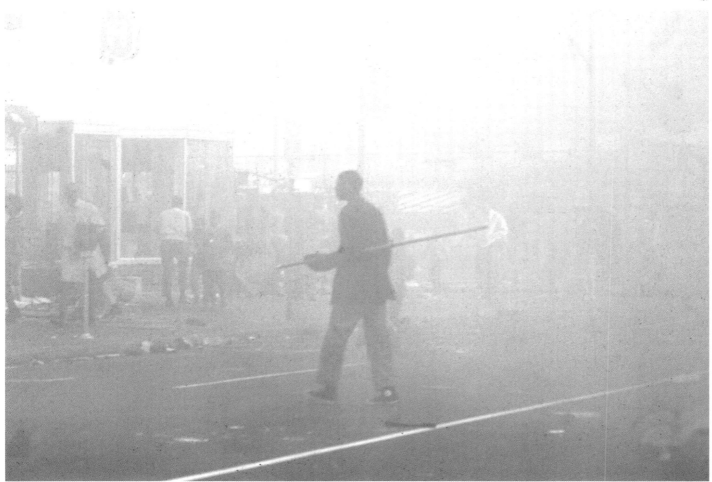

438

There was widespread grief and anger among African Americans after Martin Luther King, Jr.' assassination. Immediately following the news of his death, civil disturbances broke out in more than one hundred cities. Thirty-nine people were killed and tens of millions of dollars worth of property destroyed. President Johnson declared 9 April a national day of mourning in honor of King.

437. Aftermath of King's assassination, Atlanta, April 1968.

438. Tear-gas fog during the civil disturbances in Washington, D. C, April 1968.

439. Man protesting against the riot in Harlem, New York City, 6 April 1968.

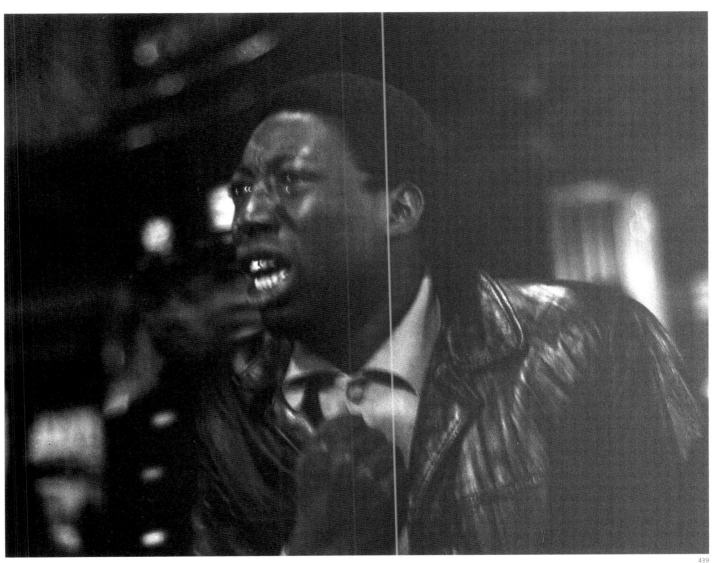

439

440. Memorial March for King in Central Park, New York City, 7 April 1968.

441–442. Martin Luther King Memorial March for Union Justice and to End Racism, Memphis, Tennessee, 8 April 1968. On 8 April, over 40,000 demonstrators participated in the march that King himself could no longer lead. Leading the march were his widow, Coretta Scott King, Ralph David Abernathy, and many national labor leaders, including Walter Reuther, president of the United Auto Workers. On 16 April, after a strike of 65 days, the black sanitation workers voted to accept a settlement from the city. Workers won a pay raise, recognition of their union, a formal grievance procedure, and a promise of no retaliation against those involved in the strike. Later the same year, the SCLC was instrumental in organizing sanitation workers' campaigns in St. Petersburg, Florida and Atlanta.

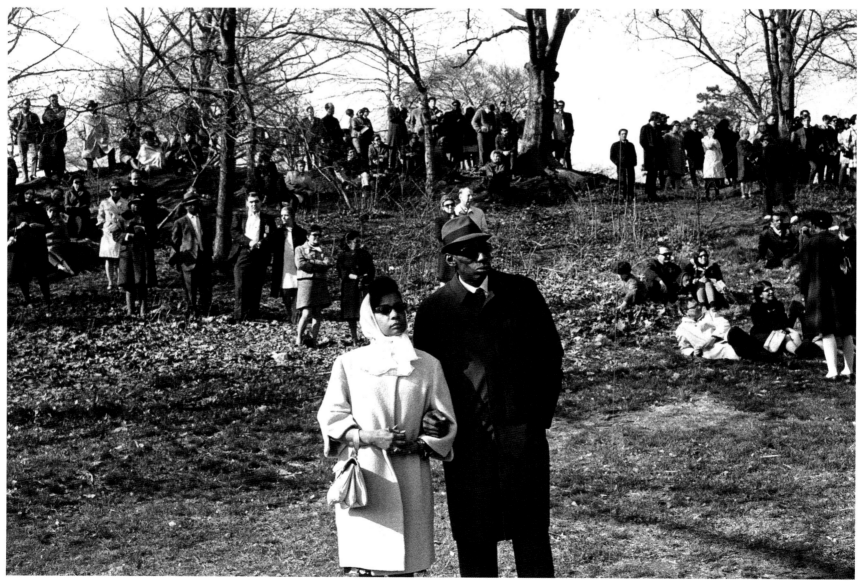

440

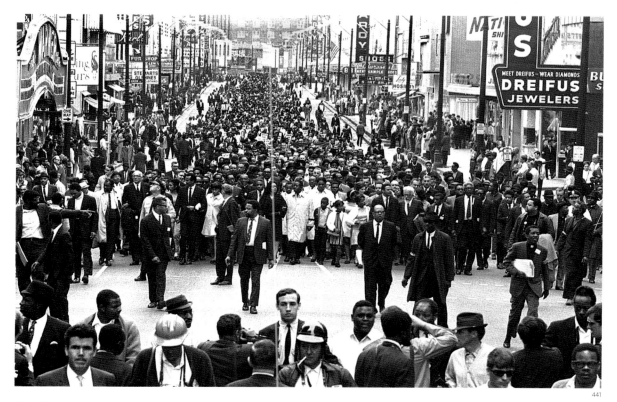

441

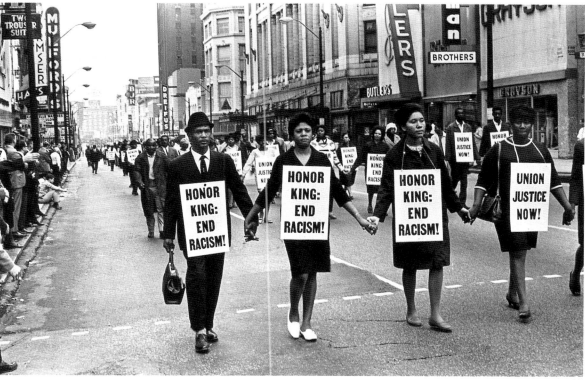

442

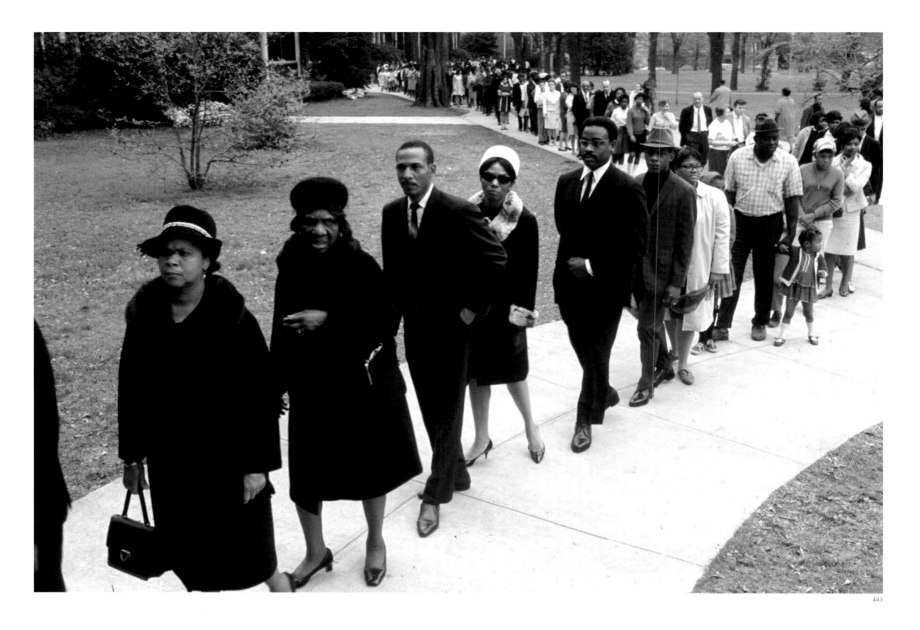

443

443–444. Mourners coming to pay their respects to the deceased Martin Luther King, Jr., Ebenezer Baptist Church, Atlanta, 9 April 1968. On the morning of 9 April, thousands gathered around Atlanta's Ebenezer Baptist Church to honor the martyr of the civil rights movement. Prominent national leaders including Vice President Hubert Humphrey and Republican presidential candidate Richard Nixon were present.

414

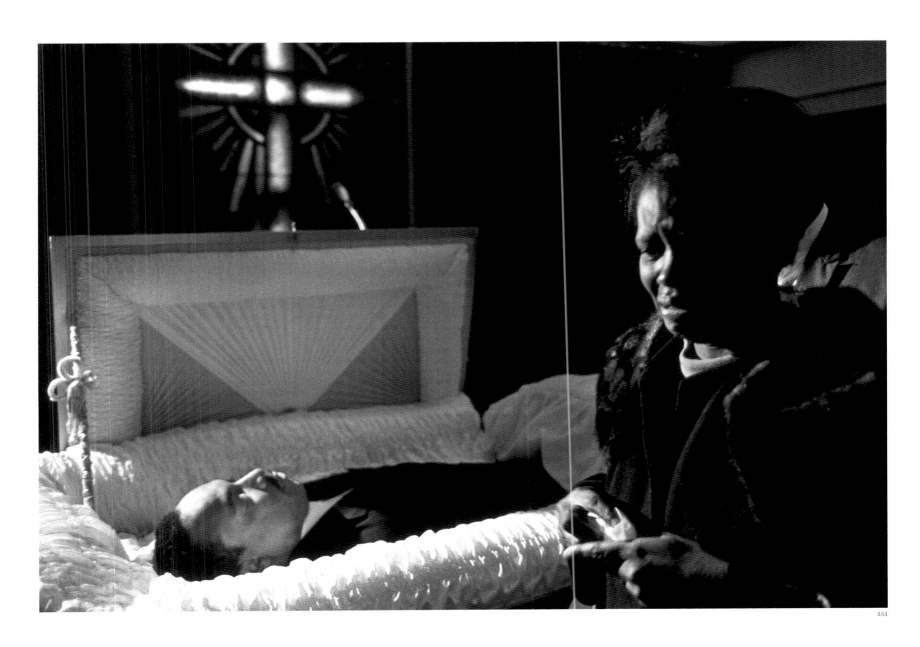

445. King's wife Coretta
Scott King, his children, and
Ralph Abernathy at the
head of the cortege leaving
Ebenezer Baptist Church,
9 April 1968. Following the
funeral service at the church,
King's body was taken by
wagon to Atlanta University
where King had been
an undergraduate student at
Morehouse College. Media
representatives from all over
the world covered the eulogy
and the solemn ceremonies.
For many African Americans
this was the end of an era.

446. Public service at
Morehouse College, 9 April
1968.

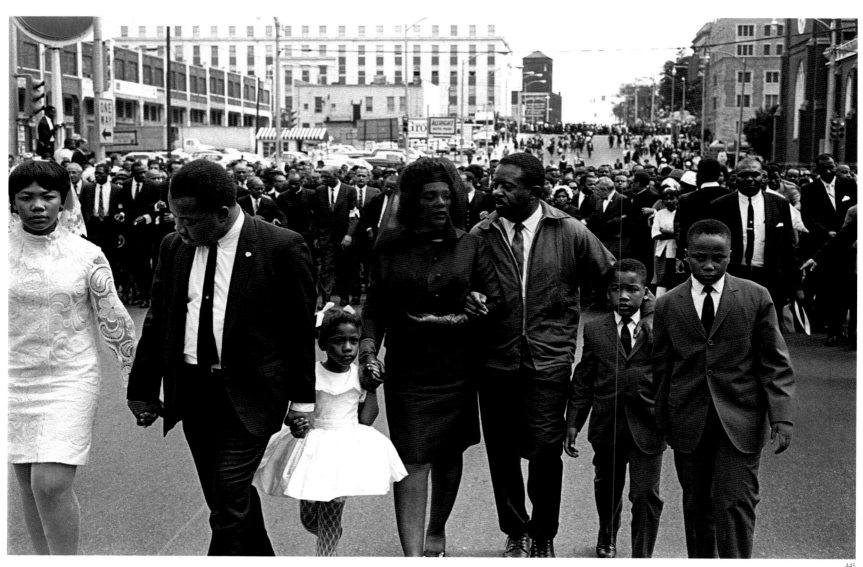

445

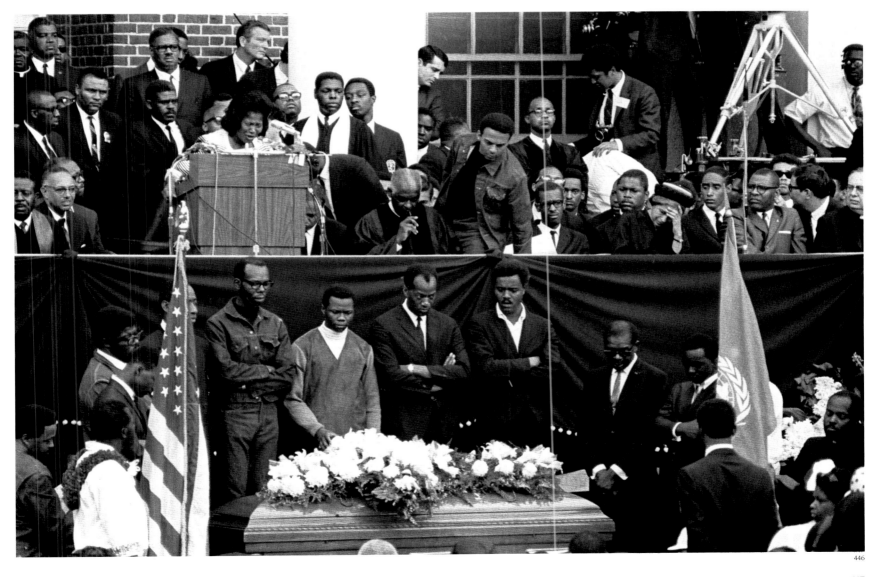

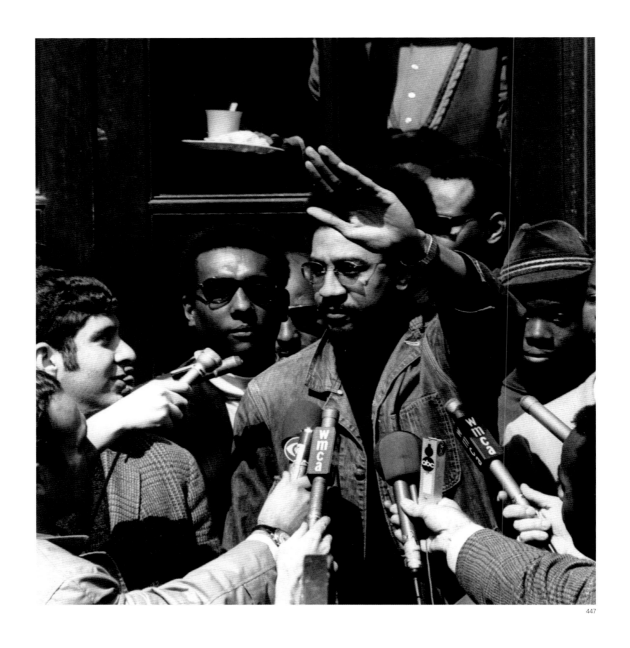

447. H. Rap Brown (right, with arm raised) and Stokely Carmichael (left) speaking to the media during the student strike at Columbia University, New York City, 23–27 April 1968. By early 1968, over 400,000 American troops were in direct combat in Vietnam and the war was growing extremely unpopular on university campuses. The Tet offensive by the South Vietnamese Liberation Army and the North Vietnamese Army dramatically demonstrated to many Americans that the war could not be won. In April, black student activists and members of the Students for a Democratic Society (SDS) seized control of some Columbia University buildings, taking several administrators hostage. Within days, as many as one thousand students occupied the campus and essentially shut down the university. After six days of occupation, over one thousand New York police officers were ordered onto the campus to clear the buildings and arrest student protestors. For many students at other campuses, the Columbia demonstrations became a model for organizing antiwar resistance.

448. Marks, Mississippi, 13 May 1968. In early 1968, under the direction of Martin Luther King Jr., the SCLC had begun to plan a nonviolent protest in Washington, D. C. that would symbolize the socio-economic plight of the poor and dispossessed. A "tent city" was to be constructed on the Mall representing a temporary home for disadvantaged Americans of all origins including Appalachian whites, American Indians, and Latinos. In the wake of King's assassination, SCLC's new leader, Ralph Abernathy, and several other organizations made a commitment to carry out King's original plan. On 1 May 1968, "Resurrection City" was born and, within several weeks, more than two thousand people lived there. Daily marches were organized at federal office buildings to denounce government policies toward the poor. On 13 May, fourteen mule-drawn wagons departed from Marks, Mississippi, en route to Washington, D. C.

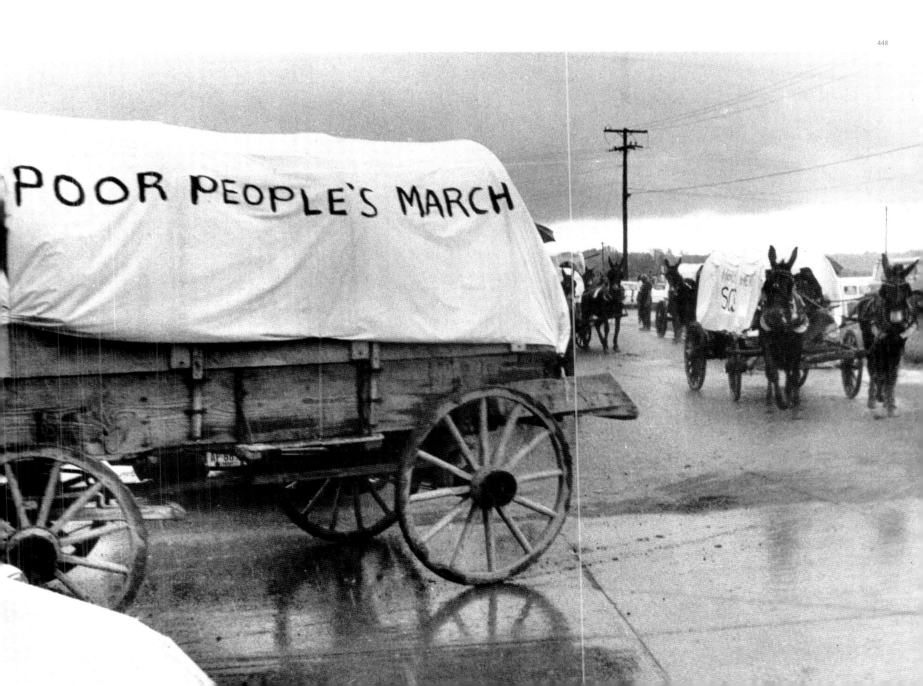

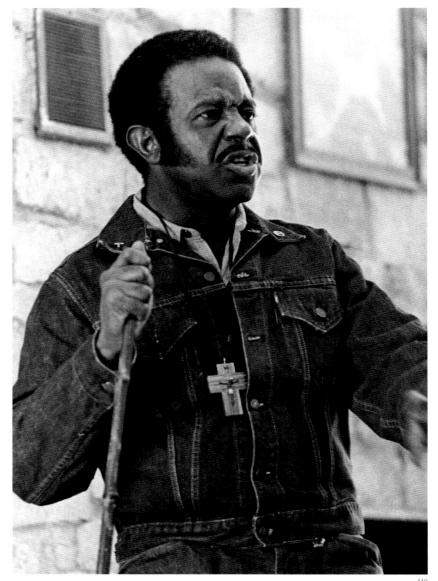

449

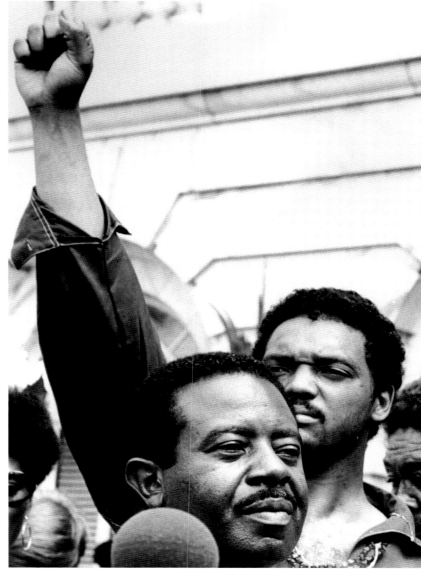

450

449. Albert Turner at the
Poor People's March,
Washington, D. C., May 1968.

450. Jesse Jackson (with arm
raised) and Ralph Abernathy
at the Poor People's March,
Washington, D. C., May 1968.

451. Resurrection City during
the Poor People's March,
Washington, D. C., May 1968.

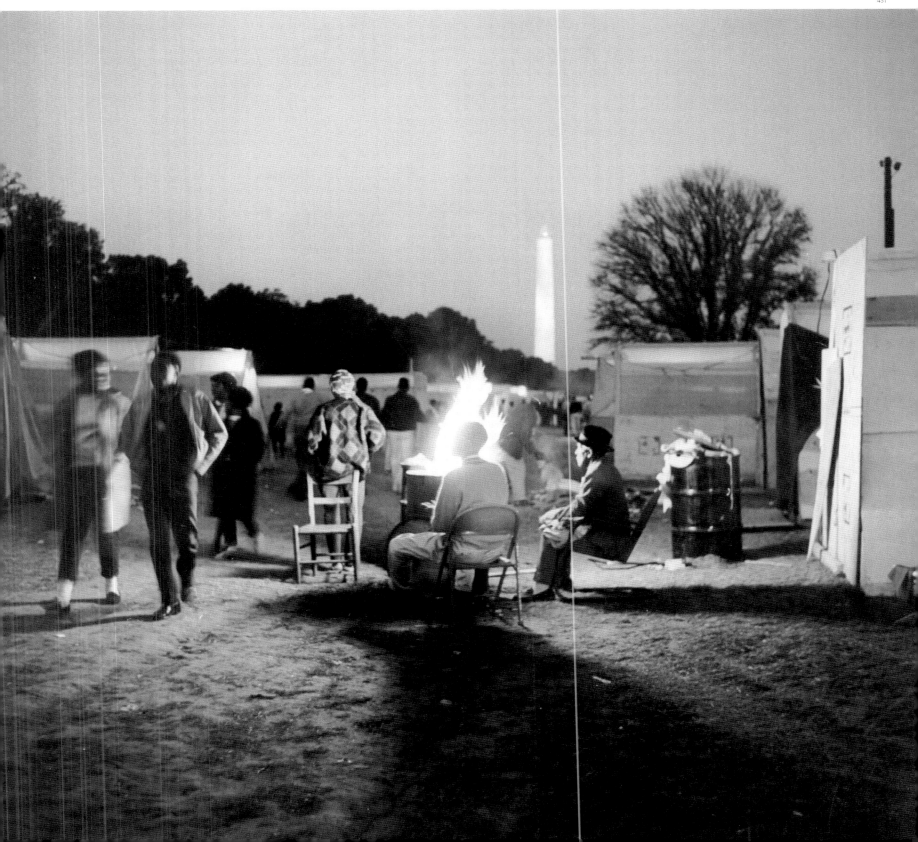

452. Spectators of Robert Kennedy's funeral train from New York City to Washington, D. C., 8 June 1968. In March, as antiwar sentiment grew throughout the United States, liberal Democratic Senator Robert F. Kennedy announced his candidacy for the presidency. Only minutes after the California Democratic primary election secured his nomination, Kennedy was assassinated. Robert Kennedy was one of the few American political leaders who drew strong support from both blacks and poor whites, and his death threw the Democratic Party into disarray. In November 1968, in a close election, Republican Richard M. Nixon won the presidency against Vice President Hubert H. Humphrey.

453. The last residents being removed from Resurrection City by the police, Washington, D. C., 24 June 1968. On 19 June 1968, over 50,000 people attended a "Solidarity Day" demonstration in Washington, D. C. on behalf of the Poor People's Campaign. On 24 June, 1,500 police officers surrounded Resurrection City, and within hours had dismantled it, arresting hundreds of people. The Poor People's Campaign represented the last major national nonviolent, social justice event of the 1960s that was initiated and led by the traditional civil rights organizations.

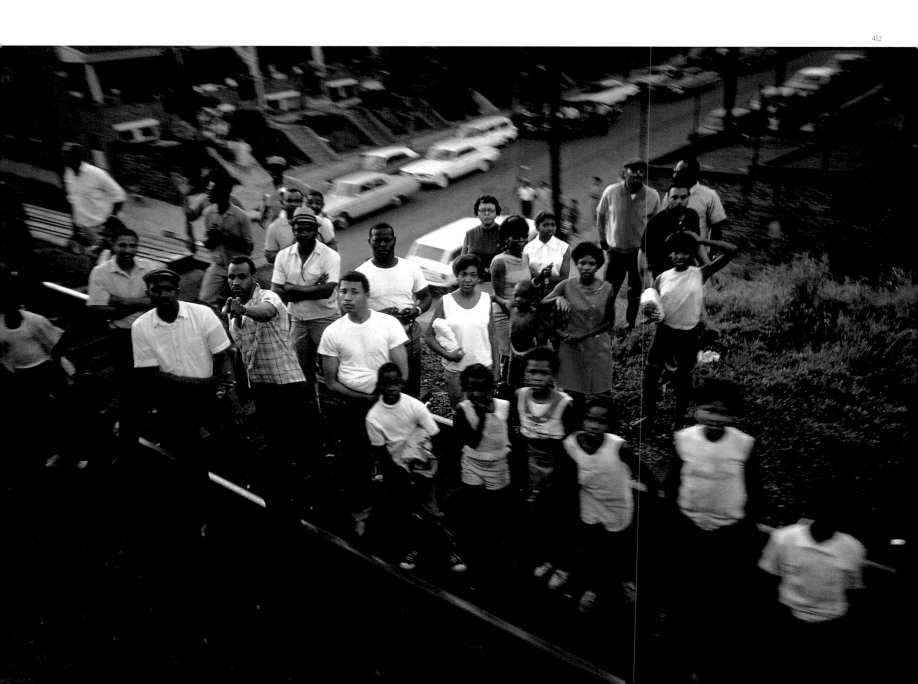

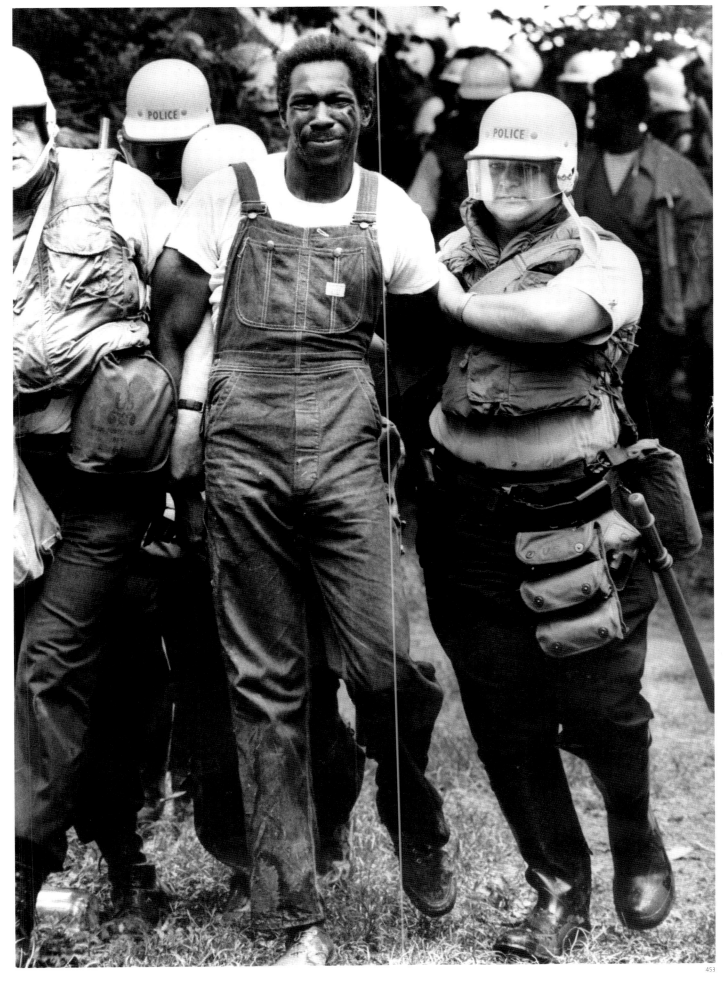

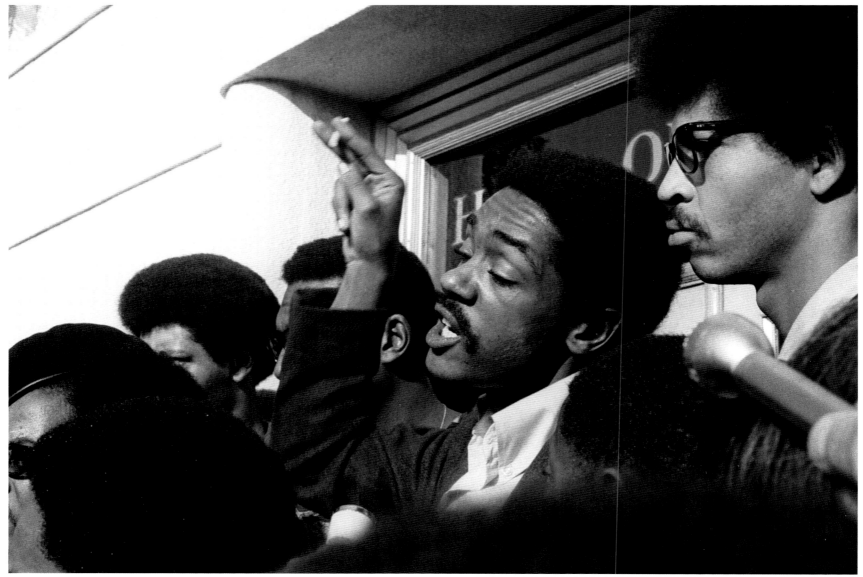

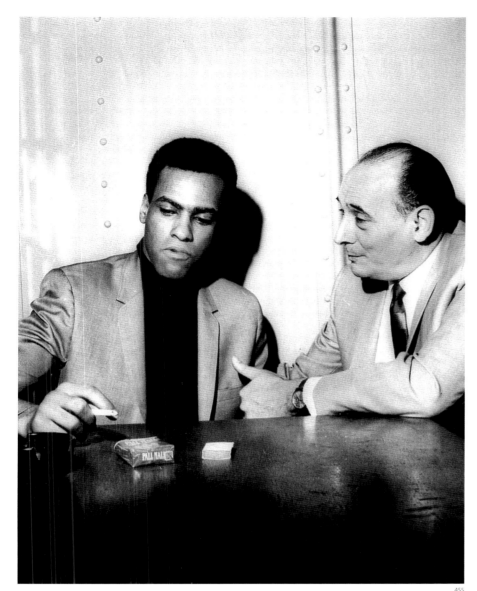

455

456

454. Bobby Seale (second from right) in front of Berkeley Hall of Justice before going to trial, California, June 1968. Born in Dallas, Texas in 1936, Seale moved with his parents to California at the age of ten. After serving in the U. S. Air Force, he enrolled in Merritt College in Oakland, California in 1961. Seale soon became involved in the Afro-American Association, a West-Coast black students' organization, and subsequently participated in the Revolutionary Action Movement (RAM) prior to founding the Black Panther Party. Later in 1968, Seale was arrested for his role in an antiwar demonstration at the Democratic Party's national convention in Chicago. During his controversial trial, he was literally gagged by the judge, and after being found guilty, served two years in prison.

455. Huey Newton (left) talking to his attorney Charles Gary during a news conference from the Alameda County Courthouse, Oakland, California, 18 July 1968. Born in New Orleans in 1942, Huey P. Newton, grew up in California. As a Merritt College student, he became friends with Bobby Seale, with whom he founded the Black Panther Party in 1966. On 28 October 1967, Newton was arrested and charged with murdering an Oakland police officer and wounding another. The BPP initiated a national campaign to "Free Huey" which brought new supporters into its ranks. Newton was convicted of homicide in 1968, but in 1970, in the wake of the campaign for his freedom, the decision was reversed.

456. Black Panther Party headquarters shot up by the police after the Huey Newton verdict, Oakland, September 1968.

457. James Brown performing "Say It Loud, I'm Black and I'm Proud," Dallas, 26 August 1968. Widely known as the "godfather of soul," singer and entertainer James Brown was born in Georgia in 1933. His first rhythm-and-blues hits were recorded in the late 1950s. In the mid- and late-1960s, Brown gained extraordinary popularity with African American youth and others by producing a series of soulful and funky hits, including "Say It Loud. . . ." Brown's original vocals and dance-oriented music had a major impact on the entire music industry, and his style continues to influence many artists.

458. U. S. athletes Tommie Smith (gold medalist) and John Carlos (bronze) during the 200-meter-race awards ceremony at the Olympic Games, Mexico City, 1968. In 1968, former basketball and track star Harry Edwards initiated the Olympic Project for Human Rights with the goal of organizing an international boycott of the 1968 Olympic Games which were scheduled to be held in Mexico City. Most black athletes, however, decided not to boycott the games, but to display their opposition to racism by wearing black armbands and making other symbolic statements of protest. In the most dramatic protest at the games, medal winners Tommie Smith and John Carlos bowed their heads and raised their fists as the U. S. national anthem was played during the awards ceremony. Their silent protest was a gesture in honor of the victims of American racism. They were suspended from the team and barred from the Olympic Village.

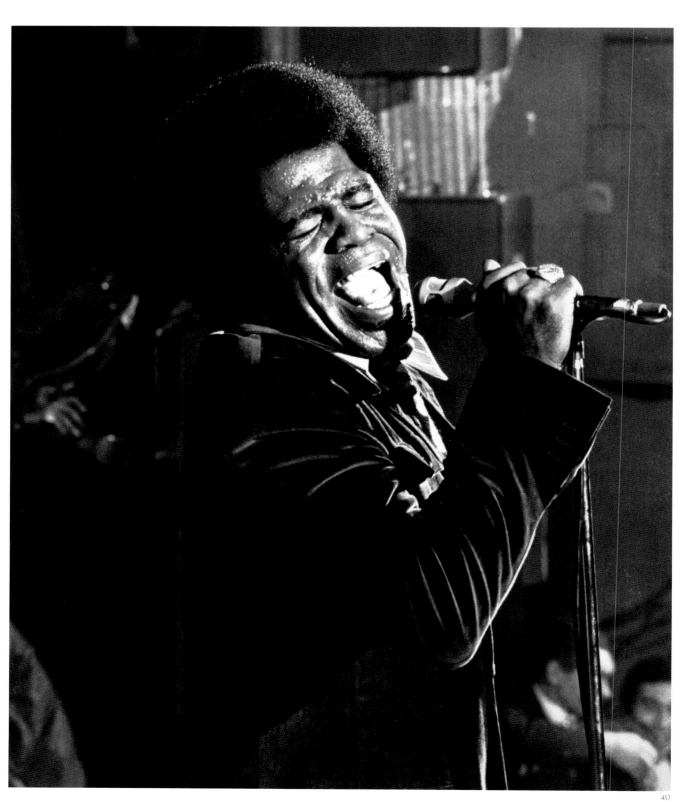

457

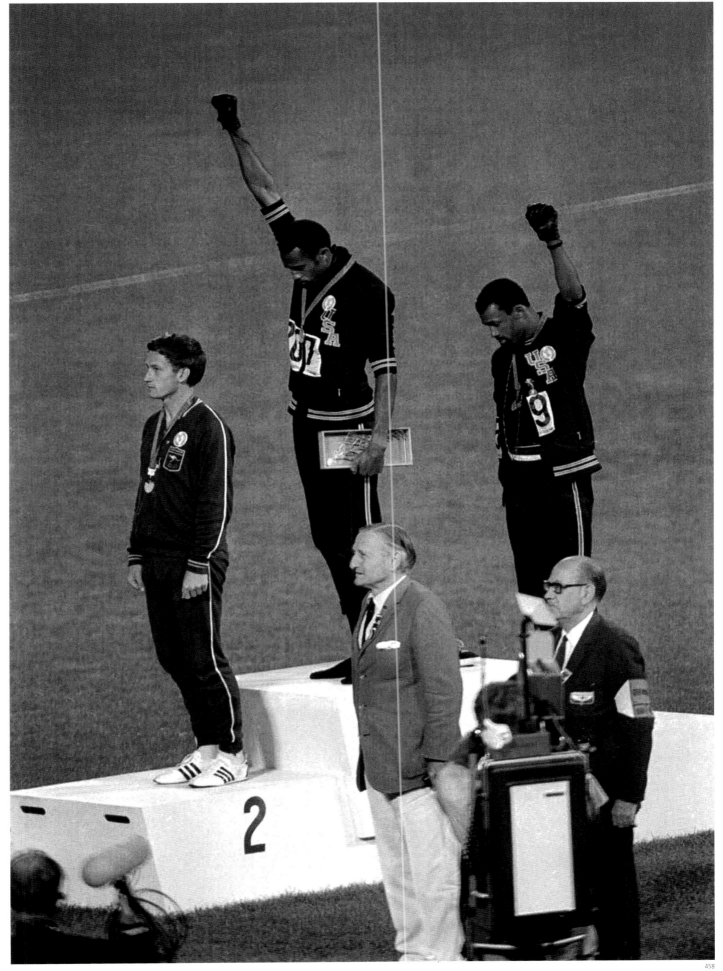

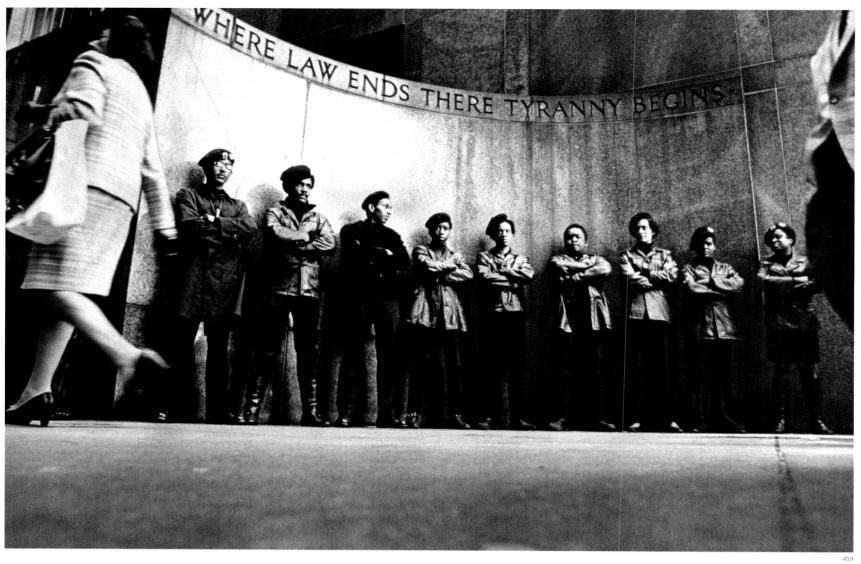

459

459. Members of the Black
Panthers demonstrating
outside the courthouse, New
York City, 11 April 1969.

460. Students leaving Willard
Straight Hall at Cornell
University, Ithaca, New York,
20 April 1969. During the
late 1960s, at hundreds of
university and college cam-
puses, African Americans
formed student organiza-
tions. These groups criticized
the lack of African American
faculty and the absence of
African and African American
studies in the curriculum.
At dozens of universities, black

students seized administra-
tion buildings in acts of
non-violent civil disobedience.
In many instances, black
student pressure forced
academic administrators to
implement meaningful
reforms. Within five years,
more than three-hundred
African American studies
departments and programs
had been established at major
colleges and universities.
At Cornell University, black

student grievances included
overt racial harassment most
recently symbolized by
a cross burning incident.
A group of African American
students seized control
of Willard Straight Hall, the
campus student-union
building. Students subse-
quently reached a negotiated
settlement with campus
administrators and left the
building without incident.
Though highly unusual, this

photograph of armed
black students was widely
publicized across the United
States, presenting an
inaccurate portrayal of the
black student movement.

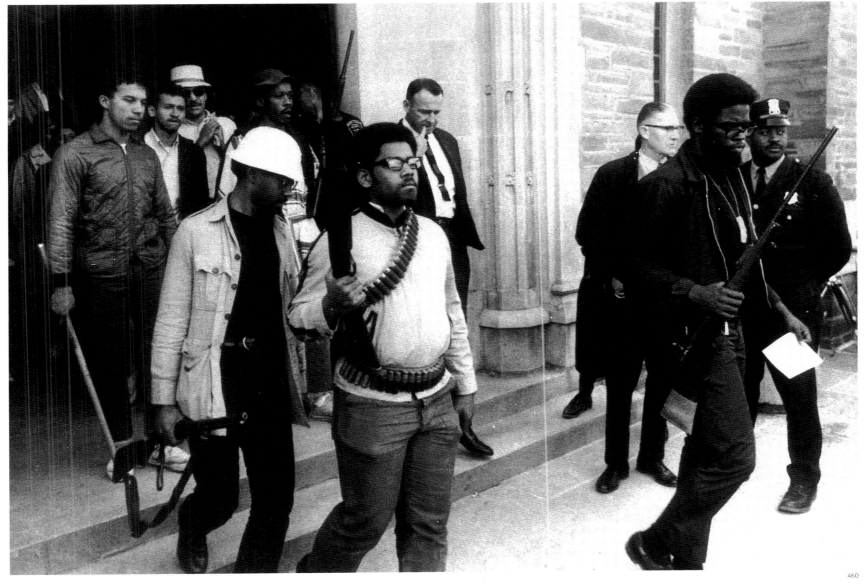

461, 463. Panthers at a "Free Huey" rally in Oakland, California, May 1969.

462. Bobby Seale speaking at the "Free Huey" rally in Oakland, May 1969.

464. Angela Davis speaking at the "Free Huey" rally in Oakland, May 1969. Angela Yvonne Davis was born on 26 January 1944 in Birmingham, Alabama. She studied at the Sorbonne in Paris and at the University of Frankfurt in Germany. She received a bachelor's degree from Brandeis University, Massachusetts and began work on her Ph.D. at the University of California at San Diego. While in California, Davis joined the Communist Party. When she was appointed to a faculty position at the University of California at Los Angeles, Governor Ronald Reagan demanded that she be fired because of her Communist Party membership. She was publicly associated with the Black Panther Party and became an advocate for imprisoned black political activists.

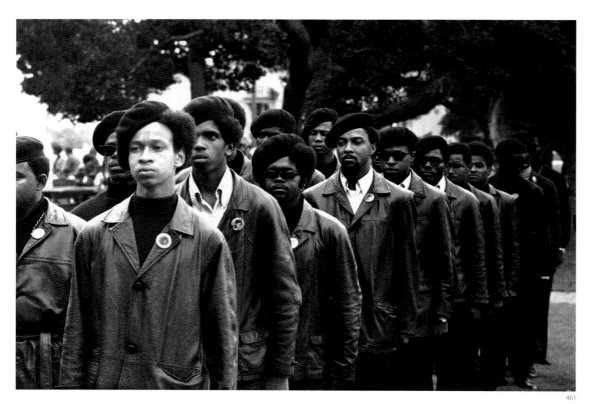

461

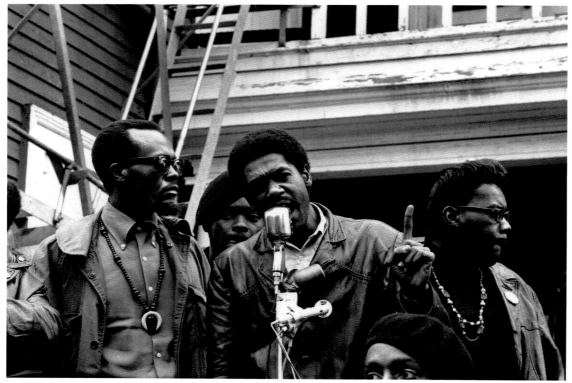

462

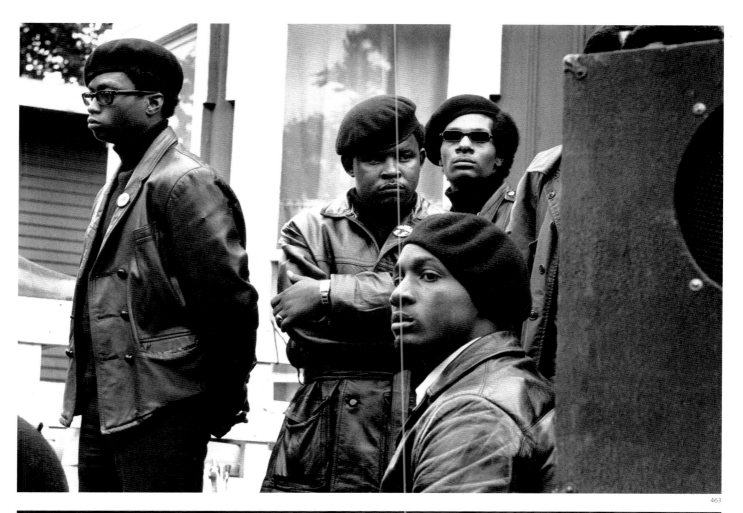

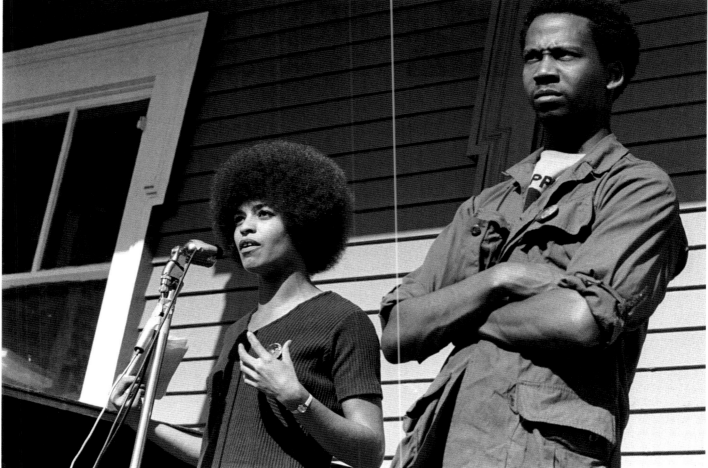

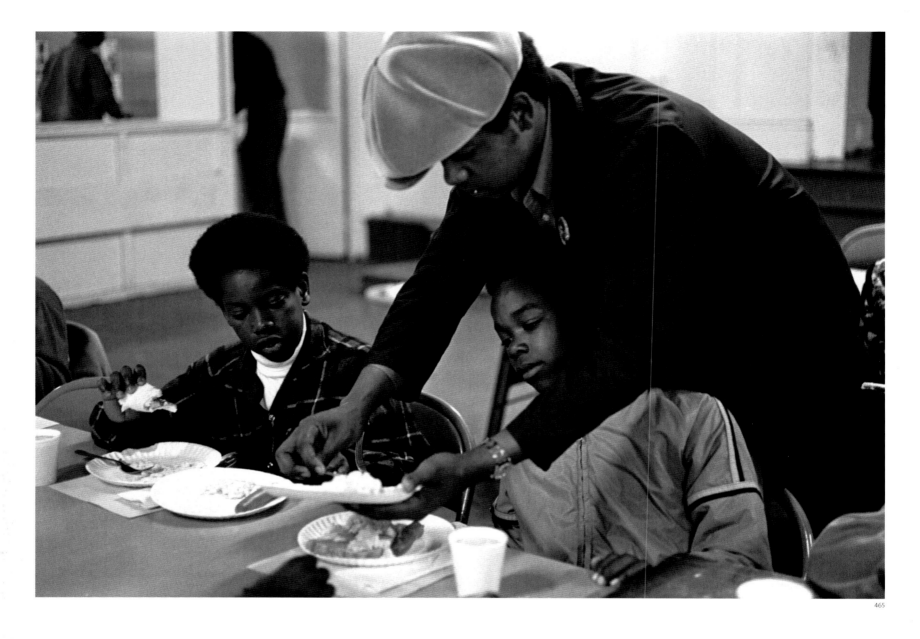

465. "Breakfast for Children" program run by the Black Panther Party, Oakland, California, 1969. By late 1968, the Panthers had come under such overt police assault throughout the country that the party retreated from some of its more extreme positions and began to emphasize the construction of human services programs for the most disadvantaged sectors of the black community. In January 1969, the BPP initiated the free breakfast program for school children. By the end of that year, over ten-thousand children of low-income families were being fed daily by the party. In several cities the Panthers provided free legal services and health care facilities, and the organization increased its popular following among black working-class and poor people, and particularly among young people.

466. Block party, Chicago, June 1969. The BPP developed chapters and local organizations in over thirty states, from Nebraska to North Carolina. The character of most local Panther groups was largely nonconfrontational and community-centered. They emphasized black political participation, improving public resources for the poor, and protesting police brutality. In Chicago, under the leadership of charismatic activist Fred Hampton, the BPP established a free medical center, directed five breakfast programs for school children, and worked effectively with street gangs to end urban violence.

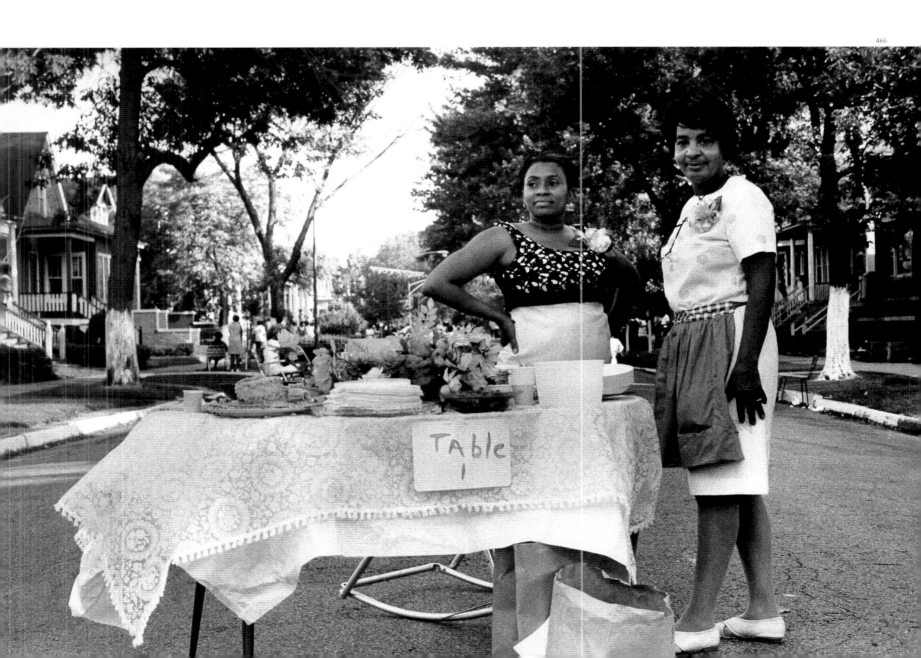

467. Memorial mass for Fred Hampton at Holy Angels Catholic Church, Chicago, 6 December 1969. On 4 December 1969, just before 5 A.M., the Chicago police stormed the apartment of twenty-one-year-old Panther leader Fred Hampton. He and Panther member Mark Clark were killed in their beds, and five others in the apartment were wounded. In one of his last speeches, Hampton had said, "You have to understand that people have to pay a price for peace. You dare to struggle, you dare to win. . . . I believe I'm going to be able to die doing the things I was born for. I believe I'm going to die high off the people." In 1983, a federal judge ruled that the FBI had illegally conspired to deny Hampton and Clark their civil rights. The survivors of Hampton and Clark were awarded over 1.8 million dollars in damages.

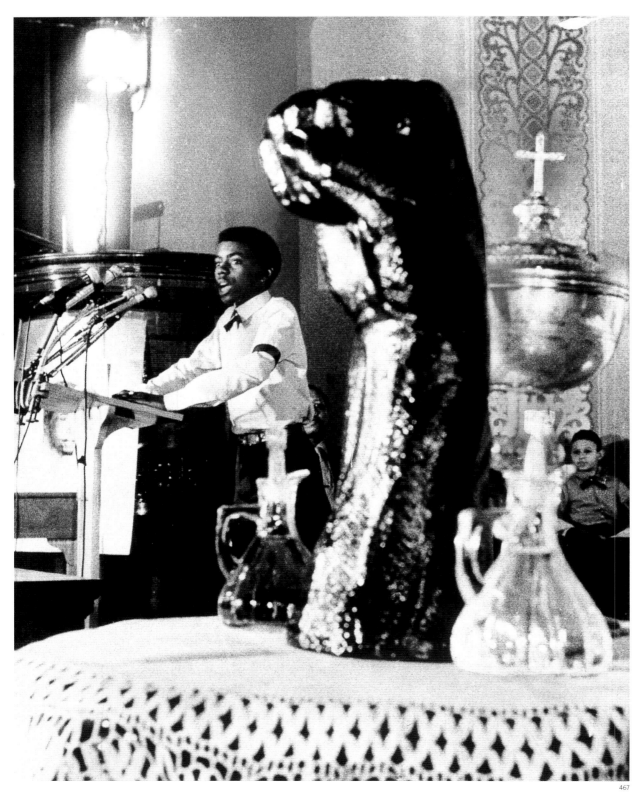

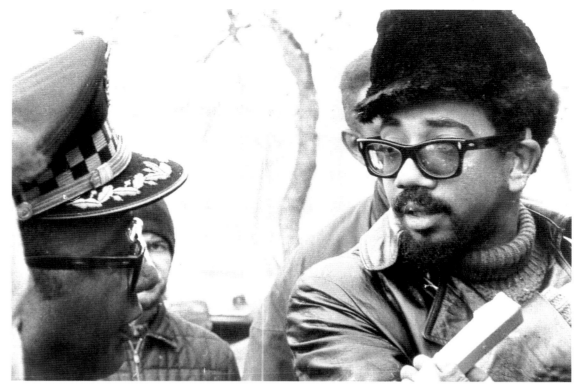

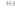

468

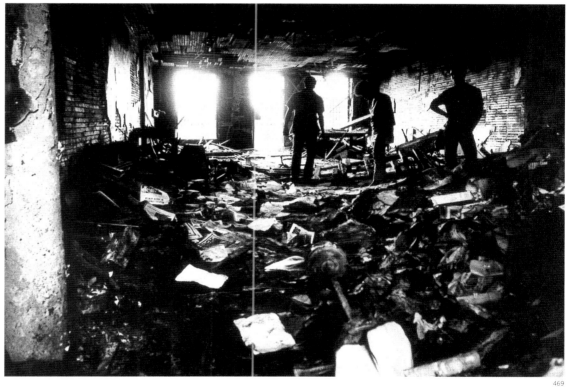

469

468. Bobby Rush (right), head of the Illinois Black Panthers, talking with Deputy Chief of Police Samuel Nolan, Chicago, 17 December 1969. Bobby Rush was a key figure in the Black Panther Party organization in Chicago. A quarter of a century later, Rush was elected to Congress from Chicago.

469. Burned-out offices of the Black Panther Party, Chicago, December 1969. FBI Director J. Edgar Hoover referred to the BPP as "the greatest threat to the internal security of the country." In 1967, when Fred Hampton was only nineteen years old, the FBI established a file on him that would soon amount to thousands of pages. In early 1968, Hampton's mother's telephone was wiretapped.

An FBI counterintelligence operative, William O' Neal, joined the Chicago chapter of the BPP, and convinced others to let him serve as the group's chief of security. Through the FBI's counterintelligence program, Cointelpro, federal agents worked closely with state and local law enforcement officials to watch, arrest, imprison, and, in several instances, to assassinate, Black Panther leaders and members. Similar tactics of surveillance had been applied to Malcolm X, Martin Luther King, Jr., and earlier civil rights leaders such as Paul Robeson. The Black Panther Party's peak of influence was in 1969–71, when it had forty-five chapters and branch organizations throughout the United States. In early 1971, the Black Panther newspaper had a national circulation of 250,000. However the BPP's organizational stability was weakened by surveillance, infiltration, and raids by federal and local police agents. In 1969 alone, twenty-seven Panthers were killed by the police and 749 were jailed throughout the country.

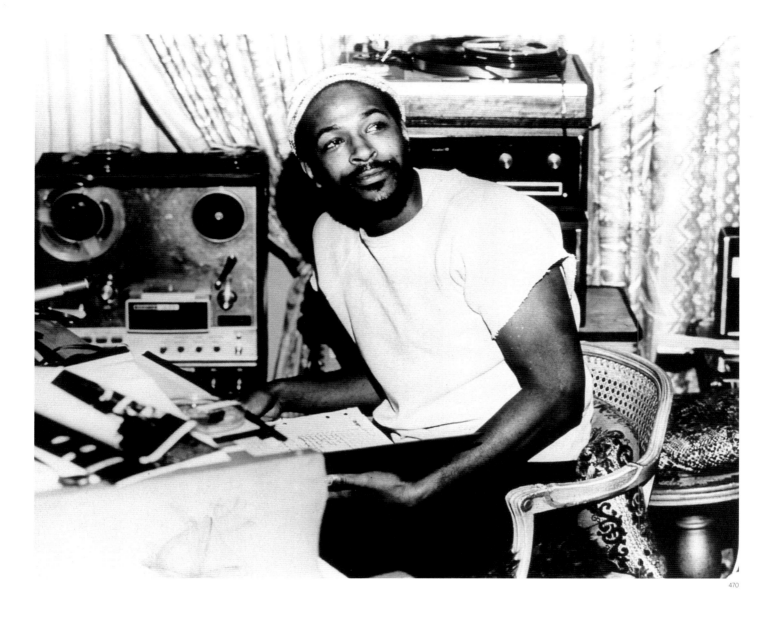

470. Marvin Gaye in his recording studio, 1971. Marvin Gaye was one of the most gifted and influential rhythm-and-blues artists. Born in Washington, D. C. in 1939, the son of a storefront preacher, Gaye was discovered by musical entrepreneur Barry Gordy, who had just founded Motown Records. Gaye's first hit, "Stubborn Kind of Fellow," was released in 1962 and led to a series of successful and popular releases. Breaking with the Motown formula, Gaye asserted his own style of music and insisted upon his artistic independence. Gaye's classic 1971 album *What's Going On?* was a powerful presentation of the artist's political perspectives about racism, war, and the environment. Tragically, on 1 April 1984, Gaye was shot and killed by his father.

471. Da Nang airport, South Vietnam, 1971. As the U. S. officially withdrew from Vietnam in 1973, the South Vietnamese regime quickly collapsed. In April 1975, the North Vietnamese entered Saigon, thus ending the war. Between January 1965 and March 1973, nearly 2.6 million Americans were stationed in South Vietnam. Between 40 and 60 percent of these troops were at some point involved in combat. Over 58,200 Americans were killed, 304,000 seriously wounded, 75,000 severely disabled, including amputations and paralysis, and 2,300 were missing in action. Approximately 275,000 African Americans served in Vietnam.

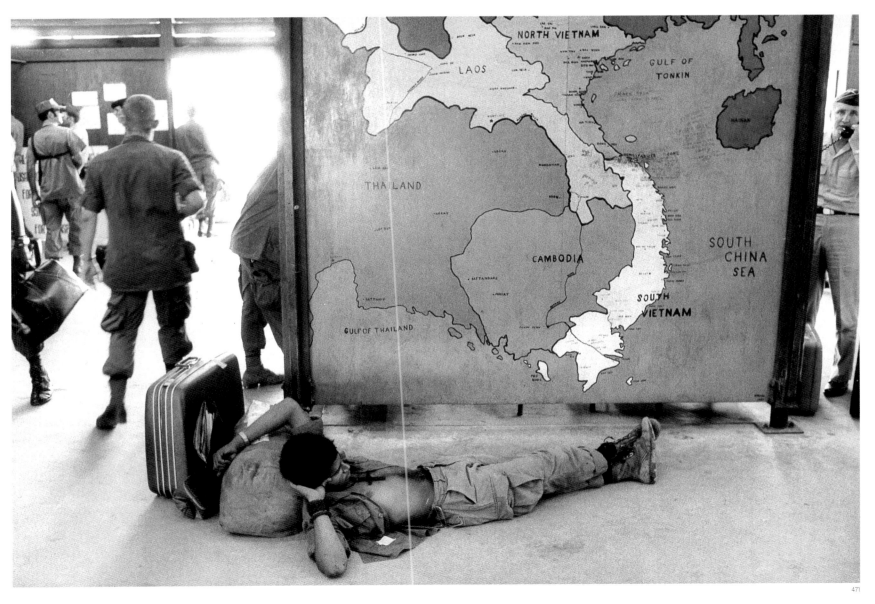

472. Anti–Vietnam War leader Abbie Hoffman (behind the microphones) and other members of the "Chicago Conspiracy" at a May Day rally in support of the liberation of Black Panther leader Bobby Seale, New York City, 1 May 1970. The legal defense of African American political radicals such as Bobby Seale, Angela Davis, and others had broad support within the predominantly white antiwar movement. White antiwar and counter-culture activists helped to organize and participated in rallies throughout the United States to raise funds and political support for Seale and others they described as political prisoners. Both Seale and Abbie Hoffman had participated in antiwar demonstrations at the 1968 Democratic National Convention in Chicago. The police actions against the demonstrators led to a widely publicized, controversial trial on the grounds that Seale, Hoffman, and other antiwar activists had conspired to provoke violence at the convention.

473. Artie Seale (center), wife of Black Panther chairman Bobby Seale, at a May-Day rally in New Haven, Connecticut, 1 May 1970. Although many histories of the Black Panther Party focus on prominent personalities such as Huey P. Newton, Bobby Seale, and Eldridge Cleaver, many of the core activists within the organization were women. Leaders such as Elaine Brown and Kathleen Cleaver were instrumental in making the Black Panther Party a successful organization. Women were important in maintaining several of the party's most popular projects, such as the children's breakfast program.

472

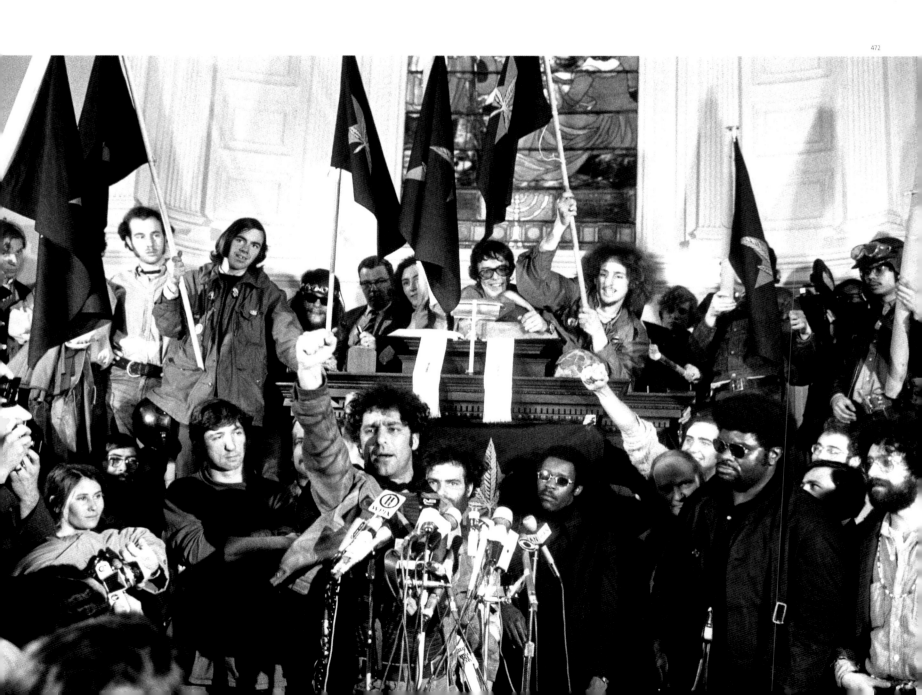

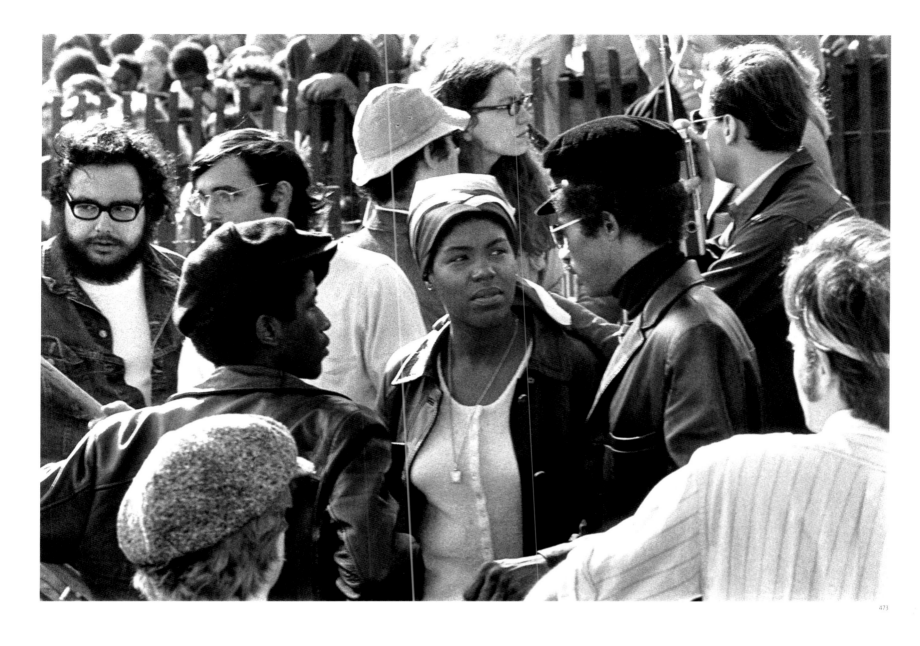

473

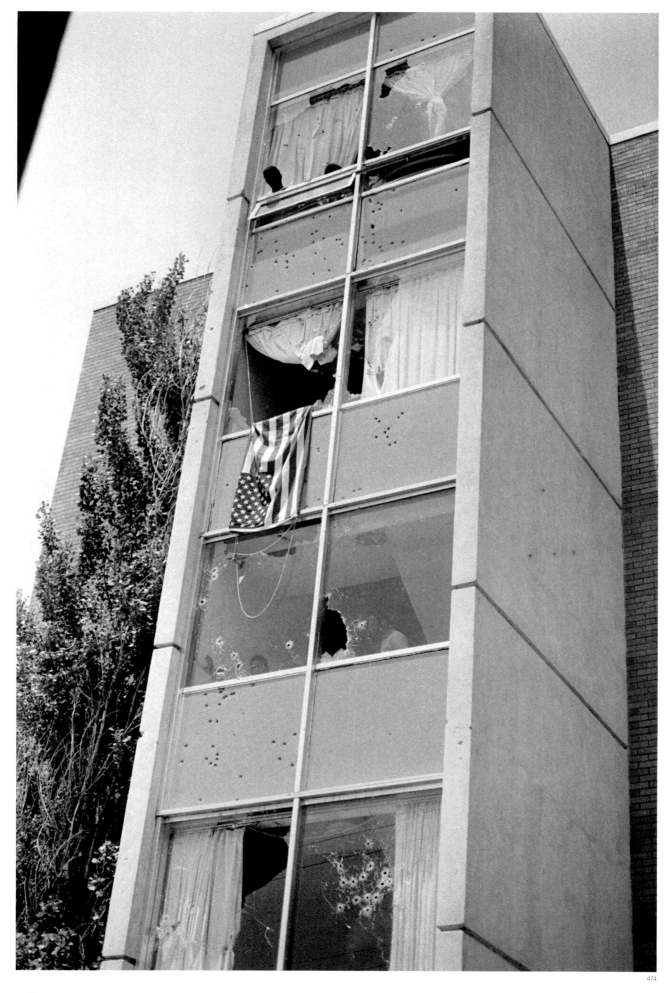

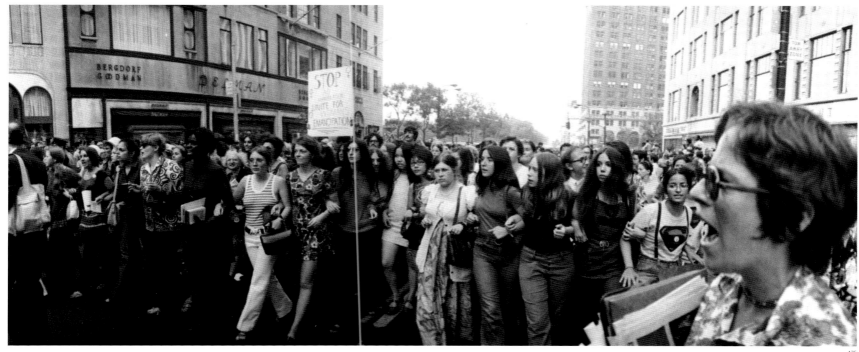

475

474. Dormitory building riddled with bullets at Jackson State College in Mississippi, 15 May 1970. On the evening of 14 May 1970, responding to student demonstrations reported at Jackson State University, a historically black college, the Mississippi state police cordoned off a thirty-block area around the campus. Approximately one hundred students congregated in front of a men's dormitory building and were confronted by police and state troopers. Although accounts differ, at about 12:05 A.M. on 15 May, the police opened fire on the unarmed students. Two were killed and twelve others were wounded. A subsequent FBI investigation found that at least 450 rounds of police ammunition had struck the dormitory building, destroying every window facing the street. In 1970 the President's Commission on Campus Unrest held hearings on the shootings at the Jackson State campus. There were no arrests.

475. Women's Strike for Equality, New York City, 26 August 1970. There has been a long historical relationship between the black liberation struggle and the movement for women's equality in the United States. Frederick Douglass, W. E. B. Du Bois, Frances Ellen Watkins Harper, Anna Julia Cooper, and Claudia Jones were staunch advocates of political suffrage and other legal rights for women. Although many prominent white women who advocated suffrage in the nineteenth century, such as Susan B. Anthony, were generally anti-racist, others such as Cary Chapman Catt and Elizabeth Cady Stanton used racist arguments to advance their goal of women's suffrage. In the 1950s and 1960s, the civil rights movement provided a pattern of popular resistance that influenced the activities of other reform movements, including women's rights. This demonstration commemorated the fiftieth anniversary of the ratification of the Nineteenth Amendment, which gave women the right to vote. A year later, Congress officially recognized 26 August as Women's Equality Day.

476. Bobby Seale in New Haven, Connecticut, freed after having served twenty-one months in prison, 28 May 1971. The release of Bobby Seale was an important victory for the Black Panther Party. In 1973 Seale ran for mayor of Oakland, California, winning a surprising 43 percent of the vote, which indicated the widespread degree of popular support the Panthers still retained in black communities. But by 1970 the FBI had sown serious divisions and rivalries within the organization. Cleaver was expelled from the party's central committee, and Seale resigned his chairman position in 1974. Through the remainder of the 1970s Elaine Brown assumed the leadership of the party, but by the early 1980s it had ceased to function. Huey Newton experienced a series of personal difficulties, and was arrested for embezzlement in 1989. That same year he was killed in a drug-related incident.

477. Demonstration for Angela Davis, New York City, 1970.

478. Angela Davis at pre-trial hearings, San Rafael, California, 15 June 1971. Through her prisoners' rights' work, Davis became friends with incarcerated prisoners' rights leader George Jackson and his brother, Jonathan. In 1970, as Jonathan attempted to free another prisoner by taking hostages at a Marin County, California courthouse, he and three other people were killed. Authorities determined that the guns Jackson had used were registered in Davis' name. Although she was not at the courthouse, Davis was charged with conspiracy, kidnapping, and murder. She was placed on the FBI's "Ten Most Wanted List," the third woman in U. S. history to be so designated. Davis went underground, but was arrested and returned to California to stand trial. She spent sixteen months in prison. The Communist Party and other political organizations initiated a "Free Angela Davis" protest movement that gained broad support in the U. S. and internationally.

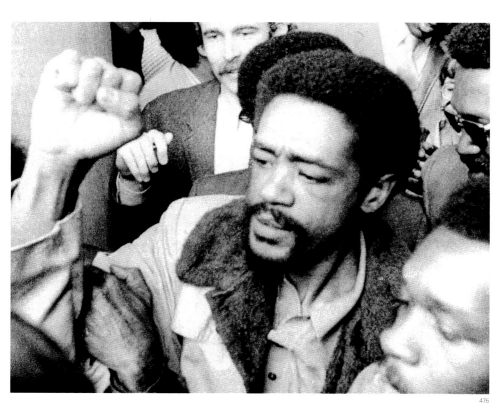

476

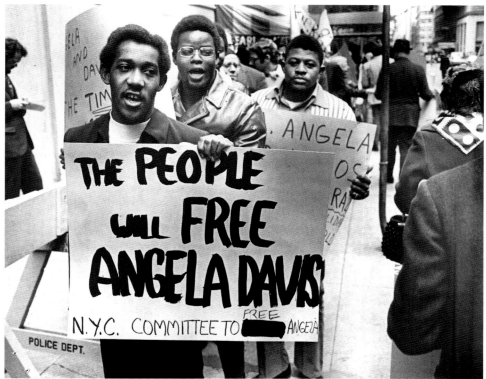

477

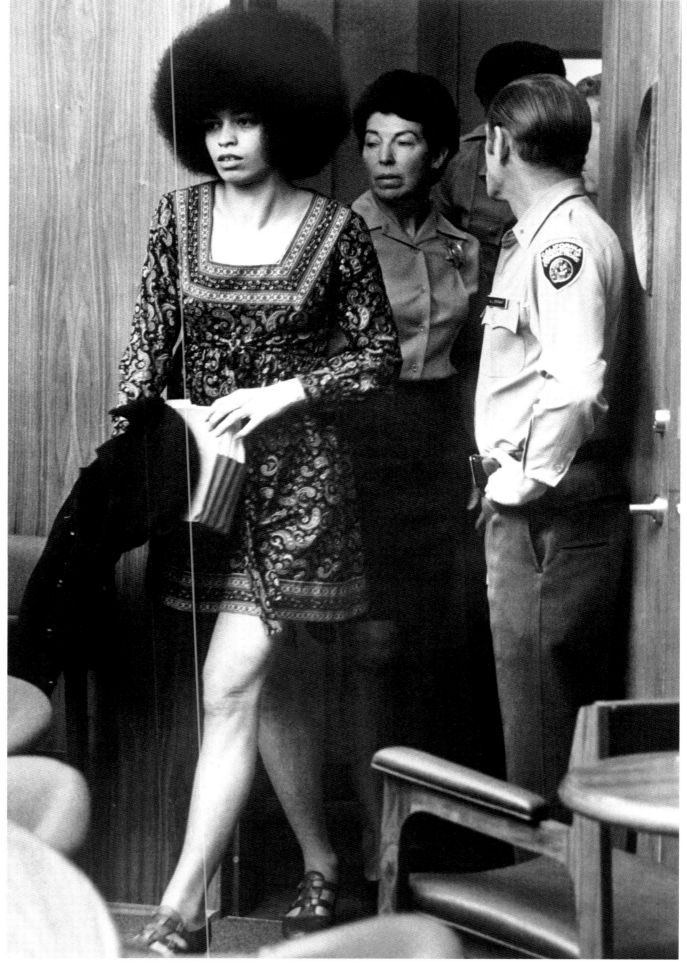

479–480. Attica State Prison inmates during the negotiation with New York prison boss Commissioner Russell Oswald, 10 September 1971. On 9 September 1971, prisoners at the Attica State prison in upstate New York seized control of the exercise yard and held prison guards hostage. Within minutes the prisoners secured control of the prison. The demands of the 1,300 prisoners included an end to all censorship of reading material, greater availability of health care and recreational facilities, the expansion of educational programs, and greater religious freedom. After several days of negotiation, New York Governor Nelson Rockefeller ordered State Troopers to storm the prison. Thirty-nine people were killed by the State Troopers — twenty-nine prisoners and ten prison guards who had been held hostage. Once the prison was under control, guards and state police brutalized hundreds of inmates, forcing some to crawl naked over broken glass. One prisoner was raped with a screwdriver. For decades police and state officials refused to accept responsibility for the deaths of the prison guards, but autopsies subsequently proved that the prisoners had not killed the hostages. In 2000, approximately five-hundred inmates and their relatives reached a settlement agreement with the State of New York, amounting to twelve million dollars in damages.

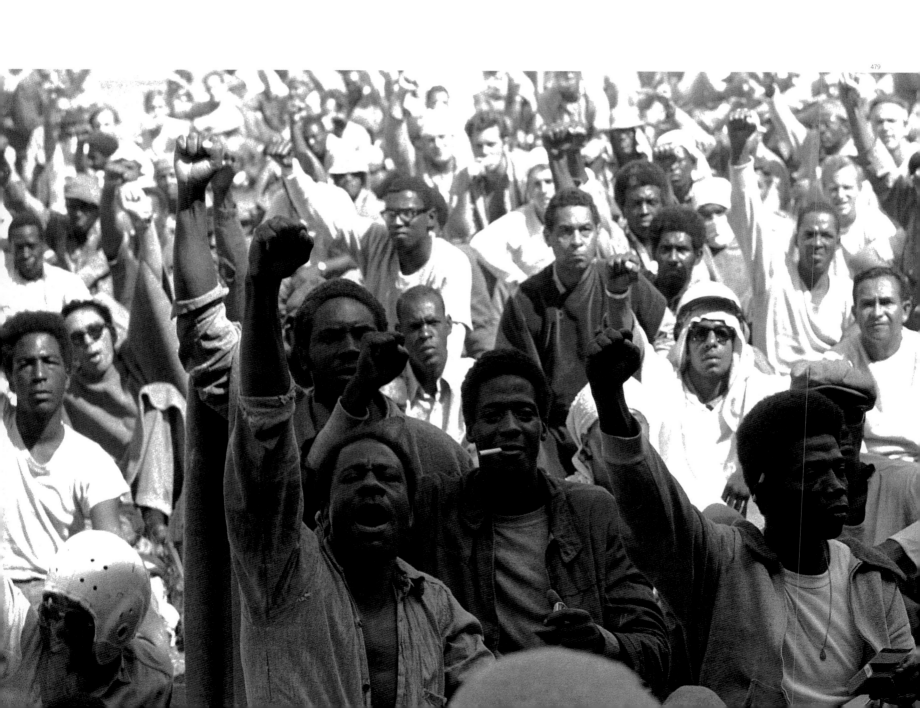

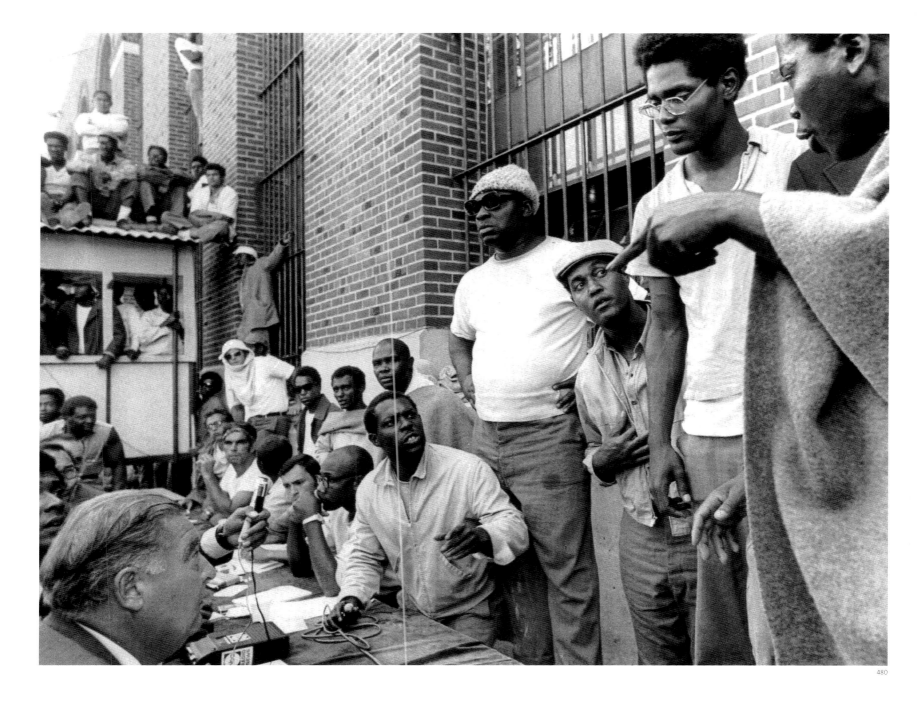

480

445

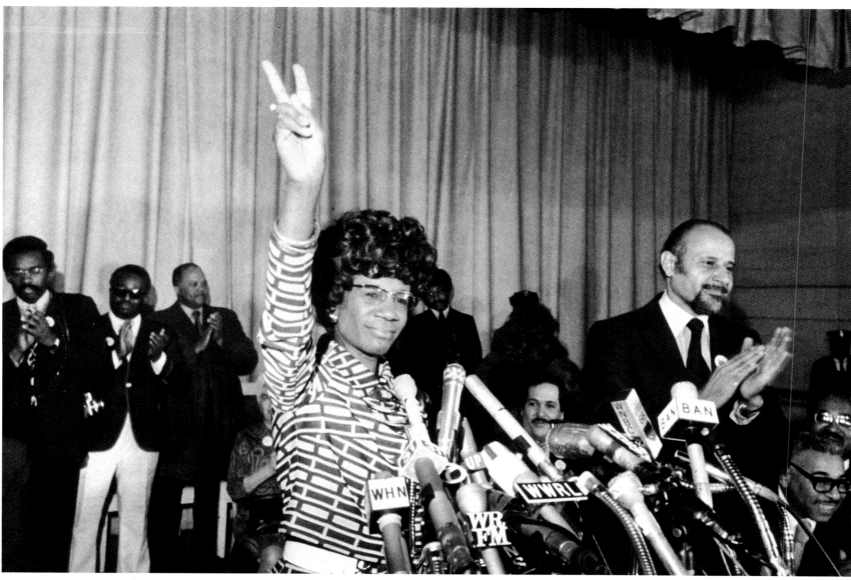

481. U. S. Representative Shirley Chisholm announces her candidacy for Democratic nomination for the presidency, Brooklyn, New York City, 25 January 1972. Born in 1924, Chisholm received a bachelor's degree from Brooklyn College in 1946 and a master's degree from Columbia University in 1952. In 1964, she was elected to the New York State Assembly from Brooklyn. Four years later, she successfully ran for Congress and became the first black women to sit in the House of Representatives. In 1972 she declared her candidacy for the Democratic presidential nomination. Although her campaign was unsuccessful, Chisholm helped to establish the possibility of African Americans contesting for the right to lead a major political party.

482. National Black Political Convention held in Gary, Indiana, 8–11 March 1972. In the early 1970s, African American activists began to discuss the possibility of creating an independent, all-black party or political formation. Black Arts leader Amiri Baraka, Detroit Congressman Charles Diggs, and the newly elected mayor of Gary, Indiana, Richard Hatcher, were particularly instrumental in planning a national convention to discuss the establishment of a new black political movement. On 8–11 March 1972 about three-thousand official delegates and more than six-thousand observers participated in the Gary Black Convention, which was the largest organized conference of political activists during the Black Power period. The basic document of the Convention, the Black

Agenda, was one of the most important political documents produced in the history of the black freedom movement. The Black Agenda's preamble states: "We come to Gary in an hour of great crisis and tremendous promise for Black America. While the white nation hovers on the brink of chaos, while its politicians offer no hope of real change, we stand on the edge of history and are faced with an amazing and frightening choice: We may choose in 1972 to slip back into the decadent white politics of American life: or we may press forward, moving relentlessly from Gary to the creation of our own black life. The choice is large, but the time is very short. . . ."

483. Angela Davis with Henry Winston, national chairman of the Communist Party, USA at "An Evening with Angela Davis" benefit at Madison Square Garden, New York City, 29 June 1972. Angela Davis was acquitted of all charges in 1972. The "Free Angela" movement went on to provide the foundation for the National Alliance Against Racist and Political Repression, which was active in working for the legal rights and civil liberties of a number of political prisoners, most prominently Reverend Benjamin Chavis. In 1980 and 1984, Davis ran for vice president on the Communist Party ticket. In 1981, with the publication of her book, *Women, Race and Class*, Davis produced a major theoretical statement that helped to define the contours of what would become known as black

feminist thought. She is currently professor in the History of Consciousness Department of the University of California at Santa Cruz. She resigned from the Communist Party in 1992 and continues to work actively on behalf of prisoners' rights and other social justice causes.

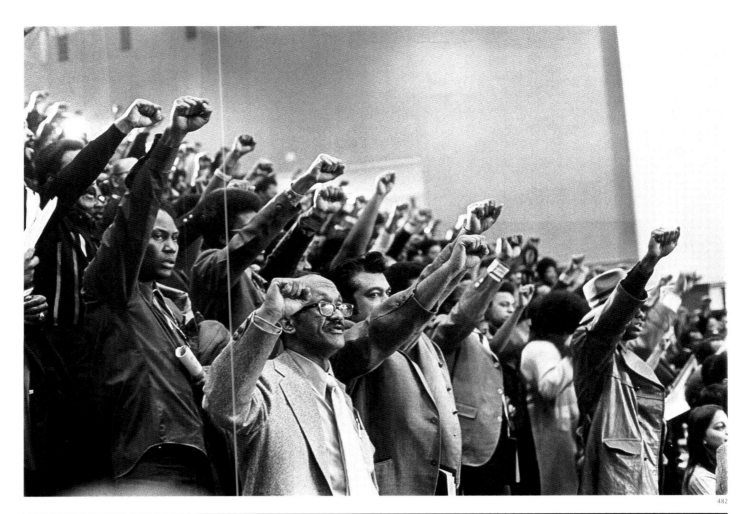

482

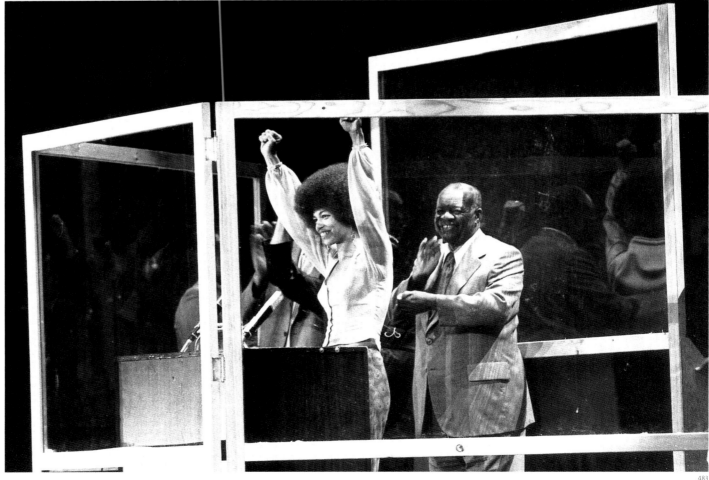

483

484. Congresswoman Barbara Jordan delivering her opening remarks at the House Judiciary Committee's impeachment hearing for President Richard Nixon, 25 July 1974. Because they themselves had, for centuries, been denied basic civil rights, African Americans were often the vanguard in defending constitutional rights. Born in 1936 in Houston, Texas, Barbara Jordan graduated magna cum laude from Texas Southern University in 1956 and received her law degree at Boston University in 1959. In 1966 she was elected to the Texas State Senate, becoming the state's first black senator since 1883. In 1972 she was elected to the U. S. Congress and became a member of the House Judiciary Committee. She came to national attention during Nixon's impeachment hearing following the Watergate scandal. Jordan became an influential leader in the Democratic Party, but, in the 1970s, she suffered from a neurological impairment that soon confined her to a wheelchair, and brought an end to her political career. She died on 17 January 1996 in Austin, Texas.

485. George Wallace, governor of Alabama, congratulating Terry Points, newly elected Homecoming Queen of the University of Alabama, 16 November 1973.

486. Muhammad Ali after his victory in the world heavyweight title fight in Kinshasa, Zaire (now Democratic Republic of Congo), 31 October 1974. (A photo of President Mobutu is in the background.) Ali's conviction for draft evasion was overturned in 1971 by the U. S. Supreme Court. In March he lost a 15-round decision to then Heavyweight Champion Joe Frazier, but defeated him three years later in January 1974. On 30 October 1974, Ali stunned the world by defeating Heavyweight Champion George Foreman in the eighth round of a highly publicized boxing match staged in Kinshasa. For many, his victory represented the triumph of an individual who had sacrificed fame and material prosperity for his opposition to the Vietnam War. Ali retired in 1981 and fell victim to Parkinson's disease. Once a political outcast, Ali has now become a popular cultural icon.

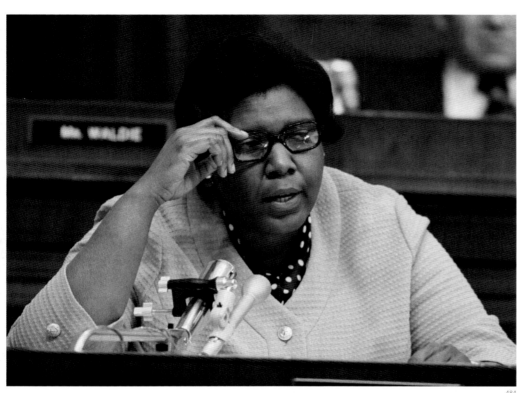

484

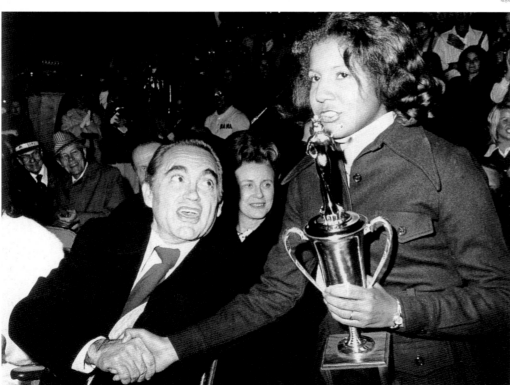

485

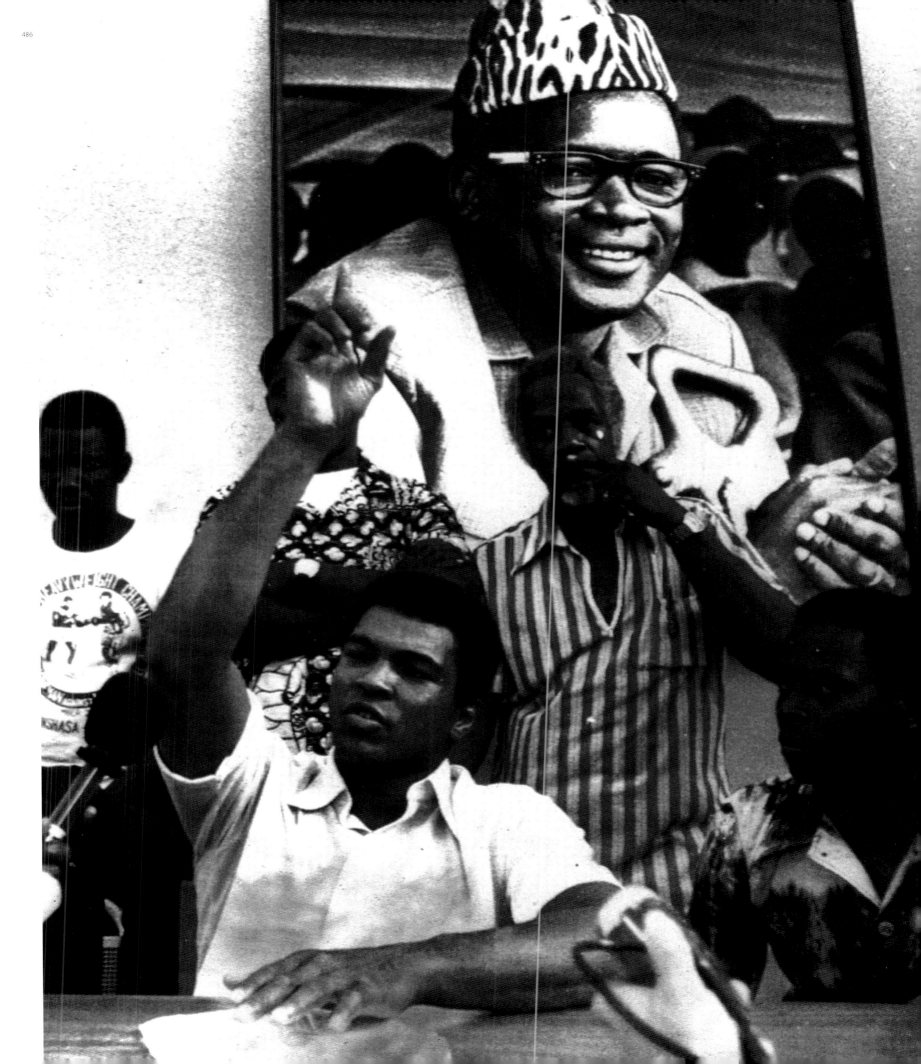

1975

PRESENT

"I was born in the slum, but the slum was not born in me. And it wasn't born in you, and you can make it. Wherever you are tonight you can make it.... It gets dark sometimes, but the morning comes. Don't you surrender. Suffering breeds character. Character breeds faith. In the end faith will not disappoint.... Keep hope alive. Keep hope alive."
— Jesse Jackson, at the Democratic National Convention in Atlanta, 20 July 1988

For the thirty million African Americans who lived in the United States in 1990, the events that had transpired in the previous thirty-six years since the *Brown v. Board of Education* decision had significantly transformed American democracy. Only a generation before, blacks had been all but invisible in government; now they ran many of America's major cities, held more than thirty congressional seats, and would soon hold more than ten thousand elective offices throughout the nation. A generation earlier, African Americans experienced the daily humiliations of being forced to the back of the bus, of not being permitted to have access to public toilets, of not being allowed to try on clothing before purchasing it at retail stores. No one who was middle-age and older could ever forget the "colored" and "white" signs that had been a constant reminder of their subordinate status. Once forbidden to read and write, African Americans had in the past half-century produced some of America's most gifted writers, poets, and playwrights: James Baldwin, Alice Walker, Toni Morrison, Ralph Ellison, Amiri Baraka, August Wilson, Lorraine Hansberry, and John A. Williams. A generation earlier, almost no blacks were professors at major research universities; by 1990 many of the country's most prominent public intellectuals and scholars at major universities were African Americans, such as Henry Louis Gates, Jr., Cornel West, William Julius Wilson, Patricia Williams, and Lani Guinier. The music, clothing, and aesthetics of black popular culture, once marginalized, had exploded into a multibillion-dollar commercial empire, influencing nearly every other society. Not long before, blacks had been segregated in the nation's armed forces; now the head of the Joint Chiefs of Staff, General Colin Powell, was an African American. So much distance had been traveled in such a short time toward the goal of freedom, yet, for all these accomplishments, black Americans knew and still know that the struggle is not yet over, and that new obstacles still have to be overcome.

The vast changes in the global economy in the last decades of the twentieth century have had a profound impact on the social character of black America. In 1970, for example, as a result of the gains of the civil rights movement, nearly 40 percent of all black workers were employed in blue collar jobs, with millions of them in heavy industry such as steel, automobile production, electrical and non-electrical machinery, appliances, food and tobacco manufacturing, and textiles. Hundreds of thousands of

blacks were also employed in the energy industry and in the food processing industry. Millions of these jobs were located in the industrial and manufacturing centers of the Northeast and Midwest, in urban areas with high percentages of African Americans, which were the first casualties for what economists soon described as "deindustrialization." Between 1973 and 1980, over four million jobs disappeared in the United States when American companies moved their operations outside the country. New York City alone lost 40,000 to 50,000 jobs in the apparel and textile industries. Corporations increasingly divested their profits from U. S.–based subsidiaries and reinvested in operations abroad. In the 1970s, over thirty million total jobs were eliminated through factory closings, relocations, and the phased elimination of operations. The shrinking of U. S.–based industries had a deep impact on labor unions, as the percentage of union members within the American labor force decreased by half in only two decades. Hardest hit were African American blue-collar workers, because in 1983, over 27 percent of all blacks in the U. S. labor force were union members.

The erosion of the public sector and the loss of millions of urban jobs contributed to a profound increase in class stratification within the national black community. In 1970, about two-thirds of all blacks over the age of fourteen in the paid labor force were blue-collar workers, farm workers, or service workers. Twenty-four percent of all African Americans were classified as white-collar employees. However, about six out of ten white-collar employees were clerical and sales workers. The number of blacks who worked in managerial and administrative positions was relatively small. The black business sector was also modest. In 1972, according to the U. S. Census Bureau, there was a total of only 24,509 black-owned and operated businesses in the entire country. Collectively, they employed less than 150,000 people. Two-thirds of all black businesses employed four workers or less. The vast majority of black businesses were confined to personal services, retail trade establishments, and automobile dealerships. Most were undercapitalized at the outset, due in part to discriminatory policies by banks. The African American community was overwhelmingly working class in composition in the 1970s. By the late 1990s, the socio-economic profile of black America had changed considerably. About 51 percent of all black employees sixteen years old and over were classified as white-collar workers. Approximately 60 percent of these were white-collar sales and clerical personnel; many in this group were non-union workers with limited benefits and wages. However, another 20 percent of the black labor force, nearly three million workers, were classified as professional and technical workers and administrators. The percentage of blue-collar workers had declined to 28 percent of the black labor force. Black farm laborers, farmers, and agricultural managers, who in 1940 had represented one-third of the entire black workforce, had virtually disappeared, with only about 80,000 jobs remaining. During this period, the black business sector had mushroomed.

By 1992, the number of black-owned businesses had grown to 621,000, with annual gross receipts of $32.2 billion, and with nearly 350,000 employees. The number of black-owned real estate, insurance, and financial lending companies had quadrupled in only fifteen years, and this sector's total gross receipts had increased six-fold. A small number of African American executives by the late 1990s had become chief executive officers and presidents of major corporations, such as AOL Time Warner and American Express. An even smaller number of black celebrities — superstar athletes such as Michael Jordan and Ervin "Magic" Johnson, and television personalities such as Oprah Winfrey and Bill Cosby, and pop star Michael Jackson — were each worth hundreds of millions of dollars. For the first time in U. S. history, a "black bourgeoisie" had come to exist.

The deindustrialization of many U. S. cities had serious consequences for the African American population. Deprived of their tax revenues from industries and manufacturing companies, city governments reduced expenditures for public institutions of all kinds — schools, hospitals, parks, libraries, public universities, and public housing. With the election of Ronald Reagan as president in 1980, the new conservative administration quickly moved to reduce federal government spending on urban development and social services. The Reagan Administration terminated the Comprehensive Employment and Training Act program, a successful job training program that had been funded in 1982 at $3.1 billion; eliminated $2 billion from the federal food stamps program; reduced federal support for child nutrition programs by $1.7 billion over a two-year period; and closed down the Neighborhood Self Help and Planning Assistance programs which provided technical and financial help to inner cities. In the first year of the Reagan Administration, the real median income of all black families fell by 5.2 percent. The number of Americans living below the federal government's poverty line grew by over two million in a single year. In 1982, over 30 percent of the total black labor force was jobless at some period during that year. In June 1982, Congress reduced federal assistance programs by 20 percent and cut federal assistance to state and municipal governments.

Beginning in the 1980s, a strong white backlash to the civil rights movement expressed itself in opposition to school desegregation in the North, hostility to increased integration in higher education and professional occupations through affirmative action programs, and resurgence of racist violence. The Ku Klux Klan and other white supremacist groups initiated national campaigns of terror, drive-by shootings of African Americans, and firebombings of black churches and residential areas. Millions of white Americans had become convinced that "too much" had been given to blacks in recent years. Middle-class African Americans also encountered more subtle, yet unmistakable, patterns of racial discrimination that severely restricted their upward mobility. Sociologist Larry Bobo has described this racial ceiling on group advancement as "laissez

faire racism." The examples today, which have been documented by numerous studies, are almost endless: white car dealerships that charge blacks hundreds of dollars more for automobiles than they do whites; hospitals that routinely provide substandard treatment for minorities; insurance companies that systematically charge black consumers higher rates than whites to insure homes of identical market value; grocery store chains that transport older produce from white suburban shopping-mall markets to groceries in predominantly black communities; the denial of employment opportunities at senior levels of management and administration in large companies and institutions.

By the 1990s, one could identify three overlapping sectors within America's social order: a black professional, or managerial middle class that, in part as a result of the anti-discrimination legislation such as affirmative action and minority economic set aside programs introduced as a result of the civil rights movement, had attained some remarkable successes; a blue-collar working class that had been steadily losing ground; and the group that sociologist William Julius Wilson described in 1987 as "the truly disadvantaged" — the millions of African Americans who could not find jobs, could only find part-time jobs, or had jobs that did not pay enough to sustain households. The traditional bonds of "linked fates" which provided a sense of cohesion and cultural continuity across class and social divisions had become weaker, as, reflecting trends in the rest of the world, stratification increased in the black community. Many middle-class blacks, confronted with the steady deterioration of public services, schools, and the elimination of jobs in central cities, relocated to the suburbs. However, because white real estate firms, banks, and financial lending institutions continued informal policies of residential discrimination, many upper- to middle-income blacks found themselves moving from segregated ghettoes to racially segregated suburbs or planned communities. Black working-class families without the material resources or credit to purchase homes outside economically depressed areas found themselves living in what, at times, had become almost urban wastelands.

In huge districts of America's major cities, neighborhoods had become desperately poor — Chicago's South Side, East New York in Brooklyn, the South Bronx, South Central Los Angeles, East Oakland, and nearly all of Detroit. Families attempting to upgrade their residences or start businesses in these neighborhoods were forced to rely on "predatory lenders," finance companies charging outrageously high interest rates on borrowed money. In such inner city communities, businesses of nearly every type, other than personal services such as restaurants, barber shops, beauty salons, and funeral homes, largely disappeared. In some inner cities in the 1990s, between 30 to 45 percent of a neighborhood's total adult population was no longer in the paid labor force. Millions survived in the informal economy, generating a subsistence income

through activities as diverse as braiding hair, childcare, collecting and selling recyclable bottles and cans, catering food, auto repair, moving, producing and selling crafts, etc. For many who had once held stable blue-color jobs, low-wage service jobs, such as in the fast-food industry, were among the few alternatives. Ironically, some fast-food restaurants in ghettoes refused to hire local residents because employers feared that they would give away food to unemployed and low-income relatives and friends.

Poverty, as Gandhi observed, is the worst form of violence. Such widespread poverty, such intense patterns of hunger and homelessness, fostered a new form of social devastation: trafficking in illegal drugs. In the early 1980s, a new addictive product, "crack," a rock-type of cocaine, was introduced into inner-city neighborhoods. Unlike powdered cocaine, the fashionable drug of choice of the wealthy, crack was very inexpensive, readily available, and highly addictive. Within a few years, several hundred thousand African Americans had become addicted to crack, and relatively few drug treatment centers were available. With the decline in employment and educational opportunities, some young people saw selling drugs as the only way to make a decent income, and violence, once relatively rare in black working-class communities, increased significantly. By 1989, federal authorities estimated that the domestic illegal drug economy was worth $150 billion. However, although several inner-city communities became the marketplace for the lucrative international traffic in illegal substances, the overwhelming bulk of the profits were reaped by those outside these communities, such as international criminal cartels and the banks that launder their money. Inner-city communities became the targets of police sweeps and searches. Many community residents found themselves caught between a desire to rid their neighborhoods of the plague of drugs and violence, on one hand, and what was often seen as indiscriminate violence by the police, on the other. Though a small minority of young men were actively involved in criminal activities connected with the drug traffic, virtually all black male youth were subject to being stigmatized as criminals by the police and media. Young black men particularly were subjected to racial profiling: routine searches without any probable cause except the color of their skin. A series of highly publicized cases of excessive use of force by the police, sometimes leading to the death of innocent victims, in New York City, Los Angeles, Miami, and Cincinnati, generated mass protest mobilizations.

The federal and state governments responded to the increased levels of criminal violence by making the penalties for drug sale and possession more severe, by eliminating parole, and by constructing a vast network of new prisons. Legislatures passed new mandatory minimum sentencing laws, requiring convicted felons to serve lengthy prison terms before becoming eligible for release. Juveniles were increasingly treated as adults, and were subjected to many of the same penalties. Developments in New York State during these years were typical of what occurred throughout the nation. Between 1817 and 1981, the state had constructed thirty-three prisons; between 1981 and 1999, it built thirty-eight new correctional facilities. New York's prison population grew in two decades from 13,500 to 74,000. Between 1988 and 1998, the state increased the budget of the Department of Correctional Services by $761 million. During that same period, support to public higher education decreased by roughly the same amount. Throughout the country, the total population of prisoners reached 650,000 in 1983, one million in 1990, and two million by 2001. One-half of these prisoners were African Americans. By 2000, one-third of all young black males in their twenties were under the control of the criminal justice system — either in prison or jail, on parole, probation, or awaiting trial. The major reason for this disproportion in incarceration is the stark racism that continues to pervade the criminal justice system. Studies have found that blacks and whites use illegal drugs at roughly the same rate. But though African Americans constitute approximately 14 percent of all illegal drug users, they comprise approximately one-third of all drug arrests and over 50 percent of all drug convictions in federal and state courts. Hundreds of thousands of these prisoners are nonviolent drug offenders, picked up by police because they were addicts or petty street dealers. The socio-economic and political consequences of mass incarceration for the black community have been profound. Hundreds of thousands of households have been destroyed; thousands of children separated from their parents and raised in foster care. In ten states, convicted felons lose the right to vote for life, and as a result, by 2000 over 1.4 million African Americans had been permanently disenfranchised. For several million blacks with criminal records, most better paying jobs were no longer available even years after their release and rehabilitation. Given the widespread unemployment, high rates of incarceration, and the lower life expectancy of black men, more and more black women found themselves in the position of having to raise children alone. Because black women historically have been the lowest paid workers, with the highest rates of unemployment, some have been forced to depend on government subsidies to supplement their incomes, often from informal sources of work. In 1996, President Bill Clinton signed into law the Personal Responsibility and Work Opportunity Reconciliation Act, which severely limited government assistance to families. In the absence of guaranteed employment at wage rates that would allow households to subsist, women and children became increasingly vulnerable.

By the mid-1980s, many of these conditions had created the basis for a renewed commitment to collective action. Several hundred thousand low-wage black and Latino workers have become active in union organizing efforts in recent years, as the AFL–CIO was pressured to organize the unorganized. In Chicago, Congressman Harold Washington led a city-wide coalition of blacks, Latinos, trade unionists, liberals, and Jewish voters

to become the city's first black mayor in 1983. A remarkable 80 percent of Chicago's black electorate turned out to vote on election day to achieve Washington's victory. In national politics, Reverend Jesse Jackson led the "Rainbow Coalition" in two successive presidential campaigns in 1984 and 1988, with the goals of promoting massive voter registration outreach in black and Latino neighborhoods and exerting a more liberal influence on the Democratic Party's politics. Jackson did not win the Democratic presidential nomination in either years, but his campaigns accomplished important goals: one million new black voters registered, and a stronger progressive political relationship developed between the black electorate and other minority groups, culminating in the subsequent elections of thousands of new minority officials in federal, state, and local races during the late 1980s and 1990s.

In the effort to combat the serious consequences of rising unemployment, deteriorating public services, and the epidemic of drugs and violence, thousands of local community-based groups initiated programs to promote neighborhood development. Faith-based institutions and voluntary associations promote anti-violence and anti-drug campaigns in schools, neighborhood centers, and in the media. Under the leadership of organizations as divergent as the NAACP and the Nation of Islam, gang summits were held in a number of cities, promoting the peaceful resolution of social conflict. Local campaigns were initiated to curtail the extensive advertisement and sale of alcohol, tobacco, and guns in black communities. Churches, mosques, fraternal organizations, and civic groups started after-school programs focusing on black youth, sponsoring athletic and cultural events. Civil rights groups such as Jesse Jackson's People United to Serve Humanity (PUSH) established "corporate covenants" with major corporations that pledged to develop minority-owned businesses and to contribute funds to nonprofit organizations involved in community development. A number of influential new movements were also initiated around the theme of gender. In universities as well as in community organizations in the 1980s, black women produced an impressive body of cultural and social criticism, "black feminist thought," that raised challenging new questions about the connections between race, gender, sexuality, and class. Black women's groups, like the Combahee River Collective, developed political perspectives and activities focusing on the special disadvantages and oppression of black women. In the political sphere, a group of energetic and committed black women leaders were elected to Congress, such as Maxine Waters and Barbara Lee from California, Cynthia McKinney from Georgia, and Sheila Jackson Lee from Texas. In working-class and economically oppressed neighborhoods, African American women largely organized and led grassroots mobilizations to improve the quality of local public schools, restore cuts in public funding for health services, check the use of excessive force and racist behavior by law enforcement officers, and promote reproductive rights and measures to reduce disparities in black women's healthcare.

This period witnessed another renaissance in black culture: "hip hop." Created in the context of poverty, high unemployment, and the drug epidemic in inner cities, hip hop culture evolved around new artistic styles created by young people in music, dancing, and street art –– graffiti. Although the lyrics in hip hop music were often misogynistic and celebrated violence, many musicians constructed their creative work around progressive political themes. "Old school" hip hop groups in the 1980s, like Grandmaster Flash and the Furious Five and Melle Mel, rapped against police brutality, unemployment, and drugs. Progressive artists such as Public Enemy, KRS One, a Tribe Called Quest and Mos Def spoke about AIDS/HIV awareness, called for an end to black-on-black violence, encouraged voter registration, and campaigned against budget cuts in public schools. Black female rap artists such as Sister Souljah, Salt-n-Pepa, and Queen Latifah provided powerful images of self confidence and activism for millions of young African American women. Successful hip hop entrepreneur Russell Simmons, co-founder of Def Jam records, initiated campaigns to promote voting among black youth and to oppose the privatization of public schools, and a public educational effort to debate the issue of "black reparations," the question of whether African Americans should finally be compensated for centuries of enslavement and Jim Crow segregation.

At the dawn of the twenty-first century, black America had become infinitely more diverse and complex than ever before. Millions of African Americans enjoyed access and opportunities in government and business that could not have been imagined decades before, yet millions also were still mired in poverty and unemployment, attended the worst schools, and experienced political disenfranchisement as a consequence of mass incarceration. The black community's capacity for collective renewal and rebirth was still strong, yet the challenges it faced ahead were still all too real. Many of these factors explain the extensive involvement and participation of several thousand black Americans at the United Nations World Conference Against Racism, held in Durban, South Africa, in August-September 2001. Black Americans challenged their own government to declare that slavery had been a "crime against humanity," and to affirm the necessity for reparations or compensation to people of African descent for centuries of discrimination — positions that the United States rejected. The Durban conference illustrated, once again, that the social and political vision of the African American people is a global and international perspective. The struggle for racial justice, important as it has been for black Americans, is part of a much larger movement to achieve human freedom. Peace, as Martin Luther King, Jr., once observed, is not the absence of conflict, but the realization of justice. The achievement of a common humanity that can experience freedom — of thought, work, spirituality, creativity, and political expression — has been the real goal of the black struggle since our arrival on America's shore in 1619. That magnificent struggle for freedom continues.

487. A white high-school student attacking a black attorney after an anti-busing meeting in Boston, 1976. School desegregation and busing was one of the most contentious civil rights issues in the 1970s. In 1971, in the *Swann v. Mecklenburg Board of Education* decision, the Supreme Court mandated the use of busing to achieve greater integration of public schools. On 21 June 1974, U. S. District Court Judge W. Arthur Garrity, Jr. sparked a major public controversy in Boston when he ordered busing to desegregate the city's public schools. Resistance to school integration was greatest in the Irish working-class and poor district of South Boston. As blacks were bused into formerly all-white schools, the police were forced to escort black students through gauntlets of bottle and rock-throwing whites, holding signs reading: "Bus Them Back to Africa." Thousands of middle-class and affluent whites in Boston withdrew their children from public school and placed them in private academies. Between 1974 and 1985, Boston's public school enrollment dropped from 93,000 to 57,000 and the percentage of white students fell from 65 percent to 28 percent. White resistance to equal access to quality education for blacks remained strong, even several decades after the 1954 *Brown* decision.

488. Andrew Young at a U. N. Security Council meeting on the Rhodesia Resolution, October 1977. Andrew Young was one of Martin Luther King, Jr.'s key associates. Born in New Orleans on 12 March 1932, he received a divinity degree from Hartford Theological Seminary. As a leader of the Southern Christian Leadership Conference (SCLC), Young became involved in a series of desegregation campaigns throughout the South in the 1960s. In 1972 he was elected to Congress from Georgia, and in 1977 was appointed U. S. ambassador to the United Nations, but he was forced to resign two years later when the media reported that he had secretly met with a representative of the Palestine Liberation Organization. Young served as mayor of Atlanta from 1981 to 1989.

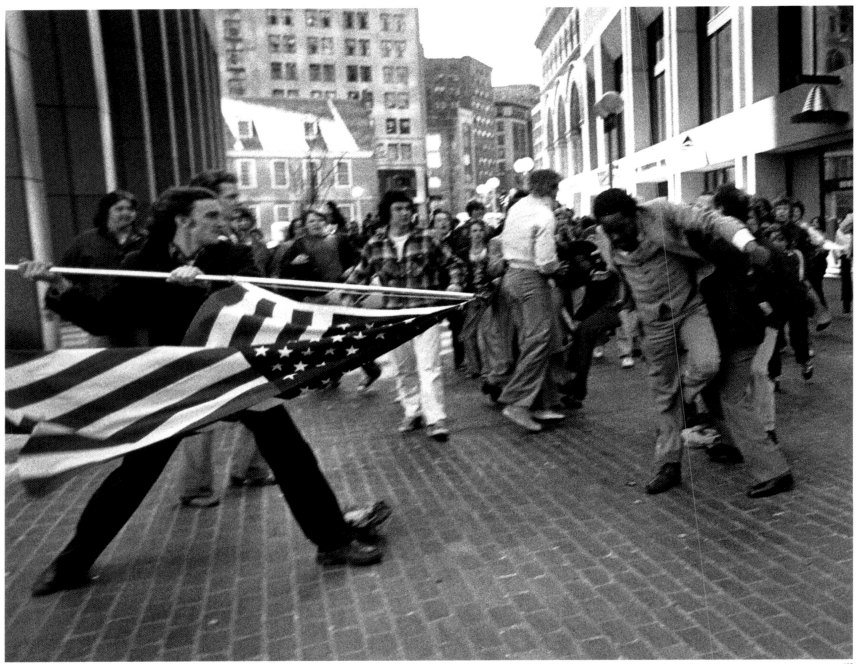

487

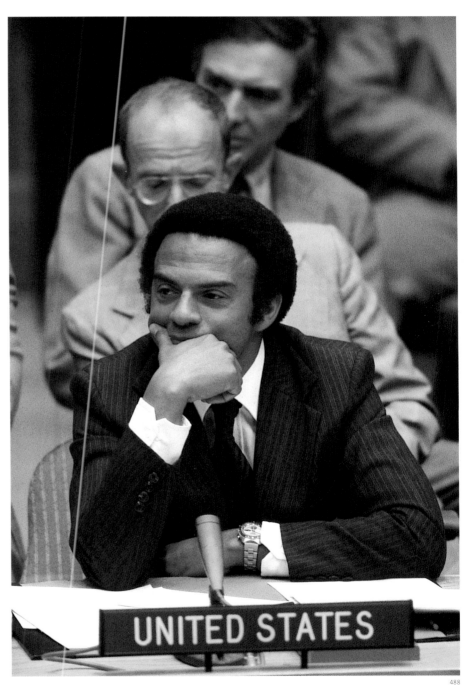

UNITED STATES

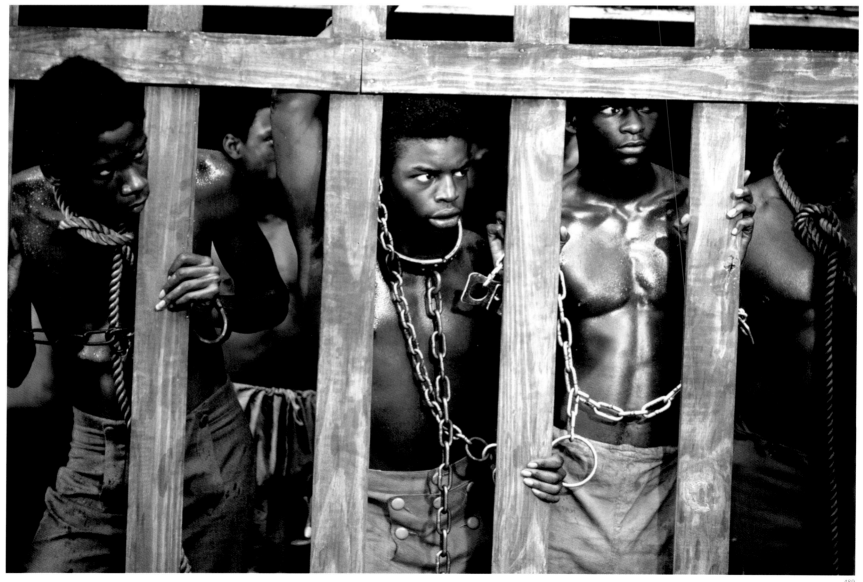

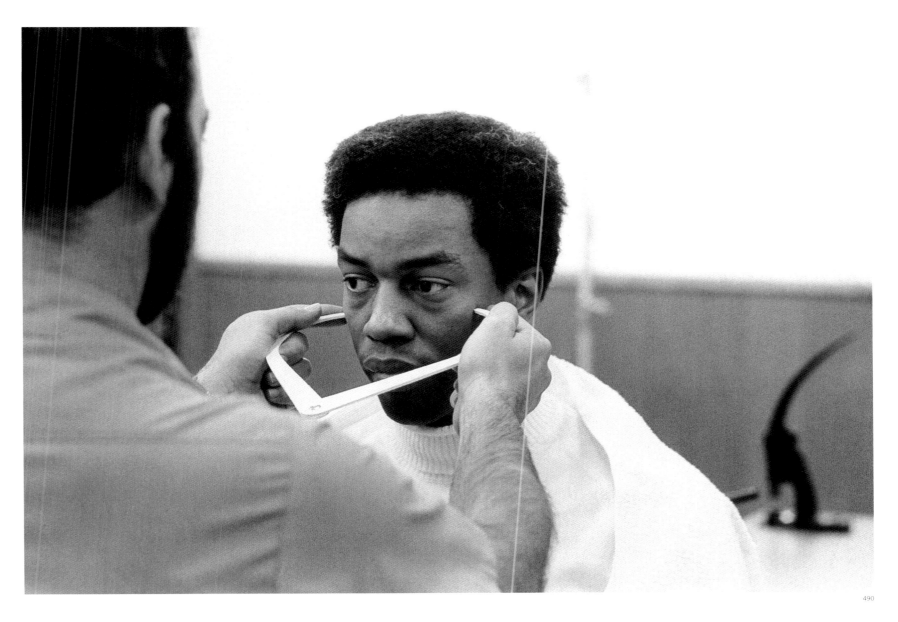

490

489. A still from the tele-
vision miniseries *Roots*, 1977.
In 1977, for the first time,
millions of Americans were
confronted with a popular
representation of the horrors
of slavery through the
twelve-hour television mini-
series *Roots*. It was based on
a book by journalist Alex
Haley, the co-author of *The
Autobiography of Malcolm X*.
For over a decade, Haley
conducted research through-

out the United States and
Africa to trace the history of
his family. He found the
names of his maternal grand-
parents while researching
the National Archives
in Washington, D. C. On the
basis of his research,
he traced his own ancestor,
Kunta Kinte, back to a West-
African village. Published in
1976, *Roots* won a Pulitzer
Prize and the National Book
award. The book and the

television series were impor-
tant in presenting an alter-
native interpretation of black
history that was at odds
with the writings of many
white historians. *Roots* dra-
matically illustrated the
atrocities of slavery, the way
in which Africans used culture
as a means of resistance,
and that black Americans did
not acquiesce to oppression
without struggle.

490. Astronaut candidate
Guion S. Bluford having his
head measured, 9 February
1978. Dr. Guion S. Bluford was
the first African American to
go into outer space. (The
first person of African descent
to go into space was Colonel
Tamayo-Mendez, a Cuban
citizen who flew on a Soviet
spacecraft in 1980.) Born in
1942, Bluford attended
Pennsylvania State University
and subsequently joined the

Air Force. He earned the
National Defense Service
Medal as a pilot while flying
144 combat missions during
the Vietnam War. After
receiving his doctorate
in aerospace engineering,
Bluford joined the NASA
space program in 1979. His
initial space-shuttle flight
in 1983 was followed by
three others. As of 2002, ten
African Americans have been
selected as astronauts.

491. Michael Donald, victim of a racist murder by the Ku Klux Klan in Mobile, Alabama, 21 March 1981. On 21 March 1981 two white members of the United Klans of America, the largest Klan organization of the 1960s and 1970s, forced nineteen-year-old Michael Donald into their car. After being kidnapped, Donald was beaten, his throat cut, and his body was hung from a tree. The FBI investigated the case and, in June 1983, Henry Hayes was convicted of murdering Donald and was sentenced to death. In 1987, an all-white jury found the Ku Klux Klan responsible for the lynching and in a civil suit sentenced the organization to pay seven million dollars to Donald's mother, Beulah Mae Donald. Hayes was executed in 1991, the first white man executed for a crime against an African American since 1913.

492. Unidentified man shouting at a member of the Ku Klux Klan, Miami, 2 January 1983.

493. Member of the Ku Klux Klan in San Jose, California, 1981.

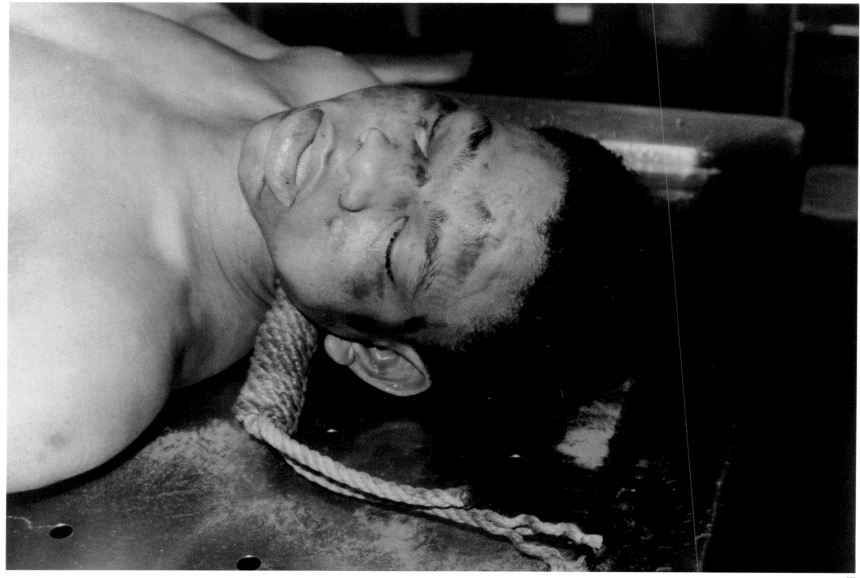

491

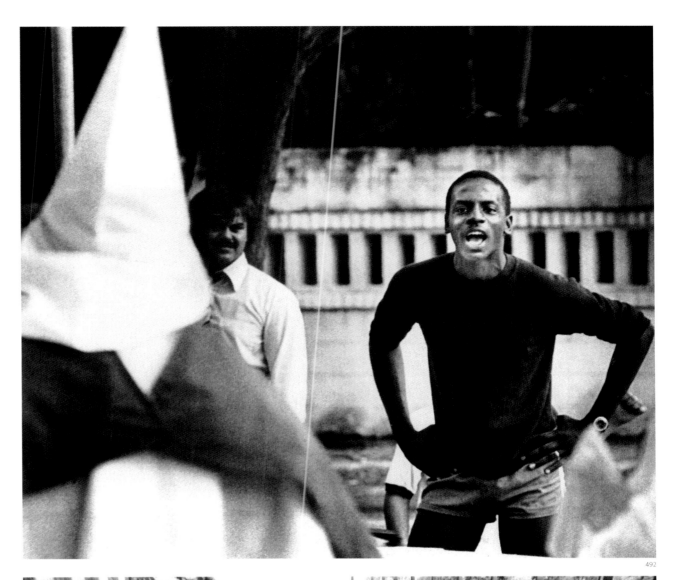

492

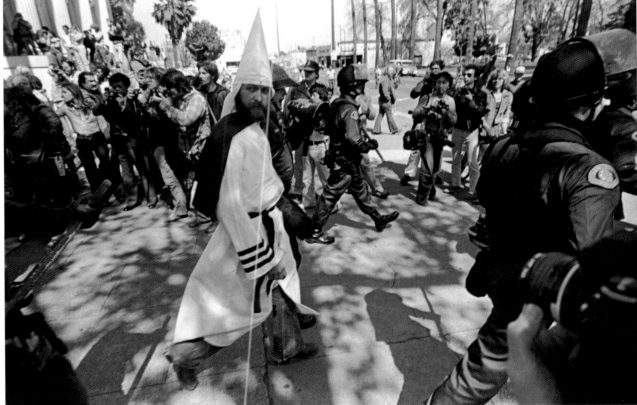

493

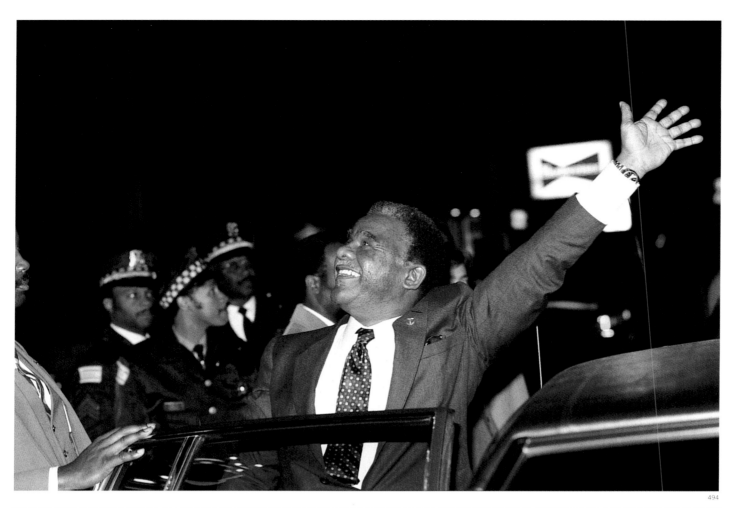

494

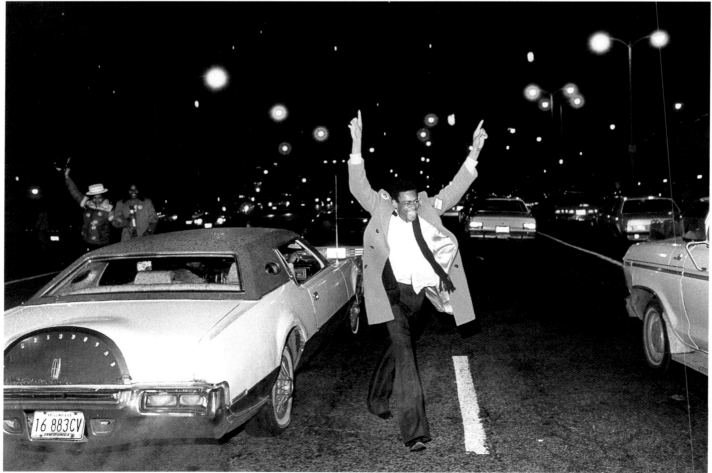

495

462

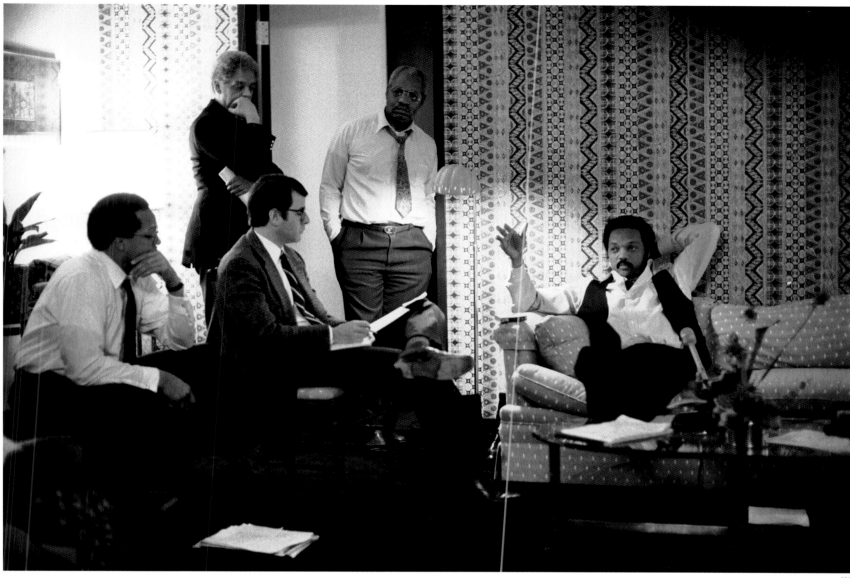

494. Harold Washington waving to the crowd on the night of his election as mayor of Chicago, Chicago's South Side, 12 April 1983. For more than fifty years the Cook County democratic machine controlled municipal government by manipulating votes and through the use of patronage and graft. Under Chicago political boss Mayor Richard Daley (from 1955 to 1976) the black community was severely disadvantaged: schools were under-funded and public services were unequally distributed. In 1980 a coalition of largely black community organizations convinced Congressman Harold Washington to challenge the Democratic machine. Born in 1922, Washington earned his law degree from Northwestern University in 1952 and was a lifelong politician. He won elections to the Illinois

House of Representatives from 1965 to 1976, the Illinois State Senate from 1976 to 1980, and the U. S. Congress in 1980. When he announced his candidacy for the Democratic nomination for the mayoral election, few experts gave him any chance of victory. But he forged an unprecedented coalition of blacks, Hispanics, labor, progressive whites, and other constituencies, sometimes referred to as a "rainbow coalition," and, in a three-way race, Washington defeated incumbent mayor, Jane Byrne, and Richard M. Daley, the son of the former mayor, to win the Democratic Party's nomination. In the general election on 12 April 1983, Washington defeated Republican challenger Bernard Epton to become the first African American mayor of Chicago. As mayor, Washington tried to eliminate

corruption, made city government more transparent, forged coalitions with neighborhood groups, expanded city services in minority neighborhoods, and restored the city's financial health through a property-tax increase. Reelected in 1987, Washington died of a heart attack on 25 November of that same year.

495. Man celebrating the inauguration of Harold Washington as mayor of Chicago, 29 April 1983.

496. Jesse Jackson (right) on the presidential campaign trail, Hartford, Connecticut, 1984. Jesse Jackson was born in Greenville, South Carolina in 1941, and received his bachelor's degree from North Carolina Agricultural and Technical University. Becoming involved in the civil rights movement first through CORE, Jackson then joined the SCLC and soon became a protégé of Martin Luther King, Jr. In the 1960s King assigned Jackson to develop a coalition between black ministers, civil rights leaders, and corporations to create job opportunities for blacks in Chicago, which resulted in the SCLC's successful Operation Breadbasket. After King's assassination, Jackson launched Operation PUSH (People United to Serve Humanity), which expanded upon the "corporate convenants" and other

business-related partnerships that he had initiated in the SCLC. In 1983, Jackson announced his candidacy for the Democratic Party's presidential nomination. Most black elected officials and prominent civil rights leaders, including Coretta Scott King and Andrew Young, opposed Jackson's candidacy. However, he successfully built an interracial coalition, similar to Harold Washington's, which included blacks, Latinos, lesbians and gays, environmentalists, peace activists, progressives from organized labor, and many others. In 1984 Jackson lost the three-way Democratic primary to Walter F. Mondale, but his "rainbow coalition" won him 3.5 million popular votes, making him the first serious African American challenger for the presidential candidacy. During his

campaign Jackson called for full employment, strong enforcement of affirmative action, environmental protection and women's rights, and opposed the U. S. nuclear arms race with the Soviet Union. The campaign illustrated that a black presidential candidate running on a progressive program could successfully appeal across racial lines.

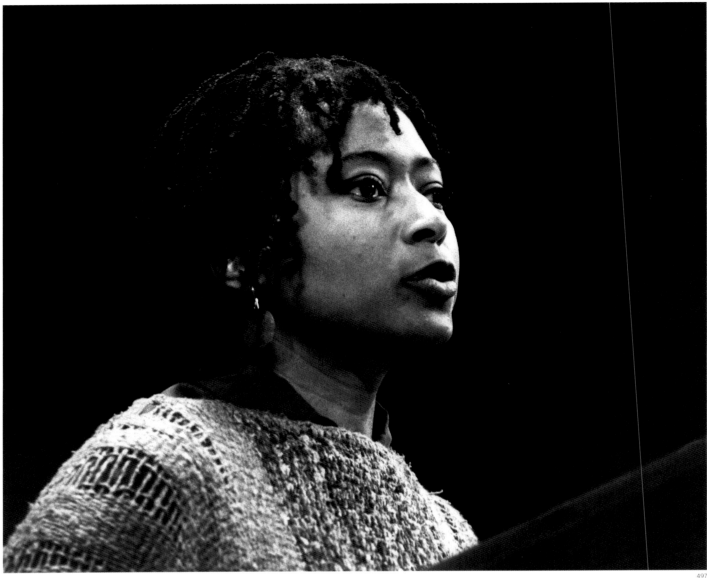

497. Author Alice Walker reading from her book *The Color Purple*, New York, 8 October 1985. Alice Walker is a celebrated novelist, poet, and essayist of the African American experience. Born in Etonton, Georgia on 9 February 1944, she was the youngest of eight children of sharecroppers. Growing up in poverty, she won a scholarship to Spelman College, Georgia in 1961. She subsequently attended Sarah Lawrence College in New York, graduating in 1985. She was active in voter registration and welfare rights work in the South during the civil rights movement. Her first novel, *The Third Life of Grange Copeland*, was published in 1970. In the 1970s she became a contributing editor for *Ms.* magazine and wrote several critically acclaimed books, and collec-

tions of essays and poetry, including *In Love and Trouble, Revolutionary Petunias and Other Poems, Meridian*, and *You Can't Keep a Good Woman Down*. Her greatest literary success came in 1982 with the publication of *The Color Purple*, which received the Pulitzer Prize and the American Book Award. In 1985 Steven Spielberg and Quincy Jones collaborated to make a film based on her book. The film was well-reviewed, although some members of the African American community criticized it for its courageous portrayal of gender roles and the oppression of black women. In 1996 Walker responded to these critics in an autobiographical work, *The Same River Twice: Honoring the Difficult*. Other prominent women writers who have made the African American experience, and

particularly the destiny of black women, the central theme of their work include Maya Angelou and Toni Morrison, who received the Nobel Prize for Literature in 1993.

498–499. Anti-apartheid rally, New York City, June 1986. For many years, African Americans had opposed the racist minority regime and called for a democratic revolution in South Africa. However, in the 1980s the Reagan Administration initiated a policy of "constructive engagement' with the apartheid regime of South Africa, which encouraged American investment in the country, thus providing economic support for the apartheid government. This prompted a series of demonstrations against apartheid and U. S. investment in South Africa. Thousands of

students on hundreds of university campuses were engaged in protests, frequently taking over university buildings, demanding that their institutions divest their stocks in corporations that did business in South Africa. Due to pressure from anti-apartheid protestors, in 1985 local municipal governments began to prohibit deposits of city funds in banks that loaned money to South Africa's government. By the end of the year many of America's largest banks, including Bank of America and Citibank, had been forced to terminate loans to South Africa, and many major U. S. corporations stopped doing business in South Africa for fear of public disapprobation. On 2 October 1986 the U. S. Congress passed, over President Reagan's veto, the Comprehensive Anti-

Apartheid Act that outlawed new bank loans to the public and private sector in South Africa. TransAfrica, an African American nonprofit lobbying organization that advocates African and Caribbean interests played an important role in the passage of the legislation.

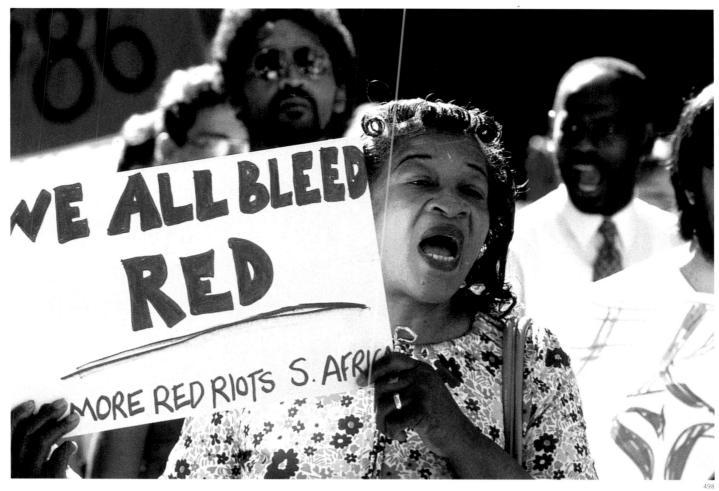

498

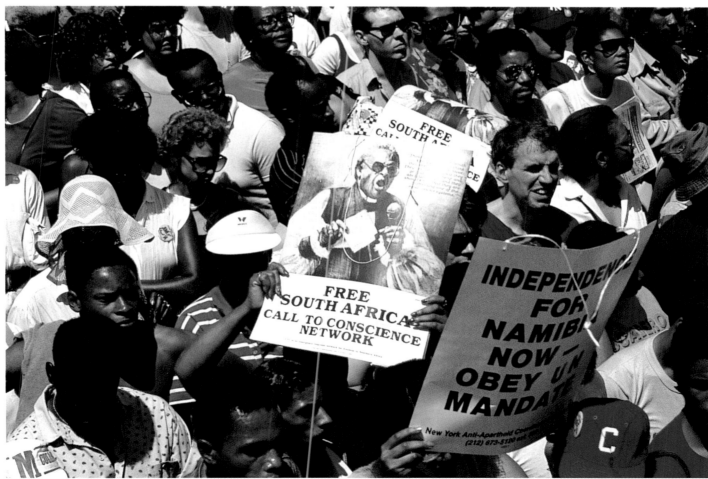

499

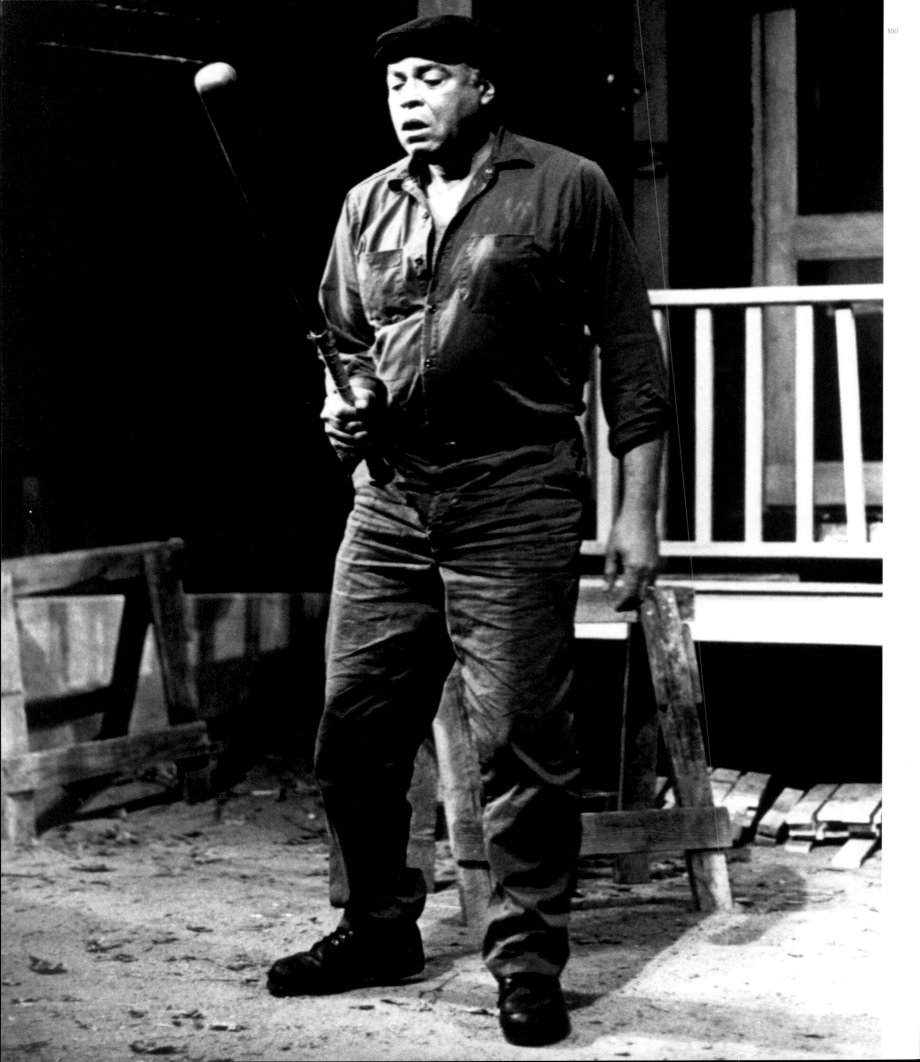

500

500. James Earl Jones as Troy Maxson in *Fences* at the Yale Repertory Theatre, New Haven, Massachusetts, 1985. First produced in 1985, *Fences*, written by African American playwright August Wilson, relates the life of a garbage collector who struggles, often unsuccessfully, to provide for his family. Performed in New York in 1987, *Fences* won the Pulitzer Prize and the New York Drama Critics' Circle Award. James Earl Jones is a prominent African American actor who has appeared in many films and stage productions over the past forty years. He has won four Emmy awards.

501. Emily, young single mother of two, with Kenny, her oldest child, East Chicago, 1986. During the 1980s the proportion of households headed by single women increased precipitously. This was the case all over the world, in industrialized as well as developing countries, and in most ethnic groups. Among African Americans, the increase was not primarily due to greater fertility, but rather to the fact that higher rates of male unemployment and incarceration resulted in a decline in the number of "marriageable men."

502. Homeless march on Highway 47 near Warrenton, Missouri, 1986. Experts estimated that the number of homeless people in the United States doubled in the 1980s. As the federal government reduced its expenditures for public housing, and, as in many areas, urban real estate prices soared, the working poor found it difficult to secure affordable shelter. Groups such as the Association of Community Organizations for Reform Now (ACORN) organized over 200,000 women, the majority of whom were black and Hispanic, to protest against government policies on housing and other social welfare issues.

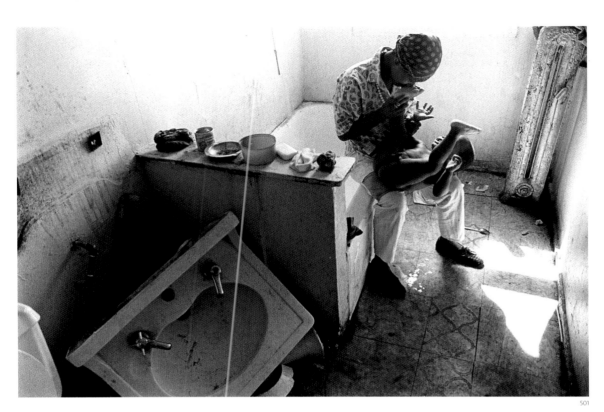

501

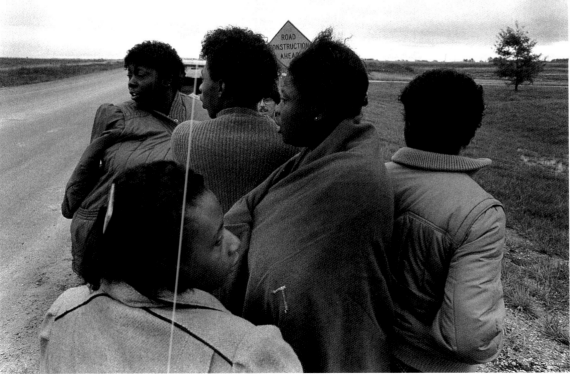

502

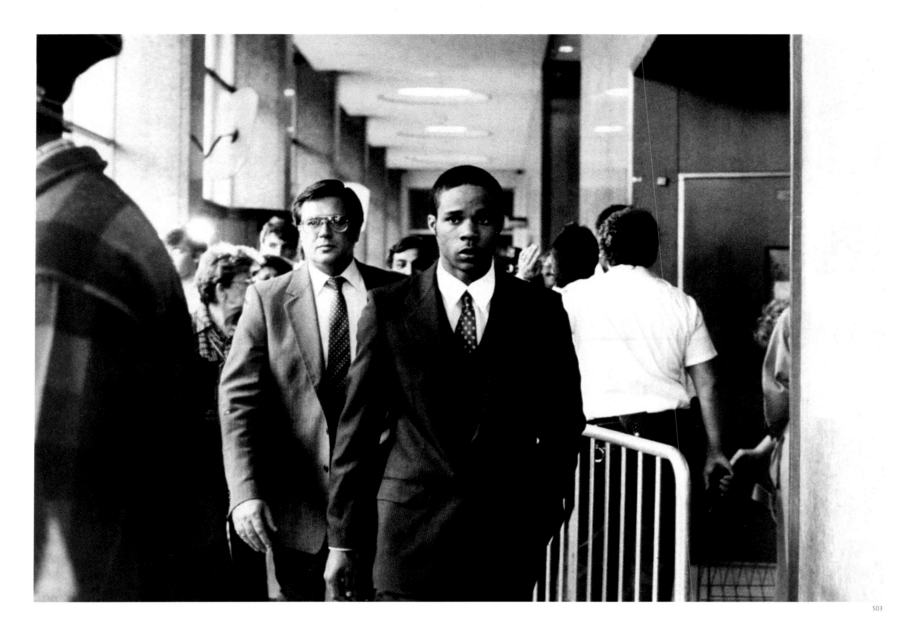

503. Timothy Grimes, one of the men attacked by a gang of whites in Howard Beach, New York City, in 1986 at the Queens Supreme Court for the trial, 15 October 1987. On the morning of 20 December 1986, three young black men were driving in Queens when their car broke down. In their search for a pay phone to summon help, they went to a nearby pizzeria in the community of Howard Beach, a predominantly Italian neighborhood. Upon leaving the shop, they were attacked by a group of white teenagers with baseball bats, who chased the young black men through neighborhood streets leading to a highway. Fleeing for his life, twenty-three-year-old Michael Griffith crawled through a fence and attempted to sprint across the road. He was hit by an oncoming car and killed, hurled nearly two city blocks from the site of the impact. One year after this vigilante incident, three of the white attackers were convicted of manslaughter and assault. One of the teenagers responsible for chasing Griffith across the highway was acquitted of all charges. The other, Robert Riley, who testified for the prosecution, received only six months in jail. Other gang members were sentenced to do community service.

504. Ossie Davis and Ruby Dee in Spike Lee's film *Do the Right Thing*, 1989.

Do the Right Thing was a popular, critically acclaimed film, written and directed by renowned African American filmmaker Spike Lee. Inspired by the vigilante attacks against blacks in Howard Beach, the film depicted the tensions of contemporary multiethnic urban life in a New York neighborhood. The central plot revolves around the conflicts between the Italian owners of a pizzeria and their customers in a neighborhood that has become predominantly black. When a black patron refuses to turn his radio down, a racial conflict escalates into physical violence, and when the police arrive they brutally strangle one of the black customers. Enraged by his friend's death, Mookie, the central character, throws a trash can through the pizzeria's front window and sparks a general uprising. The film closes with quotations from Martin Luther King, Jr. and Malcolm X, depicting two paths for black people in response to racist violence. The film was nominated for an Academy Award and received Best Director and Best Film awards from the Los Angeles Critics' Association. Actors Ossie Davis and Ruby Dee played two of the film's central characters. Ossie Davis was born in Cogdell, Georgia in 1917 and after serving in the U. S. Army established a successful career as an actor both on stage and in film. During the 1950s and 1960s, he starred in plays such as *A Raisin in the Sun*, *The Emperor Jones*, and *Purlie Victorious*. Since the 1970s, Davis has both directed and acted in a number of films. Ruby Dee studied at the American Negro Theatre in New York City in the 1940s. Over the next four decades she appeared in a series of television, movie, and stage roles, including *Decoration Day* for which she won the 1991 Emmy for Best Actress. In 1965 she joined the American Shakespeare Festival in Stratford, Connecticut becoming the first African American actress to play major roles in this arena. Davis and Dee married in 1948 and have appeared together in a number of theatrical performances. For half a century they have been actively involved in the black freedom movement. They both spoke out against McCarthyism and the political suppression of civil liberties during the 1950s. Davis delivered the eulogy at the funeral of Malcolm X and was actively involved in the struggle to free Angela Davis. In recognition of their contributions, President Clinton awarded Davis and Dee the National Medal of Arts in 1995, and in 2000 they received the highest honor of the Screen Actors' Guild, the Lifetime Achievement Award.

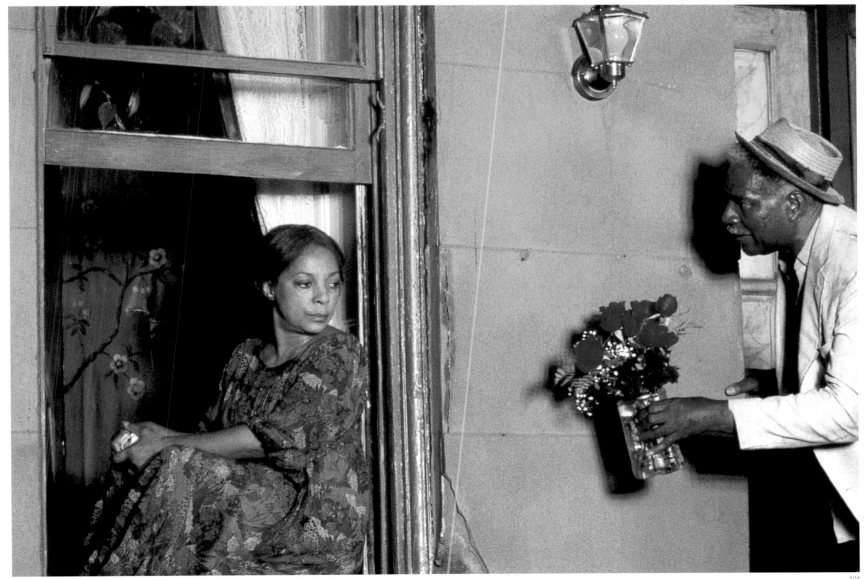

505. New National Security Council (NSC) Advisor Colin Powell speaking in the White House Rose Garden with outgoing Defense Secretary Caspar Weinberger, President Ronald Reagan, and incoming Defense Secretary Frank Carlucci (behind Powell from left to right), Washington, D. C., November 1987. Forty years after the desegregation of the U. S. Army, a number of African American professional military officers had risen through the ranks to become leaders in the armed forces. Colin Powell, the son of Jamaican immigrants, was born in New York City on 5 April 1937. He received his bachelor's degree from the City College of New York and his master's in business administration from George Washington University in Washington, D. C. Powell was commissioned as a second lieutenant in the army in 1958. He served two tours of duty in Vietnam and as battalion commander in Korea, and received numerous military decorations including the Purple Heart and the Bronze Star Medal. Powell was appointed as NSC advisor by President Reagan, whose administration greatly increased expenditures for the military.

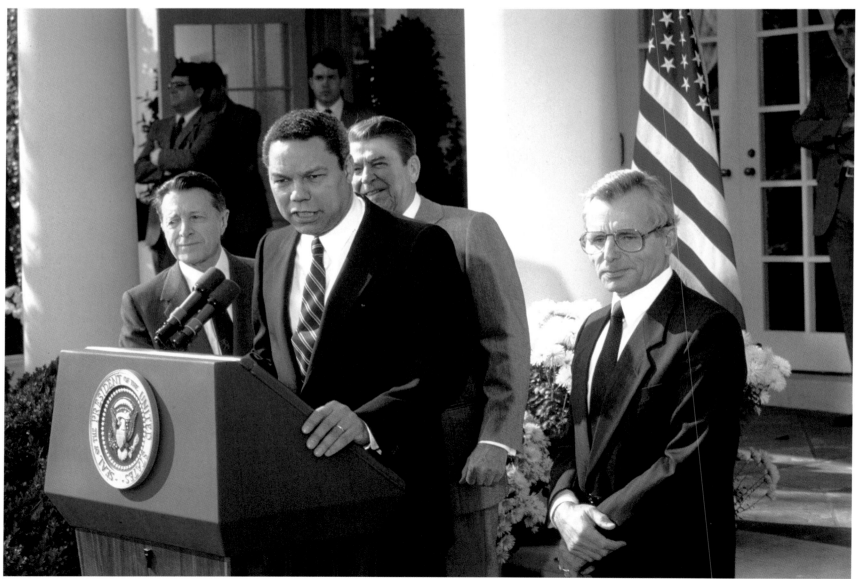

505

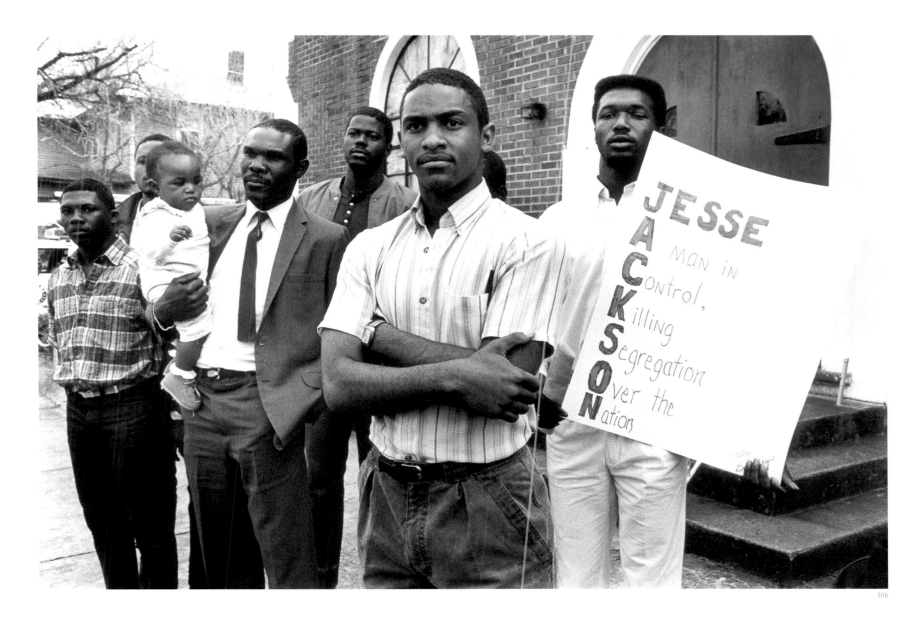

506. Supporters of Jesse Jackson during his campaign for the presidential primary, Selma, Alabama, 1988. The success of Jackson's 1984 presidential campaign created widespread support for his second effort to capture the nomination four years later. Jackson's Rainbow Coalition called for federal initiatives to address unemployment, health, education, housing, and urban problems. The campaigns mobilized an unprecedented interracial coalition and prompted hundreds of thousands of new black voters to register. Jackson received over seven million popular votes — from four million African Americans and an additional three million whites, Asians, and Hispanics — and won a series of primary contests, but lost the nomination to Massachusetts Governor Michael Dukakis, who was subsequently defeated in the general election by Republican candidate George Bush. Although many activists within the Rainbow Coalition wanted to establish a permanent progressive force independent of the Democratic Party, Jackson refused to do so. Almost immediately the coalition declined as a national force. After his 1988 campaign, Jackson moved from Chicago to Washington, D. C. where in 1990 he was named a "shadow senator" to lobby the U. S. Congress for statehood for the District of Columbia. Although the Rainbow Coalition declined in influence during the 1990s, Jackson emerged as an influential advisor to President Bill Clinton and remained a key figure within the National Democratic Party.

507. Florence Griffith Joyner (right) winning the final 100-meter race at the Seoul Olympic Games, September 1988. Born in Los Angeles, Florence Griffith first became a sports celebrity at the 1984 Olympic Games by winning a silver medal in the 200-meter race. Her colorful, flamboyant racing outfits and six-inch-long fingernails made her a popular favorite among track fans. She married her trainer Al Joyner, a former Olympic gold medalist, in 1987. At the 1988 Olympics, Griffith-Joyner won gold medals in the 100- and 200-meter races and the 4x100–meter relay, and a silver medal in the 4x400–meter relay. Widely known by her nickname "FloJo," Griffith-Joyner died of an apparent heart seizure on 21 September 1998 at the age of thirty-eight.

508. Public Enemy in concert, 1988–89. In the 1970s a new urban-based cultural movement, popularly termed hip hop, emerged. The core elements of hip hop culture include graffiti; break dancing; emceeing and deejaying; and rap music, which is based on the spoken word and its interplay with the musical beat. To many, rap's jarring style and frequent use of profanity was difficult to understand. However for many young blacks and Latinos born after the civil rights and Black Power period, hip hop embodied their own feelings and expressions about the nature of contemporary society. As the social and economic conditions of urban America deteriorated, rap music at first reflected a militant, and sometimes radical edge of criticism of the establishment. Such artists as Afrika Bambataa and the Zulu Nation, Grandmaster Flash and the Furious Five, who were later termed "old school rap" artists were unscrupulously exploited by managers and music business executives. In 1982, twenty-two-year old rapper Chuck D (Carleton Ridenhower) formed the group Public Enemy, which signed a contract with Def Jam Records. Public Enemy's second album, *It Takes A Nation of Millions to Hold Us Back*, was a bold and provocative statement of revolutionary politics. Public Enemy created the theme for Spike Lee's 1989 film, *Do the Right Thing*, called "Fight the Power." The group's 1990 album *Fear of a Black Planet* was also critically acclaimed and reached a large mainstream audience.

509. Overtown section of Miami, 16 January 1989. On 20 January 1989, the shooting to death of a black motorcyclist by police officers sparked a racial conflict in the low-income neighborhood of Overtown in Miami. The economic prosperity enjoyed by many middle-class Americans during the 1980s largely bypassed communities like Overtown where issues such as police brutality, unemployment, crime, and poor housing remained serious problems. Compounding the difficulties of the black working poor in southern Florida was the growing presence of the Cuban exile community. Increasingly, blue-collar and service employment required the ability to speak Spanish, and English-speaking African Americans found themselves excluded from many jobs. The 1989 civil disturbance in Miami, and the much larger Los Angeles racial uprising three years later, indicated that many of the socio-economic problems that had generated social unrest in U. S. cities in the 1960s still were present — and in many respects had become worse. Federal governmental cutbacks in programs targeting urban poverty and unemployment helped to create the conditions for racial violence and civic disruption.

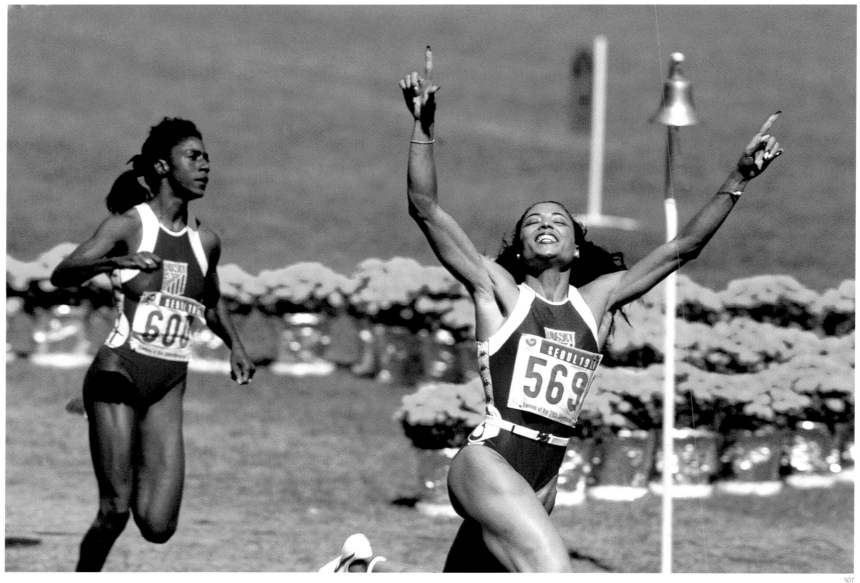

507

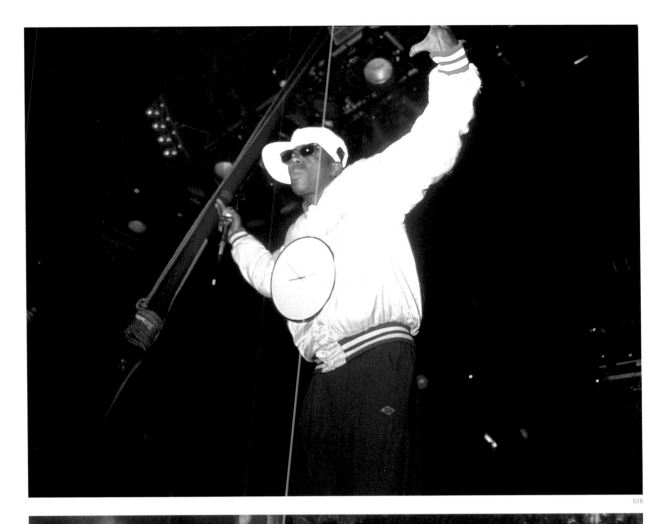

508

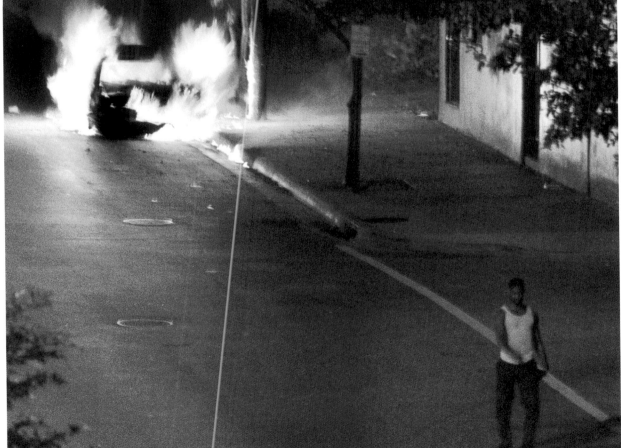

509

510. David Dinkins on the night of the Democratic primary election for mayor, Penta Hotel, New York City, 12 September 1989. Born in Trenton, New Jersey on 10 October 1927, David M. Dinkins graduated from Howard University and later served in the U. S. Marines in Korea. After obtaining his law degree, he became district leader in New York City's Democratic Party and worked his way up the political ladder to become city clerk from 1975 to 1985, and Manhattan borough president from 1985 to 1989. Dinkins challenged three-term Democratic Mayor Ed Koch in the 1989 primaries and won his party's nomination. The Dinkins campaign effectively constructed a multiracial, multiclass coalition, not unlike that of Jesse Jackson. In November 1989, he defeated Republican Rudolph Giuliani and became New York City's first African American mayor. During his four-year tenure, the Dinkins Administration divested the city from pension-fund stock invested in companies that did business in South Africa and modestly expanded access to health, education, and housing for the poor. The economic recession of the 1990s was economically devastating for New York City, as the city's budget deficit grew to over 2.2 billion dollars. To his critics, Dinkins seemed unable to control a soaring crime rate.

511. Members of the rap group Run–D.M.C. on the road between Virginia and New York City, 1989. Run–D.M.C was the first hip hop musical group to break into mainstream American culture. Joseph Simmons, Darryl McDaniels, and Jason Mizell, who grew up in the black suburbs in Queens, New York City, formed Run–D.M.C. in 1982. Their first single, "It's Like That," was released the following year. In late 1984 Run–D.M.C.'s self-titled first album was the first rap record to go gold and to have its music video aired on MTV. The group also pioneered the distribution of its music on CD formats. In 1985 they joined other artists to protest against South African apartheid. In 1986 Run–D.M.C. collaborated with the white rock group Aerosmith on a new version of Aerosmith's popular hit "Walk This Way," creating hip hop's first significant connections with the rock music market that appealed to white audiences. Joseph Simmons' older brother Russell helped to develop and promote Run–D.M.C., as well as many other influential artists. Russell Simmons co-founded, with Rick Rubin, Def Jam Records, which became a multimillion-dollar commercial empire in the 1990s. As of 2002, Run–D.M.C. has sold over twenty-five million albums.

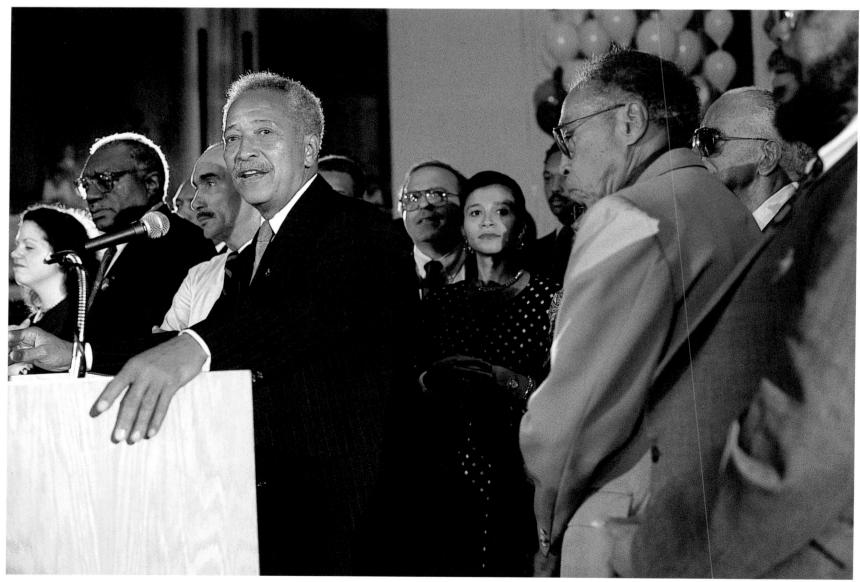

510

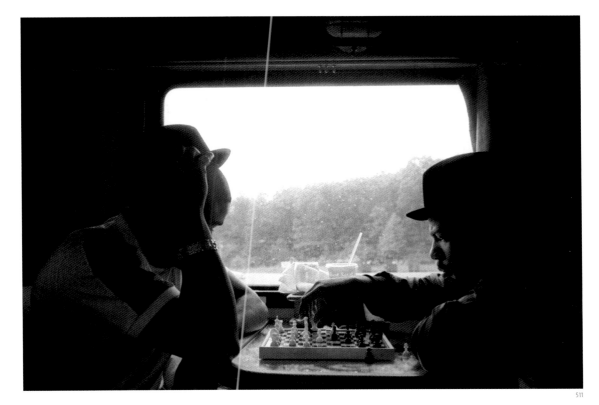

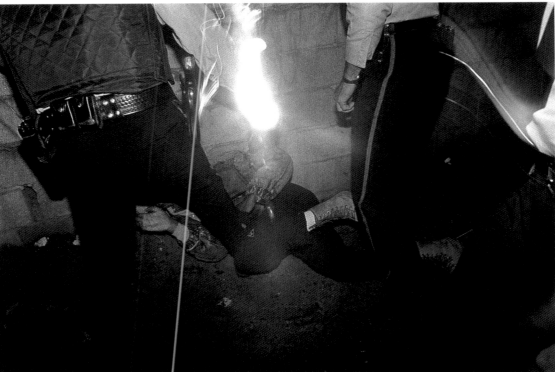

512. The "war against drugs" in Northern Philadelphia, 1989. In the early 1980s approximately 600,000 Americans were classified as addicted to illegal drugs. This situation changed dramatically with the introduction of a highly addictive, rock-type form of cocaine called "crack." With the expansion of highly organized, global networks for the financing, marketing, and distribution of this illegal substance, drug use expanded dramatically. As employment and educational opportunities declined in disadvantaged urban communities, young blacks and Latinos were increasingly pulled into this illegal traffic. By 1989 federal authorities estimated that the illegal drug trade in the United States was worth 150 billion dollars. A relatively small amount of the vast wealth generated by this illegal narcotics trade ended up in black and brown communities. In the late 1980s, in response to the expansion of illegal drug use and the expanding violence in urban areas, the U. S. government initiated the "war on drugs." Federal and state law enforcement agencies were greatly expanded, and legal punishments for narcotics prosecutions were made far more severe, but the vast majority of those arrested were relatively low-level drug users and dealers in the illegal narcotics trade. The U. S. Commission on Civil Rights reported in 1999 that blacks represented only 14 percent of all illegal drug users, but they comprised approximately one third of all drug arrests and over 50 percent of all drug convictions in federal and state courts. As of 1 January 1990, one million Americans, one half of whom were black, were in federal, state, or local correctional facilities. 23 percent of all black males in their twenties were either incarcerated, on probation, parole, or awaiting trial. This has had a devastating impact on black communities. By 2001, two million Americans were incarcerated.

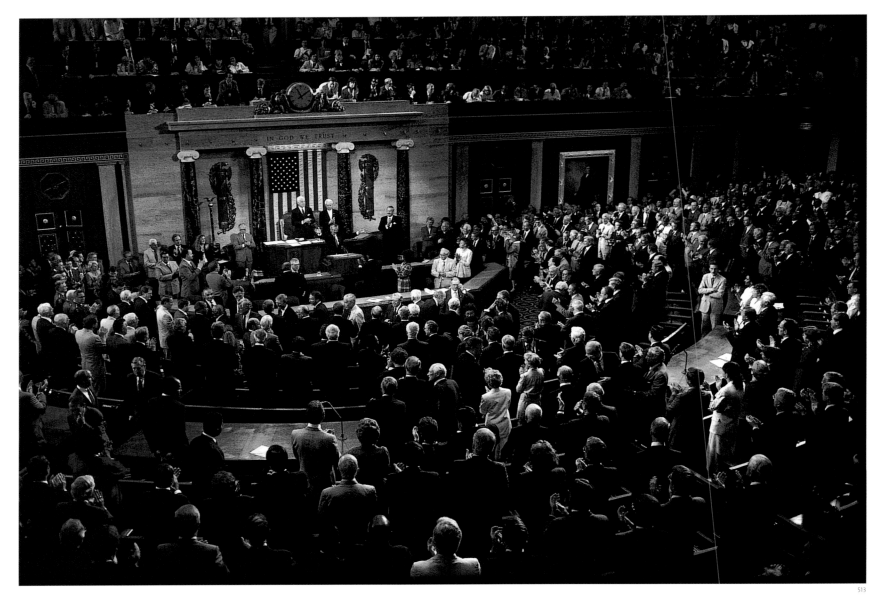

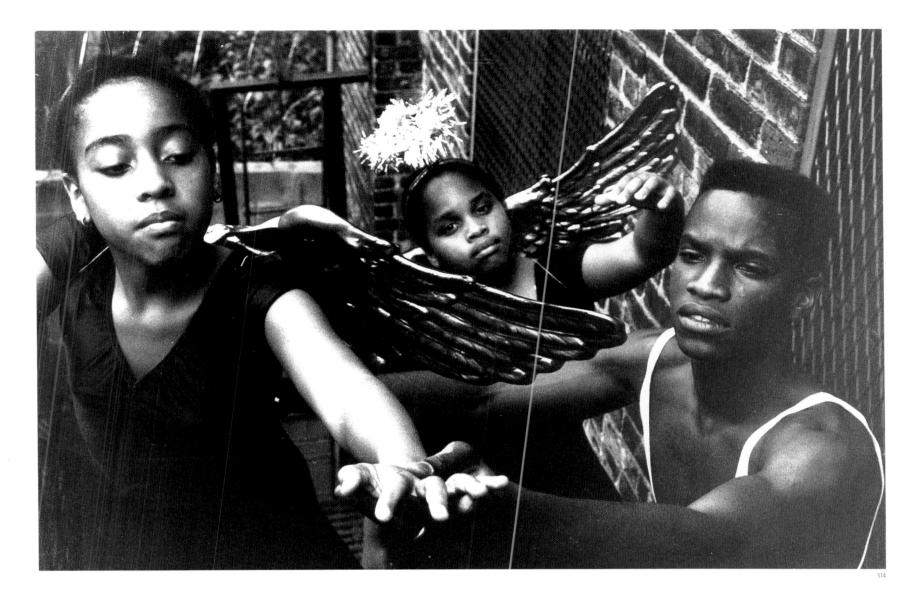

514

513. Nelson Mandela speaking before the U. S. Congress, Washington, D. C., June 1990. In the early 1990s, the African National Congress (ANC), with the aid of international solidarity movements, was successful in overturning the apartheid government of South Africa. Nelson Mandela, the formerly imprisoned leader of the ANC, whose freedom had been long sought by African Americans and others, was triumphantly welcomed in the United States.

514. Students and teacher (right) of the Dance Theatre of Harlem (DTH), 1990. The Dance Theatre of Harlem was founded in 1969 by former principal dancer of the New York City Ballet Arthur Mitchell. First housed in an auto garage in Harlem, the school developed into one of the city's major cultural institutions. The DTH sponsors extensive programs in training designed for community youth.

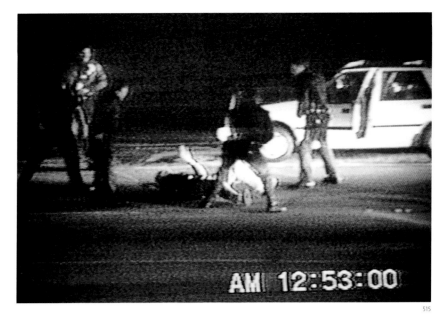

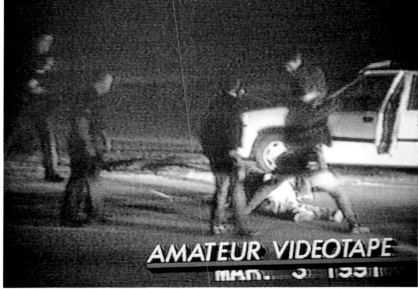

AMATEUR VIDEOTAPE

MAR. 3 1991

AM 12:53:00

515

516

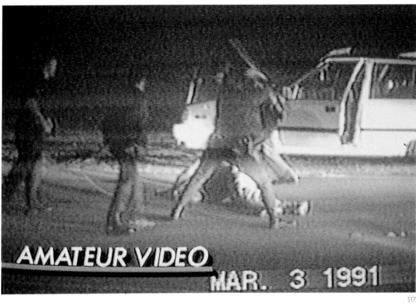

AMATEUR VIDEO
MAR. 3 1991

517

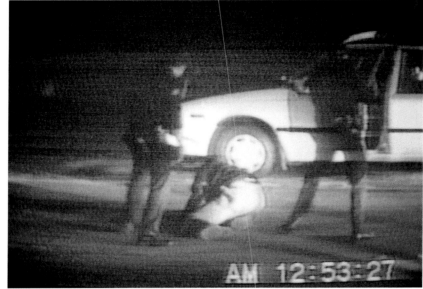

AM 12:53:27

518

515–518. Rodney King being beaten by the police, Los Angeles, 3 March 1991. On 3 March 1991, four Los Angeles police officers arrested motorist Rodney King for reckless driving and other infractions. After pulling him from his car, they restrained and brutally beat him while he was lying on the ground. An observer captured the beating on videotape from his apartment building. The

81-second amateur tape showed the officers striking the defenseless King fifty-six times with their batons. The tape was given to a local television station in Los Angeles, and almost immediately broadcast throughout the world. Four days later, all charges against King were dropped.

519. Rodney King's lawyer, Steven Berman (right), during the trial showing a photograph of King after having been beaten, Los Angeles, March 1991.

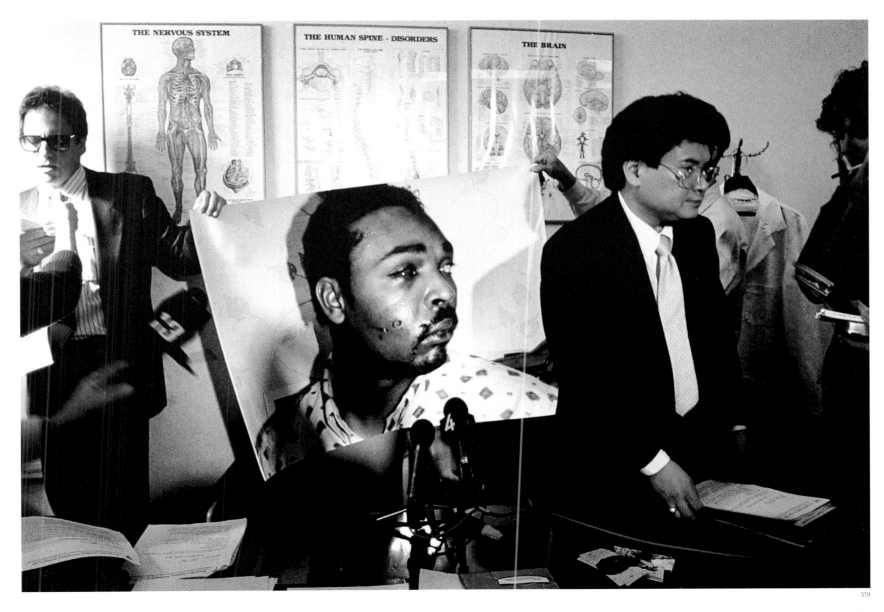

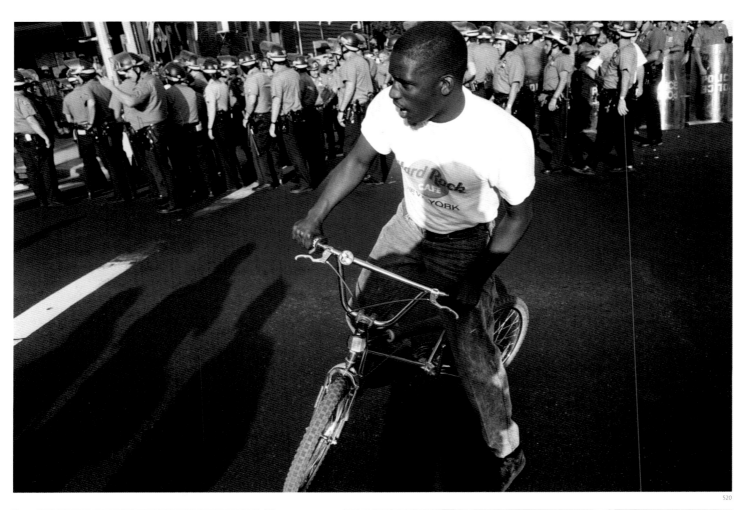

520

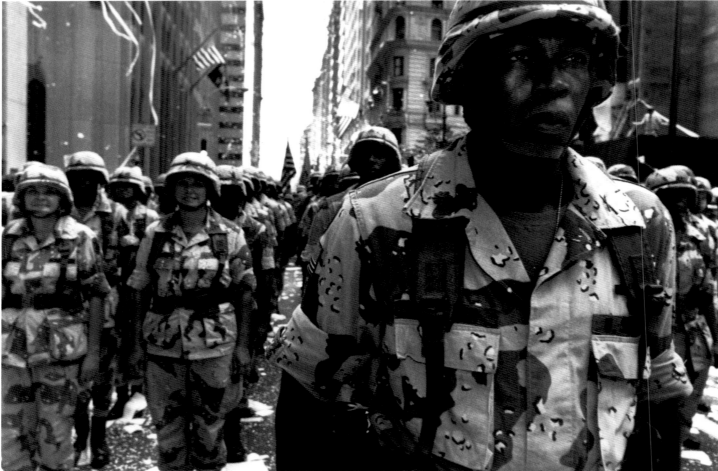

521

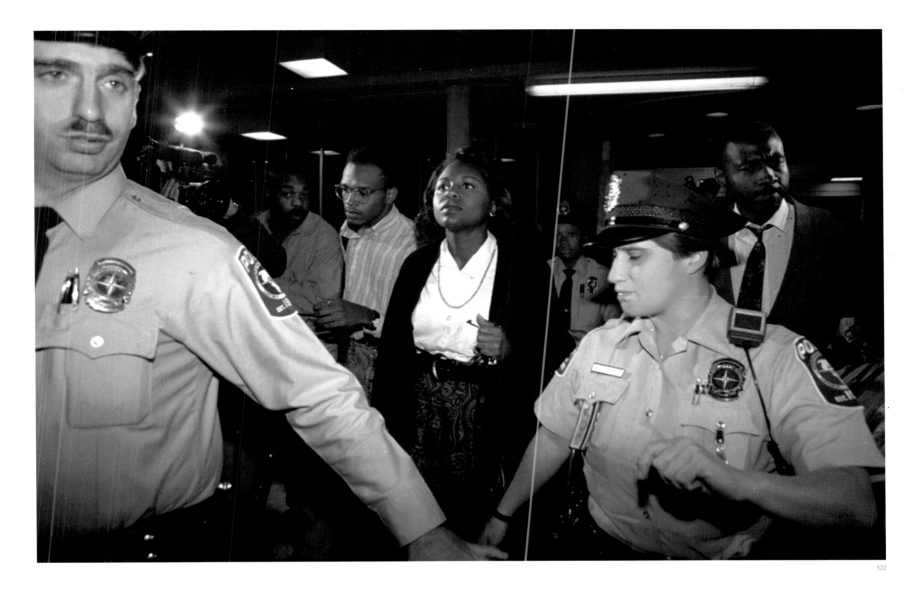

522

520. Urban unrest following the death of Gavin Cato, a seven-year-old black youth in Crown Heights, Brooklyn, New York, August 1991. There existed longstanding tensions, based on perceptions of unequal access to public resources, between the black working class and the Hasidic Jewish communities living in proximity in Crown Heights in Brooklyn. In August 1991, a car that was part of the motorcade of Lubavitch Grand Rabbi Menachem M. Schneerson, accidentally struck two black children, killing seven-year-old Gavin Cato. Young black residents responded by attacking people they perceived to be Jewish, and Jewish-owned property. Yankel Rosenbaum, a twenty-nine-year-old graduate student was stabbed and killed during the conflict. A sixteen-year-old black

youth, Lemerick Nelson, Jr. was charged with Rosenbaum's murder. He was acquitted in 1992, but was convicted five years later on federal charges of violating Rosenbaum's civil rights, and in 2002 was released from prison because of trial errors. The incident had negative consequences for black–Jewish relations in New York City. The racial conflict seriously damaged the administration of African American Mayor David Dinkins, who was accused of failing to provide effective police protection to Jewish residents and businesses in Crown Heights. Dinkins was defeated in the 1993 mayoral election by Republican candidate Rudolph Giuliani.

521. Desert Storm troops marching during Operation Welcome Home tickertape parade along the "Canyon of Heroes" traditional parade route, New York City, 10 June 1991. In the wake of the Vietnam War, the U. S. government ended the military draft and initiated an all-volunteer army. Due to limited educational and employment opportunities in the private sector, a disproportionately high number of African Americans and Latinos have joined the armed forces. During the Persian Gulf War against Iraq in 1991, 25 percent of all U. S. troops stationed there were African Americans. In 1989 President George Bush appointed General Colin Powell Chairman of the Joint Chiefs of Staff, the highest military office in the country. In this capacity, Powell played a leading role in

directing the war effort. While many African Americans took pride in Powell's success, they were also critical of the use of force in Operation Desert Storm. In a 1991 poll, white Americans favored the war by a margin of 4 to 1, while 50 percent of all African Americans opposed the use of military force against Iraq. In Congress, every black Democrat voted against the authorization of deploying military troops in the Middle East.

522. Anita Hill leaving Washington, D. C.'s National Airport amid heavy security, 10 October 1991. On 1 July 1991 Clarence Thomas, a black conservative Republican, was nominated by President George Bush to become an associate justice on the U. S. Supreme Court. Thomas was slated to replace retiring Associate Justice Thurgood Marshall, who, for over twenty years, had worked to vigorously defend civil rights laws and civil liberties and to expand the rights of the poor and disadvantaged. African American opinion was divided over the appointment, with most civil rights groups and black elected officials opposing Thomas based on his conservative views. During the Senate confirmation hearings, Anita Hill, an African American attorney and law professor, testified that Thomas had sexually

harassed her while the two had worked together in the Reagan Administration. Thomas vigorously denied any sexual misconduct and attacked Democratic senators. After extensive debate, Thomas' nomination was approved by the U. S. Senate. The televised hearings sparked an intense discussion about sexism, gender inequality, and sexual harassment in the workplace. Many African Americans who disagreed with Thomas' politics nevertheless urged his appointment arguing that the black Republican would certainly become more moderate. Thomas' subsequent record was judged by most observers to be, along with Associate Justice Anton Scalia, on the extreme right of the high court. For many feminist groups, Hill became a symbol of courage and integrity.

481

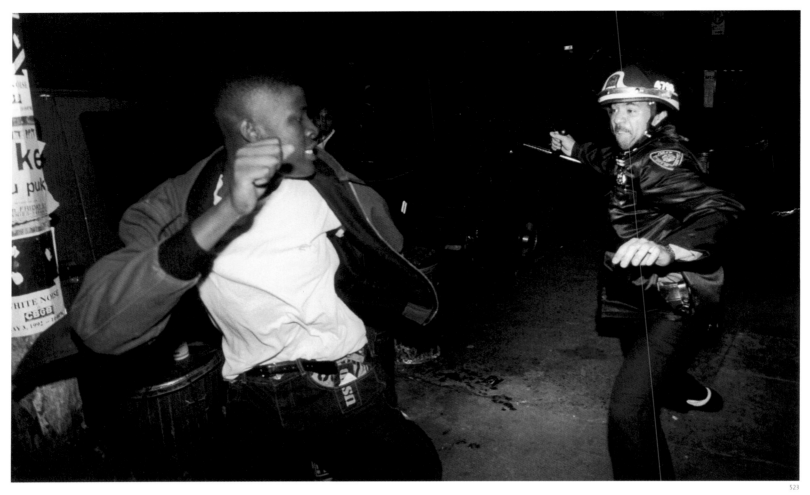

523

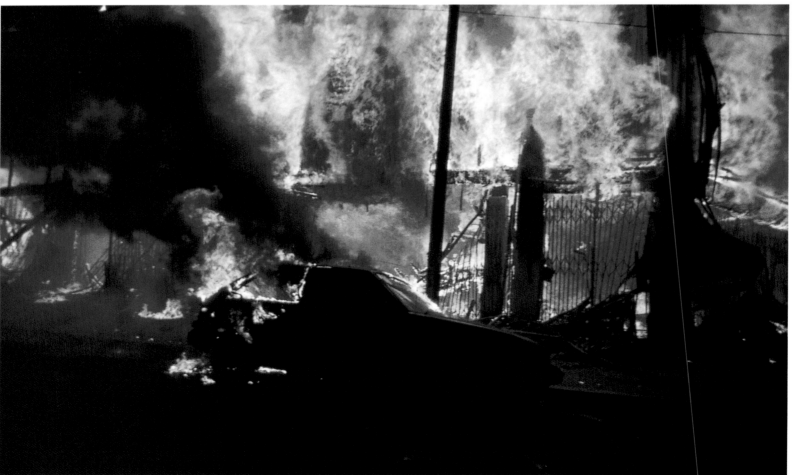

524

523. Urban unrest in the wake of the acquittal of the four Los Angeles Police Department (LAPD) officers accused of beating Rodney King, New York City, 1 May 1992. The Los Angeles county district attorney filed charges against the four white police officers who had beaten Rodney King. The trial was moved to the conservative and predominantly white community of Simi Valley. On 29 April 1992, the Simi Valley jury declared the four police officers not guilty of committing any crimes against King. The response of most African Americans in Los Angeles, and throughout the country, was outrage.

524. Los Angeles urban unrest, May 1992. Almost immediately after the acquittal of the police officers in the Rodney King case, Los Angeles police officers retreated from a number of South Central LA neighborhoods in anticipation of rioting. Young blacks and Latinos destroyed property and looted stores primarily owned by whites and Asians. After six days of civil unrest, forty-two people had been killed, over five thousand arrested, and property damage exceeded one billion dollars. Only 38 percent of those arrested were African American; the majority were Latino and 9 percent were Anglo whites. In the wake of these civil disturbances, Los Angeles Police Commissioner Daryl Gates resigned and was replaced by an African American, Willie Williams. By 2002, 47 percent of the LAPD officers were black and Latino. Approximately 80 percent of the buildings destroyed or damaged during the 1992 civil unrest were rebuilt by 2002, but unemployment rates remain high.

525. Malcolm X memorial at the site of the beginning of the Los Angeles riots, 1992.

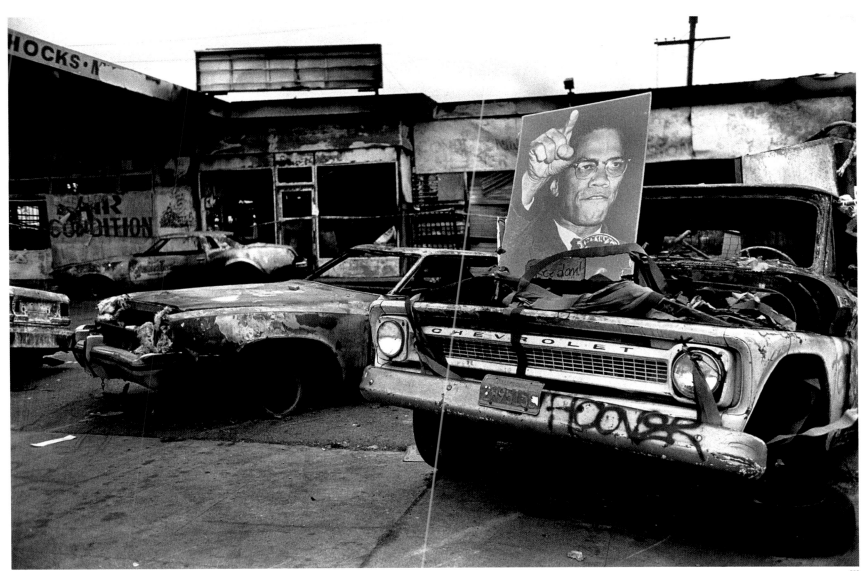

525

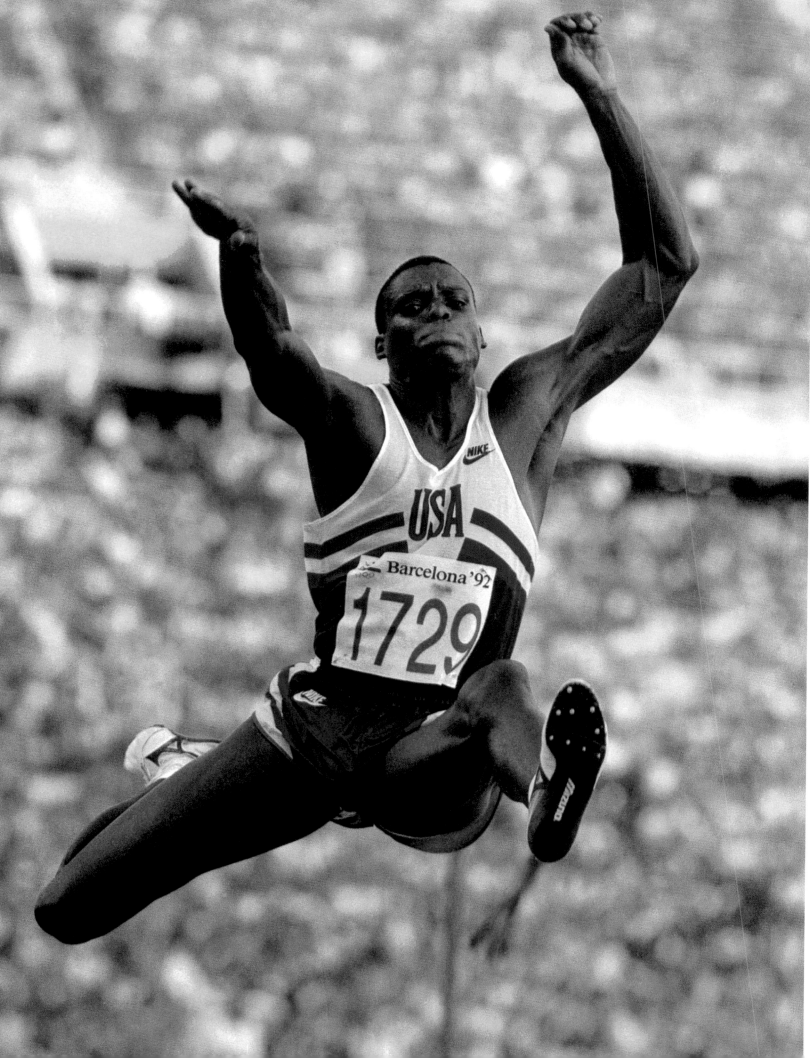

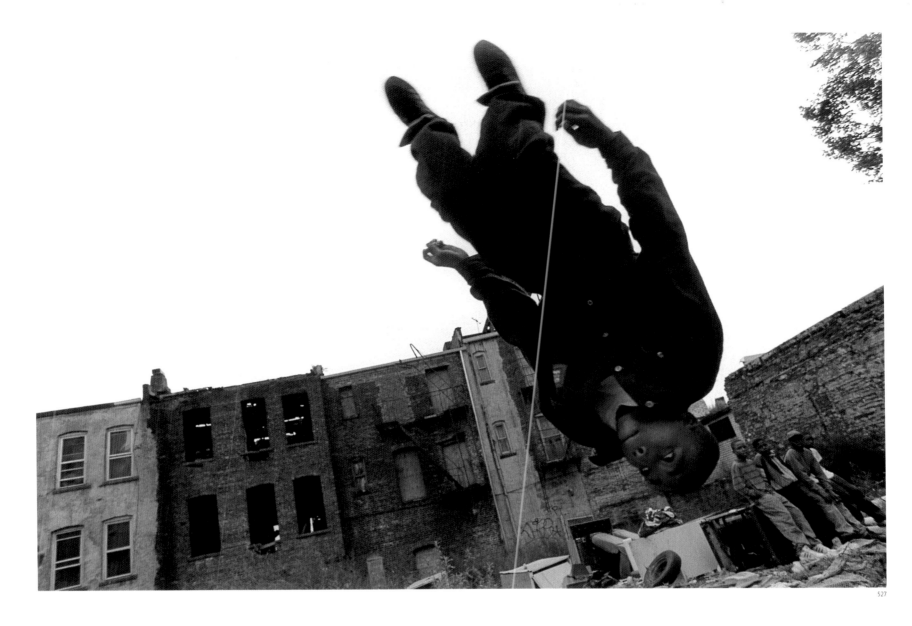

527

526. U. S. athlete Carl Lewis in the long-jump Olympic finals in Barcelona, 7 August 1992. Carl Lewis was the American track and field athlete who won the most Olympic gold medals during his career. At the 1984 Olympic Games in Los Angeles he received gold medals in the 100- and 200-meter sprints, the long jump, and the 4x100–meter relay race. At the 1988 games in Seoul Lewis won two gold medals and a silver medal. Four years later in Barcelona he won two gold medals and anchored the American 4x100–meter relay team, which set a world and Olympic record. In 1996 at the Olympic Games in Atlanta, Lewis won the long jump competition for the fourth consecutive time, receiving his ninth Olympic gold medal. During his long career, spanning nearly two decades, Lewis set nine world records in individual competition and in relays.

527. Young boy leaping off bare mattress springs in East New York, 1992.

528. Chicago Bulls basketball star Michael Jordan celebrating as the team won its third consecutive National Basketball Association (NBA) championship, 20 June 1993. Sixty years ago African Americans were largely excluded from competition in professional sports on the basis of their alleged inferiority. Today, black athletes dominate some of the most popular sports in America. Born on 17 February 1963 in Brooklyn, New York City, Jordan became a star basketball player at the University of North Carolina. In his extraordinary career as the leader of the Chicago Bulls, Jordan won six championships and was selected five times as the NBA's Most Valuable Player. Jordan became a multimillionaire as a result of commercial endorsements and personal appearances.

529. A couple celebrating after the Spelman College graduation ceremony, Atlanta, Georgia, 1993. With the desegregation of American higher education in the 1960s and 1970s, several million African Americans were able to enroll in colleges and professional schools that had previously been largely closed to them. Between 1975 and 1995 the number of African Americans enrolled in undergraduate studies doubled. By 2000, 30 percent of all young black adults ages 18–24 were enrolled in college. In 1987, 765 African Americans received Ph.D. degrees; in 2000, 1,656 doctorate degrees were awarded to African Americans. However, historically black colleges continue to play a crucial role in the education of African Americans. They produce significantly higher percentages of blacks who achieve doctorates and professional degrees than white institutions. Spelman College, founded in 1881, is a black women's college whose alumni have achieved impressive successes in a variety of fields. In the 1990s, Spelman's dynamic president Dr. Johnnetta B. Cole elevated the college's profile and prestige, making it one of the best known institutions of higher learning in the country.

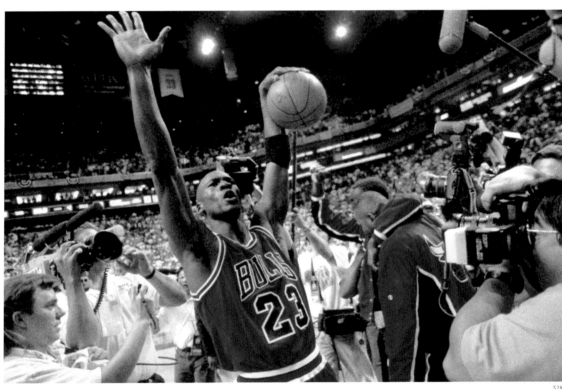

528

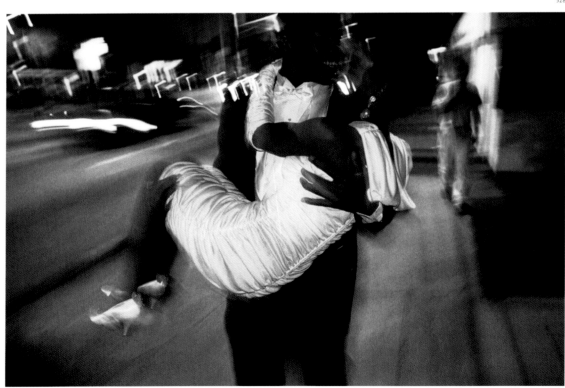

529

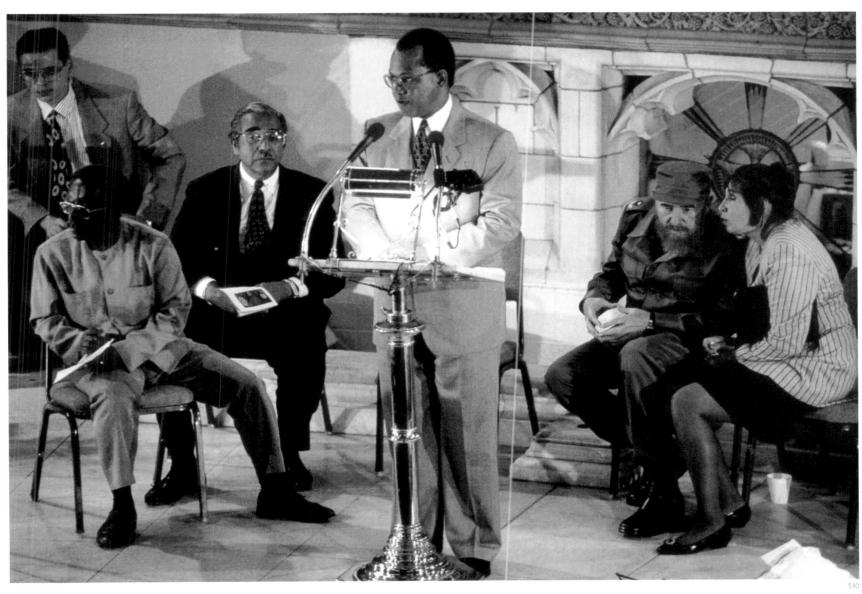

530. The Reverend Calvin Butts, Pastor of Abyssinian Baptist Church (center), addressing the congregation gathered to hear a speech by Cuban President Fidel Castro (seated, second from right), at Harlem's Abyssinian Baptist Church, New York City, 22 October 1995. The Cuban Revolution has been perceived by many African Americans as a notable effort to uproot and abolish racial discrimination. On 1 January 1959, Fidel Castro and his movement overthrew the dictatorship of Fulgencio Batista. Two months later, in a televised address, Castro outlawed racial discrimination in public accommodations, the workplace, and all schools. As a consequence, Castro is a popular figure in many black communities. In September 1960, he came to New York City to speak at the opening of the 15th session of the United Nations General Assembly. The U. S. government imposed severe restrictions on the entire Cuban delegation, forbidding them to leave the island of Manhattan. After refusing to give a Midtown Manhattan hotel $20,000 as a security fee, Castro and the Cuban delegation moved into Harlem's Hotel Theresa. Thousands of black and Latino Harlem residents cheered Castro's presence and carried pro-Cuba signs. In October 1995, Castro returned to New York and addressed an over-flowing Harlem crowd of 1,300 people at Abyssinian Baptist Church. The enthusiastic audience included most of New York's black and Latino leadership, such as congressional representatives Charles Rangel (seated second from left), Jose Serrano, and Nydia Velasquez. Wearing his traditional garb of army fatigues, the Cuban president laughed, "How could I go to Harlem in my business suit?" and added, "As a revolutionary, I knew I would be welcome in this neighborhood."

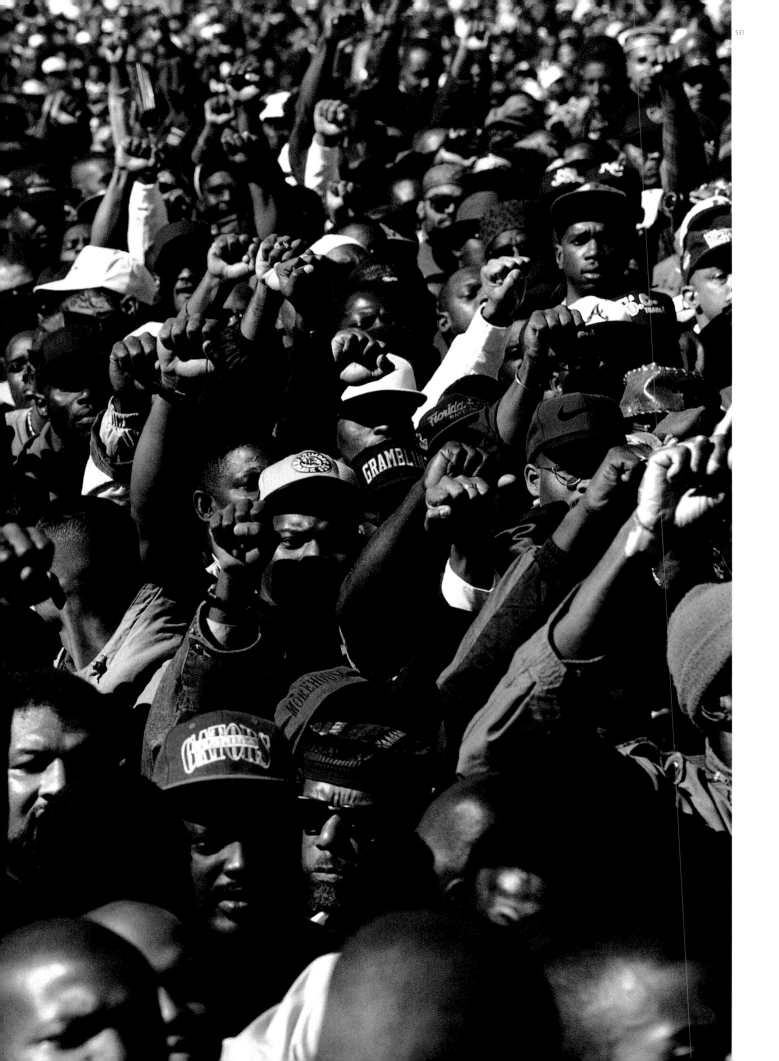

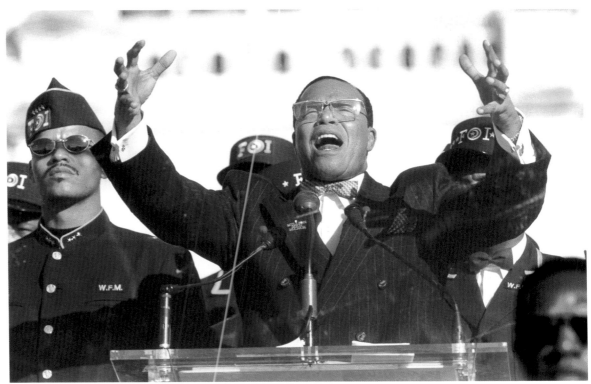

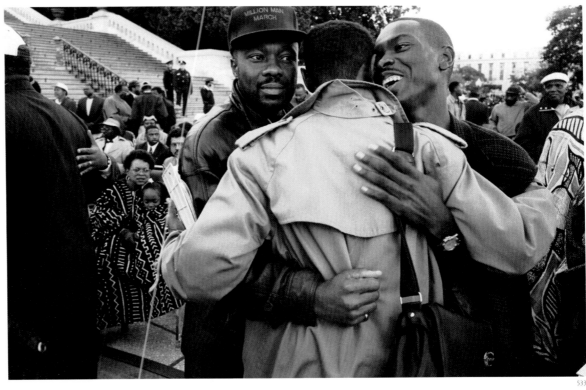

531, 533. Million Man March, Washington, D. C., 16 October 1995. In late 1994, Louis Farrakhan, the leader of the Nation of Islam (NOI), and former NAACP Executive Secretary Benjamin Chavis developed a plan to hold a national demonstration focused largely on the plight of African American males. The concept of the march, projected as "a day of atonement and reconciliation," sparked tremendous enthusiasm throughout black America, as well as bitter controversy. Black feminists condemned the patriarchy and homophobia prevalent in much of the mobilization's literature. Others praised the objective of the march but criticized Farrakhan for anti-Semitism and racism. Still others objected to the emphasis on "atonement" at a time when Congress was eliminating programs designed to help the black community. On 16 October 1995, close to a million participants poured into the Washington Mall from all over the United States. It was without question the largest single gathering of black people in U. S. history. Studies indicated that the participants were mostly of the middle class, older, and had a proportionally higher level of education than black men in general. The march was, for many, an emotional event that symbolized the coming together of black men across generations, rededicated to a common social and political project of empowerment. This perhaps explains the popular slogan in support of the mobilization: "Farrakhan may have called the march, but the march belongs to us."

532. Louis Farrakhan giving his keynote address at the Million Man March, 16 October 1995. After Elijah Muhammad's death in 1975, his son Wallace took control of the NOI and immediately steered it away from the black nationalist principles and racial separatism of his father. Loyal to Elijah's perspectives, Farrakhan broke from the organization and reconstituted the "old" Nation of Islam around his own leadership. Through its economic initiative, People Organized and Working for Economic Rebirth (POWER), the NOI effectively developed business cooperatives and marketed consumer goods in black communities. By the 1990s, Farrakhan had become a major, if still controversial, figure in black American politics.

489

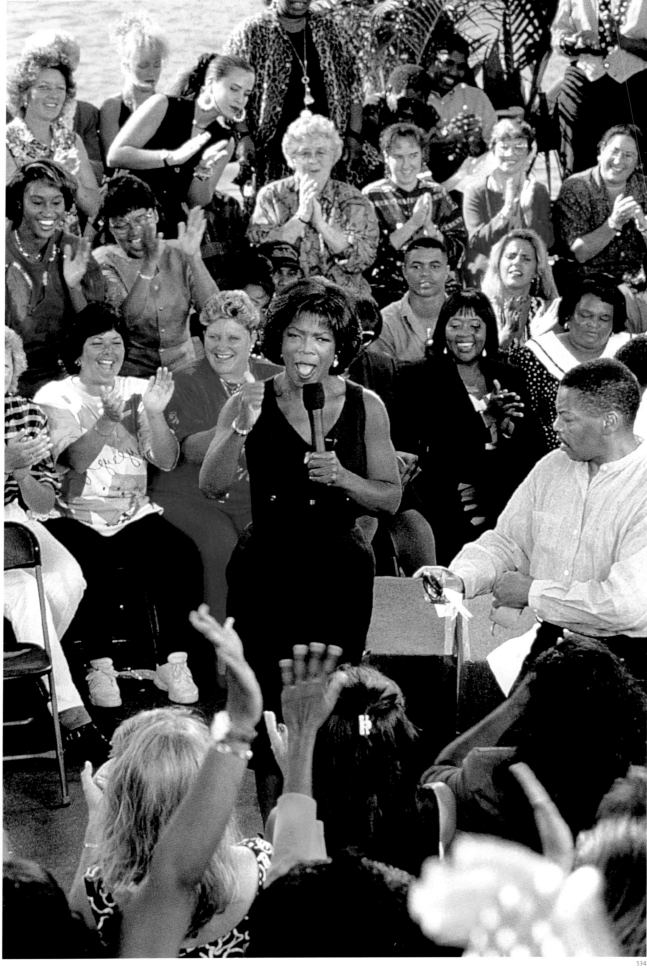

534

534. Oprah Winfrey (center) moderating *The Oprah Winfrey Show*, 1996–97. Oprah Winfrey was born into humble circumstances in rural Mississippi. Despite difficult conditions, Winfrey was a brilliant student and managed to successfully complete her secondary education. At the age of nineteen she became a television news anchor in Nashville, Tennessee, and by the age of thirty she was a successful television personality in Baltimore, Maryland. In 1986, she initiated *The Oprah Winfrey Show* as a nationally syndicated television program, and almost overnight it became a tremendously popular success. It is viewed by twenty-six million Americans every week and is aired in over one hundred countries. Winfrey's audience is substantially white, middle-class, and suburban. Her program deals primarily with interpersonal relationships, self-development, and personal motivation. The winner of thirty-four Emmy awards, Winfrey was selected by *TIME* magazine in 1998 as one of the hundred most influential people of the twentieth century. She is one of the wealthiest women entertainers in the United States and has played an important role as a philanthropist, establishing scholarships for needy students and investing in housing for the poor.

535. Jessye Norman as Emilia Marty in the Metropolitan Opera's premiere production of Leoš Janáček's *The Makropulos Case*, New York City, 1996. Jessye Norman is one of today's outstanding operatic singers, who has performed at the world's leading opera houses. She has been acknowledged as having one of the finest dramatic soprano voices of her generation, and is often cited for her innovative programming and advocacy of contemporary music. She is known for her unusually broad repertoire, from American Negro spirituals to a wide range of operas. Recognized for her artistic accomplishments as well as her dedication to humanitarian efforts, Norman has received numerous honorary distinctions. In 1997 she became the youngest recipient of the Kennedy Center Honor, the United States' highest award in the performing arts.

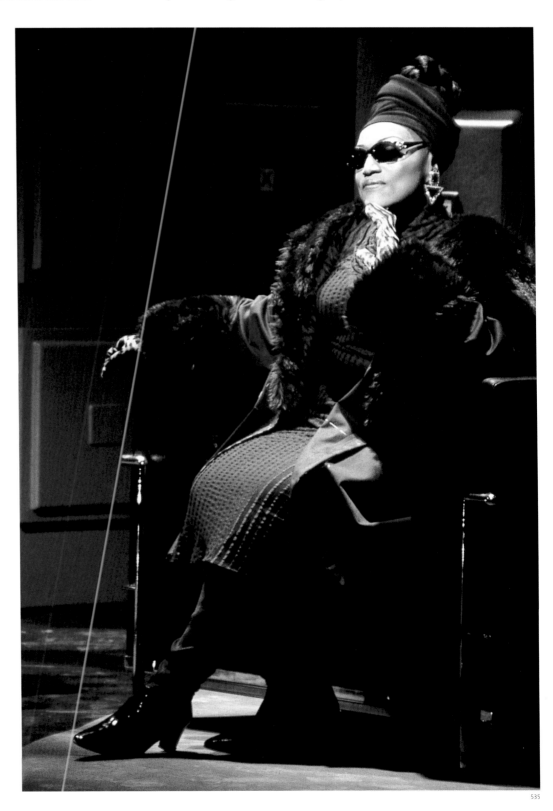

535

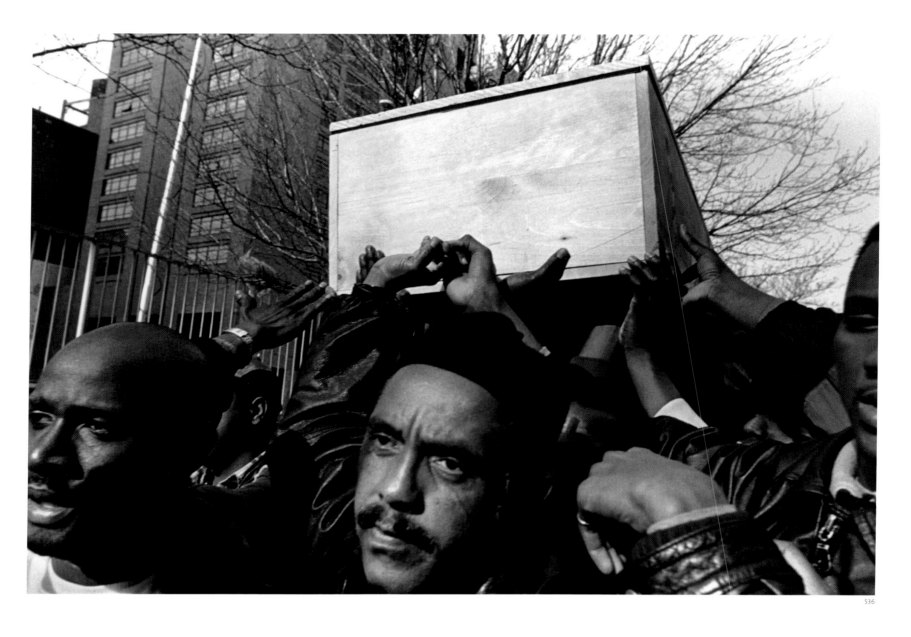

536

536. Memorial service for
Amadou Diallo, New York
City, 12 February 1999. Early
on the morning of
4 February 1999 a twenty-
three-year old West African
immigrant, Amadou Diallo,
was stopped by four
plain-clothed police officers,
members of the NYPD
Special Crimes Unit, while
entering the vestibule of his
Bronx apartment building.
The officers fired forty-one
bullets, and the unarmed
Diallo was struck nineteen
times, and killed instantly.
Police later claimed that they

thought Diallo was reaching
into his jacket and they
opened fire. A street vendor
and computer student, Diallo
was a deeply religious
Muslim, who had no criminal
record. The murder high-
lighted a pattern of police
harassment of young blacks
and Latinos throughout the
city. In 1997 and 1998 the
New York police reported
having carried out 45,000
"stop and frisk" searches
that had resulted in only
9,500 arrests. The New York
State attorney general, how-
ever, estimated that the true

number of searches probably
exceeded several hundred
thousand. Members of New
York's black community felt
that such law enforcement
policies frequently led to
questionable arrests and all
too frequently to police
misconduct. Two years
before the Diallo shooting,
police arrested a Haitian
immigrant, Abner Louima,
and sodomized him with a
broken broomstick in the
bathroom of a Brooklyn
police station.

537. Protestors at 1 Police
Plaza in New York City at a
rally in protest of Amadou
Diallo's murder, 1999. When
New York Mayor Giuliani
praised the police and
defended the officers
involved in the Diallo shoot-
ing, tens of thousands of
New Yorkers, reflecting a
broad range of ethnic and
racial groups, participated in
public marches and demon-
strations to protest against
police brutality. Over 1,200
non-violent demonstrators
were arrested, including
many prominent public

figures such as former Mayor
David Dinkins. The demon-
strations forced the police to
curtail their "stop and frisk"
policy, and the numbers of
police shootings declined.
The four police officers in
the Diallo killing were
indicted on charges of
second-degree murder, but
after the trial was moved to
Albany, New York, the four
officers were acquitted
of all charges on 25 February
2000. On the next day,
demonstrators marched
through New York City,
blocking traffic in acts of

civil disobedience. The
following day thousands of
people held a prayer vigil
outside of the United
Nations.

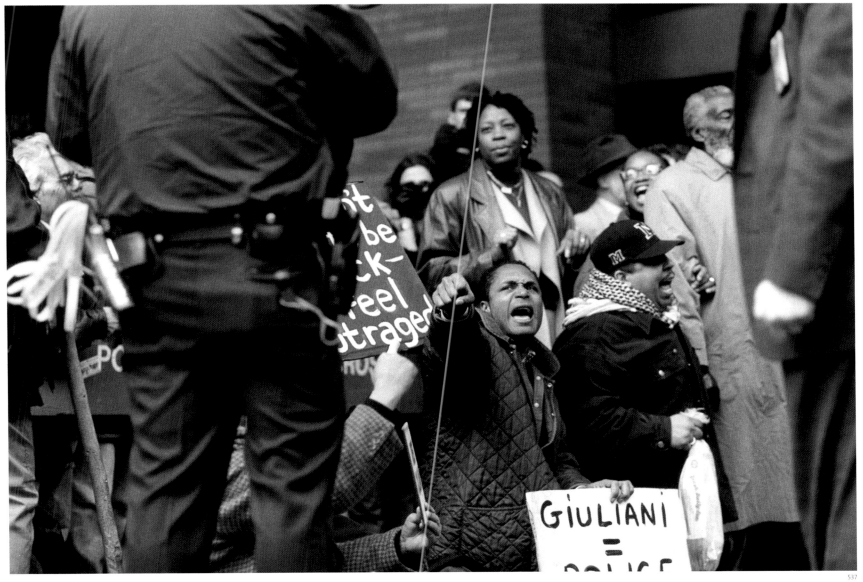

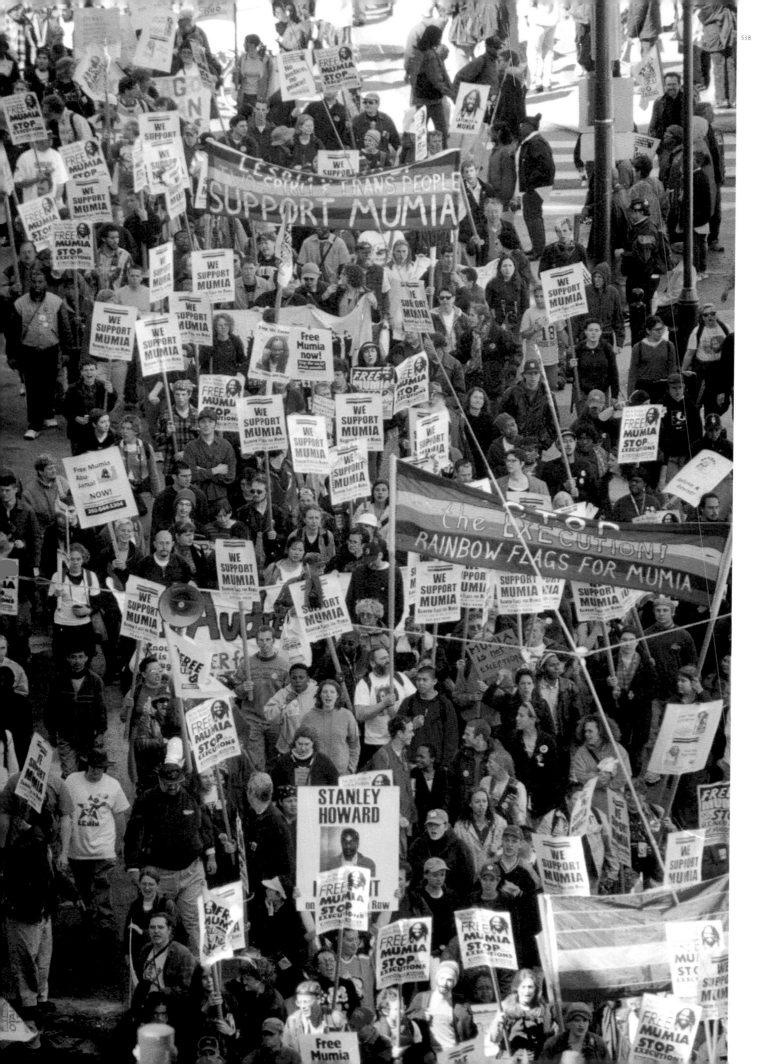

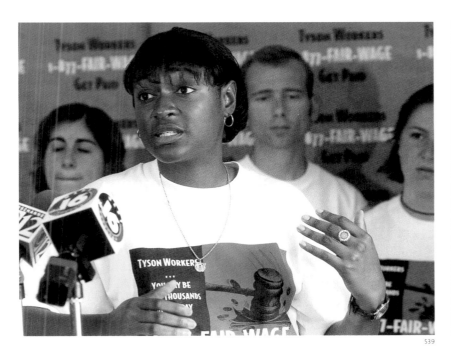

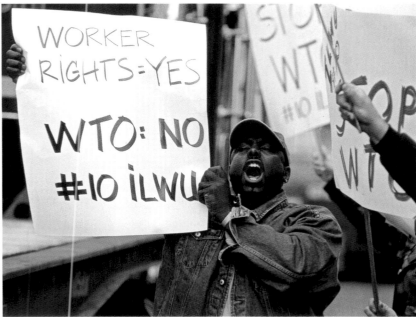

539

540

538. Demonstration in support of death-row inmate Mumia Abu-Jamal, Philadelphia, 24 April 1999. Mumia Abu-Jamal is currently the most prominent African American prisoner. As a teenager, Abu-Jamal served as Minister of Information of the Philadelphia chapter of the Black Panther Party. During the 1970s, he became a well-known journalist and public advocate for the African American radical organization MOVE. In 1981, while moonlighting as a cab driver, Abu-Jamal became involved in an altercation with a police officer in which the officer was shot and killed. Abu-Jamal was wounded and arrested, and charged with first-degree murder. Abu-Jamal, who maintains his innocence, was subsequently found guilty and sentenced to the death penalty in a trial that many

legal observers believed had numerous judicial irregularities. While on Pennsylvania's death row, a broad international movement developed for Abu-Jamal, calling for a new trial. During his incarceration Abu-Jamal has written several books and hundreds of articles and has described the role of prisons in creating profit for private companies and jobs in depressed rural areas. On 24 April 1999, several major demonstrations on behalf of Abu-Jamal were held across the United States. Twenty-five thousand people demonstrated in Philadelphia and another 20,000 marched in downtown San Francisco, calling for a new trial.

539. Conesha Coleman, a student activist in the AFL–CIO's Union Summer program, urges employees at Tyson poultry processing plants to register their complaints, Jackson, Mississippi, 9 July 1999. Approximately one out of every six union members in the United States is African American. Blacks have for many years expressed proportionally greater support for unionization than white Americans. Over the past quarter century, as the percentage of the unionized American labor has declined, labor leaders began to recognize that the future of organized labor depended upon recruiting low-wage workers. In the 1990s, the AFL–CIO launched major organizing efforts in the South, focusing on workers in the agricultural, textile, and food processing

sectors. African American workers are now leaders of major unions and are playing increasingly significant roles within the labor movement as well as in national and international politics.

540. John East, a Local 10 longshoreman, protesting against the Seattle World Trade Organization (WTO) summit, San Francisco, 30 November 1999. In the mid-twentieth century African American workers achieved dramatic increases in income and quality of life. During the past twenty years, however, millions of jobs have been exported overseas, primarily to Third World countries. American manufacturers have shut down U. S.–based businesses to employ less expensive labor abroad. This exodus of capital has had a deep impact upon the lives of black workers, many of whom have been active in labor actions critical of the WTO, the International Monetary Fund, and public policies promoting free trade. In late 1999, when over 40,000 Americans demonstrated in

Seattle against the WTO summit, black workers in union organizations across the United States demonstrated in solidarity with the protest.

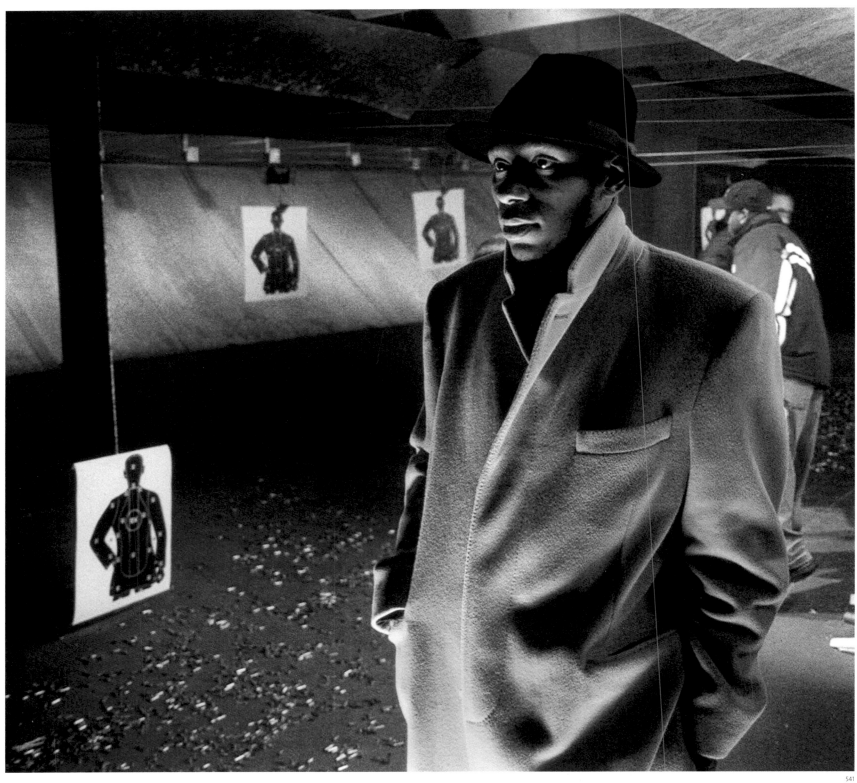

541

541. Rapper Mos Def filming a music video, inspired by Amadou Diallo's murder, in the Seneca Sporting Lane shooting gallery in Brooklyn, New York City, 19 February 2000. The popularity of rap music and hip hop grew significantly in the early and mid-1990s. Hip hop culture became a powerful influence in media, commercial advertising, and in the fashion industry. What had begun as the music and cultural expression of impoverished black and Latino urban communities has now become a multi-billion dollar international industry. Rap music reflected the growing levels of violence in many urban black communities. What was widely known as "gansta rap" frequently glorified gratuitious violence, misogyny, and homophobia. Other rap artists, however, expressed a more politically progressive version of rap. Born Dante Beze on 11 December 1973 in Brooklyn, rap artist Mos Def began rhyming at the age of nine. His first record was released in 1994 and he soon became a popular recording and performing artist. His first solo album, *Black on Both Sides*, became a gold record. More than most hip hop artists, Mos Def emphasizes progressive political issues, speaking against "black on black" violence and the use of illegal drugs, and advocating community activism.

542. Black Entertainment Television (BET) chairman and founder Robert Johnson announcing the launch of a website catering to blacks at a news conference in New York City, 12 August 1999. African American businessman Robert L. Johnson founded BET, a modest cable company that first broadcast only two hours a week, in January 1980. By 1991, it had become the first black-controlled company to be listed on the New York Stock Exchange. In 1999, Viacom, a leading global media company, purchased BET for 2.3 billion dollars.

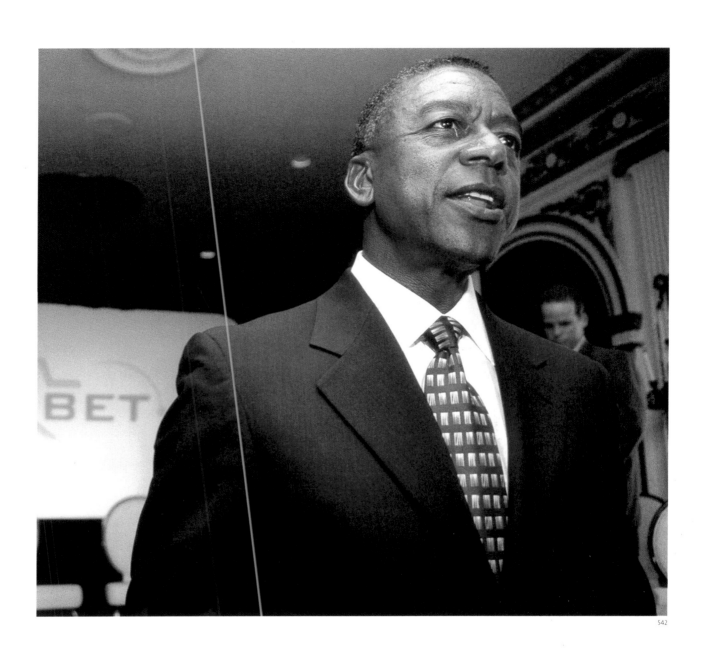

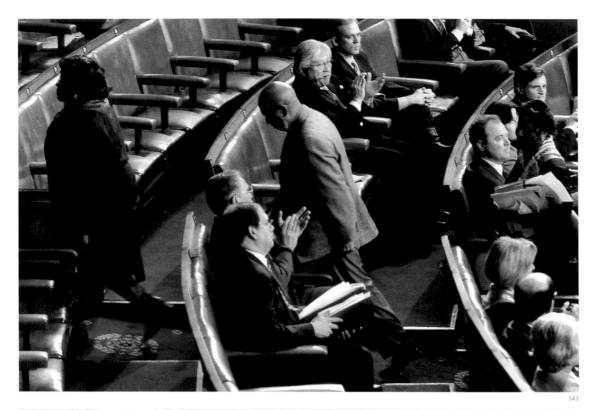

543

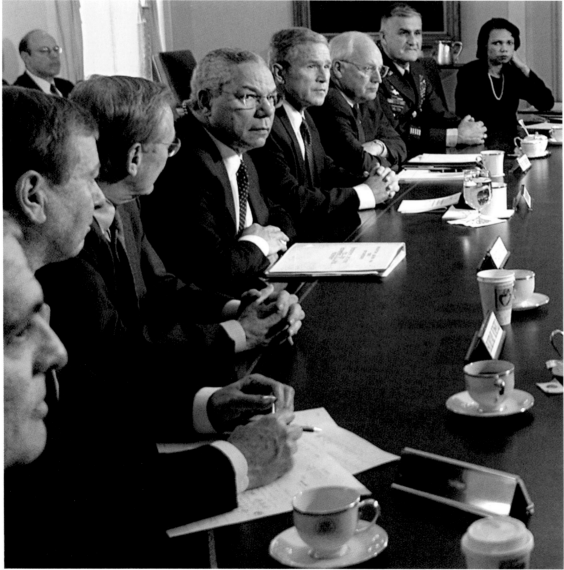

544

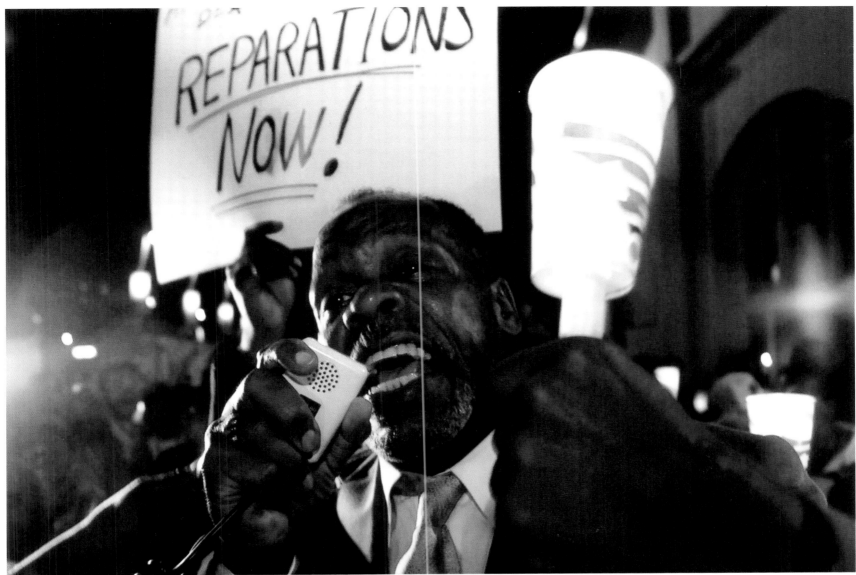

543. Congressional Black Caucus members leave the floor of the U. S. House of Representatives in protest of the Florida electoral vote count, 6 January 2001. In the election of 2000, Democratic presidential candidate Al Gore received over one half million more popular votes than his Republican challenger George W. Bush. An extremely close vote in the state of Florida called for a recount and for over one month it was unclear who the winner of the election would be. Ninety percent of all African American voters supported Gore and in the heavily contested state of Florida, 93 percent backed the Democratic candidate. In a five to four ruling, the U. S. Supreme Court declared Bush the winner of the election by only several hundred votes out of over six million in Florida. Bush was there-

fore awarded the presidency by an electoral vote margin of 271 to 266. About 8,000 voters, many of whom were black, were denied the right to vote, because they were erroneously listed as ex-felons, who in the state of Florida, are not permitted to vote. The U. S. Commission on Civil Rights later determined that the ballots of black Florida voters were nearly ten times more likely to be rejected from the official state-wide count due to alleged irregularities. Many African Americans therefore asserted that the election had been stolen by Bush. On 6 January 2001 the official count of the electoral college votes was held in the House of Representatives. All members of the Congressional Black Caucus and several other members of the House challenged this count based on the voting irregularities

that had occurred in the Florida race. The U. S. Constitution requires that at least one member of both the House and the Senate lodge an official objection in order to halt the parliamentary procedures in counting the vote, but not a single Democratic senator rose to support the Congressional Black Caucus' position. In protest, the caucus walked out of the House chamber, denouncing the election of George W. Bush as a miscarriage of justice.

544. The National Security Council during a meeting in the Cabinet Room of the White House, with CIA Director George Tenet, Attorney General John Ashcroft, Secretary of Defense Donald Rumsfeld, Secretary of State Colin Powell, President George W. Bush, Vice President Dick Cheney, Chairman of

the Joint Chiefs of Staff General Hugh Shelton, and National Security Advisor Condoleeza Rice (from left to right), Washington, D. C., 12 September 2001. With the election of George W. Bush, former General Colin Powell was nominated and confirmed as U. S. Secretary of State, making him the highest ranking African American public official in U. S. history. Bush also appointed African American Stanford University Provost Condeleeza Rice as his national security advisor. In the wake of the attacks on the World Trade Center and the Pentagon on 11 September, Powell and Rice assumed central roles in framing the administration's response.

545. Actor Danny Glover at a candlelight vigil at the World Conference Against Racism in Durban, South Africa, 5 September 2001. The United

Nations sponsored a World Conference Against Racism, Racial Discrimination, Xenophobia, and Related Intolerance (WCAR), which was held in Durban in August–September 2001. The conference was the culmination of many years of planning and outreach to several thousand groups throughout the world, including non-governmental organizations, faith-based institutions, and civic associations. For participants the conference symbolized the common aspirations and struggles of racialized minorities in different countries. Despite differences in languages, cultures, and nationalities, striking similarities are apparent among the Dalits (untouchables) of India, the Maori of New Zealand, the indigenous native peoples of Central and South America, and the diverse

societies of people of African descent. The conference was designed to facilitate the building of anti-racist global networks and to bring human rights activists and organizations in closer contact. A central debate was the issue of reparations: whether people of African descent in the United States and other countries of the African diaspora should be compensated for the crimes of slavery, racial segregation, and institutional racism. The official position of the U. S. government was that slavery was not a "crime against humanity." Citing the public controversy over the conference members' statements critical of the state of Israel, the United States government officially withdrew from the proceedings. Of the estimated 2,500 Americans at the conference, approximately 1,500 were African American.

546. Celebration of the "Juneteenth" festival in Coney Island, New York City. Juneteenth is a traditional African American celebration of freedom. The term comes from the date, June 19th 1865, when African Americans in Texas learned that slavery had been abolished. Today, Juneteenth continues to be celebrated by African Americans throughout the country as a ritual of cultural pride and historical continuity. It is a reminder that, despite the odds, African Americans have strived to be the creators of their own history and culture. The quest for freedom is closely linked with the construction of identity for people who have experienced oppression. Finding the capacity to celebrate in the face of adversity gives people the hope and strength that through collective action they have the power to change the direction of history.

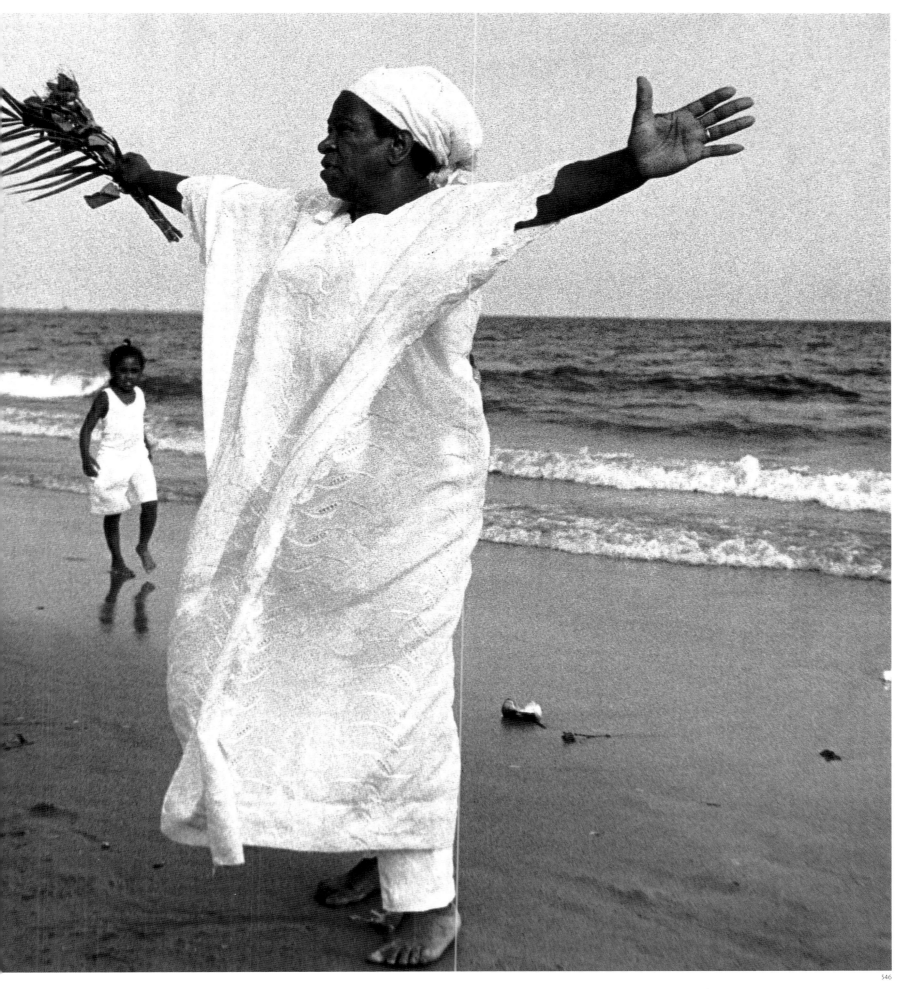

CHRONOLOGY

1619
Approximately twenty Africans are transported on a Dutch slave ship to Jamestown, Virginia. By 1750, African Americans represented over 20 percent of America's colonial population.

1739
Enslaved Africans lead an unsuccessful uprising against whites in the Stono rebellion in South Carolina.

1776
Five thousand African Americans join the American Continental Army in the war of independence against England.

1793
Invention of the cotton gin, which contributes directly to the great expansion of slavery in the United States.

1800
Gabriel Prosser's conspiracy involving one thousand slaves is discovered; Prosser and other rebel leaders are executed.

1822
Denmark Vesey leads an unsuccessful slave uprising conspiracy in Charleston, South Carolina. He and his supporters are hanged.

1827
Freedom's Journal, the first African American newspaper, is published in New York City.

1831
Nat Turner leads a slave uprising in Virginia, in which sixty whites are killed. Several hundred African Americans are murdered by whites in retaliation.

1850
Congress passes the Compromise of 1850, which includes a new fugitive slave act permitting federal marshals to arrest any black person accused of being a runaway slave.

1857
In *Dred Scott v. Sandford*, the U. S. Supreme Court declares that African Americans are not U. S. citizens and have no rights that white men are bound to respect. The decision voids the Missouri Compromise of 1820, and makes the Civil War inevitable.

1861
12 April: The Civil War begins when Confederates attack Fort Sumter in Charleston, South Carolina. At the time, approximately four million African Americans are enslaved in the United States.

1862
17 July: Congress amends the Enlistment Act, allowing African Americans to join the Union Army. By the end of the Civil War, over 186,000 African Americans had joined the ranks.

1863
Abraham Lincoln's Emancipation Proclamation goes into effect, technically freeing only slaves in areas of rebellion against the United States.

1866
The Ku Klux Klan is founded by Confederate veterans in Pulaski, Tennessee, with an agenda based on opposition to Reconstruction and promoting white supremacy.

1867–1870s
During the period of Reconstruction in the South, black male suffrage is granted, and several hundred African Americans are elected to state legislatures and the U. S. Congress.

1868
The Hampton Institute, a co-educational school for African Americans, is founded by Samuel Chapman Armstrong.

1875
Congress passes the Civil Rights Act, which declares that "all persons within the jurisdiction of the United States shall be entitled to the full and equal enjoyment" of public facilities, "applicable alike to citizens of every race and color, regardless of any previous condition of servitude."

1877
The Compromise of 1877 makes Rutherford B. Hayes president of the United States, but federal troops are withdrawn from the South; Reconstruction ends.

1881
Booker T. Washington founds the Tuskegee Institute in Alabama.

1883
The Supreme Court overturns the 1875 Civil Rights Act, declaring it unconstitutional.

1896
May 18: The U.S. Supreme Court rules in *Plessy v. Ferguson* that railroads shall provide "separate but equal" accommodations for blacks and whites, thus legally endorsing the widespread segregation of public facilities.

Mary Church Terrell, a prominent black activist, founds the National Association of Colored Women (NACW).

1905
The Niagara Movement is founded by a group of African Americans led by W. E. B. Du Bois and William Monroe Trotter as an implicit challenge to Booker T. Washington's theory of "accomodation."

1909
May 31: Founding conference of the National Association for the Advancement of Colored People (NAACP) is held in New York City.

1915–1920s
During the first wave of the Great Migration, one million African Americans leave the rural South and migrated to urban areas in the Northeast and Midwest.

1916
Jamaican-born Marcus Garvey moves to the United States, where, within a few years, his Universal Negro Improvement Association attracts hundreds of thousands of followers.

1917
The United States enters World War I. During the war nearly 2.3 million African Americans registered to serve in the military. They were organized in strictly segregated units.

1919
In a violent period known as the "Red Summer," twenty-five major race riots break out in the United States. Lynchings and attacks on blacks by white mobs are rampant.

1921
1–3 June: In Tulsa, Oklahoma, thousands of whites participate in three days of volent attacks against the black community.

1925
A. Philip Randolph founds the Brotherhood of Sleeping Car Porters (BSCP), which becomes the first black union to successfully negociate with a white-owned corporation.

1931
The "Scottsboro Boys," nine young African American males, are arrested on false charges of rape on a freight train in Alabama. An all-white jury finds all nine boys guilty and sentences eight to death.

1935
19 March: Urban unrest erupts in Harlem, New York City following the arrest of a black teenager for shoplifting.

1936
Hundreds of black organizations establish the National Negro Congress led by A. Philip Randolph.

1938
22 June: Heavyweight Champion Joe Louis defeats German boxer Max Schmelling at Yankee Stadium, New York City.

1939
As a result of pressure from civil rights organizations, President Roosevelt appoints a "black cabinet" of African Americans intellectuals, officials, and administrators to represent black interests in his administration.

1940
The NAACP Legal Defense and Education Fund is founded and becomes the primary legal arm of the civil rights movement.

1941
A. Philip Randolph organizes the first March on Washington Movement. The march is called off when on 25 June President Roosevelt signs Executive Order 8802 establishing the Fair Employment Practices Committee.

1 July: Tuskegee Army Air Field is established as the result of a federal plan to create an aviation school for African American pilots.

7 December: The U. S. enters World War II. One million African American women and men served in the armed forces during the war.

1942

James Farmer founds the Congress of Racial Equality (CORE), a civil rights organization dedicated to the use of nonviolent direct action.

28 February: Riots break out at the Sojourner Truth Housing Project in Detroit when mobs of whites block African American residents from entering the finished homes.

1943

June: Urban unrest breaks out in Detroit after confrontations occur between whites and blacks at Belle Isle Amusement Park. Federal troops are sent by President Franklin D. Roosevelt to restore order.

2 August: Urban unrest breaks out in Harlem following the shooting of a uniformed African American soldier by a police officer. In the aftermath of the disturbance, New York City Mayor Fiorello La Guardia created the Emergency Conference for Interracial Unity to reduce racial tensions and economic discrimination in white-owned businesses in Harlem.

1945–1960s

Second wave of the Great Migration brings over three million African Americans from the South to major cities in the Northeast, Midwest, and Pacific coast.

1947

April: Professional baseball is desegregated as Jackie Robinson begins his career with the Brooklyn Dodgers.

1948

26 July: President Harry Truman signs Executive Order 9981 requiring the desegregation of the armed forces.

1949

April: Paul Robeson's condemnation of military action against the Soviet Union at the World Peace Conference in Paris is distorted by the press, and leads to his accusation by the House Un-American Activities Committee.

August: Rioters prohibit Robeson from performing a concert in Peekskill.

1951

Attorney and civil rights activist William L. Patterson submits "We Charge Genocide," a petition presenting evidence of human rights violations of African Americans in the United States, to the United Nations Genocide Convention.

1952

The last all-black unit of the U. S. armed forces is disbanded during the Korean War (1950–53).

1954

In *Brown v. Board of Education of Topeka, Kansas*, the U. S. Supreme Court rules segregation of schools to be unconstitutional.

1955

1 December: NAACP activist Rosa Parks is arrested in Montgomery, Alabama, after refusing to surrender her seat to a white man on a bus.

5 December: The vast majority of African American citizens in Montgomery respond to the bus boycott called for by the Women's Political Council and NAACP and refuse to ride the city's segregated buses.

1956

February: Autherine Lucy, the first black student to be admitted to the University of Alabama, withdraws from the university after days of rioting by white students.

13 November: The Supreme Court rules to integrate Montgomery buses signaling an end to the bus boycott one month later.

1957

11 January: Martin Luther King, Jr. becomes leader of the Southern Christian Leadership Conference (SCLC).

September: For weeks, nine black students who attempted to register were prevented from entering Central High School in Little Rock, Arkansas. Finally, they were escorted into the school by the federalized National Guard.

1960

February: A widespread sit-in movement to desegregate lunch counters begins after four black college students demand service at a whites-only F. W. Woolworth's lunch counter in Greensboro, North Carolina.

15 April: The Student Nonviolent Coordinating Committee (SNCC) is established at an SCLC meeting in Raleigh, North Carolina.

1961

May: "Freedom Riders," groups of black and white protesters, start to travel together throughout the South to force the desegregation of buses and other public facilities.

In Anniston and Birmingham, Alabama, Freedom Riders are brutally assaulted by white mobs.

1962

The U. S. Supreme Court orders the admission of James Meredith to the University of Mississippi, and federal troops are deployed to escort him to class.

1963

3 April: The SCLC launches a major protest in Birmingham, Alabama, to attack the city's segregation policies. The peaceful protest meets heavy-handed repression by the police.

12 June: NAACP leader Medgar W. Evers is murdered outside his home in Jackson, Mississippi.

28 August: In response to the call by civil rights activists for a major March on Washington, D. C., approximately 250,000 demonstrators gather on the Washington Mall, where Martin Luther King, Jr. delivers his famous "I Have a Dream" speech.

15 September: The Sixteenth Street Baptist Church in Birmingham, Alabma, is bombed on Sunday morning, killing four young black schoolgirls.

1964

During the "Freedom Summer" in Mississippi, civil rights organizations call upon student volunteers to help organize a major, state-wide voter-registration campaign.

21 June: Three civil rights workers, James Earl Chaney, Michael Schwerner, and Andrew Goodman, are kidnapped and murdered by members of the Ku Klux Klan in Neshoba County, Mississippi.

2 July: President Lyndon B. Johnson signs the 1964 Civil Rights Act into effect, creating measures of legal protection against discrimination in all aspects of public life.

22 August: The Mississippi Freedom Democratic Party (MFDP), an independent party created in reaction against the pro-segregationist Missississippi Democratic Party, demand the right to represent the people of their state at the Democratic National Convention in Atlantic City, New Jersey. The MFDP refuses the compromise suggested by the convention's Credentials Committee.

November: President Johnson authorizes expanded deployment of U. S. troops in South Vietnam, beginning a dramatic escalation of U. S. involvement in the war.

10 December: Martin Luther King, Jr., is awarded the Nobel Peace Prize.

1965

21 February: Malcom X is assassinated in Harlem.

7 March: During their first attempt to walk from Selma to the Alabama capital Montgomery in a demonstration to support voters' rights, marchers are attacked by the police at the Edmund Pettus Bridge and forced to turn back.

21–25 March: Under protection from the federalized Alabama National Guard, army troops, and federal agents the marchers finally walk the distance from Selma to Montgmory.

August: President Lyndon B. Johnson signs the Voting Rights Act of 1965, prohibiting states from setting arbitrary restrictions on the exercise of the electoral franchise.

11–16 August: Urban unrest breaks out in Watts, Los Angeles, causing thirty-four casualties and thousands of arrests.

1966

6 June: James H. Meredith is shot and wounded by a gunman on the second day of his "March Against Fear," from Memphis, Tennessee, to Jackson, Mississippi. Prominent civil rights leaders such as Martin Luther King, Jr., and Stokely Carmichael continued the march that Meredith could not complete.

July: Martin Luther King, Jr., leads a large march to Chicago's city hall to protest de facto school segregation.

15 October: Bobby Seale and Huey Newton found the Black Panther Party for Self-Defense in Oakland, California.

1967

Major uprisings occur in cities throughout the U. S. during the "long, hot summer," caused by frustrated young African Americans faced with rampant discrimination, high rates of unemployment, poor housing and social services, and police brutality.

2 October: Thurgood Marshall becomes the first black U. S. Supreme Court justice.

28 October: Huey Newton is arrested and charged with the murder of an Oakland police officer.

1968

28 March: Martin Luther King, Jr. leads a first sanitation workers' strike in Memphis.

3 April: King delivers his last speech, "I've Been to the Mountaintop," during a rally at Mason Temple in Memphis.

4 April: King is assassinated on the balcony of the Lorraine Motel in Memphis.

May–June: Poor People's March to Washington, D. C.

1970

15 May: Police open fire on black students at Jackson State University, killing two students and wounding twelve.

October: Angela Davis is arrested in New York City, sparking a widespread "Free Angela Davis" campaign.

1971

9 September: Prisoners seize control of Attica State Prison in New York. After a long standoff, state troopers storm the prison under the order of Governor Nelson Rockefeller, killing 29 prisoners and 10 prison guards.

1972

March: The National Black Political Convention, the largest conference of political activists held during the Black Power period, is held in Gary, Indiana. It becomes instrumental in establishing a new black political movement.

1973

U. S. officially withdraws from Vietnam.

1974

21 June: U. S. District Court Judge W. Arthur Garrity, Jr., orders widespread busing to desegregate Boston's public schools, a move leading to protest and controversy.

1983

April: Harold Washington defeats Republican Bernard Epton to become the first African American mayor of Chicago.

Jesse Jackson announces his candidacy for the Democratic presidential nomination. He wins 3.5 million popular votes in the primary elections.

1985

Anti-apartheid protest rallies gain momentum in the United States.

1988

Jesse Jackson's second presidential campaign. Although it is unsuccessful, he wins more than seven million popular votes.

1989

20 January: In Miami, Florida, the killing of a black motorcyclist by police officers sparks racial conflict.

November: Democrat David M. Dinkins defeats Republican Rudolph Giuliani to become the first African American mayor of New York City.

1991

3 March: Motorist Rodney King is beaten by Los Angeles police officers after being arrested for reckless driving. An amateur videotape of the beating is broadcast throughout the world.

August: Tension between African Americans and Hasidic Jews in the Crown Heights section of Brooklyn, New York City, escalates after a car driving a rabbi accidentally strikes and kills Gavin Cato, a seven-year-old black youth.

1992

May: Urban unrest breaks out in Los Angeles and throughout the country after the acquittal of four LAPD officers accused of beating Rodney King.

1995

16 October: The Million Man March, organized by Nation of Islam leader Louis Farrakhan, is held in Washington, D. C.

1999

4 February: Unarmed West African immigrant Amadou Diallo is killed by members of the NYPD Special Crimes Unit while entering his Bronx apartment building, provoking public marches against police brutality.

2000

November: Following the presidential election of George W. Bush after the controversial victory of the popular election in Florida, the U. S. Commission on Civil Rights determines that a disproportionate number of African American ballots were rejected from the statewide count.

2001

January: Colin Powell becomes the first African American to be appointed U. S. Secretary of State.

August: 1,500 African Americans attend the United Nations World Conference on Racism in South Africa, which sparks debate over "black reparations."

INDEX

SELECTED BIBLIOGRAPHY

Birnbaum, Jonathan and Clarence Taylor, eds., *Civil Rights Since 1787: A Reader on the Black Struggle*. New York: New York University Press, 2000.

Carson, Clayborne, *In Struggle: SNCC and the Black Awakening of the 1960's*. Cambridge, Mass.: Harvard University Press, 1981.

Cooper, Anna Julia, *A Voice from the South, By a Black Woman from the South*. Xenia, Ohio: Aldine Printing House, 1892.

Dunbar, Paul Laurence, "We Wear the Mask" (1895), published in Joanne M. Braxton, ed., *Collected Poetry of Paul Laurence Dunbar*. Charlottesville, Virginia: University of Virginia Press, 1993.

Fairclough, Adam, *To Redeem the Soul of America: The Southern Christian Leadership Conference and Martin Luther King, Jr.* Athens, Georgia: University of Georgia Press, 1987.

Foner, Eric, "African Americans and the Story of American Freedom." *Souls: A Critical Journal of Black Politics, Culture and Society*, I, no. 1 (1999).

Foner, Philip S., *Organized Labor and the Black Worker, 1619-1981*. New York: International Publishers, 1981.

Franklin, John Hope and Alfred A. Moss, Jr., *From Slavery to Freedom: A History of African Americans*. New York: McGraw-Hill, 1994 (seventh ed.).

Franklin, V.P., *Black Self-Determination: A Cultural History of African American Resistance*. Brooklyn, New York: Lawrence Hill, 1992.

Gaines, Kevin, *Uplifting the Race: Black Leadership, Politics, and Culture in the Twentieth Century*. Chapel Hill, North Carolina: University of North Carolina Press, 1966.

Gutman, Herbert G., *The Black Family in Slavery and Freedom, 1750-1925*. New York: Pantheon, 1976.

Henry, Charles, *Culture and African-American Politics*. Bloomington, Indiana: Indiana University Press, 1990.

Hine, Darlene Clark and Kathleen Thompson, *A Shining Thread of Hope: The History of Black Women in America*. New York: Broadway Books, 1998.

Hughes, Langston, *The Panther and the Lash: Poems of Our Time*. New York: Vintage Books, 1992.

Kelley, Robin D. G., and Earl Lewis, eds., *To Make Our World Anew: A History of African Americans*. New York: Oxford University Press, 2000.

Lawson, Stephen, *Running for Freedom: Civil Rights and Black Politics in America Since 1941*. New York: McGraw-Hill, 1991.

Low, W. Augustus and Virgil A. Cliff, eds., *Encyclopedia of Black America*. New York: Da Capo Press, 1981.

Lowery, Charles D., and John F. Marszalek, eds., *Encyclopedia of African-American Civil Rights*. New York: Greenwood, 1992.

Marable, Manning, *Black American Politics: From the Washington Marches to Jesse Jackson*. London: Verso, 1985.

Marable, Manning, *Race, Reform and Rebellion: The Second Reconstruction in Black America, 1945-1990*. Jackson: University Press of Mississippi, 1991 (rev. second ed.).

Marable, Manning, *How Capitalism Underdeveloped Black America: Problems in Race, Political Economy and Society*. Cambridge: South End Press, 2000 (rev. ed.).

Marable, Manning and Leith Mullings, eds., *Let Nobody Turn Us Around: Voices of Resistance, Reform and Renewal, An African American Anthology*. Latham, Maryland: Rowman and Littlefield, 2000.

Mullings, Leith, *On Our Own Terms: Race, Class and Gender in the Lives of African American Women*. New York: Routledge, 1977.

Sitkoff, Harvard, *A New Deal for Blacks: The Emergence of Civil Rights as a National Issue: The Depression Decade*. New York: Oxford University Press, 1978.

Van Deburg, William L., *New Day in Babylon: The Black Power Movement and American Culture, 1965-1975*. Chicago: University of Chicago Press, 1992.

Williams, Juan, *Eyes on the Prize: America's Civil Rights Years 1954-1965*. New York: Viking Press, 1987.

PICTURE CREDITS

The credits are organized by picture number

001–002 Hulton Archive/Getty Images
003 Courtesy Illinois State Historical Library
004 The J. Paul Getty Museum
005–009 Peabody Museum (35-5-10/53069 - T1867, 35-5-10/53039 - T1869, 35-5-10/53044 - T1874, 35-5-10/53048 - T1178, 35-5-10/53-45 - T2490)
010 National Portrait Gallery/Smithsonian Institution/Art Resource, NY
011–012 Unknown, reprinted by the permission of Russell & Volkening as agents for the author Jackie Napolean Wilson.
013–016 Prints and Photographs Division Library of Congress (LC-USZC4-3937, LC-USZC4-3594, LC-USZC4-6768, LC-USZC4-6775)
017 The J. Paul Getty Museum
018–019 Corbis
020 Courtesy Illinois State Historical Library
021 Corbis
022 Culver Pictures Inc
023 Corbis
024-025 Hulton Archive/Getty Images
026-028 New Orleans Public Library
029 Louisiana State Museum
030 New Orleans Public Library
031–034 Louisiana State Museum
035 Stewart Collection, Mississippi Department of Archives and History, Jackson MS (PI/92.006.061)
036 Courtesy Birmingham Public Library (catalog #829.2.2.18)
037 B. L. Singley, Keystone View Company, Collection of International Center of Photography, Gift of Daniel Cowin, 1990. (456.1990)
038 J. A. Palmer, Aiken, SC, Collection of International Center of Photography, Gift of Daniel Cowin, 1990. (455.1990)
039 Louisiana State Museum
040–041 Prints and Photographs Division Library of Congress (LC-USZ62-54722, LC-USZ62-51555)
042 Tuskegee University Archives
043 Corbis
044 Collection of International Center of Photography, Gift of Daniel Cowin, 1990. (588.1990)
045 Special Collections and Archives, W.E.B. Du Bois Library, University of Massachusetts, Amherst.
046 Henry A. Strohmeyer & Henry Wyman, Collection of International Center of Photography, Gift of Daniel Cowin, 1990. (518.1990)
047–051 Prints and Photographs Division Library of Congress (LC-USZ62-107843, LC-USZ62-72445, LC-USZ62-35754, LC-USZ62-35751, LC-USZ62-51552)
052 Hulton Archive/Getty Images
053–056 Louisiana State Museum
057–060 Courtesy of Hampton University Archives
061 Allen-Littlefield Collection, Special Collections Division, Robert W. Woodruff Library, Emory University, GA
062-063 Scurlock Studio Collection, Archives Center, National Museum of American History, Smithsonian Institution.
064 Special Collections and Archives, W.E.B. Du Bois Library, University of Massachusetts, Amherst.
065–070 Tuskegee University Archives
071 Allen-Littlefield Collection, Special Collections Division, Robert W. Woodruff Library, Emory University, GA
072 North Carolina Collection, University of North Carolina at Chapel Hill.
073 Tuskegee University Archives
074 Hulton Archive/Getty Images
075 Photograph by Lewis W. Hine
076 Scurlock Studio Collection, Archives Center, National Museum of American History, Smithsonian Institution.
077 A. P. Bedou, National Portrait Gallery, Smithsonian Institution.
078 Prints and Photographs Division Library of Congress/NAACP Collection (LOT 13099 - No. 0028)
079 C. Bruce Santee, Collection of International Center of Photography, Gift of Daniel Cowin, 1990. (1085.1990)
081–083 Courtesy National Archives, Maryland (165-WW-127-121, 165-WW-127-138, 165-WW-127-44, 165-WW-127-105)
084–086: Brown Brothers, Sterling, PA
087 Courtesy National Archives, Maryland.
088 Culver Pictures Inc
089 Corbis
090 Courtesy National Archives, Maryland (165-WW-127-34)
091 Corbis
092 Brown Brothers, Sterling, PA
093 Lewis W. Hine, courtesy George Eastman House
094 James VanDerZee/©Donna Mussenden VanDerZee
095 Brown Brothers, Sterling, PA
096 Special Collections and Archives, W.E.B. Du Bois Library, University of Massachusetts, Amherst.
097 ©Bob Hower, from the book Angels of Mercy
098-100 Courtesy Special Collections Department, McFarlin Library, University of Tulsa
101–103 James VanDerZee/©Donna Mussenden VanDerZee
104 Scurlock Studio Collection, Archives Center, National Museum of American History, Smithsonian Institution.
105 Billy Rose Theatre Collection/New York Public Library
106 Corbis
107 Portrait Collection – Langston Hughes, Schomburg Center for Research in Black Culture, New York Public Library.
108 Corbis
109 Organizations – UNIA, Schomburg Center for Research in Black Culture, New York Public Library.
110 James VanDerZee/©Donna Mussenden VanDerZee
111 Redferns, London
112 Hulton Archive/Getty Images
113 Brown Brothers, Sterling, PA
114 Corbis
115 Hulton Archive/Getty Images
116 Portrait Collection – Women, Schomburg Center for Research in Black Culture, New York Public Library.
117–118 James VanDerZee/©Donna Mussenden VanDerZee
119 Hulton Archive/Getty Images
120 Courtesy Birmingham Public Library (Catalog# 49.59)
121–128 Alabama Department of Archives and History, Montgomery, AL
129 Tuskegee University Archives
130 Corbis
131 Portrait Collection – Duke Ellington, Schomburg Center for Research in Black Culture, New York Public Library.
132 Carl Van Vechten Portfolio, Schomburg Center for Research in Black Culture, New York Public Library, ©Van Vechten Trust.
133 Billy Rose Theatre Collection, New York Public Library.
134 Photograph by Peter Sekaer, Courtesy Howard Greenberg Gallery, New York.
135 Louisiana State Museum
136 Courtesy National Archives, Maryland/ Harmon Foundation Collection.
137 ©Aaron Siskind Foundation, courtesy George Eastman House.
138 Photograph by John Gutmann ©Collection Center for Creative Photography. The University of Arizona.
139–140 Corbis
141 Courtesy The Dorothea Lange Collection, Oakland Museum California.
142 Corbis
143 Prints and Photographs Division, Library of Congress (LC-USZ61-1859)
144 Alabama Department of Archives and History, Montgomery, AL
145 Photography by Addison Scurlock, Courtesy Anacostia Museum and Center for African American History and Culture, Smithsonian Institution.
146 ©Consuelo Kanaga, The Brooklyn Museum of Art.
147–148 Prints and Photographs Division Library of Congress (LC-USF33-6029-M4, LC-USF33-6021-M4)
149 Carl Van Vechten Portfolio, Schomburg Center for Research in Black Culture, New York Public Library, ©Van Vechten Trust.
150 Culver Pictures Inc
151 Morgan and Marvin Smith Collection, Schomburg Center for Research in Black Culture, New York Public Library. Courtesy Mrs Monica Smith.
152 Prints and Photographs Division Library of Congress (LC-USF341-112953-B)
153 ©Robert H. McNeill, courtesy of the photographer.
154 Prints and Photographs Division Library of Congress (LC-USF33-2349-M3)
155 ©Robert H. McNeill, courtesy of the photographer.
156 Morgan and Marvin Smith Collection, Schomburg Center for Research in Black Culture, New York Public Library. Courtesy Mrs Monica Smith.
157 ©Robert H. McNeill, courtesy of the photographer.
158 Morgan and Marvin Smith Collection, Schomburg Center for Research in Black Culture, New York Public Library. Courtesy Mrs Monica Smith.
159–161 ©Robert H. McNeill, courtesy of the photographer.
162 ©Aaron Siskind Foundation, courtesy George Eastman House.
163 ©Robert H. McNeill, courtesy of the photographer.
164 Morgan and Marvin Smith Collection, Schomburg Center for Research in Black Culture, New York Public Library. Courtesy Mrs Monica Smith.
165 ©Robert H. McNeill, courtesy of the photographer.
166 Prints and Photographs Division Library of Congress/NAACP Collection (LC-USZC4-4734)
167 Associated Press
168 Prints and Photographs Division Library of Congress (LC-USF33-2945-M4)
169 Scurlock Studio Collection, Archives Center, National Museum of American History, Smithsonian Institution.
170 Photography by Charles Peterson, courtesy of Don Peterson Jazz Photo Collection.
171 ©Robert H. McNeill, courtesy of the photographer.
172 Mississippi Department of Archives and History, Jackson, MS.
173 Prints and Photographs Division Library of Congress (LC-USF34-34558-D)
174 Courtesy National Archives, Maryland/Harmon Foundation Collection.
175–176 ©Robert H. McNeill, courtesy of the photographer.
177–178 Prints and Photographs Division Library of Congress (LC-USF33-20522-M2, LC-USF33-20574-M1)
179 ©Robert H. McNeill, courtesy of the photographer.
180 Prints and Photographs Division Library of Congress/NAACP Collection (Lot 13089 - No. 0020)
181 Morgan and Marvin Smith Collection, Schomburg Center for Research in Black Culture, New York Public Library. Courtesy Mrs Monica Smith.
182 Photograph by Alexander Alland, courtesy Howard Greenberg Gallery
183–192 Prints and Photographs Division Library of Congress (LC-USF34-43159-D, LC-USF33-1297813-M2, LC-USF34-38735-D, LC-USF34-38732-D, LC-USF33-5152-M2, LC-USF34-043925-D, LC-USF34-38802-D, LC-USF33-5146-M3, LC-USF33-16122-M2, LC-USF34-38554-D)
193–194 Walter P. Reuther Library, Wayne State University Library.

195 ©Robert H. McNeill, courtesy of the photographer.

196–199 Prints and Photographs Division Library of Congress (LC-USF34-44210, LC-USF33-5159-M3, LC-USF33-5136-M3, LC-USF33-5142-M2)

200 University Head Office, Maxwell AFB, Montgomery, AL

201 Col. Roosevelt J. Lewis Collection at Moton Field, Tuskegee, AL

202 Prints and Photographs Division Library of Congress (LC-USW3-16265-E)

203–204 The Detroit News

205–206 Prints and Photographs Division Library of Congress (LC-USW3-529-D, LC-USW3-52-D)

207 Col. Roosevelt J. Lewis Collection at Moton Field, Tuskegee, AL

208 Tuskegee University Archives

209–211 Prints and Photographs Division Library of Congress (LC-USW3-1470-D, NAACP Collection - Lot 13103 No. 0029, LC-USW3-4816-D)

212 Maxwell AFB, Montgomery, AL

213 Courtesy National Archives, Maryland (NA-208-NS-3848-2)

214 Prints and Photographs Division Library of Congress (LC-USW3-42724-C)

215 Culver Pictures Inc

216 Scurlock Studio Collection, Archives Center, National Museum of American History, Smithsonian Institution.

217–220 Prints and Photographs Division Library of Congress (LC-USW3-21946-D, LC-USW3-21925-D, LC-USW3-17732-E, LC-USW3-22019-E)

221 State Archives of Michigan

222 Corbis

223 Prints and Photographs Division Library of Congress/NAACP Collection (Lot 13078 - No. 0039)

224–225 Prints and Photographs Division Library of Congress (LC-USW3-31097-C, LC-USW3-32157-E)

226–228 Corbis

229–231 Prints and Photographs Division Library of Congress/NAACP Collection (Lot 13106 - No. 0199, Lot 13093 - No. 0090, Lot 13110 - No. 0038)

232 Corbis

233–234 Prints and Photographs Division Library of Congress/NAACP Collection (Lot 13089 - No. 0024, Lot 13091 - No. 0072)

235 ©Robert H. McNeill, courtesy of the photographer.

236 ©Griff Davis/Black Star

237 Chicago Historical Society (ICHI-19483)

238 ©Robert H. McNeill, courtesy of the photographer

239 Prints and Photographs Division Library of Congress/NAACP Collection (Lot 13099 - No. 0010)

240 ©Robert H. McNeill, courtesy of the photographer.

241 Photograph by Alexander Alland, Courtesy Howard Greenberg Gallery

242 ©Wayne Miller/Magnum Photos

243 Corbis

244 Corbis

245 Portrait Collection – Paul Robeson, Schomburg Center for Research in Black Culture, New York Public Library.

246–247 Civil Rights Congress Photograph Collection, Schomburg Center for Research in Black Culture, New York Public Library.

248 Corbis

249 Prints and Photographs Division Library of Congress, NAACP Collection (Lot 13099 - No. 0010)

250 Photograph by Willard Smith, Schomburg Center for Research in Black Culture, New York Public Library.

251 Hulton Archive/ Getty Images

252 Corbis

253 Hulton Archive/Getty Images

254 ©Robert H. McNeill, courtesy of the photographer

255 Portrait Collection – W.E.B. Du Bois, Schomburg Center for Research in Black Culture, New York Public Library.

256 Corbis

257 Courtesy National Archives, Maryland (III-SC-358355)

258 ©W. Eugene Smith/Magnum Photos

259 Corbis

260 Florence Mars Collection, Mississippi Department of Archives and History, Jackson MS (PI/Z/1770 Series II (56.1)

261 Hulton Archive/Getty Images

262 Prints and Photographs Division Library of Congress, NAACP Collection (Lot 13093 - No. 0066)

263 Florence Mars Collection, Mississippi Department of Archives and History, Jackson MS (PI/Z/1770 Series II (74.1)

264 ©Ed van der Elsken/The Netherlands Photo Archives

265 Prints and Photographs Division Library of Congress, NAACP Collection (Lot 13094 - No. 0030)

266 Don Cravens/TimePix

267 Associated Press

268 ©Paul Robertson, Sr., courtesy of the photographer.

269–271 ©Dan Weiner/Courtesy Sandra Weiner.

272 Associated Press

273 Prints and Photographs Division Library of Congress, NAACP Collection (Lot 13099 - No. 0071)

274–276 Corbis

277 ©Burt Glinn/Magnum Photos

278 Corbis

279 ©Ida Berman, Courtesy of Avery Research Center, Charleston, SC

280 Keystone, Paris

281–284 Corbis

285 ©Charles Moore/Black Star

286 ©Gordon Parks '1960

287 Corbis

288 Prints and Photographs Division Library of Congress, NAACP Collection (Lot 13100 - No. 0040)

289 ©Herman Leonard

290 ©Eve Arnold/Magnum Photos

291 Corbis

292 Don Urhbrook/TimePix

293 ©Bruce Davidson/Magnum Photos

294 Hulton Archive/Getty Images

295 Associated Press

296 ©Bruce Davidson/Magnum Photos

297–298 Hulton Archive/Getty Images

299 Corbis

300–301 ©Charles Moore/Black Star

302 ©Fred Ward/Black Star

303 ©Charles Moore/Black Star

304–305 Associated Press

306 ©Bob Adelman/Magnum Photos

307–309 ©Charles Moore/Black Star

310 ©Bob Adelman/Magnum Photos

311 Corbis

312 Associated Press

313 Birmingham News/ Courtesy Birmingham Pubic Library (Catalog# 1076.1.73)

314 ©Flip Schulke/Black Star

315 Birmingham News/ Courtesy Birmingham Public Library (Catalog# 1076.1.15)

316–317 Corbis

318–320 ©Leonard Freed/Magnum Photos

321–322 ©Steve Schapiro/Black Star

323 ©Flip Schulke/Black Star

324 ©Charles Moore/Black Star

325 Corbis

326 ©Danny Lyon/Magnum Photos

327 ©Leonard Freed/Magnum Photos

328–329 ©Charles Moore/Black Star

330 ©Steve Schapiro/Black Star

331 James Mahan/TimePix

332 ©Fred Ward/Black Star

333 ©Leonard Freed/Magnum Photos

334 ©Danny Lyon/Magnum Photos

335 ©Flip Schulke/Black Star

336 ©Builder Levy, courtesy of the photographer

337–338 ©Fred Ward/Black Star

339 ©Leonard Freed/Magnum Photos

340 ©Bob Adelman/Magnum Photos

341 Chicago Historical Society

342 Birmingham News/ Courtesy Birmingham Public Library (Catalog# 1076.1.59)

343 Corbis

344 ©Flip Schulke/Black Star

345 ©Charles Moore/Black Star

346 Courtesy Birmingham Public Library (Catalog# 85.1.20)

347–348 Corbis

349 Frank Dandridge/TimePix

350 Corbis

351–352 ©Danny Lyon/Magnum Photos

353 Corbis

354 ©Phillip Jones Griffiths/Magnum Photos

355 ©Bruce Davidson/Magnum Photos

356 Bob Gomel/TimePix

357 Corbis

358 Hulton Archive/Getty Images

359 Corbis

360 ©Danny Lyon/Magnum

361–362 ©Steve Schapiro/Black Star

363 Photograph by James Kerales, Courtesy Howard Greenberg Gallery

364 ©Herbert Randall/McCain Library and Archives, University Libraries, The University of Southern Mississippi.

365 ©Steve Schapiro/Black Star

366 Associated Press

367 Corbis

368 ©Matt Herron/Black Star

369 ©Shel Horshorn/Black Star

370 ©Bob Adelman/Magnum Photos

371 ©Herbert Randall/McCain Library and Archives, University Libraries, The University of Southern Mississippi.

372–373 ©Steve Schapiro/Black Star

374 ©Vernon Merritt/Black Star

375 ©Bob Fletcher, courtesy of the photographer.

376 Prints and Photographs Division Library of Congress.

377 ©Ballis/Black Star

378 ©Steve Schapiro/Black Star

379–380 ©Leonard Freed/Magnum Photos

381 Associated Press

382 ©Vernon Merritt/Black Star

383 Associated Press

384–386 Corbis

387 ©Bob Adelman/Magnum Photos

388 Associated Press

389 ©Spider Martin

390–391 ©Charles Moore/Black Star

392 ©Bob Adelman/Magnum Photos

393 Corbis

394 Alabama Department of Archives and History, Montgomery, AL (PN/17118)

395 ©Flip Schulke/Black Star

396 ©Matt Herron/Black Star

397–398 Hulton Archive/Getty Images

399 ©Charles Moore/Black Star

400 ©Ivan Massar/Black Star

401 ©Bruce Davidson/Magnum Photos

402 ©Builder Levy, courtesy of the photographer

403 Associated Press

404 ©Matt Herron/Black Star

405–407 Hulton Archive/Getty Images

408–409 Corbis

410 Corbis

411 ©Robert A. Sengstacke, courtesy of the photographer

412 ©Beuford Smith, courtesy of the photographer

413–414 ©Bob Fitch/Black Star

415 Associated Press

416 ©Flip Schulke/Black Star

417 ©Matt Herron/Black Star

418 ©Bob Fitch/Black Star

419 ©Robert A. Sengstacke

420 ©Rich Frishman/Black Star

421 Corbis

422–423 ©Builder Levy, courtesy of the photographer.
424 ©Hiroji Kubota/Magnum Photos
425–426 *Detroit Free Press*/Black Star
427 Hulton Archive/Getty Images
428 Redferns, London
429 Corbis
430 Associated Press
431 Corbis
432 ©Bob Fitch/Black Star
433 Courtesy Panopticon Gallery, Waltham, MA
434 ©Fred Ward/Black Star
435 Corbis
436 Joseph Louw/TimePix
437 ©Owen/Black Star
438 Hulton Archive/Getty Images
439 ©Beuford Smith, courtesy of the photographer
440 ©Sandra Weiner, courtesy of the photographer
441 ©Robert A. Sengstacke, courtesy of the photographer
442 ©Builder Levy, courtesy of the photographer
443 ©Vernon Merritt/Black Star
444 ©1968 Burk Uzzle/Chameleon Photos
445–446 ©Bob Adelman/Magnum Photos
447 ©Theodore Cowell/Black Star
448 Corbis
449–450 ©Elaine Tomlin/Courtesy of Department of Political
 History/National Museum of American
 History/Smithsonian Institute.
451 ©Robert Houston/Black Star
452 ©Paul Fusco/Magnum Photos
453 ©Dennis Brack/Black Star
454 Stephen Shames/Matrix/Katz Pictures
455 Associated Press
456 Stephen Shames/Matrix/Katz Pictures
457 Redferns, London
458 Associated Press
459 Hulton Archive/Getty Images
460 Associated Press
461–465 Stephen Shames/Matrix/Katz Pictures
466 ©Brent Jones, courtesy of the photographer
467 Chicago Historical Society
468 Corbis
469 Chicago Historical Society
470 Redferns, London
471 ©Bruno Barbey/Magnum Photos
472–474 Corbis
475 ©William E. Sauro/*The New York Times*
476 Associated Press
477 Daily World Photo
478 Corbis
479–480 Associated Press
481 Hulton Archive/Getty Images
482 J. Sims/Daily World Photo
483 Associated Press
484 Corbis
485–486 Associated Press
487 Stanley Forman, Pulitzer Prize 1977
488 ©Alon Reininger/Contact Press Images
489 Everett/Big Pictures Photo.com
490 NASA (S78-25849)
491 ©Gilles Peress/Magnum Photos
492 Corbis
493 ©Paul Fusco/Magnum Photos
494–495 ©Brent Jones, courtesy of the photographer
496 ©Eli Reed/Magnum Photos
497 Corbis
498–499 Rex Features
500 ©Gerry Goodstein/Yale Repertory Theatre
501 ©Eugene Richards
502 ©Eli Reed/Magnum Photos
503 Hulton Archive/Getty Images
504 British Film Institute Stills, Posters and Designs
505 Diana Walker/TimePix
506 ©Roger Hutchings/Network

507–508 Rex Features
509 Corbis
510 ©Tomas Muscionico/Contact Press Images
511 ©Eli Reed/Magnum Photos
512 ©Eugene Richards
513 ©J. B. Diederich/Contact Press Images
514 ©Toni Parks
515 Gamma Liaison/Katz Pictures
516 Rex Features
517 Gamma Liaison/Katz Pictures
518–519 Rex Features
520 ©Eli Reed/Magnum Photos
521 ©Bruce Davidson/Magnum Photos
522 Associated Press
523 Corbis
524 Rex Features
525 ©Paul Fusco/Magnum Photos
526 Associated Press
527 ©Eugene Richards
528 Associated Press
529 ©Eli Reed/Magnum Photos
530 Associated Press
531 ©Burt Glinn/Magnum Photos
532 Hulton Archive/Getty Images
533 ©Eli Reed/Magnum Photos
534 Rex Features
535 Winnie Klotz/Metropolitan Opera, New York.
536–537 ©Paul Fusco/Magnum Photos
538–545 Associated Press
546 ©Cheryll Miller

Phaidon Press Limited
Regent's Wharf
All Saints Street
London N1 9PA

Phaidon Press Inc.
180 Varick Street
New York, NY 10014

www. phaidon.com

First published 2002
© 2002 Phaidon Press Limited

ISBN 0 7148 4270 2

A CIP catalogue record
for this book is available
from the British Library.

Designed by Philippe Apeloig
Printed in Italy